The Adobe® Photoshop®

Lightroom Classic

Book

T0092211

Scott Kelby

The world's #1 best-selling
Lightroom book author

The Adobe Photoshop Lightroom Classic Book Team

MANAGING EDITOR
Kim Doty

COPY EDITOR
Cindy Snyder

ART DIRECTOR
Jessica Maldonado

PHOTOGRAPHY BY
Scott Kelby

Published by **New Riders**

Composed in Myriad Pro, Helvetica, and Blair ITC by Kelby Media Group, Inc.

ISBN13: 978-0-13-756533-7
ISBN10: 0-13-756533-X

5 2023

www.kelbyone.com
www.newriders.com

This book is dedicated
to my dear friend, colleague,
and one of Lightroom's guiding lights,
Winston Hendrickson.
You taught us so much, about so much.
We will miss you, always.
1962–2018

ACKNOWLEDGMENTS

I start the acknowledgments for every book I've ever written the same way—by thanking my amazing wife, Kalebra. If you knew what an incredible woman she is, you'd totally understand why.

This is going to sound silly, but if we go grocery shopping together, and she sends me off to a different aisle to get milk, when I return with the milk and she sees me coming back down the aisle, she gives me the warmest, most wonderful smile. It's not because she's happy that I found the milk; I get that same smile every time I see her, even if we've only been apart for 60 seconds. It's a smile that says, "There's the man I love."

If you got that smile dozens of times a day, for 31 years of marriage, you'd feel like the luckiest guy in the world—and believe me, I do. To this day, just seeing her puts a song in my heart and makes it skip a beat. When you go through life like this, it makes you one incredibly happy and grateful guy, and I truly am.

So, thank you, my love. Thanks for your kindness, your hugs, your understanding, your advice, your patience, your generosity, and for being such a caring and compassionate mother and wife. I love you.

Secondly, a big thanks to my son, Jordan. I wrote my first book when my wife was pregnant with him (24+ years ago), and he has literally grown up around my writing, so you can imagine how incredibly proud I was when he completed writing his own first novel (he's on number three now). It has been a blast watching him grow up into such a wonderful young man, with his mother's tender and loving heart, and compassion way beyond his years. He knows that his dad just could not be prouder, or more excited for him. #rolltide!

Thanks to our wonderful daughter, Kira, for being the answer to our prayers, for being such a blessing to your older brother, for proving once again that miracles happen every day. You are a clone of your mother, and believe me, there is no greater compliment I could give you. It is such a blessing to get to see such a happy, hilarious, clever, creative, and just awesome force of nature dancing around the house each day—she just has no idea how happy and proud she makes us.

A special thanks to my big brother, Jeff. I have so much to be thankful for in my life, and having you as such a positive role model while I was growing up is one thing I'm particularly thankful for. You're the best brother any guy could ever have, and I've said it a million times before, but one more surely wouldn't hurt—I love you, man!

My heartfelt thanks go to my entire team at KelbyOne. I know everybody thinks their team is really special, but this one time—I'm right. I'm so proud to get to work with you all, and I'm still amazed at what you're able to accomplish day in, day out, and I'm constantly impressed with how much passion and pride you put into everything you do.

A warm word of thanks goes to my in-house Editor, Kim Doty. It's her amazing attitude, passion, poise, and attention to detail that has kept me writing books. When you're writing a book like this, sometimes you can really feel like you're all alone, but she really makes me feel that I'm not alone—that we're a team. It often is her encouraging words or helpful ideas that keep me going when I've hit a wall, and I just can't thank her enough. Kim, you are "the best!"

I'm equally as lucky to have the brilliant Jessica Maldonado doing the design of my books. I just love the way Jessica designs, and all the clever little things she adds throughout. She's not just incredibly talented and a joy to work with, she's a very smart designer and thinks five steps ahead in every layout she builds. We hit the jackpot when we found you!

Also, a big thanks to our copy editor, Cindy Snyder, whom I feel very blessed to have still working with us on these books. Thank you, Cindy!

kelbyone.com

Thanks to my dear friend and business partner, Jean A. Kendra, for her support and friendship all these years. You mean a lot to me, to Kalebra, and to our company.

A big thanks to my dear friend, rocket photographer, professor of Tesla studies, unofficial but still official Disney Cruise guide, landscape photography sojourner, and Amazon Prime aficionado, Mr. Erik Kuna. You are one of the reasons I love coming to work each day. You're always uncovering cool things, thinking outside the box, and making sure we always do the right thing for the right reasons. Thanks for your friendship, all your hard work, and your invaluable advice.

Thanks to Kleber Stephenson for making sure all sorts of awesome things happen, doors open, and opportunities appear. I particularly enjoy our business trips together when we laugh too much, eat way too much, and have more fun on a business trip than was previously scheduled.

High-five to the crew at Peachpit Press, and to my editor, Laura Norman, for guiding my books safely to their birth.

Thanks to Rob Sylvan, Serge Ramelli, Matt Kloskowski, Terry White, and all the friends and educators who have helped and supported me on my Lightroom education journey. Thanks to Manny Steigman for always believing in me, and for his support and friendship all these years. Thanks to Gabe and all the wonderful folks at B&H Photo. It is the greatest camera store in the world, but it's so much more.

Thanks to these friends who had nothing to do with this book, but so much to do with my life, and I just want to give them the literary version of a hug: Ted Waitt, Don Page, Juan Alfonso, Moose Peterson, Jeff Revell, Jeff Leimbach, Larry Tiefenbrunn, Brandon Heiss, Eric Eggly, Larry Grace, Rob Foldy, Kelly Jones, British Superstar Dave Clayton, Jay Grammond, Victoria Pavlov, Dave Williams, Larry Becker, Peter Treadway, Roberto Pisconti, Fernando Santos, Glyn Dewis, Paul Kober, Marvin Derizen, Mike Kubeisy, Tonly Llanes, Maxx Hammond, Michael Benford, Brad Moore, Nancy Davis, Dave Gales, Mike Larson, Joe McNally, Annie Cahill, Rick Sammon, Mimo Meidany, Tayloe Harding, Jefferson Graham, Dave Black, John Couch, Greg Rostami, Matt Lange, Barb Cochran, Ed Buice, Jack Reznicki, Deb Uscilka, Frank Doorhof, Bob DeChiara, Karl-Franz, Peter Hurley, Kathy Porupski, and of course, Vanelli.

I owe a debt of thanks to some awesome people at Adobe: Jeff Tranberry, whom I nominate as the world's most responsive superhero; Lightroom Product Manager Sharad Mangalick, for all his help, insights, and advice; and Tom Hogarty for answering lots of questions and late-night emails, and for always helping me to see the bigger picture. You guys are the best!

Thanks to my friends at Adobe Systems: Bryan Hughes, Terry White, Stephen Nielson, Bryan Lamkin, Julieanne Kost, and Russell Preston Brown. Gone but not forgotten: Barbara Rice, Rye Livingston, Jim Heiser, John Loiacono, Kevin Connor, Deb Whitman, Addy Roff, Cari Gushiken, Karen Gauthier, and Winston Hendrickson.

Thanks to my mentors, whose wisdom and whip-cracking have helped me immeasurably, including John Graden, Jack Lee, Dave Gales, Judy Farmer, and Douglas Poole.

Most importantly, I want to thank God, and His Son Jesus Christ, for leading me to the woman of my dreams, for blessing us with two amazing children, for allowing me to make a living doing something I truly love, for always being there when I need Him, for blessing me with a wonderful, fulfilling, and happy life, and such a warm, loving family to share it with.

OTHER BOOKS BY SCOTT KELBY

The Natural Light Portrait Book

Photoshop for Lightroom Users

The iPhone Photography Book

The Flash Book

The Landscape Photography Book

How Do I Do That In Lightroom?

How Do I Do That In Photoshop?

Professional Portrait Retouching Techniques for Photographers Using Photoshop

The Digital Photography Book, parts 1, 2, 3, 4 & 5

Light It, Shoot It, Retouch It

The Adobe Photoshop Book for Digital Photographers

The Photoshop Elements Book for Digital Photographers

It's a Jesus Thing: The Book for Wanna Be-lievers

Professional Sports Photography Workflow

ABOUT THE AUTHOR

Scott Kelby

Scott is President and CEO of KelbyOne, an online educational community for photographers. He is Editor, Publisher, and co-founder of *Photoshop User* magazine; host of *The Grid*, the influential, live, weekly talk show for photographers; and is founder of the annual Scott Kelby's Worldwide Photo Walk.™

Scott is an award-winning photographer, designer, and bestselling author of more than 100 books, including *Photoshop for Lightroom Users*; *The Landscape Photography Book*; *Light It, Shoot It, Retouch It*; *The Adobe Photoshop Book for Digital Photographers*; *The Flash Book*; *The Natural Light Portrait Book*; and his landmark, and *The Digital Photography Book*, which is the #1 top-selling book ever on digital photography.

His books have been translated into dozens of different languages, including Chinese, Russian, Spanish, Korean, Polish, Taiwanese, French, German, Italian, Japanese, Hebrew, Dutch, Swedish, Turkish, and Portuguese, among many others. He is a recipient of the prestigious ASP International Award, presented annually by the American Society of Photographers for "…contributions in a special or significant way to the ideals of Professional Photography as an art and a science," and the HIPA award, presented for his contributions to photography education worldwide.

Scott is Conference Technical Chair for the annual Photoshop World Conference and a frequent speaker at conferences and trade shows around the world. He is featured in a series of online learning courses at KelbyOne.com and has been training photographers and Photoshop users since 1993.

For more information on Scott, visit him at:

His Lightroom blog: **lightroomkillertips.com**

His personal blog: **scottkelby.com**

Twitter: **@scottkelby**

Facebook: **facebook.com/skelby**

Instagram: **@scottkelby**

TABLE OF CONTENTS

TABLE OF CONTENTS

kelbyone.com

Seven Things You'll Wish You Had Known Before Reading This Book

I really want to make sure you get the absolute most out of reading this book, and if you take two minutes and read these seven (or so) things now, I promise it will make a big difference in your success with Lightroom Classic, and with this book, in general (plus, it will keep you from sending me an email asking something that everyone who skips this part will wind up doing). By the way, the captures shown here are just so there's not big, blank spaces—they're essentially for looks (hey, we're photographers—how things look matters).

(1) This book is for Lightroom Classic users (the version of Lightroom that has been around for 15 years now—the one we all know and love). If your Lightroom looks like the one you see here, you're in the right place. If your Lightroom doesn't look like this (you don't see Library, Develop, Map, etc., across the top like you see here), you're using a different version of Lightroom that is based on storing your images in the cloud, and its name is just Lightroom. This book only covers LIghtroom Classic—not the cloud-storage version (even though the two have many things in common and work the same way). You are still welcome to stay and look at the pictures, though.

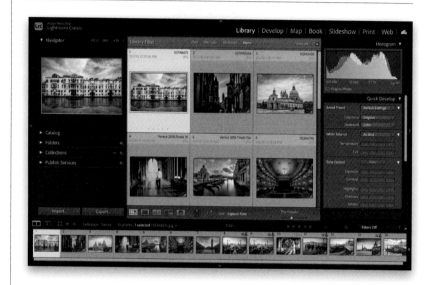

(2) You can download many of the key photos used here in the book, so you can follow along using many of the same images that I used, at **http://kelbyone .com/books/lrclassic8**. See, this is one of those things I was talking about that you'd miss if you skipped over this and jumped right to Chapter 1. Then you'd send me an angry email about how I didn't tell you where to download the photos. You wouldn't be the first.

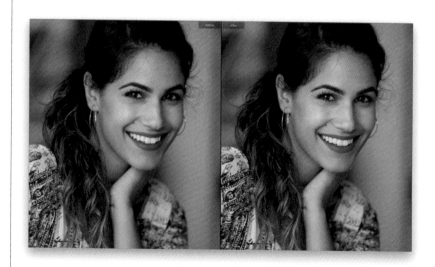

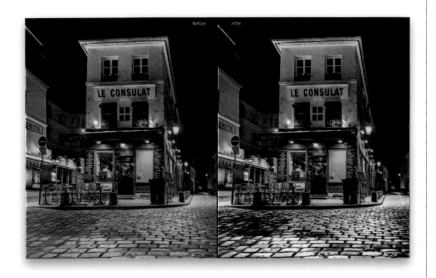

(3) If you've read my other books, you know they're usually "jump in anywhere" books, but with Lightroom, I wrote the book in the order you'll probably wind up using the program, so if you're new to Lightroom, I would really recommend you start with Chapter 1 and go through the book in order. But hey—it's your book —if you decide to just hollow out the insides and store your valuables in there, I'll never know. Also, make sure you read the opening to each project, up at the top of the page. Those actually have information you'll need to know, so don't skip over them and head straight for the steps.

(4) The official name of the software is "Adobe Photoshop Lightroom Classic" because it's part of the Photoshop family, but if every time I referred to it throughout the book, I called it "Adobe Photoshop Lightroom Classic" you would eventually want to strangle me (or the person sitting nearest you). So, from here on out, I usually just refer to it as "Lightroom" or "Lightroom Classic."

(5) Warning: The intro page at the beginning of each chapter is designed to give you a quick mental break, and honestly, they have little to do with the chapter. In fact, they have little to do with anything, but writing these quirky chapter intros is kind of a tradition of mine (I do this in all my books, and I even released a book of just the best chapter intros from all of my books. I am not making this up). But, if you're one of those really "serious" types, you can skip them, because they'll just get on your nerves. The rest of the book is normal, but that one single page, at the beginning of each chapter, well… it's not normal. Just so ya know.

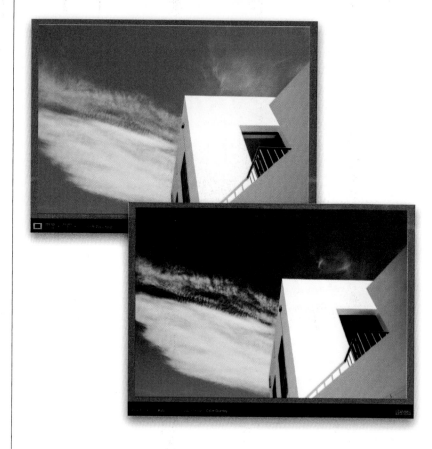

(6) Where are the chapters on the Web module and the Slideshow module? They're on the web (you'll find them at the address in #7.1). I put them there because Adobe has…well…I think they've kind of abandoned them (not officially mind you, but come on—they haven't really added any new features in quite a while, so I can't [with a straight face] recommend that you use them at all). Though, I do have one really good use for the Slideshow module, and I put that in the Video chapter (which is also on the web for you). But, just in case, I still posted those chapters on the web, so just think of them as bonus chapters you won't ever read for features you won't ever use.

(7) Who's up for some cool, free Light-room presets? I think you've earned 'em (well, at least you will have by the time you finish this book). Now, if you're a brand-new user and you're not sure what presets are yet, they are basically "one-click wonders" that make your photos look awesome. There's a huge market for presets and people sell presets like these all day long (for bunches of money). But, because I dig you with the passion of a thousand burning suns (or because you bought this book—I'll let you decide which reason fits you best), I'm giving you a whole bunch of them we created here in-house. Anyway, the link to them, and samples of how they look, are found on the downloads page (mentioned below in #7.1). See? I care.

SCOTT KELBY | PHOTOGRAPHY

(7.1) I created a couple bonus videos for you. One shows you how to get started by moving all your images onto an external hard drive (which you'll learn about in Chapter 1), and the others show you how to create a custom border in Photoshop that you can add to your prints (you'll learn how to do this in Chapter 11). You can find these at **http://kelbyone .com/books/lrclassic8**. Okay, now turn the page and let's get to work.

IMPORTING
getting your photos into Lightroom

I hate to start the book with a disclaimer, but we live in such a litigious society these days that I feel it's necessary to address some of these concerns up front. Before you read this chapter introduction (or any of them for that matter), you need to go, right now, and read #5 of the "Seven Things You'll Wish You Had Known Before Reading This Book" (on page xiv). Once you've read that, and fully understand what you're dialing up for, you'll need to sign a standard CRMC (Consent to Read Meaningless Content) release form and indemnification, and answer a few simple questions (all multiple choice). Once complete, please upload two forms of government-issued ID (driver's license, passport, military ID, etc.), and a copy of your social security card to any random online site based in the former Soviet Union. Once they've cleaned out your savings and applied for credit cards and a loan in your name, and you're at that, "Really, what do I have left to lose?" stage, then you're probably ready to give these puppies a read. Now, I have good news and bad news—which do you want first? Okay, the good news? Well, the good news is: this is the most coherent and grounded of all the chapter intros in the book. That's why I put it first. The bad news is: this is the most coherent and grounded of all the chapter intros in the book. This can only mean one thing: the worst is yet to come. Of course, depending on your overall humor acuity score, assigned to you by the Fraternal Alliance of Relatability and Testing (you can use their acronym, if you'd like) when you completed the CRMC, you'll either: (a) find that these chapter intros are an appropriate use of your time; or (b) you'll skip them altogether, because they'll chip away at a tiny bit of your soul. But, hey, it's totally your call.

Importing Photos Already on Your Hard Drive

One of the most important concepts to understand about Lightroom is this: while Adobe calls this process "Importing," it doesn't actually move or copy images *into* Lightroom. Your images never move—they're still right on your external hard drive (we'll look at storing your images on an external drive more in Chapter 2). Lightroom is just "managing" them now. It's like you told Lightroom, "See those images on my external drive? Manage those for me." Of course, they would be impossible to manage if you couldn't see them, so Lightroom creates thumbnail previews of the images and that's what you're seeing in Lightroom. Your actual images never actually move or get copied "into" Lightroom.

Step One:

First, before you start to import your photos, make sure you read that intro above—it's really important to your overall understanding of the import process. Luckily, importing images into Lightroom is about the easiest thing in the world. Go to your external hard drive and simply drag-and-drop the folder of images you want to import directly onto Lightroom's icon (in your Dock on a Mac, or on your desktop on a PC). This brings up Lightroom's **Import window** (seen here).

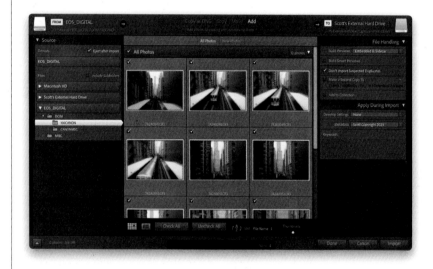

Step Two:

It assumes you want all the images in the folder imported—that's why there's a checkbox next to every one. If there's a photo you don't want imported, click on its checkbox to uncheck it, and it won't get imported. To see any image larger, double-click on it. To return to the regular thumbnail grid view, double-click again or press the **G key** on your keyboard. If you want to see all these thumbnails larger, drag the Thumbnails slider (at the bottom) to the right. There are a few other options here, but we're going to ignore those for now (don't worry, we'll get to them soon enough), so all you have to do is click the **Import button** (seen here) in the bottom-right corner of the window, and your images will appear in Lightroom. That's really all there is to doing a simple import and having Lightroom start managing those images for you.

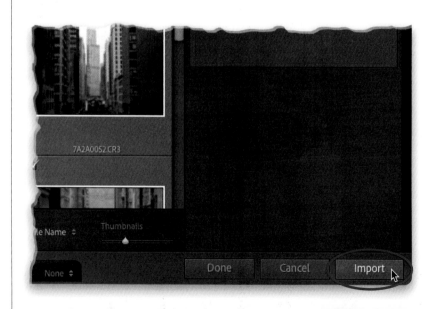

Lightroom builds image previews in different sizes: thumbnail, standard screen size, and 100% (called 1:1 in Lightroom speak). The larger the preview size, the longer it takes Lightroom to render it when you first import. Luckily, you can choose how fast these are displayed based on your personal level of patience. I have the patience of a hamster, so I want it to show me my thumbnails *now* (but, there's a price to pay for this speed)! You'll need to find which preview method suits your personality.

Choosing How Fast Your Thumbnails Appear

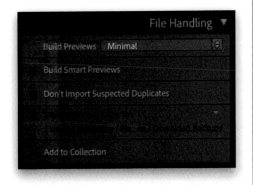

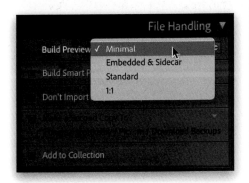

Choose from one of these:

At the top right of the Import window, in the File Handling panel, from the **Build Previews pop-up menu**, you get four choices for how fast your image previews (your thumbnails and sizes larger than just thumbnails) will appear when you zoom in on a photo in Lightroom. We'll go from the fastest to slowest:

(1) Minimal (for Very Fast Thumbnails)

This option displays your image thumbnails the fastest, and if you shoot in RAW and choose Minimal, Lightroom grabs the smallest JPEG preview it can from the ones the camera manufacturer includes within the RAW image (the same JPEG preview you see on the back of your camera when you shoot in RAW). It uses that as your thumbnail and it appears super-fast! (*Note:* This is the option I choose all the time.) These super-fast Minimal previews are not necessarily the most color-accurate, so you're temporarily trading 100% color accuracy to see your thumbnails faster. If you need to see a more color-accurate version of the image, just double-click on the thumbnail and Lightroom grabs a larger preview from the ones the camera manufacturer included with the RAW image. If they didn't include a larger image, Lightroom creates one for you (you just have to wait a few seconds longer for them to appear). *Note:* If you shoot in JPEG, your thumbnails will appear quickly anyway—zooming in is quick too, and the color will be fairly accurate. Score two-points for JPEG!

(2) Embedded & Sidecar

Choose Embedded & Sidecar for the largest previews created by your camera (if you shot in RAW). It's a little slower than Minimal in bringing up your thumbnails, but still fairly quick. Double-click to zoom in on a thumbnail, and you'll wait a second while it builds the larger preview before you can see it (you'll see a message that says "Loading"). Zoom in even closer, and you'll have to wait a few moments more (you'll see "Loading" again) because it doesn't create these larger, higher-quality previews until you try to zoom in.

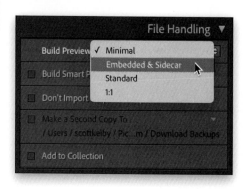

(3) Standard

Choosing Standard is slower yet. Standard-sized previews are what you see when you double-click on a thumbnail and it zooms in, or you take the image over to the Develop module. When you choose Standard you're going to wait longer, until all the standard-sized previews are rendered, so when you double-click on images later, you won't get any of those "Loading" messages. Essentially, you're pre-rendering those larger previews now, so you don't have to wait later. You'll still see the thumbnails appear, but wait until you see the progress bar, up in the top-left corner of the window, show that all the previews are rendered before you start looking at your images at that larger size.

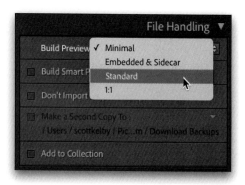

(4) 1:1 (Full 100% Size)

This is the slowest preview option. When you choose this one, it waits until the full-size 100% view of each image is complete before you can work with your images. Once it's done, you can zoom in up to 1:1 or more and you won't see any "Loading" messages ever. However, rendering these full-sized previews is notoriously slow—a "sloth covered in molasses" type of slow. It's "click the Import button, maybe make a sandwich, and then mow the lawn" type of slow before it renders the previews. But, when it's finally done, you're in the express lane—the "Loading" messages are behind you now and it's full speed ahead.

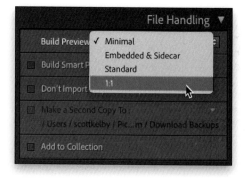

This easy method is designed for people who are new to Lightroom and might be concerned about where it's putting their images during the import process. (*Note:* If you've been using Lightroom for a while now, you can skip this and jump to page 7.) While this simple method doesn't make use of all the importing options, you'll still sleep better at night because you'll know exactly where the images you imported are stored.

Importing from Your Camera (Easy Method)

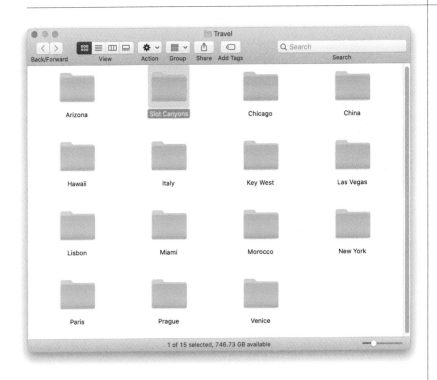

Step One:

Don't launch Lightroom (well, not yet anyway). Instead, just plug your card reader with your memory card into your computer, select all the photos on your card, and drag-and-drop them into the folder where you want to store them on your external hard drive. For example, if they're travel photos (like these photos of slot canyons I shot in Utah), you'd drag them onto your external hard drive, into a folder named, "Travel," and inside your Travel folder, you'd make a new folder named, "Slot Canyons." That's where you drag them—into that new Slot Canyons folder. Now, is there any question where your photos are? Of course not—they're on your external hard drive, in your Travel folder, in a folder named Slot Canyons. This location, where they're at right now, will not change once you import them into Lightroom (your images don't move or get copied inside of Lightroom—they stay right there on your external drive).

Step Two:

Now, just take that Slot Canyons folder and drag-and-drop it onto Lightroom's icon (in your Dock on a Mac, or on your desktop on a PC). This brings up Lightroom's Import window (seen here). From the **Build Previews pop-up menu** (at the top right of the window, in the File Handling panel), choose how long you want to wait for your previews to build (we just looked at this on page 3). I always choose Minimal, but there are a couple of other options in the Import window you might consider.

Step Three:

Again, there are other options in the Import window, but we haven't covered them yet (we will later on), so explaining them at this point wouldn't do a lot of good, but there's one option we can cover now—**Don't Import Suspected Duplicates**. When this option is turned on, if it sees a file already in the folder with the same exact filename, it skips it. This helps when you're downloading from the same memory card over a couple of days (like when you're on vacation). That way, it doesn't keep downloading the same photos you took and imported yesterday from that same memory card, and you don't wind up with a bunch of duplicates of the same photos. Again, the other options we'll cover later (in the advanced import workflow, on the next page, but don't read that until you're really comfortable about where your photos are being imported and stored).

Step Four:

Now, click the **Import button** at the bottom right of the window and your images will appear in Lightroom, and you can start scrolling through the previews, double-clicking to see them larger, and even zooming in to 100% to check for sharpness. At this point, you can start the process of finding the best images from your shoot (and I'll take you through my process of doing that in the next chapter).

If you've been using Lightroom for a while now, and you're totally comfortable with where your photos are stored—you know exactly where your photos are and have zero amount of stress over where they reside—then this is for you. When you're done with this section, you'll be importing images like a SpaceX re-entry booster lead engineer, and you'll be clicking so many features and options that even Adobe doesn't know what they do. In short, buckle up—let's light this candle!

Importing from Your Camera (Advanced Method)

Step One:
If you have Lightroom open, and connect your camera or memory card reader to your computer, the **Import window** you see here appears. The top section of this Import window is important because it shows you what's about to happen. From left to right: (1) it shows where the photos are coming from (in this case, my camera's memory card); (2) what's going to happen to these images (in this case, it's going to make copies of the images on this memory card); and (3) where they're going to (in this case, onto my external hard drive, into my Portraits folder).

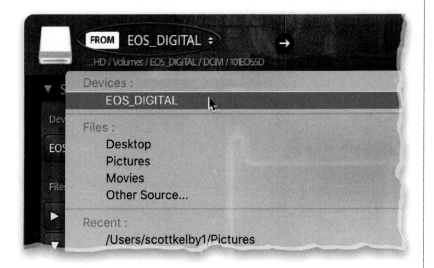

Step Two:
If your memory card is connected to your computer, Lightroom assumes you want to import photos from that card, and you'll see it listed next to "From" in the top-left corner of the window (circled here). If you want to import from a different card (you could have two card readers connected to your computer), click on the **From button**, and the pop-up menu you see here will appear. This is where you can choose your other card reader, or you can choose to import photos from somewhere else, like your desktop, or Pictures folder, or any recent folders you've imported from (which are listed at the bottom of the menu).

Step Three:

There is a **Thumbnails size slider** below the bottom-right corner of the center Preview area that controls the size of the thumbnail previews, so if you want to see them larger, just drag that slider to the right. If you want to see any photo you're about to import at a large, full-screen size, just double-click on it to zoom in, or click on it and press the **E key**. Double-click to zoom back out, or press the **G key**.

TIP: Shortcuts for Thumbnail Size

To see the thumbnails larger in the Import window, press the + **(plus sign) key** on your keyboard or press the – **(minus sign) key** to make them smaller again.

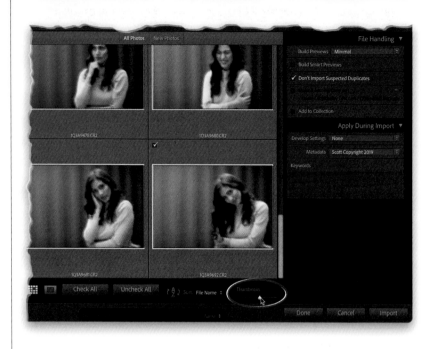

Step Four:

As I mentioned earlier, by default, all the photos have a checkmark at the top left of their grid cell (meaning they are all marked to be imported). If you see one or more photos you don't want imported, just turn off their checkboxes (as shown here— notice that once you turn off a checkbox, it dims the photo as a visual cue letting you know that photo won't be imported). Now, what if you have 300+ photos on your memory card, but you only want a handful of them imported? You'd click the **Uncheck All button** at the bottom of the window to uncheck every photo, then Command-click (PC: Ctrl-click) on just the photos you want to import, and then turn on the checkbox for any of these select- ed photos, and all the selected photos become checked and will be imported.

TIP: Selecting Multiple Photos

If the photos you want are contiguous, then click on the first photo, press-and-hold the Shift key, scroll down to the last photo you want, and click on it to select all the photos in between at once.

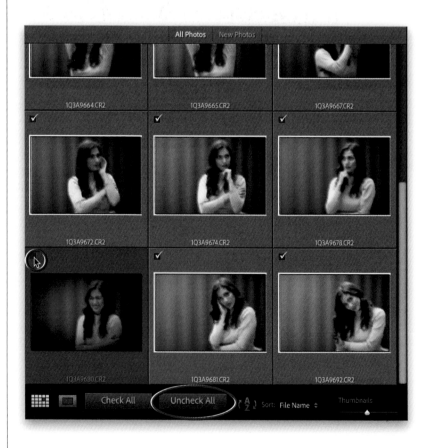

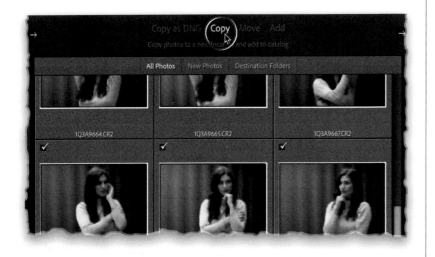

Step Five:

There are some other options at the top center of the Import window: again, Copy copies the files "as is" from your memory card (if they're RAW photos or JPEGs, they stay that way); Copy as DNG converts your RAW photos to Adobe's DNG format as they're being imported (see page 11 for more on DNG). I just leave mine set at Copy all the time. Neither choice moves your originals off the memory card (you'll notice Move is grayed out), it only copies them, so you'll still have the original images on your memory card. Below those are some view options: (1) All Photos (the default) displays all the photos on your memory card. (2) If you click on New Photos, it only shows the new photos on the card that you haven't imported yet, and it hides the rest from view.

Step Six:

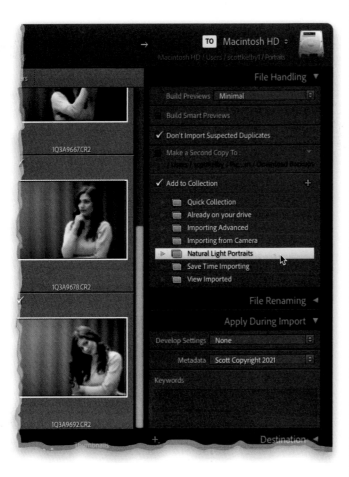

On the right side of the window there are more options (but, if you're reading this advanced import process, you probably already know what these do): In the File Handling panel is the option to create smart previews (I only turn this on if I'm traveling with my laptop and I know I won't have my external hard drive with the high-res original images with me, but I still need to be able edit them in the Develop module). There's an option to copy the images you're importing to a second external drive, but these second-drive backup photos don't get any of the edits you make in Lightroom—it's just a straight copy off the memory card. The last option in this panel is to import directly into an existing collection (as shown here) or create a new collection from scratch and import into that. There's also the Apply During Import panel, where you can apply a Develop module preset to your images as they're imported, along with your copyright info (from the Metadata pop-up menu), and you can type in keywords (search terms) in the Keywords field, if you like.

Step Seven:

Below the File Handling panel is the **File Renaming panel**, where you can have your photos renamed automatically as they're imported. I always use this to give my files a very descriptive name (in this case, something like Anna Outdoor Portraits makes more sense to me than 1Q3A9674.CR2, especially if one day I have to search for them). If you turn on the Rename Files checkbox, there's a Template pop-up menu where you have several different choices. I choose **Custom Name - Sequence**, so it adds my custom name "Anna Outdoor Portraits" followed by a numeric sequence (so, they become Anna Outdoor Portraits-1.CR2, Anna Outdoor Portraits-2.CR2, and so on).

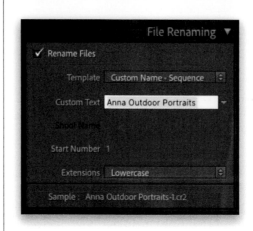

Step Eight:

Finally, let's choose where you want the images you're importing saved to. Click-and-hold on "To" at the top right, and then choose where you want these imported images to be stored from the pop-up menu that appears (shown here). In this case, let's say you want to save to an external hard drive, so you'd choose **Other Destination** and then select that external hard drive. You can also choose any folder on that hard drive where you want them saved (like your Travel folder or Portrait folder or Family folder). If you want these photos to appear in their own separate folder (you do, by the way), in the Destination panel, turn on the **Into Subfolder checkbox**, then give this new subfolder a descriptive name, like "Anna Portraits," and choose **Into One Folder** from the Organize pop-up menu. So, at this point, you know three things: (1) the photos are coming from your memory card; (2) you're making copies of those images on the card; and (3) those copies are going onto your external hard drive, into your Portraits folder, into a new folder named "Anna Portraits."

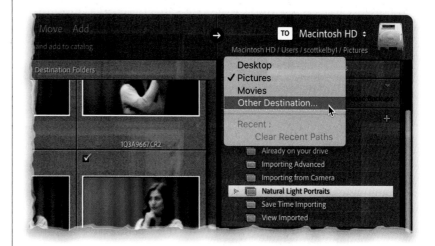

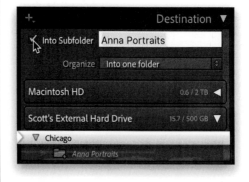

You have the option of converting your RAW images from your camera manufacturer's proprietary RAW format to Adobe's open format DNG (Digital Negative) format. DNG was created by Adobe out of concern that one day, one or more manufacturers might abandon their proprietary RAW format, leaving photographers shooting RAW out in the cold. Unfortunately, none of the big three camera manufacturers embraced this DNG format, and even I stopped converting my images a few years ago. However, if you want to convert to DNG, here's how:

Converting RAW Photos to the Adobe DNG Format

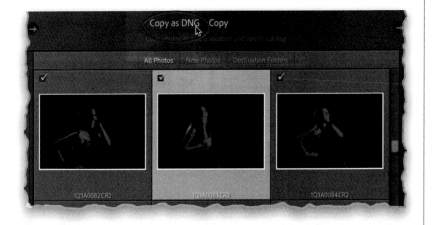

Two DNG Advantages:

There are two advantages of the DNG format: (1) DNG files maintain the RAW properties, but are about 20% smaller in file size, and (2) if you need to share an original RAW image file with someone, and you want that file to include any changes you made to it in Lightroom (including keywords, copyright, metadata, etc.), you don't have to generate a separate XMP sidecar file (a separate text file that stores all that info). With DNG, all that data is baked right into the file itself, so there is no need for a second file. If you want to convert your RAW files to DNG format as they're imported, click on **Copy as DNG** at the top of the Import window (as shown here). There are some disadvantages to DNG, as well, including importing taking longer because your RAW files have to be converted to DNG first. Also, DNGs aren't supported by all other photo editing applications. Just so you know.

Embedding Your Original RAW File into the DNG:

There is a DNG preference that lets you embed the original proprietary RAW file (your Nikon NEF file, or your Canon CR2 file, or your Sony ARW file) in your DNG, but doing this adds to the file size and pretty much kills advantage #1 above. But, in case you want to include it, you do this in Lightroom's Preferences (press **Command-, [PC: Ctrl-,]** to open them), in the File Handling tab, by turning on the **Embed Original Raw File checkbox** (as shown here).

Save Time Importing Using Import Presets (and a Compact View)

If you find yourself using the same settings when importing images, you're probably wondering, "Why do I have to enter this same info every time I import?" Luckily, you don't. You can just enter it once, and then turn those settings into an Import preset that remembers all that stuff. Then, you can choose the preset, add a few keywords, maybe choose a different name for the subfolder they're being saved into, and you're all set. In fact, once you create a few presets, you can skip the full-sized Import window altogether and save time by using a compact version instead. Here's how:

Step One:

Here, we'll assume you're importing images from a memory card, and you're going to copy them onto your external hard drive, into your Travel folder. You want your copyright info added as they're imported (see Chapter 3), and we'll choose Minimal so the thumbnails and previews show up fast. Now, go to the very bottom center of the Import window, and click-and-hold where it says "None." From the pop-up menu that appears, choose **Save Current Settings as New Preset** (as shown here) and give it a descriptive name. Now, click the Show Fewer Options button (the upward-facing arrow, circled here in red) in the bottom-left corner of the Import window, and it switches to a compact view (as seen below).

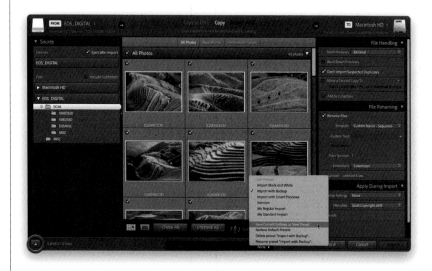

Step Two:

So, from now on, all you have to do is choose your preset from the **Import Preset pop-up menu** at the bottom (as shown here, where I chose my From Memory Card preset), and then enter just the few bits of info that do change when you import a new set of photos, like the descriptive name of the subfolder you want to save these photos inside. So, how does this save you time? Well, now you only have to choose a folder, then type in your subfolder's name, and click the Import button. That's fast and easy! *Note:* You can return to the full-size Import window anytime by clicking the Show More Options button (the downward-facing arrow) in the bottom-left corner.

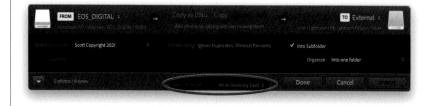

I put the import preferences toward the end of the Importing chapter because I figured that, by now, you've imported some photos and you know enough about the importing process to know what you wish was different. That's what preferences are all about (and Lightroom has preference controls because it gives you lots of control over the way you want to work).

Choosing Your Preferences for Importing Photos

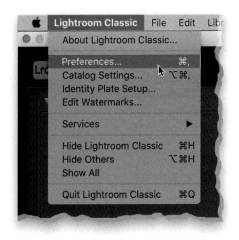

Step One:
The preferences for importing photos are found in a couple different places. First, to get to the Preferences dialog, go under the Lightroom menu on a Mac or the Edit menu on a PC, and choose **Preferences** (as shown here).

Step Two:
When the Preferences dialog appears, first click on the General tab up top (seen highlighted here). Under **Import Options** in the middle, the first preference gives you the option of having Lightroom automatically open its Import window anytime you plug a memory card reader into your computer (it's on by default). If you don't want that, just turn off its checkbox (as shown here). The next preference down is for folks who like to import their photos in the background while they're working on something else. For example, let's say you're working on some images, and then you decided to import some images from a shoot. As soon as those images start coming in, Lightroom switches you over to see those images as they're importing. If you'd prefer to keep working on your current images, and just have those other images import in the background, then turn off the Select the "Current/Previous Import" Collection during Import checkbox. Then, when you do want to see your imported images, you can go to the Catalog panel (near the top of the left side panels), click on Previous Import, and you'll see those newly imported images.

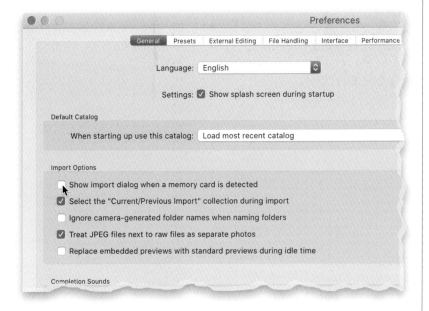

Step Three:

If you choose to use the Embedded & Side-car previews when you import photos (see page 4), there's an option you can turn on if you want to have Lightroom build the larger previews when it's not doing anything else important. Just turn on the **Replace Embedded Previews with Standard Previews During Idle Time checkbox** and it will create those larger, more color-accurate previews in the background for you.

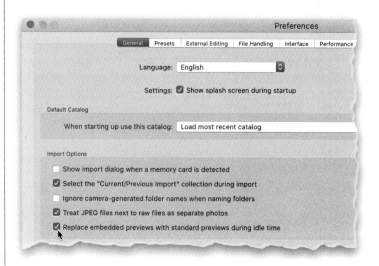

Step Four:

There are two other importing preference settings I'd like to mention that are also found on the General tab. In the **Completion Sounds section**, you not only get to choose whether or not Lightroom plays an audible sound when it's done importing your photos, you also get to choose which sound (from the pop-up menu of system alert sounds already in your computer, as seen here).

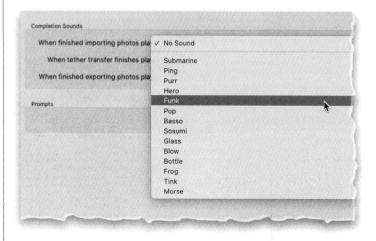

Step Five:

While you're right there, directly below the menu for choosing an "importing's done" sound are two other pop-up menus for choosing a sound for when your tether transfer finishes and for when your exporting is done. I know, the second one isn't an importing preference, but since we're right there, I thought…what the heck. I'll talk more about some of the other preferences later in the book, but since this chapter is on importing, I thought I'd better tackle these here.

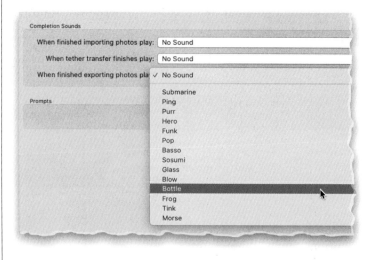

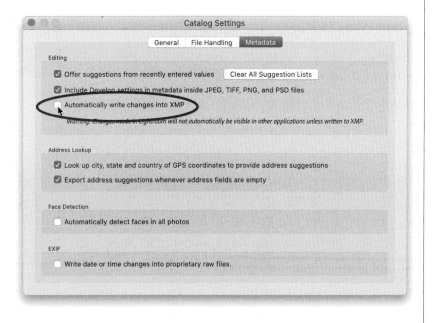

Step Six:

Now, close the Preferences dialog, because we're going to a different set of preferences where I'm going to recommend you turn a feature off. Go under the Lightroom menu on a Mac, or the Edit menu on a PC, and choose Catalog Settings. Click on the Metadata tab up top, and then make sure the **Automatically Write Changes into XMP checkbox** is turned *off*! It should be off already, but if it's on, it can slow down your Lightroom performance significantly. It's a feature that in the right situation can be helpful, but most folks aren't in that situation. When it's turned on, everything you do (every edit, every keyword you add, every slider you move for a particular image) is stored in your Lightroom catalog. That's a good thing. However, if you have Automatically Write Changes into XMP turned on, each time you move a slider or change anything to an image, it writes that change to a totally separate file on your hard drive called an XMP file (also known as a "sidecar"), so now you have two files for every RAW image.

Step Seven:

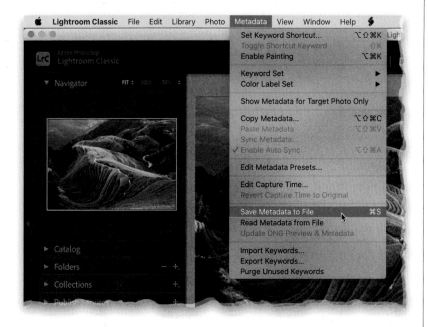

This is helpful if you're sharing a RAW file with another photographer or designer and you want them to have your edits intact when they open your original RAW image, but outside of that very specific instance, it mostly just slows things down a lot, so I don't recommend leaving it turned on. If you do wind up in a situation where you actually need to send an original RAW file to a friend or client (or if you need to open your RAW photo in another application that supports XMP sidecar files), in the Library module, under the Metadata menu up top, choose **Save Metadata to File** (as shown here) or just press **Command-S (PC: Ctrl-S)**. This writes any edits you made to the RAW image to that separate XMP file, and when you give this image to your client or friend, etc., you'll need to give them both files—your RAW file and the XMP sidecar file.

Viewing Your Imported Photos

Before we get to organizing our photos (which we cover in the next chapter), let's take a minute to learn the ins and outs of how Lightroom lets you view your imported photos.

Step One:

When your imported photos appear in Lightroom, they are displayed as small thumbnails in the center of the Library module's **Preview area** (as seen here). You can change the size of these thumbnails using the Thumbnails slider that appears on the right side of the toolbar (the dark gray horizontal bar that appears directly below the center Preview area—if you don't see the toolbar, press the letter **T** to make it visible). Drag that slider to the right, and they get bigger; drag it left and they get smaller (the slider is circled here). You can also press **Command-+ (PC: Ctrl-+)** to zoom in, or **Command-- (PC: Ctrl--)** to zoom out.

Step Two:

To see any thumbnail at a larger size, just double-click on it, press the letter **E** on your keyboard, or press the **Spacebar**. This larger size is called **Loupe view** (as if you were looking at the photo through a loupe), and by default it zooms in so you can see your entire photo in the Preview area surrounded by a light gray background. This is called Fit in Window view. If you don't like seeing that gray background, go up to the Navigator panel in the top left, click on Fill, and now when you double-click on a thumbnail, it will zoom in to fill the whole Preview area (no gray background). Choosing 1:1 will zoom your photo in to a 100% actual size view when it's double-clicked, but it's kind of awkward to go from a tiny thumbnail to a huge, tight, zoomed-in image like that.

Step Three:

I leave my Navigator panel setting at Fit, so when I double-click I can see the entire photo fitting in the center Preview area, but if you want to get in closer to check sharpness, you'll notice that when you're in Loupe view, your cursor has changed into a magnifying glass. If you click it once on your photo, it jumps to a 1:1 view of the area where you clicked. To zoom back out, just click it again. To return to the thumbnail view (called Grid view), just press the letter **G** on your keyboard. This letter "G" is one of the most important keyboard shortcuts to memorize. This is particularly handy, because when you're in any other module, pressing G brings you right back here to the Library module and your thumbnail grid, which is kind of "home base" for Lightroom Classic.

The default cell view is called Expanded and gives you the most info

Press J to switch to Compact view, which shrinks the size of the cell, hides all the info, and just shows the photos

Step Four:

The area that surrounds your thumbnail is called a cell, and each cell displays information about the photo, from the filename, to the file format, dimensions, etc.—you get to customize how much or how little it displays, as you'll see in Chapter 4. But, in the meantime, here's another keyboard shortcut you'll want to know about: press the letter **J**. Each time you press it, it switches you to another of the three different cell views, each of which displays a different group of info. There's an expanded cell with lots of info, a compact cell with just a little info, and one that hides all that distracting stuff altogether (great for when you're showing thumbnails to clients). Also, when you hide (or show) the toolbar by pressing T, if you press-and-hold T, it hides it temporarily—only for as long as you have the T key held down.

Press J one more time and it adds back some info and numbers to each cell

Shooting Tethered (Going Straight from Your Camera, Right into Lightroom)

One of my favorite features in Lightroom is the built-in ability to shoot tethered (shooting directly from your camera into Lightroom). Shooting tethered allows you to see your images much bigger on your computer's screen than on that tiny LCD on the back of the camera, which makes checking sharpness and lighting much easier. And, you don't have to import after the shoot—the images are already there. *Note:* This feature is available for Nikon and Canon cameras (Sony hasn't given Adobe the code needed to allow direct tethering, but see the next technique for a workaround, or get the Smart Shooter plug-in from Tether Tools, which comes with a Lightroom plug-in for direct Sony tethering).

Step One:

The first step is to connect your camera to your computer using that little USB cable that came with your camera. (Don't worry, it's probably still in the box your camera came in.) If you don't have one, you can get the same one I use from tethertools .com. You plug one end of this cable into the USB port on your camera, and the other end plugs into the USB port on your computer. The tethered setup I use in my studio is shown here, and it all mounts on a tripod. The horizontal bar is the Tether Tools Rock Solid 4-Head Tripod Cross Bar, and the table holding my laptop is the TetherTable Aero. I make sure my laptop doesn't slide off while moving it by using their Aero Secure Strap. You can't see it here, but my tripod is sitting on a set of wheels called the Rock Solid Tripod Roller, which I highly recommend for making the whole rig easy to move during the shoot.

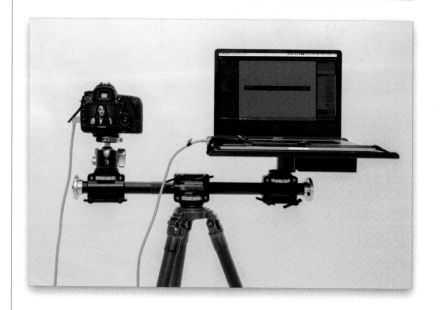

Step Two:

Now go under Lightroom's File menu, under Tethered Capture, and choose **Start Tethered Capture**. This brings up the dialog you see here, where you enter pretty much the same info as you would in the Import window (you type in the name of your shoot at the top in the Session Name field, and you choose whether you want the images to have a custom name or not. You also choose where on your hard drive you want these images saved, and if you want any metadata or keywords added—just like usual).

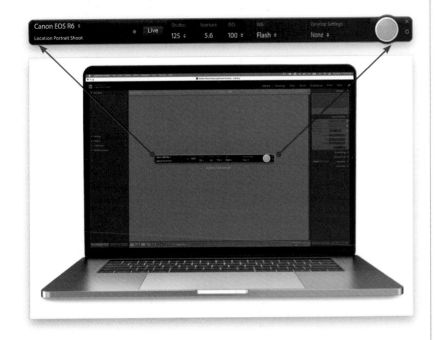

Step Three:

When you click OK, the **Tethered Capture window** (Adobe calls it a "Heads Up Display" or "HUD" for short) appears (seen here). If Lightroom sees your camera, its model name will appear on the left (if you have more than one camera connected, you can choose which one to use by clicking on the camera's name and choosing from the pop-up menu directly to the right of your camera's name). If Lightroom doesn't see your camera, it'll read "No Camera Detected," in which case, you need to make sure your USB cable is connected correctly, and that Lightroom supports your camera's make and model for tethering (you can see Adobe's updated list at http://kel.by/tetherlr).

Step Four:

So, assuming Lightroom sees your camera (make sure your camera's awake—if it goes into sleep mode to save battery, Lightroom won't be able to see it's connected), let's go ahead and take a shot. So, press your camera's shutter button and your photo appears in Lightroom in just a second or two (RAW photos take a second longer to appear, but it's still really quick). The whole idea behind tethering is to see your images at a much larger size during the shoot, so once your first photo comes in, double-click on it so it appears larger onscreen. In fact, after you double-click to view your photos at a larger size, you might want to press **Shift-Tab** to hide all the side, top, and bottom panels to make your image even larger onscreen. This is what I do, but then I bring back the right side panels (as seen here), so I can have my editing controls there in case I want to tweak the image or color during the shoot (you'll start learning how to do this in Chapter 5). **TIP:** If you want to hide the floating Heads Up Display from view, press **Command-T (PC: Ctrl-T)**.

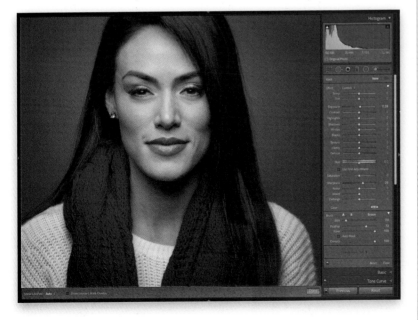

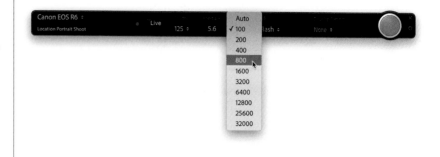

Step Five:

Okay, now that we've got tethering up and running, there are some other tethering features that are pretty handy that you'll want to know about. Let's start right in the **Heads Up Display (HUD)**. To the right of where you see your camera's make and model, you'll see your camera's current settings displayed—your shutter speed, aperture (f-stop), ISO, and white balance. If you want to change any of those settings, you don't have to go to your camera—you can change them right here in the HUD. Just click-and-hold on a current setting and a pop-up menu appears (like the one shown here, where I clicked-and-held on ISO) where you can choose the setting you'd like.

TIP: What to Do If Your Nikon Camera Won't Tether

If you have a Nikon and you're having trouble getting tethering to work, try popping the memory card out of the camera and try again. Canon cameras automatically write a copy of what you're shooting to the memory card in your camera, but Nikons don't, and if you have a card in while tethering, it won't work.

Step Six:

Not only can you change your settings from the HUD, you can actually take the picture from there, too. That round button on the far-right side of the HUD is actually a **shutter button** (well, Adobe calls it the "capture" button), and if you click it, it'll take a photo just as if you were pressing the shutter button on your camera itself (pretty slick). There's also a space-saving trick you can do with the HUD: you can shrink it down to where all that's showing is the shutter button itself. To do this, press-and-hold the Option (PC: Alt) key, and the little X button in the top right (which you'd normally use to close the HUD) changes into a minus sign (as seen here, below left). Click on that and you'll get the little minimized floating shutter button you see here on the bottom right.

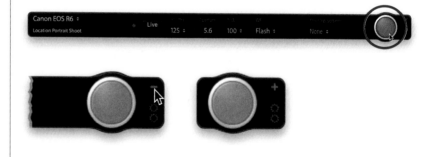

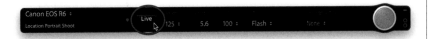

Step Seven:

If you'd like to see a view of what your camera is seeing (called a "Live View"), click the **Live button** (shown circled here in red) and a floating resizable window appears (seen here) showing you what your camera is seeing. It's not as smooth as the Live View mode on the back of your camera, but if you're on a tripod, it works pretty nicely. If you hand-hold, there's a bit of a lag from the low-frame rate it displays at, so if you use it and it seems less than awesome, at least you know it's not you. I do think this is something that will get better over time (when it was introduced, it literally said "Beta" across the top, letting you know "this is not the final version" and was more of a work in progress. So, by the time you read this, it might be working like a champ, but I just wanted to give you a heads-up in case you get less than optimal results. And that's being kind).

Step Eight:

There's a feature we skipped earlier in the Tethered Capture Settings dialog (the one that comes up when you choose Start Tethered Capture) that can be really handy. It's the **Segment Photos By Shots checkbox**, and turning that on lets you organize your tethered shots as you go by separating each shoot into their own separate folders. So, for example, let's say you're doing a location portrait shoot, and you're shooting in three different locations: by a window, in front of the staircase, and by the pool. You can separate each of these locations into its own folder by clicking Shot Name (this will make more sense in a moment). For now, just try it out by turning on the Segment Photos By Shots checkbox and clicking OK. When you do this, a naming dialog appears (shown here), where you can type in a descriptive name for your first shoot (here, I chose "By The Window").

Step Nine:

Now that you turned on Segment Photos By Shots, here's how you use it: Let's say you just finished your shoot by the window, and now you're moving to the staircase. Over in the HUD, right under where it shows your camera's name, you'll see what you named your first location (in this case, it's "By The Window"). Click on that, and it brings up the **Shot Name dialog** (seen here) for you to enter the next location's name (here, I named it "Staircase"). Now, you continue your shoot. When you're done with that staircase location, click on Staircase in the HUD, and it will bring up the Shot Name dialog again, so you can name your third shoot (in this case, "Pool"). When you've wrapped up your shoot, you'll have three folders inside your main Location Portrait Shoot folder: (1) By The Window, (2) Staircase, and (3) Pool. Just for a frame of reference, here's how this all looks in your Folders panel, with your main folder and subfolders.

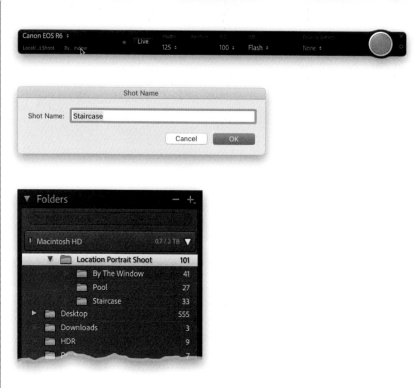

TIP: Shortcut for Starting a Tethered Capture

You can trigger a tethered capture by pressing **F12** on your keyboard.

Step 10:

There's one more feature in the HUD, and I don't want to get too ahead of ourselves because we haven't gotten to the chapter that discusses this yet, but you can choose to automatically apply any of the built-in or custom **Develop module presets** as your photos are imported. You can choose which preset you want by clicking-and-holding on the word "None," directly under Develop Settings on the right, and a menu with all your presets appears (as seen here). Now, if that sentence has you scratching your head, it's only because, again, we haven't covered Develop presets yet, but don't worry, you'll learn about them soon enough, and then you'll think back to this and go, "Ohhhhhhh. That's pretty cool!"

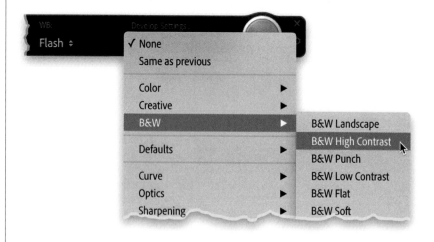

This feature is an automated way to import photos into Lightroom. You make a new empty folder, and then you tell Lightroom: "Anything I drop in this folder, automatically import those straight into Lightroom." You even get to choose all the import settings you want right up front. This can be a really helpful feature.

Things You Drop in This Folder Drop into Lightroom Automatically

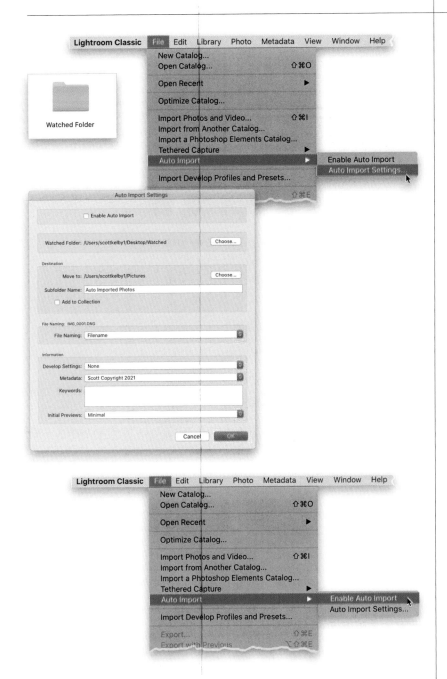

Step One:
The first step is to create a new empty folder on your computer (I always name mine "Watched Folder," so it's very clear to me what this folder is for). Next, go under the File menu, under Auto Import (that's the official name of this feature), and choose **Auto Import Settings** (as shown here) to bring up the settings dialog (seen here below). At the top of the dialog, you choose which folder you want to be your "watched" folder (the one Lightroom monitors to see if you drop any photos in there—the one I named "Watched Folder" here). The rest of the dialog is the same type of import options you're already used to using (naming and such).

Step Two:
Making those choices in the Auto Import Settings dialog doesn't actually have Lightroom start watching that folder—you have to enable the feature. You do that by going back under the File menu, under Auto Import, and choosing **Enable Auto Import** (as shown here). Now, anything you drop in that folder gets imported into Lightroom automatically.

GETTING ORGANIZED
my system for a happy Lightroom life

Even though Lightroom was designed from the ground up to help you organize your images, I'll bet if I asked you, you'd tell me that your Lightroom organization is a mess, bordering on disaster, something akin to that movie *The Day After Tomorrow*, where things just keep getting worse and worse. But, of course, The Rock is in that movie, and no matter how dire things get, he always seems to find a way out. Doesn't matter how clear it is that this is the end, and he's trapped, and some boulder or cruise ship is about to fall on his head, the smoke clears and he emerges from the debris, walking triumphantly through the smoke in slow motion. And, you're like, "Thank goodness he's alive," but of course, this all happens within the first 12 minutes of the movie, and if the star dies in the first 12 minutes, it's going to be kind of a messed-up movie. So, you know that he's not really dead the whole time, but even though you know he's alive, there's still this tension. It's the same tension you feel when you open Lightroom and you know your images are in there somewhere, but you really have no idea exactly where. Sometimes you'll even find a thumbnail of the image you were looking for, but then you can't find the original high-res file. So, what I want to do for you in this chapter is this: I want you to emerge through the smoke and debris in slo-mo, with that confident "I'm not dead" type of strut The Rock has every day—even when he's just walking through Target to pick up a bath mat and some decorative hand towels. Step One: Get a fog machine (like the AGPTEK 500W Portable LED Smoke Machine with Lights & Wireless Remote Control; $54.99 on Amazon). Step Two: Get some debris. Now, practice walking very, very slowly.

How to Get Around in Lightroom

Now that your images have been imported, there are some tips about working with Lightroom's interface you're going to want to know about right up front that will make working in it much easier.

Step One:

There are seven modules in Lightroom, and each does a different thing. When your imported photos appear in Lightroom, they always appear in the center of the Library module, which is where we do all our sorting and organizing. The Develop module is where you do your photo editing (changing the exposure, white balance, tweaking colors, etc.), and it's pretty obvious what the other five do (I'll spare you). You move from module to module by clicking on the module's name up in the **taskbar** across the top, or you can use the shortcuts **Command-Option-1** for Library, **Command-Option-2** for Develop, and so on (on a PC, it would be **Ctrl-Alt-1**, **Ctrl-Alt-2**, and so on).

Step Two:

There are five areas in the Lightroom interface overall: that taskbar along the top, the left and right side panels, a Filmstrip across the bottom, and your photos appear in the center Preview area. You can hide any panel (which makes the Preview area, where your photos are displayed, larger) by clicking on the little gray triangle in the center edge of the panel. For example, go ahead and click on the little gray triangle at the top center of the interface, and you'll see it hides the taskbar. Click it again; it comes back. I also hid the left and right side panels here.

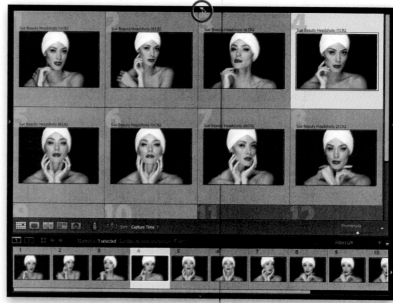

Step Three:

Auto Hide & Show is a feature designed to help you manage all these panels. The idea behind it sounds great: if you've hidden a panel and need it open again, just move your cursor over where the panel used to be and it pops out. When you're done and move your cursor away, it automatically tucks back out of sight. Sounds great, right? The problem is one of those panels seems to pop out anytime you move your cursor to the far right, left, top, or bottom of your screen, so they often pop open when you don't actually want them to. It really drives some people nuts (I'm on that list), and it's the #1 inter-face complaint I hear from Lightroom users. I've had people offer me money to show them how to turn that "feature" off. To turn off Auto Hide & Show, Right-click on the little gray triangle next to any panel and choose **Manual** from the pop-up menu (as shown here, where I clicked on the arrow on the left side panels). Manual works on a per-panel basis, so you'll have to do it to each of the four panels. Highly recommended.

Step Four:

Now that you're in Manual mode (and the panels are not just popping in and out on their own), you can open and close panels as you need them, either by clicking on the little gray arrows, or you can use keyboard shortcuts: **F5** closes/opens the top taskbar, **F6** hides the Filmstrip, **F7** hides the left side panels, and **F8** hides the right side (on a newer Mac keyboard or a laptop, you may have to press the Fn key with these). Press the **Tab key** to hide both the left and right side panels, but the shortcut I use the most is **Shift-Tab**, because it hides all the panels at once and leaves just your photos visible (as seen here). Also, each module's panels kind of follow the same basic idea: the left side panels are used primarily for presets and templates and giving you access to your collections; the right side panels have all the adjustments.

First: Move All Your Photos onto One External Hard Drive

Before you dive into Lightroom, in fact, before you even launch it, to have a happy Lightroom life, start by setting up an external hard drive to hold all your photos (don't use the one in your computer—it will be full before you know it). This step is more important than it sounds, and it will save you loads of frustration down the road (and that road always gets here sooner than you'd think). The good news is, external hard drives have never been cheaper than they are today (I just saw a 6-terabyte WD external hard drive for just $104, which is just incredible for that much storage).

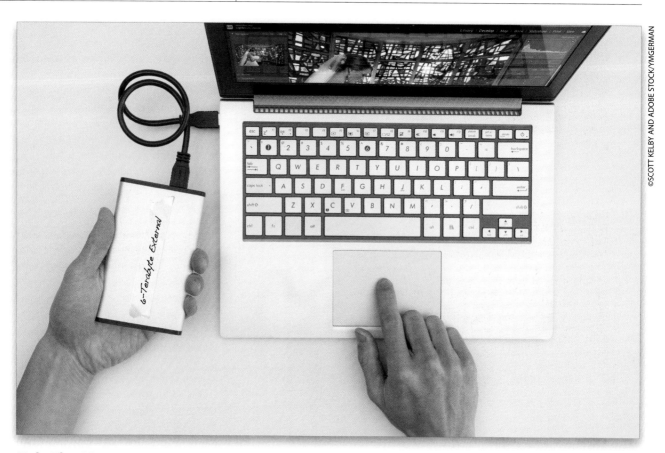

©SCOTT KELBY AND ADOBE STOCK/YMGERMAN

Make That Move:

Okay, now that you've got your external hard drive connected to your computer, you are going to *move all* your photos onto that one, single, external hard drive. All of them, starting with the ones already on your computer (I'll show you how on the next page. It's simple). So, gather all your photos—from old CDs and DVDs, and other portable drives—and drag them all onto this one external hard drive (make sure you buy a much bigger amount of storage on this external hard drive than you think you'll need. It will fill up faster than you ever imagined, thanks to today's crazy-high-megapixel cameras, and they're only getting larger going forward). Getting all these photos from different places all together in one place might take a little time, but it will so be worth the peace of mind of knowing that, maybe for the first time ever, all your photos are together in one place, which makes it much easier to keep your image library backed up. Plus, the good news is, people have told me time and time again that doing this process of gathering all their images turned out to be much easier and faster than they thought it would be. So, that's the first part of this process: gather all your portable hard drives, CDs, and DVDs, and let's bring all the photos on them all together onto this one external hard drive. Now, let's look at moving the photos already on your computer onto this drive without Lightroom losing track of anything.

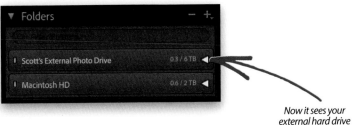

Now it sees your external hard drive

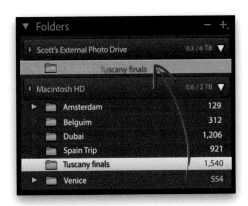

Step One:

When you plug in your external hard drive, Lightroom won't recognize it because it doesn't have any photos on it yet. So the first thing we have to do is to get Lightroom to see your connected external hard drive. We do that by going to Lightroom's Folders panel in the Library module (one of the rare times we go there for anything), clicking on the + (plus sign) button in the top-right corner, and from the pop-up menu that appears, choosing **Add Folder**. It brings up a window from your operating system where you choose where you want this new folder to appear. Choose your external hard drive, create a new folder named "Photo Library" or "My Photos" or whatever, then click the Choose button. Now, Lightroom will recognize this external hard drive and you'll see it appear in the list of drives at the top of the Folders panel (as seen here).

Step Two:

Moving your images off your computer, and onto that external hard drive is as simple as dragging-and-dropping each folder (or if you have nested folders, the top level folder) from your computer's hard drive onto that external hard drive. Here, I'm dragging my folder of Tuscany finals from my Macintosh HD (my computer's internal hard drive) over into my Photo Library folder on Scott's External Photo Drive. This physically moves (not copies— moves!) the photos for you, but since you did this move within Lightroom's own Folders panel, Lightroom still knows where these photos are, so everything still works just like it did before the move (no broken links or missing images). So, you'll be doing a lot of dragging-and-dropping to get everything moved over to that external hard drive. Now, if you wind up taking images off a CD or DVD or a different drive and you drag them onto that external drive (like we looked at on the previous page), that doesn't add them to Lightroom. You'll have to import those new images you just added to that external hard drive, so Lightroom can now manage those, too.

You Need a Second Backup Hard Drive

It's good that external hard drives are so cheap, because you're going to need *two* of them. Why two? Because all hard drives eventually crash and die (sometimes on their own, or we knock them over, or lightning strikes, or the dog pulls it off your desk by accident). It's not just hard drives that die—every media storage unit goes bad at some point (CDs, DVDs, portable drives, optical drives, you name it), and you're going to need a backup when yours goes to the place where hard drives go to die (the most prevalent theory is that they go to Cleveland, since that's where promising quarterbacks go to die. Sorry, somebody had to say it).

It Has to Be a Totally Separate Drive:

Your backup has to be a totally independent external hard drive from your main external hard drive—not just a partition or another folder on the same external hard drive. I talk to photographers who use partitions not realizing that, when your hard drive dies, both your main folder of photos and your backup folder on the partition will both die at the same time. The result is the same—all your images are probably lost forever.

Where to Keep Your External Hard Drives:

Not only do you need two separate drives, but, ideally, they would be kept in *two* separate locations. For example, I keep one at home and the other at the office, and about once a month I bring the one from home to the office and sync 'em up, so they have all the stuff I've added in the past month. By keeping them in two separate places, if a fire strikes or there's a break-in, or a flood, or a tornado, I still have a backup drive at a different location. Also, this is the reason why you can't use your computer as a backup (what if it dies in a flood or fire or is stolen?), and you cannot put your backup drive right there on your desk next to your main external hard drive (for the same reasons).

HOME OFFICE

©SCOTT KELBY AND ADOBE STOCK/GEORGEJMCLITTLE

©ADOBE STOCK/PETOVARGA

Oh, come on, this is overkill!!! Really, three backups? Yup. You've gotta have a cloud backup—ask anybody that experienced the epic floods in Houston or Hurricane Katrina or any of the myriad of natural disasters these past few years where people lost all their photos. We're talking about the visual history of your life here—irreplaceable photos, along with client images, and family photos, and stuff you just can't put a price on. This third leg of protection has never been more important. You don't have to do it, but you'll sure sleep better if you do.

And I Would Super-Recommend a Cloud Backup, Too

Why You Should Add a Cloud Backup, Too:

If a natural disaster (hurricane, major flood, etc.) hits your area, you could lose both your photo drives, even though they're in different locations. That's why I recommend having a cloud-based backup, as well (ask folks who have survived major hurricanes, but still lost everything). I use Backblaze.com as my cloud backup for one simple reason: it's only $6 per month for (get this) unlimited storage! It works in the background and automatically backs up your external hard drive to the cloud.

Don't Look at the Upload Progress:

The thing about Backblaze (or any cloud-based backup) is that you have to copy your entire photo library up to the cloud—terabytes of images, most likely—and that takes time. How much time? I'd say, for most folks, a month at the quickest, but probably six weeks to two months for serious photographers, and perhaps longer for working pros. The upload speed for most Internet connections is a fraction of the download speed, so I recommend that you don't even look at the upload progress for at least a month, or you'll be like "It's only 6%! Arg#%$&!" Save yourself the aggravation—tell it to back up your external hard drive, and then just go about your life. In six weeks from now, you can have your photo library fully backed up in the cloud…or not—the time is going to pass either way.

It Really Helps If You Get Your Photos Organized FIRST (Before You Start Working in Lightroom)

I talk to photographers almost every day who are somewhat or totally confused about where their photos are located. They're frustrated and feel disorganized and all that has nothing to do with Lightroom. However, if you get organized first (I'm about to share a really simple way to do this), before you start using Lightroom, it will make your Lightroom life sooooooo much easier. Plus, not only will you know exactly where your photos are, you'll be able to tell someone else their exact location, even when you're not in front of your computer.

Step One:

Go to your external hard drive (see page 28) and, on that drive, create a single new folder. This is your main photo library folder and creating this one folder, and putting all your images (old ones you've taken in years past and new ones you're about to take) inside this one folder is the key to staying fully organized before you ever even get to the Lightroom part of this. By the way, I name this one all-important folder "Photo Library" (you may have already created this folder when you moved your images to your external hard drive), but you can name yours anything you like. Whatever you name it, just know this is the new home for your entire photographic library. Also know that when you need to back up your entire library, you only have to back up this one folder. Pretty sweet already, right?

Step Two:

Inside that folder, you're going to create more folders and name them with topics of things you shoot. For example, I have nine separate folders: Architecture, Automotive, Aviation, Family, Landscape, Misc., People, Sports, and Travel—all separate folders within my Photo Library folder. Now, since I shoot a lot of different sports, inside my Sports folder, I have created separate folders for football, baseball, motorsports, basketball, hockey, and other sports. You don't have to do that last part; I just do it because, again, I shoot a lot of different sports and that makes it easier to find stuff when I'm not in Lightroom.

Step Three

Now, you probably have lots of folders full of photos on your computer already. Your job (this is easier than it sounds) is to drag those folders from your computer onto your external hard drive (if you haven't already), directly into the topic folder that matches what they are. So, if you have a folder with photos from your trip to Hawaii, drag that folder into your Photo Library folder, and into the Travel folder. By the way, if your folder of Hawaii vacation images isn't named something really easy, like "Maui Trip," now would be the time to rename it. The simpler and more descriptive your folder names, the better. Let's continue: If you shot your daughter's softball championship game, drag that folder into your Photo Library folder, and into the Sports folder. Now, you might decide, since the photos are of your daughter, to instead put them in your Family folder. No problem, that's your choice, but if you choose your Family folder, then from now on, all your kid's sports should go in that Family folder—not some in Sports and some in Family. Consistency is key.

Step Four:

So, how long will it take to move all these images from your hard drive into the right folders? Not as long as you'd think. A few hours tops in most cases. What does this accomplish? Well, for starters, you'll know exactly where every photo you've taken is, without even being in front of your computer. For example, if I asked you, "Where are your photos from your trip to Italy?" You would already know they were in your Photo Library folder, in your Travel folder, in a folder called "Italy." If you went to Italy more than once, maybe you'd see four folders there—Rome 2021, Tuscany with the kids, Venice 2016, and Venice Trip 2009—and I'd be totally jealous that you got to go to Italy four times, so I probably wouldn't ask you this question in the first place. But, if I did, at least you'd know the answer. But there's more.

Step Five:

There's a trap you might be tempted to fall into that I want to save you from, and that trap is organizing folders by date. It's a trap because it really relies on you remembering when you did…well…everything. Besides, Lightroom is already keeping track of the exact time and date (even the day of the week) that every single photo in your library was taken (it does this by looking at the camera info embedded by your camera when you took the shot). Want to see which photos you took way back in 2012 on the 8th of May (it even shows you it was a Tuesday)? Well, for me, it was the two you see here. To see your photos organized by date like this, press the \ **[backslash] key** to bring up the Library Filter bar across the top of Lightroom's Grid view, then click on **Metadata**, and in the first column, choose **Date** from the pop-up menu. Now, click on any year, then on a month, then on a day, to see just the photos taken on an exact date. It's already organizing by date for you automatically, so you don't have to.

Step Six:

Now, if you shoot a lot of landscape photos, and I asked, "Where are your shots from Yosemite?" You'd say, "In my Landscape folder on my external hard drive." End of story. That's where they are, and your computer can put them in alphabetical order, making them even easier to find. How straightforward is that? As long as you use simple, descriptive names for all your shoot folders, like "Acadia Nat'l Park" or "Rome" or "Family Reunion 2016," you're in a happy place. Yes, it can be that easy. Just spend a little time now (again, probably not more than a few hours) dragging all your images into their proper topic folders, and you'll reap the glorious benefits forever (they're not actually glorious, but it's such an awesome adjective, and one I don't get to use often, so I exercised some artistic writer's license there).

Step Seven:

What if you're importing new images from your camera's memory card? You do the same thing: you'll copy them from the card directly into the right topic folder, and then inside that topic folder, you'd create a new folder for these images with a simple name describing the shoot. So, let's say you took photos at a KISS and Def Leppard concert (awesome show, by the way). They would go onto your external hard drive, inside your Photo Library folder, inside your Concerts folder, and inside your Kiss – Def Leppard folder. (*Note:* If you're an event photographer, you might need a topic folder called "Events," with a bunch of other subfolders inside, like Concerts, Celebrities, Award Shows, and Political Events, to stay organized.)

Step Eight:

Another example: if you're a wedding photographer, you'd have a Weddings folder, and inside that you'd see other folders with simple names like Johnson_Anderson Wedding, and Smith_Robbins Wedding, and so on. That way, if Mrs. Garcia calls and says, "I need another print from our wedding," you'd know exactly where their photos are: inside your Photo Library folder, inside Weddings, inside the Garcia_Jones Wedding folder! Couldn't be easier (well, it actually can be easier, in Lightroom, but that comes later because you do all this organizing before you ever even launch Lightroom). This simple organization of your photo library is the secret. Now, while we're passing on secrets, here's the secret to a happy marriage. It's simple, but it works. The secret is… (wait for it, wait for it…) separate bathrooms. There. I said it. Two secrets, both in one book. Whodathunkit?

Four Really Important Things to Know Next

In this chapter, you're going to learn an organizational system—the same one I use for organizing my own images. I call it the "SLIM" system, which stands for the Simplified Lightroom Image Management system. First, the good news: you've already tackled a good chunk of it, because all that organizing you did when you moved all your photos onto one external hard drive and sorted them into the topics that you shoot, that's a core part of the SLIM system because we mimic that in Lightroom. But, there are a few more things you'll need to know up front (well, four, to be exact):

#1: Stay Away from the Folders Panel

When I meet somebody with a sad story about losing some (or all) of their photos forever, it was because they were messing around in Lightroom's Folders panel. That's why I don't recommend working in the Folders panel at all. It's too risky—make a mistake there and it's forever. Here's a car analogy: we can drive around, get to where we want, and be happy just driving, but if we open the hood and start messing around with the engine, and we don't really know what we're doing, we can mess up our car, right? Treat the Folders panel the same way—you can live a happy life without opening Lightroom's "hood" and messing around with stuff. Now, the Folders panel (like your car's engine) is essential for Lightroom to operate, but let's consider it an "under-the-hood" part of Lightroom and just stay out of there.

#2: Lightroom Was Designed for You to Use Collections Instead

That's why the Collections panel is available in all seven modules, but the Folders panel is only in the Library module. Collections are safe. They're forgiving. They protect you from messing up. Plus, you can put the same photo in multiple collections (you can have a photo of your dog in your Dogs collection, and in your Family collection, and in your Pets collection, and all is still right with the world)—with folders, you can't. If you've already been working in folders, don't sweat it. To make any folder a collection, just Right-click on it and choose **Create Collection**. Can it really be that easy? Yup.

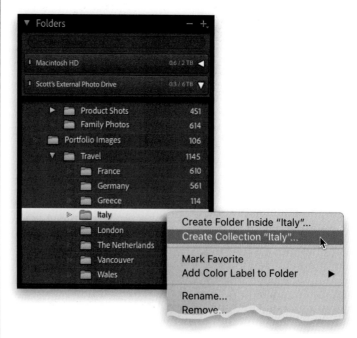

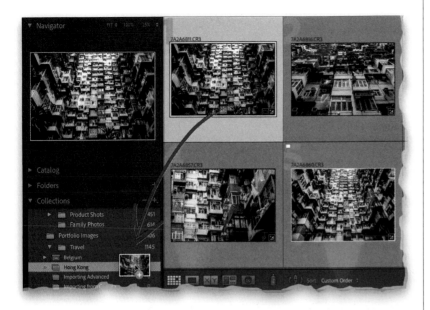

#3: Think of Collections as Photo Albums

Think back to the film days—we'd get our film developed, then we'd take our favorite prints and organize them in a photo album, right? Well, we do the same thing in Lightroom, but instead of calling them "photo albums," we call them "collections." We can drag-and-drop our favorite images into them, and arrange them in any order, and even have the same image appear in multiple collections. In short: collections are awesome!

#4: You Organize Your Collections Inside Collection Sets

If you've got a bunch of related collections, like collections from your trips to Italy and San Francisco, and Hawaii, and your trip to Paris, you can organize all those inside a collection set (and you'd probably name that set "Travel"). That way, all your travel collections are together (like the folders on your hard drive). If you look at a collection set's icon, it looks like that box you buy at Office Depot or Staples to put file folders inside of, and that's essentially what is it—a collection you can put other collections inside. You can even put other collection sets inside of it. For example, if you create a "Sports" collection set, you can put another collection set inside it called "Football," and then all the football games you shot can go inside that. If you shoot high school and college football or pro football, you can have a collection set for each of these—one with all your high school games ("Predators vs. Blazers," "Sabercats vs. Huskies"), then your college games in a separate collection set ("Buckeyes vs. Seminoles," "Vols vs. Crimson Tide"). Working with collections and collection sets also opens up a whole new world of features that you can only access if you work in collections. For example, if you want to work with Lightroom on your phone or tablet (see Chapter 14 for more on this), you have to use collections (you can't do this with folders). The future of Lightroom is a collections-based workflow, so no sense in fighting it, let's do it right from the start.

Want a Happy Lightroom Life? Use Just One Catalog

You may think it might be too late for you—you might already have a dozen different catalogs—but don't worry, it's not too late (you're about to learn how to fix that). If you want a happy, organized Lightroom life (and avoid a mountain of time-wasting frustration), go with just a single catalog for everything. So, how many images can you have in a single catalog and still work at full speed? We don't know the limit—Adobe has users with over 6 million images, and they're still rocking right along, so stick with one catalog and life will be good.

Step One:

If you're new to Lightroom, this is the easiest thing in the world. When you open Lightroom, what you see onscreen with your photos, that's your catalog. Just don't create a new one. That is your catalog, and that's what you're working with. But, what if you have three, five, or 15 different catalogs? You have two choices: (1) Combine all your catalogs into just one single existing catalog (ahhh, that's a beautiful place to be). Don't worry, it keeps everything intact—all your sorting, metadata, edits, and so on—that's why there's nothing hard about doing this. Start by opening whichever catalog is your favorite (or is the most complete, or the one you like the best etc.), and that will be the catalog you build upon. So, make that decision now.

Step Two:

Now, find your other catalogs and import them all (yes, all of them) into this one catalog. To do that, go under the File menu, choose **Import from Another Catalog**, then go to wherever you store your Lightroom catalogs on your computer (I'm guessing it's in a folder named "Lightroom" inside either your computer's Pictures folder or My Pictures folder). Once you find one of those catalogs, click Choose to start the process.

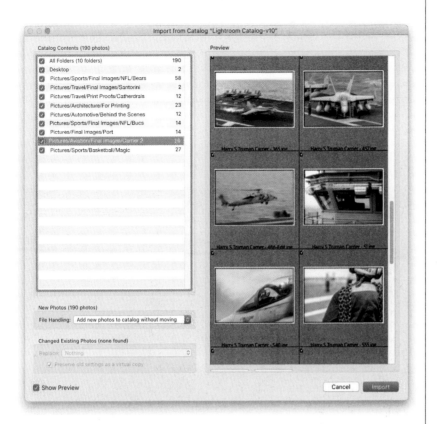

Step Three:
When you hit that Choose button, it's going to bring up the **Import from Catalog dialog** you see here. In the center is a list of all the collections in this other catalog and how many photos are in each. The only reason I would turn off one of these (and not have it import) is if I knew I already had a collection with the same name and photos as one in the catalog I currently have open. Also, leave the File Handling pop-up menu set to **Add New Photos to Catalog without Moving**. Otherwise, I just hit the Import button at the bottom right, and I go make a cup of coffee (it's a Keurig machine, so it's pretty quick), and then all those collections are added to my currently open catalog. Once I confirm they're there, I do two things: (1) I sort all the images into their proper collection sets by topic, and (2) I throw away the old catalog (there's no reason to keep it now—I've combined that catalog into this one). Now do that for all your other catalogs (this will take much less time than you think), and when you're done, all your photos are finally in just one catalog. Ahhhh, life is good.

Step Four:
The other option (2) is if you have multiple catalogs, but you really don't like any particular one, so you don't have one you want to start with. In that case, just create a brand new, clean, empty catalog and import all your other catalogs into it. Go under the File menu and choose **New Catalog**. This creates a new catalog with nuthin' in it, ready for you to start importing all your other catalogs using the method I just showed. The result is the same: one single catalog with all your photos in it, and you are on your way to a happy Lightroom life.

Where to Store Your Catalog

While we do want to store our images on an external hard drive, to get the best performance from Lightroom, you'll want to store your Lightroom catalog directly on your computer.

Step One:

Like I mentioned above, if you want the best performance from Lightroom, you'll want to store your Lightroom catalog file right on your computer—not on your external hard drive (that's just for photos). If you've already stored your catalog on your external hard drive, it's easy to copy it back onto your computer, but let's do this right so we don't mess anything up. First, I recommend creating a new empty folder on your external hard drive, naming it "Catalog Backup," and then dragging your existing catalog into that folder, along with the file named "Previews." Moving it in this folder does two things: (1) It creates a backup in the unlikely case that something goes wrong during this process (it won't, but just in case). And, (2) it keeps Lightroom from launching the catalog on your external hard drive by mistake.

Step Two:

Now, go into that Catalog Backup folder and click-and-drag the following files onto your computer: (1) the one with the extension .lrcat (that's your actual catalog file); (2) the one with the extension .lrdata (those are your thumbnail previews); and (3) you might also see a third file named "Helper" followed by .lrdata. All three files go onto your computer, inside your Pictures or My Pictures folder, inside a folder named "Lightroom" (you may already have one named that). Once that's done, double-click that .lrcat file you just copied onto your computer, and from now on, you'll be working from that catalog on your computer.

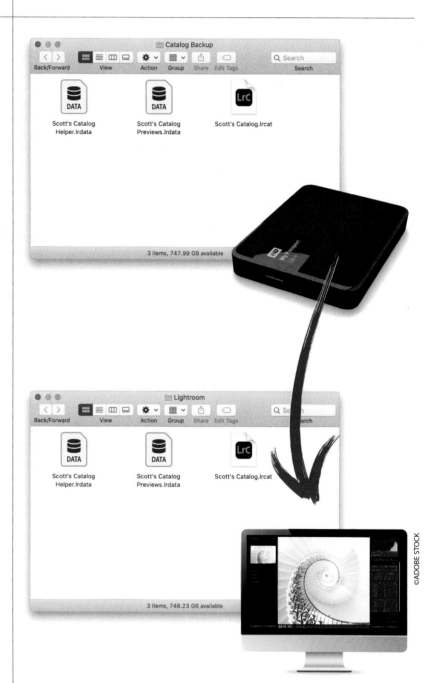

Okay, we've got to get off using folders—they're just too dangerous (and if you read that and you're like, "What?!" it just means you didn't read the "Four Really Important Things..." earlier in this chapter, so go back and read those now). Anyway, we're getting off folders before something bad happens, so here's how to make a collection from a folder. Now, just so ya know, we're not deleting any folders, we're just going to use collections instead. Those folders are sacred because our actual photos are inside, so we're just going to leave them alone once we make our collections.

How to Make a Collection from a Folder

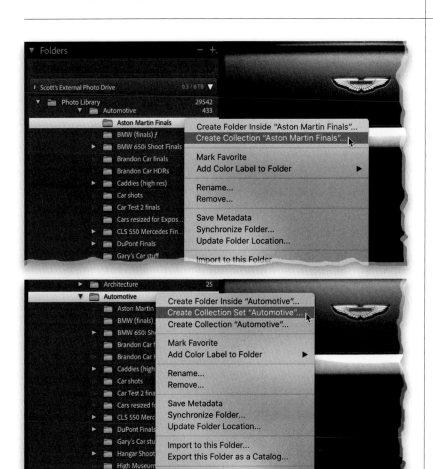

Step One:
This used to be more complicated, but thankfully Adobe made the process of creating a collection from a folder amazingly simple. Just go to the Folders panel, Right-click on the folder you want to also have as a collection, and from the pop-up menu that appears, choose **Create Collection**. Boom. Done. Drops the mic. That's really all there is to it. Go and look in the Collections panel and you'll see your new collection (they appear in alphabetical order).

Step Two:
If you have a folder with other folders inside of it, then you only change one thing: when you Right-click on the top-level folder (the one with other folders inside it), choose **Create Collection Set**, instead. That creates a collection set and keeps all those nested folders inside intact, but now you've created collections from them. Everything's the same, but now you're working in collections, and it's a happy place, with puppies and rainbows, and where small animals will come up and eat from your hand. You're on your way to a happier, healthier Lightroom life using collections.

WARNING: I know I've said this before (like up in the introduction on this page), but now that you've made collections from your folders, *do not delete any folders*. They contain your actual image files. Just ignore them. Leave them alone. Don't mess with them, etc. You're a collections person now, so just ignore that old way of working.

Organizing Photos Already on Your Hard Drive

I'm going to take you through my simple system for organizing the images already on your external hard drive (I say "external hard drive" because I'm hoping you've already moved them all onto an external hard drive, but if for some reason you haven't done that yet, you can of course still use this exact system, so don't let that hold you back).

Step One:

Okay, I'm counting on you having already read the first part of this chapter, so we can dive right in. Here's what we're going to do: Remember those topic folders you created on your external hard drive? The ones you created to organize your images before you even launched Lightroom? Well, we're going to mimic that same setup here in Lightroom using collection sets and collections. So, start by going to the Collections panel, clicking on the + (plus sign) button on the right side of the panel header, and choosing **Create Collection Set**. Give it the name of one of those folders on your external hard drive.

Step Two:

Once you create that first collection set, you're then going to drag your existing collections that fit into that topic inside this collection set. Let's say the first collection set you created is called "Sports," and you have collections from all the different sports you shoot. You simply drag-and-drop them right on this collection set and they move inside of it. If you have a lot of a particular topic—let's say you shoot a lot of car racing—you might need to create a Racing collection set inside that Sports collection set, and then drag your racing shoots inside that collection set. Inside my own Sports collection set, I have collection sets for Football, Baseball, Tennis, Motorports, Misc Sports, Hockey, and Basketball. However, inside my Football collection set, I have a collection set for College and another for NFL, and inside NFL I have even more: one to keep all my Bucs games together, one for all my Bears games, etc.

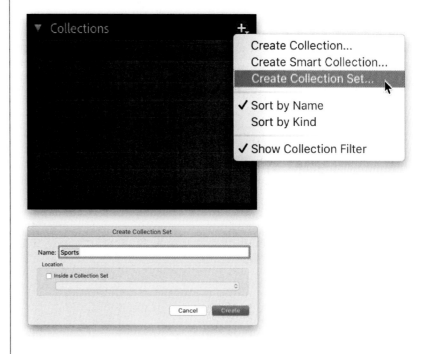

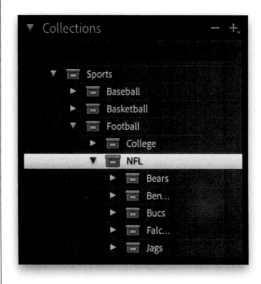

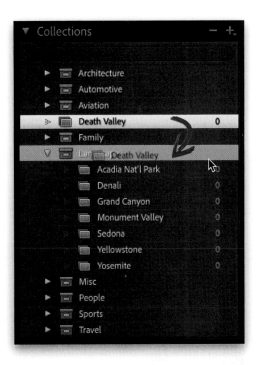

Step Three:

Now you're going to create a collection set for every topic folder you have on your external hard drive (if you haven't already done this following the previous technique). Then, you're going to drag-and-drop any collections you've created from folders, or already had in your Collections panel, or whatever, and put them into their corresponding topics (here, I'm dragging my Death Valley collection into my Landscape collection set—it highlights in yellow when you're right over it, as seen here). So, shots from a high school football game go in Sports; shots from your son's graduation get dragged into the Family collection set. That one time you shot close-up photos of flowers, goes in the Misc collection set (unless you start shooting flowers a lot, then you'd create a topic called Flowers at some point). Now, what if you have shots from your kid's football game, and you're not sure whether to put them in Sports or Family? Why not create a collection in both? That's the great thing about collections—your images can be in more than one location (whereas they can't if you're still using folders).

TIP: Deleting Collections

If you want to delete a collection or collection set, just Right-click on it, and from the pop-up menu, choose **Delete**. It'll remind you that the photos in that collection will still remain in your catalog (which is a good thing).

Step Four:

Here, at the top, is what it should look like on your external hard drive (you're seeing my topics—of course, yours will reflect the topics you shoot), and here, at the bottom, is what your Lightroom Collections panel should look like after you're done mimicking that structure with collection sets. If you click on a little "flippy" triangle, it expands the set and shows you all the collections inside.

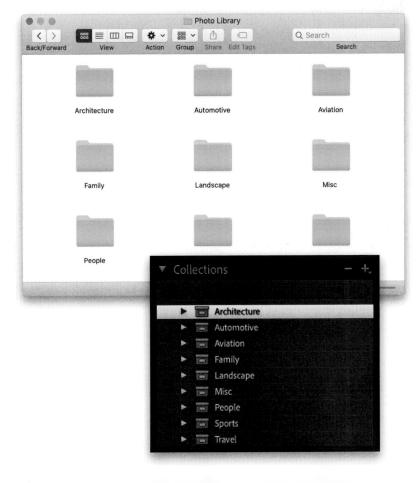

Use Pick Flags Instead of Star Ratings

If I'm teaching a workshop and I see one of my students stuck, it's almost a lock that it's one of two things they're stuck on, and one of them is the massive time-suck that is the 1–5 star rating system. They'll ask me, "What do you think? Is this a 2-star or a 3-star?" Who cares? You're not going to show anyone your 2s or 3s, right? No one will ever see them, so why waste time giving them a rating at all? Either it's in the running to be one of your best shots from that shoot (one you might share online) or it's one of those out-of-focus, probably-should-just-delete shots (you should ignore the rest altogether). That's why Pick flags make so much sense. Here's how we use them as the core of our organizational system:

Step One:
When you boil it down, we're looking for the best photos from our shoot, and we also want to get rid of the photos where the subject is out of focus, you pressed the shutter by accident, the flash didn't fire, etc. There's no sense in storing photos that you'll never use, right? **Pick flags** make marking your "keepers" (shots that are in the running), and the really bad shots you need to delete, super-quick and easy. First, you'll want to see images at a large size, so double-click on a photo, and then either press **Shift-Tab** to hide all the panels, or press **F** on your keyboard to go full screen. Now, take a quick look at the photo (good photos stand out even at a quick glance), and if it's a good shot, press the letter **P** to mark it as a Pick. If you hid the panels, you'll see "Flag as Pick" appear near the bottom of the image (as seen here). If you're in full screen, you'll just see a small white flag appear onscreen.

Step Two:
That's that the plan—if you see a good shot, you press P; if it's not good, you don't do anything, you just move on by pressing the **Right Arrow key** on your keyboard. If you see a really bad shot (out of focus, like the shot here, the subject's eyes are closed, etc.), press the letter **X** to mark it as a **Reject**. If you mark an image as a Pick or Reject and you change your mind, just press **U** to unflag that image.

TIP: Using Auto Advance for Picks
If you turn on **Auto Advance**, under the Photo menu, when you mark a Pick, it automatically moves to the next image.

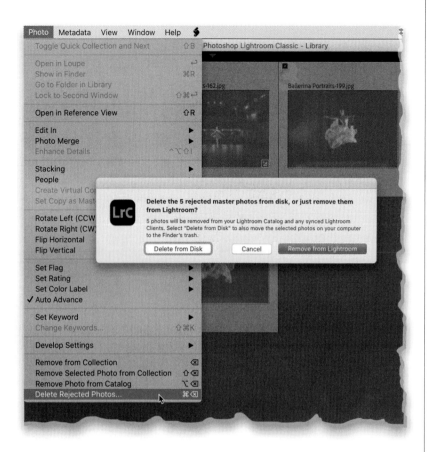

Step Three:

When we get into the system (starting on the next page), we'll get into what to do with those Picks, but at this point, you can just deal with those Rejects (you can really deal with them at any time, but the sooner you get them out of your life, the less time they'll appear onscreen just taking up space, so I like to deal with them early in the process). To get rid of all your Rejects at once, switch to Grid view **(G)**, then go under the Photo menu up top, and all the way at the bottom of the menu, choose **Delete Rejected Photos** (as shown here). This displays all the photos you're about to delete (I guess to give you one last chance to change your mind). A dialog will appear asking if you just want these out of Lightroom or deleted from your disk. I always choose Delete from Disk because if I marked them as Rejects, they truly are rejects, and I want them out of my life.

Step Four:

So, do we ever use star ratings? Yes. But only one: the **5-star rating** (here, I pressed the number **5** on my keyboard to assign a 5-star rating to this photo). We'll talk about why (and how it comes in handy having this second style of rating), but we don't use the 1-, 2-, 3-, or 4-star ratings, just the 5-star. If you're an "anti-starite" and don't want to use stars, you could go with color labels instead, but the downside of these is that they don't transfer to Lightroom on mobile devices, so I skip them in my rating process. However, here's where I do use color labels: If I do a shoot with a professional model, and I have a makeup artist, fashion stylist, and hair stylist onset, I let them use a different color label to mark each of their favorites. That way, I can quickly find each person's favorites, and can email or text them finals for their portfolios or social media.

Organizing Photos You're Importing from Your Camera

Here, we're going to look at how to organize your images from a shoot you just imported, and I'm going to show you the same method I use for organizing my shoots. It's pretty straightforward, but like any part of this system, the key is consistency.

Step One:

In reality, of course, Step One is to import your photos from your camera's memory card, so we're going to pick this up from the point where you literally just imported your photos. When you import your photos, they appear in Grid view, waiting for you to sort, edit, etc., but if you didn't create a new collection or collection set for them upon import (see page 9), you'll want to do that first. So, go to the Collections panel, click the + (plus sign) button on the right of the panel header, and from the pop-up menu, choose **Create Collection Set**, and then give that new set a very descriptive name. In our example here, these are shots from London, so I'm naming the collection set (wait for it…wait for it…) "London." I have a collection set called "Travel" with all my travel photos inside, so in the Create Collection Set dialog, I'd turn on the **Inside a Collection Set checkbox**, choose Travel from the pop-up menu, then click Create.

Step Two:

At this point, you have an empty collection set named London (inside your main Travel collection set), so go under the Edit menu and choose **Select All** (or press **Command-A [PC: Ctrl-A]**) to select all those photos from London you just imported. Go back to the Collections panel, click the + sign button again, but this time choose **Create Collection** from the pop-up menu. When the Create Collection dialog appears, name this new collection "Full Shoot" (that way, any time you want to see all the images from your London shoot, you'll just click on this Full Shoot collection).

Step Three:
In the Location section, turn on the Inside a Collection Set checkbox, and from the pop-up menu below, choose London (all the collection sets you've created will appear in this menu). Below that, in the Options section, the Include **Selected Photos checkbox** should already be turned on, but if for some reason it's not, turn it on (otherwise, it will ignore the photos you just selected to be in this new collection). Now you can click Create, and it puts this new "Full Shoot" collection inside of your London collection set. Okay, so far, so good. Now it gets more fun (not harder, it actually does get more fun at this point).

Step Four:
This is where I begin the process of finding my best images from the shoot using the **Pick flag method** I showed back on page 44. I double-click on the first image to see it larger onscreen (this puts it in what Lightroom calls "Loupe view"), then I get all the panels out of the way by pressing **Shift-Tab**, and then I start going through my images. If I see an image I like, I press **P** on my keyboard. If I don't like the photo, I don't do anything—I just hit the **Right Arrow key** on my keyboard and move on. If I see a photo that's so messed up it needs to be deleted, I press **X**. If I mess up doing either, I press **U** to unflag it. I do this pretty quickly, because I'll have an opportunity to be really choosy in the next stage, but for now, when the image appears onscreen, I make a quick decision—it's a Pick or I move on. You'll be amazed at how quickly you'll move through an entire shoot using this method. Okay, we're not done yet, but we're well on our way.

Step Five:

Once you've got your Picks and Rejects flagged, let's get rid of the Rejects. Switch back to Grid view **(G)**, and in the Catalog panel (press Shift-Tab again to make it visible), click on Previous Import. Then, go under the Photo menu and choose **Delete Rejected Photos**. This displays just the photos you've marked as Rejects, and a dialog appears asking if you want to remove them from Lightroom. Go ahead and click on the **Delete from Disk button** to remove them from your hard drive.

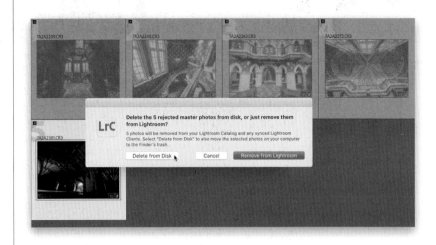

Step Six:

Now to see just your Picks (and hide the rest), click back on your Full Shoot collection in your London collection set, and make sure the Filmstrip along the bottom is visible. Near the top right of the Filmstrip, you'll see the word "**Filter**," and to the right of it are three grayed-out flags. To see just your Picks, click twice on the first flag (the white one), and it will display just your Picks. By the way, you only have to click twice like that the first time you use it, and just in case you were curious, clicking the center flag would display just the images you didn't flag.

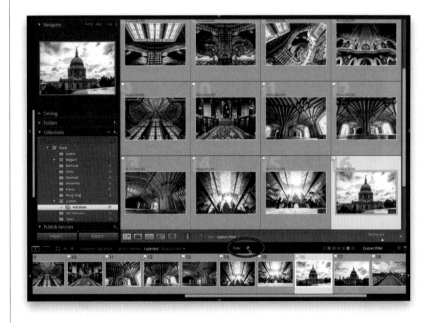

TIP: Use the Other Picks Filter

You can also choose to see just your Picks, Rejects, or your unflagged photos from the **Library Filter bar** that appears across the top of the center Preview area (if you don't see it, just press the \ **[backslash] key** on your keyboard). Just click on **Attribute** and a bar pops down. Click on the white Pick flag, and now just your Picks are visible.

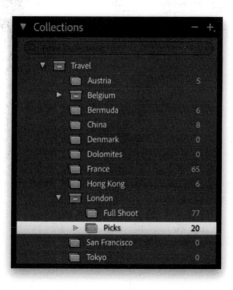

Step Seven:

Now that only your Picks are visible, press **Command-A (PC: Ctrl-A)** to select all the currently visible photos (your Picks), and let's put them into a collection. Press **Command-N (PC: Ctrl-N)**—that's the keyboard shortcut to create a new collection (well, to bring up the Create Collection dialog anyway), and this is a good one to know because you're going to create a *lot* of new collections. When the Create Collection dialog appears, name this collection "Picks" and, of course, you are going to choose to put this in that same London collection set, because these are the Picks from that shoot, so choose London from the Inside a Collection Set pop-up menu (if it's not already selected for you), leave the Include Selected Photos checkbox turned on (we always leave that on), and click Create. So, where are we now in this process? Inside our Travel collection set, we have a collection set named London, and inside of that we have a regular collection called "Full Shoot" and one called "Picks." We're almost there.

Step Eight:

Within our Picks collection, there are some shots that really stand out—the best of the best, the ones you actually will want to email to the client, or print, or add to your portfolio. So, we need to refine our sorting process a little more to find our best shots from this group of keepers—our "Selects." We're already done with our Pick flags since all our Picks are already in their own collection. So, we could just select all the photos in our Picks collection and press the letter U to unflag them all, and then we could use the Pick flags all over again to narrow our Picks down to the best-of-the-best (our Selects). But what if, instead, we use that 5-star rating we've been saving for just such an occasion? Doing this will come in really handy later (when we get into smart collections) and those Pick flags won't help us then (more on this later).

Step Nine:

So, we're going with just using the 5-star rating for separating our very best shots from the Picks—our "good shots" (you'll be glad later that you did it this way). Okay, now we're looking for our best-of-the-best shots from our shoot (again, I call these our "Selects"). Getting to these Selects is when we really take our time. We get much pickier (no pun intended) about which photos make the cut, and we don't zoom through the images (and we don't have to, because we're starting with our Picks and it should be a much smaller number of images than our full shoot). In your Picks collection, double-click on the first photo (the first thumbnail in the top-left corner) to make it larger (take it into Loupe view), press **Shift-Tab** (or go full screen), and let's start finding our 5-star images.

Step 10:

Start going through your images, and when you see a shot that's really good (one that you might fully edit, share online, send to the client, etc.), just press the number **5** on your keyboard, and you'll see **"Set Rating to 5"** appear onscreen (if you're in full-screen mode, you'll see five stars appear across the bottom of the screen. Not the words "5 stars," you'll actually see five stars).

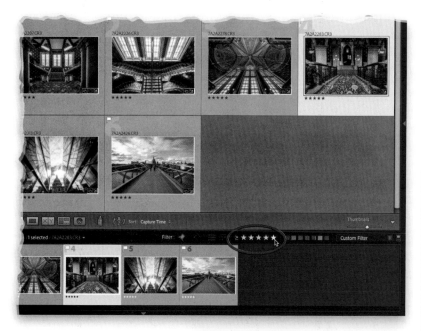

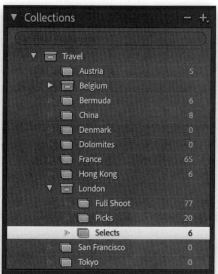

Step 11:
Once you've carefully made your choices on which Picks should be your 5-star images, it's time to put them in our third and final collection. But first, we have to see only those 5-star images. So, go to the Filmstrip again, and to the right of the Pick flags, you'll see five grayed-out stars. Click-and-drag your cursor from left to right to highlight all five stars (as shown here), and it filters out everything else, leaving your 5-star-rated images visible. You probably know what to do from here: select all and create a new collection, name it "**Selects**," and save it inside the London collection set.

Step 12:
Now, if you look in your London collection set, you'll see three individual collections: (1) Full Shoot, (2) Picks, and (3) Selects. From here on out, you'll probably just work with your Selects collection, and that's okay—those are your best images from the London shoot. If you need extra images (maybe for a photo book or slide show), you'd look in your Picks, because those are still at least "good shots." Okay, now that you know the routine, what would a portrait shoot's collection set look like? It would be in my Portraits collection set, named with my subject's name (like "Allison's Headshots"), and inside that collection set, you'd find three collections: Full Shoot, Picks, and Selects. What if it was a landscape shoot from Yosemite? Then, it would be in my Landscapes collection set, inside a collection set named "Yosemite," and inside that Yosemite collection set would be three collections: Full Shoot, Picks, and Selects. It doesn't matter what the topic is, each shoot breaks down the same way—Full Shoot, Picks, and Selects. Keep it consistent like this and the process gets really quick (and you'll be able to find anything really quickly).

Two Tools to Help You Find Your Best Shots: Survey and Compare View

Sometimes it's tough getting down to just a few shots that are your best of the best—especially if the shots look very much alike (like from a portrait shoot). But, there are two tools built into Lightroom that can help make the process easier: they are Survey view and Compare view.

Step One:

I use **Survey view** when I have a number of shots that are similar (like a number of shots of the same basic pose) and I'm trying to find the best ones from that group. You enter Survey view (seen here) by selecting the similar photos (click on one, then press-and-hold the Command [PC: Ctrl] key and click on the others— I selected a group of six images here), and then pressing the letter **N** on your keyboard. While it's hard picking which images from a similar set of shots are the best ones, it's much easier picking which ones from a set you like the least. That's what Survey view is all about— the process of elimination. See which image you like the least, then move your cursor over it and an "X" appears in the bottom-right corner (as shown here).

Step Two:

Click on that X to remove that image from screen. It doesn't delete it, and it doesn't remove it from the collection or anything like that, it literally just removes it from the screen for now (as seen here, where there are now just five images left onscreen). Then, do the same for the next image you like least, and the next, and so on, clicking on that X in the bottom-right corner of any image you don't like, and it's removed from the screen.

Step Three:

Here, I'm down to just three images. If you like all three, you could mark them all as 5-star images, or continue on, and when there's only one left, that's the shot that made it through (in this case) all five rounds of elimination. Press the number **5** on your keyboard to mark it as a 5-star image for your Selects collection. Another method for narrowing things down is using **Compare view**. Instead of putting a bunch of images onscreen at once, it's more like a head-to-head battle between two images at a time. Press **Shift-Tab** to hide all the panels, then start by selecting the group of images you want to narrow down, and press the letter **C** to enter Compare view. This puts one image on the left, called the "Select," and one on the right, called the "Candidate" (as seen below).

Step Four:

At the end, whichever image winds up as the Select is your favorite, but for now (when you first start), you need to decide which of these two you like better. If you like the image on the left (the Select) better than the one on the right (the Candidate), press the **Right Arrow key** on your keyboard. The Select image stays the same, but a new Candidate image appears to challenge your current Select. Or, if you like the Candidate better than the Select, click the **Swap button** (circled here) down in the toolbar, and it moves over to the left to become the Select and a new photo appears as the Candidate. (*Note:* If you don't see the toolbar, press **T**.) That's pretty much it. If you selected seven images to start, when you get to the last image to be compared, it stops there (no more images will appear as the Candidate). It's now down to these last two. If you still think the Select looks best, well, that's your favorite (it beat all the other contenders). If you like that Candidate best, hit the Swap button, then click the Done button in the toolbar to go to Loupe view, where you can then press 5 on your keyboard to mark the winning image as your Select. That's it.

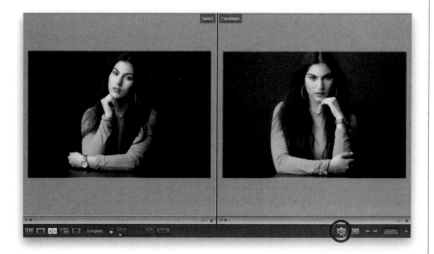

Smart Collections: Your Organizational Assistant

Wouldn't it be awesome to have an assistant that you could assign Lightroom housekeeping tasks to, like "Gather all my 5-star photos from the last 60 days, but only ones that were taken with my R6 body, and only ones that I shot horizontally, and that have GPS data, and put them in a collection for me automatically"? That's what smart collections do—they gather photos based on a range of criteria you choose, and put them in a collection for you automatically. Like an assistant. Or a magical photo butler. Let's go with that second one.

Step One:

To understand the power of smart collections, let's build one from scratch. One that creates a collection of all our 5-star photos of libraries taken in the past three years, but in horizontal format, so we can create a calendar as a gift for friends and family (ya know, in lieu of a good gift ;-). In the Collections panel, click on the + (plus sign) button on the right side of the panel header, and choose **Create Smart Collection** from the pop-up menu to bring up the **Create Smart Collection dialog**. In the Name field at the top, name your smart collection (maybe something simple like, "Best of Libraries"), and from the Match pop-up menu, choose **All**, so a photo must include criteria we add to be included in our smart collection.

Step Two:

Then, from the pop-up menu beneath that, to the right of "Rating" (that's the default for the first pop-up menu), make sure it's set to **Is**, and you'll see five black dots to the right. Click on the fifth dot and it changes to five stars. If you clicked the Create button at this point, it would create a new collection with every 5-star image in your entire catalog, but let's narrow things down by adding another criterion, so we get just the 5-stars from the past three years. To create another criterion, click on the little + (plus sign) button on the far right of those stars. From the first pop-up menu, under Date, choose **Capture Date**, then from the menu to the right of that, choose **Is in the Range**, and then in the text fields that appear, enter "2019-01-01" to "2021-12-31."

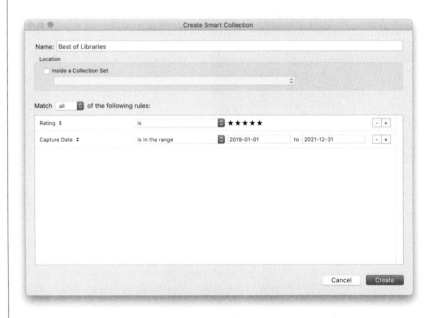

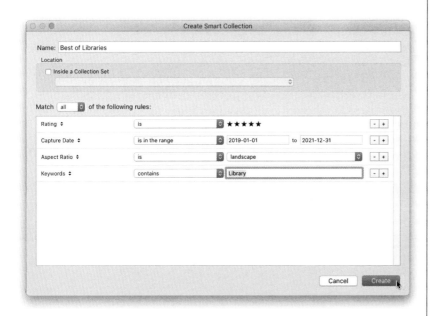

Step Three:

For our calendar layout, we need the images to be wide (not tall), so let's add another criterion. Click the + button on the right of the last criterion, and from the first pop-up menu, under Size, choose **Aspect Ratio**. From the next menu, choose **Is**, and then from the menu to the right of that, choose **Landscape**. Now, if you click the Create button, you'd get all your 5-star images from the past thee years that are wide. Let's add a final criterion to only include photos that have the keyword "Library" (as seen here. Keywords are search terms—see page 58 for more on these).

Step Four:

Click the Create button and it looks through your entire photo library and adds all the photos that match your criteria into a smart collection (you'll see it in your Collections panel, and you'll know it's a smart collection because it'll have a little gear in the bottom-right corner of its icon). What's nice is any new photos you import (or existing ones you edit) that match the same criteria you set up will get added to that smart collection automatically. A couple of things: If you want to change, add, or delete any criteria from this smart collection, just double-click on its name to open the Edit Smart Collection dialog. Also, smart collections don't have to have this level of depth—they can be "one liners" that compile any photos that don't have your copyright data added, or have a particular keyword (or have no keywords), or don't have GPS data (you can add GPS data—see page 74), so don't think they always have to be these in-depth multi-criteria searches.

ADVANCED TIP:
Adding Sub-Criteria

If you're looking for even smarter smart collections, press-and-hold the Option (PC: Alt) key and the + button next to a line of criteria changes to the # (number sign) button. Click it, and it adds a sub-criteria line with more advanced options.

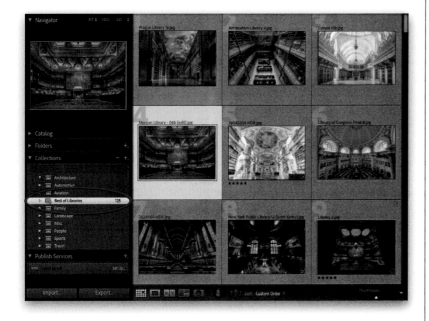

Reducing Clutter Inside Your Collections by Using Stacks

One way to simply "de-clutter" any collection is to use Lightroom's Stacking feature, where you use one thumbnail to represent a bunch of photos that pretty much look alike. A great use for this would be when you shoot a pano with a bunch of frames (that look just slightly different) or an HDR, where you took seven frames, but just need one frame to represent all seven (since it's the exact same scene, just brighter or darker). You can do this manually, but you'll love the automatic method even more.

Step One:

Here, we've imported images from an air show, and you can see what I was talking about above, where there are several shots that look alike (I made the thumbnails really, really small and there are still parts of the shoot that aren't visible). To cut through the clutter of seeing all these similar images, we're going to group similar shots into a stack with just one thumbnail showing (the rest of the photos are grouped behind that photo), but with the number of photos behind it visible right on the thumbnail. Start by clicking on the first photo of a similar shot (as seen highlighted here), then press-and-hold the Shift key and click on the last similar photo (as shown here) to select them all (you can also select photos in the Filmstrip, if you prefer).

Step Two:

Now press **Command-G (PC: Ctrl-G)** to put all your selected photos into a **stack** (this keyboard shortcut is easy to remember, if you think of G for Group). If you look in the grid now, you can see there's just one thumbnail visible with that plane. It didn't delete or remove those other photos—they are stacked behind that one thumbnail (in a computery, technical, you'll-just-have-to-trust-that's-what's-happening kind of way). If you look in the top-left corner of that thumbnail, you'll see the number 12 in a small white box. That's letting you know there are 11 similar images stacked behind this one thumbnail.

Step Three:

Here, I selected each set of images of the same plane, pressed Command-G to stack them, and now I'm down to just these eight thumbnails, which represent all the images in the collection in Step One. Talk about cutting the clutter! The view you're seeing here is called the **Collapsed view.** To see all the photos in a stack, click on it and press the letter **S** on your keyboard, or you can click on that little number in the top-left corner of each stack's thumbnail, or click on one of the two little thin bars that appear on either side of the thumbnail. (To collapse the images back into the stack, just do any of these again.) To add a photo to an existing stack, just drag-and-drop it right onto the existing collapsed stack. To stop stacking, Right-click on a stack's thumbnail, and from the pop-up menu, under Stacking, choose **Unstack.**

TIP: Pick Your Stack Cover Photo

The first photo you selected when creating a stack becomes the cover thumbnail. To choose a different photo as your cover, expand the stack, go the photo you want, then click on its stack number in the top-left corner. That moves it to the front, and it becomes the new cover image.

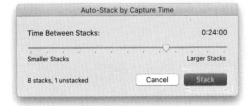

Step Four:

Manually stacking like this does takes time, which is why I love having Lightroom do it for me automatically, based on the time the photos were taken. Go under the Photo menu, under Stacking, and choose **Auto-Stack by Capture Time.** This brings up a dialog with a slider, and it shows how many stacks it would create automatically based on whether you want it to stack images with less time between them (drag left) or more time (drag the slider right). When you click Stack, it looks like nothing happened—that's because the stacks are expanded. To see the tidied up look, go back under the Stacking menu and choose **Collapse All Stacks.**

Adding Keywords (Search Terms)

There are a number of pros, including journalists, commercial photographers, and folks who sell their images as stock, who have to add keywords (search terms) as part of their job. For the rest of us, it just takes a lot of time, and it may even be a big waste of time if you're pretty organized, in which case, finding the images you're looking for is quick and easy even without keywords (I don't usually use keywords myself). If you're not organized, keywords are your only hope, and for those folks (and people who just like keywording), here's how to add them:

Step One:

I just want to mention up front that I'm going to start with the keywording basics, as most folks won't need the level of keywording I get into after just a couple of pages. But, if you're a commercial photographer, or if you work with a stock photo agency, keywording all your images is pretty much what you have to do. Luckily, Lightroom makes the process fairly painless. There are a few ways to add specific keywords, and there are different reasons why you might choose one way over another. We'll start with the **Keywording panel** in the right side panels. When you click on a photo, it will list any keywords already assigned to that photo near the top of the panel (as shown here). By the way, we don't really use the word "assigned," we say a photo has been "tagged" with a keyword, as in, "It's tagged with the keyword NFL."

Step Two:

I tagged all the photos here with some kinda generic keywords when I imported them, like NFL, Dolphins, Miami, AFC East, New York Jets, and Hard Rock Stadium. To add another keyword, you'll see a **text field** below the keyword field where it literally reads, "Click here to add keywords." Just click in that field, and type in the keyword you want to add (if you want to add more than one keyword, just put a comma between them), then press the **Return (PC: Enter) key**. So, for the selected photo in Step One, I added the keyword "Catching Pass." Easy enough.

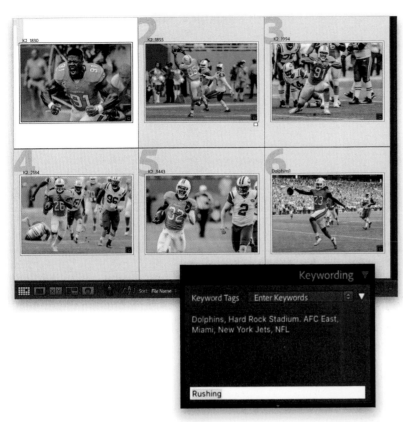

Step Three:

If you want to apply the same keyword(s) to a bunch of photos at once, like 71 photos taken during the celebration, you'd select those 71 photos first (click on the first one, press-and-hold the Shift key, then scroll down to the last one, and click on it to select all the photos in between), then in the Keywording panel, add your keyword(s) in the **Keyword Tags text field**. For example, here I typed "Rushing" and it added that keyword to all of these photos. So, the Keywording panel would be my first choice if I needed to tag a number of photos from a shoot with the same keywords.

TIP: Choosing Keywords

Here's how I'd choose my keywords: I'd ask myself, "If, months from now, I was trying to find these same photos, what words would I most likely type in the Search field?" Then, I'd use those words. It works better than you'd think.

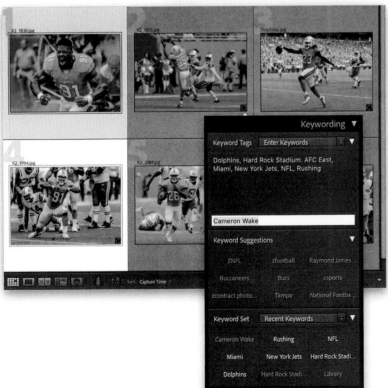

Step Four:

Say you wanted to add some specific keywords to just certain photos, like adding the name of a particular player to shots of just him. You'd Command-click (PC: Ctrl-click) on the photos of him to select them, then use the Keywording panel to add this keyword, and it would add it to just those photos.

TIP: Create Keyword Sets

If you use the same keywords often, you can save them as a Keyword Set, so they're just one click away. To create a set, just type the keywords in the Keyword Tags text field, then click on the **Keyword Set pop-up menu** near the bottom of the panel. Choose **Save Current Settings as New Preset** and they're added to the list, along with built-in sets like Wedding, Portrait, etc.

Step Five:

The next panel down, **Keyword List**, lists all the keywords you've created or that were already embedded into the photos you've imported. The number to the right of each keyword tells you how many photos are tagged with that keyword. If you hover your cursor over a keyword in the list, a white arrow appears on the far right. Click on it and it displays just the photos tagged with that keyword (in the example shown here, I clicked on the arrow next to "Entrance," and it brought up the photos tagged with that keyword.

TIP: Drag-and-Drop and Delete Keywords

You can drag-and-drop keywords in the Keyword List panel right onto photos to tag them and vice-versa—you can drag-and-drop photos right onto keywords. To remove a keyword from a photo, in the Keywording panel, just delete it from the Keyword Tags field. To delete a keyword entirely (from all photos and the Keyword List panel itself), scroll down to the Keyword List panel, click on the keyword, then click the – (minus sign) button on the left side of the panel header.

Step Six:

It doesn't take long for your list of keywords to get really long. So, to keep things organized, you can create a keyword that has **sub-keywords** (like NFC as the main keyword, then inside that is 49ers, Bears, and so on). Besides having a shorter keyword list, it also gives you more sorting power. For example, if you click on NFC (the top-level keyword) in the Keyword List panel, it will show you every image in your catalog tagged with 49ers, Bears, etc. But, if you click on 49ers, it will show you only the photos tagged with 49ers. This is a huge timesaver, and I'll show you how to set this up in the next step.

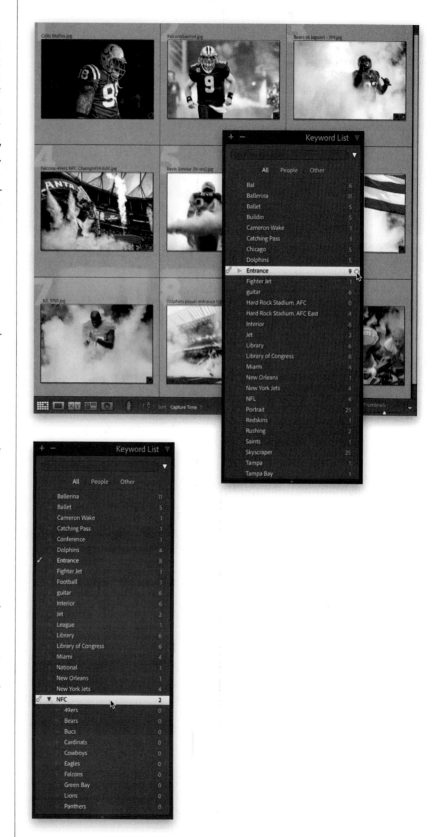

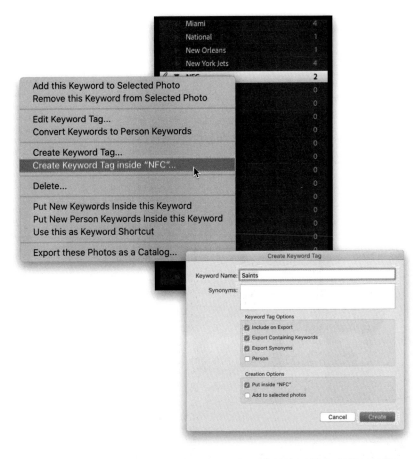

Step Seven:
To make a keyword into a top-level one, just drag-and-drop other keywords directly onto it. That's all you have to do. If you haven't added the keywords you want as sub-keywords yet, do this instead: Right-click on the keyword you want as a top-level keyword, then from the pop-up menu, choose **Create Keyword Tag Inside** (as shown here) to bring up a dialog where you can create your new sub-keyword. Click the Create button, and this new keyword will appear under your main keyword. To hide the sub-keywords, click the triangle to the left of your main keyword.

TIP: "Painting" On Keywords
Another way to add keywords is to paint them on using the **Painter tool**. Click on the Painter tool down in the toolbar, then from the pop-up menu to its right, choose **Keywords** and a text field will appear to its right. Type in your keyword(s) that relates to particular photos, then click-and-drag that paint can over just those photos you want to have that keyword(s). You'll see a confirmation appear onscreen as they're tagged.

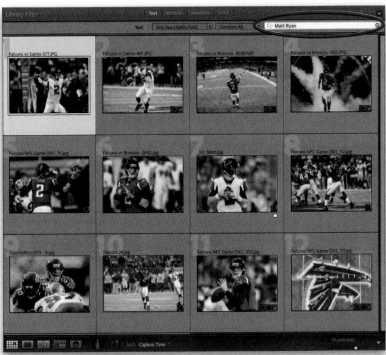

Step Eight:
Besides working in the Keywording and Keyword List panels, once you've tagged your images with keywords, you can then use the **Library Filter** to search for images by their keyword. For example, if you're looking for shots of a particular player, you can just press **Command-F (PC: Ctrl-F)** and the **Text Search field** will appear in the top right, above your thumbnail grid. Type in the name of the player, and just the shots of him you tagged with his name will instantly appear in the grid below. Keywords really are just that—search terms. Some you add are generic (like NCAA football), but you can add more specific ones (like Matt Ryan) as well.

Renaming Your Photos

If you didn't rename your photos when you imported them from your camera's memory card, it's really important (for searching purposes, if nothing else) that you rename them now with descriptive names (we name collections, sets, photos—everything—with descriptive names). If all you have are the numeric names assigned by your camera, like "_AKOU6284.jpg," your chances of finding your images using a text search are pretty dim. Here's how to rename your photos to something that makes sense (and makes searching easy):

Step One:

Press **Command-A (PC: Ctrl-A)** to select all of the photos in your current collection, then go under the Library menu and choose **Rename Photos**, or press **F2** on your keyboard to bring up the **Rename Photos dialog** (shown here). From the File Naming pop-up menu, choose whichever preset you want to use. I always use the Custom Name - Sequence preset, which lets you type in a custom name (as I did here, so I'll be changing the name of all these files to "Dave On Set"), and then it starts automatically numbering each image, starting with whatever number you like (I generally choose to start with the number 1). That's all there is to it.

Step Two:

Now just click OK, and all the photos are renamed in an instant (Dave On Set -1.jpg, Dave On Set -2.jpg and so on). This whole process takes just seconds, but makes a big difference when you're searching for photos—not only here in Lightroom, but especially outside of Lightroom in folders, in emails, etc., plus it's easier for clients to find photos you've sent them for approval.

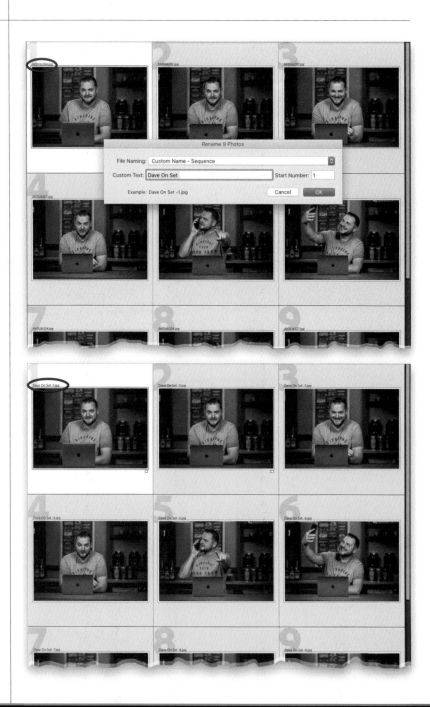

Lightroom uses facial recognition software to help you find, and then tag, people easily. When it works, it's pretty helpful, but well…it's still "a work in progress," shall we say? If you're ever depressed and need a good laugh, turn on face tagging and watch it bring up things like a potato, as it asks, "Is this Larry?" Then, a bar of soap, "Is this Larry?" and then plate of scrambled eggs, "Is this Larry?" Sometimes it actually brings up Larry. Okay, it's not quite that bad, but it's not quite that good either. It may be worth using for tagging family members with their names (to use with keywords for searching).

Face Tagging to Find People Fast

Step One:

First, a heads-up: While we might refer to Lightroom's face tagging as "automatic," it's going to feel more semi-automatic because you do a lot of the initial work yourself. At first, it only recognizes that there's a face in the photo—it doesn't know who it is. That part is up to you, as you have to tell it who it is, so that it can go about its business of mis-assigning that face to the wrong person. So, if you have a decent-sized catalog, and you want your entire catalog set up with face tagging, you might need to set aside a morning to initially set this up. Okay, now that you know that, to start face tagging, go to the Library module and click on the **People icon** in the toolbar (shown circled here; or choose **People** from the View menu, or just press the letter **O** to jump there fast).

Step Two:

The first time you launch this, you get a screen that lets you know that it takes a while for Lightroom to go through your catalog and search each image for faces (luckily, it does this in the background, so it doesn't stop you from working). But, it does give you a choice: start now and do your entire catalog in the background, or just do it when you actually click the People icon. Choose whichever option you want, and it starts searching for faces. (By the way, as I'm writing this, Lightroom just displayed a lamp post, an archway, and a group of flags for faces. I am not making this up.)

Step Three:

As it finds what it thinks are faces, they'll be displayed in the **Unnamed People section** with a "?" below each thumbnail, letting you know it doesn't know whose face that is (which makes sense—you haven't told Lightroom who's who yet). It found a way out-of-focus shot and some kind of pattern it thought was a face, so I would stop and delete those from this People view right now. To remove faces, just move your cursor over the thumbnail of the face (or non-face) you want to remove and click the "X" icon that appears in the bottom-left corner of the thumbnail (shown circled here in red). *Note:* Don't worry—this doesn't remove these photos from Lightroom, just from this People view. I'd go ahead and get rid of that texture image in the bottom row, too.

Step Four:

The next step is to let Lightroom know who each of these people are, and you simply just need to tag a photo with the person's name (which is just a special type of keyword used for searching). To add a name, just click your cursor right on the little question mark below the photo, and a text field appears. Type in their name (like I did here, where I typed in "Sue" for that face, because…well… that's her name). Now, press the **Return (PC: Enter) key** on your keyboard to lock in that name. Once you tag a face with a name, it moves up top to the **Named People section** (as seen here, where Sue is the only person tagged so far). If you see faces in the Unnamed People section that match someone in the Named People section up top, you can just drag-and-drop them right onto their thumbnail in Named People.

Step Five:

If Lightroom recognizes faces that it thinks are the same person, it groups them together in a stack to help keep things tidy. Take a look at the fifth thumbnail from the left in the top Unnamed People row here—it found nine similar faces and it grouped them together (there's a "9" in the top left of the thumbnail). To see the faces in that stack, click on its thumbnail, then press **S** on your keyboard and the stack expands to show all nine images. To collapse it back, press S again. To just take a quick peek inside a stack, press-and-hold the S key to see inside, then when you release that key, it collapses back again. Once you start tagging faces with names, you'll notice after just a few minutes, it will start "catching on," and a you'll see it suggest names of people it thinks it recognizes followed by a question mark, like this: "Anna?" If it is indeed Anna, click the **checkmark icon** (as shown here) and it moves that image to her thumbnail up into the Named People section. If it's not, her, click the "No!" symbol. Also, once you tag someone, give Lightroom a minute or two to find and tag other similar faces. It learns as it goes. Creepy. Well, kinda.

Step Six:

We're now at the point where it has found all the faces it can find, and it has grouped the ones it thinks are the same person, and you're still left with a whole bunch of Unnamed People. So, it's now up to you to name them or drag-and-drop unnamed faces onto the right thumbnails up in the Named People section. You'll see a **green + (plus sign)** appear when you're over the named thumbnail, letting you know that you're adding this face to that tag.

Step Seven:

If you double-click on a tagged photo in the Named People section, it takes you to the **Confirmed section**, which shows you which photos are confirmed to be that person. In the **Similar section** below, it shows you other photos it thinks may be that person (a question mark appears after the person's name, as seen here). Expect this to happen pretty frequently). To confirm it's a photo of Anna, hover your cursor over the thumbnail, click on the checkmark, and it moves up to the Confirmed section. Lightroom now uses that information to present other images. If it's not Anna, click on the "No!" symbol, or click on the name to add the correct one.

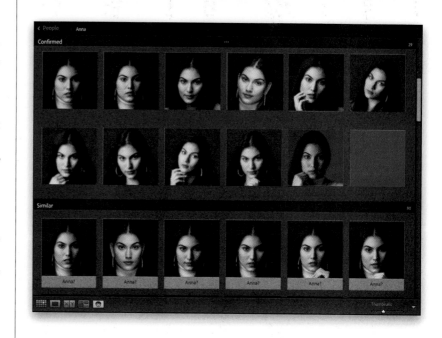

Step Eight:

What happens if you double-click on an untagged photo? It opens in a **Loupe view window** and displays a rectangle around any region it thinks is a face (as seen here. I love how it thinks three different people in this image are "Cindy"). If you know who the person (or people, in this case) is, click on the name and tag the image with their correct name. Also, if it missed recognizing a face in an image, you can create a region over one by simply clicking-and-dragging over a face. If it selected an area that isn't a face, click on the rectangle and then click on the little "X" in the top right. To close Loupe view and return to People view, press the **O key**, then click on the word "People" in the top-left corner of the window.

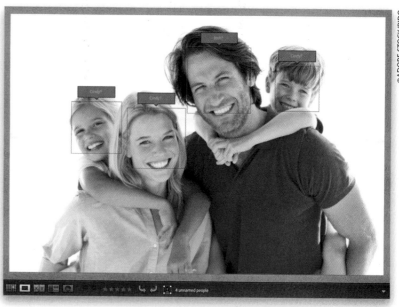

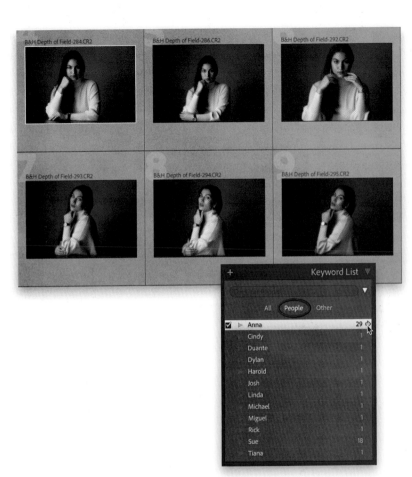

Step Nine:

Once you've got these People keywords applied, they work like regular keywords to help you find tagged images fast. Just go to the Keyword List panel, click on the **People tab** (up top) and now it only shows names (in this case, I'm searching for shots of Anna). If you move your cursor over the People keyword "Anna", an arrow appears to its right. Click on that, and it now displays just those images that are tagged with "Anna." You can also search using the standard old **Command-F (PC: Ctrl-F)** text search by typing in the name of the person you're trying to find and they'll come right up.

Finding Photos Using a Simple Search

To make finding our photos easier, we gave them descriptive names (either when we imported them, or when we renamed them afterward), and because we did that simple step, searching for our images by name is a breeze (of course, we can search by more than the name—we can search by everything from your camera's make and model, to the lens you used, and more).

Step One:

Before you start searching, first you need to tell Lightroom where you want it to search. If you want to search just within a particular collection, go to the Collections panel and click on that collection. If you want to search your entire photo catalog, then look down on the top-left side of the Filmstrip and you'll see the path to the current location of the photos you're viewing. Click-and-hold on that path and, from the pop-up menu that appears, choose **All Photographs** (some other choices here are to search the photos in your Quick Collection, your last import of photos, or any of your recent folders or collections. If you're syncing your photos, you'll also see some sync options).

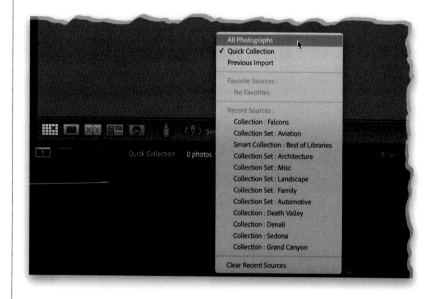

Step Two:

Now that you've chosen where to search, the easiest way to start a search is to use a familiar keyboard shortcut: **Command-F (PC: Ctrl-F)**. This brings up the **Library Filter bar** across the top of the Library module's Grid view. Chances are you're going to search by text, so just type in the word(s) you're searching for in the **search field**, and by default it searches for that word everywhere it can—in the photo names, in any keywords, captions, embedded EXIF data, you name it. If it finds a match, those photos are displayed (here, I searched for "Austria"). You can narrow your search using the two pop-up menus to the left of the search field. For example, to limit your search to just captions, or just keywords, choose those from the first pop-up menu.

Step Three:

Another way to search is by attribute, so click on the word **Attribute** at the top of the Library Filter and those options appear. Earlier in this chapter, we used the Attribute options to narrow things down to where just our Picks were showing (you clicked on the white Pick flag), so you're already kind of familiar with this, but I do want to mention a few other things: As for the star ratings, if you click on the fourth star, it filters things so you just see any photos that are rated four stars or higher (so you'd see both your 4-star and 5-star images, but of course I'm hoping you're following the system and not using any 4-star ratings at all). If you want to see your 4-star rated images only, then click-and-hold on the ≥ (greater than or equal to) sign that appears to the immediate right of the word Rating, and from the pop-up menu that appears, choose **Rating Is Equal to**, as shown here. You can also use the Library Filter to see photos based on whether they've been edited yet using the Edits icons to the left of the star ratings.

Step Four:

Besides searching by text and attributes, you can also find the photos you're looking for by their embedded metadata (so you could search for shots based on which kind of lens you used, or what your ISO was set to, or what your f-stop was, or a dozen other settings). Just click on **Metadata** in the Library Filter, and a series of columns will pop down where you can search by date, camera make and model, lenses, or labels (as shown here, where I searched by lens and this is the one photo in my catalog I took with my 15mm fisheye lens. We'll take a closer look at these search options on the next page).

Lightroom Is Automatically Organizing Your Photos by Date Behind the Scenes

I mentioned earlier that you don't need to organize your photos by date, because Lightroom is actually already doing this for you automatically behind-the-scenes, using the exact time, day, month, and year embedded in the image file by your camera. Here's how to see your entire library organized by date:

Step One:

In the Library module, along the top of the Preview area is the **Library Filter** (if you don't see it, press the \ **[backslash] key** on your keyboard to bring it up). This searches based on where you're currently working in Lightroom (so if you're currently in a collection, it shows the details of what's in that collection), so go to the Catalog panel (near the top of the left side panels) and click on All Photographs, so we're looking at our entire catalog of images and not just one collection. There are four tabs across the top. Click on the **Metadata tab**, and it brings up four data columns: The first one on the left is your catalog sorted by **Date**, starting with the earliest year you have photos for in Lightroom.

Step Two:

To see the images taken in a particular year, click the right-facing arrow to the left of the year (in this case, I'm clicking on 2021), and it shows you each month in that year that you took photos, and how many photos were taken in that particular month. Click on the arrow to the left of a month, and it displays all the days of that month represented by photos, along with the day of the week they were taken (helpful if you know the photos you're looking for were taken on a weekend) and the number of photos taken on that day. Click on one of those days, and the photos taken on that date are displayed in the grid below, as seen here.

Step Three:
Did you notice that the other three columns to the right dynamically update to show you even deeper data on those photos? For example, I clicked on Thursday, April 15, 2021, and in the second and third columns, it shows me which camera(s) I used to take the photos on that day, and it breaks down which lenses I used for each as well, so I can filter things down by camera make and model, or by lens used on that particular date. This is handy if you know you used a particular lens in the shot you're searching for (maybe you remember it was a fisheye shot, or maybe taken with a tilt-shift or a macro lens). In this case, I clicked on the Tamron SP 150–600mm and it brings up just those photos, taken on that day, using that particular lens. Come on, that is pretty cool that it's keeping track off all this stuff for you behind the scenes.

Step Four:
The last column is set to **Label**, by default, and shows you if any color labels were assigned to these photos, but if you click-and-hold directly on the column header "Label," you can choose from a long list of search attributes that might be more helpful to you (especially if you don't use color labels). You can change any of these four column headers to search by whichever criteria you'd like (for instance, you can choose Month from the second column, and Day from the third to search by date, instead of seeing these options in the Date column).

TIP: Searching by Multiple Criteria

If you Command-click (PC: Ctrl-click) on more than one of the three search options up at the top in the **Library Filter**, they're additive (they just pop down one after another). To do this, just Command-click on each one you want to add to your search. So, for example, you could start by clicking on Text, and then type in a word you want to search for (in this case, I typed in "Blue Angels"), and then you could narrow that search down by Attribute (I clicked the white Pick flag, so now I only see Blue Angels photos I marked as a pick), and then lastly, you could Command-click on Metadata, so you can narrow it down even further to just images taken on a particular date (here, I chose Sunday, April 18, 2021). Now you're just seeing Blue Angels photos marked as a pick and taken on that particular day. That's a pretty powerful search, folks.

Your camera doesn't need GPS to do this—in fact, you'll learn two easy ways to use this feature without even having GPS. But, if your camera does have built-in GPS, Lightroom places your images on a world map for you, automatically, behind the scenes without you even asking. Pretty amazing stuff! Next thing you know, they'll put a man on the moon and people will be driving around in electric cars.

Lightroom Is Automatically Organizing Your Images on a Map, Behind the Scenes

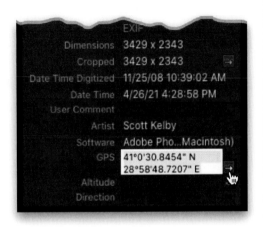

Step One:
If you've imported any photos that were taken with a camera that has built-in (or add-on) GPS, click on one of those photos, then in the Library module, go to the **Metadata panel** in the right side panels. Near the bottom of the EXIF section, you'll see a metadata field labeled GPS with the exact coordinates of where that shot was taken (as seen here). Click on the little arrow that appears to the far right of the GPS field.

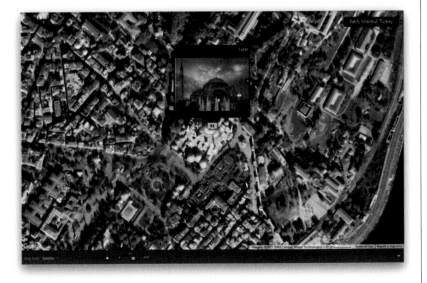

Step Two:
When you click on that little arrow, Lightroom takes you over to the **Map module** and displays a full-color satellite image with a pin at the exact location you were standing when you took the shot. (*Note:* I chose **Satellite** from the Map Style pop-up menu down in the toolbar to get this map.) How cool is that?! It's not just this one shot that's organized on the map—Lightroom automatically adds all your GPS-tagged shots to the map for you, so now you can find images by their location on the map, instead of just by name or keyword. To see all the photos represented by that little pin, hover your cursor over it and a preview window pops up that shows you a thumbnail of the first image (as seen here. By the way, if you double-click on the pin, the preview window pops up and stays). To see more photos, just click the left and right arrows on the sides of the preview window (or you can use the **Left/Right Arrow keys** on your keyboard).

If Your Camera Doesn't Have GPS, You Can Still Use the Map

There are two ways to add your photos to the global map, at the right location, without having GPS built-in to your camera. The first method gets your photos very close to the right location, and the second uses a clever trick to get your photos to the exact GPS location.

Step One:

The first method is to simply search the map and find the location where you took the shot (either with a simple city/country search for a general location, or by searching for an exact place or monument, like the Eiffel Tower in Paris, or in our case here, Rockefeller Center in New York City). You do this in the top-right corner of the **Map module**—in that **Search field**, type in the location you're looking for and a yellow pin appears marking that location (as seen here). *Note:* Lightroom's Map module uses a special version of Google Maps, so you'll have to be connected to the Internet for this GPS/map feature to work.

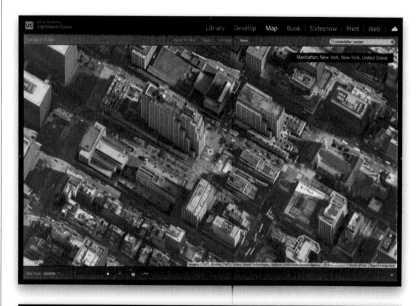

Step Two:

Now that it has located the general area of Rockefeller Center, go down to the Filmstrip along the bottom, select the images you took around that location, and then drag-and-drop them onto that pin on the map. Not only does it add those photos to the map at that location, it also embeds that exact GPS data from the pin directly into the images (as seen here, in the **Metadata panel**). Now, there's another method that's a bit more accurate, but you'll have to do a little trick to get the exact GPS coordinates without having GPS in your camera.

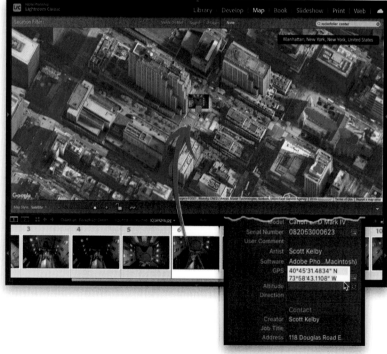

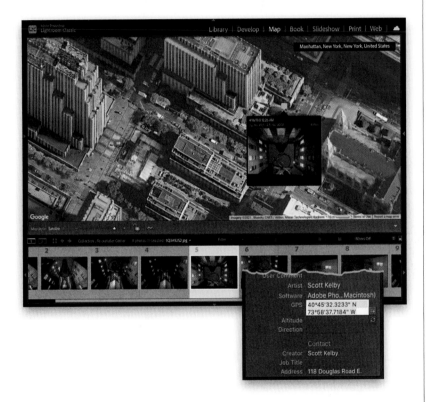

Step Three:
The second method starts while you're at the location shooting. Take one photo with your phone's camera. Your phone has built-in GPS, so that shot will have the GPS coordinates embedded (if you have this feature turned on, of course). When you import the photos from your camera into Lightroom, also import that one shot from your cell phone because we're going to use its exact location on the map to add our non-GPS images to the map.

Step Four:
Drag that phone photo into the same collection as your DSLR or mirrorless camera shots, click on it, then in the Metadata panel, scroll down to GPS, and click the little arrow to the right. This opens the Map module with a pin at the exact location where you took that photo. You're not "ballparking" it (like when we searched)—this is exactly where you were standing when you took the shot (you can see it's on the other side of Rockefeller center—not the spot our search marked). Now, go to the Filmstrip, select all the images from your regular camera at that location, and drag-and-drop them onto that pin from your phone photo. It not only adds those images to the map in the right place, it also embeds the GPS data into them.

TIP: Saving Favorite Locations
Name any pin as a favorite location, so you can get back to it without searching. Click on a pin, then in the **Saved Locations panel** (in the left side panels), click the + (plus sign) button on the right side of the panel header. Name this location, then use the Radius slider to determine how far out you want other nearby photos tagged with that same location. As you drag the slider, it visually shows the radius as a white circle on the map, so you can see the area being covered. Turning on the Private checkbox tells Lightroom to strip out your GPS data if you save these files outside of Lightroom. Click Create, and this location is added to your Saved Locations panel.

Making Collections from Locations on the Map

Since now we know that, behind the scenes, Lightroom is automatically adding any of our images that have embedded GPS data to a map of the world, we can use that to make collections from any location. For example, if you see it added a bunch of shots you took in Paris to a tag over Paris in the Map module, you can instantly turn that tag into a collection, and then all those shots from Paris are instantly in a collection. It's almost too easy because Lightroom is pretty much doing all the work for you.

Step One:

Go to the **Map module** (I chose to view the map in a Satellite view, here—you choose these different views from the Map Style pop-up menu in the left side of the toolbar). Here, you can see a pin representing 209 photos I took in Paris. Lightroom automatically added these images to the map for me because I had the GPS feature turned on in my DSLR. To put those 209 photos from Paris into a collection, start by Right-clicking on the pin, and from the pop-up menu that appears, choose **Create Collection** (as shown here).

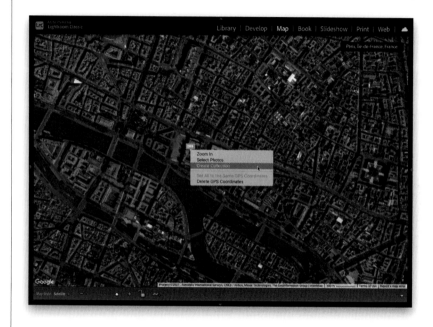

Step Two:

This brings up the **Create Collection dialog** (seen here) where you can name your new collection (I gave mine a rather obvious name), and of course, all the standard options for creating a new collection are here, including the option to add this new collection to an existing collection set (ya know, putting it under my Travel collection set sounds like a pretty good choice). Click the Create button, and your new collection is created and added to the Collections panel, with just those images from Paris, and Lightroom did all the gathering of those images for you automatically. Not too shabby.

If you work for any amount of time in Lightroom, at some point, you're going to take an image to the Develop module and see the warning "The file could not be found." If you go back to Grid view, you'll see a little exclamation point icon in the top right of the thumbnail, which is telling you that Lightroom can't find the original photo. All this means is that you moved the photo and Lightroom doesn't know where you moved it to, and all you have to do to fix this problem is simply tell Lightroom where you moved it.

What to Do If Lightroom Can't Find Your Original Image

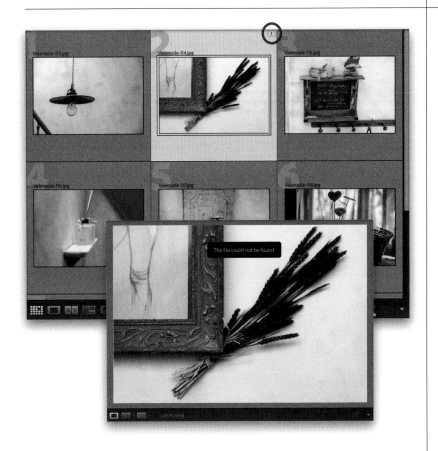

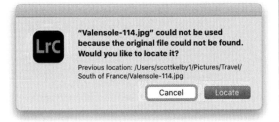

Step One:
In the thumbnails shown here, you can see one of them has a little **exclamation point icon**, letting you know Lightroom can't find the original high-resolution photo (so it only has this low-res thumbnail). If you took this photo over to the Develop module, you'd see the dreaded "The file could not be found" warning appear near the top of the image. This usually means that either (a) you moved the photo to another location, so Lightroom has lost track of it (nothing wrong with that—you should be able to move your photos wherever you want, right?), or (b) the original photo is stored on an external hard drive and that drive isn't connected to your computer right now, so Lightroom can't find it. Either way, it's a pretty easy fix, but first let's figure out which of those two scenarios it is.

Step Two:
To find out where the missing photo was last seen, click on that little exclamation point icon and a dialog will pop up telling you it can't find the original file (which you already knew), but more importantly, below the scary warning it shows you its previous location (so you'll instantly be able to see if it was indeed on a removable hard drive, flash drive, etc., or if you moved the file from where Lightroom last saw it).

Step Three:

Click on the Locate button, and when the **Locate dialog** appears (shown here), navigate your way to where that photo is now located. (I know you're thinking to yourself, "Hey, I didn't move that file!" but come on—files just don't get up and walk around your hard drive. You moved it—you probably just forgot you moved it, which is what makes this process so tricky.) Once you find it, click on it, then click the Select button, and it relinks the photo. If you moved an entire folder, then make sure you leave the Find Nearby Missing Photos checkbox turned on, so that when you find any one of your missing photos, it will automatically relink all the missing photos in that entire folder at once, and you can then edit your photos in the Develop module once again.

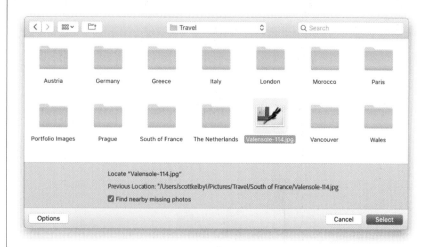

TIP: Keeping Everything Linked

If you want to make sure that all your photos are linked to the actual files (so you never see the dreaded exclamation point icon), go to the Library module, and under the Library menu up top, choose **Find All Missing Photos**. This will bring up any photos that have a broken link in Grid view, so you can relink them using the technique you just learned here.

A question mark on a folder in Lightroom's Folders panel just means that when you moved your folders of photos off your computer and onto that external hard drive, Lightroom lost track of them. No biggie—you just have to tell Lightroom where you moved 'em, and it will relink the photos automatically. If you're an advanced Lightroom user, and you're switching to this organization system I'm teaching here in the book, you might be able to get around this whole question mark thing altogether (read on for how to get around it).

What to Do When You See a Question Mark on a Photo Folder

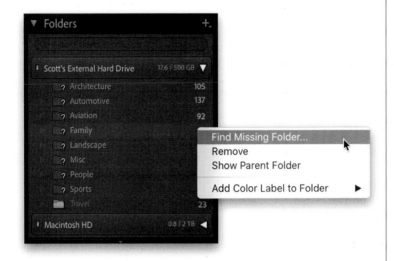

How to Tell Lightroom Where You Moved Your Folders:

After you've moved your images from your computer over onto an external hard drive, if you look over in the Library module's Folders panel, you'll see a bunch of grayed-out folders with question marks on them. That just means that Lightroom no longer knows where those folders are. The fix? Just tell Lightroom where you moved 'em—Right-click on any folder with a question mark, and from the pop-up menu, choose **Find Missing Folder** (as shown here). This brings up the standard Open dialog, so just navigate your way to your external hard drive, find the missing folder, and click the Choose button. That's it—Lightroom knows where they are now and it's business as usual.

Advanced Lightroom Users:

If you're really comfortable working in the **Folders panel**, instead of dragging the folders from your computer onto your external drive in Finder (PC: File Explorer), do it from right within the Folders panel itself. When you make the move within this panel, since you're moving them using Lightroom, it knows where you moved them and you don't have to do any relinking. *Note:* Remember, if you plug in a new, empty, external hard drive, Lightroom won't recognize it (the drive won't appear in the Folders panel), so click the + (plus sign) button on the right side of the Folders panel header, navigate to the new external hard drive, and make a new empty folder on the drive. Now that drive will appear in the panel and you can drag-and-drop your folders directly onto it.

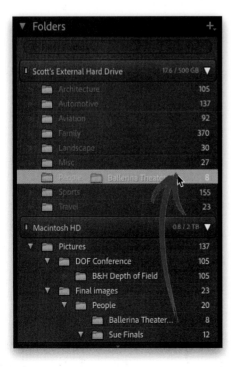

Backing Up Your Catalog (This Is VERY Important)

All the sorting into collections, all the Develop module edits, all the copyright info, keywords, and stuff you do to your photos in Lightroom is stored in your Lightroom catalog file. As you might imagine, this is one incredibly important file, and if for any reason, one day you open up your catalog and get a warning that it has become corrupted, if you don't have a backup, you will be starting over from scratch. The good news is Lightroom will back up your catalog for you—and even ask you to do it—but you have to tell it to. Here's how:

Step One:

When you quit Lightroom, you'll notice that from time to time it will bring up the **Back Up Catalog dialog**, giving you the opportunity to make a backup of your all-important catalog (it has all your edits, sorting, metadata, Pick flags, etc., stored in its database). At the top, it has a pop-up menu where you can choose how often to bring up this backup dialog, giving you the opportunity to back up from once a day to once a month (I would choose how often to back up based on how many days of work you're willing to lose if your catalog did become corrupt, and you had to use a backup catalog). By default, it stores this backup in a folder called (wait for it…wait for it…) "Back-ups" inside the Lightroom folder where your regular catalog is stored on your computer. That's okay, as long as your computer's hard drive doesn't ever crash or your computer doesn't get stolen.

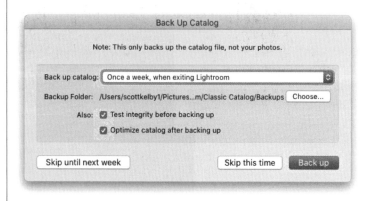

Step Two:

That's why I recommend saving your backup to an external hard drive or to the cloud. In case the unthinkable happens, you've got a backup stored somewhere else. To change where your backup catalog is stored, click the **Choose button** to the right of Backup Folder. I leave the two Also checkboxes turned on, so when it does the backup, it tests it to make sure nothing's wrong with it, and it optimizes the backup catalog, as well. Both are well worth having it do for you.

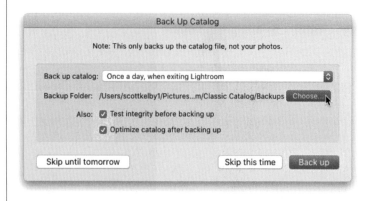

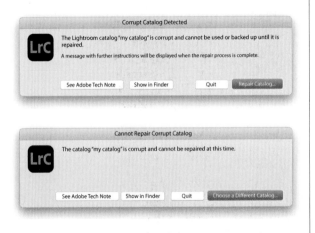

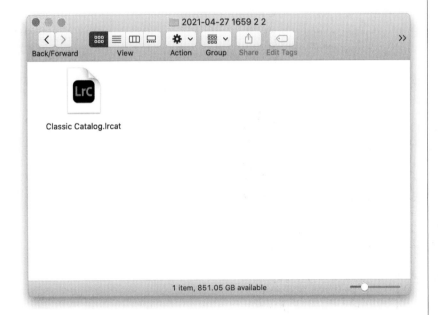

Step Three:

So, what do you do if "the unthinkable" happens: you launch Lightroom one day, and you get a warning dialog letting you know that your catalog is "...corrupt and cannot be used or backed up until it is repaired"? Well, first you'd click the **Repair Catalog button**, and say a few prayers, and with any luck at all it will fix whatever was wrong with your catalog, and you're back up and running. But, what if, for whatever reason, you get the dialog seen here at the bottom and it can't repair your catalog? Well, we go to Plan B.

Step Four:

Plan B is to restore your latest backup copy of your catalog. Here's how: In the "I can't repair your catalog" second warning dialog, click the **Choose a Different Catalog button**, and when the catalog chooser dialog appears (I have no idea if that's its proper name, by the way), click on Create New Catalog. You're doing this just so you can access Lightroom's menus (without a catalog open, you can't get to those menus), so name it "Trash Me," or whatever (it's just temporary). Once it opens this empty catalog, go under Lightroom's File menu and choose **Open Catalog**. In the dialog, navigate to your **Backups folder** (wherever you chose to save it in Step Two), and you'll see all your backups listed in folders by date and 24-hour time. Open the folder for the most recent backup, double-click on the .lrcat file (that's your backup), click the Open button, and you're back in business.

TIP: You Might Not Need to Back Up At All

If you have an automated backup for your entire computer (I use Backblaze for daily complete backups; see page 31), then you may not need this Lightroom backup catalog because you already have a backup catalog on your backup external hard drive.

ADVANCED STUFF
the next level of importing and organizing

I'm going to be honest with you here, and I don't want to hurt your feelings, but I think it's important for an author to be straight with their readers. This is a relationship, after all, and it's one built on trust. You bought this book trusting that it would have the information I claimed it would on the back cover of the book, and I appreciate that trust and I don't take it for granted. I know that if I don't deliver or if I'm inauthentic or misleading with you, the reader, I will lose that trust, so I'm about to "be real" with you, so keep all that in mind when I tell you (deep breath here), you're probably not ready for this chapter. You're still at that stage where you're working on learning Lightroom, and many of you reading this book are even brand new to Lightroom, but yet here you are reading an advanced techniques chapter. However, it's entirely possible that you're ready for this chapter,

so you're in the right place for where you are on your Lightroom journey, and if that's the case, I want to welcome you to the rarified air of advanced Lightroom user land. I can tell you, the skies here are a little bluer. The water is crisp and clean, and the streets are paved with milk and honey (which is why we recommend keeping your dog indoors, because they'll sink right down into the street about four inches. They'll try to eat their way out, and then they'll get a tummy ache, and well it just spirals from there, and before you know it, you're at the vet. Have you seen what vets charge to care for a sick dog these days? Well, it has just gotten crazy, but I guess it helps them deal with the issues they carry with them from their war time in the military. But hey, it gets us a day off every November to honor the vets who take care of our pets, so I guess it's worth it).

Using Image Overlay to See If Your Images Fit Your Layout

This is one of those features that once you try it, you fall in love with it, because it gives you the opportunity to make sure an image you're shooting for a specific project (like a magazine cover, brochure cover, inside layout, wedding book, etc.) looks and fits the way you want it to, because you get to see the artwork as an overlay in front of your image as you're shooting tethered. This is a big time and frustration saver, and it's simple to use (you just need a little tweaking in Photoshop to set up your artwork).

Step One:

You'll need to start in **Photoshop** by opening the layered version of the cover (or other artwork) you want to use as an overlay in Lightroom. The reason is this: you need to make the background for the entire file transparent, leaving just the type and graphics visible. In the cover mock-up we have here, the cover has a solid gray background (of course, once you drag an image in there inside of Photoshop, it would simply cover that gray background). We need to prep this file for use in Lightroom, which means: (a) we need to keep all our layers intact, and (b) we need to get rid of that solid gray background.

Step Two:

Luckily, prepping this for Lightroom couldn't be simpler: (1) Go to the Background layer (the solid gray layer in this case), and delete that layer by dragging it onto the Trash icon at the bottom of the Layers panel (as shown here). Now, (2) all you have to do is go under the File menu, choose Save As, and when the **Save As dialog** appears, from the Format pop-up menu (where you choose the file type to save it in), choose **PNG**. This format lets you keep the layers intact and, since you deleted the solid gray background layer, it makes the background transparent (as seen here). By the way, in the Save As dialog, it will tell you that it has to save a copy to save in PNG format, and that's fine by us, so don't sweat it.

Step Three:

That's all you have to do in Photoshop, so head back over to Lightroom and go to the Library module. Now, go under the View menu, under Loupe Overlay, and select **Choose Layout Image** (as shown here). Then, find that layered PNG file you just created in Photoshop and choose it.

Step Four:

Once you select your layout overlay image, your cover appears over whichever image you currently have onscreen (as shown here). To hide the cover, go under the same Loupe Overlay menu, and you'll see that Layout Image has a checkmark by it, letting you know it's visible. Just choose Layout Image to hide it from view. To see it again, choose it again. Or press **Command-Option-O (PC: Ctrl-Alt-O)** to show/hide it. Remember, if you hadn't deleted the Background layer, what you'd be seeing here is a bunch of text over a gray background (and your image would be hidden). That's why it's so important to delete that Background layer and save in PNG format. Okay, let's roll on, because there are a few more features here you'll want to know about.

Step Five:

Now that your layout image overlay is in place, you can use the **Left/Right Arrow keys** on your keyboard to try different images on your cover (or whatever file you used). Here's what it would look like with a different shot, but I would go ahead and close the left side panels—you don't need it open and hiding it (by pressing **F7**) will give you a cleaner, less cluttered look while you're trying to choose which image looks best on the cover.

Step Six:

If you want to reposition the cover to see a different part of the image, just press-and-hold the Command (PC: Ctrl) key and your cursor changes into the **grabber hand** (shown circled here in red). Now, just click-and-drag on the cover and it moves left/right and up/down. What's kind of weird at first is that it doesn't move your image inside the cover. It actually moves the cover. It takes a little getting used to at first, but then it becomes second nature. Here, I dragged the cover so the gondola is over on the right side, so it shows more of the buildings on the left. Not sure I like it as much as the gondola being centered like it was back in Step Five, but if I didn't move it, there would be nothing here in Step Six... so...ya know, there's that.

Step Seven:
You can control the **Opacity level** of your overlay image, as well (I switched to a different image here). When you press-and-hold the Command (PC: Ctrl) key, two little controls appear near the bottom of the overlay image. On the left is Opacity, and you just click-and-drag to the left directly on the word "Opacity" to lower the setting (as seen here, where I've lowered our cover overlay to 45%). To raise the opacity back up, drag back to the right.

Step Eight:
Okay, let's hit the Right Arrow key again and take a look at a different image. The other control, which I actually think is more useful, is the **Matte control**. You see, in the previous step, how the area surrounding the cover is solid black? Well, if you lower the Matte amount, it lets you see through that black background so you can see the rest of your image that doesn't appear inside the overlay area. Take a look at the image here. Now that the Opacity is lowered, you can see there is more of the gondolier and the steps down to the gondola on the far right, just outside the image area. You can now reposition your cover image if you want to show more of him. Pretty handy, and it works the same as the Opacity control—press-and-hold the Command (PC: Ctrl) key and click-and-drag right on the word "Matte."

Creating Your Own Custom File Naming Templates

Staying organized is critical when you have thousands of photos, and because digital cameras generate the same set of names over and over, it's really important that you rename your photos with a unique name right during import. A popular strategy is to include the date of the shoot as part of the new name. Unfortunately, only one of Lightroom's import naming presets includes the date, and it makes you keep the camera's original filename along with it. Luckily, you can create your own custom file naming template just the way you want it. Here's how:

Step One:

Start in the Library module, and click on the Import button on the bottom-left side of the window (or use the keyboard short-cut **Command-Shift-I [PC: Ctrl-Shift-I]**). When the Import window appears, click on Copy at the top center and the File Renaming panel will appear on the right side. In that panel, turn on the **Rename Files checkbox**, then click on the Template pop-up menu and choose **Edit** (as shown here) to bring up the Filename Template Editor (shown below in Step Two).

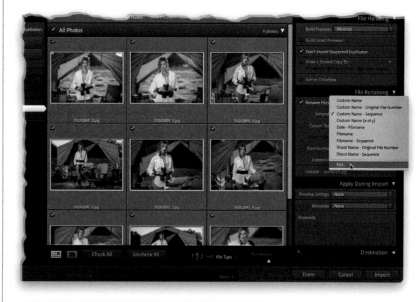

Step Two:

At the top of the dialog, there is a pop-up menu where you can choose any of the built-in naming presets as a starting place. For example, if you choose Custom Name – Sequence, the field below shows two blue tokens (that's what Adobe calls them; on a PC, the info appears within braces) that make up that preset: The first represents the text (to type in your own custom text, double-click on that blue Custom Text token and it highlights, so you can type in whatever name you like). The second blue token represents the auto numbering. To remove either token, click on it, then press the Delete (PC: Backspace) key on your keyboard. If you want to just start from scratch (as I'm going to do), delete both tokens, choose the options you want from the pop-up menus below, and it automatically inserts the tokens for you (there's no need to click Insert if you choose from a menu).

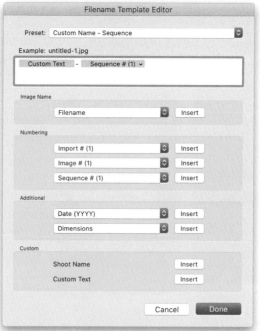

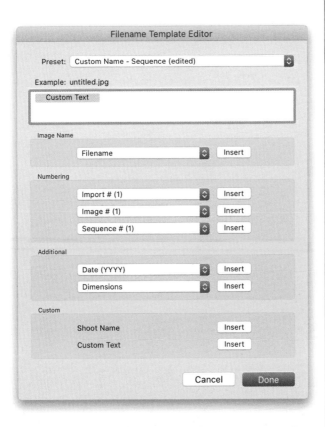

Step Three:

Let's go ahead and make one from scratch (this is only an example—you can create a custom template later that fits your needs). We'll start by adding a **Custom Text token** (later, when we're actually doing an import, we'll customize this name to fit the images we're importing), so near the bottom of the dialog, click the Insert button to the right of Custom Text to add a Custom Text token (as seen here). By the way, if you look right above where the tokens appear, where it says "Example," it shows you a preview of the filename you're creating. At this point, our name is "untitled .jpg" (it will show whatever the actual file extension is, so if it's a JPG or CR3 or NEF or RAW, that's what it will show as the extension automatically).

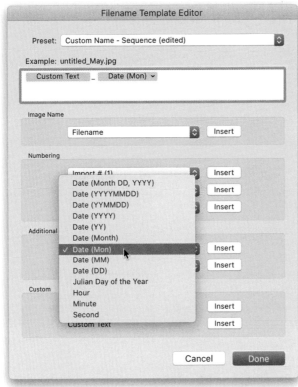

Step Four:

Now, let's add the month it was taken (dates are drawn automatically from the metadata embedded into your photo by your camera when the shot was taken), but if you just add the month, it doesn't put a space between the letters, so the month's name will butt right up against our custom name. Luckily, we can add a hyphen or underscore to create some visual separation. So, press-and-hold the Shift key, then press the hyphen (dash) key, and it adds an underscore after the custom name. Now, we'll have some visual separation when we add the month after it. Go down to the Additional section, and from the Date pop-up menu, choose **Date (Mon)**, as shown here. This gives you the month's three-letter abbreviation, rather than the full month (the letters in the parentheses show you how the date will be formatted. For example, choosing Date [MM] would show the two-digit month, like "06," instead of showing "Jun").

Step Five:

Now let's add the year (by the way, Lightroom is keeping track of all your images by date automatically—you can access this sorting by going to the Library Filter bar, clicking on the Metadata tab at the top, and choosing Date in the first column [see page 70]—so I don't actually add the date to my filenames. This is just to help you learn how to use the Filename Template Editor). You could add another underscore between the month and year, but to visually change things up, let's add a dash. Now let's choose the year. In this case, I went with the four-digit year option (as shown here), and it adds it after our dash. Take a look at our name example now, it's "untitled_May-2021.jpg."

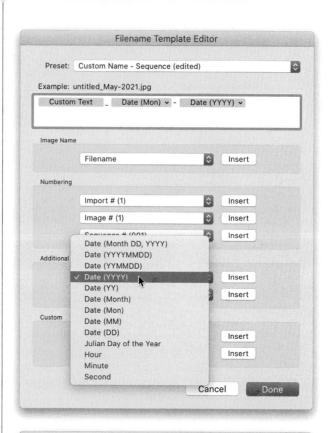

Step Six:

Lastly, you're going to have Lightroom automatically number these photos sequentially. To do that, go to the Numbering section and choose your numbering sequence from the third pop-up menu down. Here, I added a dash and then chose the Sequence # (001) token, which adds three-digit auto-numbering to the end of your filename. So, now my files will be named "untitled _May-2021-001.jpg," "-002.jpg," and so on (you can see this in the Example).

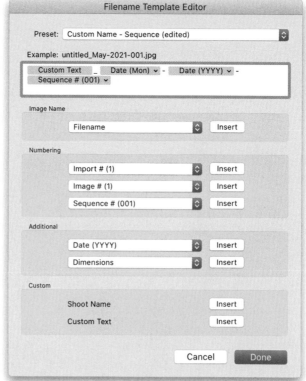

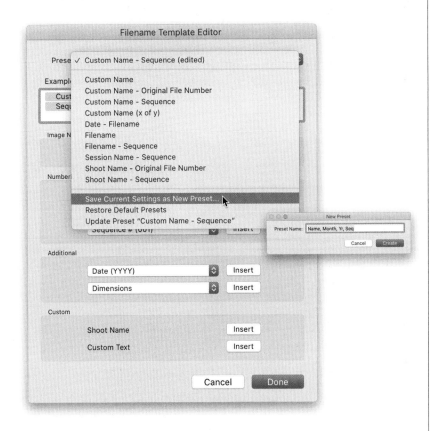

Step Seven:

Once the little naming example looks right to you, go under the Preset pop-up menu up top, choose **Save Current Settings as New Preset** (as shown here), and a dialog will appear where you can name your preset. Type in a descriptive name (so you'll know what it will do the next time you want to apply it—I chose "Name, Month, Yr, Seq"), click Create, and then click Done in the Filename Template Editor. Now, next time you're importing some images in the Import window and you click on the File Renaming panel's Template pop-up menu, you'll see your custom naming template as one of the preset choices (as seen selected in the next step).

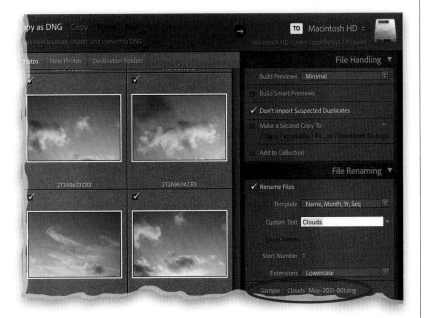

Step Eight:

So, how does this work for other shoots? Smooth as glass. Here's why: After you choose this new naming template from the Template pop-up menu, click below it in the Custom Text field (this is where that Custom Text token we added earlier comes into play) and type in the descriptive part of the filename (in this case, I typed in "Clouds"). That custom text will appear before an underscore, giving you a visual separator so everything doesn't run together (see, it all makes sense now). Once you type it in, if you look at the Sample at the bottom of the File Renaming panel, you'll see a preview of how the photos will be renamed. Once you've chosen all your Apply During Import and Destination panel settings, you can click the Import button.

Creating Your Own Custom Metadata (Copyright) Templates

I mentioned earlier in the book that you'll want to set up your own custom metadata template, so you can easily and automatically embed your own copyright and contact information right into your photos as they're imported into Lightroom. Well, here's how to do just that. Keep in mind that you can create more than one template, so if you create one with your full contact info (including your phone number), you might want to create one with just basic info, or one for when you're exporting images to be sent to a stock photo agency, etc.

Step One:
You can create a metadata template from right within the Import window, so press **Command-Shift-I (PC: Ctrl-Shift-I)** to bring it up. Once the Import window appears, go to the Apply During Import panel, and from the Metadata pop-up menu, choose **New** (as shown here).

Step Two:
A blank New Metadata Preset dialog will appear. First, click the **Check None button** at the bottom of the dialog, as shown here (so no blank fields will appear when you view this metadata in Lightroom—only the fields with data will be displayed).

Step Three:
In the **IPTC Copyright section**, type in your copyright information (as seen here). Next, go to the **IPTC Creator section** and enter your contact info (after all, if someone goes by your website and downloads some of your images, you might want them to be able to contact you to arrange to license your photos). Now, you may feel that the Copyright Info URL (web address) that you added in the previous section is enough contact info, and if that's the case, you can skip filling out the IPTC Creator info (after all, this metadata preset is to help make potential clients aware that your work is copyrighted, and tell them how to get in contact with you). Once all the metadata info you want embedded in your photos is complete, go up to the top of the dialog, give your preset a name—I chose "Scott Copyright 2023"—and then click the Create button.

Step Four:
As easy as it is to create a metadata template, deleting one isn't much harder. Go back to the Apply During Import panel and, from the Metadata pop-up menu, choose **Edit Presets**. That brings up the Edit Metadata Presets dialog (which looks just like the New Metadata Preset dialog). From the Preset pop-up menu at the top, choose the preset you want to delete. Once all the metadata appears in the dialog, go back to that Preset pop-up menu, and now choose **Delete Preset [Name of Preset]**. A warning dialog will pop up, asking if you're sure you want to delete this preset. Click Delete, and it is gone forever.

Using Lights Dim, Lights Out, and Other Viewing Modes

One of the things I love best about Lightroom is how it gets out of your way and lets your photos be the focus. That's why I love the Shift-Tab shortcut that hides all the panels. But if you want to really take things to the next level, after you hide those panels, you can dim everything around your photo, or literally "turn the lights out," so everything is blacked out but your photos. Here's how:

Step One:
Press the letter **L** on your keyboard to enter **Lights Dim mode**, in which everything but your photo(s) in the center Preview area is dimmed (kind of like you turned down a lighting dimmer), and a thin white border appears around your image (seen here). Perhaps the coolest thing about this dimmed mode is the fact that the side panels, taskbar, and Filmstrip all still work—you can still make adjustments, change photos, etc., just like when the "lights" are all on.

Step Two:
The next viewing mode is **Lights Out** (you get Lights Out by pressing **L** a second time), and this one really makes your photo(s) the star of the show because everything else is totally blacked out, so there's nothing (and I mean nothing) but your photo(s) onscreen (to return to regular Lights On mode, just press L again). To get your image as big onscreen as possible, right before you enter Lights Out mode, press **Shift-Tab** to hide all the panels on the sides, top, and bottom— that way you get the big image view you see here. Without the Shift-Tab, you'd have the smaller size image you see in Step One, with lots and lots of empty black space around it.

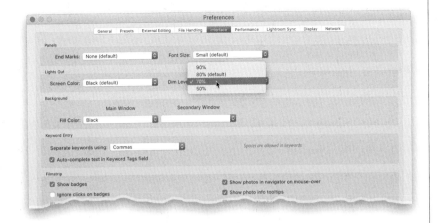

TIP: Controlling Lights Out Mode
You have more control over Lightroom's Lights Out mode than you might think: just go to Lightroom's preferences (under the Lightroom menu on a Mac or the Edit menu on a PC), click on the **Interface tab** up top, and you'll find pop-up menus that control both the Dim Level and the Screen Color when you're in full Lights Out mode.

Step Three:
If you want to view your grid of photos without distractions, first press Shift-Tab to hide all the panels. Then press **Command-Shift-F (PC: Ctrl-Shift-F)** on your keyboard. That makes the window fill your screen and hides the window's title bar and the menu bar at the top of your screen. If you really want the maximum effect, press **T** to hide the toolbar, and if you have the Library Filter bar showing across the top, you can hide it, too, by pressing the \ **(backslash) key** to get the view you see here at the top, which is just your photos on a solid, top-to-bottom gray background. If you want a black background behind your images, with even the file names hidden, press L twice to see your grid in Lights Out mode (seen here at the bottom). Press L once to return to Lights On view, and then press **Shift-F** to return to your normal view.

Using Guides and Grid Overlays

Just like in Photoshop, Lightroom has its own moveable, non-printing guides (only these may be better than Photoshop's). But, beyond these guides, you also have the ability to put a resizable, non-printing grid over your image, as well (helpful for lining things up or for straightening a part of your image), but it's not just a static grid, and it's not just resizable. We'll start with the guides.

Step One:

To make the guides visible, go under the View menu, under Loupe Overlay, and choose **Guides**. A white horizontal guide and white vertical guide will appear centered on your screen. To move them in tandem, press-and-hold the Command (PC: Ctrl) key, then move your cursor directly on the black circle in the middle where they intersect. Your cursor changes from the zoom tool (magnifying glass) to the hand tool (as shown here), and you can then drag the two guide lines wherever you'd like. To move either guide individually, move your cursor away from the center, hover it right over either guide, and now you can drag that individual guide where you want it. To clear the guides, press **Command-Option-O (PC: Ctrl-Alt-O)**.

Step Two:

You also have a grid that pretty much works the same way. Go under the View menu, under Loupe Overlay, and choose **Grid**. This puts a non-printing grid over your image, which you can use for alignment (or anything else you want). If you press-and-hold the Command (PC: Ctrl) key, a control bar appears at the top of the screen. Click directly on the word "Opacity" to change how visible the grid is. Click directly on the word "Size," to change the size of the grid blocks themselves—drag left to make the grid smaller or right to make it larger (here, I increased them to 58). To clear the grid, press **Command-Option-O (PC: Ctrl-Alt-O)**. *Note:* You can have more than one overlay, so you can have both the guides and grid visible at the same time.

Let's say you're meeting with a potential client who is considering hiring you to do their product photography. Using the Quick Collection feature, you can quickly put together a temporary collection of various product shots you've taken over the years to show them at your meeting as a slide show (without even having to create a slide show), and when you're done, you can choose to make this a permanent collection or you can just forget about it. That's just one way to use this really handy feature.

When to Use a Quick Collection Instead

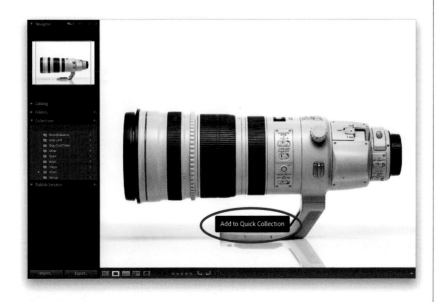

Step One:
There are a lot of reasons why you might want a temporary collection, but most of the time, I use Quick Collections when I need to gather images from a number of different collections into one collection, just temporarily. We'll use the example I laid out in the intro above, and we'll look through our product shot collections and choose some of our individual favorites from each to be in our quick, simple collection and slide show. So, start by looking in one of your product shot collections, and when you see a shot you might want to include, just press the letter **B** and that image gets added to your Quick Collection (you get a message right onscreen letting you know it has been added, as seen here).

Step Two:
Now go to another collection of product shots and do the same thing—each time you see an image you want in your Quick Collection, press B and it's added. You can also add photos to your Quick Collection by clicking on the little circle that appears in the top-right corner of each thumbnail in Grid view when you move your cursor over the thumbnail—it'll turn gray with a thick black line around it when you click on it. (*Note:* You can hide that gray dot by pressing **Command-J [PC: Ctrl-J]**, clicking on the Grid View tab up top, then turning off the **Quick Collection Markers checkbox**, as shown on the bottom here.) Using this method, in no time at all, you can whip through 10 or 15 collections and mark the ones you want in your Quick Collection.

Step Three:

To see the photos you put in a Quick Collection, go to the Catalog panel (in the left side panels), click on **Quick Collection** (as shown here), and now just those photos are visible. To remove a photo from your Quick Collection, just click on it and press the **Delete (PC: Backspace) key** on your keyboard (it doesn't delete the original, it just removes it from this temporary Quick Collection). You can also click on any photo, press B again, and it will remove the image from your Quick Collection.

TIP: If You Want to Save This Quick Collection

If you decide you want your Quick Collection to be saved as a regular collection, just go to the Catalog panel, Right-click on Quick Collection, choose **Save Quick Collection** from the pop-up menu, and a dialog appears where you can give your new collection a name.

Step Four:

Now that your photos from all those different collections are in a Quick Collection, you can see these images as a slide show at any time by pressing **Command-Return (PC: Ctrl-Enter)**. This kicks in Lightroom's **Impromptu Slideshow feature**, which plays a full-screen slide show (as seen here) of the photos in your Quick Collection, using the Default preset in Lightroom's Slideshow module. To stop the slide show, just press the **Esc key**. So, when you're done, do you have to delete this Quick Collection? That's up to you. As I mentioned in the tip above, you can save it and make it a real collection (with its own name and all that) or you can clear all the photos out of that Quick Collection by Right-clicking on it (in the Catalog panel) and choosing **Clear Quick Collection**. Now you can use it for something else.

We just talked about Quick Collections and how you can temporarily toss things in there for an impromptu slide show, or until you figure out if you actually want to create a collection of those images, but something you might find more useful is to replace the Quick Collection with a target collection. You use the same keyboard shortcut, but instead of sending things to the Quick Collection, now they go to an existing collection. So, why would you want to do that? Read these two pages and you'll totally see why these are so handy (you are soooo going to dig this!).

Using Target Collections (and Why They're So Handy)

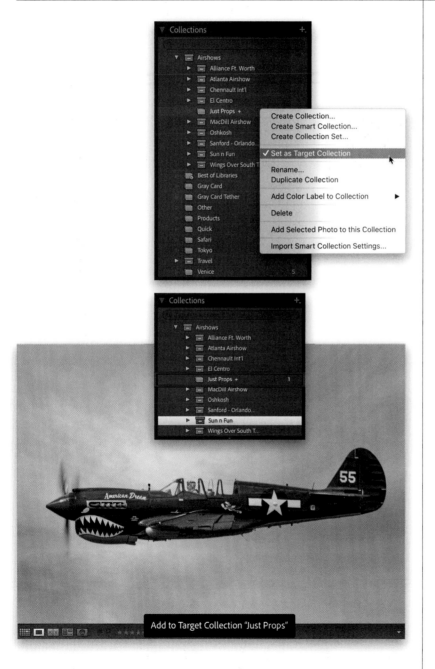

Add to Target Collection "Just Props"

Step One:
Let's say you're into shooting air shows (well, I am, so go with me here), and you'd find it handy to have all the prop planes you've photographed just one click away. If that sounds handy to you (it sure does to me), then create a new collection and name it "Just Props" Once it appears in the Collections panel, Right-click on it and choose **Set as Target Collection** (as shown here). This adds a + (plus sign) to the end of the collection's name, so you know at a glance it's your target collection (as seen here). *Note:* You can't make a smart collection into your target collection. Just so ya know.

Step Two:
Now that you've created your target collection, adding images to it is easy—when you see a prop plane shot you like, no matter which collection it's in, press **B** on your keyboard (the same shortcut you used for Quick Collection), and that image is added to your Just Props target collection. For example, here we're looking at a shot taken at the Sun 'n Fun Aerospace Expo. It's in my Sun n Fun collection set, but since it's a prop plane, I want it added to my Just Props target collection, so I click on it and press B. I get a confirmation onscreen that reads, "Add to Target Collection 'Just Props,'" so I know it was added. It doesn't remove it from my Sun n Fun collection set, it simply adds it to the Just Props target collection, as well.

Step Three:

Now, if I click on that Just Props target collection, I see that plane from Sun 'n Fun, plus any prop planes I added from my other collections. It's a quick and easy way to create a custom collection like this that's made up of shots from a bunch of other collections (I told you this was handy, right?).

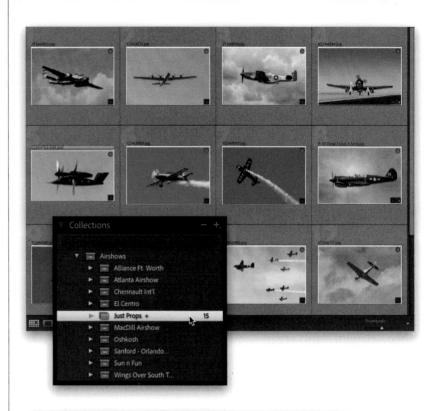

Step Four:

If you wind up creating these target collections fairly often, here's a time-saver: anytime you create a new collection, there's a checkbox in the Create Collection dialog that will make your new collection the target collection—just turn on the **Set as Target Collection checkbox** and this new collection is your new target collection. By the way, you can only have one target collection at a time, so when you choose a different collection to become the target collection, it removes the target from the previously selected collection (the collection is still there—it doesn't delete it. But, pressing B doesn't send images to that collection anymore—it sends them to the new collection you just designated as the target collection). Also, keep in mind that if you want to go back to creating a Quick Collection (using the B keyboard shortcut), you'll need to turn off your target collection, by Right-clicking on it and choosing **Set as Target Collection**.

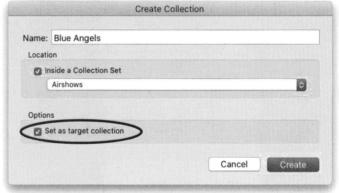

Your digital camera automatically embeds all kinds of info right into the photo itself, including everything from the make and model of the camera it was taken with, to the type of lens you used, and even whether your flash fired or not. Lightroom can search for photos based on this embedded information, called EXIF data. Beyond that, you can embed your own info into the file, like your copyright info, or photo captions for uploading to news services.

Adding Copyright Info, Captions, and Other Metadata

Step One:
You can see the info embedded in a photo (called metadata) by going to the **Metadata panel** in the right side panels in the Library module. By default, it shows you some of the different kinds of data embedded in your photo, so you see a little bit of the stuff your camera embedded (called EXIF data—stuff like the make and model of camera you took the photo with, which kind of lens you used, etc.), and you see the photo's dimensions, any ratings or labels you've added in Lightroom, and so on, but again, this is just a small portion of what's there. To see all of just what your camera embedded into your photo, choose **EXIF** from the pop-up menu in the left side of the panel header (as shown here), or to see all the metadata fields (including where to add captions and your copyright info), choose **EXIF and IPTC**.

TIP: Get More Info or Search
While in Grid view, if you see an arrow to the right of any metadata field, that's a link to either more information or an instant search. For example, scroll down to the EXIF metadata (the info embedded by your camera). Now, hover your cursor over the arrow that appears to the right of **ISO Speed Rating** for a few seconds and a little message will appear telling you what that arrow does (in this case, clicking that arrow would show you all the photos in your catalog taken at 320 ISO).

Step Two:

Although you can't change the EXIF data embedded by your camera, there are fields where you can add info. For example, to add captions (maybe you're uploading photos to a news organization or photo wire service), choose **Default** from the pop-up menu, then click inside the Caption field, and start typing (as seen here). When you're done, press **Return (PC: Enter)**. You can also add a star rating or label in the Metadata panel, as well (though I usually don't do that here). If you only want to see the fields that you can edit, and hide those that you can't, click on the icon to the left of the pop-up menu (the eye with the pencil, circled here) to go to **Edit-Only mode**.

TIP: Customize and Arrange the Metadata Default Panel

To choose what you see in this panel, click the **Customize button** at the bottom of the panel, and then turn on/off the check-boxes for the things you want or don't want to see. Click the **Arrange button** at the bottom of this dialog, and you can then click-and-drag the order in which you see these things.

Step Three:

If you created a Copyright Metadata preset (see page 92), but didn't apply it during import, you can apply that now from the **Preset pop-up menu** at the top of the Metadata panel. Or if you didn't create a copyright preset at all, you can add your copyright info manually. Scroll down to the **Copyright section**, and just type in your copyright info (and make sure you choose **Copyrighted** from the Copyright Status pop-up menu). By the way, you can do this for more than one photo at a time. First, Command-click (PC: Ctrl-click) to select all the photos you want to add this copyright info to, then click on **Selected Photos** near the top of the panel, and when you add the information in the Metadata panel, it's added to every selected photo.

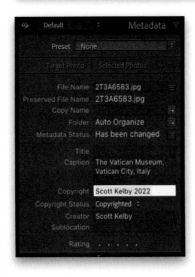

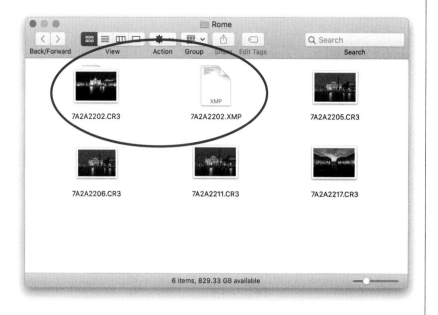

Step Four:

This metadata you're adding is stored in Lightroom's database, and when you export your photos as either JPEGs, PSDs, or TIFFs, this metadata (along with your color correction and image editing) gets embedded into the file itself at that moment. However, it's different when working with RAW photos. To give someone your original RAW file (maybe a client or coworker), or use it in another application that processes RAW images, the metadata you've added in Lightroom (copyright info, keywords, color correction edits) won't be visible because you can't embed info directly into a RAW file. Instead, all this information gets written into a separate **XMP sidecar file**. But, these aren't created automatically—you create them by pressing **Command-S (PC: Ctrl-S)** before you give someone your RAW file. After you do this, look in the photo's folder on your computer, and you'll see your RAW file, then next to it an XMP sidecar file with the same name, but with the XMP file extension (both are circled here). These two files need to stay together, so if you move it, or give the RAW file to a coworker or client, be sure to grab both files.

Step Five:

Now, if you converted your RAW file into a DNG file when you imported it, then when you press Command-S (PC: Ctrl-S), it does embed the info into the single DNG file (a big advantage of DNG—see page 11), so there will be no separate XMP sidecar file. There actually is a Lightroom catalog preference (choose **Catalog Settings** from the Lightroom [PC: Edit] menu, then click on the Metadata tab, seen here) that automatically writes every change you make to a RAW file to the XMP sidecar, but the downside is a speed issue. Each time you make a change to a RAW file, Lightroom has to write that change into XMP, which slows things down a bit, so I leave the **Automatically Write Changes into XMP checkbox** turned off.

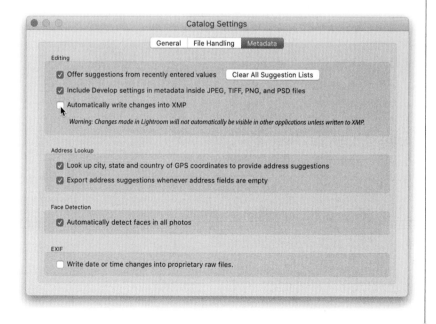

Merging the Lightroom Images on Your Laptop with Lightroom on Your Desktop Computer

If you're running Lightroom on a laptop during your location shoots, you might want to take all the edits, keywords, metadata, and of course the photos themselves, and add them to the Lightroom catalog on your studio computer. It's easier than it sounds: basically, you choose which collection to export from your laptop, then you take the folder it creates over to your studio computer and import it—Lightroom does all the hard work for you, you just have to make a few choices about how Lightroom handles the process.

Step One:
Okay, we're on location (or on the road), and we've imported our images, organized them in a collection set, and tweaked some of them—we pretty much did everything we need to do to these images on our laptop.

Step Two:
Once you get back home, on your laptop, go to the Collections panel and Right-click on the collection set you created—the one you want to merge with your desktop computer in your studio. (*Note:* If you work in folders, instead of collections, the only difference would be you'd go to the Folders panel and Right-click on the folder from that shoot instead.) From the pop-up menu that appears, choose **Export This Collection as a Catalog** (as shown here).

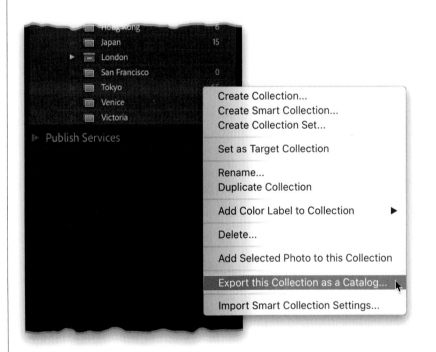

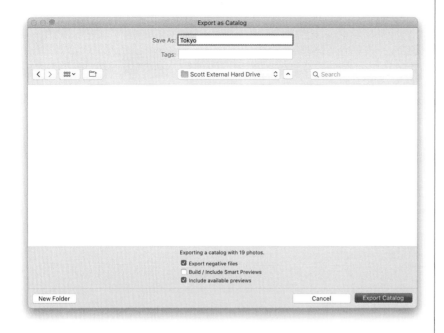

Step Three:

When you choose this, it brings up the **Export as Catalog dialog** (shown here). First, let's choose where to save this exported catalog. Since you'll need to get these images from your laptop to your desktop computer, I recommend using either a small portable hard drive or a USB flash drive with enough free space to hold your exported catalog, previews, and your original images (you can get a SanDisk 16GB USB flash drive for $6. That's cheaper than an appetizer at Chili's). So, give your exported collection a name, choose that portable drive to save it onto, then turn on the Export Negative Files checkbox (near the bottom of the dialog), so that it not only saves your edits, but it saves your images to that portable drive, too. Make sure to turn on the Include Available Previews checkbox, as well (so you don't have to wait for them to render when you import them later). You can also choose to include smart previews if you'd like.

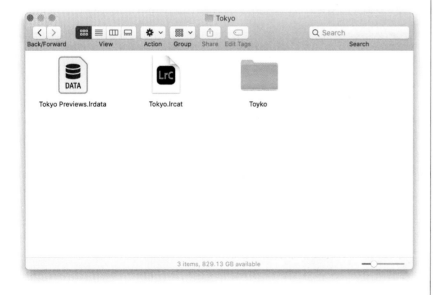

Step Four:

When you click the Export Catalog button, it exports your collection (it usually doesn't take very long, but of course the more photos in your collection or folder, the longer it will take), and when it's done exporting, you'll see a new folder on your portable drive (or USB flash drive). If you look inside that folder, you'll see three or four files (depending on whether you chose to export smart previews or not). You'll see (1) a folder with the actual photos; (2) a file that includes the previews; (3) a file that includes any smart previews, if you chose to export those; and (4) the catalog file itself (it has the file extension .lrcat (as seen here).

Step Five:

Now, on your desktop computer, go under Lightroom's File menu and choose **Import from Another Catalog**. Navigate to that folder you created on your portable drive, then inside that folder, click on the file that ends with the file extension .lrcat (that's the catalog file you're importing), and then click the Choose button. That brings up the **Import from Catalog dialog** (seen here). If you want to see thumbnails of the images you're about to import, turn on the Show Preview checkbox in the bottom-left corner, and the thumbnails will appear on the right side of the dialog (seen here). If, for some reason, you don't want one or more of these photos imported, uncheck the checkbox in the top-left corner of its thumbnail.

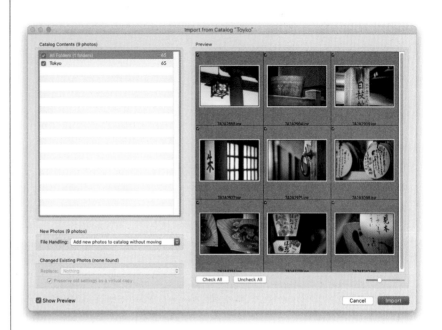

Step Six:

So far we're just importing your previews and the edits you made on your laptop, but we haven't moved the photos from that folder on your portable or USB flash drive over to your desktop computer's storage device (which I'm hoping is an external hard drive—see Chapter 1). To make sure your original images get moved over as well, go to the New Photos section on the left and, from the File Handling pop-up menu, choose **Copy New Photos to a New Location and Import** (as shown here). When you choose this, a button appears right below asking you to choose where you want these images copied to. In our case, they would go onto your desktop computer's external hard drive, inside your main folder, inside your Travel folder. So, navigate there and click the Choose button. Now, click Import, and your exported collection will be added to your desktop computer's catalog, with all your edits, previews, metadata, etc., all intact, and copies of your original images will be copied onto your external hard drive.

It's pretty unlikely that you'll have a major problem with your Lightroom catalog (after all these years of using Lightroom, it has only happened to me once), and if it does happen, chances are Lightroom can repair itself (which is pretty handy). However, the chances of your hard drive crashing, or your computer dying, or getting stolen (with the only copy of your catalog on it) are much higher. Here's how to deal with both of these potential disasters in advance, and what to do if the big potty hits the air circulation device. (*Note:* We touched on this in Chapter 2, but go into it a little further here.)

Dealing with Disasters (Troubleshooting)

Step One:
If you launch Lightroom and you get a warning dialog like you see here (at top), then go ahead and give Lightroom a chance to fix itself by clicking the **Repair Catalog button**. Chances are pretty likely it'll fix the catalog and then you're all set. However, if Lightroom can't fix the catalog, you'll see the bottom warning dialog instead, letting you know that your catalog is so corrupt it can't fix it. If that's the case, it's time to go get your backup copy of your catalog (ya know, the one we talked about back in Chapter 2).

Step Two:
Now, as long as you've backed up your catalog, you can restore that backup catalog, and you're back in business (just understand that if the last time you backed up your catalog was three weeks ago, everything you've done in Lightroom since then will be gone. That's why it's so important to back up your catalog fairly often, and if you're doing client work, you should back up daily). Luckily, restoring from a backup catalog is easy. First, go to your backup hard drive (remember, your backup catalog should be saved to a separate hard drive. That way, if your computer crashes, your backup doesn't crash along with it), and locate the folder where you save your Lightroom catalog backups (they're saved in folders by date, as seen here, so double-click on the folder with the most current date), and inside you'll see your backup catalog.

Step Three:

Next, find the corrupt Lightroom catalog on your computer (on my Mac, it's inside my Pictures folder, inside a folder named "Lightroom." On a Windows PC, look inside your My Pictures folder), and delete that file (drag it into the Trash on a Mac, or into the Recycle Bin on a PC). Now, drag-and-drop your backup catalog file into the folder on your computer where your corrupt file used to be (before you deleted it).

TIP: Finding Your Catalog

If you don't remember where you chose to store your Lightroom catalogs—don't worry—Lightroom can tell you. Go under the Lightroom (PC: Edit) menu and choose **Catalog Settings**. Click on the General tab, then under Location it will show the path to your catalog. Click on the Show button, and it will take you there.

Step Four:

Now, simply open this new catalog by going under the File menu and choosing **Open Catalog**. Go to where you saved that backup copy (hopefully, on an external hard drive), find that backup file, click on it, then click OK, and everything is back the way it was (again, provided you backed up your catalog recently. If not, it's back to what your catalog looked like the last time you backed it up). By the way, it even remembers where your photos are stored (if it doesn't, go back to Chapter 2 where we looked at how to relink them).

TIP: If Your Computer Crashed...

If, instead of a corrupt catalog, your computer crashed (or your hard drive died, or your laptop got stolen, etc.), then it's pretty much the same process—you just don't have to find and delete the old catalog first, because it's already gone. So, you'll start by just dragging your backup copy of the catalog into your new, empty Lightroom folder (which is created the first time you launch Lightroom on your new computer, or new hard drive, etc.).

Step Five:

If you think your catalog's okay, but Lightroom has locked up or is just acting wonky, a lot of the time, simply quitting Lightroom and restarting will do the trick (I know, it sounds really simple, and kind of "Duh!" but this fixes more problems than you can imagine). If that didn't work, and Lightroom is still acting funky, it's possible your preferences have become corrupt and need to be replaced (hey, it happens). To do that, quit Lightroom, then press-and-hold **Option-Shift (PC: Alt-Shift)**, and relaunch Lightroom. Keep holding those keys down until the dialog appears asking if you want to reset your preferences. If you click on **Reset Preferences**, it builds a new, factory-fresh set of preferences, and chances are all your problems will be gone.

Step Six:

Next, if you have installed Lightroom plug-ins, it's possible one of them has gotten messed up or is outdated, so check the plug-in manufacturers' sites for updates. If your plug-ins are all up to date, then go under the File menu and choose **Plug-in Manager**. In the dialog, click on a plug-in, then to the right, click the **Disable button**, and see if the problem is still there. Turn each off, using the process of elimination, until you find the one that's messing things up. If you wind up disabling them all and the problem is still there, then it's time to do a reinstall, either from the original install files (if you have Lightroom 6) or from the Adobe Creative Cloud app (if you use Lightroom Classic). Start by uninstalling Lightroom from your computer (it won't delete your catalogs), and then do your install. One of those will most surely fix your problem. If none of those worked, it may be time to call Adobe, 'cause something's crazy messed up (but at least you'll have already done the first round of things Adobe will tell you to try, and you'll be that much closer to a solution).

CUSTOMIZING
how to set up Lightroom your way

Now, I'm going to be dating myself a bit here by revealing this, but I went through a phase of my life where I was hooked on the MTV show *Pimp My Ride*, where people who had kinda messed up cars would submit photos of their messed up cars and their stories to MTV. The *Pimp My Ride* people would then choose a car, but they didn't just give it a makeover—they turned it into an amazing show car. They worked with a company called West Coast Customs (who customizes a lot of celebrities' and pro athletes' cars), and they would do everything from insane custom paint jobs, to adding over-the-top car stereo systems, to putting on expensive custom chrome wheels, basically "pimping out" that old, messed-up car to where it looked just incredible. The before/after images were jaw-dropping. Anyway, even though I had no interest in actually owning a pimped-out car (they're a little too flashy for my "black rock band T-shirt and jeans" lifestyle), I still loved that show. Well, that's kind of what this chapter is all about—it's about taking a boring, "out of the box"–looking Lightroom, and pimping it out so it reflects your personal style. In fact, a great name for this chapter would've been "Pimp My Lightroom." Anyway, I think you'll be surprised at how many options you have for making Lightroom look and feel the way you want it. In this latest version of Lightroom, Adobe introduced "Themes," which essentially put a skin over the entire interface. So, now you can have a *Star Wars* look to your Lightroom, and there's a *Game of Thrones* skin, and even a *Ted Lasso* UK football–themed skin (that's the one I use), and you can even buy custom skins online from iwishthiswereactuallytrue.com (use this discount code for 15% off: ifellforit).

Choosing What You See in Loupe View

When you're in Loupe view (the zoomed-in view of your photo), besides just displaying your photo really big, you can display as little (or as much) information about your photo as you'd like as text overlays, which appear in the top-left corner of the Preview area. You'll be spending a lot of time working in Loupe view, so let's set up a custom Loupe view that works for you.

Step One:
In the Library module's Grid view, click on a thumbnail and press **E** on your keyboard to jump to the **Loupe view** (in the example shown here, I hid everything but the right side panels, so the photo would show up larger in Loupe view).

Step Two:
Press **Command-J (PC: Ctrl-J)** to bring up the Library View Options dialog and then click on the Loupe View tab. At the top of the dialog, turn on the **Show Info Overlay checkbox**. The pop-up menu to the right lets you choose from two different info overlays: Info 1 overlays the filename of your photo (in larger letters) in the upper-left corner of the Preview area (as seen here). Below the filename, in smaller type, is the photo's capture date and time, and its cropped dimensions. Info 2 also displays the filename, but underneath, it displays the exposure, ISO, and lens settings.

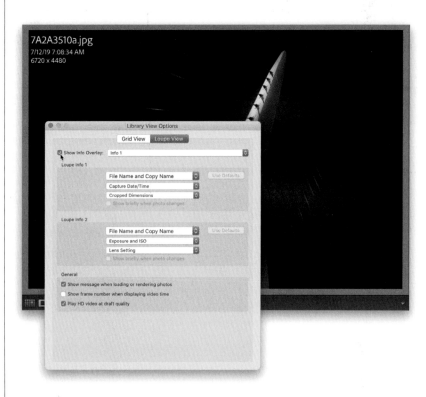

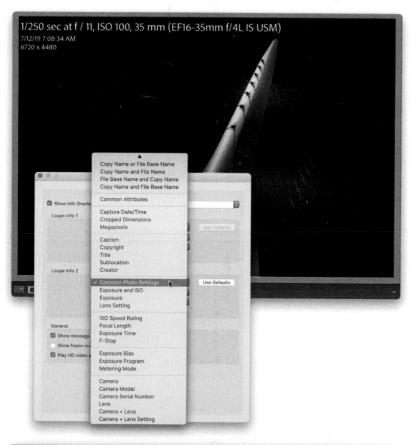

Step Three:

Luckily, you can choose which info is displayed for both info overlays using the pop-up menus in this dialog. So, for example, instead of having the file-name show up in huge letters, for Loupe Info 2, you could choose something like **Common Photo Settings** from the first pop-up menu (as shown here). By choosing this, instead of getting the file-name in huge letters, you'd get the same info that's displayed under the histogram (like the shutter speed, f-stop, ISO, and lens setting) found in the top panel in the right side panels. You can customize both info overlays separately by simply making choices from these pop-up menus. (*Remember:* The top pop-up menu in each section is the one that will appear in really large type.)

Step Four:

Any time you want to start over, just click the Use Defaults button to the right and the default Loupe Info settings will appear. Personally, I find this text appearing over my photos really, really distracting most of the time. The key part of that is "most of the time." The other times, it's handy. So, if you think this might be handy, too, here's what I recommend: (a) Turn off the Show Info Overlay checkbox and turn on the **Show Briefly When Photo Changes checkbox** below the Loupe Info pop-up menus, which makes the overlay temporary—when you first open a photo in Loupe view, it appears on the photo for around four seconds and then hides itself. Or, you can do what I do: (b) leave those off, and when you want to see that overlay info, press the **I key** to toggle through Info 1, Info 2, and Show Info Overlay off. At the bottom of the dialog, there's also a checkbox that lets you turn off those little messages that appear onscreen, like "Loading" or "Assigned Keyword," etc., along with some video option checkboxes.

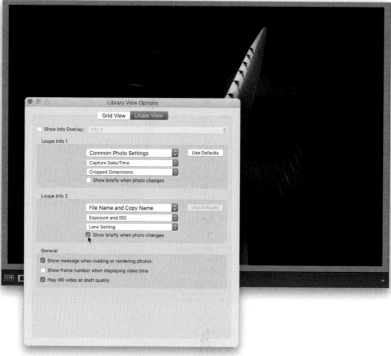

Choosing What You See in Grid View

Those little cells that surround your thumbnails in Grid view can either be a wealth of information or really distracting (depending on how you feel about text and symbols surrounding your photos), but luckily you get to totally customize not only how much info is visible, but in some cases, exactly which type of info is displayed (of course, you learned in Chapter 1 that you can toggle the cell info on/off by pressing the letter **J** on your keyboard). At least now when that info is visible, it'll be just the info you care about.

Step One:

Press **G** to jump to the Library module's Grid view, then press **Command-J (PC: Ctrl-J)** to bring up the Library View Options dialog (shown here), and click on the **Grid View tab** at the top (seen highlighted here). At the top of the dialog, there's a pop-up menu where you can choose the options for what's visible in either the Expanded Cells view or the Compact Cells view. The difference between the two is that you can see more info in the Expanded Cells view.

Step Two:

We'll start at the top, in the **Options section**. If you add a Pick flag and left/right rotation arrows to your cell, and turn on the Show Clickable Items on Mouse Over Only checkbox, it means they'll stay hidden until you move your mouse over a cell, then they appear so you can click on them. If you leave it unchecked, you'll see them all the time. The Tint Grid Cells with Label Colors checkbox only kicks in if you've applied a color label to a photo. If you have, turning this on tints the gray area around the photo's thumbnail the same color as the label, and you can set how dark the tint is with the pop-up menu. With the Show Image Info Tooltips checkbox turned on, when you hover your cursor over an icon within a cell (like a Pick flag or a badge), it'll show you a description of that item. Hover your cursor over an image thumbnail, and it'll give you a quick look at its EXIF data.

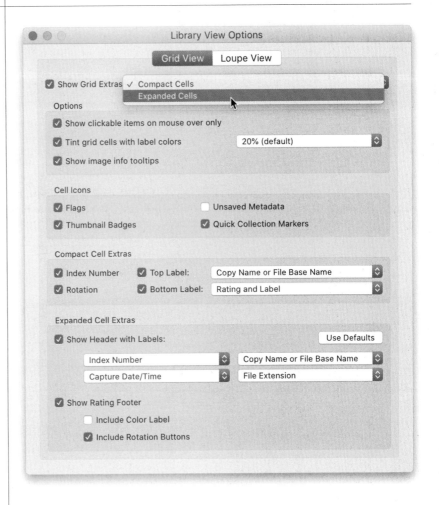

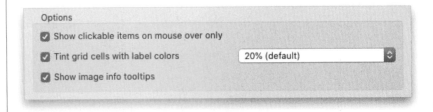

The thumbnail badges show you (from L to R) that a keyword has been applied, the photo has GPS info, it has been added to a collection, it has been cropped, and it has been edited

The black circle in the upper-right corner is actually a button— click on it to add this photo to your Quick Collection

Click the flag icon to mark it as a Pick

Click the Unsaved Metadata icon to save the changes

Step Three:

The next section down, **Cell Icons**, has two options for things that appear right over your photo's thumbnail image, and two that appear just in the cell. Thumbnail badges appear in the bottom-right corner of a thumbnail to let you see if: (a) the photo has had keywords added, (b) the photo has GPS info, (c) the photo has been added to a collection, (d) the photo has been cropped, or (e) the photo has been edited in Lightroom (color correction, sharpening, etc.). These tiny badges are actually clickable shortcuts. For example, if you wanted to add a keyword, you could click the Keyword badge (whose icon looks like a tag), and it opens the Keywording panel and highlights the keyword field, so you can just type in a new keyword. The other option on the thumbnail, Quick Collection Markers, adds a black circle (that's actually a button) to the top-right corner of your photo when you mouse over the cell. Click on it to add the photo to (or remove it from) your Quick Collection (it becomes a gray dot).

Step Four:

The other two options don't put anything over the thumbnails—they add icons in the cell area itself. When you turn on the Flags checkbox, it adds a Pick flag to the top-left side of the cell, and you can then click on this flag to mark this photo as a Pick (shown here on the left). The last checkbox in this section, Unsaved Metadata, adds a little icon in the top-right corner of the cell (shown here on the right), but only if the photo's metadata has been updated in Lightroom (since the last time the photo was saved) and these changes haven't been saved to the file itself yet (this sometimes happens if you import a photo, like a JPEG, which already has keywords, ratings, etc., applied to it, and then in Lightroom you added keywords, or changed the rating). If you see this icon, you can click on it to bring up a dialog that asks if you want to save the changes to the file (as shown here).

Step Five:

We're going to jump down to the bottom of the dialog to the **Expanded Cell Extras section**, where you choose which info gets displayed in the area at the top of each cell in Expanded Cells view. By default, it displays four different bits of info (as shown here): It's going to show the index number (which is the number of the cell, so if you imported 63 photos, the first photo's index number is 1, followed by 2, 3, 4, and so on, until you reach 63) in the top left, then below that will be the pixel dimensions of your photo (if the photo's cropped, it shows the final cropped size). Then in the top right, it shows the file's name, and below that, it shows the file's type (JPEG, RAW, TIFF, etc.). To change any one of these info labels, just click on the label pop-up menu you want to change and a long list of info to choose from appears (as seen in the next step). By the way, you don't have to display all four labels of info, just choose None from the pop-up menu for any of the four you don't want visible.

Step Six:

Although you can use the pop-up menus here in the Library View Options dialog to choose which type of information gets displayed, check this out: you can actually do the same thing from right within the cell itself. Just click on any one of those existing info labels, right in the cell itself, and the same exact pop-up menu that appears in the dialog appears here. Just choose the label you want from the list (I chose **ISO Speed Rating** here), and from then on it will be displayed in that spot (as shown here on the right, where you can see this shot was taken at an ISO of 100).

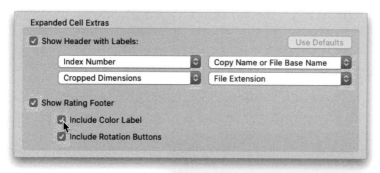

Step Seven:

At the bottom of the Expanded Cell Extras section is a checkbox that is on by default. This option adds an area to the bottom of the cell called the Rating Footer, which shows the photo's star rating, and if you keep both checkboxes beneath **Show Rating Footer** turned on, it will also display the color label and the rotation buttons (which are clickable and will appear when you move your cursor over a cell). If you assign a color label to an image, its cell now appears in that color (as shown here, where I chose the Green label for this image). When you click on a color-labeled image like this, the cell turns back to its normal gray (so it doesn't mess with your perception of the image's color), but a thin colored border appears around the image itself, so you still know it's labeled.

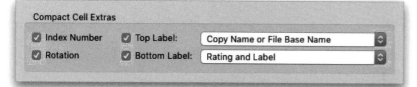

Step Eight:

The middle section we skipped over is the **Compact Cell Extras section**. The reason I skipped over these options is that they work pretty much like the Expanded Cell Extras, but with the Compact Cell Extras, you have only two fields you can customize (rather than four, like in the Expanded Cell Extras): the filename (which appears on the top left of the thumbnail) and the rating (which appears beneath the bottom left of the thumbnail). To change the info displayed there, click on the label pop-up menus and make your choices. The other two checkboxes on the left hide/ show the index number (in this case, it's that huge gray number that appears along the top-left side of the cell) and the rotation arrows at the bottom corners of the cell (which you'll see when you move your cursor over the cell, as shown here). One last thing: you can turn all these extras off permanently by turning off the Show Grid Extras checkbox at the top of the dialog.

Choosing What the Filmstrip Displays

Just like you can choose what photo information is displayed in the Grid and Loupe views, you can also choose what info gets displayed in the Filmstrip, as well. Because the Filmstrip is pretty short in height, I think it's even more important to control what goes on here, or it starts to look like a cluttered mess. Although I'm going to show you how to turn on/off each line of info, my recommendation is to keep all the Filmstrip info turned off to help avoid "info overload" and visual clutter in an already busy interface. But, just in case, here's how to choose what's displayed down there:

Step One:
Right-click on any thumbnail in the Film-strip and a pop-up menu appears (seen here). At the bottom of it are the **View Options** for the Filmstrip. There are four options: Show Ratings and Picks adds tiny flags and star ratings to your Filmstrip cells. If you choose Show Badges, it adds mini-versions of the same thumbnail badges you see in Grid view (which show if the photo is in a collection, whether keywords have been applied, whether it has been cropped, or if it has been adjusted in Lightroom). Show Stack Counts adds a stack icon with the number of images inside the stack. The last choice, Show Image Info Tooltips, kicks in when you hover your cursor over an image in the Filmstrip—a little window pops up showing you the info you have chosen in the View Options dialog for your Info Overlay 1. If you get tired of accidentally clicking on badges that launch stuff when you're navigating around the Filmstrip, you can leave the badges visible but turn off their "click-ability" (if that's even a word) by choosing **Ignore Clicks on Badges** here, too.

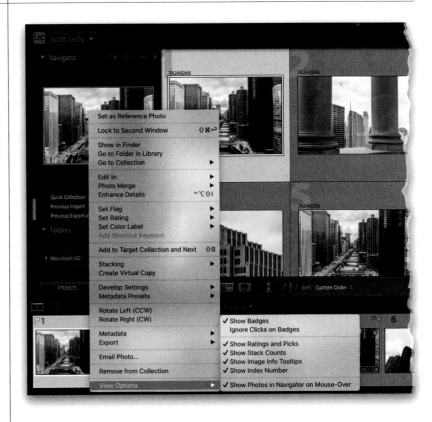

Step Two:
Here's what the Filmstrip looks like when these options are turned off (top) and with all of them turned on (bottom). You can see Pick flags, star ratings, and thumbnail badges (with unsaved metadata warnings). I hovered my cursor over one of the thumbnails, so you can see the little pop-up window appear giving me info about the photo. The choice is yours—clean or cluttered.

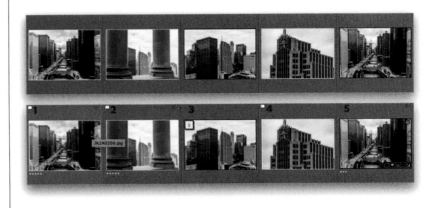

Using dual monitors with Lightroom is glorious! You can sort through all your thumbnails on one screen, and at the same time, see a huge, full-screen version of any photo you click on, on the other. Plus, it just looks cool. Also, Adobe included some other cool things you can do once it's set up (and here's how to set it up), so it's worth checking out.

Using Two Monitors with Lightroom

Step One:

The controls for using Lightroom with a second display are found down in the top-left corner of the Filmstrip, where you'll see two buttons: one marked "1" for your main display and one marked "2" for the second display (I circled that one here in red since it's the one you'll mostly be messing with). If you don't have a second monitor connected, you can still get the two-monitor feel by clicking on "2" (the **Second Window button**). This brings up a small floating window showing you what would be seen in the second monitor (as seen here in the inset). If you have a big enough screen, you can leave this window open to have it show a much larger view of any thumbnail you click on either in the thumbnail grid or in the Filmstrip.

Step Two:

If you do have a second monitor connected to your computer, when you click on the Second Window button, whichever image you currently have selected in Lightroom appears nearly full screen on the second monitor. This is the default setup here, which lets you see Lightroom's interface, panels, and controls on your main display, and then this larger Loupe view of your selected image on your second display (if you look in the left side of the navigation bar at the top of the second display, you'll see **Loupe** is selected as the second monitor view. Any image you click on gets displayed larger on that display).

Step Three:

You could choose what appears on your second display by clicking on it in the navigation bar at the top of the second display, but then you'd have to move your cursor over to that second display, and then back once you've made your choice. That's why you might prefer making the choice right from your main display. Just go down to the left side of the Filmstrip and click-and-hold on the "2" button to bring up the **Secondary Window pop-up menu** (shown here at the top). Now you can choose from here what you want to see over there. Again, by default, you're in Loupe – Normal view on that second display—you click on a thumbnail and a larger view of that image appears on your second display. But, there's another option, **Loupe – Live**, that you might like even better. It lets you just hover over any thumbnail (as I'm doing here on the main display, hovering over the first thumbnail in the center row) and that image now appears large on your second display. No need to click on it to see it—just hover your cursor over it and it appears instantly on the second display. Give both versions a try to see which you like best.

Step Four:

There are a few more options in this Secondary Window pop-up menu: If you choose Grid, you'll see your thumbnails appear on the second display, so you can work on something else on your main display. You can choose to use either Survey view or Compare view (see page 52) on the second display, and if you press-and-hold the Shift key, you can even use the same keyboard shortcuts we normally use for these views (but don't forget to hold down the Shift key—that tells Lightroom to "Do this on the second display"). So, for example, you could have your thumbnails on your main display, but then choose **Compare view** for the second display (as I've done here), so you can compare two similar selected images.

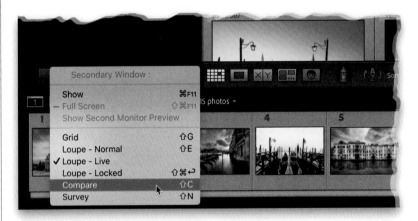

Step Five:

Another view option is called **Loupe –Locked** and when you choose this from the Secondary Window pop-up menu, it locks whatever image is currently shown in Loupe view on the second display. That way you can look at and edit other images on the main display, and the image on the second display doesn't change. This works nicely if you have a client on the shoot and you don't want them to see every image that goes by—you just want them to see the good ones. You can lock a good image onscreen for them and skip past the bad images (flash didn't fire, subject was between poses, etc.), but when you see a good shot and want them to see it on the second display, you can just Right-click on the shot and chose **Lock to Second Window** from the pop-up menu (as shown here).

Step Six:

By the way, those navigation bars at the top and bottom of your second display don't have to be there (and hiding them will make your image larger onscreen, which is a great thing). If you want those hidden, you can either click on the little gray arrows at the top and bottom of the screen to tuck them out of sight, or you can Right-click on either arrow to bring up the hide/show options for them and choose **Auto Hide**. One more thing I like to do on this second display is to change the gray canvas area surrounding my image to solid black. You do that by Right-clicking anywhere outside your image, and from the pop-up menu that appears, choosing **Black** (as shown here). Now you've got a larger image, with fewer distractions, and a solid black background.

Here's the second display with the navigation bars hidden and the canvas area set to black, which gives a larger, cleaner view

Adding Your Studio's Name or Logo for a Custom Look

See where is says "Adobe Photoshop Lightroom Classic" up in the top-left corner of the Lightroom window? You can use the Identity Plate feature to replace Adobe's logo with your own logo (either as a graphic or text). It's a nice touch when you're doing client presentations as it makes it look like Adobe designed it just for your studio. The Identity Plate feature goes beyond just letting you put your name up there (as you'll see as we go deeper into the book), but for now, here's how to use it to customize that name plate:

Step One:
First, just so we have a frame of reference, here's a zoomed-in view of the top-left corner of Lightroom's interface, so you can clearly see the logo we're going to replace starting in Step Two. Now, you can either replace Lightroom's logo using text (and you can even have the font of the modules in the taskbar in the top right match that same font) or you can replace the logo with a graphic of your logo (we'll look at how to do both). Go under the Lightroom menu (the Edit menu on a PC) and choose **Identity Plate Setup** to bring up the Identity Plate Editor (shown in the next step).

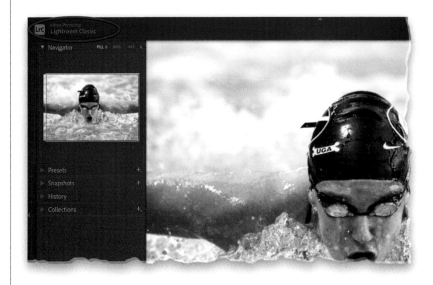

Step Two:
There's an Identity Plate pop-up menu in the top left, and you'll see Lightroom Classic as the chosen Identity Plate (which means you see that Lightroom logo). If you choose Adobe ID from that pop-up menu instead, then it displays the name you used to registered the software. To create your own custom Identity Plate, choose **Personalized**, which brings up two text entry/preview fields (seen here). In the left field, you'll type in whatever name you want to use as your Identity Plate. To change the font, font style (bold, italic, condensed, etc.), or font size, first highlight the text (the same way you would in any program) and make your choices from the pop-up menus right below. The right field lets you match the fonts of the modules in the taskbar to what you chose for your name (if you care to do that).

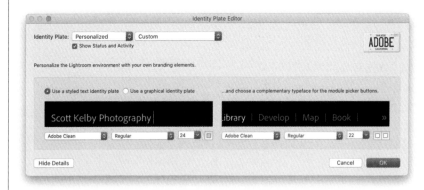

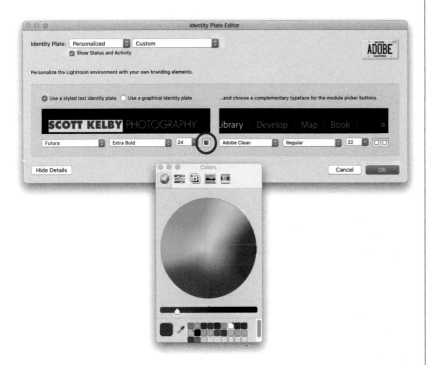

Step Three:

If you want to change only part of your text (for example, if you wanted to change the font of one of the words, the font size, or the color of a word), just highlight the word you want to adjust before making the change. Here, I retyped my name in all caps, and then used the Futura Extra Bold font for my name and Futura Extra Light for "PHOTOGRAPHY." Once you highlight your name, to change the color of that highlighted text, click on the little square color swatch to the right of the Font Size pop-up menu (it's shown circled here). This brings up the Colors panel (you're seeing the Mac's Colors panel here; the Windows Color panel will look somewhat different, but don't let that freak you out. Aw, what the heck—go ahead and freak out!). Now just choose the color you want your selected text to be, then close the Colors panel.

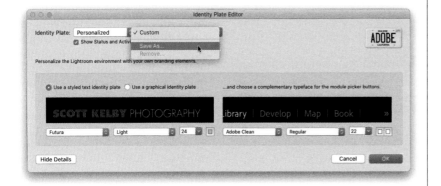

Step Four:

If you like the way your custom Identity Plate looks, you can save it by clicking on the second pop-up menu (the one to the right of the Identity Plate pop-up menu—where it says "Custom") and choosing **Save As** (as shown here). Give your Identity Plate a descriptive name, click OK, and now it's saved. From here on out, it will appear in that pop-up menu, where you can get that same custom text, font, and color with just one click. The nice thing about having this saved is that you can add this Identity plate to other things—like to a slide show or to a print—so having a saved Identity Plate isn't just for replacing the Lightroom logo.

Step Five:

Once you click the OK button, your new Identity Plate text replaces the Lightroom logo that was in the upper-left corner (as shown here). If you want to use a graphic (like your company's logo) instead, first get your logo down to a size that will fit (there's no resize slider in the Identity Plate editor, so you have to have it at the right size before you import it). Adobe says to make it no more than 41 pixels high on a Mac or 46 pixels high in Windows, but I've been getting away with 57 pixels high, so that's what I'm going with. You can make it around 350 pixels wide. Also, putting your logo on a black background (I do both of these in Photoshop) will help it blend in (otherwise you'll see a white box around your logo).

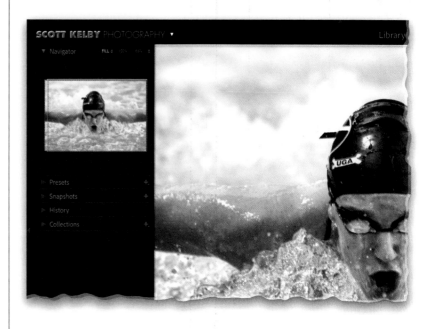

Step Six:

Also, be prepared to "futz" (technical term) with the logo placement in Photoshop a bit to get it looking right (well, I've always had to), so you might have to slide it left or right inside that 57-pixel by 350-pixel black rectangle, or drag it up above center, so it looks right when you bring it into Lightroom (at least that's been my experience). Once you have your logo sized to fit, and either on a black background or saved with a transparent background in PNG format, go to the Identity Plate Editor again, click the **Use a Graphical Identity Plate radio button** (as shown here), then click on the Locate File button (found above the Hide/Show Details button near the lower-left corner) and find your logo file. Once it comes in, you'll see it in the preview on the left, but the only real way to see if it fits right is to just hit the OK button to see how it looks. Then, again, you might have go back and tweak the logo a bit to get it to fit. And, by "might" I mean, you will.

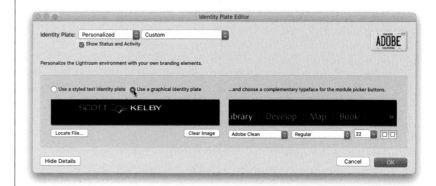

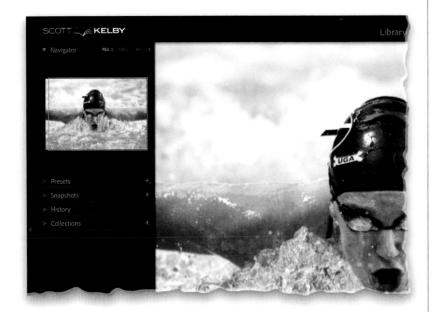

Step Seven:
When you click OK, the Lightroom logo (or your custom text—whichever was up there last) is replaced by the new graphic file of your logo (as shown here). If you like your new graphical logo file in Lightroom, don't forget to save this custom Identity Plate by choosing Save As from the second pop-up menu at the top of the dialog.

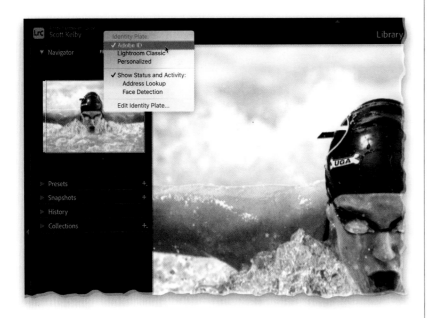

Step Eight:
If you decide, at any point, that you'd like the original Lightroom logo back instead, or the Adobe ID plate (which is seen here), you can Right-click on your logo and from the pop-up menu that appears (also seen here), choose which one you want (Lightroom Classic, Adobe ID, or your Personalized plate). Remember, we'll do more with one of your new Identity Plates later on in the book.

How to Keep from Scrolling So Much

Lightroom has an awful lot of panels, and you wind up spending a lot of time just scrolling up and down in the panels to get to the one you want. Luckily, it doesn't have to be that way because of an incredibly awesome feature called Solo mode. Once you turn it on, it displays only that one panel you're working in and collapses the rest neatly out of the way.

Step One:

Take a look at the two sets of panels shown here. The one on the left shows how the Develop module's right side panels look normally—a long scrolling group of panels with all their features and sliders visible. Not only is there a lot of scrolling up and down in those panels, but having all of them open all the time is just plain distracting, and you may have to scroll down a ways just to get to the panel you want. Now look at the same set of panels on the right when Solo mode is turned on—all the other panels are collapsed out of the way, so you can just focus on the panel you're working in (in this case, it's the HSL/Color panel). To work in a different panel, just click on its name, and the active panel tucks itself away automatically and the panel you clicked on opens. Just that one panel.

Step Two:

To turn on Solo mode, Right-click on any panel in the side panels, and from the pop-up menu that appears, choose **Solo Mode** (as shown above, on the right). That's all there is to it. To go back to "endless scrolling mode," just Right-click again and uncheck Solo Mode (but my guess is that once you use Solo mode, you'll be hooked). It's one of the most helpful and yet underrated workflow features in all of Lightroom. You're going to super-dig it!

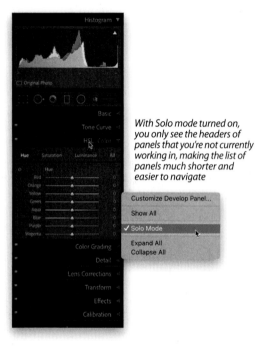

With Solo mode turned on, you only see the headers of panels that you're not currently working in, making the list of panels much shorter and easier to navigate

Just a portion of the Develop module's right side panels with Solo mode turned off

There are panels you're never going to use (even though you might not know yet what those are, but I'll give you a suggestion for at least one), and there are even entire modules you'll probably never use (like the Web module or the Slideshow or Map modules). But, luckily, you don't have to see all the stuff you're not going to use because you can just simply hide it, which unclutters your work area and cuts your scrolling, too.

Hiding Things You Don't Use (and Rearranging Things You Do Use)

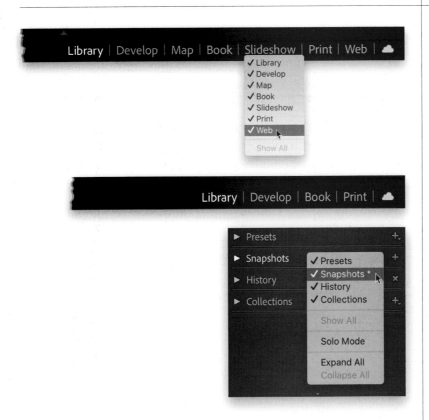

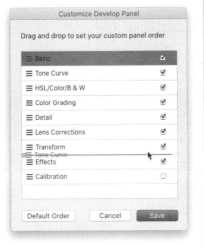

Step One:

Let's start up top with the taskbar. To hide any modules you don't use (like the Web module, which I believe only 14 people alive today still use), simply Right-click anywhere up there near a module's name and a pop-up menu appears (as shown here at the top). Choose any module you want to hide (maybe Slideshow or Map, if you don't use them), and it unchecks that module and hides it in the taskbar (as seen here at the bottom, where you now only see the Library, Develop, Book, and Print modules). If you decide for any reason that you want them all back, just Right-click up there again and chose **Show All** from the bottom of the pop-up menu, or choose any individual unchecked module to make it visible again.

Step Two:

To hide a panel (not including those in the Develop module's right side panels, which uses a different method), Right-click on a panel's name and a pop-up menu will appear with a list of panels in that panel area (as seen here, at the top). To hide one from view, just choose it from this list and it turns off (and hides). The Develop module's right side panels allow more customization because you can not only hide panels (like the Calibration panel, for instance—not all that useful, day-to-day, for most folks), but you can also reorder them. Right-click on a panel's name and chose **Customize Develop Panel** to bring up the dialog you see here. To hide a panel, uncheck its checkbox. To reorder one, click on it and drag it in the list where you want it to appear. That's it.

GETTING YOUR COLOR RIGHT
if your color's not right...it's wrong

Nailing your color is really important when it comes to photography. But, while someone looking at your image might not know how green the grass was that day, or how blue the sky really was, there is one thing that's pretty much universally known, and that's skin tone. If your skin tone is off, people will know it. This happens most often because of Auto white balance. It's actually good in most situations, but where we get burned is when we're shooting a portrait outdoors, and to get out of the harsh direct sun, we move our subject under a tree or over to the shady side of a building. Because our camera is set to Auto WB while we're shooting in the shade, it adds a blue tint over the entire image, which is not only very obvious, it's unflattering. Think about it—in TV shows and movies where they want to make a character look dead, what do they do? They add blue makeup, and sure enough, that character looks dead. Now, how can you use this information to your advantage? Let's say a potential client

contacts you for a photo shoot, and they say, "I want to look dead in this photo" (which is a very common request). Your first thought might be, "I need to buy some ketchup to use as fake blood." Rookie mistake. If you were really up on your insurance fraud photography best practices, you'd realize that most life insurance policies have a murder exemption, so you can't make it look like they were killed—you have to make it look like an accident. Step One: Find a shady street with a large pothole in the road. Step Two: Buy an old broken bike from a junk yard, and position it and your subject on the ground near the pothole. Step Three: Set your white balance to Auto, and take the shot. Next, attach the photo to your life insurance claim and just wait for your check (it takes about four to six weeks, but I've gotten a few sooner). Now, I'm not saying I've done this. This is, of course, all just hypothetical. But, better to be prepared in case of an unexpected tragedy, or aggressive pothole.

If You Shoot in RAW, Start Here

If you shoot in JPEG on your camera, skip these two pages, and start on page 132. If you shoot in RAW, when you import your RAW image into Lightroom, it applies a default "look" to it—a starting place for your image editing. Adobe figures if you shot in RAW, you want to keep it looking as much as like what the camera captured as possible (with a few minor exceptions). This default "look" is called "Adobe Color," and it creates a slightly enhanced version of your RAW image (it has a little more contrast, slightly more vibrant color, and some sharpening applied). But, what if you want to choose something better than Adobe's default? Well, you can.

Step One:

Note: Again, this only applies to you, if you shoot in RAW. If you shoot in JPEG, skip these two pages. If you shoot in RAW, make sure you read the intro above first.

When you shoot in JPEG, your camera applies all sorts of processing adjustments in-camera—like contrast, vibrance, sharpening, noise reduction, and so on. That's why JPEG images look so much better straight out of the camera than RAW images do. RAW images don't have any of that stuff applied to them yet, so they look kind of flat. When you open a RAW image in Lightroom, it applies a RAW profile—a default "look" for your RAW image (as I talked about above). This default RAW profile is called "Adobe Color" (if you go to the Develop module, near the top of the Basic panel and to the right of the word "Profile," you'll see Adobe Color is chosen as your RAW profile, as seen here). This profile makes your RAW image look pretty close to the RAW image your camera captured—it actually enhances the look of it a bit. It makes the color look a little more vibrant and contrasty, and it applies some sharpening and other stuff—probably because if you saw how flat and boring and untouched a RAW image really looks, you might jump out a nearby window. The good news is you don't have to stick with Adobe's default RAW profile, and I think we can do better by choosing a different one—one that better matches the type of image we're working on.

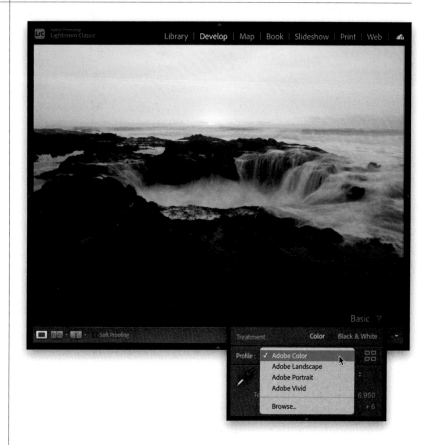

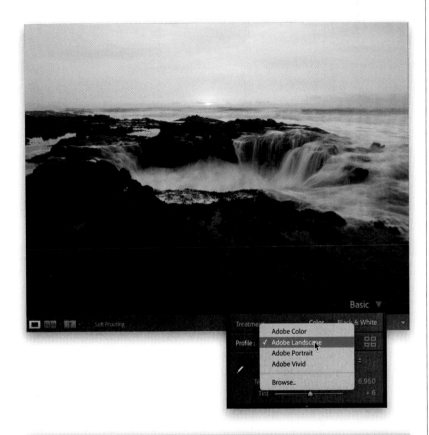

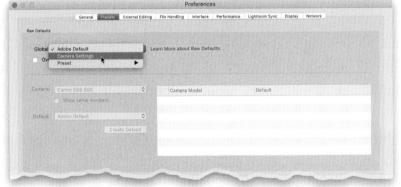

Step Two:

In your camera, you can choose different picture styles or looks for particular types of images (Canon calls these Picture Styles, Nikon calls them Picture Controls, Sony calls them Creative Styles, and so on), and these tweak the look of your image, color and contrast-wise. In Lightroom, you have RAW profiles that let you do the same thing, and (this is just my opinion, but I'm not alone in this) any of the other RAW profiles you choose usually look better than the default Adobe Color profile. For the image we have here, I went to the Basic panel and chose **Adobe Landscape** from the Profile pop-up menu as my RAW profile—look at how much better the image looks by simply choosing a different profile. The colors look more vibrant, there's more contrast, and I think it's just a better starting place.

Step Three:

While I wind up choosing Adobe Landscape most often (even if the photo is not a landscape), it does depend on the image. Sometimes, Adobe Vivid looks better, and if it's a portrait, I prefer Adobe Portrait as my starting place. So, it's worth taking a look at both Adobe Landscape and Adobe Vivid to see which one looks best for your image (my money's on Adobe Landscape), but either way, 99.2% of the time, whichever one you choose will look better than the default Adobe Color. One more important thing (but this is totally optional): If you shoot in RAW and choose a picture style in your camera, by default, Lightroom ignores your choice. However (and this is a fairly new feature), you can have Lightroom honor that in-camera picture style and it can automatically apply the matching style. You turn this feature on by going to Lightroom's Preferences **(Command-, [PC: Ctrl-,])** and clicking on the Presets tab up top. Here, you'll see a Raw Defaults section, and from the Global pop-up menu (it's set to Adobe Default), choose **Camera Settings** (as shown here).

Setting the White Balance Using Presets

After I've set my RAW profile, I start my editing process by first setting the white balance. I do this for two reasons: (1) Changing the white balance affects the overall exposure of your image big time (take a look at the histogram while you drag the Temp slider back and fourth a few times, and you'll see what a huge effect white balance has on your exposure). And, (2) I find it hard to make reasonable decisions about my exposure if the color is so off it's distracting. I find that when the color looks right, my exposure decisions are better. But hey, that's just me. Or is it?

Step One:
The White Balance controls are found near the top of the Develop module's Basic panel. Your photo reflects whichever white balance you had selected in your camera, so that's why the **WB pop-up menu** is set to "As Shot"—you're seeing the white balance "as it was shot," which in this case, is way too blue (I had been shooting under fluorescent lights earlier, then wound up shooting in this natural light setting and forgot to change my white balance to match the lighting conditions). There are three ways to adjust the white balance in Lightroom, and I'm going to show you two here, but I use the third way (coming up) most of the time because it's just so fast and easy. Still, it's important to know these two methods because you might prefer them for certain types of photos.

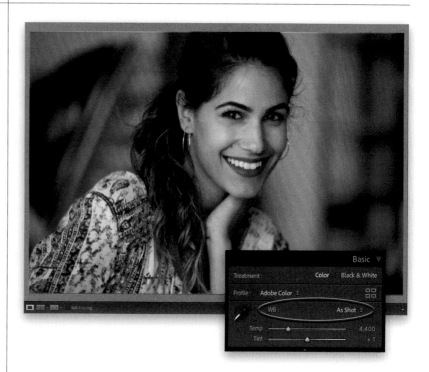

Step Two:
First, you can try the built-in White Balance presets. If you shot in RAW, click-and-hold on As Shot and a pop-up menu of **White Balance presets** appears. Here, you can choose the same white balance presets (seen here, on the left) you could have chosen in your camera. If you shot in JPEG mode, you only get one preset, Auto (seen here, on the right), because your white balance choice was already embedded in the file by your camera. You can still change the white balance for JPEG images, but you'll have to use the next two methods instead. *Note:* If your list looks different than mine here on the left, it's because you're using a different make/model of camera. The WB pop-up menu is based on which camera brand you shot with.

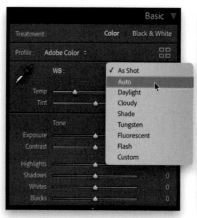

WB presets if you shot in RAW

WB presets if you shot in JPEG

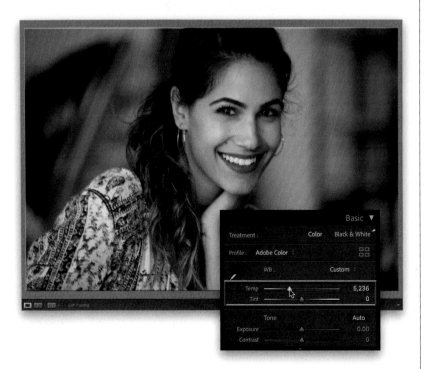

Step Three:

In our photo in Step One, the overall tone is really blue, so it definitely needs a white balance adjustment. (*Note:* To follow along using this same image, you're welcome to download it from the book's companion webpage, mentioned in the book's introduction.) I usually start by choosing Auto from the **White Balance pop-up menu** to see how that looks (as you can see here, it's much better all around. In person, her skin has a warmer tone, but the Auto preset is actually not warm enough). Go ahead and try out the next three presets, but spoiler alert: Daylight will be a bit warmer, with Cloudy and Shade being progressively even warmer. So, I'd choose Cloudy or Shade (just so you can see how much warmer that will make her skin tone, as well as the whole photo for that matter). You can skip Tungsten and Fluorescent—they're going to be way crazy blue (in fact, it was Fluorescent that we accidentally had our white balance set to from the beginning). By the way, the last preset isn't really a preset at all—Custom just means you're going to set the white balance manually instead of using a preset.

Step Four:

If you go through the WB presets and none look right to you (or if you shot in JPEG, so your only choice was Auto, and it didn't look right), then we move on to Method #2, which is to choose the WB preset that is the closest to being right (in this case, for me, it was Auto), then drag the Temp and Tint sliders (found right below the pop-up menu) to tweak the color more to your liking. Take a look at those two sliders. Without me even explaining how they work, if I wanted more blue in this photo, which way would I drag the Temp slider? That's right—those color bars behind the sliders are a huge help. In this case, I think her skin is too blue, so I dragged the **Temp slider** away from the blue side and more toward yellow, looking at the image while I dragged.

Step Five:

Let's stop and evaluate what we've done with our white balance. I think it looks a tiny bit too yellow now (it's a balancing act, right?), so to finish things off, let's drag the **Temp slider** back just a little bit toward blue (as shown here), and then let's also drag the **Tint slider** a little toward magenta. It looks pretty good overall now. A before/after is shown below, using the Auto WB preset and then tweaking the Temp and Tint sliders.

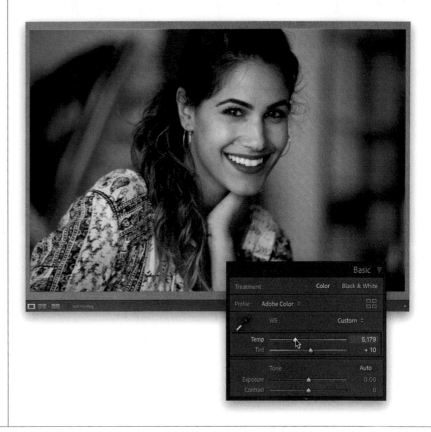

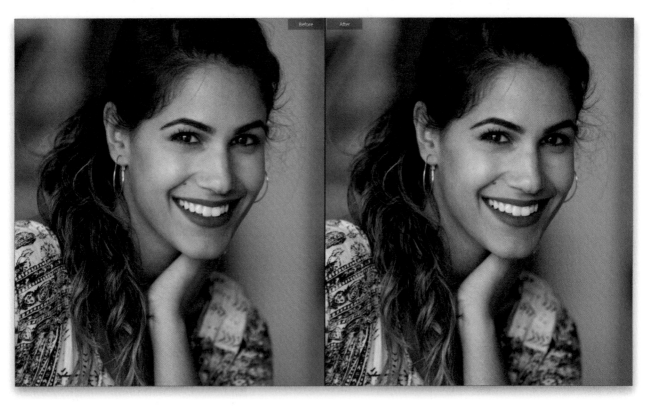

On the previous page, I showed a before and after, but I didn't get a chance to show you how I did that. I love the way Lightroom handles the whole before and after process because it gives you a lot of flexibility to see these the way you want to see them. Here's how:

Seeing a Before and After

Step One:
If you're working in the Develop module and want to see your image before you started tweaking it (the "before" image), just press the \ **(backslash) key** on your keyboard. You'll see the word "Before" appear in the upper-right corner of your image (as seen here). This is probably the **Before view** I use the most in my own workflow. To return to your After image, press the \ key again (it doesn't say "After;" the Before just goes away).

Step Two:
To see a **side-by-side Before and After view**, with the before on the left and the after on the right (as seen here), press the letter **Y** on your keyboard. Press Y again to return to the normal view. There are some other before/after options, but to access those, you'll need to make sure the toolbar beneath the Preview area is visible (as seen here). If it's not, press the letter **T**.

Step Three:
If you prefer a different before/after layout, like a split-screen view, where your image is split down the center with the left half in the Before view and the right half in the After, click the **Before and After Views button** (circled here in red) once in the toolbar. Click it again for a top/bottom split-screen before and after. The three buttons to the right of Before & After do this: the first one copies the Before image's settings to the After image, the second one copies the After's settings to the Before, and the third just swaps the Before/After settings. To return to normal view, press the letter **D** on your keyboard.

My Favorite Way to Set White Balance

While the White Balance presets often work pretty well, and being able to use them as a starting place and then tweaking the white balance using the Temp and Tint sliders is handy, it's not the way I usually set my white balance. In fact, I rarely use either one of those options because I love the White Balance Selector tool so much. It's easy, flexible, and it works wonders with just a click or two.

Step One:
In our shot here, the whole image has kind of a reddish tint to it, and his skin tone doesn't look right, so let's fix it. Click on the **White Balance Selector tool** (the big ol' eyedropper) in the top left of the white balance section in the Basic panel (or press **W** on your keyboard to get it). This tool couldn't be easier to use—you simply click it on a neutral area in your image (ideally, something light gray). If there's no gray in the photo, look for an area that's kind of a neutral color, like tan, ivory, taupe, or beige. Okay, now that you have the White Balance Selector tool, let's put it to work.

Step Two:
Our subject is wearing a gray shirt here, so we can just take the tool, click it once on his shirt (as shown here, where I circled the tool in red), and it sets the white balance based on that neutral color (as seen here where the image is now much less red). Click. Boom. Done. Well, it's certainly less red, and this is a better white balance choice, but I'm not sure his skin tone is spot on, so let's try clicking somewhere else to see if we can get a better result. That's the great thing about this tool—if you don't like the result from the first place you clicked, just click it somewhere else. Now, if you click on his shirt and the tool is suddenly gone (you see it back in the Basic panel where you first clicked on it), it's because a really annoying feature called **"Auto Dismiss"** is turned on. You can turn this off (and I suggest you do) by turning off its checkbox down in the toolbar (it's also circled in red here).

Step Three:

Okay, let's keep clicking around until it looks better (one thing that will let you know you have your color right will be that the gray background will actually look gray). Here, I clicked on the background behind him, and I think his fleshtone (and the overall color) looks much better. That's the great thing about properly setting your white balance. It's not like their fleshtone is going to look natural and their hair is going to look bright green. Once you get the overall white balance looking right, the overall color looks right. That doesn't mean you won't have to tweak some particular color once in a while (you'll learn how shortly), but once you get your white balance looking good, the rest of the color falls into place.

Step Four:

Now, what happens if you click the eyedropper in a totally wrong spot? Trust me, you'll know (see how the whole image turned blue here when I clicked on his cheek?). When this happens and you get some crazy color (and it will happen), don't sweat it—just click somewhere else, including trying a place you wouldn't think would give you an accurate white balance. One more thing: If you're using the White Balance Selector tool and you see a floating grid following your eyedropper around, that's just what we call "the useless annoying grid." Theoretically, it's supposed to help you find a neutral color by showing you the pixels under the location of the eyedropper, along with the RGB values, and if you get all three of those numbers to match up (it happened once, in a sci-fi movie), that would be a truly neutral color. I only recommend using this grid to people I don't really like. It kind of evens the score. Anyway, to turn it off, turn off the **Show Loupe check-box** (shown circled here in red) down in the toolbar. When you're done with the eyedropper, just click it back in its "home" in the Basic panel or click the Done button in the toolbar.

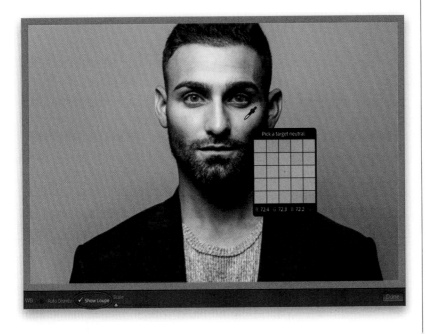

Using a Gray Card for More Accurate Color

So far, the methods we've been using to set our white balance have been pretty much "eyeing it," which actually works well most of the time. But, when you need a very accurate white balance (like if you're doing client work for commercial retail clothing or products where the color has to be spot on), a very popular method is to use a gray card, which puts a gray area in your photo that you can use to set your white balance accurately using the White Balance Selector tool.

Step One:

The whole idea of a gray card is that when you add one to your shoot, you're assured of having something gray in your shot to click the White Balance Selector tool on to accurately set your white balance. These gray cards are not just any random amount of gray—they are a perfectly neutral 18% gray, which is the ideal gray for setting white balance for photography. The one shown here is the collapsible, pop-up EzyBalance Grey/White Card from Last-olite by Manfrotto (they make great stuff), but I included a free tear-out gray card for you right in the back of this book. Just tear it out and you're ready to go. Here's how to use it: once your lighting is set (or your subject is in position outside), ask your subject to hold the gray card up near their face (as shown here) and take a shot.

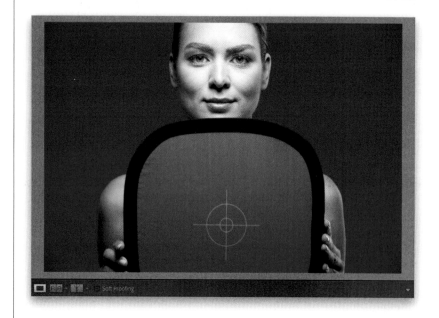

Step Two:

Now, to set the white balance for this shot, it's really easy: get the **White Balance Selector tool (W)** from the top of the Develop module's Basic panel, click it once anywhere on the gray part of the gray card (as shown here), and it sets the white balance for you. But, that's just one photo. What do we do with all the rest? Well, that's where this gray card really gets useful. By the way, what if you're not photographing a person? What if it's a product shot? Then just position part of the card so it's clearly visible in the frame, so you can click on it with the eyedropper.

Step Three:

There's an easy way to set the white balance in the other shots from this shoot: simply sync it from this photo to all the other photos taken in those same lighting conditions (look down in the Filmstrip along the bottom here, and you can see how blue all the other shots look). After you've fixed the white balance on the photo where your subject is holding the gray card, press-and-hold the Shift key and then scroll over to the last photo you want to fix the white balance for and click on it, and it will select all the images in between. Now, just click the **Sync button** at the bottom of the right side panels to bring up the Synchronize Settings dialog (seen here below). Click the Check None button at the bottom left to turn off all the things you could potentially sync, then turn on the checkboxes for White Balance and Process Version, and then click the **Synchronize button**. (*Note:* If you were applying this setting[s] to only one other image, you could use the Copy and Paste buttons at the bottom of the left side panels instead of Sync.)

Step Four:

If you look down in the Filmstrip now, you can see all those images have had their white balance changed to match the gray card shot (as seen here, at the top). Another method is to skip the whole Synchronize Settings dialog and start off (even before you fix the gray card shot) by selecting all the photos from that shoot first, and then use a little feat of magic called "Auto Sync." Once all the photos are selected, click on the little switch to the left of the Sync button, and it'll change to **Auto Sync** (as seen circled here, at the bottom). What Auto Sync does is this: whatever you do to the first selected photo, it also does to all the other selected photos. So, with this on, when you fix the white balance for the image with the gray card, all the other selected images will automatically update live with the new white balance you choose with the eyedropper.

Setting Your White Balance Live While Shooting Tethered

The fact that you can shoot tethered directly from your camera, straight into Lightroom, is one of my favorite features in Lightroom, but when I learned the trick of having the correct white balance applied automatically, as the images first come into Lightroom, it just put me over the top. So much so that I was able to include a free, perforated, tear-out 18% gray card in the back of this book, so you can do the exact same thing (without having to go out and buy a gray card. A big thanks to my publisher, Peachpit Press, for letting me include this). You are going to love it!

Step One:

Start by connecting your camera to your computer (or laptop) using a USB cable, then go under Lightroom's File menu, under Tethered Capture, and choose **Start Tethered Capture** (as shown here). This brings up the Tethered Capture Settings dialog, where you choose your preferences for how the images will be handled as they're imported into Lightroom (see Chapter 1 for more details on this dialog and what to put in where).

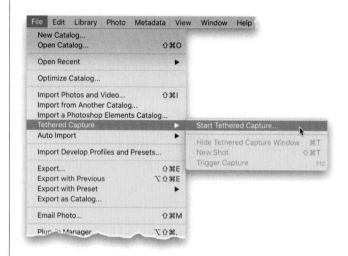

Step Two:

Once you get your lighting set up the way you want it (or if you're shooting in natural light), place your subject into position, hand them a gray card (go to the back of this book and tear out the perforated 18% gray card if you don't have one), and ask them to hold it while you take a test shot (if you're shooting a product instead, just lean the gray card on the product, or somewhere right near it in the same light). Now, take your test shot with the gray card clearly visible in the shot (as shown here).

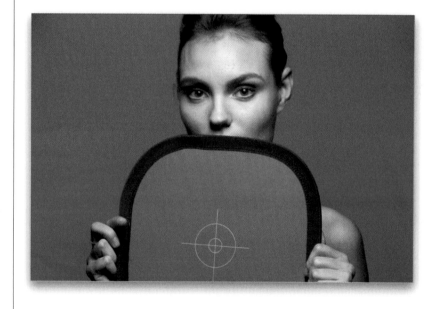

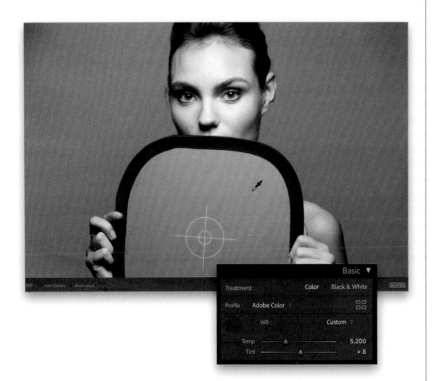

Step Three:

When the photo with the gray card appears in Lightroom, get the **White Balance Selector tool (W)** from the top of the Develop module's Basic panel, and click it once on the gray card in the photo (as shown here). That's it—your white balance is now properly set for this photo. Now, we're going to take that white balance setting and use it to automatically fix the rest of the photos live as you shoot.

Step Four:

Go to the Tethered Capture window (press **Command-T [PC: Ctrl-T]** if it's no longer visible) and on the right side, from the Develop Settings pop-up menu, choose **Same as Previous** (as shown here). That's it—now you can take the gray card out of the scene (or get it back from your subject, who's probably tired of holding it by now), and you can go back to shooting. As the next photos you shoot come into Lightroom, they will have that custom white balance you set in the first image applied to the rest of them automatically. So, now, not only will you see the proper white balance for the rest of the shoot, that's just another thing you don't have to mess with in post-production afterward. Again, a big thanks to my publisher, Peachpit Press, for allowing me to include this gray card in the book for you.

Creative
White Balance

So far, we've been looking at getting a fairly (or very) accurate white balance, so our image looks like it did when we were standing in front of our subject. But, what if an accurate white balance isn't your goal? What if you're not trying to make it look like it really did, and instead, you want to get creative and make it look better? Then we use a couple of the White Balance tools in a different way.

Step One:
Here's our image (taken in Canada's Banff National Park), and you're seeing the original As Shot white balance. It doesn't look bad at all (the shot is taken right around sunrise), but color-wise it doesn't look awesome. The tools I use when I want to get creative with my white balance are the Temp and Tint sliders. What's great about them is that the color each produces is found right behind the slider itself. So, you'll know if you want to add more blue to your image, you can look at the Temp slider and you'll see blue on the far left of the slider. To make your image more blue, you would just drag that slider to the left toward blue. Yup, it's that easy.

Step Two:
Let's try a few white balance looks to get the hang of it. If you wanted to make the image warmer, you would simply drag the **Temp slider** to the right, over toward yellow (as seen here, where I dragged it over to 9,981). By the way, when I'm working from a creative point of view, I don't look at the numbers at all (those numbers represent the Kelvin scale, which is the international unit used for measuring color, but it's also my sister-in-law's boyfriend's name. Coincidence? I think not).

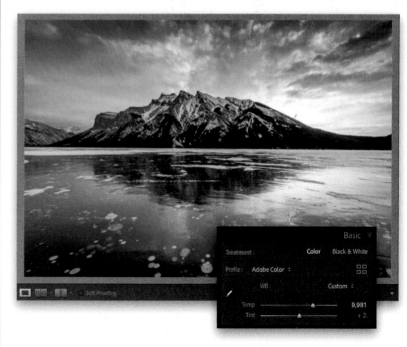

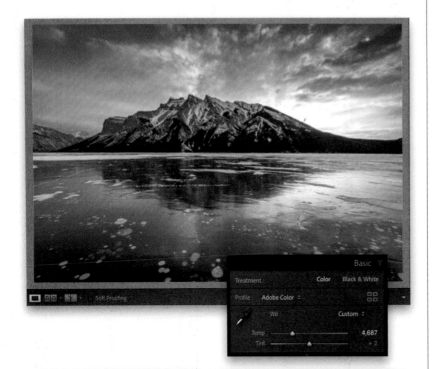

Step Three:

If you move either the Temp or Tint slider and wish you hadn't, just double-click directly on the word "Temp" or "Tint" and it will reset that slider back to the original As Shot white balance. That way, you don't have to worry about messing up your color while experimenting with different Temp and Tint combinations. You can always just double-click to get back to where you started. Okay, let's try another white balance look. This time drag the **Temp slider** in the opposite direction, over toward blue (to 4,687) to give the image a cooler feel color-wise. I think it looks pretty good in blue actually (I like it better than the warm look in Step Two).

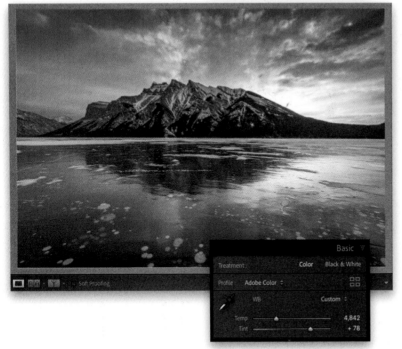

Step Four:

Just a quick heads up: When you're working with a RAW image, the Temp and Tint numbers are displayed in the Kelvin scale we talked about earlier. But, if you shot in JPEG on your camera, it doesn't use that scale. Instead, both sliders start in the center, set to 0 (zero), and you can drag either to the right to +100 or to the left to –100 like most of the other sliders in the Basic panel. Okay, let's give this image one more round of color tweaking by including the Tint slider this time around. Here, I dragged the **Temp slider** over toward blue (to 4,842), and then dragged the **Tint slider** over to toward magenta (to +78) to give the overall image kind of a violet/purpley look (and yes, purplely is a word widely used by people like me who aren't very good at words). One more quick thing: Besides resetting the sliders by double-clicking on the name of each one (it also works if you double-click on the little slider knob you click on for each slider), but even better, if you double-click directly on the letters "WB," it resets both sliders to As Shot for you.

Making Flesh Tones Look Good

If there's a person (or people) in your image, it's important that their flesh tone looks good, so I'm including a couple of scenarios here that you're likely to run across and how to easily deal with both.

Method One:

For those situations where your subject's skin is either too red, or has a lot of red splotches (I get lots of emails asking how to deal with these two related flesh tone issues), Lightroom can easily handle this. In the HLS part of the Develop module's HSL/Color panel, click on **Saturation** at the top of the panel to bring up the Saturation sliders, and then click on the circle with two arrows near the top left. This is the **Targeted Adjustment Tool** (TAT, for short). When you click it on an area of your image, it knows exactly which sliders control the colors beneath where you clicked. Here, you'd click it on a red area of his skin (I clicked it on his cheek on the right), then drag down, and it only moves the sliders that control that redness in his face (it desaturated mostly Orange here, but some Red, as well), which takes care of the issue.

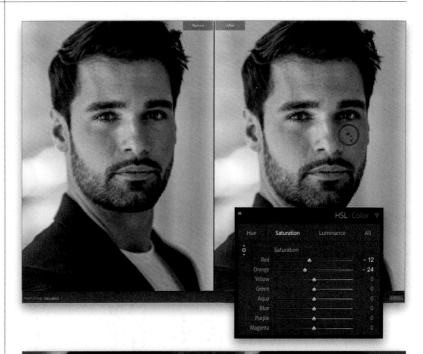

Method Two:

This one is less of a problem and more of a modern look for how we display flesh tones these days. What we do is desaturate the overall image just a bit, so your subject's skin doesn't look so warm. You see this a lot right now, and I routinely do this to nearly every portrait I process. Go to the bottom of the Basic panel and drag the **Vibrance slider** to the left a bit, which desaturates the overall color and that usually does the trick. If it desaturates too many other colors in the image, then get the Brush tool (see Chapter 7), drag the Saturation slider a bit to the left (there is no Vibrance slider there), and then paint over just the flesh tone areas.

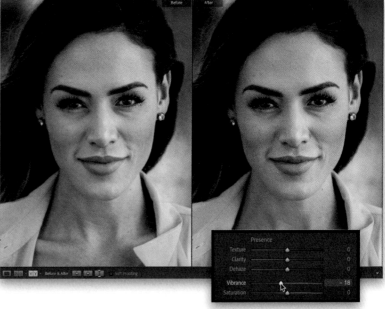

Photos that have rich, vibrant colors definitely have their appeal (that's why professional landscape photographers back in the film days got hooked on Fuji Velvia film and its trademark saturated color). Lightroom has a Saturation slider for increasing your photo's color saturation, but the problem is it increases all the colors in your photo equally, and…well…let's just say it's not awesome (and that's being kind). That's why I love Lightroom's Vibrance slider (a great name for it would have been "Smart Saturation"). It lets you boost colors without trashing your photo, and it does it in a very smart way.

Making Your Overall Color Punchier

Step One:

In the Presence section (at the bottom of the Basic panel) are two controls that affect the color saturation—one is brilliant; one is…well…crappy. There, I said it. It's crappy. I only use the Saturation slider to reduce color (desaturating), never to boost it because the results are pretty awful (it's a very coarse adjustment where every color in your image gets saturated at the same intensity). This is why I use Vibrance instead—it boosts the vibrance of any dull colors in the image quite a bit. If there are already saturated colors in the image, it tries not to boost them very much at all. Lastly, if your photo has people in it, it uses a special mathematical algorithm to avoid affecting flesh tones, so your people don't look sunburned or weird.

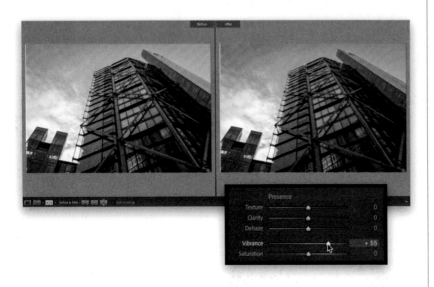

Step Two:

Here's an example: Take a look at the building and sky back in Step One (or here on the left). You can see how dull the sky is and the reflections of color in the building are dull, too (well, it is just reflecting a dull-colored sky, so you can't really expect too much). Now, drag the **Vibrance slider** over to the right until the sky starts to look blue and the richer blue sky is reflected in the mirrored glass on the building. The blue got boosted the most, but the other colors on the drapes in the building didn't get oversaturated or go too far, which is what I love about the Vibrance slider. Here, I cranked it up an awful lot, but in most cases, you won't have to drag this far to the right to get it looking punchy color-wise.

GETTING YOUR EXPOSURE RIGHT
the essential editing stuff

If there's anything that we, as photographers, overthink, it's exposure. Ideally, we'd like to get the exposure correct in-camera, but if for whatever reason our image winds up a bit too dark or a bit too bright, we can fix that in Lightroom by simply dragging a slider 1/4" or so one way or the other. Even though it's so easy to fix, this is something I see photographers stress about every day. I think one reason is that they fear their exposure will be publicly judged by the International Committee for Proper Exposure (or ICPE, for short), which is the accrediting body that oversees the overall brightness levels of images posted to Instagram, and has the authority to impose a hefty fine on photographers whose exposure for a particular image falls outside generally acceptable ranges. I will say this: although I don't always agree with the ICPE's rulings, I am pleased that they recently changed their name to the ICPE, both because it's more accurate and accepted than their previous name, which was the International Coalition for Understanding Photography (the ICUP, for short). The problem was every time they used their acronym during a lecture or symposium, for some reason they didn't refer to themselves as "I-cup," but instead, they said, "I-C-U-P," and about half the crowd would start giggling uncontrollably. It would totally disrupt the meetings, and it sometimes took 5 or 10 minutes to quiet everyone back down. It was really quite an issue. Of course, that pales in comparison to the situations that arose from their original name, which was the "Photographic Organization on Professional Optic Output" (or POOPOO, for short). I am not making this up, and I swear this on my honor as a founding member of the "Photography Education Engineers Panel Exploring Exposure."

I Start by Expanding the Image's Tonal Range

I start the process of nailing my exposure by setting my white and black points, which expands the tonal range of my image by making the whites as bright as I can get them (without damaging the highlights), and then, I make the blacks as dark as I can get them without them turning totally black. We used to do this manually (back in the old days), but now Lightroom will actually do this really important step for us. It's part of a two-part move that helps us easily get our overall exposure right where we want it.

Step One:

I set my white and black points on pretty much every image I edit, and this is another technique where the worse the original image looks, the more dramatic the results. Here's the original image and you can see it looks pretty flat. We're going make the whites brighter and the blacks darker, which is going to expand our tonal range, and we're going to let Lightroom do all the heavy lifting for us.

Note: Workflow-wise, I do this "setting the white and black points" technique after I choose my RAW profile (if I shot in RAW), and after I set my white balance (we looked at both in Chapter 5).

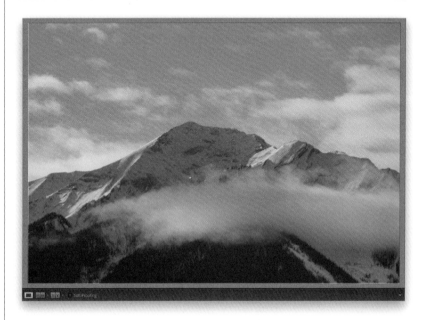

Step Two:

To have Lightroom automatically set your white and black points, in the Develop module's Basic panel, just press-and-hold the Shift key, and first, double-click directly on the word "Whites" (as seen here). That automatically sets your white point for you, and you'll see the **Whites slider** has now moved, usually to the right, either a little or a lot (depending on the photo).

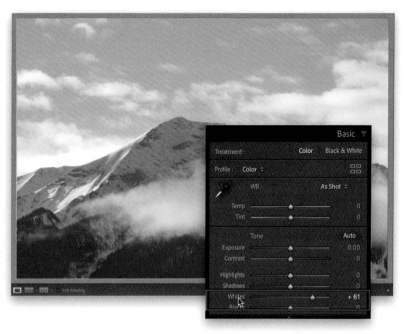

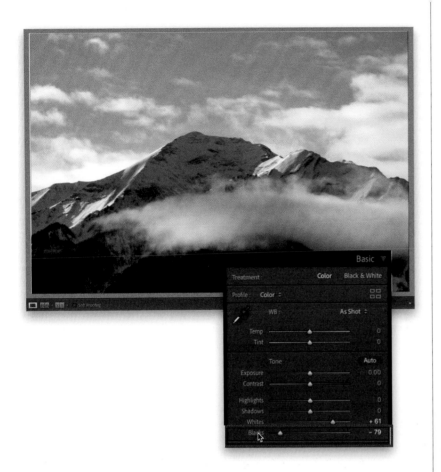

Step Three:

Now, keep holding down the Shift key and double-click on the word **"Blacks"** (as seen here), and it automatically sets your black point for you. That's it. It's that easy to set your white and black points, but there's one more thing we do (as you'll learn on the next page) to wrap the overall exposure up and it's a really important part of all this. By the way, if your Whites and Blacks sliders barely move or just stay at zero, that means your original capture pretty much had its tonal range already expanded.

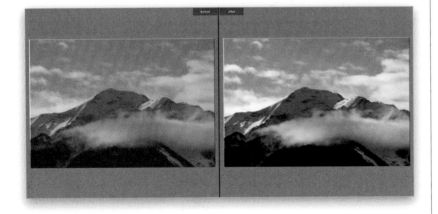

Step Four:

Here's a before/after of our image after we've had Lightroom automatically set the white and black points for us. If you're curious about how do to this manually (I never do it manually by the way), just press-and-hold the Option (PC: Alt) key, click-and-hold on the Whites slider (the image screen will turn black), and then start dragging to the right. Keep dragging until areas start to appear in white (those areas are getting clipped—see page 152), and then back off a bit (dragging back to the left), so it's back to solid black. *Note:* If you see red, blue, or yellow, it means you're clipping in just that individual color channel (not as big a worry). However, if you see solid white areas, you're clipping highlights in all three channels, and you've gone too far. Do the same thing with the Blacks, but this time, the image screen turns sold white and you stop and back off a bit when black areas start to appear.

Then, Just Tweak the Exposure Slider

The third part of setting your basic overall exposure is to use the Exposure slider to dial in your overall brightness (more on this in a sec), but we only do this after we've set the white and black points. This slider mostly controls the midtones, and if you hover your cursor over the histogram (at the top of the right side panels), you'll see a light gray shaded area that shows how much of the tonal range this slider affects. You'll see it covers the center 1/3 (if not more) of the entire histogram because it controls more than the midtones—it also controls the lower highlights and upper shadows, too. That's a lot of range for one slider.

Step One:
Here's a different photo. Go ahead and set the white and black points first, like you learned on the previous pages.

TIP: Get a Larger View as You Edit
Since the controls we're going to use for editing our image are in the right side panels, you can close the left side panels, so your image appears much larger onscreen. Just press **F7** on your keyboard, or click on the little, gray, left-facing triangle on the far-left center edge to collapse it and tuck it out of sight.

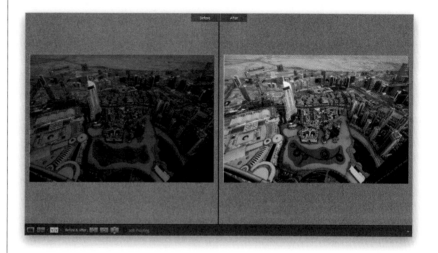

Step Two:
Okay, now that your white and black points are set, look at the image to see if you think it's too dark or too bright. This is a call only you can make (there's no international council of brightness), so if you think it looks too dark, drag the **Exposure slider** to the right until the overall brightness looks right to you (I thought it looked a little too dark, a tad underexposed, so I dragged the Exposure slider a little to the right to +0.40, so less than one-half stop brighter). If your image looks too bright to you after setting the white and black points, you'd drag the Exposure slider to the left instead. This is one powerful slider, and as I mentioned above, it covers a wide range of midtones, lower highlights, and upper shadow areas. So, when I need an image to look a little brighter or darker overall, this is the slider I reach for, but usually only after setting my white and black points.

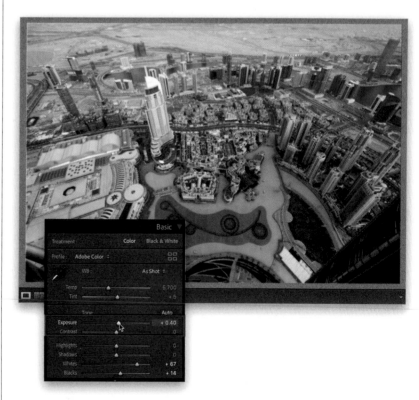

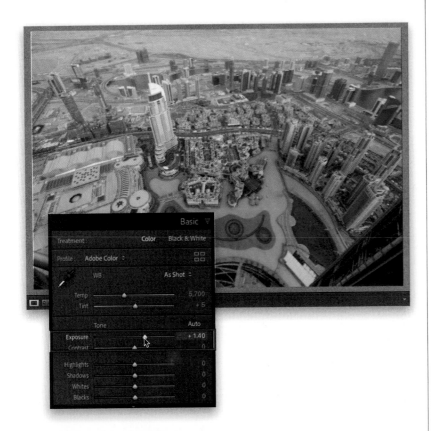

Step Three:

I know I keep harping on "set your white and blacks points first," but it's only because it makes that big a difference. For example, hit the Reset button (at the bottom of the right side panels), so we can start from scratch, but this time skip setting the white and black points, and instead, make your image brighter by just dragging the **Exposure slider** to the right. Here, I dragged it over to +1.40 (nearly a stop and a half) and now look back at the image in Step Two. Notice how flat this one looks in comparison? This is why the three-part method (Whites, Blacks, and then the Exposure slider) for setting your overall exposure is so handy.

Step Four:

I went ahead and set up a side-by-side example for you here, comparing only using the Exposure slider (that's on the left—the "Before" image), and then the full monty (so to speak) on the right (the "After" image) where I set the whites and blacks first, and then just tweaked the Exposure slider to add a little brightness at the end. You probably will wind up having to move the Exposure slider very little in your day-to-day work using this three-part technique (let's call it the "Exposure Trio," just 'cause it sounds like the name of a '70s lounge band). Keep in mind that during your editing process, if at any time you think your image looks too bright or too dark, you can just drag the Exposure slider to get to where you need to be. It doesn't have to be just during this "Exposure Trio" process (see, that name is kinda catchy, right?).

Dealing with Highlight Problems (Clipping)

One of the things we worry about most while shooting is making sure that we don't clip off important highlight detail. It's why most cameras have a built-in highlight warning feature, because if the brightest highlights get too bright, they literally clip off, leaving no pixels, no detail, no nuthin'. If you were to print the image, there wouldn't even be any ink on those areas. If you didn't catch the problem in-camera, no worries, we can usually recover those clipped highlights right in Lightroom.

Step One:

Here's a shot of the staircase in the St. Pancras Renaissance London Hotel. The stairs themselves are okay, but the windows look blown out and are probably clipping (a loss of detail—see the intro above for what clipping means). But, if you're not sure if those windows (or anything else) are clippping, don't worry—Lightroom will warn us. Take a look at the triangle up in the top-right corner of the **histogram** (seen circled here). That triangle is normally dark gray, which means everything's okay—no clipping. If you see a color inside that triangle (red, yellow, or blue), that means the highlights are clipping in just that color channel, which isn't the end of the world. However, if you see that triangle filled with white (like it is here), then it's clipping the highlights in all your channels, and you'll need to deal with it if it's an area where there's supposed to be detail.

Step Two:

Okay, now we know we have a highlight clipping problem somewhere in our image, but exactly where? To find out, go up to that white triangle and click directly on it (or press the letter **J** on your keyboard). Now, any areas that are clipping in the highlights will appear in bright red (as seen here, where big parts of the windows and most of the light fixtures are clipping badly). Those areas will have *no* detail whatsoever (no pixels, no nuthin') if we don't do something about it.

Step Three:

You could drag the **Exposure slider** over to the left until all those red clipped warning areas go away (as shown here), but that will affect the overall exposure of the image, making the entire image underexposed (look at how dark this image has now become just to make the windows look good). You fixed one problem, but created another. That's why the Highlights slider is so awesome—it lets you leave the overall exposure right where it is and it just addresses those super-bright clipped areas because it just affects the highlights and not the entire exposure.

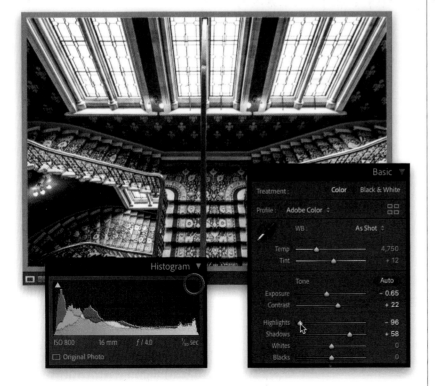

Step Four:

Let's put the **Highlights slider** to work. Just drag it to the left until you see the red, onscreen clipping warning go away and the triangle turn dark gray (as shown here). The warning is still turned on, but dragging the Highlights slider to the left fixed the clipping problem and brought back the missing detail, so now there are no areas that are clipping. *Note:* I also ended up decreasing the Exposure and increasing the Contrast and Shadows, here.

TIP: This Rocks for Landscapes

The next time you have a blah sky in a landscape or travel shot, drag the Highlights slider all the way to the left to –100. It usually does wonders with skies and clouds, bringing back lots of detail and definition. I use this trick fairly often.

Fixing Backlit Photos and Opening Up Dark Areas

Why do we take so many backlit photos? It's because our eyes are so darn amazing and adjust for such huge differences in tonal range automatically. So, our subject could be standing there totally backlit, but our eyes automatically adjust for it and they look fine to us. The problem is: even the best camera sensors today don't have nearly the range of our eyes, so even though it looks fine to us when we look through our viewfinder, when we press the shutter button, the sensor can't handle that much range and we wind up with a backlit photo. Luckily for us, help is just one slider away.

Step One:

Here's the original image and you can see the subject is backlit (and if you read the intro above, you know why this happens). This often happens if you're shooting a DSLR because what you're seeing through the viewfinder is the same thing your eyes see (and your eyes auto-adjust for the wide range of tones). The nice thing about the electronic viewfinder (EVF) in a mirrorless camera is it shows what the camera is seeing, so if you saw your subject backlit like this in your EVF, you might use exposure compensation to fix it. But, that would brighten the background, too, right? That's why this Lightroom fix is so nice—it just brightens your subject without messing with the background.

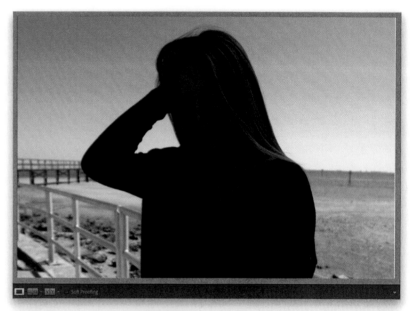

Step Two:

Go to the Basic panel's **Shadows slider**, drag it to the right (here, I dragged it to +78), and as you do, just the shadow areas of your photo are affected. As you can see here, the Shadows slider does an amazing job of opening up those shadows and bringing out detail in the image that was just hidden in the shadows. *Note:* Sometimes, if you really have to drag this slider way over to the right, the image can start to look a little flat. If that happens, just increase the Contrast amount (dragging to the right), until the contrast comes back into the photo. You won't have to do this very often, but at least when it happens, you'll know to add that contrast right back in to balance things out.

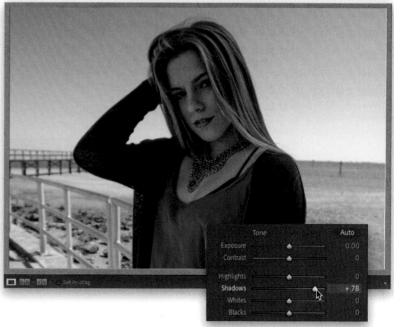

When you want to bring out detail in your image (which is nice because it makes the image look sharper before you've even sharpened it), go for the Texture slider. It's one of the best things that has happened to Lightroom in years. Our go-to tool for enhancing detail used to be the Clarity slider, but the problem with Clarity is it changes the overall tone of your image, and it can make it look a bit grungy (which is great, if that's the look you're going for). The Texture slider brings out glorious texture, but without messing with the overall tone of your image.

Enhancing Detail (Texture Slider)

Step One:

When you have an image with a lot of detail you want to bring out, the Texture slider is your best friend (and it's so easy to use). Again, as I mentioned above, what I love about adding Texture is that it doesn't mess with the tone of your image—the detail comes out, but your overall exposure and tone stay the same.

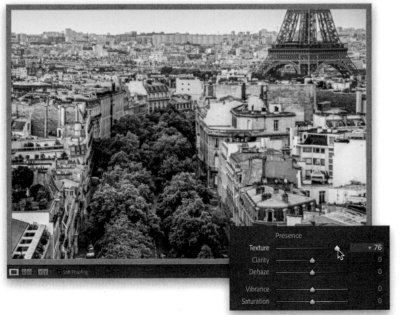

Step Two:

To bring out the texture and detail in our image here, drag the Basic panel's **Texture slider** quite a bit to the right. Here, I dragged it to +76, so you can really see the effect. Look at the trees and the sides of the buildings and even the Eiffel Tower. Everything looks crisper. *Note:* The Texture slider doesn't replace using the Clarity slider (see the next page). Yes, they both enhance detail, but they do it in different ways, so each has its own look. That's why I like to use them together—I add a lot of Texture, and then I add about half as much or less of Clarity to make the image really look nice and crisp. Texture doesn't really have any side effects, but Clarity does, so make sure you check out the next page.

Adding "Punch" to Your Image

If you're looking for the nerdy technical explanation, the Clarity slider adjusts the amount of midtone contrast, but since that's of little help (well, I guess it is to nerds), then here's how I look at it: I drag this slider to the right when I want to enhance texture or detail (and don't mind if my exposure or tone change a bit), or I want to make water or metallic surfaces look shiny, or I want to give my image kind of a grungy look. It does all of those in just one slider. Be careful, though, because you can over-apply Clarity—if you start to see halos around objects in your image or your clouds have drop shadows, that's a warning sign you've gone too far.

Step One:

Which kinds of shots work best with added Clarity? Usually anything with a lot of wood (from churches to old country barns), landscape shots (because they generally have so much detail), cityscapes (buildings love clarity, so does anything glass or metal), cars, motorcycles, or basically anything with lots of intricate detail (even an old man's craggy face looks great with some added Clarity). Here's our original image and there's lots of detail we can enhance here. *Note:* I don't add Clarity to photos where you wouldn't want to accentuate detail or texture (like a portrait of a woman, or a mother and baby, or just a newborn).

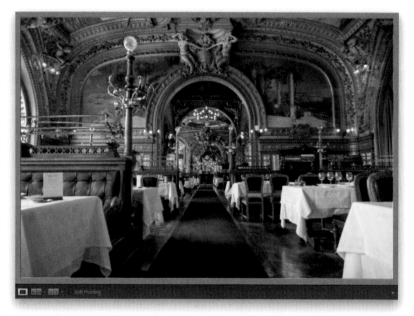

Step Two:

To add more punch and bring out the texture and detail in our image here, drag the **Clarity slider** quite a bit to the right. Here, I dragged it to +74, so you can really see the effect. Look at the added detail throughout the image. If you start seeing a black glow appear on the edges of objects, you know you've dragged too far. If that happens, just back it off a bit until the glow goes away.

Note: The Clarity slider does have a side effect—it can affect the brightness of the photo, sometimes making it look darker. That's easily fixed with the Exposure slider, but I just wanted you to keep an eye out in case that happens.

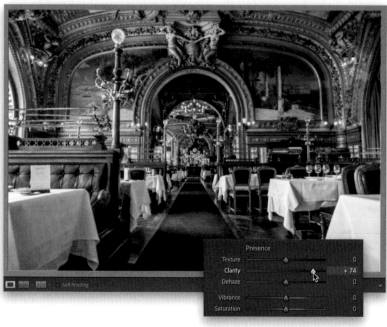

Okay, you've heard me raving about how awesome the Texture slider is because it doesn't mess with the tone of your image. And yes, it is awesome, but when it comes to enhancing detail, the Texture slider doesn't replace the Clarity slider—yes they both enhance detail, but they do it in different ways so each has its own look, and sometimes depending on the image, Clarity might look better. Also, I most often use the two together. I add a lot of Texture, and then I add about half as much or less of Clarity to make the image really look nice and crisp. Here's a side-by-side look at how each looks when applied to the same image:

Texture vs. Clarity

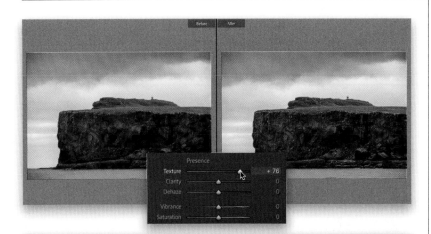

Just Texture:
Here's the original image, which I haven't done anything to yet (no Exposure, Contrast, etc.). Let's apply +76 of Texture. In the After image, notice that the detail is enhanced in the rocks on the side of the tiny island, but the overall tone of the image pretty much looks the same.

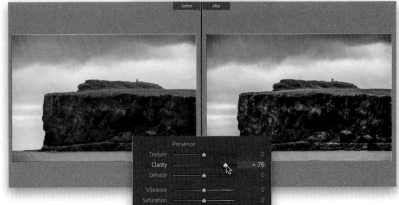

Just Clarity:
Let's look at the same image, but with a similar amount of only Clarity. Notice how much darker it looks than the one with just Texture above. Take a look at those rocks now—the detail is enhanced, but you can see the image looks a lot more contrasty, gritty, and the overall tone has changed. That's what I'm talking about when I say Clarity messes with the tone.

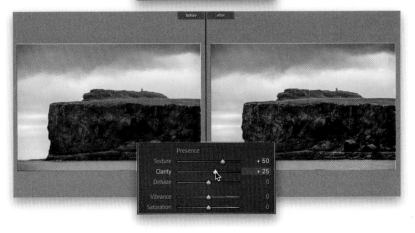

Both Texture and Clarity:
Here are both together—a lot of Texture, and about half as much of Clarity. It does change the tone a bit, but not as much as just going with only Clarity. It's a nice combo and the one I use the most by far.

Adding Contrast (More Important Than It Sounds)

I host a live weekly photography show called *The Grid* (it's now in its ninth year), and once a month, we invite our viewers to submit images for a blind photo critique (we don't mention the photographer's name on the air, so we can give honest critiques without embarrassing anyone). So, what's the #1 most common post-processing issue we see? Flat-looking photos. That's a shame because it's fixed so easily, and with just one slider.

Step One:
Here's our flat, lifeless image. Before we actually apply any contrast (which makes the brightest parts of the image brighter and the darkest parts darker), here's why contrast is so important: when you add contrast it (a) makes the colors more vibrant, (b) expands the tonal range, and (c) makes the image appear sharper and crisper. That's a lot for just one slider, but that's how powerful it is (in my opinion, it's perhaps the most underrated slider in Lightroom).

Step Two:
To add contrast, drag the **Contrast slider** to the right (don't be afraid to drag it way over if the image looks really flat—here, I went to +82), and look at the difference. The colors are now more vibrant, the tonal range is greater, and the whole image looks sharper and snappier. If your image looks a little dark after adding contrast (which is often the case), you can get that brightness back by boosting the **Exposure slider** a bit, like I did here—just a tiny move to +0.40. Adding contrast is such an important tweak, especially if you shoot in RAW mode, which turns off any contrast settings normally added in your camera, and is why RAW images look flatter and less contrasty right out of the camera. Adding that missing contrast back in is pretty important, and it's just one slider.

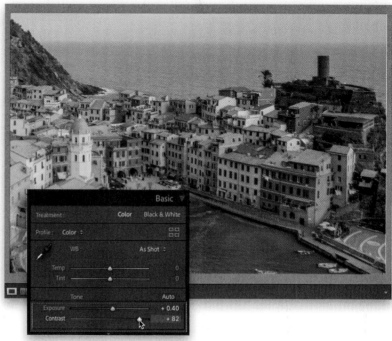

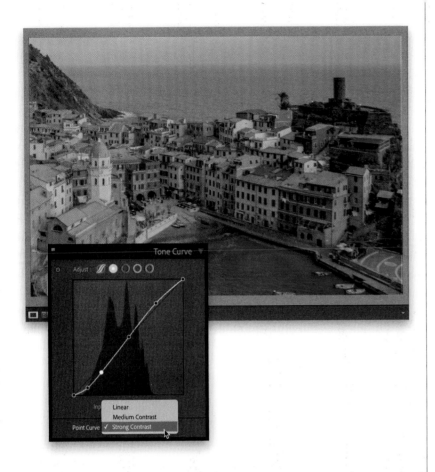

Step Three:

If you're really into contrast, and there's at least a tad bit of nerd in you, there's another more advanced method for applying contrast (well, there's an easy method and an advanced method, both in the same tool), and that's through using the **Tone Curve** (it's in the Develop module's right side panels). Using it in its "simple" mode is…well…simple. There's a Point Curve pop-up menu at the bottom of the panel, which is set to Linear, and to add more contrast all you have to do is choose either Medium Contrast or Strong Contrast (as shown here). That takes that straight, linear, diagonal line and bends it slightly into the shape of an "S," which is called (wait for it… wait for it…), that's right, an "S-curve." By the way, if for some reason you don't see the Point Curve pop-up menu, just click the white circle at the top of the panel, and then you'll see it.

Step Four:

The advanced method is to not use the pop-up menu and to just draw your own curve. The steeper the S-curve you make, the more contrast it adds to your image. So, start by clicking once in the center of that diagonal line to add a point to the curve. That center point controls the midtones of your image (dragging it up toward the left corner brightens the midtones; dragging it down and to the right darkens the midtones). For adding contrast, you'll mostly leave that point there (not dragging it anywhere) so it kind of locks the midtones down, so you can make the highlights and shadows more intense. You adjust the highlights by adding another point between the center point you added and the one in the top-right corner, and then dragging up to brighten them (as shown here). You then adjust the shadows by adding another point between the center point and the one in the bottom-left, and then dragging down to darken them.

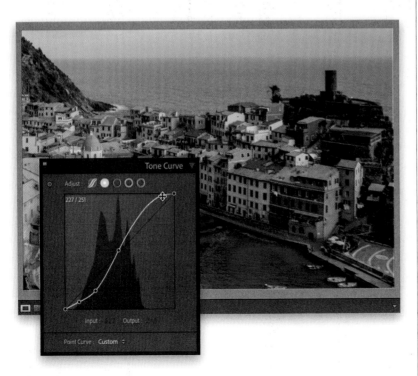

Removing Haze

Lightroom's Dehaze feature is so awesome it has its own fan base because it does that good of a job at removing haze, fog, etc. (Bonus Tip: If you drag the slider to the left, it actually adds fog or haze, so there's that.) It's actually just another form of contrast, but it's a form that loves to cut through haze, so I'm all for it. Here's how it works:

Step One:
Here's our original image, taken up in Banff, Canada. It was a very hazy day, but I still kept shooting because I knew the Dehaze slider would bail me out.

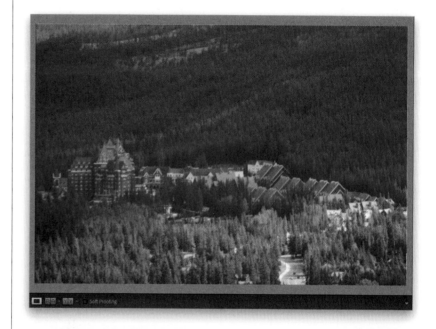

Step Two:
In the Presence section of the Basic panel, drag the **Dehaze slider** over to the right and the haze literally just goes away (as shown here).

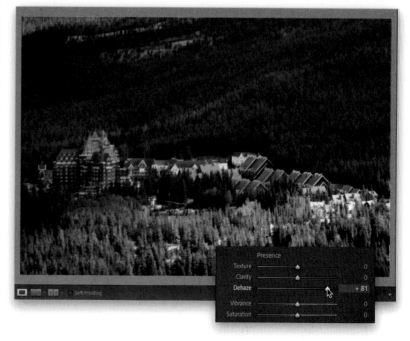

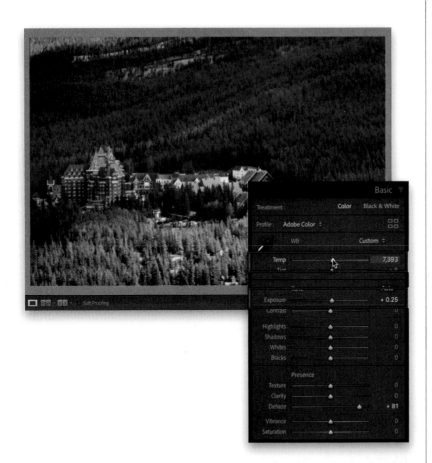

Step Three:

I don't know if you noticed in that last step, but when we dragged that Dehaze slider way over to the right, while it did an amazing job of getting rid of the haze, it has two side effects: Since Dehaze is a form of contrast, it sometimes darkens the image a bit, so just keep an eye on that. If that happens to your image, drag the **Exposure slider** to the right a bit (here, I dragged it to +0.25). The second side effect, which is actually a bigger one, is that if you add a lot of Dehaze it tends to add a blue tint to your image. So, also be prepared to drag the white balance **Temp slider** a bit toward yellow (here, I dragged it to 7,393), which offsets that blue and makes the color look natural again. Just a couple of things to keep in mind, but again, you'll probably only have to deal with either of these if you apply a lot of Dehaze.

Step Four:

Here's a before/after of our image, and you can see what a huge difference Dehaze made. One more thing: As I mentioned, Dehaze is another form of contrast, so you can use it even on images that don't have haze as it gives its own contrasty look.

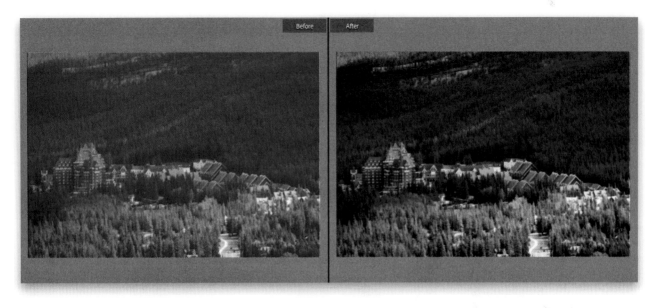

Using the Library Module's Quick Develop Panel

There's a version of the Develop module's Basic panel right within the Library module, called the Quick Develop panel. The idea is that you can make some quick, simple edits right there in the Library module, without having to jump over to the Develop module. The problem is, the Quick Develop panel is kind of clunky to use because there are no sliders. Instead, there are buttons you click that move in set increments, which makes it a bit frustrating to get just the right amount. But, in some certain instances, it not only make sense, but it does something handy the Develop module doesn't even offer (as you'll learn in Step Four).

Step One:

The Quick Develop panel (shown here) is found in the Library module, under the Histogram panel, at the top of the right side panels. Although it doesn't have the White Balance Selector tool, it has pretty much the same controls as the Develop module's Basic panel (like Highlights, Shadows, Clarity, etc.; if you don't see all the controls, click on the triangle to the right of the Auto tone button). Also, if you press-and-hold the Option (PC: Alt) key, the Clarity and Vibrance controls change into the Sharpening and Saturation controls (as seen on the right. *Note:* The Dehaze slider hasn't made it over to Quick Develop yet). If you click a single-arrow button, it moves that control a little. If you click a double-arrow button, it moves it a lot. For example, if you click the single-right-arrow for Exposure, it increases the Exposure amount by 1/3 of a stop. Click the double-right-arrow and it increases it by a full stop.

Step Two:

One way I use Quick Develop is to quickly see if an image (or a set of images) is worth working on, but without actually doing a full edit in the Develop module. For example, these skyscraper images all looked like they could use some more blue in the sky (and reflected in the buildings), so to quickly see how they would look with some added blue, I selected them, went to **Temperature**, and clicked once on the double-left-arrow to move it a lot toward blue. If I wanted just a small amount of blue, I would have clicked on the single-left-arrow to move it just a bit.

Step Three:

Another way I use Quick Develop is for comparing changes I'm making to one image to other similar images. Here, I de-selected all the images except for the top-left one. Then, I clicked on the double-left-arrow next to **Vibrance** to make this one image desaturated—like a bleach bypass effect (as seen here). Now I can quickly see how doing this compares to the rest. This is handy because in the Develop module, you only see one image at a time, or small thumbnails down in the Filmstrip.

TIP: Finer Increments in Quick Develop

You can adjust in smaller increments by Shift-clicking a single-arrow button. For example, Shift-clicking on the Exposure single-right-arrow, moves it up 1/6 of a stop, instead of 1/3 of a stop (so just +0.17 instead of +0.33).

Step Four:

Perhaps the coolest feature of Quick Develop is that you can make relative changes. For example, let's say I had already adjusted these images in the Develop module, but I think the whole group could use more contrast. One image had its Contrast set to +15, another to +27, the third to +12, and the fourth to +20. If I select all four photos and in the Develop module, change the Contrast to +30, all the images would now be set to +30. Well, that's not what I want. I want each of them to keep the amount of contrast I had originally chosen for it, but add that +30 on top (making the first image's Contrast setting now +45, the second's +57, and so on). I want a relative change added to their current Contrast settings, not an absolute where they all change to the same setting. Quick Develop lets me do that: I select the images (in this case, just the top two) and click the Contrast double-right-arrow to increase it by +20, then I click the single-right-arrow twice to add +10, for a total of +30. This doesn't change both images to +30; it adds +30 to their current Contrast amounts (as seen here).

Original Contrast of the first image was set to +15

In the Develop module, if you select multiple images and set the Contrast to +30, it sets all the images to +30

Original Contrast of the first image was set to +15

If you increase the Contrast by +30 in Quick Develop, all the images increase by +30 instead of changing to +30 (so now the first image is +45)

Original Contrast of the second image was set to +27

If you increase the Contrast by +30 in Quick Develop, all the images increase by +30 instead, making the second image +57

If You Don't Know Where to Start, Try Auto Tone

We used to joke that the old Auto tone feature was simply the "overexpose by two stops" button. It was fairly useless, but a few years back, Adobe went and put some serious math and muscle behind the Auto tone button (it uses Sensei, Adobe's artificial intelligence and machine learning platform, previously known as Skynet), and now it's actually a pretty decent starting place if you're not sure where to start. Plus, if you click Auto and it doesn't do a great job, you can just undo it, right? It's one click—whatdaya got to lose?

Step One:

Auto Tone is a one-click fix (or at least, a good starting place) and the worse your photo looks at the start, the better job it seems to do. It uses AI and machine learning, and by golly, it ain't bad! Here's an underexposed, dull, flat-looking original RAW image. Click the **Auto button** once (as shown here, in the Basic panel, at the top right of the Tone section), and Lightroom quickly analyzes the image and applies what it thinks is the proper correction for this photo. It only moves the sliders it thinks are needed to make the image look decent (the obvious ones, like Exposure, Contrast, Shadows, and the other stuff in the Tone section, but it'll also adjust Vibrance and Saturation. At this point, though, it does not adjust the Texture or Clarity amounts).

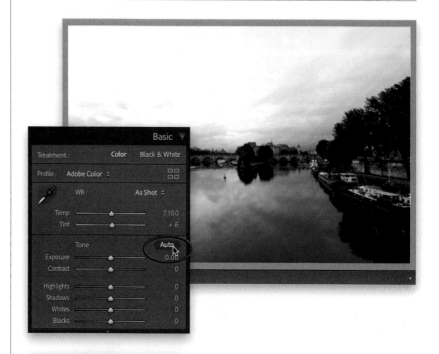

Step Two:

Just one click of the Auto tone button and look at how much better the image looks here (especially the sky)? Compare the slider settings here versus the previous step, and you'll see what it moved to get here. Remember, you can think of this as just a starting place, where you can now start tweaking sliders or adding effects. But, if you're happy with how it looks, it can be your finishing place. By the way, if you don't like the results from the Auto tone button, no harm done, just press **Command-Z (PC: Ctrl-Z)** to undo the auto toning.

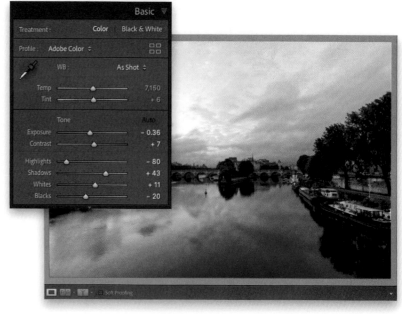

Now that you've learned all that, I wanted to share the order in which I use all those Basic panel sliders (and yes, I pretty much do the same thing every time, in the same order). While there are still things yet to learn, including local adjustments and special effects and lots of other fun stuff, this is the fundamental image editing I do, and it's often the only editing I do to my image (it just depends on the image). Almost everything else I apply to an image (special effects, or looks) will happen after I'm done with this phase here. I hope you find this helpful.

Putting It All Together (Here's the Order I Use for My Own Editing)

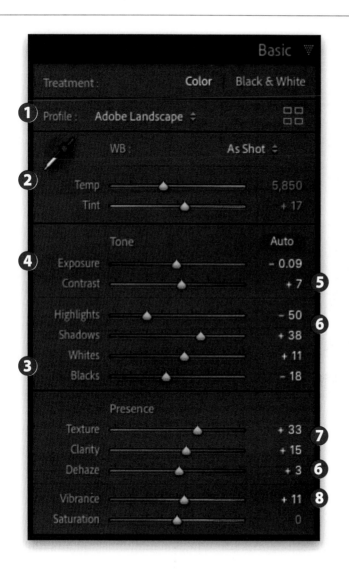

1) I choose my RAW Profile
The default Adobe Color is okay, but I usually go with Adobe Landscape, or in some cases, Adobe Vivid as my RAW profile and starting place.

2) I set my white balance
If your color isn't right…it's wrong. I use the White Balance Selector tool (the eyedropper) most of the time.

3) I have Lightroom set my white and black points
I expand my overall tonal range by Shift-double-clicking on the word "Whites," and then on the word "Blacks."

4) I tweak the overall brightness
If after setting the white and black points, I feel the image is too dark or too bright, I drag the Exposure slider until it looks right.

5) I add lots of contrast
I don't want a flat-looking image, so I generally add a pretty good amount of contrast (probably more than your average bear).

6) If I have problems, I fix 'em now
If the photo is backlit, I open up the Shadows. If there's clipping, I pull back the Highlights. If it's hazy, I use Dehaze.

7) Enhance Details
To bring out detail (in photos that should have their detail brought out), I use a lot of Texture and half as much of Clarity.

8) Boost colors
By this time my color usually looks pretty poppin', but if I think it needs more, I increase the Vibrance amount.

My Lightroom Editing Cheat Sheet

Here's a quick look at the sliders in the Basic panel (this isn't "official"—it's just how I think of them). By the way, although Adobe named this the "Basic" panel, I think it may be the most misnamed feature in all of Lightroom. It should have been called the "Essentials" panel, since this is precisely where you'll spend most of your time editing images. Also, something handy to know: dragging any of the sliders to the right brightens or increases its effect; dragging to the left darkens or decreases its effect.

Apply a RAW Profile:
From the **Profile pop-up menu**, you can choose the overall "look" you want to apply to your RAW photo. Do you want a flat, untouched starting point, or something a bit more colorful and contrasty?

Automatic Toning:
If you're not sure where to start, try clicking the much improved **Auto button**, which automatically tries to balance out the tones in an image for you. It's low risk—if you don't like the results, just press **Command-Z (PC: Ctrl-Z)** to Undo the Auto adjustment.

Setting Your Overall Exposure:
I use these three sliders together: First, I set the **white and black points** to expand the image's tonal range (see page 148 for how Lightroom can do this for you automatically), and after that, if the image looks a little too bright or a little too dark, I tweak the overall brightness by dragging the **Exposure slider** to the left to darken or to the right to brighten.

Fixing Problems:
If there are exposure problems (often caused by the limitations of our camera's sensors), one or both of these sliders will usually provide the fix. I use the **Highlights slider** when the brightest areas of my photo are too bright (or the sky is way too bright), and the **Shadows slider** opens up dark areas in your photo and makes things "hidden in the shadows" suddenly appear—great for fixing backlit subjects.

Fixing Flat-Looking Photos:

If your photo looks flat and drab, drag the **Contrast slider** to the right—it makes the brightest parts brighter, the darkest parts darker, and makes all your colors punchier.

Enhancing Detail:

The **Texture slider** enhances detail, and it does it without messing with the tone or exposure of the photo, so it's my go-to slider when I want to bring out detail.

More Detail and Grit:

Technically, the **Clarity slider** controls midtone contrast, which also enhances detail and makes the image look sharper overall, and it makes metal and water look shiny. However, Clarity affects the overall tone of the image, too and using too much makes your image look gritty and a bit HDR-ish), so be especially careful using it on portraits.

Reducing Fog or Haze:

The **Dehaze slider** works miracles in reducing or even eliminating fog and haze—just drag it to the right. If you drag it to the left, it adds a hazy fog-like effect.

Getting Your Color Right:

The **Temp and Tint sliders** help either correct your white balance (i.e., you'd drag the Temp slider to the right to reduce a blue color cast, or to the left to remove a yellow color cast by adding in some blue), or you'll use them to get creative, like making a slightly yellow sunset a glorious orange, or a drab sky a gorgeous blue.

Making Your Colors More Colorful:

I drag the **Vibrance slider** to the right when my image needs a color boost. You'll notice I didn't mention the Saturation slider. That's because I stopped using it years ago when Vibrance was introduced. Now, I only use the Saturation slider (dragging it to the left) if I want to wash out or remove color altogether. I never drag it to the right. Yeech!

PAINTING WITH LIGHT
the brush & other masking tools

Now, you've probably heard the photographic term "light painting," which is when you shoot a very long exposure (usually late at night, while shooting the night sky or Milky Way) and you use a low-powered flashlight to gently sweep over the foreground with just a kiss of light, so the rocks (or lake or abandoned plane, if you're in Iceland) get a hint of light on them. You only let the light appear in your shot for a second or two while your shutter is open, and there's a whole industry built around accessories (like small, low-powered, dimmable LED flashlights) for light painting. But, luckily, for what we're doing in this chapter, which is the opposite of light painting—it's painting with light—it requires none of that stuff. Well, I mean, you do of course, need a computer, and it has to have a decent amount of RAM, and you need lots of free hard drive space, so make sure yours has lots of both, and of course, it all runs better if your hard drive is an SD drive, and those are more expensive, but they're so worth it. You'll also need a really good display (monitor), and it goes without saying that you'll need a copy of Lightroom as well, and it wouldn't hurt to have Photoshop, of course, so maybe Adobe's Creative Cloud Photography plan might be a good investment, but hey—at least you don't have to buy some fancy dimmable LED flashlight, because a decent one is like $32. Also, if you're going to hike out to where you can get a good shot of the Milky Way, you should get one of those flashlights that straps around your head, so while you're hiking, you don't fall into a giant pit of snakes (happens every day), and the more I talk about this, the better "painting with light," after the fact, in Lightroom sounds.

Five Handy Things to Know Right Up Front about Masking

When you move a slider in the Develop module's Basic panel, it affects your entire image, but if you want to work on just part of the image (maybe you just want to adjust the aircraft seen in the image below), then you'd use a mask, so only the area you want adjusted gets affected. This will all make a lot more sense in a few minutes, but to start off, here are a few things that will help you get comfortable with the awesomeness of masking. Once you learn these things (along with the rest of the stuff in this chapter), you'll find yourself making fewer trips over to Photoshop, because you can do so much right here in Lightroom.

#1: The Whole Red Tint Thing

When you use one of Lightroom's masking tools, by default, the selected area (the area you choose to mask) appears in a red-tinted color overlay (as seen here, in the main image). As soon as you move any of the adjustment sliders, that red tint goes away, but you can turn this overlay off at any time by turning off the **Show Overlay checkbox** at the bottom of the Masks panel. You can also see your mask in other ways besides the red tint by clicking on the three dots to the right of the Show Overlay checkbox and choosing a different overlay option from the pop-up menu (as seen here, in the inset). I put three examples of the overlay choices at the top here: on the left is Image on White, in the middle is Color Overlay on B&W, and on the right is White on Black.

#2: Docking Your Masks Panel

When you create a mask, the Masks panel appears to the left of the right side panels, covering part of your image. You can move it around by clicking on the panel's header and dragging it, but again, it may still cover part of your image. If that annoys you (like it does me), you can dock it with the right side panels, so it appears like a regular panel. Just click-and-drag it over to the toolbox (beneath the histogram, at the top of the right side panels) and a blue horizontal line appears (as seen here). When you see that blue line, let go of your mouse button and it docks the panel right below the toolbox. But, what's nice is the Mask panel only appears when you create a mask, so it doesn't take up space when you're not masking.

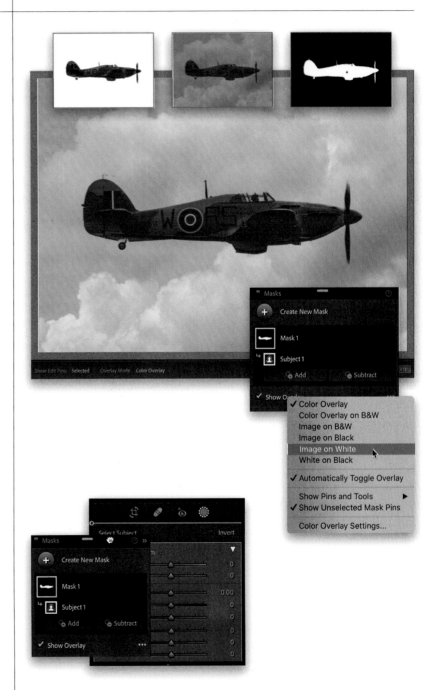

#3: The Hidden Add & Subtract Buttons

There are two buttons that allow you to add to the initial mask you created, or to remove an area from it, but sometimes those buttons are hidden. If you see the Masks panel on the left here, with only the mask's name and no buttons below it, just click once on the mask and the rest of the panel, including the Add and Subtract buttons, will pop down, as seen here on the right.

#4: You Can Rename Your Masks

If you start adding a number of different masks, it starts to get a bit confusing as to which mask selects which part of your image. This is when renaming your masks with descriptive names becomes important. To rename a mask, double-click on the mask's current name (i.e., Mask 1, Mask 2, etc.) in the Masks panel, and the **Rename dialog** will appear where you can type in a more descriptive name.

#5: The Sliders Reset Automatically When You Create a New Mask

Once we have a mask in place, we make our edits using the adjustment sliders, which are the same sliders as the ones we use in the Basic panel (with one small exception: there is no Vibrance slider. But, if you drag the Saturation slider to the right, it uses Vibrance math to make the colors more vibrant, and if you drag it to the left, it uses Saturation math to desaturate [take away] color). To have the sliders all reset to zero when you create a new mask, make sure the **Reset Sliders Automatically checkbox** is turned on at the bottom of the panel (as seen circled here; it's on by default). If, instead of creating a new mask, you're adding to or subtracting from one (using the Add or Subtract buttons), you're working on the same mask, so the sliders won't reset (they should stay the same if you're working on the same mask, right?).

Editing Your Main Subject

Lightroom has borrowed some amazing technology from its cousin Photoshop that uses AI and machine learning to determine what the subject of your image is and it isolates (masks) that area, so you can adjust only your subject without affecting the rest of the image. This is really powerful stuff and opens up a whole new world of editing right here in Lightroom, without having to jump over to Photoshop (which we previously had to do for stuff like this).

Step One:

At the top of the right side panels, click on the Masking icon (the circle with the white dotted lines around it, in the tool-box right below the histogram) to reveal the Add New Mask panel with the masking tools. Now, click on **Select Subject** (as shown here) to have Lightroom analyze the image, determine what the subject is, and mask only that subject so you can edit it without affecting the rest of the image.

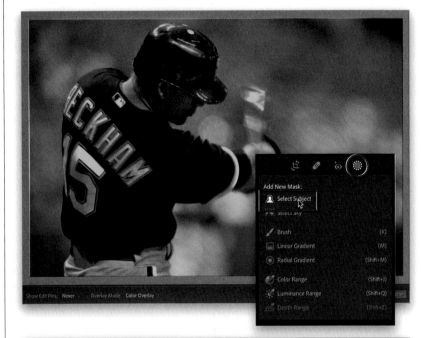

Step Two:

When you click Select Subject, after a second or two, it puts a red tint over your subject (as seen here), letting you know what it masked (if it didn't perfectly select your subject, I cover what to do when that happens starting on page 174). When a mask is created like this, the Masks panel appears floating to the left of the right side panels. You'll see "Mask 1" appear in the panel and that represents the area that is masked. Below that mask, it shows that Select Subject (Subject 1) was used to create the mask (if you only see Mask 1, click on it to expand it, so it looks like what you see here).

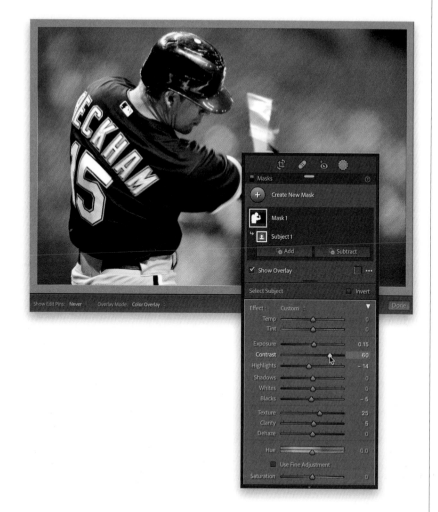

Step Three:
If you scroll down a bit beneath the tool-box, you'll see the **adjustment sliders** you can use to adjust your masked subject. If they look familiar, it's because they're the same sliders from the Basic panel, with one exception: there's no Vibrance slider, only a Saturation slider. But, Adobe engineered this one slider to be Vibrance when you drag it to the right, and Saturation when you drag it to the left (to desaturate the image). Pretty slick. Now that your subject is masked, as soon as you drag an adjust-ment slider, the red tint goes away, so you can clearly see your adjustments as you make them. Here, I increased the Contrast quite a bit, increased the Exposure a little, decreased the Highlights and Blacks a bit, and added some Texture and a little Clar-ity. The edits you make in this panel only affect your subject, not the rest of the image, because you masked (selected) your subject using Select Subject.

Step Four:
Below, I pressed the **Y key** to give you a before/after look, so you can see how the changes we made only affected the subject and not the rest of the image.

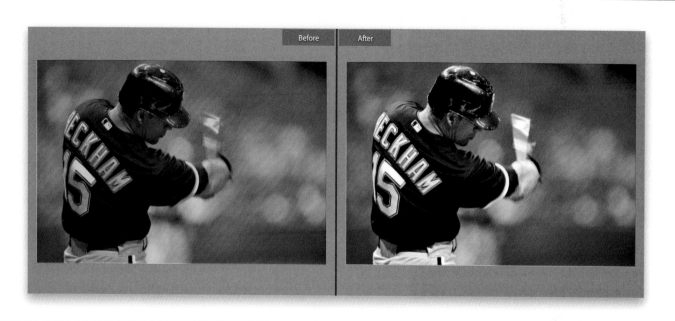

What to Do If It Doesn't Work Perfectly

As amazing as Select Subject and Select Sky (which we'll look at more next) usually are, they aren't 100% all the time, every time, so you'll want to know what to do when they need a little help to get you the selection you're looking for.

Step One:
Here, we want to select just the subject in this image (the Erechtheion, in Athens, Greece), so we can brighten it and add some texture and clarity, without affecting the sky behind it. At the top of the right side panels, click on the Masking icon (the circle with the white dotted lines around it, in the toolbox right below the histogram) to reveal the Add New Mask panel with the masking tools. Now, click on **Select Subject** (as shown here).

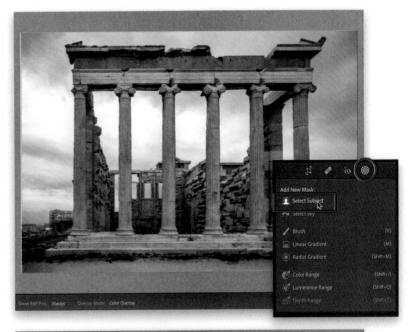

Step Two:
You can see from the red-tinted overlay that Select Subject did a decent job of selecting most of the structure here, but it also selected part of the sky between the columns on the left and on the right, which we don't want (so it actually over-selected a little bit). You can see the mask it created in the Masks panel (seen here in the inset).

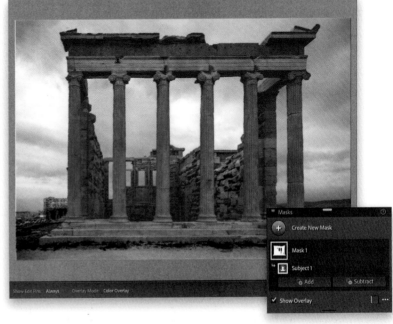

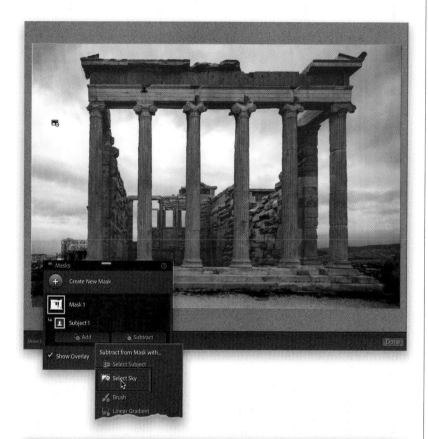

Step Three:

What we want to do is unmask those areas of the sky between the columns, so in the Masks panel, click on the **Subtract button** (because we want to subtract from what's already masked. If you don't see it, click on Mask 1 to reveal it). From the pop-up menu that appears, choose **Select Sky** and it subtracts any areas of sky (as seen here, where the sky between the columns is now removed from the mask). There's still one area that's not quite right, and it's those rocks between the second and third columns from the right—they're not masked—but we can fix that by adding to our mask.

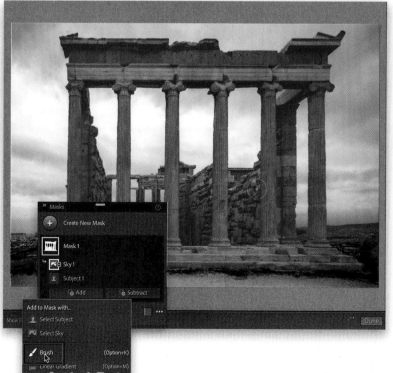

Step Four:

Since we need to add that area of rocks to our mask, in the Masks panel, click on the **Add button**, and from the pop-up menu that appears, click on the **Brush tool**. Now, simply paint over those rocks and they're added to the mask. So, that's the process: If something's masked that's not supposed to be, you'll click the Subtract button, and then choose whichever tool makes removing that area the easiest (you'll learn more about each of these tools in this chapter). If an area doesn't get masked that you want to be (like those rocks), you'll click the Add button and choose whichever tool makes adding that area the easiest.

Step Five:

Now that we have the mask just the way we want it, with just the ruins fully selected and no sky, we can scroll down to the adjustment sliders. As soon as we move a slider, it turns off the red-tinted overlay, so we can clearly see how the sliders are affecting our masked area (so, the masked area is still masked; it just turns off the Show Overlay checkbox temporarily). Let's drag the **Exposure slider** to the right to make the ruins brighter, and then we'll increase the detail by dragging the **Texture** and the **Clarity sliders** to the right a bit until it looks good to us. The sky remains untouched because only the ruins are masked.

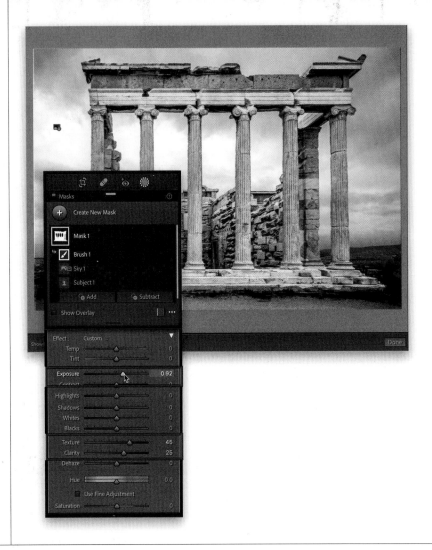

Step Six:

Below, is a before/after of the ruins after we brightened only them (I think I actually brightened them a bit too much, but at least you can clearly see how only they are affected. See how I turned that mistake into a "win?" It's a gift). Okay, we're not done yet, because there are some other important things we need to learn right up front for working with these masks.

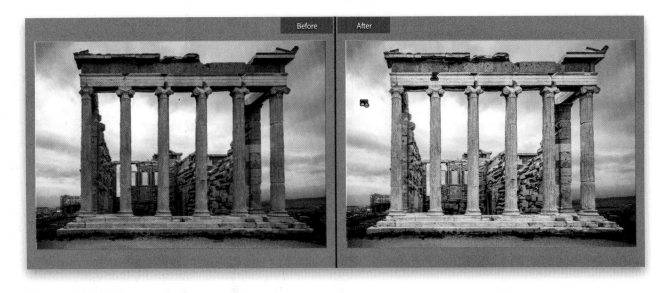

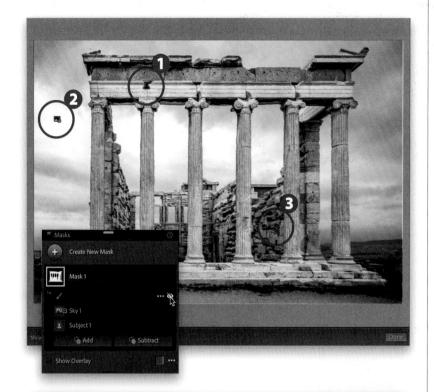

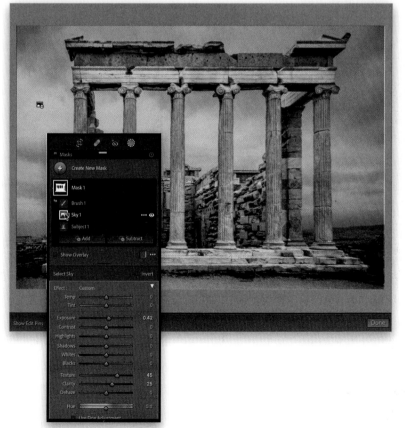

Step Seven:

If you look at the image now, you'll see three tiny icons on it that represent the three mask adjustments we added. We started with **(1) Select Subject**, so it put its icon (a silhouette of a head and shoulders) right on the ruins itself. That's an "Edit Pin" for that adjustment (this will make more sense in a moment). Then, we added **(2) Select Sky** to remove the sky from our mask—its Edit Pin appears in the sky and looks like a tiny landscape photo. Lastly, we chose the **(3) Brush tool** and painted over the rocks, so its tiny paint brush Edit Pin appears where you started painting. If you look in the Masks panel, you'll see the main mask we started with (Mask 1), and then below it, the three things we did to that mask: the Brush (Brush 1), Select Sky (Sky 1), and Select Subject (Subject 1). Hover your cursor over any of those mask adjustments and three dots appear to the right of its thumbnail, and if you click these, it reveals a pop-up menu with more options (like the ability to delete the adjustment). If you want to hide the effects of a mask adjustment, click on the eye icon to the right of its thumbnail and it hides it from that mask (here, I hid the Brush 1 adjustment, where we painted over the rocks, and you can see they're dark again).

Step Eight:

To change a mask's settings, just click on it, or on one of its adjustments, and make your changes (I clicked on the Sky 1 mask adjustment to fix the Exposure, lowering it to 0.42, so now it looks more balanced). If you hover your cursor over an adjustment thumbnail, it highlights the area(s) that particular mask adjustment affects in red tint (as shown here, where my cursor is over Sky 1). To adjust a different area than the ruins here, you'd click on Create New Mask at the top of the panel, start masking, and it would leave your original mask (Mask 1), and all its settings, untouched. So, this new mask would be entirely separate. You can switch between masks by clicking on Mask 1, Mask 2, etc., in the Masks panel.

Better Looking Skies, Method 1: Select Sky

We're going to look at four different ways to make better looking skies, and the first one is the easiest because it uses more of that AI/machine learning to automatically select the sky for you. Once the sky is masked, you can then apply whatever edits you want and they'll only be applied to the sky.

Step One:
At the top of the right side panels, click on the Masking icon (the circle with the white dotted lines around it, in the toolbox right below the histogram) to reveal the Add New Mask panel with the masking tools. Now, click on **Select Sky** (as shown here), and it selects the sky for you (even if it's a pretty tricky sky to select).

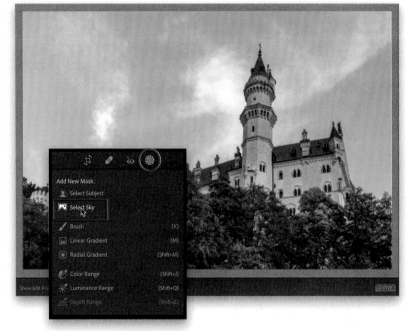

Step Two:
After a second or two a red tint appears over the sky (as seen here), which lets you know what Select Sky has masked for you.

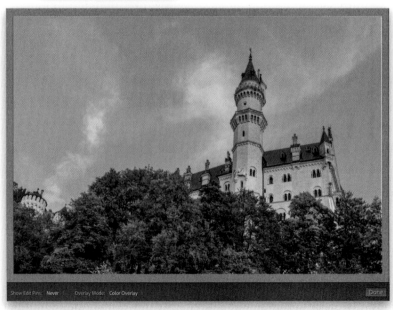

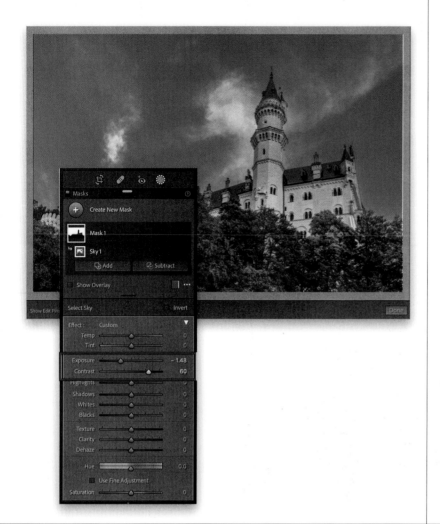

Step Three:

Once the sky is masked, I have a simple two-move edit that I often use to make it look deeper and richer: (1) I lower the brightness of it by dragging the **Exposure slider** to the left until it's looking good (when you click on a slider, the red tint is hidden, so you can clearly see your sky as you're editing), and then (2) I drag the **Contrast slider** to the right to add more contrast to the sky. This two-step move works really well for making the sky look better in most images (sadly, nothing works perfectly for every image, but that's why we have different methods, right?).

TIP: Seeing Which Masks You Used

If you go to the Masks panel and click on Mask 1 (or Mask 2, Mask 3, etc.), it reveals which edits you made to that mask. In this case, if you clicked on Mask 1, you'd see a smaller thumbnail below it and the words "Sky 1," so you'd know that you applied a Select Sky adjustment mask.

Step Four:

Below, I pressed the **Y key** to show you a before/after of our image once we made the sky deeper and richer. Again, this is just one method—we've got three more to go.

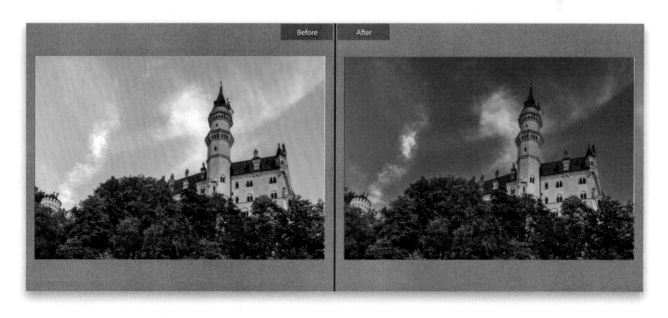

Better Looking Skies, Method 2: Linear Gradient

The Linear Gradient tool lets you recreate the look of a traditional neutral density (ND) gradient filter (these are glass or plastic filters you put in front of your lens that are dark on top, and then graduate down to fully transparent). These are popular with landscape photographers because you're either going to get a perfectly exposed foreground or a perfectly exposed sky, but not both. However, Lightroom's version actually has some big advantages over using a real ND gradient filter.

Step One:
At the top of the right side panels, click on the Masking icon (the circle with the white dotted lines around it, in the toolbox right below the histogram) to reveal the Add New Mask panel with the masking tools. Now, click on **Linear Gradient** (as shown here), and a set of sliders appears like the ones you're used to seeing in the Basic panel (as seen in Step Two).

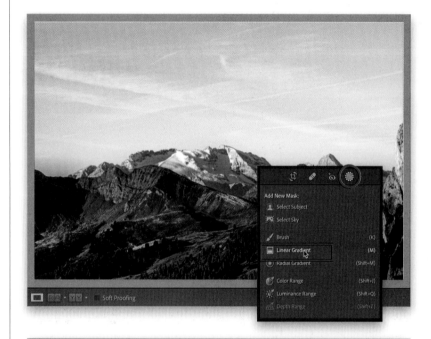

Step Two:
If the sliders are not already set to zero, start by double-clicking on the word "Effect," at the top left, which resets them, and then drag the **Exposure slider** to the left to –2.12 (as seen here) as a starting place (this amount is just a guess—we can dial in the right amount afterward). Press-and-hold the Shift key (to keep your gradient straight), then click on the top center of your image, and drag straight downward until you reach just past the horizon line. You can see the darkening effect it has on the sky, and the overall tone looks more balanced. The gradient is darkest at the top (the line with the red dot) and stays like that until it hits the black square in the center, and then it transitions to transparent between that black square and the first white dot on the bottom line. You can click-and-drag that white dot to change how far down the gradient goes. To rotate it, hover your cursor over the second white dot (below the line) and it changes into a two-headed arrow that you can click-and-drag in a circular direction. In this case, just lowering the exposure helped our sky quite a bit, but we can do more than just darken the exposure.

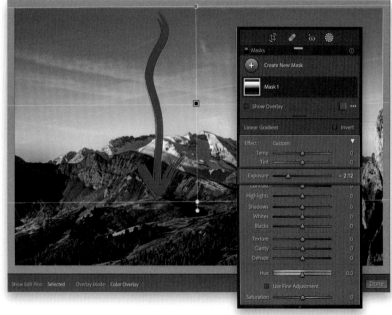

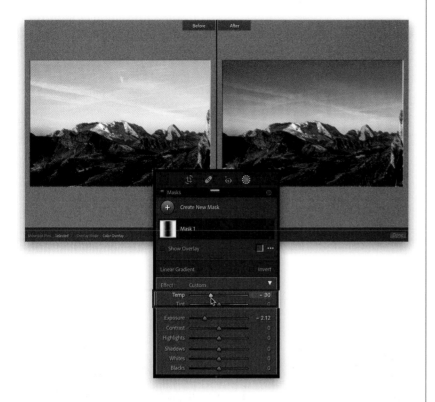

Step Three:

If lowering the Exposure amount didn't make your sky look as awesome as you'd like, the next thing you can do is add some blue into your sky gradient by simply dragging the **Temp slider** to the left toward blue (as shown here, where I dragged it to –30). Here's a before/after with the added blue in the gradient. That's something you could never do with the real filter. A couple more quick things: (1) To delete your gradient, click on the black square in the center and press the Delete (PC: Backspace) key or go to the Masks panel, click-and-hold on the three dots to the right of the mask thumbnail, and from the pop-up menu that appears, choose Delete Mask "1." (2) You can rotate your gradient while you're dragging it out, if you don't press-and-hold the Shift key to make it straight. And, (3) to move the entire Linear Gradient, click-and-drag the black square in the center.

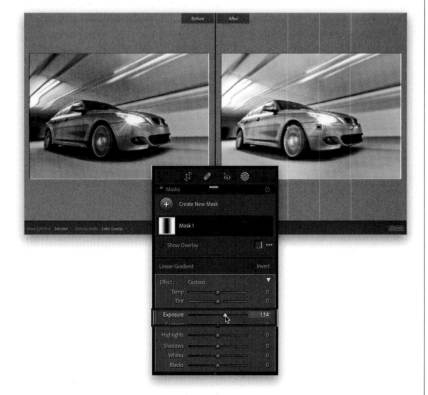

Step Four:

Let's change images, so I can show you another way I use the Linear Gradient tool (it's not just for landscapes), which is to use it to rebalance the light in an image. In this image, I want a quick way to brighten the left side of the car, so it matches the front of it and the right side of the image without having to spend a bunch of time painting it all brighter with the Brush tool. I add a Linear Gradient mask, increase the **Exposure amount** (in this case, to 1.14), then click-and-drag from around the center of the image to the right. So, everything from the black square in the center to the left is brighter, and then it smoothly graduates to transparent on the front of the car, balancing the overall tone. Everything to the left of the red dot, and all the way to the black square in the center, is 100% of that 1.14 Exposure amount.

Better Looking Skies, Method 3: Masking Objects

You just learned the technique for adding a Linear Gradient to a sky to darken it and make it richer and bluer, but you're going to run into a trickier situation, like with the image you see below: when you drag out your gradient to darken the sky, it winds up darkening the foreground object (the cone, in this case, but it could be a mountain, a person, a building, etc.). But, luckily, there's an easy fix.

Step One:
Here's the original image (this is the elevator to the parking garage in the City of Arts and Sciences, in Valencia, Spain), and you can see the sky is just screaming for us to use the Linear Gradient tool to fix it. What we want here is the sky to be darker, bluer, and better behind the cone in the photo, but even if you were to put a traditional screw-on filter in front of your lens, you'd have the same problem, which is it would darken the sky, but it would also darken part of the cone. That's a limitation of traditional lens filters, but in Lightroom, we can get around this really easily. At the top of the right side panels, click on the Masking icon (the circle with the white dotted lines around it, in the toolbox right below the histogram) to reveal the Add New Mask panel with the masking tools. Now, click on **Linear Gradient** (as shown here), and then scroll down to the sliders and lower the **Exposure amount** to –2.74 (that's just a starting place).

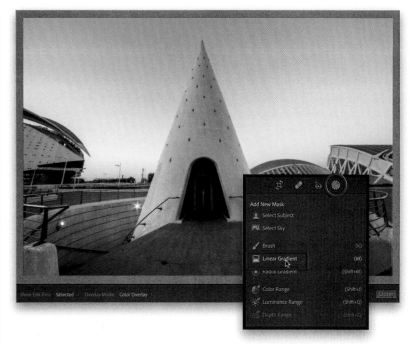

Step Two:
Now, press-and-hold the Shift key (to keep your gradient straight), and drag the Linear Gradient from the top of the image downward a little past the horizon line (as shown here). A red tint shows you the area that's being masked by the gradient, and you can see it's darker at the top and then graduates down to transparent at the white circle at the bottom.

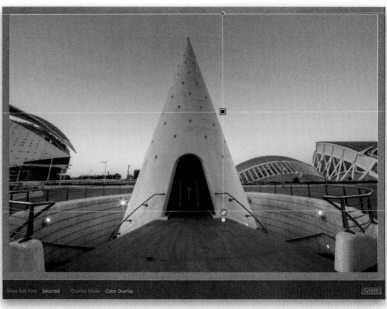

Step Three:

While it did an awesome job darkening the sky, it also darkened a lot of the cone, as well (as seen here)—same as what would have happened if you put an actual gradient filter over your camera's lens.

TIP: Adding More Gradients

If you want to add another gradient (maybe to brighten the left side of the image) and keep the one on the sky you already have in place, just go to the Masks panel, click on **Create New Mask**, then click on Linear Gradient again, and then drag out your new gradient, which you can adjust separately.

Step Four:

To fix this, go to the Masks panel and you'll see two buttons below your Linear Gradient mask: Add and Subtract (if you don't see them, click on Mask 1 to make them visible). Our gradient goes right over that cone, but of course, we don't want that cone masked, so we're going to remove it (subtract it) from our Linear Gradient mask. Click on the **Subtract button** and from the pop-up menu that appears, choose **Select Subject** (as shown here). That's all there is to it. Lightroom's AI recognizes the subject (the cone) and it removes (subtracts) it from your gradient mask. That's something you can't do with an actual filter you put on your lens, and a huge advantage of Lightroom's Linear Gradient (plus, it's just so darn easy to use).

Better Looking Skies, Method 4: Preserving Your Clouds Using a Luminance Mask

The Linear Gradient works great on a cloudless sky, but when you have clouds, and you darken the sky by adding a gradient, it also darkens the clouds, which can make your nice, white clouds look dark and ominous. Luckily, there's a feature called Luminance Range that lets you create a mask based on the highlight or shadow areas in your image (so you can select all the bright areas or all the dark areas to work on), which is incredibly handy in all sorts of situations. In this case, we're going to use the Linear Gradient tool to make the entire sky a rich blue, but then we'll use Luminance Range to remove the clouds from the mask, so they don't look gray and still appear white and fluffy.

Step One:

Here's our original image with a light sky, so we're going to do the same stuff as usual to darken it. At the top of the right side panels, click on the Masking icon (the circle with the white dotted lines around it, in the toolbox right below the histogram) to reveal the Add New Mask panel with the masking tools. Now, click on **Linear Gradient** (as shown here).

TIP: Seeing/Hiding Your Edit Pins

You have a choice of how Lightroom displays your Edit Pins (the tiny pins that appear over your image, each representing a mask you've applied), and you make that choice from the **Show Edit Pins pop-up menu** down in the toolbar beneath the Preview area. Choosing Auto means when you move your cursor outside the image area, the pins hide. Always means they're always visible, and Never means you never see them. Selected means you only see the currently active pin.

Step Two:

Now, drag the **Exposure slider** to the left quite a bit (I went to –1.61, here), then press-and-hold the Shift key (to keep it straight as you drag), and then click-and-drag from around the top of building downward to near the bottom (as shown here) to darken the sky. But, as you can see, it darkens both the building and the clouds, as well, which is not awesome (well, in most cases, it's not awesome). We'll start with the building, but as you've learned, you're just two clicks away from removing (subtracting) that area from the Linear Gradient mask.

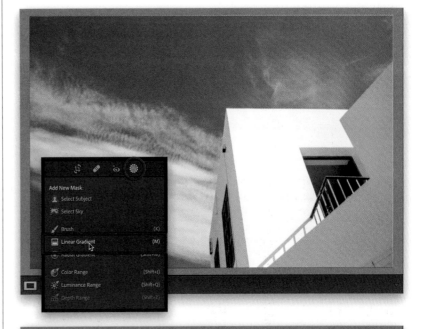

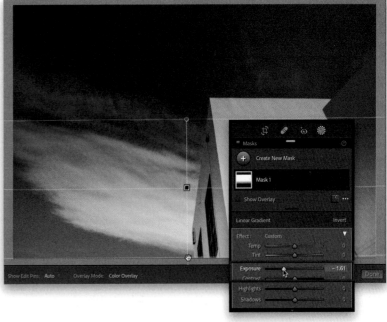

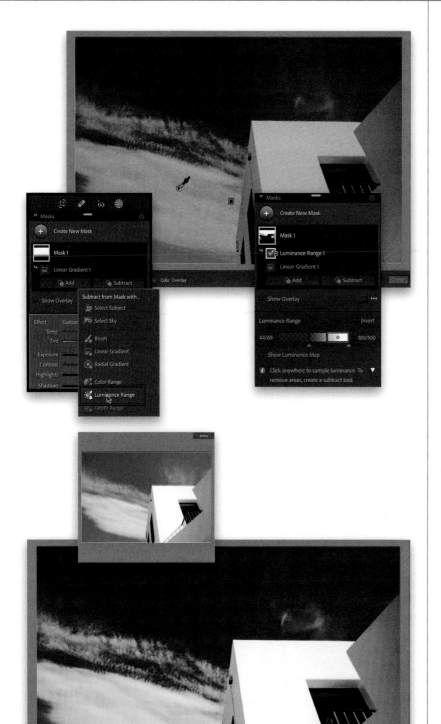

Step Three:

In the Masks panel, click on the **Subtract button** (if you don't see the Add and Subtract buttons, click on Mask 1 to make them visible), and then from the pop-up menu that appears, click on **Luminance Range** (as shown here, in the inset on the left). Now, when the Luminance Range panel appears (as seen here, in the inset on the right) your cursor will change into an eyedropper tool. Just click it on the area you want to subtract from your image. In this case, I clicked on the clouds, but we got lucky in that it also selected the building as well (as seen in the next step), because they're of a similar brightness. As I mentioned in the intro on the previous page, this tool makes its mask based on the brightness of the area, so in this case, it removed everything of a similar brightness from that mask. If it hadn't removed the building, we would have just clicked the Subtract button again, and chosen Select Subject for it to remove the building, the subject of this photo, from the gradient mask.

Step Four:

Besides using the Luminance Range eyedropper, you can also drag the **Luminosity Range sliders** (seen in Step Three) to limit or add to the amount of tones it's masking for you. You do this by dragging the upward-facing arrows directly below the tone ramp. Dragging the left arrow to the right limits how many highlights are selected, and dragging the right arrow to the left limits the amount of shadow areas that are selected. It helps to turn on the Show Luminance Map checkbox (which adds a red tint overlay when it's turned on), making it much easier to see which areas are being affected. Here's our final image with the sky much darker and richer, thanks to the Linear Gradient, but the clouds didn't get darkened thanks to removing them (the highlights) from the mask using Luminance Range. A Before of how the sky looked before the Luminance Mask is shown here at top.

Five Really Helpful Things to Know Now About the Brush Masking Tool

After these two pages, we're diving into an incredibly powerful masking tool, simply known as "the Brush" (formerly known as "the Adjustment Brush"), but there are some things that if you learn them now, before you start working with the Brush, it will make your brush life easier. So, let's start with these:

#1: Changing the Size of the Brush
When you choose the Brush tool **(K)**, in the Add New Mask panel, a panel of options appears (as seen here, at the bottom), where there's a Size slider that you can drag to change the size of your brush. But, there's a much faster and easier way to change its size: just the use the **Bracket keys** on your keyboard (they're located to the right of the P key on a standard US keyboard). Pressing the **Left Bracket key ([)** makes your brush size smaller (as seen here, on the top left) and pressing the **Right Bracket key (])** makes it larger (as seen here, on the top right).

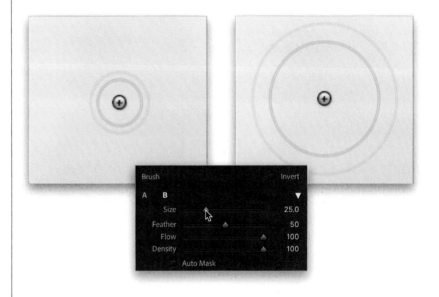

#2: There's an Erase Brush, If You Mess Up or Paint "Outside the Lines"
If you're painting over an area and you paint somewhere you didn't mean to (for example, while painting over the dome here, on the top left, you can see red tint extending into the sky, where I accidentally painted outside the dome), that's when you reach for the **Erase brush**. You can click on the word "Erase" in the Brush section of the panel to switch to the Erase brush, but it's much faster to press-and-hold the **Option (PC: Alt) key** to temporarily switch to it, and then paint where you messed up (as shown here, on the top right, where I'm painting over the spill-over to erase it from my mask). Two notes: (1) You don't have to leave the red-tinted overlay on to do this; it's just much easier to see what you're doing with it on. (2) You can choose the Erase brush's settings by clicking on Erase, and then moving the sliders below.

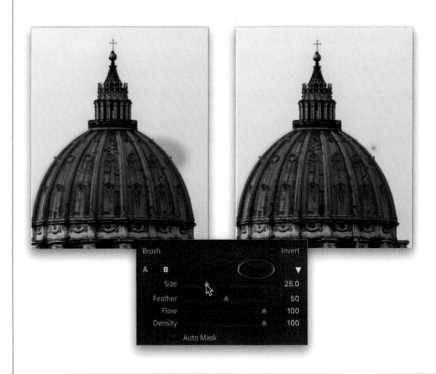

#3: You Have a Second Brush

You actually have two brushes to choose from: "A" (your regular brush) and "B," an alternative brush you can switch to at any time, using the \ **(backslash) key** on your keyboard (or, of course, you can just click on "B" in the Brush section of the panel). What's nice is you can choose your own settings for each brush. I usually give my "A" (regular) brush a soft edge, with a high Feather amount (as seen here, on the left), and my "B" brush a hard edge, by lowering the Feather amount to zero (as seen here, on the right). So, if I run into a situation where I'm painting along a wall, or another area where a soft edge looks weird, I can toggle over to my hard-edged "B" brush.

#4: Feather, Flow, and Density

There are three brush controls (besides Size) that are important: Feather is the softness of the edge of the brush (the higher the number, the softer and more blending the edge of the brush will be). The outer circle of your brush shows the Feather amount you have applied—the closer that outer circle is to the inner circle, the harder the brush edge. The Flow amount, if set below 100, lets the brush "build up" as you paint, kind of like spray paint or an airbrush. So, if you paint with the Flow set at 20, and then paint over it again and again, it gets darker and darker, and so on until it gets to 100% solid. You can limit how many times you can paint over an area (so it never gets to 100) by lowering the Density amount.

#5: There are Brush Presets

If you click on the word "Custom" to the right of Effect, at the top of the Brush adjustments panel, a pop-up menu of presets appears, and you can use any of these as a starting place for your edits. You can also create your own preset, if you wind up creating a look you like—just choose **Save Current Settings as New Preset** from the bottom of the menu.

Painting with Light (Also Known as "Dodging & Burning")

Another one of our main tools for masking is the Brush tool, which lets us "paint with light" just where we want it. In the darkroom days, this was called "dodging and burning," which simply means brightening (dodging) some areas and darkening (burning) others. This is way bigger than it sounds (and you can do more with this brush than just brighten and darken, but this is primarily what we do with it, so we'll start there).

Step One:
Here's the original image, taken inside the Washington National Cathedral in Washington, DC. Some areas are quite dark (like inside the arches on both sides, and the whole area above the doors), and some are too bright (like the front doors, and the stained glass above them). This is why it's so awesome to be able to "paint with light" to better balance the overall lighting in the scene. Once I get the basic overall exposure looking decent, I use the Brush tool to brighten (add light to) areas that are too dark and darken areas that are too bright. It's kind of weird how the brush works, but once you get it, you'll actually like it: (1) you drag a slider to a random amount (brighter or darker), (2) you paint over an area you want to adjust, and then (3) you go back to that slider and dial in the right amount of adjustment.

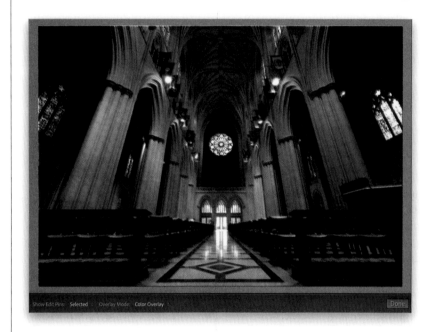

Step Two:
At the top of the right side panels, click on the Masking icon (the circle with the white dotted lines around it, in the toolbox right below the histogram) to reveal the Add New Mask panel with the masking tools. Now, click on **Brush** (as shown here). This will bring up the same adjustment sliders we've been using throughout this chapter.

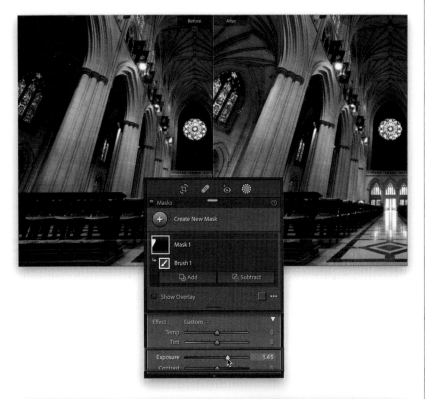

Step Three:

Let's start by brightening the dark archway on the left. Drag the **Exposure slider** to the right a bit (I usually start at around 1.50, but the amount doesn't matter too much at this point because you'll choose the right amount after you paint), and then paint over that area on the front-left side (as seen here, in the After image). A red tint will appear over the area you're masking, but that tint goes away as soon as you move any of the sliders. Now, compare the brightness of that archway on the left in the After image on the right here, to the original Before image on the left (I pressed the **Y key** on my keyboard to show this before/after view).

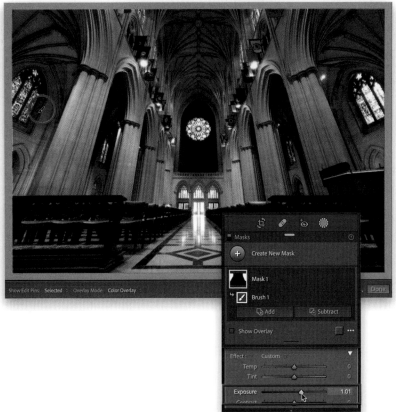

Step Four:

The archway on the right side looks similarly dark, so let's paint over that side, as well (compare these side archways with those in Step One, and you'll see what a difference balancing the light has made). It's now time to tweak the brightness to the amount we think is right (this is a creative decision—you, as the photographer, get to make the call on how bright you think those areas should be). I thought they looked a bit too bright, so I dragged the **Exposure slider** back to around 1.00 (so about a half-stop lower than the amount I originally painted with). That's pretty much how this brush masking process works: with the sliders set to zero, you (1) drag the Exposure slider either to the left (to paint darker) or to the right (to paint brighter), and paint over an area you want to adjust, and then (2) dial in just the right amount of brightness or darkness with the Exposure slider. When you paint over an area, it leaves a tiny **Edit Pin** (that tiny brush icon circled here). That pin represents the area you masked over (it drops that pin right where you first clicked to start painting). These help you see where you've made masks and you can click on them to make them active (more on this in a moment).

Step Five:

Next, let's brighten the area above the doors in the back. We don't want to mess with what we've already adjusted (the archways on the sides)—we want to leave that in place and start editing a different area we can control separately. So, go to the Masks panel, click **Create New Mask** (as shown here), and then from the panel that appears, click on Brush. Now, we'll do our two steps: (1) Raise the Exposure amount to around 1.50, and then paint over the area above the doors (don't paint over the round, stained glass window, though—it's already a little too bright). Then, once you've painted over that area, (2) lower the Exposure amount until it looks right to you. Since we created a new mask (Mask 2; seen in Step Six), these edits only affect that area above the doors—it's totally separate from what we did earlier to the archways. *Note:* I also had to drag the Tint slider to the left a bit because that area looked too magenta after I brightened it.

Step Six:

Okay, that's enough brightening for now. Let's head to the windows above the doors and reduce some brightness there. Click Create New Mask again, and then click on Brush, but this time drag the **Highlights slider** way over to the left to pull back (darken) the highlights, and then paint over those windows (as seen here, skip the open doors in the middle—they're totally blown out, and painting them just turns them gray—but I did paint over the doors on the left and right). See how much detail comes back in the stained glass when we do this?

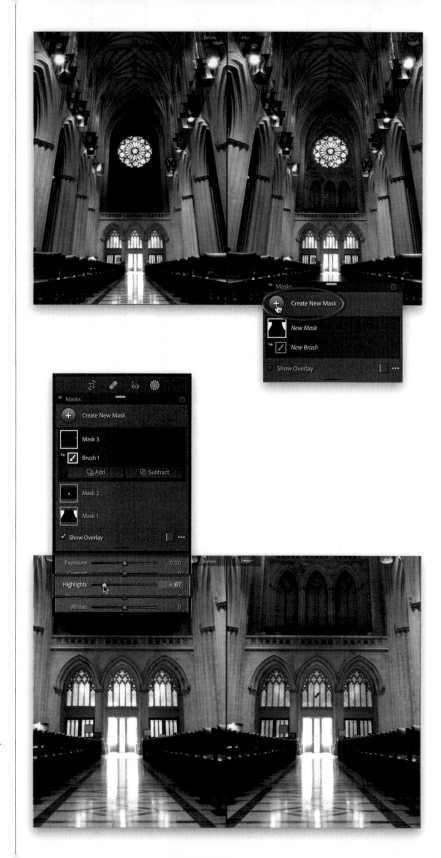

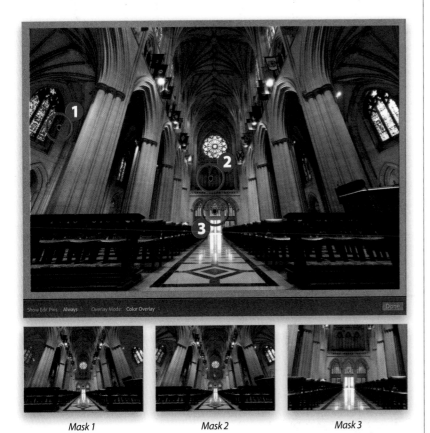

Mask 1 Mask 2 Mask 3

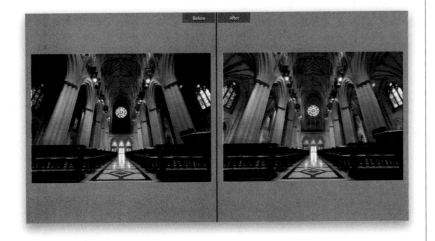

Step Seven:

If you look at your image now, you'll see that you have three black **Edit Pins**, and each one represents an area you masked (you now have three masks). If you move your cursor over any of them, the masked area highlights in a red tint (same as if you go to the Masks panel and hover your cursor over any of the mask thumbnails). If you want to edit any one of those areas, just click on its mask (or its Edit Pin). When you do this, you'll see that it remembers exactly which sliders you used, with exactly the same amounts you entered, so you can pick right up where you left off. Here, at the bottom, I hovered my cursor over each Edit Pin, so you can see the areas we masked as they appear with their red-tinted overlays. You can also start to see why renaming your masks will come in handy as you start adding more of them (we looked at this on page 171).

TIP: How to Delete an Edit Pin

If you want to remove an Edit Pin from an area, just click on it and hit the **Delete (PC: Backspace) key**.

Step Eight:

There's one more edit we should probably make before we're done here. In the image in Step Seven, look at the second set of archways. It's kinda dark in those areas, but that's an easy fix: we can click on Mask 1 (the first one we created where we brightened the first set of archways), and then paint over those second archways and it will use the same settings, adding to the original archways mask we created earlier, so it's all the same brightness. Here's a before/after of painting with light to balance out the light in the image. *Note:* I don't do brush adjustments like this until I've already done my basic overall edits first, like setting my exposure, contrast, whites and blacks, and all that stuff. This "painting with light," dodging-and-burning-type of stuff comes after all that Basic panel stuff.

The Brush's Awesome Auto Mask Feature

When you're masking with the Brush tool, sometimes it's hard to paint "inside the lines," so that's when the Auto Mask feature comes in to save the day. It senses the edges of areas where you're painting, and even if the edge of your brush extends outside the area, it won't spill over onto another area (which is pretty amazing) as long as you follow a simple rule that makes it all work (which you're about to learn).

Step One:
If you grabbed the Brush tool (**K**), dragged the Exposure slider to the left, and then started painting over the building on the right here to darken its exposure, when you got to the edge of the roof, your darkening would probably spill over onto the sky (as seen here). This is what's so awesome about the Brush tool's **Auto Mask feature**. First, you turn it on by just turning on its checkbox at the bottom of the Brush section (as shown circled here).

TIP: Making Your Brush Faster
Only turn on Auto Mask when you get near the edge of something—not when you're painting across a large wall or a big sky—because the crazy math it does as you're painting slows the brush down quite a bit. You can press the **A key** to toggle it on/off as needed.

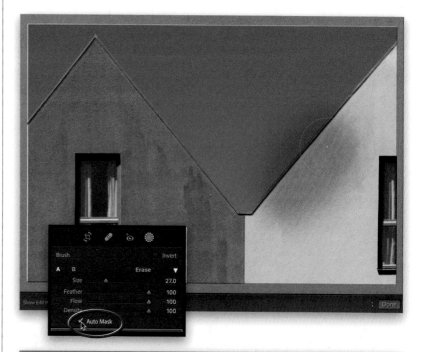

Step Two:
Now, with Auto Mask turned on, it senses where the edges of things are in your image and keeps you from accidentally painting over onto other areas (like the sky). You can see here the edge of my brush is extending way over onto the sky, but the exposure darkening is staying inside the edge of the roof and is just applying the effect to the edge of the house.

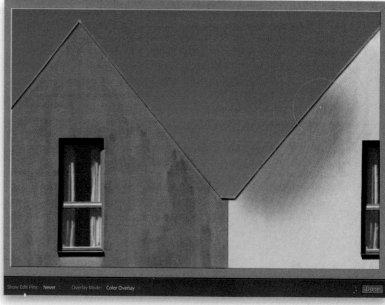

Step Three:

The trick to using this feature successfully is knowing how it works: You see that little + (plus sign) icon (circled here in red) in the center of the brush? That determines what gets affected as you paint. So, any area that the + travels over gets painted. It's okay if the outside edge of the brush strays outside the area, as long as that + in the center doesn't stray over an edge. Keep that + over the house and it usually won't spill over. Here, I intentionally let the + extend over onto the sky, so you can see what I mean, and now it's darkening the exposure of the sky as I paint.

Step Four:

Let's hit undo **(Command-Z [PC: Ctrl: Z])** to remove that intentional spillover, and then let's paint over the the building on the right. Again, all we have to really keep an eye on is that center + (plus sign) as we paint. Even though the edge of my brush is extending well outside the roofline here, it's keeping my masking to the building. Same thing when I painted right up to the edge of the window, with the outside of my brush extending all the way onto it. But, since that little + didn't stray over the window, it didn't darken it.

A Better Way to Reduce Noise

I'm not a fan of noise reduction for two reasons: (1) it basically blurs your image to hide the noise, and (2) nobody notices noise, except for other photographers. So, I generally don't apply noise reduction at all, even if I shot at a very high ISO (like the 8,000 ISO I shot with here). But, if I feel it's really necessary, this is how I do it because I don't want to blur my entire image just to get rid of some visible noise in the shadow areas (that's where noise is usually found). With this method, I only apply noise reduction where it's most needed, and the rest of the image doesn't get blurred at all.

Step One:

This hallway (in a bed and breakfast in southern France) is much darker than it seems (which is why I had to shoot it at 8,000 ISO). If you zoom in, you will see the noise, especially on the seat of the chair, since it's kind of in shadow. When you open up the shadows a lot (using either the Shadows or Exposure sliders, or both) to where the image is properly exposed, you'll see all the noise. So, like I said above, if I have to reduce noise, I'm only reducing it in the areas that need it (brighter areas don't show much noise), and not applying it to the entire image. Why blur the whole thing when only part of it has a problem?

Step Two:

At the top of the right side panels, click on the Masking icon (the circle with the white dotted lines around it, in the toolbox right below the histogram) to reveal the Add New Mask panel with the masking tools. Click on **Brush**, drag the **Noise slider** quite a bit over to the right, and then paint over the dark areas of the chair to reduce the noise in just those areas. The goal is to find that sweet spot for the Noise slider where that area is now visibly less noisy, but it's not too blurry. It's a bit of a balancing act, so once you've painted over an area, drag the slider back and forth a few times to see if you can find that sweet spot. Also, don't forget about all the other sliders here. Once you've painted in your noise reduction, you can add some sharpening (with the Sharpness slider, like I did here) if it looks too blurry, or drag the Exposure slider to the left to darken those areas a little, which helps hide the noise, too.

This is one of those things you might not think of, but it has saved my bacon more than once (and if you've priced bacon recently, well…). The ability to paint color like this can be a real image-saver. One instance where it helps big-time is when you shoot in Auto white balance, which usually works really well unless your subject is in the shade because they'll end up with a bluish tint (that's just the way Auto white balance works on your camera). That's why there's a Shade white balance setting—it warms the color to offset the blue tint. Here's how to fix the problem if you didn't shoot with your white balance set to Shade:

Painting with White Balance

Step One:
Take a look at the image here, where the background is in daylight, so the color looks great using Auto white balance. But, since this part of the play is in shade, the players have a blue tint on what should be their white uniforms. Pretty typical when part of your image winds up in shade (I face this a lot shooting sports when part of the field is in shade in late afternoon games and part is in daylight). This is where the ability to paint white balance in just certain areas is incredibly helpful, so press the **K key** on your keyboard to get the **Brush tool**.

Step Two:
Now, drag the **Temp slider** over to the right a bit (toward yellow) and start painting over your subject (don't forget the other players in shade, in this case). As you do, the yellow white balance you're painting neutralizes the blue tint (as seen here in the before/after). If you start painting and it's not enough (it still looks bluish), drag the Temp slider toward the right some more. In this case, once I removed the bluish tint, it looked a little magenta (reddish), so I dragged the **Tint slider** toward green (away from red) and that did the trick. Another trick I use, especially if the subject is wearing white or a light color, is to also lower the **Saturation** a little, which removes the color from the area you painted over. One last thing: if one area still looks blue, click on Create New Mask, at the top of the Masks panel, choose the Brush again, increase the amount of yellow a lot more, and then paint over just that one area with another mask.

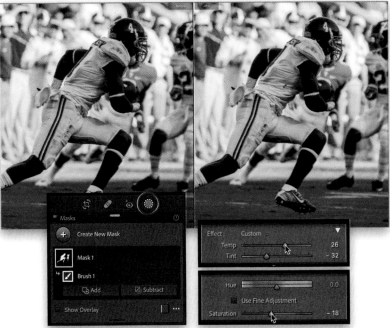

Retouching Portraits

While Photoshop is still king when it comes to pro-level portrait retouching (and just removing distracting things, in general), it's amazing how many portrait retouching tasks we can now do right here in Lightroom without having to jump over to Photoshop. Here are a few of the key things you'd do to a portrait, and it's a great way to see how these tools work together.

Step One:

Here are the things we're going to retouch in this image: (1) remove any major blemishes and wrinkles, and darkening under her eyes; (2) soften her skin; (3) brighten her eyes; and (4) sharpen her eyes. Although we're seeing the full image here, for retouching, it's best to zoom in quite a bit, so you can really see what you're doing as you're working.

Step Two:

Press **Command-+ (PC: Ctrl-+)** a few times to zoom in tight like you see here, and then, at the top of the right side panels, click on the **Spot Removal tool** (circled here in red), in the toolbox right below the histogram, or just press the **Q key**. This tool works with just a single click, but you don't want to retouch any more than is necessary, so make the brush Size a little bit larger than the blemish you're going to remove (the one we're going to remove first is the minor one on her chin on the right, also circled here). Also, in the Spot Removal tool's options, make sure Spot Edit is set to Heal (as seen here)—we only switch to Clone if something we're trying to remove smears, but for everyday use, we leave it set to Heal for the best results.

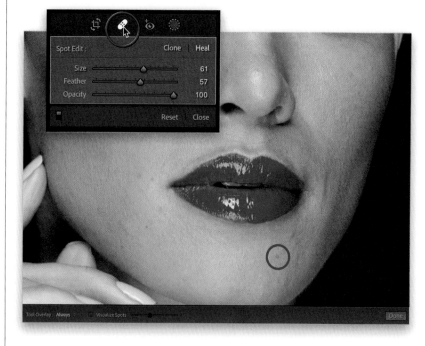

Step Three:

Now, just move your brush over the blemish and click once. You'll see a circle where the blemish was, as well as a second circle, showing you where it sampled an area of clean skin texture from. Not surprisingly, it picked a weird spot to sample from (rather than choosing a clean spot right nearby, it chose a patch of skin from her neck. It does stuff like that). But, luckily, you can choose your own spot to sample from (it should be somewhere near the blemish you want to remove) by clicking-and-dragging the second circle (the one with the thicker white outline) to where you want it to sample from. I dragged the second circle to a nearby area of skin here. You can also press the **Forward Slash key (/)** on your keyboard and Lightroom will choose a different area to sample from for you. Each time you press that key, it chooses a different area, which is really helpful.

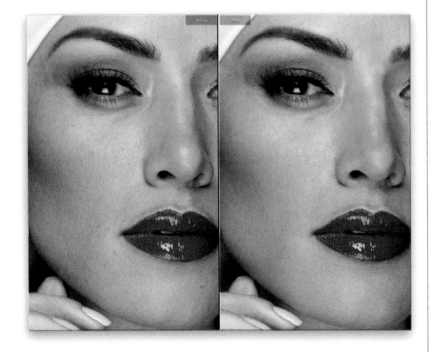

Step Four:

Go ahead and continue removing any blemishes using the Spot Removal tool. Remember, if it picks a bad area to sample from (the retouch doesn't look natural), press the Forward Slash key to have it choose a different spot. Here's a before/after with the minor blemishes removed. Next, let's reduce the darkening and minor wrinkles under her eyes.

Step Five:

Zoom in tighter, and with the Spot Removal tool still active, paint a stroke over the wrinkles under her eye on the left. The area you paint over turns white (as seen here), as a visual cue for what you're painting over.

Step Six:

It doesn't always work this poorly, but once again, it chose kind of a crazy place to sample from (when you try this, you'll immediately see what I'm talking about). But, we can either press the Forward Slash key (/) to have it pick a different area for us or we can just click-and-drag the second stroke someplace nearby to get better results. Here, I just clicked inside the second stroke and dragged it down below the first one beneath her eye and it did a much better job. Now, in most cases removing all the wrinkles and darkening is unrealistic, so for a more realistic retouch, we need to "reduce" the wrinkles instead of removing them. After you've found a better place to sample from, go to the Spot Removal tool's options, and decrease the **Opacity amount** by dragging the slider to the left (as shown here) to lower the strength of the removal, bringing back some of the original wrinkles and darkening. One more thing: don't forget to do the other eye.

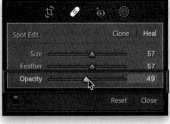

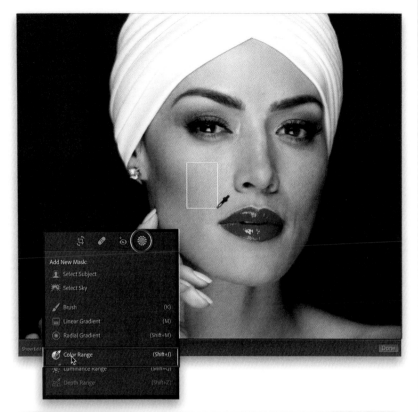

Step Seven:

Next, let's do some light skin softening, but of course, we only want this softening to affect the skin, not the detail areas, like her lips, eyebrows, hair, eyes, eyelashes, etc. While we could use the Brush tool to carefully paint over just the skin areas, instead, we can use some of Lightroom's other masking tools to make this job really quick and easy. At the top of the right side panels, click on the Masking icon (the circle with the white dotted lines around it, in the toolbox right below the histogram) to reveal the Add New Mask panel with the masking tools, and then click on **Color Range**. When you move your cursor out over your image, it turns into a large eyedropper, which we're going to use to select an area that represents her skin tone. So, just click-and-drag out a rectangular selection on her face with the eyedropper (as shown here) to tell Lightroom that these are the colors, the tones, we want to include in our mask.

Step Eight:

When you let go of your mouse button, it instantly selects only her skin areas based on where you clicked-and-dragged out that rectangle. Notice how it didn't mask her eyes, eyebrows, lips, or even her earring, here—it just masked the skin tones, which is awesome. But we can take this a step even further. If you only want to soften the skin on her face, and not all of the other skin areas on her shoulders, hands, etc., you can use another masking tool to subtract from this mask, so just her face will be affected by the softening (we'll do this in the next step).

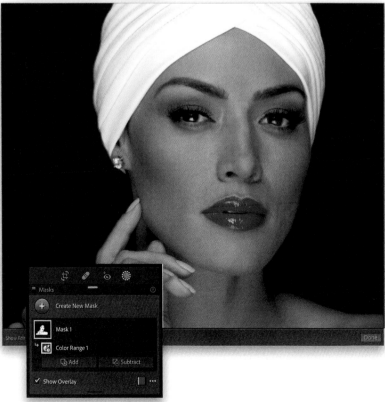

Step Nine:

This is going to sound counterintuitive at first, but it actually works really well for only selecting the face, and not all of the other visible skin. Go to the Masks panel and click on Mask 1, so the Add and Subtract buttons are visible, then click the **Subtract button**, and from the pop-up menu that appears, choose **Radial Gradient** (as shown here, in the inset). This tool lets you apply a mask as an oval, and you determine its size and shape, either as you're dragging it out or after the fact. I know what you're thinking (well, I'm guessing): "Didn't we just choose to subtract? If we drag out an oval on her face, won't it remove her face from our mask?" Yes, it will, but this is only step one out of two steps. So, with the Radial Gradient tool, drag out an oval over her face. If it's not just right, use the control handles (the white dots) on the top, bottom, and sides to reshape and resize it, and you can click-and-drag the black dot in the center to reposition the entire oval. To rotate it, click your cursor just outside one of the control handles (as seen here) and drag in a circular motion.

Step 10:

The second step (the one that makes this all work) is super-easy: just go to the top of the Radial Gradient's options and turn on the **Invert checkbox** (as shown here, circled in red). That inverts the oval and now only her face is masked (as seen here), with her other skin areas outside the mask. So, our softening won't affect those other skin areas now. How cool is that?

TIP: Keep from Seeing Too Many Pins

To see just the currently selected Edit Pin, choose **Selected** from the Show Edit Pins pop-up menu in the toolbar beneath the Preview area.

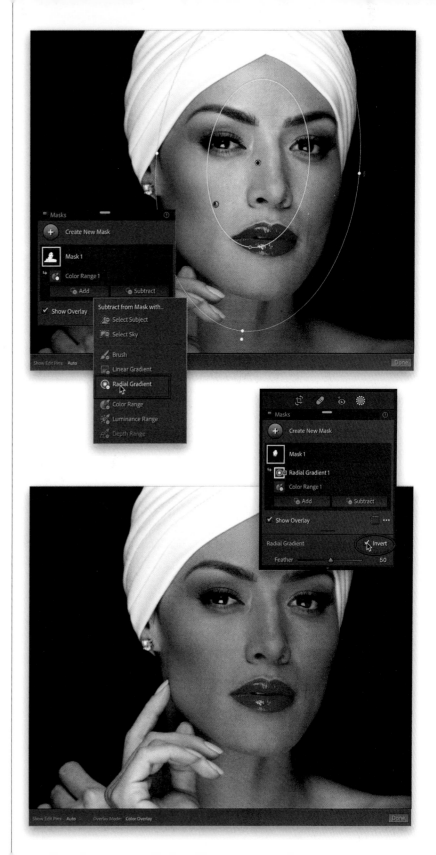

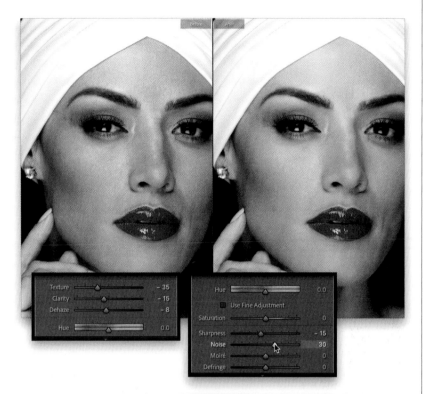

Step 11:

Now that only her face is masked (without the eyes, lips, etc.), we can do our minor skin softening. While there's a **Soften Skin** preset you could choose from the Effect pop-up menu at the top of the adjustments panel, and while it's "okay," I think there is a more effective combination of sliders we can use when it comes to skin softening—one that softens, but also adds back in some noise to help keep the look of skin texture. Double-click on Effect at the top of the **adjustments panel** to reset the sliders to zero (if they're not already reset), then lower the Texture (I went to –35, here), Clarity (to –15), and Dehaze (to –8) sliders (as seen in the inset on the left). Then, lower the Sharpness slider (to –15), but raise the Noise slider (to 30; as seen in the inset on the right). With a younger subject like this, where skin softening isn't really needed, the softening acts to smooth the tonal variations (like bright spots) and gradations in her skin, which it did a great job of here (I'm showing a before/after here with the skin before the softening on the left). *Note:* I turned off the Show Overlay checkbox here at the bottom of the Masks panel.

Step 12:

Let's wrap up with a little brightening of the eyes, and while we're there, we'll sharpen them, too. We want to leave all the skin softening in place, so we'll need to create a new mask by going to the Masks panel and clicking on Create New Mask. Then, from the pop-up menu, that appears, choose **Brush**. Increase the **Exposure amount** to around 0.75, and then paint over an entire eye, eyelashes and all. It will be too bright, but it helps to see what you're painting over if it's too bright to start. After you've painted both eyes, lower the Exposure amount until it looks natural (I lowered it to 0.44. I usually go no higher than 0.50). Lastly, with your eyes masked, increase the **Sharpness amount** to 30 to finish off the retouch.

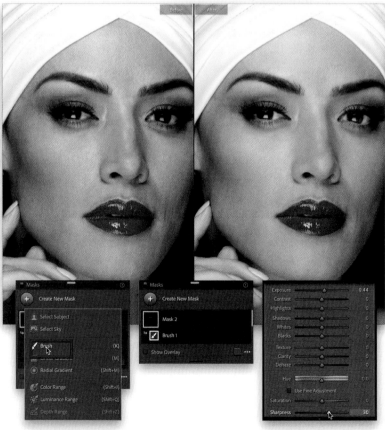

Editing Your Background

You've learned how to have Lightroom automatically mask your subject so you can adjust your subject's brightness, and tweak any other settings you'd like, but what if you want the opposite? What if the thing that needs tweaking in the image isn't your subject as much as it is the background? Here's the easy way to do just that:

Step One:

Here's the image we want to work on, and I feel like the background is a bit too bright with lots of distracting bright spots. So, what we want to edit is the background, darkening it and pulling back those high-lights, so our subject stands out more and the viewer's eye isn't drawn to it. We'll start by having Lightroom mask our subject. So, at the top of the right side panels, click on the Masking icon (the circle with the white dotted lines around it, in the toolbox right below the histogram) to reveal the Add New Mask panel with the masking tools, and then click on **Select Subject** (as shown here).

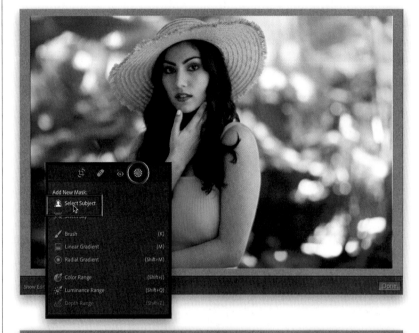

Step Two:

When you choose Select Subject, a red tint appears over the area Lightroom masked for you (your subject; as seen here), and it did just what it was supposed to do—it recognized the subject, and it even did a really good job of selecting the fringe on the edge of her hat. Of course, this is the opposite (or to use a more nerdy term, the "inverse") of what we want—we want the background masked.

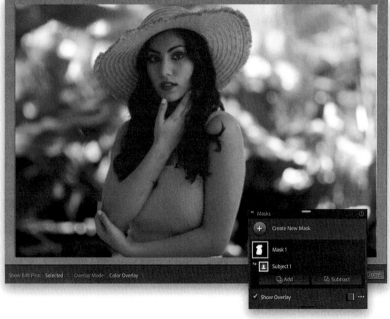

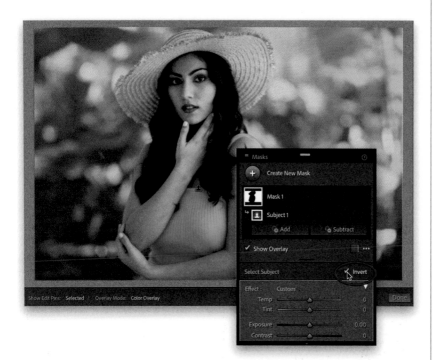

Step Three:

To get Lightroom to switch your masked area to the background, right above the adjustment sliders you'll see the name of the last mask you applied (in this case, Select Subject), and to the right of that you'll see the **Invert checkbox** (shown circled here in red). Turn that checkbox on and it gives you the opposite—the inverse of your Select Subject mask. You now have the background selected, and that area appears in the red tint (as seen here).

Step Four:

Now that the background is masked, use the **adjustment sliders** to darken the Exposure (I dragged it to –1.05), pull back the Highlights (to –82), maybe lower the Contrast a tad (to –65), and then make the background even more blurry by dragging the Clarity slider to the left (to –85; as seen in the inset on the left). With the background brightness where we want it now, if we wanted to go back and work on our subject, to brighten her up a bit, you'd need to create a new mask (to leave the background edits in place and edit her separately). So, click on **Create New Mask**, at the top of the Masks panel, then choose Select Subject to select her again. Now that only she's masked again, drag the Exposure slider to the right a bit to brighten her (as seen in the inset on the right, where I increased her overall brightness by just over 1/3 of a stop to 0.38). Using the Invert checkbox like this can be mighty handy in your editing going forward.

Adjusting an Individual Color Using a Color Range Mask

You already learned about Luminance masks (back on page 184), where you select an area to mask based on its highlight and shadow areas, but there's another type of mask you can use that's based on color. It's called the Color Range mask, and it's ideal for changing the color of something, or making that color brighter or darker, and it would also be perfect for selecting skies (you'd just click-and-drag out a rectangular selection in the sky, but I couldn't bring myself to do yet another sky technique—you get the idea). Here, we're going to use a Color Range mask to change the color of our background.

Step One:
Here's our original image, where we want to change the background color. So, go to the top of the right side panels, click on the Masking icon (the circle with the white dotted lines around it, in the toolbox right below the histogram) to reveal the Add New Mask panel with the masking tools, and then click on **Color Range** (as shown here).

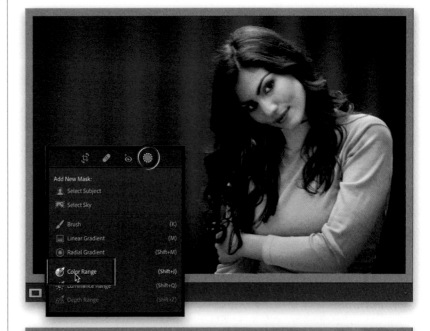

Step Two:
When you click on Color Range, your cursor changes into an eyedropper that will sample the color you want to make a mask from. So, just move your cursor over the image and click it somewhere on the background color, like I did here, and a red-tinted overlay appears showing the areas it masked. Besides just clicking, you can also click-and-drag out a rectangular selection over an area to include a wider amount of different tones you want included in your Color Range mask. If you didn't select a wide enough area of color, you can refine this mask, and increase the amount of color it has masked, by dragging the **Refine slider**, in the Color Range options, to the right. Dragging it to the right has it select more colors; dragging it to the left has it select fewer colors.

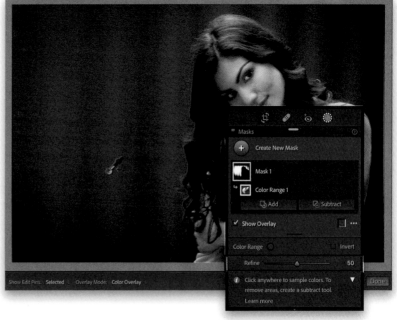

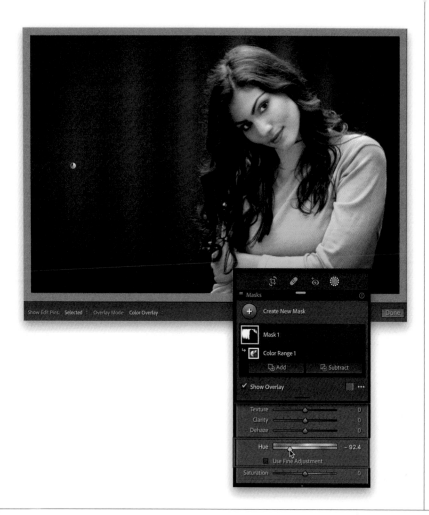

Step Three:

Once you have enough of the background color selected, changing the color is super-simple, as well. Scroll down to the **Hue color ramp** down in the adjustment sliders and simply click-and-drag the slider directly below the ramp to whichever color you'd like for your background. As soon as you start to drag that slider, the red-tinted overlay disappears, so you can clearly see the color you're choosing.

TIP: You Can Add More Than One Eyedropper

You're not limited to just one eyedropper to sample a color. You can press-and-hold the Shift key and add up to five different areas to sample color from, and those colors are added to your Color Range mask.

Step Four:

Below, is a before/after of our changing the background color behind our subject, using the Color Range mask. Remember, you can use this technique to add to an existing mask you already have in place, or subtract from one, the same way we did with the Luminance mask (see page 184).

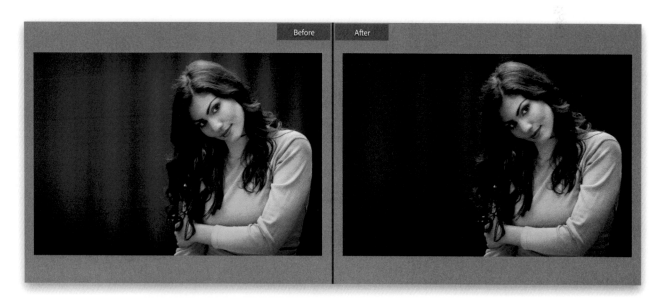

Ten *More* Masking Things You'll Want to Know

Before we move on to the next chapter, here are some more handy little features and techniques to know about masking:

#1: The Hidden Amount Slider

This is such an awesome feature because it allows you to lower (or increase) the intensity of the edits you've made with the adjustment sliders. But, rather than having to lower each slider the appropriate amount, this one slider lowers them all for you, which is just so incredibly handy (especially if you're reviewing your edits and you feel like you went a bit too far—you can reach for this slider and just pull it all back a bit). The Amount slider is hidden, but it's easy to find once you know where to look: click on the down-facing arrow to the right of the word "Effect," at the top of the adjustments panel (circled here in red, on the left), and it tucks the sliders out of the way, replacing them with the Amount slider (as shown here, on the right).

#2: Changing the Red Tint Color

If you like the red-tinted overlay (I do), but you're working on an image with a lot of red in it (like a robin, or a red car, or robin sitting on a red car), you might not be able to see that tint clearly. Your first thought might be that you have to change to a different mask view (we looked at these back on page 170), but you can actually just change the red tint color to pretty much any color you'd like. Click on the red color swatch in the bottom-right corner of the Masks panel (as shown here), which brings up a **Color Picker** where you can click on any overlay tint color you'd like. To reset it to red, just click on the red Custom Colors swatch in the picker, and then close it by clicking on the "X" in the top right.

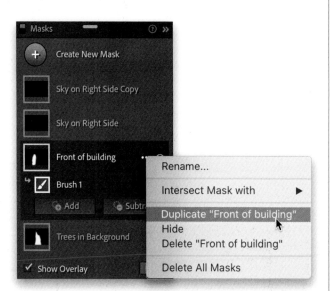

#3: Duplicating & Moving Masks

If you have a mask in place and you want a copy of it—to maybe use somewhere else in that same image—in the Masks panel, click on the three dots to the right of the mask's thumbnail, and choose **Duplicate [name of mask]** from the pop-up menu (as shown here). Once you have the duplicate, you can click on its Edit Pin on your image and drag the mask to whatever position you want. *Note:* You don't have to duplicate a mask to move it—you can click-and-drag an Edit Pin any time you want.

#4: Another Way to Dock the Masks Panel

Like I mentioned back on page 170, I dock my Masks panel in the right side panels, so it appears beneath the toolbox, by just dragging-and-dropping it over there. Another way to easily do this is to just Right-click on the panel's header, choose **Dock to Panel**, and it docks right beneath the toolbox for you.

#5: Resizing the Floating Masks Panel

If you leave the Masks panel floating (rather than docking it with the right side panels), you can have it cover less of your image by clicking on the two right-facing arrows in the right side of the panel's header. That shrinks the panel down to a tall, vertical strip with just the mask icons showing (as seen here, on the right).

#6: Intersecting One Mask with Another

If you have a mask in place and you want to intersect it with another mask (leaving the area where the two masks overlap as the resulting mask), in the Masks panel, click on the mask you want intersected, then click on the three dots that appear to the right of the mask's thumbnail. From the pop-up menu that appears, under **Intersect Mask With**, choose which of the masking tools you want to use to intersect with your current mask (as shown here, where I chose Select Sky to intersect with my current Select Subject mask).

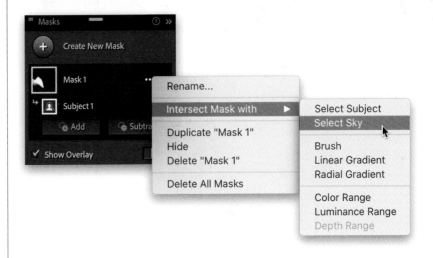

#7: Existing Adjustment Brush & Filter Edits Become Masks

If you open an image you already edited in a previous version of Lightroom Classic, one where you made edits using the Adjustment Brush, or the Radial Filter or Graduated Filter tools, those edits will still be in place, but they'll now appear as masks. So, you'll still see those edits, and still be able to work with them, from the Masks panel now (as seen here, where on the left, I had used the Graduated Filter tool, and on the right, it now appears as a Linear Gradient mask).

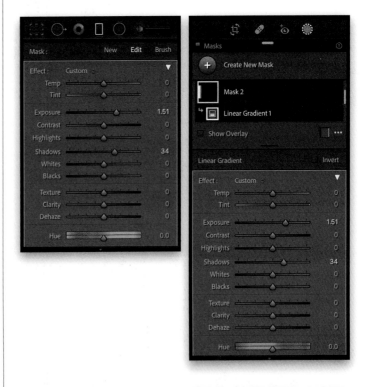

Your sliders get moved a lot during the editing process

Double-click on Effect and it resets them all to zero

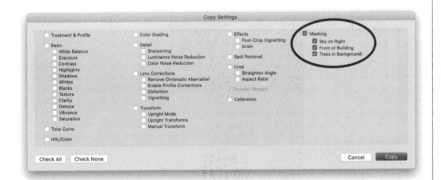

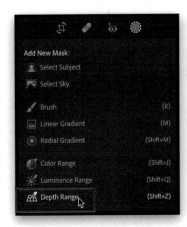
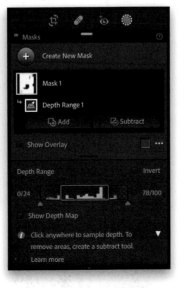

#8: Resetting Your Sliders

As we're editing, we sometimes wind up moving a lot of adjustment sliders. If we don't like the results and want to reset them back to zero, that could be an awful lot of sliders to have to reset one by one. Now, you could just delete the mask and start over, but luckily, there's an easier way to do this: just double-click directly on the word "**Effect**," in the top-left corner of the panel (as shown here, circled in red), and it resets all your sliders to zero for you.

#9: Copy/Paste/Sync Masks

If you copy-and-paste (or sync) settings from one image to another (by clicking on the Copy button, at the bottom of the left side panels, or the Sync button, at the bottom of the right side panels, when you have multiple images selected), you have the option of choosing which masks you created get copied-and-pasted. On the right side of the Copy Settings (or the Synchronize Settings) dialog, you'll see a **Masking checkbox**, and below that are the individual masks you can choose to include or exclude (this is another reason to rename your masks, if you have more than a couple, as seen here. Otherwise, they just appear as "Mask 1," "Mask 2," etc.). Just turn on the checkboxes beside the masks you want to copy-and-paste.

#10: The Depth Range Mask

At the bottom of the Add New Mask panel is a choice that's always grayed out: **Depth Range**. The reason is: it's only for images where a depth map is created (like those taken with a recent iPhone in Portrait mode, which saves the out of focus area behind your subject as a depth map, or those taken with Lightroom mobile's camera; see page 455 for more on this). When you have that type of image in Lightroom, you can choose that mask, and then adjust it using the Depth Range sliders. Once the mask is in place, you can then use the editing tools to adjust only that masked area.

SPECIAL EFFECTS
making your images look…well…special!

When you think of the phrase "special effects," what's the first thing that pops into your mind? Hollywood movies, right? No? That's not what popped into your head? Well, that's odd. May I ask, and I'm trying not to sound judgemental here, what did pop into your head when I said "special effects?" It's okay, you can share—this is a safe space and you're among friends. A chili dog? Seriously? That's what popped into your head when I said "special effects?" Really? Okay, now I am being judgemental because…come on…a chili dog? I just don't know what to say (and that totally took the wheels off my entire train of thought for this chapter opener). By the way, since you brought up chili dogs (and I consider myself somewhat of a chili dog connoisseur), did you know that on a "real," proper, honest-to-goodness chili dog, the chili on top does not have beans? That's right—if you go to a serious hot dog hut and ask for a chili dog, if the place is legit, there will be no beans in that chili. Also, I'll never forget a sign I saw at a famous hot dog stand in Indianapolis (I think it was Portillo's Hot Dogs), which read something to the effect of: "Once you're over 18, you don't put ketchup on your hot dog anymore." I knew right then that this place spoke to me. Okay, back to our special effects thing. I have to admit, your "chili dog" answer, when I set you up to answer "Hollywood," kind of threw me (I was not expecting that), so let's try another angle. Instead, can you tell me which movies you have seen? *Transformers*? Okay, this is great—now we're getting somewhere. Now, remember how in the movie those cars transformed into giant robots and battled the Decepticons, and they flew and they shot rockets? That was all Hollywood special effects. Wait, you don't recall there being any cars or robots? Okay, you beat me. I'm done. You win. You can skip this chapter.

Applying "Looks" Using Creative Profiles

Back in Chapter 5, we looked at applying profiles to your RAW images. Well, besides those, there are a bunch of nice special effect "looks" you can apply with just one click, and they're not just limited to RAW photos—you can add them to JPEGs, TIFFs, whatever. Plus you can control the amount of the effect, as well. These creative profiles have a big advantage over standard presets because presets just move your Develop module sliders to a "pre-set" amount (like somebody processed the photo for you). However, creative profiles don't move your sliders—they're totally separate—so after you apply a creative profile, you can still edit your image any way you want.

Step One:

Here's our original image (remember, creative profiles don't need a RAW image—you can apply them to JPEGs, TIFFs, and PSDs, as well). In the Develop module, at the top of the Basic panel, to the far right of Profile, click on the button whose icon looks like four little rectangles (shown circled here in the inset) to bring up the Profile Browser (seen in the next step). You can also just choose **Browse** from the bottom of the Profile pop-up menu.

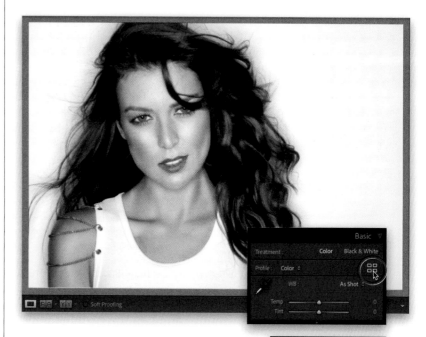

Step Two:

Clicking that icon brings up the **Profile Browser** with rows of thumbnails that show a preview of each look applied to your image, so you can quickly see what looks good without even having to click on one. You can also preview these profiles on your full-size image by just hovering your cursor over any thumbnail. There are four sets of creative profiles here: Artistic, B&W (which I cover in this chapter on page 231), Modern, and Vintage. To apply a profile, just click on one. Here, I clicked on the very first one in the Artistic set called "Artistic 01," and it adds a purple/reddish tone to the image and increases the contrast. If you don't like a profile you've clicked on, press **Command-Z (PC: Ctrl-Z)** to undo it or click on a different profile.

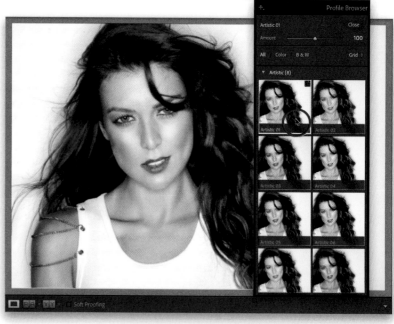

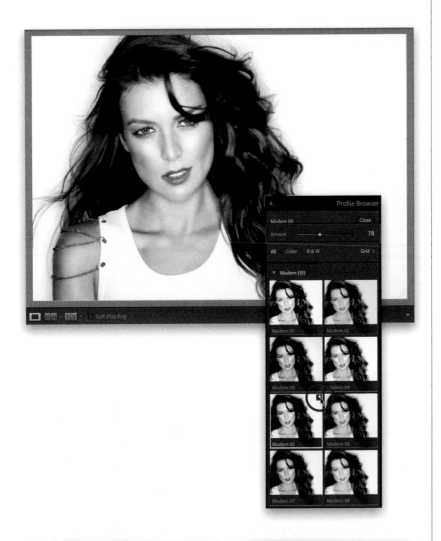

Step Three:

Let's try another set: Scroll down to the Modern profiles, and click on one you like (here, I chose Modern 05, which has kind of a nice desaturated look). Once you apply a creative profile, an **Amount slider** appears at the top of the browser so you can increase the intensity of the look or back it off if it's too much. Here, I lowered the Amount to 78 (the default is 100), so it's not quite so desaturated. (*Note:* The Amount slider only appears for Creative Profiles. RAW profiles don't have an Amount slider.) If there's a profile you really like, you can save it as a favorite and it will appear at the top of the browser (so you don't have to go digging for it). You do that by clicking on the **star icon** in the top-right corner of the profile you have selected (it doesn't appear until you move your cursor over or click on a particular profile).

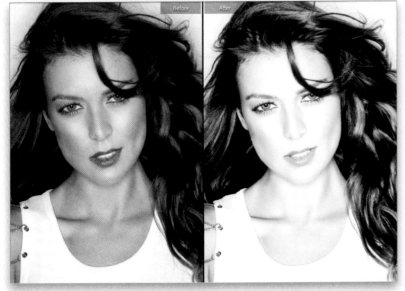

Step Four:

Let's try one more. Scroll down to the B&W set and find one that looks good to you. Here, I went for a B&W profile (B&W 02) that adds a tone of highlights and contrast and her skin gets nearly blown out, so all her features stand out against it. It's not a traditional black-and-white look, but I dunno, maybe that's why I like it. (I pressed the **Y key** to get this side-by-side before and after.) When you're done choosing profiles, click the Close button at the top of the Profile Browser (you can see it in the previous step) to return to the Basic panel. If you apply a profile and later change your mind about it, just choose **Color** from the Profile pop-up menu to return to the default color profile.

Virtual Copies—
The "No Risk" Way
to Experiment

Let's say you added a vignette to a bridal shot. Well, what if you wanted to see a version in black and white, and a version with a color tint, and a really contrasty version, and then maybe a version that was cropped differently? Well, what might keep you from doing that is having to duplicate a high-resolution file each time you wanted to try a different look, because it would eat up hard drive space and RAM like nobody's business. But luckily, you can create virtual copies, which don't take up space and allow you to try different looks without the overhead.

Step One:

You create a virtual copy by Right-clicking on the original photo and then choosing **Create Virtual Copy** from the pop-up menu (as shown here), or using the keyboard shortcut **Command-'** (apostrophe; **PC: Ctrl-'**). These virtual copies look and act the same as your original photo, and you can edit them just as you would your original, but here's the difference: it's not a real file, it's just another thumbnail with a set of instructions, so it doesn't add any real file size. That way, you can have as many of these virtual copies as you want, and experiment to your heart's content without filling up your hard disk. So, let's go ahead and create a virtual copy.

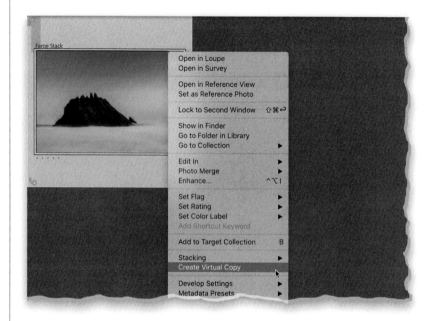

Step Two:

Once you create a virtual copy, you'll know which version is the copy because (a) virtual copies have a curled page icon in the lower-left corner of the image thumbnail (circled in red here) in both Grid view and in the Filmstrip, and (b) virtual copies are named Copy 1 (as seen here), Copy 2, and so on.

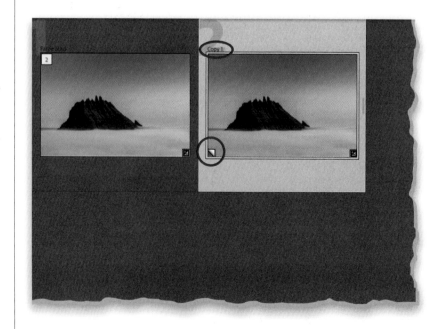

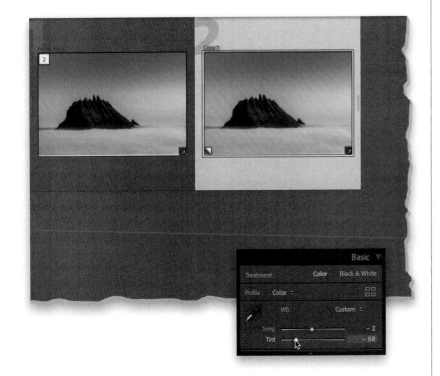

Step Three:

This virtual copy is pretty much independent from the original, so you can make changes to it, experiment, and get creative with no risk to your original, and again, it doesn't take up any real space on your hard drive, so you can make as many as you want. Let's go ahead and tweak the white balance on this virtual copy. Here, I dragged **Temp** to –2 and **Tint** to –58, and you can see the original (on the left) is untouched. This is why virtual copies are so awesome—you can experiment as much as you want. *Note:* When you edit a virtual copy, you can hit the Reset button at the bottom of the right side panels to return it to how it looked when you first created it. Also, you don't have to jump back to the Library module each time you want to make a virtual copy—that Command-' (PC: Ctrl-') shortcut works in the Develop module, too. To delete a virtual copy, just click on one and then hit Delete (PC: Backspace) .

Step Four:

One thing I use virtual copies for is to try a bunch of different edits to see which one I like the best. For example, go ahead and make seven more virtual copies (so we have a total of nine thumbnails— the original and eight copies) and change the white balance of each one. Then, select all nine and press the **N key** on your keyboard to enter **Survey view** (seen here), so we can clearly see which one (or ones) we like best (and we could mark them as Picks or give them a 5-star rating). To remove a thumbnail from Survey view, move your cursor over it and click the "X" that appears in the bottom-right corner. What's really cool about these virtual copies is that they act just like the real thing. If you wanted to export one as a JPEG, you'd click on it, choose Export from the File menu, and it pings the original to export a copy that looks identical to your virtual copy. It's like they're separate, but they all point to the original if it's time to export or jump over to Photoshop.

Using Presets for One-Click Looks

Lightroom comes with a decent-sized collection of pre-designed presets, which give you different looks and do different tasks for you. You click on a preset, and it moves all the sliders and settings it needs to create that look for you (it's like having a friend that's really, really good at Lightroom). Besides using the default presets that come built-in with Lightroom, you can find loads of Lightroom presets online (some free, and some not) that you can import and start using in your own work. Here's how to use the ones that are there and how to import any that you download:

Where They Live:
They're called "Develop presets," so they're found in the **Presets panel** (seen here) in the left side panels of the Develop module. They're separated into groups (sets) to make it easier to find what you're looking for (portrait presets, cinematic looks, futuristic looks, and so on), and then down at the bottom are more production-type presets for sharpening, lens corrections, etc. At the top of the panel are your User Presets (the ones that you create and save yourself—more on these on page 218—or those that you download and import).

Seeing Previews/Applying a Preset:
You can see a preview of how any of these presets will look, even before you apply one, by simply hovering your cursor over it in the Presets panel. The effect appears both up in the Navigator panel, at the top of the left side panels, and on your image itself—as seen here, where I'm hovering over preset **TR03** in the Travel group, which puts a greenish/blue tint on the image and boosts the contrast, among other things. Check out some of the other presets in this group while you're there (I like TR10 a lot), but of course, these can look vastly different depending on the image you're working with. To apply a preset, all you have to do is click on it. If you want to tweak things after the preset has been applied, you can just grab the sliders in the Basic panel and go to town!

Hiding Presets You Don't Need:

If you find yourself not using Adobe's built-in presets, or if there are just groups of theirs (or anybody else's for that matter) that you don't use, you can hide them from view. It doesn't delete them, so you can make them visible again at any time. Here's how to hide them: In the right side of the Presets panel's header, click on the + (plus sign) button and choose **Manage Presets**. That brings up the Manage Presets dialog (seen here) where you can turn off the checkboxes for any groups of presets you want to hide. Click Save when you're done (and remember, they're not deleted—just hidden). To make them visible again, come back to this same Manage Presets dialog and turn their checkboxes back on.

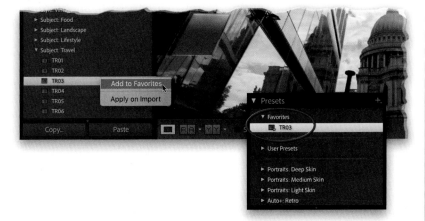

Saving Favorites:

If you find that you apply certain presets often, you can save them to a Favorites group so they're not only grouped together, but appear right at the top of the panel. To add a preset to your Favorites group, Right-click on the preset and choose **Add to Favorites** (as shown here). Now, when you go to the Presets panel, at the very top, you'll see a new Favorites group and inside it will be just those presets you chose to add as favorites (as seen here, where I added that Travel TR03 preset to my Favorites).

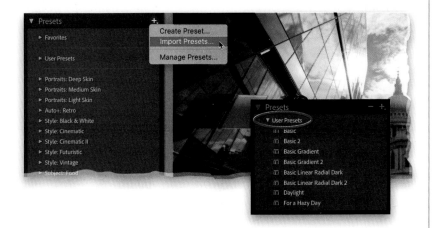

Importing Downloaded Presets:

Like I mentioned, you can find a ton of Lightroom presets online that you can download, import into Lightroom, and apply to your images. Once you've downloaded some, In the right side of the Presets panel's header, click on the + (plus sign) button and choose **Import Presets** (as shown here). Now, just navigate to the preset, or folder of presets you downloaded on your compter, click Import, and you'll now find them under your User Presets group (as seen here).

Creating Your Own Presets

If you come up with a look you really like and want to be able to use that same exact look again, you can save those settings as a preset and apply it to a different photo with just one click. You can start from scratch or, of course, you can use any built-in preset as a starting place and customize the look the way you want it, and then you can save that as your own custom preset. Here, we'll look at how to build your own preset from scratch (it's easier than it sounds):

Step One:

The first step is to apply a look you like (in this case, we're starting from scratch, so the image you see here is the original image). What we're going to do here (well, in Step Two) are three simple things: (1) pull back the highlights just a little, so her face isn't too bright; (2) add some color grading; and (3) we're going to add a stronger than usual vignette (darkening) around the outside edges off the image (we'll look at vignetting more on page 225). So, that's the plan, and after we apply those edits, we'll save them as a preset.

Step Two:

First, go to the Basic panel and just drag the **Highlights slider** to the left a bit (I dragged it to –16). Then, go to the **Color Grading panel**. For the Shadows, click-and-drag the circle in the middle of the color wheel downward toward blue to add lots of blue in the shadows. For the Midtones, click-and-drag the circle in the color wheel toward magenta to add some pink tones there, and lastly, for the Highlights, click-and-drag the circle in the color wheel toward yellow (as shown here). Now, go to the Effects panel and in the **Post-Crop Vignetting section**, drag the Amount slider to the left (I dragged it over to –36, much more than my usual –11, but we're going for a "look," so I pushed it a bit). Now, let's save all these settings as a preset, so we can apply this same look to other photos with just one click.

Step Three:
In the left side panels, click on the + (plus sign) button in the right side of the Preset panel's header and choose **Create Preset** to bring up the **New Develop Preset dialog** (seen here). Give your new preset a name (I named it "Heavy Blue Shadows"). Now, in the Settings section, we only want to include the things we did to this image (we want the checkboxes beside just those settings turned on) and we want everything else to remain unchecked (turned off). If everything is turned on, a quick way to turn on just the ones we adjusted is to click the Check None button at the bottom left of the dialog, which turns off all the checkboxes for you. Now, just turn on those beside Highlights, Color Grading, and Post-Crop Vignetting (the things we applied, as seen here). You will always need to leave the Process Version checkbox turned on (long story, and a boring one).

Before

Step Four:
Now, click the Create button to save all the edits you just made as your own custom preset, which will appear under the User Presets group in the Presets panel. To apply this preset to a different photo, just click on a photo down in the Filmstrip and then click on the preset in the Presets panel (as shown below).

TIP: Updating a User Preset
If you tweak a User Preset and want to update it with the new settings, Right-click on it in the Presets panel and choose **Update with Current Settings** from the pop-up menu.

TIP: Deleting a User Preset
To delete a User Preset, just click on it, and then click on the – (minus sign) button to the left of the + (plus sign) button in the Presets panel's header.

After

Creating Presets That Automatically Adapt to Your Image's ISO

If you're just changing the white balance or the Highlights amount, the ISO you shot the image with doesn't matter all that much in the editing process. But, when it comes to things like applying noise reduction (for times when you shot at a high ISO), it does matter. Luckily, you can create presets that can, for example, apply more noise reduction (or less sharpening, etc.) to higher ISO shots automatically. These ISO adaptive presets look at the ISO metadata embedded into the image, so it can apply the right amounts for you. It's pretty slick, and easy to set up.

Step One:

This whole idea is based on using at least two (or more) source images to set this up. This would be one photo taken at your camera's cleanest native ISO (for my particular camera, that would have me using one photo taken at ISO 100), and another taken at what would be the top ISO you'd normally use (here, I'm going to use 1,000 ISO, as this preset would be for football shoots during daylight). So, you need two shots like that: one at the low end of your ISO range and one at the high end. You can use more photos if you'd like—I don't, I just go with two—but if you shoot from 100 ISO to 25,600 or higher, then you should use more images in between. Select the low-ISO image and go ahead and create the look you want, including any noise reduction and sharpening. Here, I added Contrast, increased the Whites and Blacks, and added some Texture and Clarity for a high-contrast look, then I went to the Detail panel and increased the **Sharpening Amount** to 90 and the **Radius** to 1.2.

Step Two:

Now, select the image with the higher ISO, and then click the Previous button (at the bottom of the right side panels) to apply the settings we just tweaked on the previous image to this higher-ISO image. On this high-ISO image, go to the Detail panel and in the Noise Reduction section, increase the Luminance and/or Color amounts (see page 258) until the image looks good to you. You can also set what you feel is the appropriate amount of sharpening for this high-ISO image, as well. Basically, get this image looking how you'd like it.

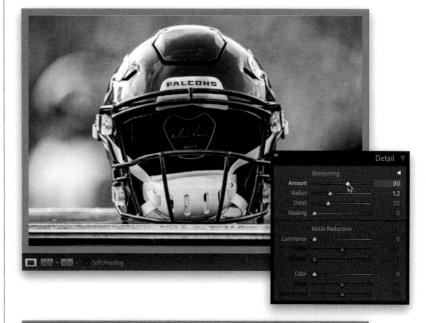

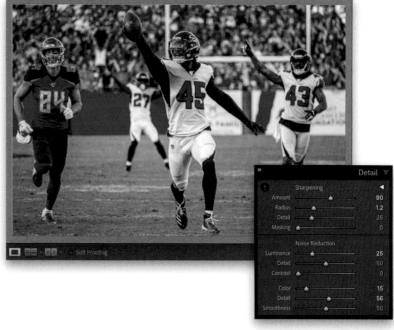

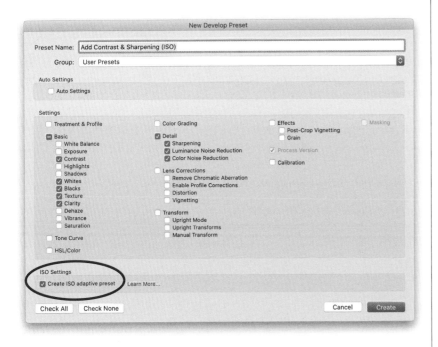

Step Three:

Now, down in the Filmstrip, Command-click (PC: Ctrl-click) to select both images (the low- and high-ISO images), then go to the Presets panel, click the little + (plus sign) button in the right side of the panel's header, and from the pop-up menu, choose **Create Preset**. When the New Develop Preset dialog appears, give your preset a name (you might want to include "ISO" in the name, so you know it's an adaptive ISO preset). If all the checkboxes are turned on, click the Check None button at the bottom left to turn them all off, and then just turn on those for the things you want to include in your preset (don't forget to turn on Sharpening and Noise Reduction). At the bottom of this dialog, in the ISO Settings section, you'll see the **Create ISO Adaptive Preset checkbox**. Turn that on. *Note:* If that checkbox is grayed out, you either (a) don't have at least two images selected, or (b) the two images you have selected don't have different ISOs.

Step Four:

Click the Create button to create your preset, and you can now use it like any other preset. But, when you apply this preset to other images, it will check the ISO the image was taken at and adjust the Noise Reduction and Sharpening amounts appropriately based on the image's ISO. Here, I selected a different image and applied my ISO adaptive preset, and you can see it increased the amount of Luminance and Color Noise Reduction since my ISO was higher than 100, but not as much as in Step Two, to match the lower ISO (320) of this image. Pretty slick stuff, right?

Other Places to Apply Presets

Of course, the most obvious place to apply a preset is from the Presets panel, but there are other places where you can apply them from that can save you time and make your preset life easier.

Apply Presets During Import:
If you're planning to apply a particular preset (either a built-in one or one you created) to a bunch of images that you're importing, you can actually have that preset applied to them as they're imported into Lightroom. You do this right within the Import window. Just go to the Apply During Import panel, where you'll choose which preset you want to apply from the **Develop Settings pop-up menu** (as shown here).

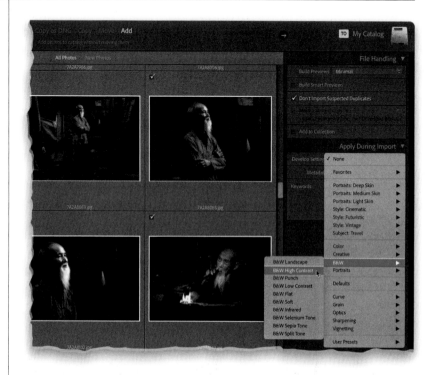

Apply Presets in Quick Develop:
Another place you can apply these Develop presets is from right within the Library module in the Quick Develop panel. At the top of the panel, you'll see the **Saved Preset pop-up menu**. Click-and-hold on it and a menu of presets appears (seen here) that you can you apply to your selected photo(s).

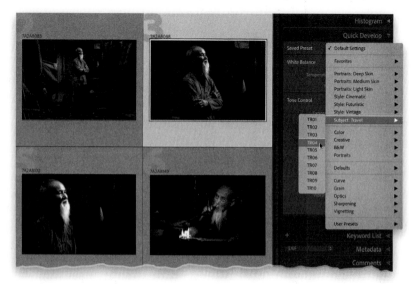

Anytime you have just one color you want to adjust in an image (for example, let's say you want all the reds to be redder, or the blue in the sky to be bluer, or you want to change a color altogether), one place to do that would be in the HSL panel (HSL stands for Hue, Saturation, Luminance). This panel is incredible handy (I use it fairly often) and luckily, because it has a TAT (Targeted Adjustment tool), using it is really easy. Here's how this works:

Changing Individual Colors

Step One:
When you want to adjust an area of color, scroll down to the **HSL panel** in the right side panels. That HSL acronym corresponds to the three tabs you see across the top of the panel: Hue, Saturation, and Luminance. Those aren't just words; those are clickable tabs, and you can adjust each of those attributes separately, which is what we're going to do here (well, in the next step anyway). The Hue panel lets you change an existing color to a different hue by using the sliders, and if you understand which combination of sliders make up the exact color you want to adjust, you can just click-and-drag those sliders. However, for the rest of us, we'll need a little help, and luckily, it's there waiting for us.

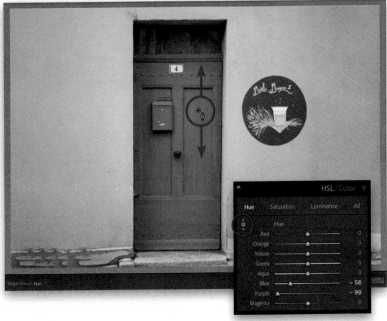

Step Two:
Our color helper is the **Targeted Adjustment Tool** (or TAT, for short), which makes these color adjustments super-easy. First, make sure the **Hue tab** is selected at the top of the panel, then click on the TAT (it's that little round target, circled here in red, near the top left of the panel). Here's how it works: Let's say we want to change the Hue of the door. Click-and-hold the TAT on the door and drag up or down and it knows exactly which sliders correspond to the area where you clicked and it moves only those sliders as you drag up or down (as shown here, where I clicked on the door and dragged downward to change the hue from purple to blue). As I dragged, it moved the Blue and Purple sliders to the left to the right amounts (as seen here).

Step Three:

Okay, so the Hue tab is where we go to change our hue. Now, click the **Saturation tab**, and you'll notice the sliders are all reset to zero. That's because these sliders are just for adjusting saturation (if you click back on the Hue tab, your previous changes will still be in place). Saturation controls how vivid our colors are, so now that you're in the Saturation panel, click-and-drag downward on the door, and you'll see it desaturates the door's colors (as shown here—compare this door to the one in Step Two). If you drag upward instead, it will make that blue door a more vibrant blue, and the farther up you drag and the more it moves those sliders for you, the more vibrant that door will become. Okay, that's the "H" and "S" of HSL. One more to go.

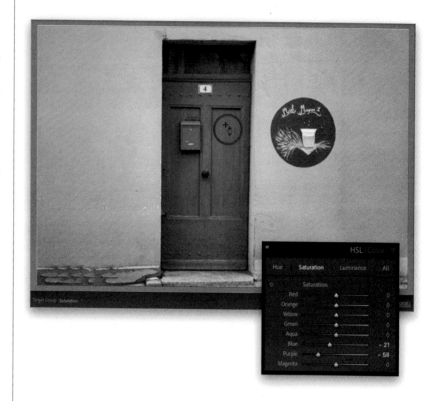

Step Four:

Click on the **Luminance tab** at the top of the panel and a new set of eight color sliders appears all zeroed out. Luminance controls the brightness of a color, so let's use it on the wall. Take the TAT and click-and-drag straight downward on the wall, and as you can see here, its color gets much darker (the luminance for both Orange and Yellow has decreased). Two last things: Clicking the All tab displays all three panels in one long, scrolling, vertical list. If you click on Color in the panel header, it switches to the Color panel, which breaks the colors all into sets with three sliders (HSL) for each color. But, regardless of which layout you choose, they all work the same way.

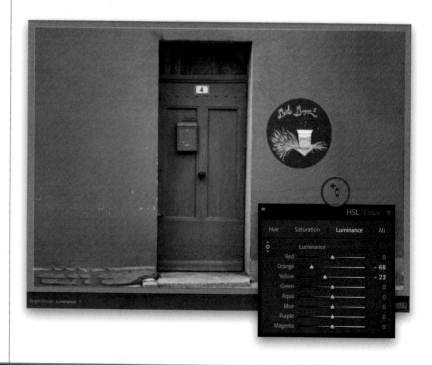

There are two types of vignetting: The first is the "bad" vignette, which is caused by your lens, and it's when you see dark areas in the corners of your image (I'll show you how to get rid of this on page 284). Then, there's the "good" vignette, which doesn't just appear in the corners. It's a very popular effect that evenly darkens the edges all around your entire image to draw the viewer's eye toward the center. I use this as a finishing effect with a subtle enough amount you wouldn't even know I've added a vignette until you toggle its visibility on/off. Then you'll realize how much a subtle vignette can add.

How to Add Edge Darkening (Vignette) Effects

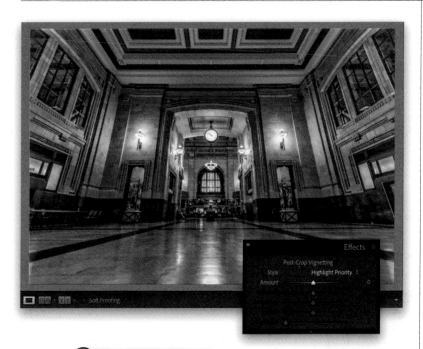

Step One:

Here's our original image, and we want to subtly darken the outside edges all the way around to draw the viewer's eye to the center and de-emphasize parts that don't matter as much. Plus, it just looks good (as long as it's subtle. If you go too far, 2004 will call and ask for their vignette back). Scroll down to the Effects panel in the right side panels, and you'll see the vignette controls right at the top (it's called **"Post-Crop Vignetting"** because if you crop the image, it will automatically re-adjust itself, so the effect doesn't get cropped away). At the top of this section is the Style pop-up menu and you have three choices: (1) Highlight Priority (the default), (2) Color Priority, and (3) Paint Overlay (though the only one that looks good is Highlight Priority, so it's the only one I ever use).

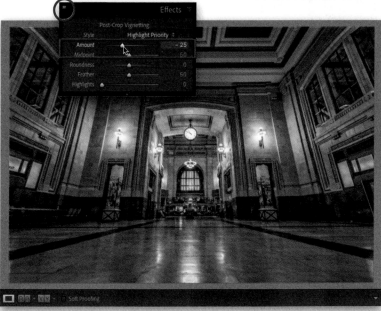

Step Two:

The **Amount slider** determines how dark the edges will be, so go ahead and drag it over to –25 (as I did here) and it adds a fairly subtle edge darkening all the way around the outside edge of your image. Now, looking at this, you might think, "I'm not sure it really did anything," but this will help: in the left side of the panel header is a toggle switch (circled here in red), which turns on/off the effect. Toggle that bad boy on/off a few times and you'll be like, "Ohhhhh. Wow, that does make a difference." Give it a try and you'll see.

Step Three:

There's only one more slider you might adjust here from time to time and that's the **Midpoint slider**. It controls how far your darkening extends from the edges into your image. Its default setting is actually really good, but to totally "get" what this sliders does, we're going to create something that looks pretty awful (as seen here), but it will really help the learning process. In that Effects panel, drag the **Feather slider** all the way to the left to zero, which gives you a fairly hard edge (as seen here, but outside of this exercise, I never touch the Feather slider—I leave it set at its default of 50). Okay, now drag the Midtone slider back and forth a few times (I also decreased the Amount to –33), and you'll see the oval's size change. As you drag to the right, the oval grows and less and less of the image is getting darkened (the area outside the oval). This will make a lot more sense when you drag the slider yourself, but you can see here, where I made the oval really large, that pretty much just the areas in the corners are getting darkened. If I drag the slider farther to the right, making the oval even bigger, the darkening will literally be only in the corners.

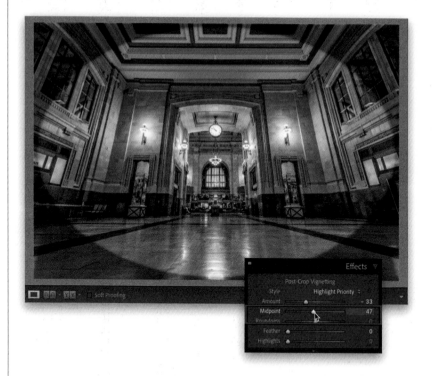

Step Four:

I don't ever mess with the Roundness slider (and you probably won't either), but it controls how round the vignette is. (While you still have the Feather amount set to zero, drag the Roundness slider back and forth to see how it affects the oval. Okay, now reset your Feather amount to 50.) So, I use this edge vignetting in my own workflow as a "finishing move"—something I add at the very end to give the image that little finishing touch—and I have a magic number that I use pretty much every time that adds a very subtle amount (again, toggle it on/off to see what a difference it makes—it's so subtle no one knows I even added it). So, what is this magic number? It's –11. Anticlimatic, I know, but that's what I use.

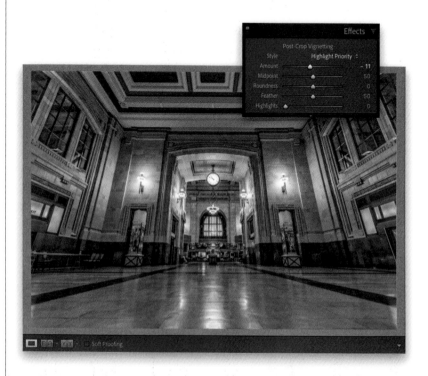

You see this look, and variations of it, all over Instagram every day. A combination of flattening the overall tones and adding "grit" to the image, along with a slight color tint, gives it its own "city" look. It takes a few sliders, and a simple Curves move, but it's really easy. Well, it's easy if you don't mind moving a lot of sliders.

The "Gritty City" Look

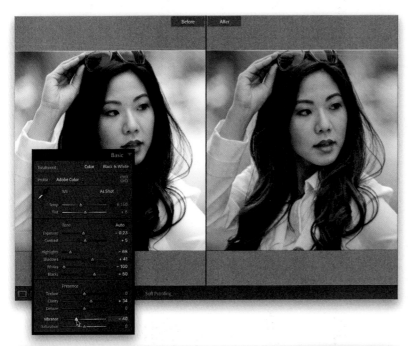

Step One:
Start in the **Basic panel** by clicking the Auto button just to get a reasonable starting place. Now, drag the Whites slider all the way to the left to −100, and then set the Blacks slider to +50. Next, we're going to crank up the "grit" by adding some Clarity (here, I used +34, but depending on the image, you can go as high as +40 or +45). To get kind of a desaturated-skin look, drag the Vibrance slider to the left quite a bit (I dragged it to −40). Don't go too far or you'll wind up with a black-and-white image. You still want some color, but much less vibrant skin tones for the most part (like you see here). You can leave the other sliders where the Auto setting set them (well, for now anyway).

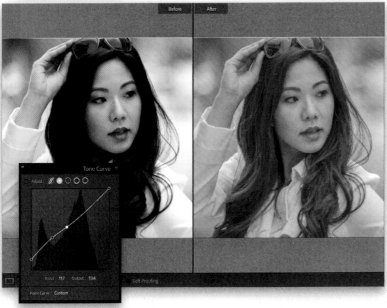

Step Two:
Next, go to the **Tone Curve panel** and make sure the Point Curve is visible (as seen here. Click on the circle with the white dot at the top of the panel if it's not). We're going to use this curve to give our image a "flat" look. So, click on the bottom-left control point and drag straight upward a bit (drag it right along that left side). Then, click in the center of the diagonal curve line and drag downward just a tiny bit to deepen the midtones. Now, click right in between those two control points to add another point, and then drag up a little. In short: make the curve look like the one you see here. If you mess up, just Right-click on a point, choose **Delete Control Point**, and start again.

Step Three:

Now let's bring in a dash of color. Go to the **Color Grading panel**, click on the circle in the center of the Shadows color wheel, and then drag it downward and to the left toward blue. Next, go over to the Highlights color wheel, click in the center of that wheel, and then drag the circle a little way toward yellow. Just a little—don't drag too far or you'll get very saturated yellows in your highlights. Now, you see the slider beneath the Shadows color wheel? That controls the brightness (luminance) of the color you added to the shadows. In this case, drag that slider almost all the way to the left. Then, drag the luminance slider beneath the Highlights color wheel almost all the way to the right to brighten the highlights color. Lastly, near the bottom of the panel, drag the Blending slider way over to the right (here, I dragged it to 69). Depending on your photo, you might have to play with these color wheels a bit to get blues in your shadows and yellows in your highlights, so it might take a second to dial those in, but you know what you're going for—a hint of added color, not a big crushing tint.

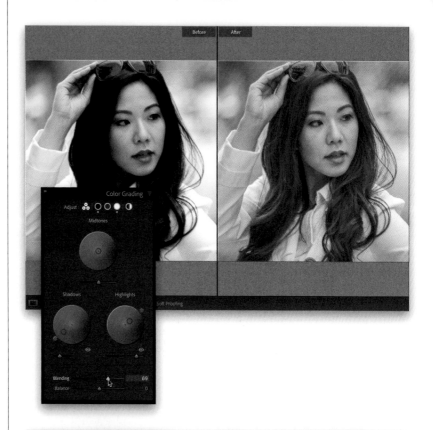

Step Four:

The final step in bringing the overall grit factor up (at least on this photo) is to go back to the Basic panel and (1) drag the **Contrast slider** way over to the right (I dragged it to +54), and then (2) drag the **Highlights slider** to the right, as well (to around zero), to create even more contrast. That's a lot of slider moving, but you're there. Now, save this as a preset (see page 218), so you can apply this gritty city look to other images.

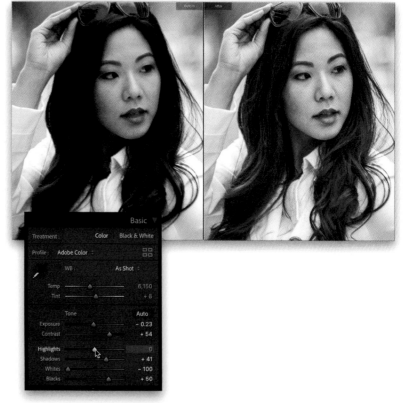

This matte finish look has become really popular in the last couple of years, and luckily, it's pretty easy to pull off. It's just a simple Curves move (and even if you've never used Curves before, you'll be able to do this).

Creating a Matte Look

Step One:

Here's the original image we want to apply our matte look to (or upon, or some word so my sentence doesn't end with a preposition. However, Grammarly says this: "It's not an error to end a sentence with a preposition, but it is a little less formal. In emails, text messages, and notes to friends, it's perfectly fine." So, since we're all friends here, here's the original image we want to apply our matte look to. Drops the mic).

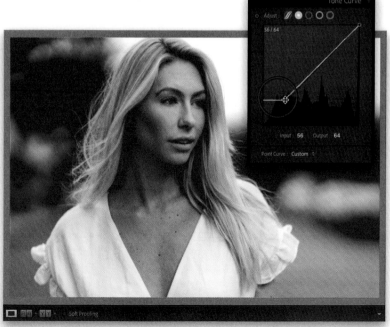

Step Two:

Go to the **Tone Curve panel** in the right side panels, and in the bottom-left corner of the curve grid, click on that round control point, and drag straight up, right along the left edge, until you reach the first horizontal grid line to create a low-contrast look (of course, depending on the image, you might need to drag a little higher or lower to make it look washed out and low-contrasty, so don't get hung up on that "hitting the grid line" thing). Now, just drag that point a bit over to the right and that blotches up the blacks and gives you the look. That's it—you've got the matte look, and are ready to rule Instagram like a boss!

Making Great Duotones

This is such a simple technique, but it's so effective. I learned this trick years ago from my buddy and Adobe Worldwide Evangelist, Terry White, who learned it from another photographer who works for Adobe, and now I'm passing it on to you. Of all the methods I've used to create duotones over the years, this is definitely the easiest, but crazily enough, it's also the best.

Step One:

Although the actual duotone is created in the Color Grading panel (in the right side panels), to get the classic duotone look, you should convert your image to black and white first. So, go to the **Profile Browser**, by clicking on the icon with the four little rectangles in the top right of the Basic panel, and scroll down to the B&W profiles (see page 212 for more on these). For now, just find one that looks good to you as a starting point, click on it to apply your black-and-white conversion (I chose B&W 04 here), and then click the Close button in the top right of the browser. *Note:* You can get this before/after view by pressing the **Y key** on your keyboard.

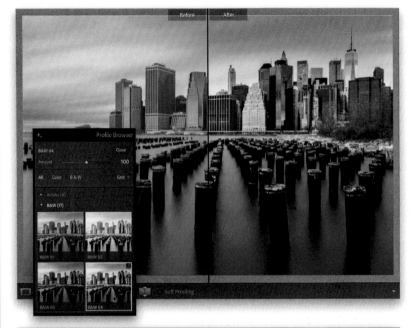

Step Two:

The trick to creating duotones is actually incredibly simple: you only add the color tint in the shadows, and you leave the highlights and midtones completely untouched (as tempting as it may be to mess with them, don't do it). Go down to the **Color Grading panel** and you'll see three color wheels. The bottom-left wheel controls the shadows, so click-and-hold in the center of the wheel and drag just a little ways upward toward a brown tone (as shown here). The farther you drag, the more saturated and vivid the color becomes, but we want a subtle amount of tint here, so just drag a little ways from that center. You can rotate that outside orange pin a little to dial in the exact brownish hue you want (or you could choose a different hue, maybe a blue or reddish duo color). That's it.

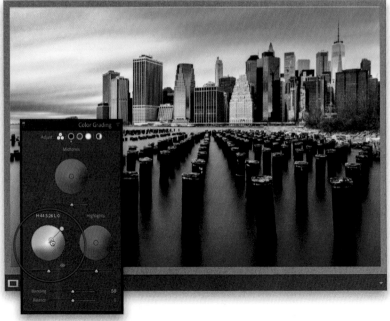

There are two methods for converting your images from color to black and white, and I'll start with the method that has been in Lightroom from the start. But, the newer method (definitely my preferred method) gives you more choices, live previews, and, I think, a far better result. Plus, once you've made the conversion, you can use the same techniques you learned in Chapters 5 and 6 to really fine-tune your conversion.

Creating Black-and-White Images

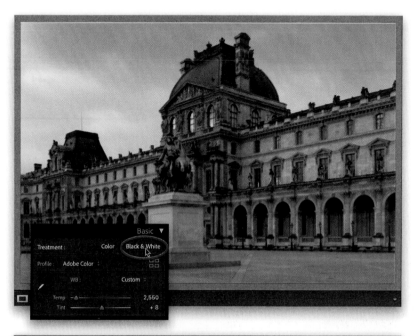

Step One:
Here's our original color image of a section of the Louvre Museum in Paris, and I thought it would make a good candidate for converting to black and white (not every color image makes a good black-and-white image, no matter how good the conversion technique). At the top right of the Basic panel is a **Black & White button**, but I don't ever recommend using it for your black-and-white conversion. Essentially, it just removes the color from your image and you wind up with a very flat-looking, boring conversion, so I don't use it at all.

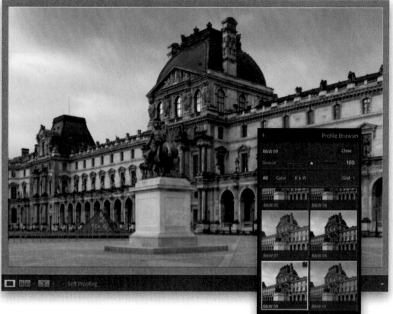

Step Two:
Instead, we can get a better conversion by clicking the icon with the four little rectangles just below that to bring up the **Profile Browser**. There are 17 different black-and-white conversion profiles here, some emulating classic darkroom conversions using different color filters to achieve different looks. The thumbnails display a preview of how the different conversions would look on your photo, but if you hover your cursor over any thumbnail, it gives you the preview on your actual image. Scroll through the list and find one that looks good for your image (I wind up using B&W 04 and B&W 09, as seen here, the most by far. I love how contrasty they are, but I still hover over all 17 just to see if there's a better conversion for the particular image I have onscreen).

Step Three:

A lot of what I do with a black-and-white image is to introduce a lot of contrast. While you will see some "flat matte-look" black-and-white images on Instagram (mostly portraits), for the most part, what makes a stunning black-and-white image is applying a good dose of contrast. Let's start by closing the Profile Browser (click on the Close button at the top right) to get back to the **Basic panel** and set the white and black points (see page 148), and then let's crank up the Contrast quite a bit. Don't be shy with that Contrast slider—it's your friend, especially when creating black-and-white images. I also pulled back the Highlights to –100 to help bring some detail back into the sky, and I opened up the Shadows a bit, so things don't get too dark. Okay, this is a decent start. *Note:* You'll notice that once you apply one of those B&W creative profiles, at the top of the Basic panel, you now have an Amount slider. That controls the amount of the B&W profile you chose—dragging it to the right intensifies the effect (usually making the image brighter with B&W conversions), and dragging it to the left lessens the effect, making it darker.

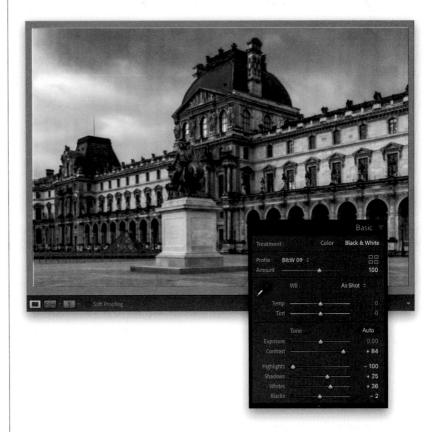

Step Four:

Once I get my base contrast set, then it's time to "bring out the big guns" with the mac-daddy of contrast, the Tone Curve. So, head down to the Tone Curve panel and from the Point Curve pop-up menu, choose **Strong Contrast** (as shown here) to add an "S-curve" to the diagonal line in the panel. That S-shape adds contrast, and the steeper you make that "S" (by dragging the points on the curve), the more contrast it adds. I love what just applying the preset did here, but if your image needs even more, click on the first point below the top-right one and drag it upward to brighten the highlights (making the S-curve steeper). To darken the shadows, click on the second point from the bottom-left one and drag downward (making the curve even steeper).

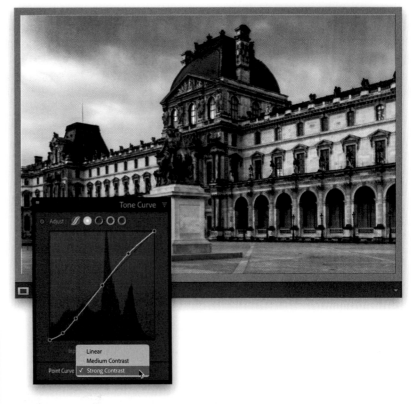

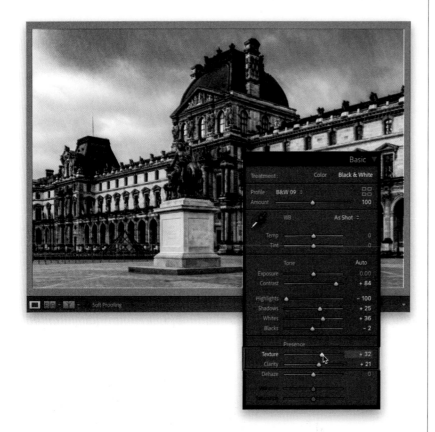

Step Five:

At this point, I boost the **Clarity** because it controls midtone contrast and it looks great on images like this with lots of detail. I also drag the **Texture slider** farther than the Clarity slider to further enhance the detail. Now, this image is starting to look super-crisp, on the verge of "crunchy," so I should probably back off on those numbers a bit, but I know in the printing process some of that will be lost, so I'm leaving it there for now. But, just a heads-up to keep an eye out while you're adding Clarity and Texture, so you don't get super-aggressive with them.

TIP: Would This Make a Good B&W Image?

Wondering if a particular photo would make a good black-and-white? Press the **V key** on your keyboard and it makes the image black and white. If it doesn't look good, press V again to return to the full-color image.

Step Six:

If you want to tweak particular areas of your image, there's a **B&W panel** (seen here) that lets you do that. Each color slider corresponds with the underlying colors that were in the image before the conversion. So, for example, if you wanted to make the sky in this black-and-white image darker, you'd drag the Blue slider to the left. If you're not sure which color slider controls which parts of your image, you can get the Targeted Adjustment Tool (called the TAT, for short—see page 223 for more on how it works), click on an area you want to adjust, and it knows the underlying sliders for that area and will move them for you as you drag up/down. This is how, before we had B&W profiles, we used to do our black-and-white conversions. We'd hit the Black & White button at the top of the Basic panel, and then come to this panel to tweak the colors. But, the profiles offer us so much more, and we can still use the B&W panel to tweak things.

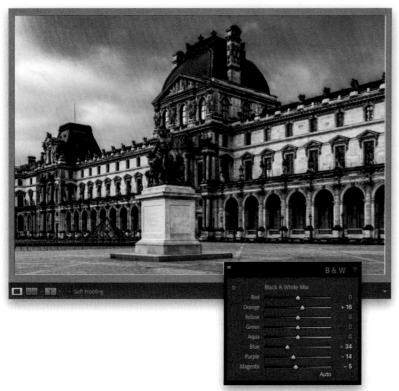

Step Seven:
The first part of this last step is optional, but it's a very popular one with photographers who want a more traditional darkroom black-and-white look, and that is to add some film grain to the image. Go to the Effects panel, under **Grain**, and increase the Amount to add a noisy/grainy look to your image (as I've done here, but at the small size you're seeing here in the book, I'm not sure it'll be that visible). The farther you drag this slider to the right, the grainier it gets (I dragged the slider over to 20). Lastly, you want a really sharp image, so don't forget to head over to the Detail panel and add some nice bouncy sharpening (if you're wondering what "bouncy" sharpening is, you're not alone. I just came up with that term as I was typing that sentence, but if I had to describe it, it's somewhere right between a "frisky" amount of sharpening, and some "zippy" sharpening).

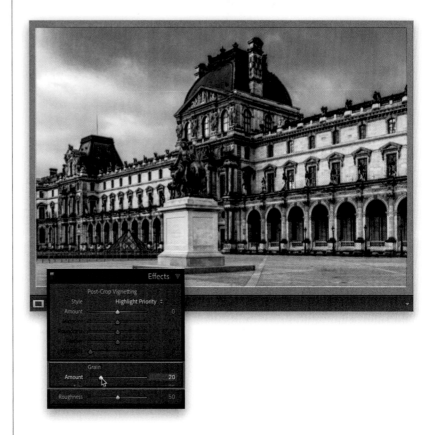

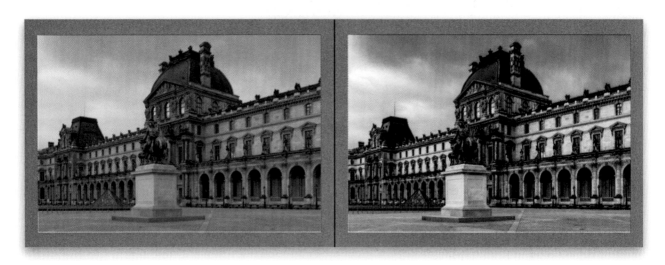

Step Eight:
Here's a before/after, where I'm comparing the conversion of the color image by just hitting the Basic panel's Black & White button (on the left) with the method you just learned (on the right).

Sun flare effects are really popular right now, and thankfully, they're pretty darn easy to do. Plus, there are two ways you can pull this off. I'll go with my favorite method first, and I'm adding the second method as a tip, since it uses the same settings—just a different tool.

Sun Flare Effect

Step One:
Here's our original image, and if you look at her hair and the little bit of backlighting she's getting from the sun peeking through the trees, it looks like we should put our sun flare on the top-right corner of the image.

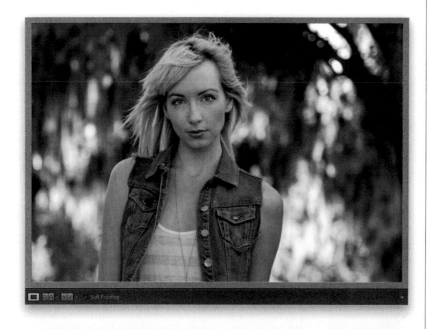

Step Two:
Click on the Masking icon (seen circled here), in the toolbox beneath the histogram, and from the panel of tools that appears, click on the **Radial Gradient** (as shown here; or press **Shift-M**). Before you click-and-drag the sun flare out, drag the Temp slider way over to the yellow side (here, I dragged it over to 65). Then, crank up the Exposure (it is the sun, ya know, and in this case, I dragged it over to the right to 2.45, so basically adding about 2-1/2 extra stops of exposure). Now, click-and-drag the sun flare out in the top-right corner (as seen here). Notice the position of the oval here—I'm intentionally letting it spill a little over onto the side of her face.

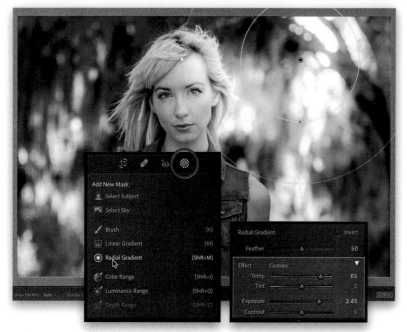

Step Three:

Next, we're going to add some negative Clarity to soften our sun flare, so drag the **Clarity slider** way over to the left (here, I dragged it over to –60). Don't forget— you can reposition your sun flare any time by clicking on the little black edit pin and dragging it right where you want it. *Note:* In case you were wondering, I docked my Masks panel here beneath the toolbox by just clicking-and-dragging it from its usual spot on the left of the right side panels.

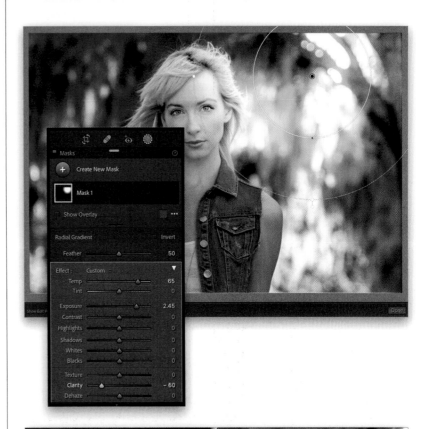

Step Four:

To make the effect look more realistic, you're going to need to somewhat match up the color of the rest of the image with the very warm color you just added with this sun flare. So, click the Done button at the bottom right of the Preview area, then go to the Basic panel and drag the **Temp slider** over to the right until the color blends in with the color of the sun flare (here, I dragged it to +41). To finish things off, back off the contrast a bunch (one of the rare times I add negative contrast, but in this case, with the sun bursting in, it helps sell the look by lowering the contrast of the rest of the image). Here, I dragged the **Contrast slider** down to –63, and I also ended up dragging the **Dehaze slider** a little to the left to –15. A before and after is shown here.

TIP: Optional Second Method

If you're not comfortable using the Radial Gradient yet, you can use the **Brush tool (K)** instead. Just make your brush size really big, and then click it a couple of times in that top-right corner to get a similar look.

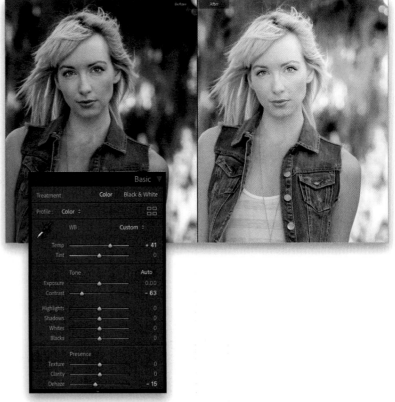

This effect makes use of the fact that Lightroom has two brushes, and you can make each of the brushes a different size and switch between the two. We use that to create a transition between a small brush and a large brush, and the feathering keeps the transitions smooth. Super-easy to do, and on the right image, it's really effective.

Painting Beams of Light

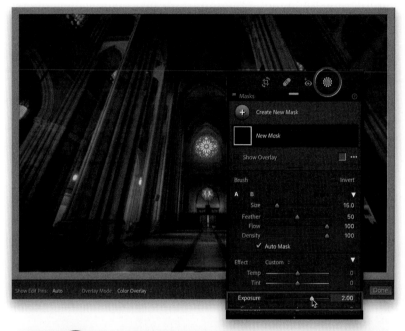

Step One:
Here's the original image we want to add light beams to (this is the rear interior view of The Cathedral of St. John the Divine in New York City). We're going to bring in a light beam from that stained glass window up in the top-left corner, but you could also bring in beams from the right, or from that round stained glass window in the back, or from some unseen window. To create our first beam, click on the Masking icon (seen circled here), in the toolbox beneath the histogram, and from the panel of tools that appears, click on **Brush** (or just press the **K key**). Now, if the sliders are not already set to zero, double-click on the word "Effect" to reset them, and then crank up the **Exposure** to around 2.00 (as shown here).

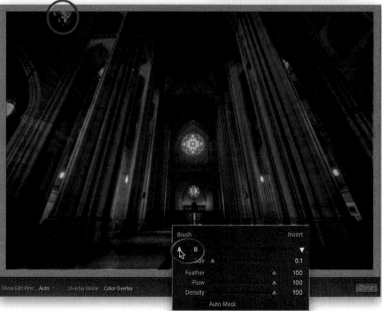

Step Two:
At the top of the Brush panel, we have two brushes we can use marked "A" and "B" (seen circled here in the inset). Click on the **A brush**, set the Feather amount to 100 (to make the edges of your brush soft), and then set the Flow amount to 100 (so we get a consistent amount of the effect we're going to apply). Now, drag the Brush Size slider all the way to the left to 0.1 (as seen here. That is one tiny brush!). Take that tiny brush and click it once on the stained glass window in the top left of the cathedral. Your brush is so small, you won't actually see anything, but you should see a little black Edit Pin (brush) appear in the spot where you clicked (as seen circled here). This is where our beam will start.

Step Three:

Now click on the **B brush**. Make sure the Feather and Flow are set at 100, but set this brush at a much larger Size (here, I set it to 14.1). Now that you have the B brush, move it over to an area on the floor, press-and-hold the Shift key (holding this makes it draw a straight line between where you first clicked on the stained glass window and your second click), and then just click once with that larger B brush. It will draw a straight line between the two spots, starting at that small size up at the window and gradually growing larger until it reaches the floor. That's it—you have your first beam! If it looks too bright (or not bright enough), you can adjust the brightness using the Exposure slider. If you want to add more beams, do the same thing (click on Create New Mask first, at the top of the Masks panel, before you start your new beam), but there's something else we can do to make the process of adding more beams quicker.

Step Four:

Instead of going over to the Brush panel every time we need to switch between the A and B brushes, we're going to use a keyboard shortcut to make the process much faster. With the A brush selected, click once on the window, then press the **/ (forward slash) key** to switch to the B brush, press-and-hold the Shift key, and click on the floor to the right or left of your original beam. So, that's the process. Click once on the window with the A brush, press the forward slash key, then press-and-hold Shift and click on the floor, and each time you do this, it adds another beam. Three more tips: (1) It'll look more realistic if you vary the size of each beam a bit, so change the Size of the B brush after each beam. (2) To soften the beam of light, drag the Clarity slider to the left. The farther left you drag it, the softer it gets. (3) Also try varying the Exposure amount a bit for each individual beam (as I did here).

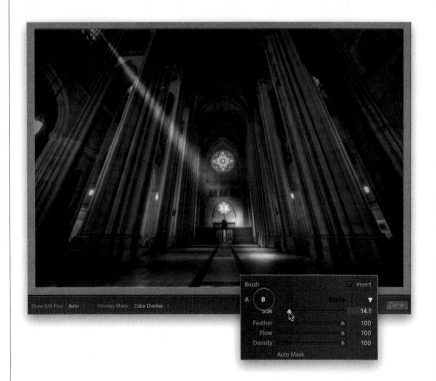

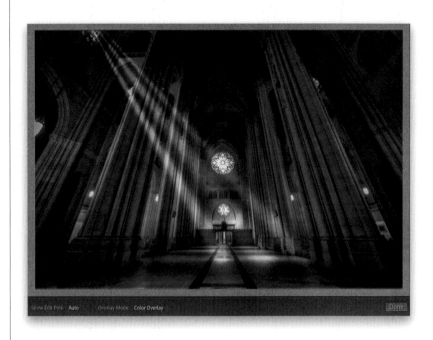

This is a trick I've been using for a while to make streets look wet in my travel photos, and what I love about it is that it's so simple (you just use two sliders) and yet it's amazingly effective (especially on cobblestone streets, where it looks especially good, but also on just regular ol' asphalt streets, too).

Making Streets Look Wet

Step One:

Here's the original image, taken in the Montmartre section of Paris. The cobblestone street in the foreground looks very dry and while it's reflecting some of the colors from the surrounding buildings, if we make those cobblestones look wet, those reflections will be enhanced.

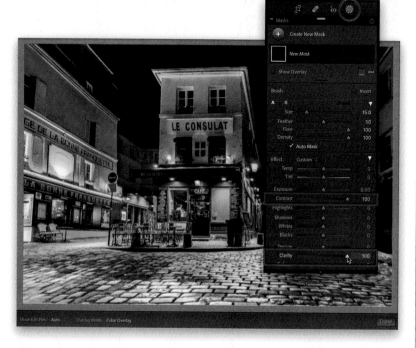

Step Two:

Click on the Masking icon (seen circled here) in the toolbox beneath the histogram, and then in the panel that appears, click on **Brush (K)**. If the sliders aren't already set to zero, double-click on the word "Effect" to reset them. You only have two sliders to adjust here: (1) drag the **Contrast slider** to 100, and then (2) drag the **Clarity slider** to 100, as well. That's it—that's the recipe. Now, paint over the surface you want to appear wet (here, I'm painting over the street in the foreground). As you paint, the area begins to look wet and reflections are added just like an actual wet street.

Step Three:

If you paint over the street and it doesn't look wet enough, Right-click directly on the Edit Pin (brush icon) the Brush created when you started painting, and from the pop-up menu that appears, choose **Duplicate "Brush 1"** (as shown here). This has a doubling-up effect as you stack another adjustment on top of the first one (you'll see Brush 1 Copy in the Masks panel), painting over the exact same area you did the first time, so it looks twice as wet. If it gets a little too bright looking, you can lower the Exposure slider for this brush copy (that's what I did here, lowering it to –0.26, so about 1/4 of a stop). Now it has the same approximate brightness, but the streets look wetter (more wet?).

Step Four:

A before and after of our wet street effect is below. This technique looks particularly great on cobblestone streets, but it also works for most regular paved streets, as well. Okay, that's it. Instant wet streets.

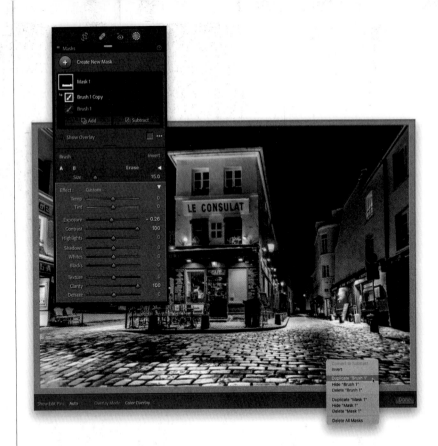

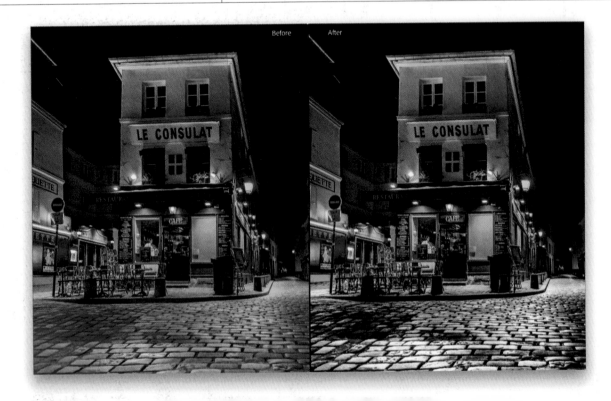

Before After

We create this spotlight effect using the Radial Gradient masking tool, which allows us to draw a circle or an oval, and then we can use the tool's sliders to brighten, darken, or make any other standard adjustment to either: (a) any areas that appear inside the oval, or (b) all the areas outside the oval. This is an awesome tool for creating a bit of drama by adding anything from a soft pool of light to a beam of light (by using a really thin oval).

Quick and Easy Spotlight Effect

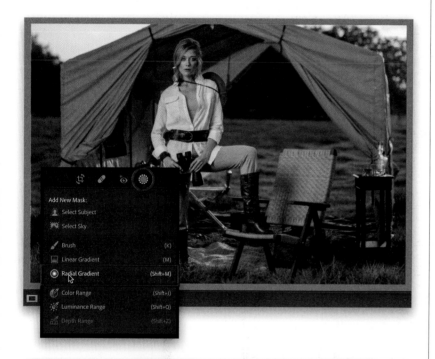

Step One:

I use this technique to lead the viewer's eye to my subject, since our eyes are drawn to the brightest part of an image first. One thing I love about this technique is that it gives the appearance of your subject being brighter. But, because we're not actually brightening them—we're darkening the area around them—it doesn't actually make your subject brighter or overexpose them. Here, the whole image looks kinda flat, but we're about to change that. Click on the Masking icon (seen circled here), in the toolbar beneath the histogram, and then in the panel that appears, click on **Radial Gradient** (as shown here. Or, you can just press **Shift-M**).

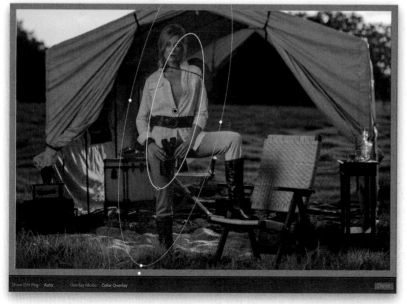

Step Two:

To create your spotlight, click-and-drag down over your subject to create an oval shape (like you see here). Once the oval is in place, you can change its shape by clicking-and-dragging the white control handles on the top, bottom, and sides. To rotate the oval, move your cursor just outside of it and your cursor will change into a two-headed arrow. You can then click-and-drag to rotate the oval in the direction you want (as shown here). To reposition the oval, click anywhere inside of it, and then drag it right where you want it.

Step Three:

Next, scroll down to the adjustment sliders and drag the **Exposure slider** to the left to around –1.80. Now, this will make the center of it really dark, but we want the opposite of that—we want everything outside the oval dark. To do that, at the top of the panel, turn on the **Invert checkbox** (as seen circled here), and now you're darkening the area outside the oval. To better match the angle of the setting sun, you might want to rotate the oval a little more (like I did here), and move it so the brightest part of it (the center) hits more on her face (I dragged it up a bit, too). By the way, the transition between the brighter area and the darker area is nice and smooth because the edges of the oval have been feathered (softened) to create that smooth transition (if you want a harder or more abrupt transition, just lower Feather amount at the top of the panel. I have it set to 50 here).

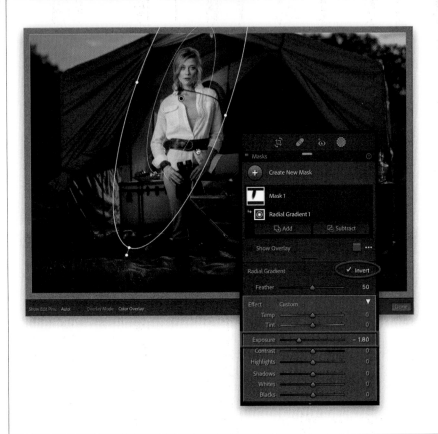

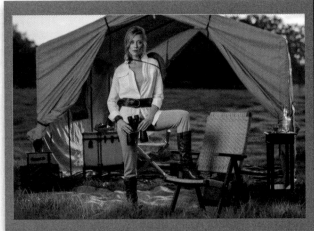

Step Four:

Here's a before/after. *Note:* If you'd like to add a second spotlight to your image (though this particular image doesn't have an obvious area that needs a second one), Right-click on the edit pin inside your oval and choose **Duplicate "Mask 1."** This puts another oval right on top of your current one, so the area outside of it looks even darker. But, you're going to change three things: (1) Turn off the Invert checkbox. (2) Click-and-drag this second oval someplace else in the image you want to lighten instead (resize it, if you need to). And then, (3) drag the Exposure slider to the right to brighten that area. There ya have it—an instant spotlight (or two!).

This is a really simple technique for adding a background light behind your subject, like you lit it that way when you took the shot, and thanks to Lightroom's masking tools, it's not only super-easy (way easier than actually setting up a light behind your subject in real life), but you can change the intensity of the light and even add a colored gel to it after the fact.

Adding a Light to the Background

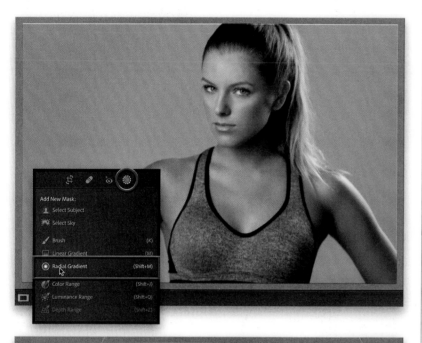

Step One:
Here's our original image. When I took the shot, while I did add a kicker light to one side, I didn't light the background, but of course, we can easily add one here in Lightroom. Click on the Masking icon in the toolbox beneath the histogram, and then in the panel that appears, choose **Radial Gradient** (as shown here. Or just press **Shift-M**). This tool allows us to create and affect a round or oval-shaped area of our image.

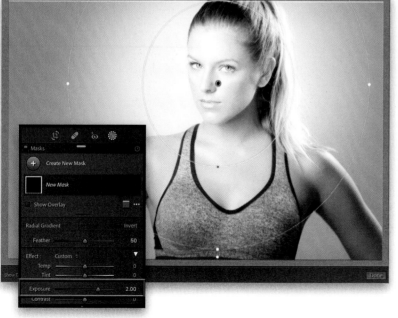

Step Two:
First, drag the **Exposure slider** over to 2.00. That will probably be way too much, but it's just a starting place—we'll dial in the right amount of brightness once the light is in place. Making it really bright from the start like this makes it easier to see the effect as you apply it, so I tend to start at a really high number, like +2 stops. Now, click-and-drag out your light. If you press-and-hold the Shift key, it makes your gradient a perfect circle (like you see here). If you don't, it makes it a free-form oval that you can shape either as you drag it out, or afterward by clicking-and-dragging the little white dots (they're actually control handles) on the top, bottom, and sides. If you need to reposition it, click on the black edit pin in the center and drag it right where you want it.

Step Three:

Now, of course, the problem is: our spotlight goes right over the front of our subject, instead of just lighting the background behind her, but we can fix that with two clicks (well, Lightroom can fix it for us). Go to the Masks panel and click on Mask 1 to reveal the Add and Subtract buttons, because we need to subtract our subject from that bright light we just added. So, click on **Subtract**, and from the pop-up menu that appears, choose **Select Subject** (as shown here), and Lightroom will automatically remove our subject from that Radial Gradient mask (as seen here). It even did a really good job here at keeping her hair intact, too. The final step would be to go back to the Exposure slider and lower the brightness of the light to where it looks good to you by dragging it to the left. Now, the technique is done, but if you want to add a colored gel to your light (totally optional), go on to the next step.

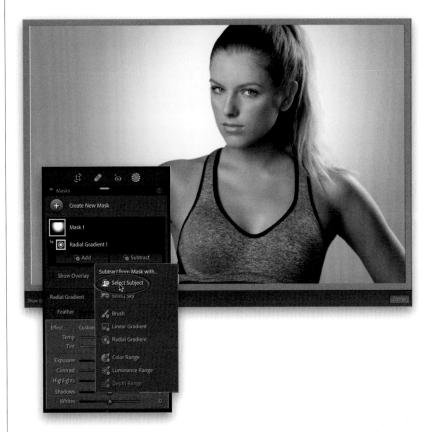

Step Four:

To add a colored gel, first go to the Masks panel and click on Radial Gradient 1 to activate it again (Subject 1 should still be active, because that's what we used last). Next, scroll down to the bottom of the sliders, to **Color**, and to the right of it, you'll see a white box with an "X" in it, which is letting you know that no color tint has been applied. To add a color tint, click on that box and a **Color Picker** appears (seen here, below right) where you can click on any color you'd like to add as a tint to your light and it'll apply that color (as shown here, where I clicked on a blue color). As you click-and-drag your cursor around the Color Picker, the colors change live, in real time, so when you find one you like, just stop, then click the little "X" in the left top of the picker to close it, and you're done. *Note:* If you add a color gel and later decide you don't want it, just double-click on the word "Color" and it will reset the color to none.

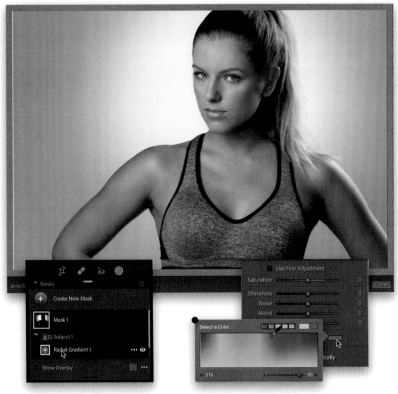

This is a look that caught fire on social media and it's now everywhere (and it's still very popular). Basically, what you do is just what is says: add an orange

Getting the "Orange & Teal" Look

Step One:
Here's the original image, which I already tweaked using the "standard stuff," so this would normally be my final image. But, in this case, we're going to add this orange and teal look at the very end.

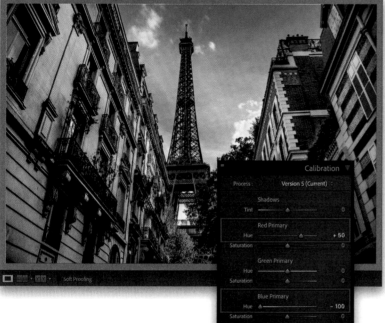

Step Two:
There are a dozen ways to do this technique, including a bunch of really complicated ways, but this simple one is my favorite and the only way I do it these days. Go go the Develop module's Calibration panel, at the bottom of the right side panels, where you only have to do two things: (1) drag the **Red Primary Hue slider** to +50, and then (2) drag the **Blue Primary Hue slider** to –100. That's it. That gives you the essential look, but there's one more tweak I usually wind up doing to make the teal more teal and the orange more orange to it up a notch.

Step Three:

Go up to the HSL/Color panel, click the Saturation tab at the top of the panel, and then drag the **Orange slider** to the right to intensify the amount of orange, and then drag the **Aqua slider** to the left (and sometimes the Blue slider, if you think the particular image you're working on needs it), until you have a nice aqua color in the sky (as shown here).

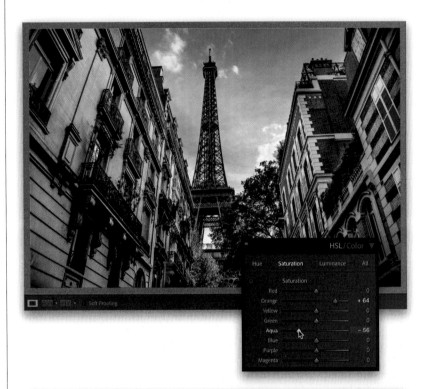

Step Four:

Here's a before/after of this image (at the top). *Note:* You can change the balance between the orange and teal colors by going to the Basic panel and using the white balance Temp and Tint sliders. That's what I did with the Dubai image here (in the before/after at the bottom). I started with the standard orange and teal effect, and once it was in place, I dragged both the **Temp and Tint sliders** a bit to the right to create a warmer look, but it still has that orange and teal look. There ya have it.

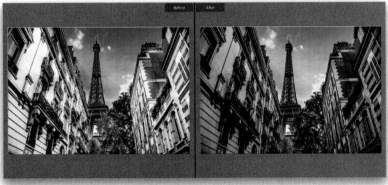

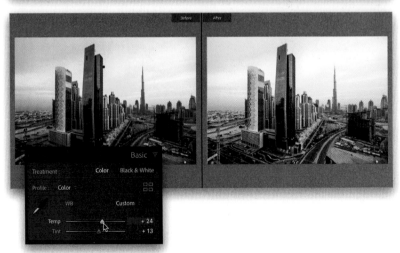

Lightroom's panoramic feature (which stitches multiple frames into one very wide, or very tall, shot) is one of the best out there, and one of the coolest things about it (besides how fast it is, and the great options it has) is that the final panoramic image it creates is still a RAW image. What?!! I know. Crazy, right? But, that's how it works (well, that's how it works if you started with RAW images anyway).

Creating Panoramas

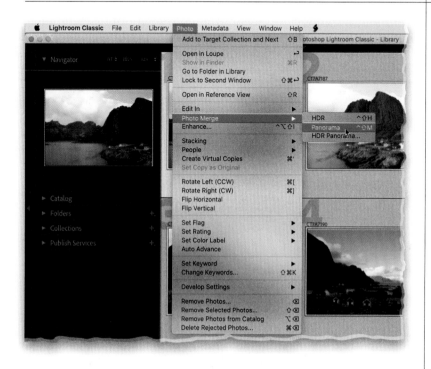

Step One:

The first step happens in your camera because you can help Lightroom successfully stitch your shots into a panorama (we just call them "panos," for short) by making sure to overlap each frame by at least 20% when you're taking it. This helps Lightroom determine which frames go together. So, as long as you keep that overlapping thing in mind while you're shooting, Lightroom will do the rest. Now, once you've imported your images, in the Library module, start by selecting those that you want combined into a pano. Then, go under the Photo menu, under Photo Merge, and choose **Panorama** (as shown here) or just press **Control-Shift-M (PC: Ctrl-Shift-M)**. You can also Right-click on any of the selected images, and from the pop-up menu, under Photo Merge, choose Panorama.

Step Two:

This brings up the **Panorama Merge Preview dialog** (seen here). It has three Projection choices for creating your pano, but it automatically chooses which one it thinks is best. I generally wind up using Spherical, and according to Adobe, it works best for wide panos. If you shoot architectural panos, where you'd want to keep the lines that are supposed to be straight, Adobe recommends the Perspective projection. Lastly, the Cylindrical projection is a cross between the two, as it's supposed to work better for panos that are really wide, but still need straight vertical lines. All that being said, I still usually wind up just using Spherical.

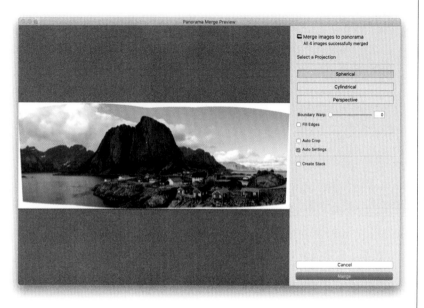

Step Three:

Before we deal with those white gaps you see around your pano, there's an organizational feature you might want to consider: **Create Stack**. When you turn on this checkbox (shown circled here in red), when your pano is complete, you'll see a thumbnail for your pano, but the images that make up this particular pano will be stacked (tucked behind) with the pano itself. They're "stacked" together. You'll be able to tell it's a stack because you'll see a number in the top-left corner of the thumbnail showing the total number of stacked images. If you click that number, it reveals them all. Just an option, but I think it's a helpful one. Also, this dialog is resizable—just click on the bottom-right corner and drag (I like to stretch mine out wide, so it fills my screen).

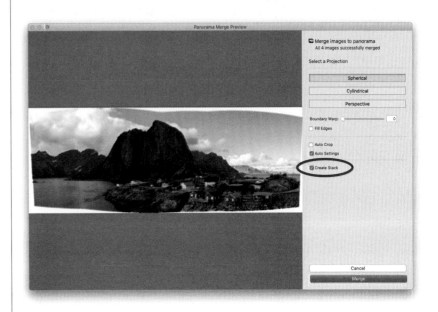

Step Four:

Now let's deal with the white gaps. There are three ways to deal with them: Two of them work like magic and the other one, Auto Crop, just crops the photo, so all that white space is cropped away. It works, but of course, it makes the image smaller all the way around (and it could crop off things like mountain tops), so I avoid this one if I can. The other two options are awesome. The best is probably **Fill Edges**, which borrows its math from one of Photoshop's best features, Content-Aware Fill, to intelligently fill in the missing areas based on what's around those areas in your photo. As you can see here, it did a brilliant job (and often does), plus it keeps the size of your pano intact. The other option is the Boundary Warp slider, and it's awesome as well. It somehow reshapes or bends the pano to fill in those open gaps and yet, when it's done, it doesn't look funky—it looks fantastic! The farther you drag this slider to the right, the more of the gaps it fills (I normally drag it all the way to 100%). I have some examples for you on the next page comparing these three options for dealing with the white gaps.

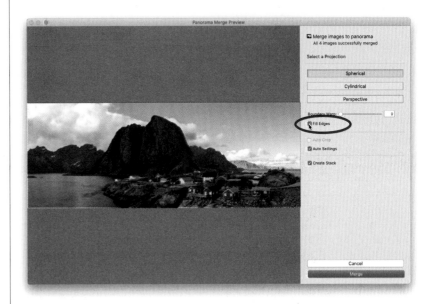

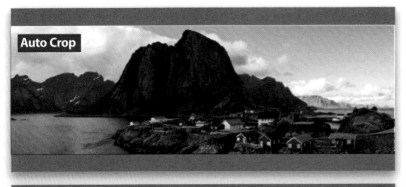

Auto Crop

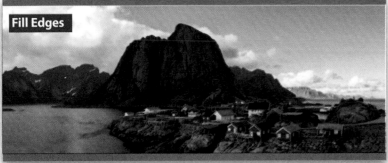

Fill Edges

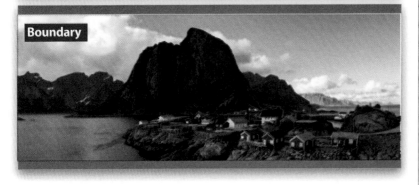

Boundary

Step Five:

Again, just for visual comparison purposes, here are the three gap removal options: At the top is Auto Crop (you'll notice it's the thinnest of the three because it crops in). In the middle is Fill Edges, and at the bottom is the Boundary Warp slider dragged all the way over to 100%. There is no wrong answer here—you can choose whichever one you want, including making no choice at all and cropping later using Lightroom's Crop Overlay tool. Totally your call.

Step Six:

Now, click the Merge button and it will render the final high-res version of your pano (it renders in the background, but you'll see a progress bar in the upper-left corner of Lightroom). When it's finished, your final stitched pano appears as a DNG file in the same collection as the images you used to create the pano (provided, of course, that the images were in a collection when you started. If not, it'll appear in the same folder, but usually at the bottom of the folder), and now you can tweak this pano like you would any other image. By the way, you're seeing the stacked images here, like I mentioned in Step Three. You can see the pano thumbnail and the number 5 in the top-left corner, letting you know there are five stacked images here (the four original images, plus the pano).

Creating
HDR Images

HDR (high dynamic range) images are images that combine multiple exposures (taken in-camera using Exposure Bracketing) into a single image that has greater tonal range than your camera's sensor can capture by itself. Lightroom's HDR feature has a secret weapon, which is that you can open up the shadow areas of your photo big time without seeing lots of noise. It's pretty miraculous really, so if noise is an issue, HDR is your friend. I shoot three bracketed photos (one normal, one two stops darker, and one two stops brighter), and Lightroom combines them into a single RAW HDR image.

Step One:

First, select your bracketed shots in the Library module. Here, I have three bracketed shots (the regular exposure, one shot that is two stops *underexposed*, and one shot that is two stops *overexposed*), but according to Adobe's own engineers, Lightroom doesn't actually need more than just two frames to do its thing—the one that's two stops underexposed and the one that's two stops overexposed. So, here, I just selected those two shots. Now, Right-click on one of them, then go under Photo Merge, and choose **HDR** (as shown here; or just press **Control-Shift-H [PC: Ctrl-Shift-H]**).

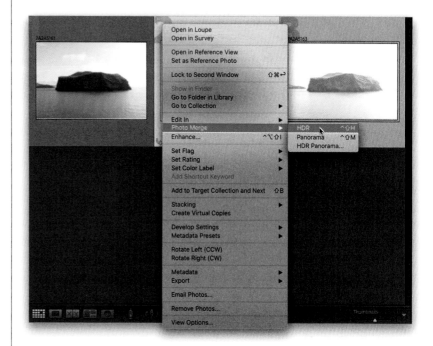

Step Two:

This brings up the **HDR Merge Preview dialog** with a preview of your HDR image. (*Note:* This dialog is resizable—just click-and-drag the edges.) Near the top right, the Auto Settings checkbox is on by default and it's the same as Auto Tone from the Basic panel. It actually works surprisingly well with HDR so I leave it on. If you hand-held when taking your bracketed shots (HDR shots generally work best shot on a tripod), you can turn on the Auto Align checkbox to have it align your images for you before it makes the HDR. It does a pretty decent job.

TIP: Faster HDR Processing

To skip this dialog and have it create your HDR in the background (using whatever settings you used on your last HDR image), just press-and-hold the Shift key when you choose HDR from the Photo Merge menu.

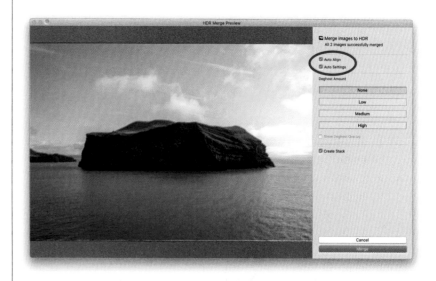

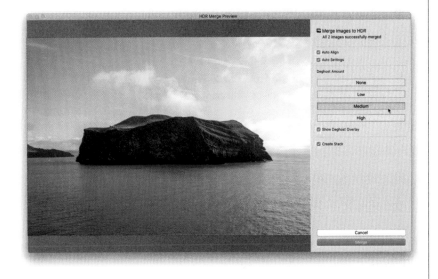

Step Three:

The next section down is for deghosting, which you'd only have to deal with if something was moving when you took your bracketed photos. When they're combined into an HDR image, that moving object has a ghosted effect, and **Deghost Amount** helps get rid of that. By default, it's set to None (so it's off), but if you have something moving, it's worth trying each of the three choices (Low, Medium, and High) to see if that gets rid of the ghosting effect. In this image, there's nothing really moving (well, the ocean is, but just a tiny bit—so little that I didn't see any difference using a Deghost Amount). If you turn the Show Deghost Overlay checkbox on, it shows an outline around the areas where it applied the effect (when I turned it on, there was no outline, so it didn't do anything). Now, if there had been a seagull flying through the foreground here, it probably would have fixed that (it does work fairly well). Anyway, when you're done, hit the Merge button and it creates your HDR image (if you want to turn on the Create Stack checkbox, see page 248, Step Three for more on that).

Step Four:

Now you can tweak your HDR image just like you would any other regular RAW image (the resulting HDR image that Lightroom creates is a RAW image). Remember, Auto Tone has already been applied, so don't be surprised if you see some sliders have already been moved. However, the big advantage of creating an HDR image is the expanded tonal range, so you can open the Shadows to +100, or even use the Brush tool to paint over the front shadow side of the island to open up those shadows big time without experiencing anywhere near the noise increase you would normally see. In fact, you probably won't see much visible noise at all, and that's pretty remarkable. There's so much extra tonal range that you can tweak an HDR image to death without any worries.

Creating
HDR Panos

If you want to create a panoramic image, but you also want it to have the same expanded total range of an HDR, you are clearly an overachiever. Be that as it may, if you're willing to do what it requires in-camera (which is to set up your camera to shoot in Exposure Bracketing mode and take at least three bracketed shots for each frame of your pano, so you wind up with a bunch of photos, like you see here below), then the Lightroom part is really a breeze.

Step One:
Here are the images—each frame of a four-frame panorama taken with Exposure Bracketing turned on in my camera, for a total of 12 images. So, essentially, you shoot a bracketed exposure shot (that's three images), and then move your camera over a bit (keeping in mind to overlap this second frame by at least 20% with the previous frame), and then take another series of bracketed exposures, and so on, until you reach the end of your pano. Yeah, it's kind of a pain, which is why I don't do it very often, but then, I'm an underachiever. Well, maybe a neutral achiever. Either way, it's kind of a pain. But, I digress.

Step Two:
Select all 12 images (or however many you have), and then go under the Photo menu, under Photo Merge, and choose **HDR Panorama** (as shown here).

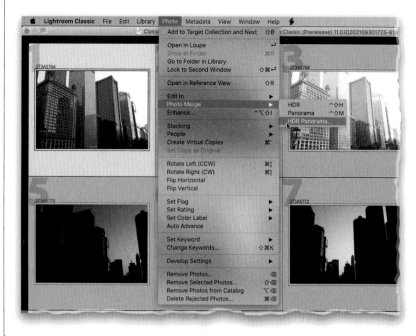

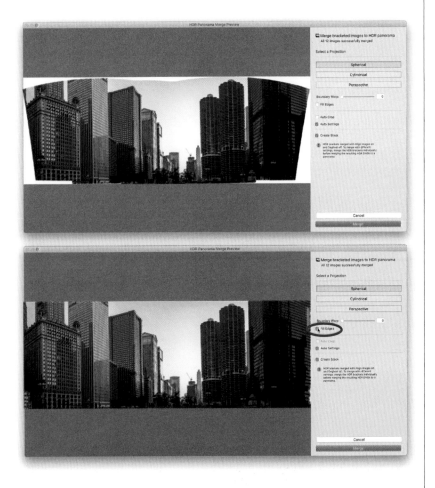

Step Three:

This brings up the **HDR Panorama Merge Preview dialog**, which is pretty much... okay, identical to the regular Panorama Merge Preview dialog, with the same options and all. On this particular image, I tried the Fill Edges feature for filling in those white gaps and I was amazed at how well it did filling in those areas—really just pretty jaw-dropping. I also tried the Boundary Warp slider and it looked okay, but not nearly as good as Fill Edges, so I went with that one.

Step Four:

When you're done, click the Merge button, and now you have an HDR panorama, and it's even a RAW DNG image, which is great (the final HDR pano is shown below as a stacked thumbnail. That's why there's a "13" in the top-left corner—that represents the 12 images that made up the pano, and the pano itself). Now, if you're thinking, "But Scott, I had some ghosting in my HDR image, and there are no deghosting controls in this dialog?" This is true, and if you have ghosting (something that moved in your image while you were taking the pano), you'll have to go "old school" and skip this "one-stop HDR pano shop," and instead, do it all manually. First, combine each set of bracketed exposures into single HDR images, then select them (in this case, you'd select four HDR images), go under the Photo menu, under Photo Merge, choose Panorama, and it'll stitch all those HDRs together into a pano. The result will look the same as what you see here—it'll just take a little bit more doing on your part. Or, you can use the Merge to HDR Panorama command, and then take a trip over to Photoshop for some clever masking or cloning or some other Photoshop wizardry.

PROBLEM PHOTOS
dealing with common image problems

Why do we, after all these years, still have to deal with so many problems caused by the limitations of our cameras' sensors? I mean, we're in the 21st century, and correct me if I'm wrong, but we were promised that by now, we'd all be cruising around on moving sidewalks, and we'd have flying cars, and stuff like that. But, if we can't even get a decent exposure on a backlit photo, what chance do we have of getting a flying car? Now, you could argue that moving sidewalks technically do exist, like the one under the runway at Chicago's O'Hare International Airport, connecting two United Airlines terminals. But, if you're not in Chicago, connecting to a United flight, you're not exactly zipping around on moving sidewalks. (*Note:* If you are at O'Hare, make sure you stop at Garrett Popcorn Shops in Terminal 1, Concourse B, Gate B7, and get a bag of Cashew CaramelCrisp®—life changing.) Also, yes, they have experimental car-like helicopters and planes, but nobody really has one (outside of the lab testing them), so in reality, our dream of moving sidewalks and flying cars is still a ways off. But, can we at least get a camera that fixes some of the problems we've been dealing with since the dawn of photography, back in the early 1800s? Well, so far, that's a dream, too. So, what does our future actually hold, based on the technology we can use today? Well, I think you'll see more and more cameras incorporating artificial intelligence (AI), where we're taking exposure problems and noise issues and handing those tasks off to an AI, who will not only take control of these events, but to a greater extent, they will replace our jobs as photographers altogether as they enslave the entire human race, forcing us to work in dimly lit factories endlessly building more AI robots. See? Having to walk on our own between two airport terminals doesn't seem so bad now, does it?

Fixing Backlit Photos

I think the reason we take so many backlit photos is that our eyes capture such an incredible tonal range, instantly adjusting for things like backlighting, so when we're standing there, our subject doesn't look dark at all. However, our camera's sensor captures only a fraction of the tonal range of what our eyes see. Luckily, as we learned in Chapter 6, Lightroom's Shadows slider was born to fix situations just like this, but there is an extra step you need to know to make it look right.

Step One:
Here's our backlit subject (you can see from looking at her hair that the sun is behind her on the right). While I was standing there, even though she was backlit, to my eyes she looked properly exposed. When I held my camera up and looked through the viewfinder, it looked the same, but then this is what my camera's sensor came up with—my subject is kind of a silhouette. This we can deal with.

TIP: Watch Out for Noise
If an image has noise in it, it's usually in the shadow areas, so if you do open the shadows a lot, any noise gets amplified. Keep an eye out for it as you drag that Shadows slider. If things get really noisy in those shadow areas, you might need to get the **Brush tool (K)**, drag the Noise slider to the right, and paint over just that shadow area to keep that noise in check (see page 194 for more on doing this).

Step Two:
In the Develop module, go to the Basic panel and drag the **Shadows slider** over to the right until your subject's face starts to look balanced with the rest of the light in the image (I dragged it to +63 here). Don't make it too bright or it'll start to look unnatural.

Step Three:

Three things to keep an eye out for if you wind up dragging that Shadows slider way over to the right: (1) Your photo can look washed out. One way to get rid of that is to drag the Contrast slider over to the right a bit until the washed-out look is gone. (2) Sometimes it can look unnatural, so make sure what you're seeing onscreen doesn't just look brighter, but also looks natural. If it starts to look weird, pull the Shadows slider back a bit to the left. Another thing you can consider is using the Brush tool, with just the Exposure slider increased by around +1.00 as a starting place, and painting over your subject. Then, evaluate the brightness and if it's too bright, drag the Exposure slider back to the left. You might also need to drag the Shadows slider to the right, as well. Lastly, (3) if your colors look too vivid (like mine did here), reduce the **Vibrance amount** until it looks good (here, I dragged it to –22).

Reducing Noise

If you wind up shooting at a high ISO or in very low light, chances are your image is going to have some noise—either luminance noise (a visible graininess throughout the photo, particularly in shadow areas) or color noise (those annoying red, green, and blue spots). Lightroom can handle them both, but an added advantage is that it can apply this noise reduction while the image is still in its 16-bit RAW state (most commercial plug-ins can only work once the image has been converted to a regular 8-bit image).

Step One:
To reduce the noise in a "noisy" image like this go to the Develop module's Detail panel, and you'll see the **Noise Reduction section** at the bottom (seen here in the inset). This particular shot was taken on an older iPhone, so when you open up the shadows like I did here, you see there's a ton of noise on that lifeguard shack.

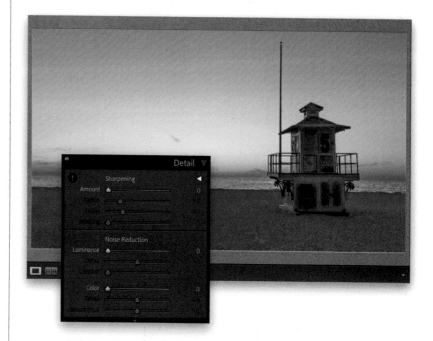

Step Two:
I usually start by reducing the color noise, simply because it's so distracting (if you shoot in RAW, Lightroom automatically applies color noise reduction to your image—Color is set to 25—to replace the noise reduction turned off in your camera when you chose to shoot in RAW). So, start by dragging the **Color slider** to 0, and then slowly drag it to the right. As soon as the color in the specks goes away, stop, because once it's gone, it doesn't get "more gone" (it just gets blurrier). Here, I stopped at 57. If you feel you lost detail in the process, drag the **Detail slider** to the right to help it protect color details in edge areas, as shown here, where I dragged it to 64. (*Note:* The Detail slider starts at 50 instead of zero like the Color slider.) If you keep this setting really low, you avoid adding colors speckles, but you might get some color bleeding (like they're glowing a bit). Dragging the Smoothness slider to the right softens the color speckles, but I don't mess with this slider because I haven't seen an instance where it didn't make the image look blurry and worse.

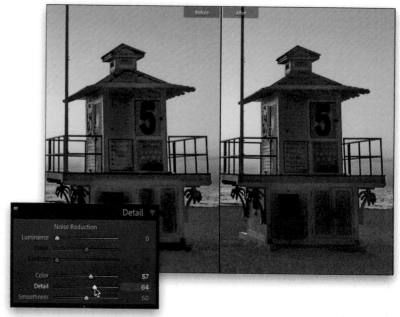

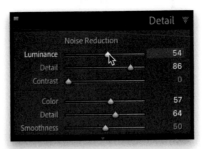

Step Three:

Once the color noise has been dealt with, your image now just looks grainy, which is a different kind of noise (luminance noise). So, drag the **Luminance slider** to the right until the noise is greatly reduced (here, I dragged it over to 54). I gotta tell you, this baby works wonders all by itself, but you have additional control with the other two sliders beneath it. The "catch" is this: your image can look clean, or it can have lots of sharp detail, but it's kinda tricky to have both. The Detail slider (in Adobe speak, the "luminance noise threshold") really helps with seriously blurry images. So, if you think your image looks a little blurry now, drag the **Detail slider** to the right (I dragged it to 86)—just know this may make your image a little more noisy. If, instead, you want a cleaner-looking image, drag the Detail slider to the left—just know that you'll now be sacrificing a little detail to get that smooth, clean look (there's always a trade-off, right?). If you feel you've lost contrast in this process, drag the Contrast slider to the right, but know that it might create some blotchy-looking areas. Again, it's a trade-off and ultimately, you'll decide if using it helps or hurts your particular image.

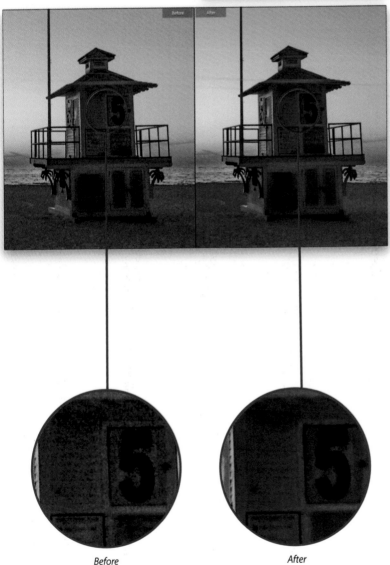

Before After

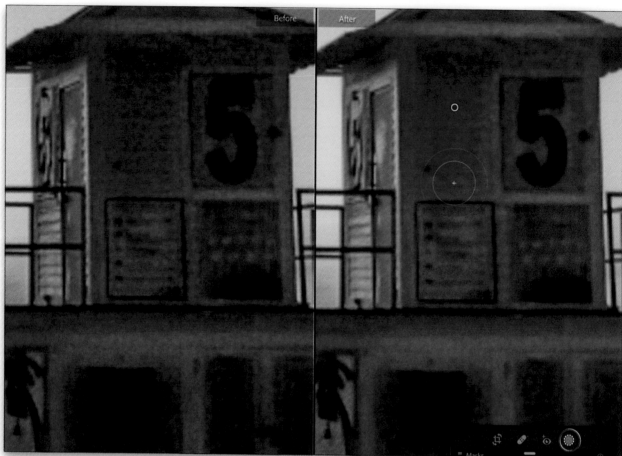

Step Four:

Another method for removing noise when you have it in just a particular area, like in the sky or one dark area you opened up, is to "paint" noise reduction using the **Brush tool** (**B**; we looked at this back on page 194). In the Brush's panel, you'll see the Noise slider near the bottom. Drag this slider to the right a bit, and then paint over an area in your image, and it helps to reduce noise where you painted. It's not awesome (as you might expect) and it tends to make those areas blurry to hide the noise, but on some particular images, it works great, and it only blurs the areas where you paint and not the entire image, like normal Noise Reduction in the Detail panel tends to do. Remember, you can also apply the Detail panel's Noise Reduction first, then paint noise reduction over just really bad areas.

Lightroom keeps track of every edit you make to your photo and it displays them as a running list, in the order they were applied, in the Develop module's History panel. So, if you want to go back and undo any step, and return your photo to how it looked at any stage during your editing session, you can do that with just one click. Now, unfortunately, you can't just pull out one single step and leave the rest, but you can jump back in time to undo any mistake, and then pick up from that point with new changes. Here's how it's done:

Undoing Anything (or Everything!)

Step One:
Before we look at the **History panel**, I just wanted to mention that you can undo anything by pressing **Command-Z (PC: Ctrl-Z)**. Each time you press it, it undoes another step, so you can keep pressing it and pressing it until you get back to the point where you first imported the image into Lightroom, so it's possible you won't need the History panel at all (just so you know). However, if you want to see a list of all your edits to a particular photo, click on the photo, then go to the History panel in the left side panels (shown here). The most recent changes appear at the top. (*Note:* A separate history list is kept for each individual photo.)

Step Two:
If you hover your cursor over one of the history states, the small **Navigator panel** preview (which appears at the top of the left side panels) shows what your photo looked like at that point in history. Here, I'm hovering my cursor over the point where I had converted this photo to black and white, but since then I changed my mind and switched back to color. By the way, like I mentioned, every single change you make to your photo in Lightroom is tracked, but when you change images or close Lightroom, your unlimited undos are saved automatically. So, even if you come back to a photo a year later, you'll see your complete history, and you'll always be able to undo what you did.

Step Three:

If you actually want to jump back to what your photo looked like at a particular stage, then instead of hovering over the state, you'd click once on it and your photo reverts to that state (as shown here). By the way, if you use the keyboard shortcut for your undos (instead of using the History panel), the edit you're undoing is displayed in very large letters over your photo. This is handy because you can see what you're undoing, without having to keep the History panel open all the time.

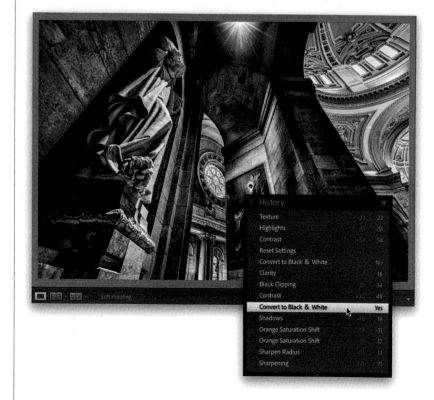

Step Four:

If you come to a point where you really like what you see and you want the option of quickly jumping back to that point, go to the Snapshots panel (right above the History panel) and click on the + (plus sign) button on the right side of the panel header. The **New Snapshot dialog** appears where you can give it a name that makes sense to you (I named this one "Duotone," so I'd know, even if I came back a year from now, that if I clicked on that snapshot, I'd get what it looked like when I made it a duotone, even if I made more changes to it after that). Click Create and that moment in time is saved to the Snapshots panel (as seen here, where I've saved three snapshots I can jump to and get that look with one click). By the way, you don't have to actually click on a previous step in the History panel to save it as a snapshot. Instead, you can just Right-click on any step and choose **Create Snapshot** from the pop-up menu. Pretty handy.

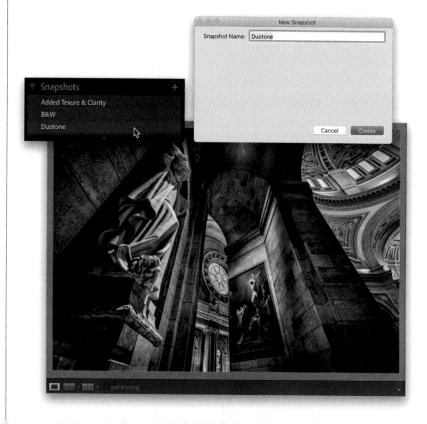

The Crop Overlay tool is the most-used tool in all of Lightroom, and the way Lightroom handles cropping is really very slick, but it might take a few minutes to get used to it if you're used to cropping in other applications. Once you do, though, you'll wonder why every app doesn't handle its cropping like this.

Cropping Photos

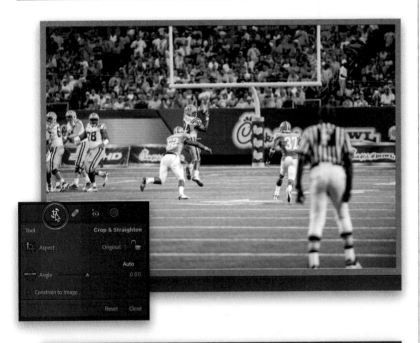

Step One:

Here's the original photo. The action happened down field a bit, and even though I was shooting a 400mm lens, the action is still pretty far away. So, we need to crop in tight because the shot isn't about the ref, or the players who aren't involved in the play (on the left)—the shot is about the receiver catching the ball. To crop the photo, go to the Develop module and click on the **Crop Overlay tool** (circled here in red, or just press the **R key** on your keyboard) in the toolbox below the histogram, and options pop down below it.

Step Two:

When you click on the Crop Overlay tool, you'll see a cropping border appear around your image with a rule of thirds grid inside to help with cropping composition. There are cropping handles in the corners and on the sides, so to crop in on the photo, click on a handle and drag inward (here, I dragged the top-left, and then the bottom-right corners inward to crop in nice and tight on those players). As you drag the cropping border, the area outside of it (the parts that will be cropped away) get dimmed (as seen here). By default, it's going to crop while keeping the same original aspect ratio of your image (so your cropped image will still be a wide rectangle like the original—just smaller). If you want a free-form crop (so you can make it whatever dimensions you want), click on the **Lock icon** near the top right of the tool's panel to unlock it (as shown here in the inset).

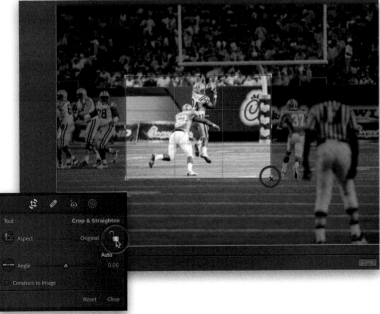

Step Three:

If you need to reposition the photo inside the cropping border, just click-and-hold your cursor inside of it. Your cursor will change into the **grabber hand** (it's circled here in red), and now you can drag the cropping border wherever you want it.

TIP: Canceling Your Crop

If, at any time, you want to cancel your cropping, just click on the Reset button at the bottom-right side of the Crop & Straighten options panel.

Step Four:

When the crop looks good to you, press the **Return (PC: Enter) key** or the **R key** on your keyboard to lock in your crop. This removes the rule of thirds overlay and the cropping border, giving you the final cropped version of the photo (as seen here). But there are two other choices for cropping we haven't looked at yet.

TIP: Hiding the Grid

If you want to hide the rule of thirds grid that appears within your Crop Overlay border, press **Command-Shift-H (PC: Ctrl-Shift-H)**. Or, you can have it only appear when you're actually moving the cropping border itself, by choosing **Auto** from the Tool Overlay pop-up menu in the toolbar beneath the Preview area. Also, there's not just a rule of thirds grid, there are other grids—just press the **O key** to toggle through the different ones.

Step Five:

If you know you want a particular size ratio for your image, you can do that from the **Aspect pop-up menu** at the top right of the Crop & Straighten options. Go ahead and click the Reset button, below the right side panels, so we return to our original image, and then click on the Crop Overlay tool, again. Click on the Aspect pop-up menu and a list of preset sizes appears. Choose **1x1** from the pop-up menu (as shown here), and you'll see the left and right sides of the cropping border move in to show a square "1x" crop. Now, you can shrink the cropping border and be sure that it will maintain that perfectly square aspect ratio.

Step Six:

Another free-form way to crop: simply click-and-drag out a cropping border in the size and position you'd like it, right over your image. Don't let the fact that when you choose the Crop Overlay tool it puts that full-screen rule of thirds grid over your image throw you off. Just ignore that grid and click-and-drag over the area you want to keep (as shown here). Once you've dragged out your cropping border, it works just like before (grab the corner handles to resize it, and reposition it by clicking inside it and dragging). When you're done, press Return (PC: Enter) to lock in your changes. So, which way is the right way to crop? The one you're most comfortable with.

Lights Out: the Best View for Cropping

When you use the Crop Overlay tool, the area that will get cropped away is automatically dimmed to give you a better idea of how your photo is going to look when you apply the final crop. That's not bad, but if you want the ultimate cropping experience, where you really see what your cropped photo is going to look like, then do your cropping in Lightroom's Lights Out mode. You'll never want to crop any other way.

Step One:
To really appreciate this technique, first take a look at what things look like when we normally crop an image—lots of panels and distractions, and the area we're actually cropping away appears dimmed (but it still appears). Now, let's try Lights Out cropping: First, click on the **Crop Overlay tool** (in the toolbox beneath the histogram) to enter cropping mode. Then, press **Shift-Tab** to hide all your panels.

Step Two:
Press the **L key** on your keyboard once to enter Lights Dim mode, which dims not just the area outside your cropping border, it dims your panels and sliders, the Filmstrip, everything. But, it doesn't help your cropping all that much, besides just making the interface less distracting. However, if you press the L key one more time, you're now in **Lights Out mode** (seen here), where the entire Lightroom interface is hidden—all you see it just your photo centered on a black background, but with your cropping border live and still in place. Now try clicking on a corner handle and dragging inward, then clicking-and-dragging outside your cropping border to rotate it, and watch the difference—you see what your cropped image looks like live as you're dragging the cropping border. It's the ultimate way to crop (it's hard to tell from the static graphic here, so you'll have to try this one for yourself—you'll never go "dim" again!).

If you've got a crooked photo, Lightroom's got four great ways to straighten it. One of them is pretty precise, two are automatic, and with the last you're pretty much just "eyeing it," but with some photos, that's just what ya gotta do.

Straightening Crooked Photos

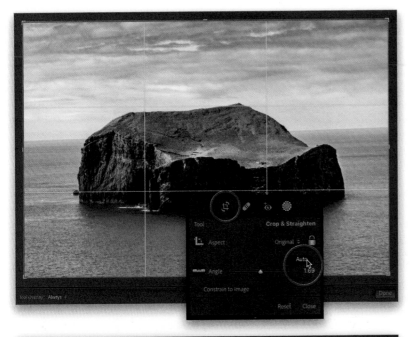

Step One:
Here's a shot with a pretty badly tilted horizon line that needs some serious straightening, and for the first three ways to do this, we use options found in the Crop & Straighten panel. So, go to the Develop Module and click on the **Crop Overlay tool** in the toolbox beneath the histogram (or just press the **R key**). Now, for the first method, click on the **Auto button** (as shown here; it's the auto straighten button) and it straightens it right up—one click and you're done.

Step Two:
Notice how when you hit the Auto button it doesn't complete the process? It just rotates the cropping border to the precise amount it would take to crop the image? If it looks straight to you, you can click the Done button below the bottom-right corner of the Preview area to complete the straightening. So, why are there three other methods for straightening if we can just click Auto? It's because Auto doesn't always work. It needs something obvious in the photo for it to use to straighten your image, like a horizon line, or a wall that's supposed to be straight, and not every photo has something that obvious. So, you need the other methods, too (but start with this one. If it doesn't work, just click Reset at the bottom right of the tool's panel, and then try method #2).

Step Three:

The second method is manual, but it's pretty precise: you can use the **Straighten tool**, found in the Crop & Straighten panel (it looks like a level and is circled in red in the inset here). Click on it, and then click-and-drag it left to right along something that's supposed to be level in your image (as shown here, where I've dragged it from the left along the horizon line—I added a red arrow, so it's clear). This works really well (and you can even drag it vertically, or use the Angle slider to tweak it). The third method is to bring up the cropping border again, and then move your cursor outside of it, so it turns into a two-headed arrow. Now, just click-and-drag to rotate the image. When it looks straight (yes, you're just eyeing it, but a small grid will appear over your image to help you out), hit the Done button down in the toolbar. The downside to this method is that it may leave white gaps in all four corners of the image. So, after you straighten it, you'll then have to crop in a bit tighter to crop away those gaps.

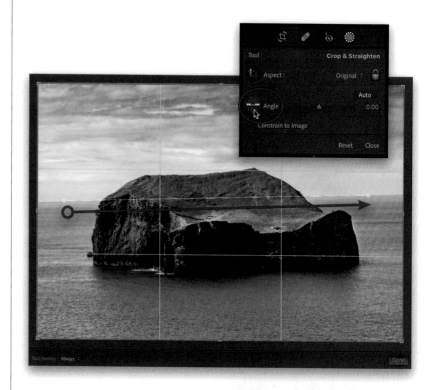

Step Four:

The fourth method is another one-click auto straighten, but it has an advantage: when it rotates your image to make it straight (just like the first method), it automatically crops away any white gaps that may be created, all in one step. So, this one is truly a one-step crop. This auto level feature is found down in the Transform panel (in the right side panels). In the Upright section at the top, click the **Level button** (as shown here), and it automatically straightens the photo. Truth be told, the Auto button in the Crop Overlay tool's panel is just a shortcut for this Upright Level feature, but the advantage is, of course, that it auto crops away any white gaps that may appear in the corners. It's good to know all four methods, because at some point, you'll wind up using them all.

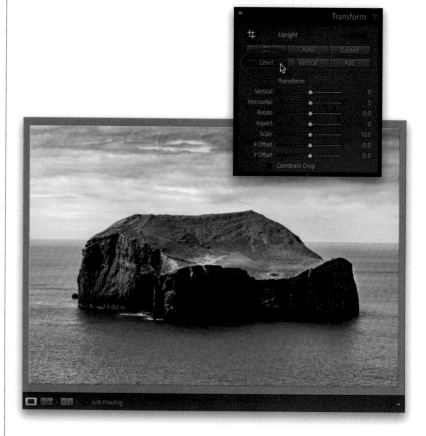

This tool is actually pretty well named—it's great for removing spots or the occasional power line or distracting soda bottle in the background on the beach. However, don't confuse it with Photoshop's awesome Healing Brush. I've used the Healing Brush. The Healing Brush was a friend of mine. Spot Removal tool: you are no Healing Brush (but, it's all we've got, so let's at least learn how to use it).

Removing Stuff with the Spot Removal Tool

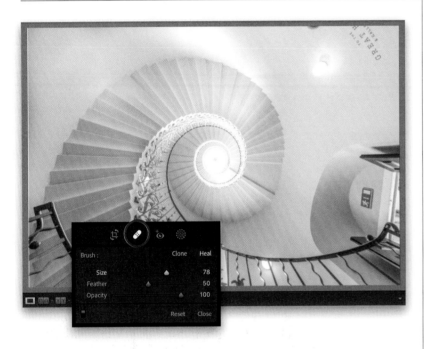

Step One:
Here's the image we want to retouch—it's the Tulip Stairs in the Queen's House (part of the Royal Museums Greenwich in London). To make the image look a lot cleaner, we're going to get rid of anything distracting, like the stuff up in the top-right corner here (the light, the text, and whatever that thing is that's sneaking in from the top), and then we're going to remove the green exit sign near the bottom right. Our tool for removing everything from spots and specks to distracting things like these, is the **Spot Removal tool** (shown circled here in red). So, click on it in the toolbox beneath the histogram (or just press the **Q key**).

Step Two:
As a general rule, we make the brush a little bigger than the spot or object we want to remove. You can change your brush size by using the Size slider in the tool's panel, or by using the **Left and Right Bracket keys** on your keyboard (they're just to the right of the letter P). First, we're going to remove the light fixture on the ceiling (you can see it back in Step One). Just make your brush larger than the light (and the light spill, as well), and then click once! Well, this didn't go as well as it usually does (it put part of the stairs over the light). You see those two outlined areas? The thin outline (around my cursor) is showing the area where I clicked, and the thicker one (on the stairs) is the area that the Spot Removal tool chose to sample from to make the repair. It's usually at least decent at it, but in this case…ummm…not so much.

Step Three:

Usually, the sample area it picks is pretty close to the area you're trying to fix, but sometimes (for reasons I can't begin to understand), it decides to sample somewhere totally weird (like the stairs here). When that happens (notice I didn't say "if"), there are two things you can do about it: The first is to press the / **(Forward Slash) key** on your keyboard (named after the Guns N' Roses guitarist). Each time you press it, Lightroom picks a different area to sample from, and usually, its second or third choice is a pretty decent one. That's the automatic way. The second method is manual. Just click inside the thicker sample outline and drag it to a different area yourself (as shown here, where I dragged it fairly close to where the light used to be). Also, I made the brush just a little larger (you can also click-and-drag the circle to resize it), so it got all of the light spillover.

Step Four:

Now, let's get rid of that text in the right corner. Besides just clicking over things you want to remove, for something larger like this, you can paint a stroke with the Spot Removal tool. Just click-and-drag it right over the text. As you paint, the area you're painting over turns white (as seen here), so you can see where you painted. When you release your mouse button, after just a second or two, it chooses a sample area and removes the text. In this case, it picked a good area, and the text is gone. Okay, let's remove some more distracting stuff.

Step Five:

Each time you remove something it leaves an Edit Pin for a brush stroke, just like the Brush tool does, or a circle for a brush click (as seen here; I also removed that thing sneaking in from the top), so you can click on any one of them to edit that repair. To delete an area where you used the Spot Removal tool, just click on the circle or pin to activate it, and then hit the **Delete (PC: Backsapce) key**. Okay, let's continue removing stuff—this time the exit sign over in the lower right. Paint over it and it's gone (the tool picked a good spot to sample from here). So, that's the process: you navigate around your image, clicking once on small spots with a brush a little larger than the spot you want to remove, and for larger spots or for groups of spots, you paint a stroke by clicking-and-dragging the tool over the area you want to repair. A before/after is below, with those distracting things removed.

Finding Spots and Specks the Easy Way

There is nothing worse than printing a nice big image, and then seeing all sorts of sensor dust, spots, and specks in your image. If you shoot landscapes or travel shots, it is so hard to see these spots onscreen against a blue or grayish sky, and if you shoot in a studio on seamless paper, it's just as bad (maybe worse). Luckily, this feature makes every little spot and speck really stand out, so you can remove them fast!

Step One:
Here's an image of the Emirates Towers in Dubai, UAE, and if you look at the sky, you can see spots and specks (dust? Sensor spots? I dunno, but it's some kind of junk on my photo. I've circled a bunch of them here). It's the spots that you can't see clearly onscreen at this size that "Getcha!" Of course, you eventually do see them—like after you've printed the image on expensive paper, or when a client asks, "Are these spots supposed to be there?"

Step Two:
To help those spots or specks stand out (if they're easier to find, they're easier to get rid of), first click on the **Spot Removal tool** (**Q**; it's shown here circled in red) in the toolbox beneath the histogram. Then, down in the toolbar (beneath the Preview area), turn on the **Visualize Spots checkbox** (also circled here) to get an inverted view of your image, which not only makes it easier to see your spots, but you'll usually see more than you would with your naked eye (spots you would have probably missed, which is why this is so awesome).

Step Three:

Once you're in Visualize Spots view, you can help the spots stand out even more by dragging the **Visualize Spots slider** (to the right of the checkbox). Drag this slider back and fourth a few times (it changes the contrast) until you find that point where the spots stand out, but without the threshold overwhelming everything by bringing out what looks like snow or noise over your image (as seen here).

TIP: When to Use Clone

At the top of the Spot Removal tool's panel, there are two methods for how it fixes your spots—Clone or Heal. We leave it set to Heal unless (and this rare, but it does happen) the spot you're trying to remove is on or near the edge of an object in your image and when it removes the spot, it leaves a smear. If that happens, hit Reset (at the bottom of the panel), switch to Clone, and try it again.

Step Four:

I usually wind up keeping the Visualize Spots slider pretty far to the right, so I get a nice dark background and can see just the spots that really stand out (as seen here). What's nice about this view is that you can remove spots while you're still in it. Make your brush just a little larger than the spot you want to remove, and then click once over it (as seen here). You can use either the Size slider (in the tool's panel) or the **Left and Right Bracket keys** on your keyboard to resize the brush.

TIP: Click-and-Drag a Brush Size

When using the Spot Removal tool, you can press-and-hold Command-Option (PC: Ctrl-Alt) and click-and-drag out a selection around your spot (start by clicking just to the upper left of the spot, then drag across the spot at a 45° angle). As you do, it lays down a starting point and then your circle drags right over the spot.

Removing Sensor Dust from Lots of Images Fast!

If the spots you're seeing in your images are from dust on your camera's sensor, I have good news and bad news: If you see those spots on an image, they're not just on that image—they're on all the images from that shoot, and they appear in the exact same place in every shot. The good news is, it's easy to fix them fast using this technique (we're talking seconds, not minutes. Well, unless you have a ton of spots, then we're probably talking a minute or two):

Step One:

If it's sensor dust, the spots appear in the exact same place in every image, so here's what we do: First, remove all these spots from one of the images using the **Spot Removal tool** (**Q**; see the previous project). Then, while that photo is still selected, go down to the Filmstrip and select all the similar photos from that shoot (Command-click [PC: Ctrl-click] on them), then click the Sync button at the bottom of the right side panels (if it says "Auto Sync," click the toggle switch to its immediate left to switch to Sync). This brings up the **Synchronize Settings dialog** (seen here). Click the Check None button (circled here in red), so nothing is selected. Then, turn on the Process Version checkbox (this should always stay on) and most importantly, the Spot Removal checkbox (as seen here), and then click the Synchronize button.

Step Two:

This applies that same spot removal you did to the first photo to all the other selected photos—all at once (as seen here). However, I do recommend taking a quick look at the other photos you fixed because depending on the subject of your other shots, the fixes could look more obvious than on the photo you just fixed. If you see a photo with a spot repair problem (like we have here, where two of the spot repairs appear over the buildings), just click on that particular circle, hit the **Delete (PC: Backspace) key** on your keyboard to remove it, then use the Spot Removal tool to redo that one spot repair manually.

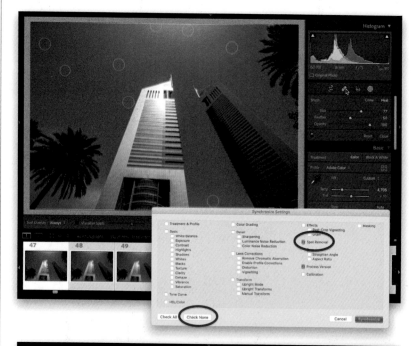

If you wind up with red eye in your photos (point-and-shoots are notorious red-eye generators thanks to the flash being mounted so close to the lens), Lightroom can easily get rid of it. This is really handy because it saves you from having to jump over to Photoshop just to remove red eye from a photo of your neighbor's six-year-old crawling through a giant hamster tube at Chuck E. Cheese. Here's how it works:

Removing Red Eye

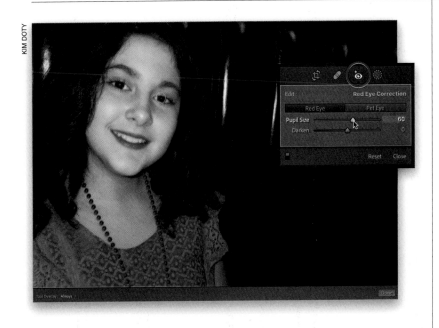

Step One:
Go to the Develop module and click on the **Red Eye Correction tool**, found in the toolbox right below the Histogram panel (its icon looks like an eye, and it's circled here in red). Click the tool in the center of one of the red eyes and drag down, and when you release the mouse button, it removes the red eye. If it doesn't fully remove all the red, you can expand how far out it removes it by going to the Red Eye Correction tool's options (they appear in the panel once you've released the mouse button), and dragging the **Pupil Size slider** to the right (as shown here) or clicking-and-dragging the edge of the circle itself (it allows you to reshape it, as well). If you need to move the correction, click-and-drag inside the circle.

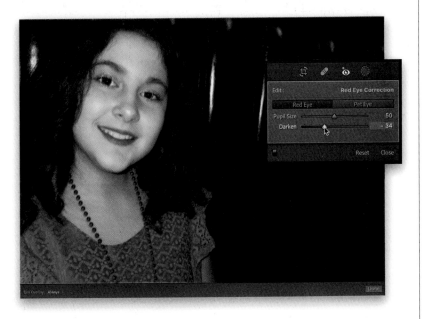

Step Two:
Now do the same thing to the other eye (the first eye you did stays selected, but it's "less selected" than your new eye selection—if that makes any sense). As soon as you click, this eye is fixed, too. If the repair makes it look too gray, you can make the eye look darker by dragging the **Darken slider** to the left (as shown here). The nice thing is that these sliders (Pupil Size and Darken) are live, so as you drag, you see the results right there onscreen—you don't have to drag a slider and then reapply the tool to see how it looks. If you make a mistake and want to start over, just click the Reset button at the bottom right of the tool's panel.

Automatically Fixing Lens Distortion Problems

Ever shoot some buildings downtown and they look like they're leaning backward? Or maybe the top of a building looks wider than the bottom, or a doorway or just a whole image seems like it's "bulging" out. All these types of lens distortion problems are really pretty common (especially if you use wide-angle lenses), but luckily for us, fixing them is usually just a one- or two- (maybe three-, seldom four-, rarely five-, but I once did six-) click fix.

Step One:

This image has a couple of very common lens problems. The first is barrel distortion, and you'll see this issue most often with wide-angle lenses—it makes an image look like it's bulging outward or bloated. A telltale sign an image has this is when lines that you know should be straight are curved. For example, look at the tile in the foreground here, and also look at how the ceiling bows upward. Those things should be straight, right? Another common lens problem is darkening that appears in only the corners of an image. This is called "lens vignetting," and we'll dig more into this over on page 284. But, there's a way to kill two problems with one stone here, because when we fix the barrel distortion, it fixes some of the lens vignetting, too.

Step Two:

Our first stop any time we're doing a lens fix of any kind is the Develop module's Lens Corrections panel to turn on the **Enable Profile Corrections checkbox**. When you turn this on, Lightroom looks at the EXIF data embedded in your image to learn which lens the image was taken with, and then it searches its built-in database to find a lens profile for your exact lens that fixes the problems (as shown here). Just doing this usually removes the outward bloating, along with fixing a lot (some-times all) of the vignetting (darkening) in the corners. If it can't find a matching lens profile on its own, you'll have to help it out by choosing your lens make and model from the Lens Profile pop-up menus, and then it does the rest. If you don't see your exact lens there, just pick a close match.

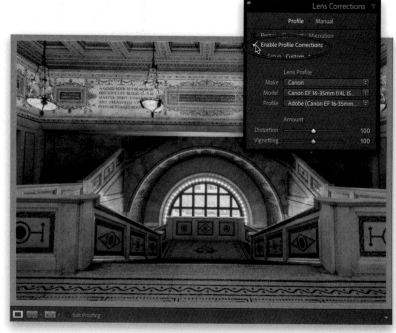

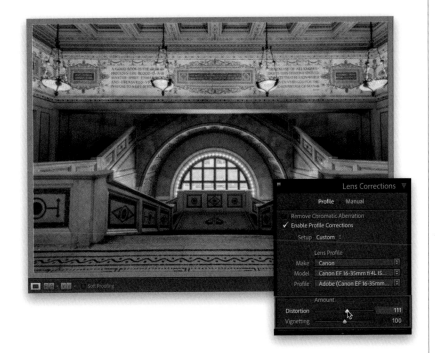

Step Three:
Now, take a look at the tile in the foreground back in Step Two and you'll see it's still not straight—it's still a bit curved. But, we can fix that using the fine-tuning Amount sliders that appear at the bottom of the panel. They let you tweak the effects of the profile you just applied, and in this case, by dragging the Distortion slider a bit to the right, we're able to straighten out that tile and remove the bulging effect caused by the lens. If you drag this Distortion slider back and forth a few times, while looking at your image, it'll help you see exactly what that slider does and how it affects your image.

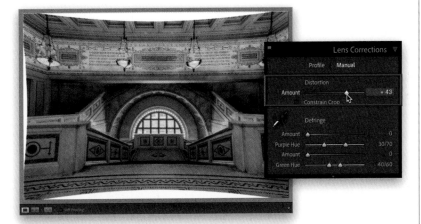

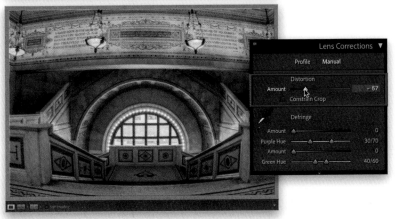

Step Four:
At the top of the Lens Corrections panel, to the right of the Profile tab, is the Manual tab, and at the very top is another **Distortion slider**. This one is very different from the other Distortion slider we used in the previous step—that one was just for fine-tuning the distortion amount. You go to this one when you have a serious barrel distortion problem—one that's way beyond what the fine-tuning slider in the Profile tab can do. Just so you can see what they really do, I used a much greater amount here than I would normally use, but it makes it easier to see just what barrel distortion is all about. Dragging this slider to the right (as shown here, at the top), sucks in that bulging big time (so much so it leaves white gaps around the edges). Now, drag the slider way over to the left and it does the opposite—it actually adds the bulging effect (as shown here, at bottom). You'll rarely have to make corrections this extreme, but at least now, if you do, you'll know to go to that Manual tab for its Distortion Amount slider.

Step Five:

Let's change photos to work on a different part of the lens correction process. Take a look at this shot—it's mighty wonky from a perspective point of view. The columns are leaning backward, the the top is pinched in and the bottom is pulled out wider, and it's crooked, and well, it needs some work. The first step with any of these lens fixes is to apply a lens profile correction, because doing so makes most of the options we use to fix these work that much better, so we'll start there. So, go to the Lens Corrections panel and turn on the **Enable Profile Corrections checkbox**, which will help reduce any barrel distortion and any darkening (vignetting) in the corners a bit, too. *Note:* For whatever reason, Lightroom couldn't determine the make and model of lens I shot this image with, so I chose Canon from the Make pop-up menu. But, it didn't offer the Canon 16–35mm this was shot with as a choice (even though that profile is in Lightroom), so I chose the closest match—the 17–40mm—and it worked just fine.

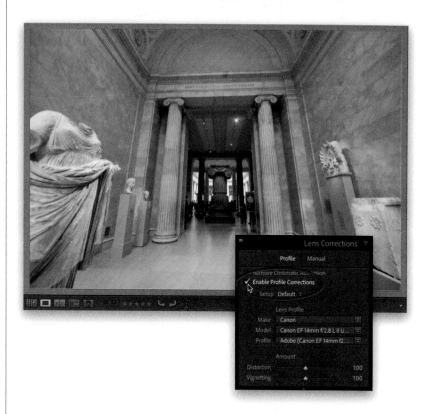

Step Six:

Next, go to the Transform panel (right below the Lens Corrections panel), where you'll find the Upright options. They are for making thing "upright" (well-named by the way). My go-to choice here is, hands-down, the **Auto button**, so click on that, and then look at the columns, and the room in general now. The columns aren't leaning backward anymore and lot of the overall wonkiness is gone. We do have the white triangles to deal with (very common when doing a big correction like this), so we'll deal with those in the next step. There are other Upright options here, but I rarely use them because they're "too strict." The Auto button gives you a balanced correction and it nearly always look best. The others (except for Level, which is just auto straightening) give you extreme corrections, in most cases, which while they may be technically correct, they aren't pleasing to the eye, so I usually avoid them.

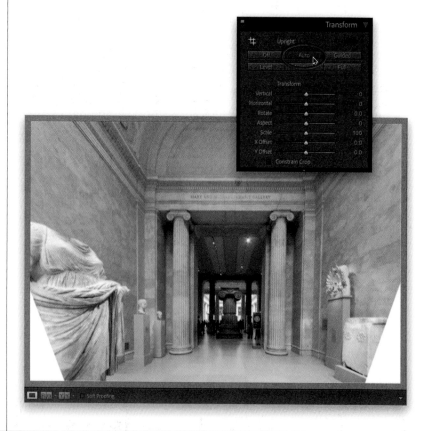

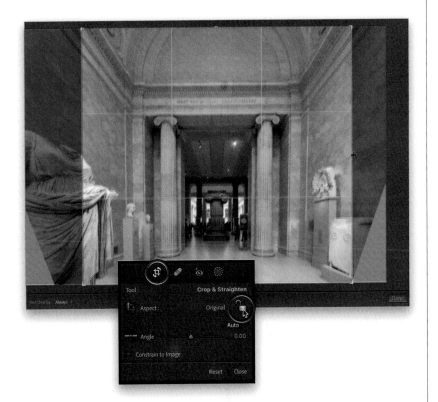

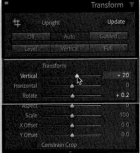

Step Seven:

Let's crop away those white, triangle-shaped gaps in the corners now using the **Crop Overlay tool** (**R**; or you click on it in the toolbox beneath the histogram). We need to make sure that we can adjust each side of the cropping border independently (so, a free-form crop, rather than one with its original aspect ratio locked), so go to the tool's panel, and click on the **Lock icon** to unlock it (unless, of course, the icon shows that it's already unlocked). Now, you can click-and-drag each side of your cropping border independently (as I did here to get it just inside those white gaps in the bottom corners). When you're done, hit **Return (PC: Enter)** to lock in the final crop.

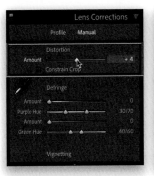

Step Eight:

After cropping, I could still see some bulging (barrel distortion) in the columns and a bit of curvature in the trim work above them. So, I went back to the Lens Corrections panel's Profile tab and used the Distortion slider to remove it, but that slider (which, again, is just used for fine-tuning) wasn't enough. So, as you learned earlier (and, as I said was pretty rare, and now with egg on my face), I had to go to the Manual tab and use "the big guns" of the full **Distortion Amount slider**, dragging it over to +4 (as seen here, at the top left). After all that, you'll still need to tweak some of the settings using the Transform panel's **Transform sliders**. There was still a little bit too much "lean" in those columns, but dragging the Vertical slider to the right (to +20) helped take care of that. Lastly, it was still (still!) a tiny bit crooked, but a small drag to the right with the Rotate slider (to +0.2) took care of that. A before and after is shown here, post-crop. One last thing: a great way to learn what the Transform sliders do is to simply drag them back and forth a few times, watch how your image responds, and they'll make a lot more sense.

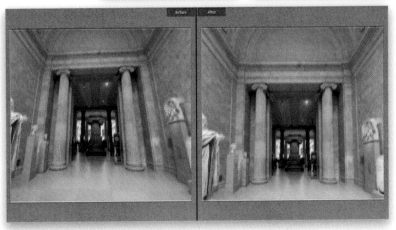

Fixing Lens Problems Yourself Using Guided Upright

If you have a shot where buildings or walls are leaning backward, and using the Auto Upright feature didn't fix it (or it didn't fix it as well as you would have liked), then your next stop is the "do-it-yourself" version of Upright, called "Guided Upright" (it's easy and awesome!). You drag out guides along walls or windows or anything that should be straight, and it takes over from there. You can draw up to four perspective correction guides and reposition them once they're in place, and their corrections will update live.

Step One:

Here's an image (taken in Valensole, France) where the building looks like it's leaning backward, courtesy of a 16mm ultra-wide-angle lens and my bad camera technique (shhh, don't mention that last part too loudly). When using Guided Upright, you tell Lightroom what's supposed to be straight in your image and it straightens it for you. You get up to four straightening guides: two for correcting the horizontal perspective and two for correcting the vertical (you don't have to use all four, or even three). They work by dragging the guides out along parts of the image that should be straight. Before you start using Guided Upright, though, to get better results from these corrections, first go to the Lens Corrections panel and turn on the **Enable Profile Corrections checkbox** (as shown here).

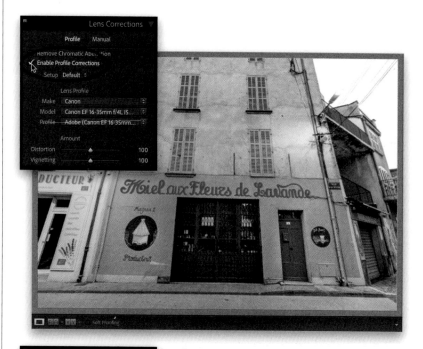

Step Two:

Now, go to the Transform panel and click the **Guided button** (as shown here). Move your cursor out over the image and click-and-drag a guide out along something that's supposed to be straight (like I did here, on the right edge of the building). As you drag, a vertical guide appears (seen here). Once it's in place, you can reposition the guide by clicking-and-dragging one of its circular end points. To help you line your guides up more precisely, there's a little floating window (also seen here), which magnifies the edge under your cursor. At this point, with just one guide added, our image still looks the same, but that's about to change.

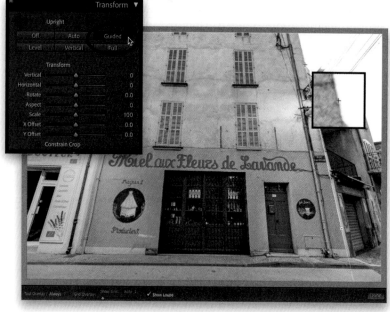

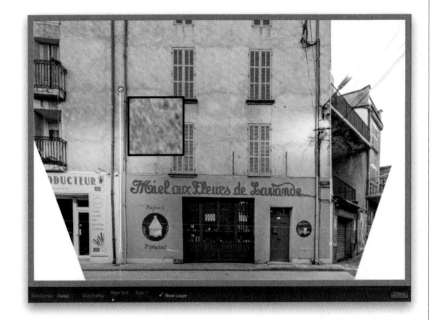

Step Three:

Next, let's drag out another vertical guide along the left side of the shop (where the yellow paint ends). Nothing happens while you're dragging, but when you release your mouse button, now that two guides have been placed, it applies the correction (as seen here where the building isn't falling backward any longer—a big fix for just dragging out two guides). You'll see white, triangle-shaped gaps in the bottom corners (we'll deal with them later), but for now, just take a moment to enjoy how straight this building looks now. Ahhhhhh, that's better. But, there's still a little work to do because the right side of the building is taller than the left, making it look like it's leaning a bit to the right. Luckily, we still have two horizontal guides we can use to fix the horizontal perspective issues.

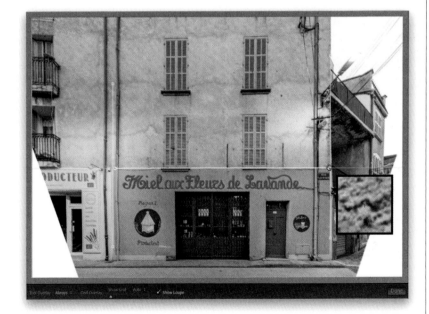

Step Four:

Let's click-and-drag out a horizontal guide along the top of the yellow paint. I chose that because I'm looking for parts of the image that I know should be straight (so, I hope they painted that line pretty straight). Just dragging out this one guide already helped the horizontal perspective a bunch (as seen here). When you add this third guide, it applies the correction as soon as you add it—same with a fourth guide. This is great because you can see if it looks good, and if it doesn't, you can press **Command-Z (PC: Ctrl-Z)** to Undo adding that guide, and try a new location. Also, if you want to delete a guide altogether, just click on it to select it and then hit Delete (PC: Back-space). Okay, one more horizontal guide to place.

Step Five:

Next, let's drag out our final guide across the tops of the two upper windows (as seen here) and voilà—our building is straight. I happened to choose the windows here, but we could have chosen any number of other areas that should be straight, like the top of the shop windows, or along the edge of the sidewalk in front, to see how it would look. It doesn't hurt to try different places because if you drag it out and it doesn't look good, again, just press Command-Z (PC: Ctrl-Z) to Undo adding that guide and drag it out somewhere else to see if that looks better. You can fine-tune your correction using the Transform sliders beneath the Upright section, and here, I dragged the **Rotate slider** just a tiny bit to the right (to +0.4) to straighten the entire image out a bit more.

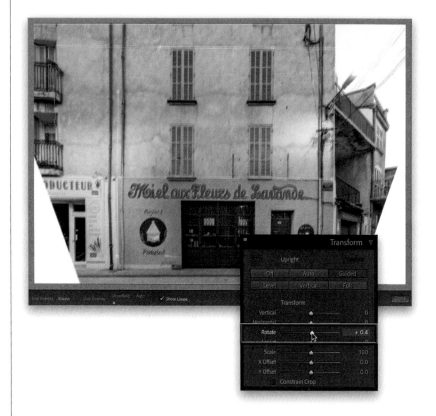

Step Six:

Now that our building is straight, we're going to crop away those white, triangle-shaped gaps in the corners using the **Crop Overlay tool** (**R**; or just click on it in the toolbox beneath the histogram). So we can make a free-form crop and keep as much of the original as we can, first go to the tool's panel, and click on the **Lock icon** to unlock it (if it's not already unlocked; as shown here). Now, we can drag each side of the cropping border independently (that's what I did here to get it just inside those white gaps in the bottom corners). When you're done, hit **Return (PC: Enter)** to lock in the final crop. We still have one more lens-related issue to deal with here, but it's an easy fix.

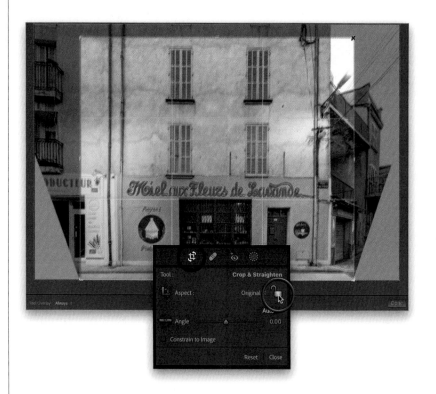

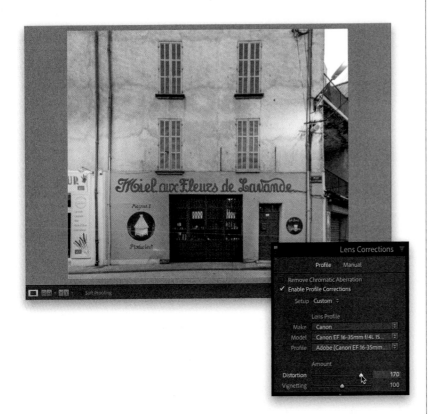

Step Seven:

The final lens issue we have to deal with is called "barrel distortion" and it makes the image look like it's bulging or bloated outward, making what should be straight lines look curved, so it's definitely worth fixing. If you look at the image back in Step Six, you can see it has some barrel distortion and the bulging out-look I'm talking about. To get rid of this, go back to the Lens Corrections panel, and in the Amount section at the bottom, you'll see the **Distortion slider**. Simply drag this slider to the right until the bloating and bulging are gone (as shown here. Yup, it's that easy). By the way, while you're dragging this slider a grid appears over your image to help you see when the lines look straight again. A before and after is shown below, and you can really see what a great job this Guided Upright correction did.

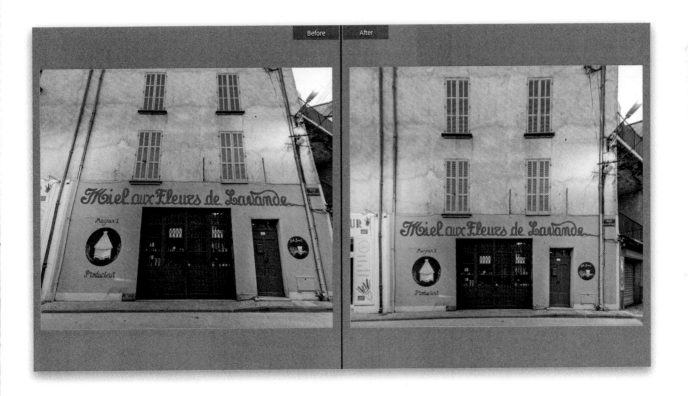

Fixing Dark Corners (Vignetting)

Lens Vignetting is a lens problem that causes the corners of your photo to appear darker than the rest of the photo. This problem is usually more pronounced when you're using a wide-angle lens, but can also be caused by a whole host of other lens issues. Now, this darkening in the corners is not to be confused with adding a post-crop edge vignette effect all the way around your image (not just the corners), which is something we sometimes intentionally add to focus attention away from the edges (I covered adding edge vignette effects in Chapter 8).

Step One:

In the photo shown here, you can see how the corner areas look darkened and shadowed. This is the bad vignetting that I mentioned above, and is a problem caused by your lens when you took the shot. Vignetting like this can happen in expensive lenses and cheaper lenses (it's just often more pronounced in cheaper lenses), but getting rid of it is, thankfully, really easy.

Step Two:

Our first line of defense is to go to the Lens Corrections panel (in the Develop module's right side panels) and turn on the **Enable Profile Corrections checkbox** (as shown here). This applies a fix from Lightroom's built-in database of lens corrections, and it tries to automatically remove any edge vignetting, based on the make and model of the lens you used (it learns all this from the EXIF data embedded in your image). You can see here it did a decent job. It didn't get it all, but it seems to have gotten most of it (we'll tweak these results in a moment). If, for some reason, it wasn't able to find a profile for your lens (the pop-up menus in the Lens Profile section are set to none or appear blank), just choose your lens make from the pop-up menus and that alone will often bring up your lens profile. If not, choose the closest one to your lens from the list.

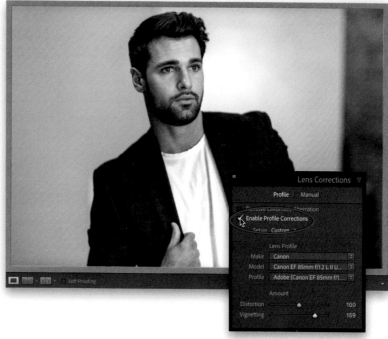

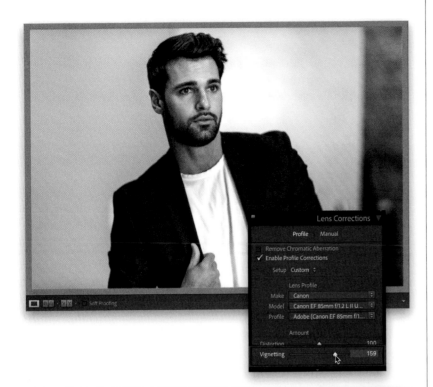

Step Three:

Once you apply this Lens Profile correction, if enough of the vignetting didn't go away, you can fine-tune the results in the Amount section (at the bottom of the panel), using the **Vignetting slider**. Here, I had to drag it all the way over to 159 until all of the vignetting was gone. However, this slider only goes over to 200. What happens if you drag to 200 and it's still not gone? Well, these two sliders (Distortion, for dealing with barrel distortion, and Vignetting) are just "fine-tuning" sliders that you use to gently tweak the two things applying a Lens Profile correction addresses. If that subtle fine-tuning doesn't do the trick, then it's time to bring out "the big guns" (which is what we'll do in the next step).

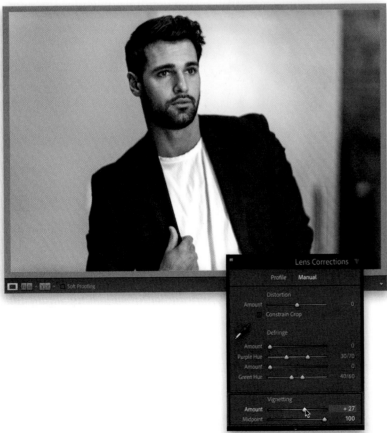

Step Four:

At the top of the Lens Correction panel, click on Manual, and you'll see a Vignetting section at the bottom. There are two sliders here: the first slider controls the amount of brightening, and the second slider lets you adjust how far in toward the center of your photo the corners will be brightened. In this photo, the edge vignetting is pretty much contained in the corners and doesn't spread too far into the center of the photo. So, start by slowly clicking-and-dragging the **Amount slider** to the right, and as you do, keep an eye on the corners of your image. As you drag, the corners get brighter, and your job is to stop when the brightness of the corners matches the rest of the photo (as seen here). To keep the brightening to just the ends of the corners, drag the **Midpoint slider** over to the right until your brightening is just affecting what's up in the very tips of the corners (as I did here). That's the manual version, which you probably won't have to use all that often, but if you do, now you know how to do it.

Sharpening Your Photos

Lightroom has some really nice sharpening controls (three in all), and two of them are kind of "must do," but the third one is optional. They all do a nice job and work well together, and we're going to cover all three here.

Step One:

To sharpen your image, go to the Detail panel in the Develop module, and at the top, under **Sharpening**, you'll see four sliders. If you shot in RAW, you'll see a default Amount of 40 has already been applied to your image (as seen here, at the bottom left). That's because when you shoot in RAW, you're telling your camera not to apply the sharpening it normally would to a JPEG, so this Amount of 40 is replacing some of the sharpness that's lost because your camera's sharpening is turned off. If you took the shot in JPEG mode, Lightroom doesn't automatically apply any sharpening—it sets the Amount to zero for all JPEGs (as seen here, at the bottom right). This sharpening that's applied to RAW photos in Lightroom is referred to as "capture sharpening" because it's replacing sharpening lost at capture when you shoot in RAW.

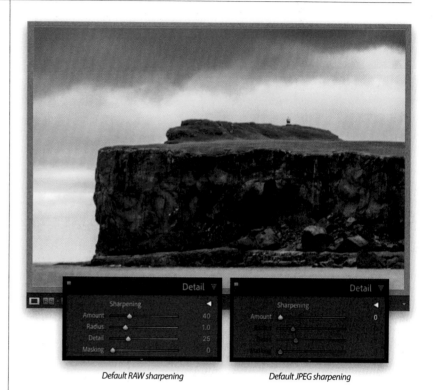

Default RAW sharpening Default JPEG sharpening

Step Two:

When you go to the Detail panel, you'll probably see a exclamation point **warning icon** (as seen circled here). That's warning you that to accurately see the amount of sharpening you're applying (or more realistically, to see it at all), you need to be viewing your image at a 100% (1:1) view, and that you're not currently at a 100% view, so you're kinda flying blind. What's nice is, if you click directly on that warning icon, it actually zooms in to a 100% view for you. So, the actual first step of sharpening is to zoom in to a 1:1 (100% view).

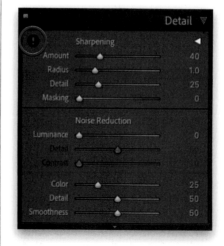

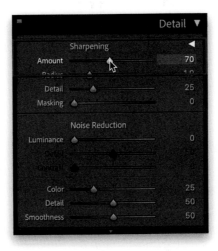

Step Three:

We adjust the amount of sharpening that gets applied to our image using the Amount slider (thank you, Captain Obvious), and if you shot in RAW, remember, Lightroom has already applied an Amount setting of 40 to your RAW image. The problem is, I feel that default Amount setting is too low. Quite a bit, actually, especially if you're shooting a high-megapixel camera (36-megapixels or higher, in which case, it's way low!). I haven't found a photo yet that doesn't need more capture sharpening than just 40. I'm usually between 50 (on the low end) and 70, depending on the type of image (I use higher amounts on images with lots of detail, like landscapes or automotive shots, cityscapes, etc., and lower amounts on portraits or when the subject is of a softer nature).

Step Four:

Also, if you're shooting a high-megapixel camera, you'll have to raise your Amount setting higher to get the same amount of sharpening I'm getting when sharpening the images here from my 24-megapixel camera. While an Amount setting of 80 looks like a lot of sharpening on my images, that might not look like a lot on images from your 61-megapixel camera (or a 100+-megapixel medium format camera). So, don't be afraid to crank the Amount slider if, when you're viewing the image zoomed in to 100%, you're not seeing enough sharpening. At the end of the day, how much capture sharpening you apply is your call, based on how sharp you want the image to be from the start, but again, this is just a start. One more thing, when it comes to sharpening and dragging the Amount slider to the right, Adobe says: "In most cases, this is all you need to do." (That's a direct quote from Adobe.) So, you could just skip out and move on to another part of this chapter, but you would miss out on some of the other cool (and very important) sharpening stuff we haven't covered yet).

Step Five:

Right beneath the Amount slider is the **Radius slider**, which lets you choose how many pixels out from the edge the sharpening will affect (basically, how far out the sharpening spreads). Here's how Adobe describes Radius: "The Radius slider controls the thickness of the edge where the contrast is applied. Lower values give you a thinner edge, while larger values give you a thicker edge." Well, that's helpful [insert the eyeroll emoji here]. Anyway, for everyday use, I leave this set at 1.0, but if I really need some mega-sharpening, I'll bump it up to 1.1 or 1.2. You have to be careful bumping this up too much because you can start to get a white line or hard-edged halo around the edges of objects. So, I usually crank the Amount rather than increase the Radius, but again, if you need "mega-sharpening," you can increase the Radius amount a bit.

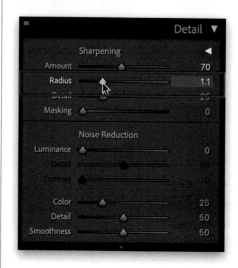

Step Six:

Beneath the Radius slider is the **Detail slider**, and I think of this as the "halo avoidance" slider. It's designed to keep you from having those halos we talked about earlier, and if you increase its amount, it actually removes your halo protection and gives you a crunchier, more haloey (if that's even a word) sharpening, so I don't touch this slider at all. By the way, if you were to drag the Detail slider all the way to the right, it would give you the same quality of sharpening as Photoshop's Unsharp Mask. Unfortunately, with that comes (wait for it…wait for it…) halos, so that's why I don't move it. By leaving the Detail slider at its default setting of 25, we can apply more sharpening to our image without any of the bad side effects you'd get with Photoshop's Unsharp Mask.

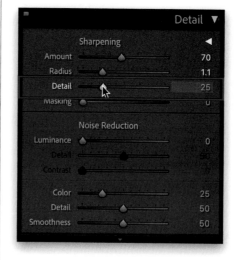

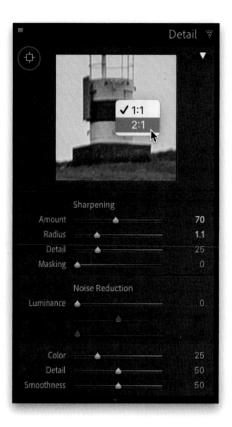

Step Seven:

We're going to skip over the Masking slider for just a minute (it's a whole thing, coming up shortly). At the top of the Detail panel, there's a small **preview window** that zooms in to 100% on one small area of the image (if you don't see it, click on the left-facing triangle to the right of Sharpening at the top of the panel). When you move your cursor over the preview, it changes to the grabber hand, so you can click-and-drag to move around. You can also click on the little icon near the upper-left corner of the panel (shown circled here), then move your cursor out over your image, and that area will now appear zoomed in the preview window (to keep the preview on that area, just click on the area in the main image). To turn this off, click that icon again. If you want to zoom in even tighter, you can Right-click inside the preview window, and choose a 2:1 view from the pop-up menu (as shown here). Just for the record, I bailed on using this tiny preview window years ago—it's just about useless, especially since I'll be zooming in to 100% for sharping, so I hide it by clicking the down-facing triangle doohickey to its right.

Step Eight:

The last Sharpening slider, Masking, is to me, the most amazing one of all because it lets you control exactly where the sharpening is applied. For example, some of the toughest things to sharpen are things that are supposed to be soft, like a child's skin, or a woman's skin in a portrait, because sharpening accentuates texture, which is exactly what you don't want. But, at the same time, you need detail areas to be sharp—like their eyes, hair, eyebrows, lips, clothes, etc. Well, the Masking slider lets you do just that—it kind of masks away the skin areas, so it's mostly the detail areas that get sharpened. To show how this works, we're going to switch to a portrait.

Step Nine:

First, press-and-hold the Option (PC: Alt) key and then click-and-hold on the **Masking slider**, and your image will turn solid white (as shown here). What this solid-white image is telling you is that the sharpening is being applied evenly to every part of the image. So, basically, everything's getting sharpened.

TIP: Toggling Off the Sharpening

If you want to temporarily toggle off the changes you've made in the Detail panel, just click on the little switch on the far left of the Detail panel's header.

Step 10:

As you click-and-drag the Masking slider to the right, parts of your photo will start to turn black, and those black areas are now not getting sharpened, which is our goal. At first, you'll see little speckles of black, but the farther you drag that slider, the more non-edge areas will become black—as seen here, where I've dragged the **Masking slider** over to 85, which pretty much has the skin areas in all black (so they're not being sharpened), but the detail edge areas, like the eyes, lips, hair, nostrils, and outline, are being fully sharpened (which are the areas still appearing in white). So, in reality, those soft skin areas are being automatically masked away for you, which is really pretty darn slick if you think about it.

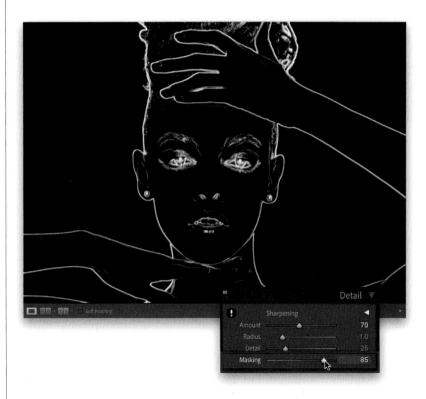

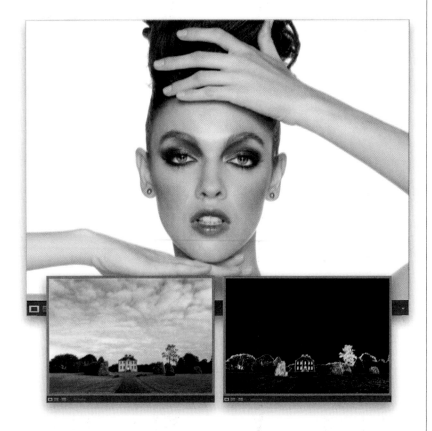

Step 11:

When you release the Option (PC: Alt) key, you see the effects of the sharpening, and here you can see the detail areas are nice and crisp, but it's as if her skin was never sharpened (in fact, I was able to crank up the Amount after the masking). Now, just a reminder: I only use this Masking slider when the subject is supposed to be of a softer nature, where we don't want to exaggerate texture, *or* this works nicely on landscape images where you might not want to sharpen the clouds in the sky (well, where else would clouds be? I probably could have left that "in the sky" part out). Anyway, I put an outdoor shot here, as well, to show how dragging the Masking slider to the right removes the sharpening from the sky (as seen here, at the bottom right).

Step 12:

The second stage of sharpening (this is the one that's totally optional) is called "creative sharpening." This is sharpening you apply using the **Brush tool (K)**. Once you have the brush, drag the Sharpness slider to the right—it's just one slider—and you're applying this sharpening only in areas where you are trying to lead the viewer's eye (like on this image, where I want you to see the words "Blue Angels," I painted over that area to make it super-sharp because our eyes are drawn to sharp areas of an image). Again this creative or "spot" sharpening is totally optional—you're using it to lead the viewer's eye (or simply for creative reasons).

The Third Stage of Sharpening:

The last one (which is pretty much a necessity) is called "output sharpening." It's a brilliantly designed sharpening algorithm based on the size and resolution of your image and where it's going to be viewed (in print or onscreen). I cover this third stage on page 301 in the Export chapter. I can't overstate how important this third stage is for getting the type of sharpening you've been hoping for (you don't have to hope any more).

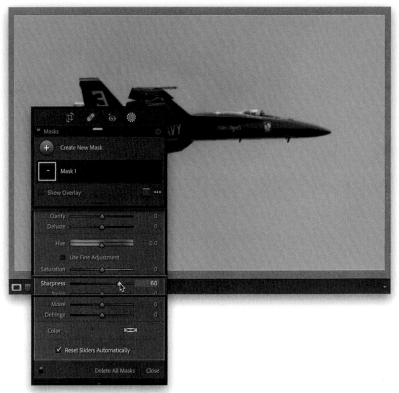

Removing Color Fringe (Chromatic Aberrations)

Have you ever seen an image that has either a purple or green color halo or fringe around the edges of things in the image? If you haven't, you're probably just not looking because these color fringes (called "chromatic aberrations") show up fairly often (it's a lens problem), and you can actually exacerbate them (how's that for a $10 word) by applying a lot of contrast or clarity. But, I wouldn't stop applying either one because Lightroom has a very effective way to fix this.

Step One:
Here's the original image, and at the Fit in Window size you see here, you really can't tell that there's a color fringe problem (chromatic aberrations) on the edges at all. But, when you zoom in (or print the image), you'll see it easily (and so will everybody else).

Step Two:
While they're kind of visible at a 100% full-size view, let's zoom in really tight, so you can see what I'm talking about. I zoomed in even tighter here (to 300%), and you can see that it almost looks like someone traced the outside edges with a lime green marker and the inside edges with a pale purple marker. That's the color fringe stuff we need to get rid of.

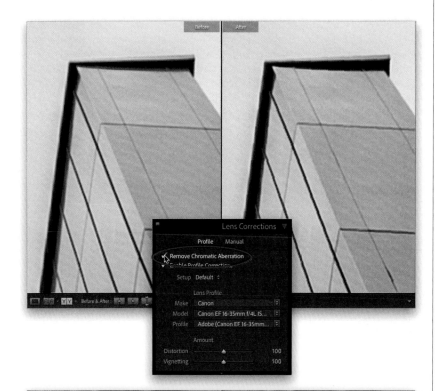

Step Three:

Let's get rid of these by first going to the Develop module's Lens Corrections panel, and on the Profile tab, turning on the **Remove Chromatic Aberration check-box** (as shown here). A lot of the time, just turning on this checkbox is enough to fix the problem (it sure was with this image—take a look here, and you'll see the green and purple edge fringe is gone). Just one checkbox. How easy is that? Now, what do you do if that doesn't work? Well, you go on to Step Four, that's what ya do.

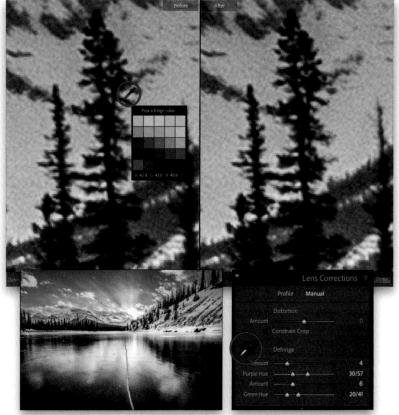

Step Four:

I switched to a different image here (you can see the full image in the inset below on the left), and then I zoomed way in. The Remove Chromatic Aberrations checkbox didn't work well enough for this image, so let's click on the Manual tab at the top of the panel. There are two ways to get rid of the color fringe here: One way is to click on the **Fringe Color Selector tool** (the eyedropper, circled below in red), and then click it once directly on the purple and green colors that are fringing in the photo (as shown here). The purple and green Amount sliders will automatically move right where they need to be to remove that color fringe. The other method is to skip the eyedropper and just drag the Amount sliders to the right until the fringe disappears. If that reduces it, but doesn't fully get rid of it, you might have to drag the Purple Hue or Green Hue sliders back and forth to find the hue range of those colors, so they can neutralize it. Both ways work just fine, so use whichever one you're more comfortable with.

Fixing Color Problems in Your Camera

Each camera puts its own color signature on your photos, which is why certain cameras look better for landscapes, some render flesh tones better for portraits, and so on. If you feel your camera has an obvious color bias (maybe it adds too much red), you can use the Calibration panel to create a more neutral look, or you can use it for creating special color effects. This differs from the HSL/Color panel, which we use for adjusting a particular color, like making the sky more or less blue. The Calibration sliders are red, green, and blue (the same RGB primary colors that make up your image), so when you move those sliders, you're changing the RGB color of your overall image, not just tweaking individual colors.

Step One:

Before we start, using camera calibration is totally optional. In fact, I imagine most people will never need it because they don't notice a big enough consistent color bias with their camera to even worry about it (or they like their camera's color bias, which many people do). However, if it bugs you, then this is for you. Go to the Develop module's **Calibration panel**, found at the very bottom of the right side panels (if Adobe thought you'd use this a lot, it would be near the top, right?).

Step Two:

Let's say your camera produces photos that have a bit too much red cast in them. You could back off that red by dragging the Red Primary Hue slider to the right (more toward orange), which backs off that red a bit (as seen here) for a more natural look in the reds from this camera. If you think the greens are too green, you can just lower the Saturation of that color. So, you can either change the color (using the Hue sliders) or back off the intensity of the color (using the Saturation sliders). The topmost slider (Shadows) is for adjusting any green or magenta tint that your camera might be adding to the shadow areas of your photos. By looking at the color bar, you'll see which way to drag. For example, here I'm dragging the **Tint slider** toward green to reduce any reddish color cast in the shadow areas, but the change in this photo is so subtle you can hardly see a change.

Step Three:

When you get your colors looking the way you want, and you've tested these Calibration settings on several different images from that same camera, you can save these settings as a default for images you import into Lightroom from that particular camera. Go to the Presets panel (in the left side panels), click the + (plus sign) in the right side of the panel header, and choose Create Preset, and then in the New Develop Preset dialog (shown here at left), click the Check None button at the bottom left. Turn on the Process Version and Calibration checkboxes and click Create. Now, go to Lightroom's Preferences **(Command-, [PC-,])**, click on the Presets tab, and in the Raw Defaults section, turn on the **Override Global Setting for Specific Cameras checkbox**. Next, choose your camera make and model from the Camera pop-up menu, and then from the Default pop-up menu, choose the preset you just created (as seen here, on the right). That's it! Now, when you open a RAW image from that camera, it will apply that camera calibration you created automatically.

Step Four:

Besides just fixing color biases in our cameras, some photographers like to use these Calibration sliders to create specific color looks or effects by shifting the colors and creating interesting combinations. You see these looks quite a bit on Instagram, and there is no set formula to follow because it's a creative decision. Here, I've shifted the colors from warm natural colors in the Before image (though, granted, I probably had too warm a white balance on the shot) to a creative color look with pinks in the highlights and greens in the shadows (in the After image). When it comes to getting looks like these, honestly, I'd go to the Color Grading panel (see Chapter 8) and do these types of things there (it's so powerful and so easy). But, there's nothing wrong with creating your new color scheme here, so why not try both to see which one resonates with you?

EXPORTING
saving as a JPEG, TIFF, and more

You might be wondering why saving your file as a JPEG or TIFF or whatever would take an entire chapter of its own. Well, if you were just saving it as a JPEG or TIFF, then maybe it wouldn't. It's when you add "whatever" that things get really squirrelly. But, before we get to that, you might also be wondering why Adobe chose the term "export," instead of just "save." If they had a Save As command (like almost every other program on earth), we could have skipped this chapter altogether, because you'd already know that to save your image as a JPEG, you'd go to Save As, right? Of course. Too easy. Too obvious. So, they named the menu command "Export," which, by the way, is what Adobe calls the command for exporting your file as a PDF in almost every other Adobe program. But, I guess calling it "Export" is better than what it was originally named in early beta versions of Lightroom 1.0. It wasn't called "exporting" your file. It was called "ejecting," which they chose because this was all so long ago that people still used VCRs, and to get a VHS tape out of your VCR, you'd hit the Eject button, so it would feel familiar to users. This all fell apart when they wrote the first Lightroom user manual (they did stuff like that back then). When it came to describing the act of "ejecting" your file as a JPEG, they called that process "ejectulation," and well…let's just say they received some severely negative feedback. The only saving grace, from Adobe's standpoint, was that Twitter had not been invented yet, so the only way anyone could really complain was to write a letter to the local newspaper (people read those back then). But, that letter would be buried in the "Letters to the Editor" section, which nobody read, except for people who wrote letters to the editor and yelled things like, "Stay off my lawn!" and "How do I eject this dang file as a JPEG?"

Saving a JPEG or a TIFF

Since there is no Save command for Lightroom (like there is in most programs), one of the questions I get asked most is, "How do you save a photo as a JPEG?" Well, in Lightroom, you don't save. You export. You export it as a JPEG (or a TIFF, or a DNG, or a Photoshop PSD). It's a simple process, and Lightroom has added some automation features that can kick in when your photo is exported.

Step One:

Start by selecting which photo(s) you want to export as a JPEG (or a TIFF, PSD, or DNG). You can do this in either the Library module's Grid view or down in the Filmstrip in any other module by Command-clicking (PC: Ctrl-clicking) on all the photos you want to export (as seen here). If you're in the Library module, click on the **Export button** (circled here in red) at the bottom of the left side panels. If you're in a different module and using the Filmstrip to select your photos for export, then use the keyboard shortcut **Command-Shift-E (PC: Ctrl-Shift-E)**. Whichever method you choose, it brings up the Export dialog (shown in the next step).

Step Two:

Along the left side of the Export dialog are some export presets Adobe included to get you started. Export presets are a good idea because they keep you from having to fill out this entire dialog every time from scratch when you export. However, the real power is when you create your own presets (those will appear under User Presets, and we'll cover that here). For now, let's assume you want to save as a JPEG for uploading to Instagram, or your portfolio, or Facebook, or even to an online print lab. So, start up at the top, and from the **Export To pop-up menu**, choose **Hard Drive** (as seen here).

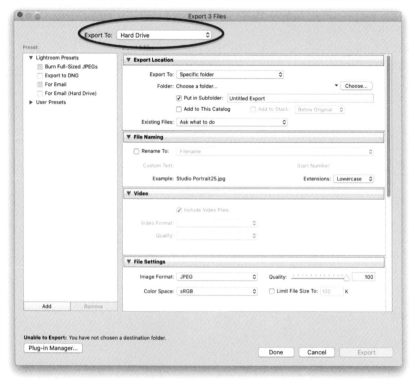

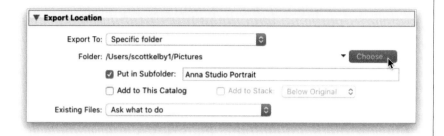

Step Three:

Near the top of the dialog is the **Export Location section** (I'm only showing the top section of the Export dialog here), and this is where you tell Lightroom where to save these files. Click on the Export To pop-up menu, and it'll bring up a list of likely places you might choose to save your files. In this case, just choose **Specific Folder**, and then click the Choose button to its right to choose which folder you want these JPEGs saved into (I chose my Pictures folder here, because my external hard drive isn't connected right now; I also could have chosen Pictures from the menu). Below that menu is a Put in Subfolder checkbox, which will save them into a separate folder inside your selected folder (that's what I did here, and I named that folder "Anna Studio Portrait"). If these are RAW files and you want the exported JPEGs added into Lightroom, turn on the Add to This Catalog checkbox. Lastly, when you export the images, if it finds a file already in the folder with a same name, it can Ask What to Do, or you can have it rename the file, write over it, or skip it. These are all choices in the Existing Files pop-up menu.

Step Four:

The next section down is for renaming your files as they're exported. You have to turn on the **Rename To checkbox** to have it do the renaming, otherwise, it skips this. There are a lot of naming options in the Rename To pop-up menu, but I generally choose **Custom Name – Sequence** (as seen here), so I can simply type in the name and which starting number I want the files to have (this is handy when you're exporting more than one photo at a time). So here, I'm going to rename the files "Anna Studio," starting with number 1. It shows you an example of what the new names will be at the bottom of the section, so these files, when exported, will be named "Anna Studio - 1.jpg," "Anna Studio - 2.jpg," etc.

Step Five:

The next section down, **Video**, will be grayed out unless one of the files you selected to export is a video clip. If you want it included in your export, turn on the Include Video Files checkbox (as shown here). Below that checkbox, you'll choose the video format (H.264 is a popular compression format for HD video; DPX format is usually for visual effects). Next, choose your video quality—Max (for large, high-quality files) to Low (for smaller, lower-quality files). You can see how different format and quality choices affect the exported file by looking at the target size and speed listed to the right of the Quality pop-up menu. Again, if you don't have any videos selected to export, this section will be grayed-out.

Step Six:

The **File Settings section** is really important because its Image Format pop-up menu is where you choose which file format to save your exported photos in—JPEG, TIFF, PSD, DNG, PNG, or if you're exporting RAW files, you could choose Original to export the original RAW photo (see page 312 for more on exporting the original). Since we're saving JPEGs, there's a Quality slider (the higher the quality, the larger the file size), and I generally choose a setting of 80, which I think gives a good balance between quality and file size. You also get to choose the color space of the exported JPEG files from that pop-up menu (if these images are going to be posted on the web, I choose sRGB, so they look as close as possible to what I saw in Lightroom). If you chose the PSD, TIFF, or DNG format, their individual options will appear (you get to choose things like their bit depth and compression settings. Fun stuff like that).

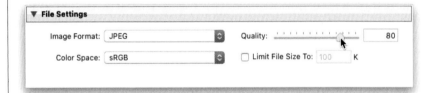

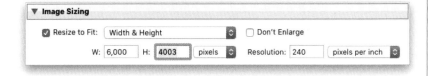

Step Seven:

Lightroom assumes you want to export your photos at their full original physical size, but if you want them to be smaller, in the **Image Sizing section**, turn on the Resize to Fit checkbox (as seen here). There's a pop-up menu of options (the default being Width & Height, as seen here), and you can type in smaller width and height dimensions in the W and H fields below the pop-up menu. Some other choices in the pop-up menu are Long Edge (handy if you're exporting a photo to enter into a photo competition as they often have strict size requirements, like "no longer than 2,000 pixels on the long edge"), or if you want the file reduced by a specific percentage (maybe you want the files to be 25% of their full physical size). There's a Resolution field here, but I don't touch it if the images are for online viewing because the resolution is determined by the pixel dimensions (actually, I don't touch it for print either).

Step Eight:

Next, is the all-important **Output Sharpening section**. If you turn the Sharpen For checkbox on (please turn this on!), it adds sharpening to your photos based on where they will be seen. I add output sharpening to every image I export (see page 291 for more on this). Briefly, if your image is going to be viewed onscreen (Instagram, Facebook, your portfolio, emailed, etc.), then from the Sharpen For pop-up menu, choose Screen. To the right of that, choose how much sharpening you want added. There is no preview of this sharpening, so you have to apply it, then look at the file to evaluate if the Amount you chose was right. Without seeing the final image, here's my quick take on these: Low is barely perceptible to the human eye (however, dogs can see a slight difference), Standard means "low," and High means "medium." I most often go with High, sometimes Standard (depending on the subject of the image), but never Low. Low is too low. For me, low is "no."

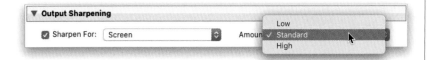

Step Nine:

If, instead of sharing your exported images onscreen, let's say you're exporting them to send to a print lab, from the **Sharpen For pop-up menu** choose the type of paper you'll be printing on (either matte or glossy), and then choose the **Amount** of sharpening (spoiler alert: I always choose High for print because the ink spreads when it hits the paper, which creates a loss of sharpness, and I like really crisp prints. But, that's just me). The ideal way to do this is to do a test print, evaluate the Amount of sharpening, and then decide what looks right for you and the image you're printing.

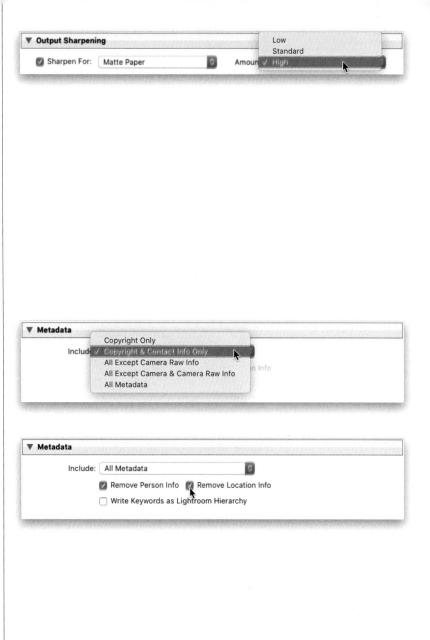

Step 10:

In the **Metadata section**, you can choose how much information (about you and about how these images were taken) you want to be embedded into your images. You choose this from the Include pop-up menu (seen here, at the top). When you choose All Metadata is gives whoever you give these files to (including people who download them from the web) everything about these images—the camera you took them with and its make, model, and serial number, the lens, your Camera Raw data, everything! The rest of the choices all limit how much info can be seen (I use Copyright & Contact Info Only because it hides all your exposure settings, your camera's serial number, and other stuff your clients probably don't need to know), and leaves just your copyright and contact info (if you're including your copyright, you probably want to include a way for people to contact you if they want to license your photo), or just your copyright. If you do choose All Metadata, All Except Camera Raw Info, or All Except Camera & Camera Raw Info, you can still have Lightroom remove any people keywords by turning on the Remove Person Info checkbox or any GPS data by turning on the Remove Location Info checkbox (as shown here, at the bottom).

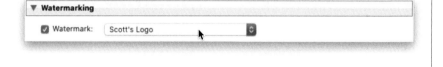

Step 11:

The next section down lets you add a visible watermark to the images you're exporting (watermarking is covered in detail starting on page 306). To add your watermark to each image you're exporting, turn on the **Watermark checkbox**, then choose a simple copyright or your saved watermark from the pop-up menu (as shown here, where I've chosen the logo I saved on page 309 as my watermark).

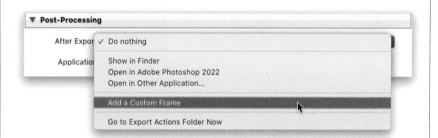

Step 12:

The final section, down at the very bottom, is **Post-Processing**, and this is where you decide what happens after the files are exported from Lightroom. If you choose Do Nothing from the After Export pop-up menu, they just get saved into that folder you chose back in the beginning and that's that. If you choose Open in Adobe Photoshop, they'll automatically be opened in Photoshop after they're exported (okay, that one didn't actually need an explanation). You can also choose to open them in another application or in a Lightroom plug-in. Go to Export Actions Folder Now opens the folder on your computer where Lightroom stores your export actions (these are automated Photoshop tasks you create in Photoshop). So, if you wanted to run an action from Photoshop, you could create a droplet and place it in this folder. That droplet would then show up in the After Export pop-up menu (as seen here), and choosing it would open Photoshop and run the action on the photos you were exporting from Lightroom. (*Note:* I made a video to show you how to create an action and a droplet in Photoshop. See page xv.)

Step 13:

Now, let's do something that will save us a bunch of time when we export some images. Let's create our own custom preset, so we don't have to make all these choices and check all these boxes every time. Instead, we can simply choose this preset from right within Lightroom (skipping the Export dialog altogether) and it'll do its thing for us behind the scenes. So, first, choose the settings you'd want for exporting a JPEG, but we need to change one thing from what we already learned, and we generally only use it when we're making a preset. In the Export Location section, from the Export To pop-up menu, choose **Choose Folder Later** (as shown here). Otherwise, each time we export a JPEG it will be saved into that folder called "Anna Studio." Instead, we want to be able to choose where our exported photos are saved each time we export them and this will allow us to do that.

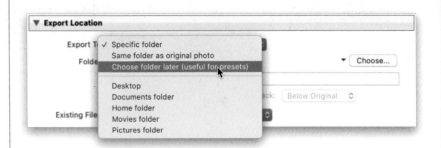

Step 14:

To save these settings as a preset, click the **Add** button at the bottom-left corner of the dialog (shown circled here in red), and then give your new preset a name (in this case, I named mine "Save JPEG to Hard Drive." That name lets me know exactly what file format I'm exporting and where it's going).

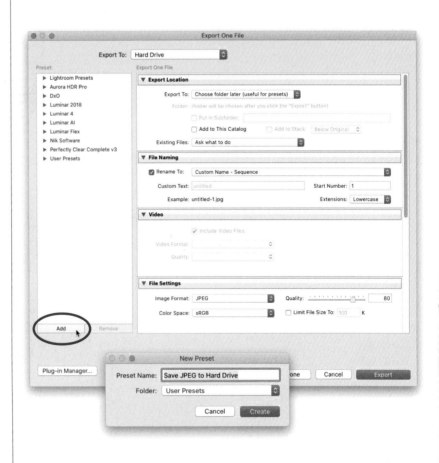

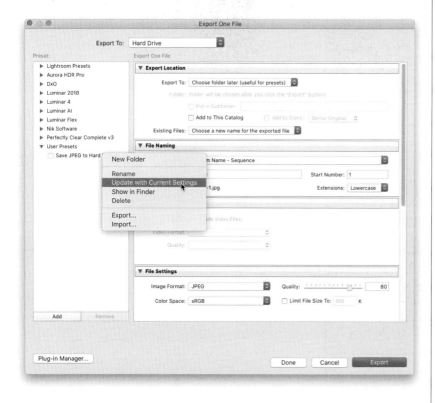

Step 15:
Once you click the Create button, your preset is added to the Preset section, under User Presets, and from now on, you're just one click away from exporting JPEGs your way. If you decide you want to make a change to your preset (as I did in this case, where I changed how it deals with existing files by choosing Choose a New Name for the Exported File from the Existing Files pop-up menu), you can update it with your current settings by Right-clicking on your preset, and from the pop-up menu that appears, choosing **Update with Current Settings** (as shown here). While you're here, you might want to create other presets for situations you commonly export for. Maybe you have a client that asks for images to be saved in TIFF format (it happens), so you could change your file format (and anything else you need changed) and save that as a preset, too. I'm not sure if there's a limit to how many presets you can create, but I can tell you this: I've yet to hit that limit.

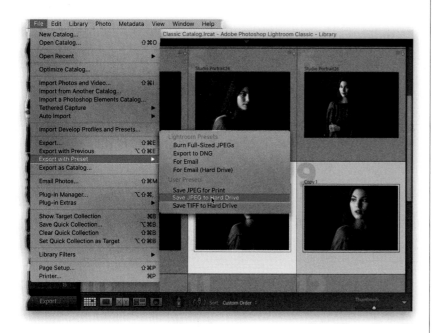

Step 16:
Now that you've created your own presets, you can save time and skip the whole Export dialog thing altogether. Just select the photos you want to export, then go under Lightroom's File menu, under **Export with Preset**, and choose the export preset you want (here, I'm choosing the Save JPEG to Hard Drive preset). When you choose it this way, it just goes and exports the photos and the only thing it asks is which folder you want them saved into. Sweet!

Adding a Watermark to Your Images

One thing some photographers do to help deter people from downloading their images online and using them without permission (or payment) is to put a visible watermark on them. That way, if someone downloads your image without permission and uses it, it'll be pretty obvious to everyone that they've stolen someone else's work. But, beyond the idea of protecting your images from unauthorized use, many photographers today use a watermark as branding and marketing for their studio.

Step One:

To create your watermark, press **Command-Shift-E (PC: Ctrl-Shift-E)** to bring up the Export dialog, then scroll down to the Watermarking section, turn on the Watermark checkbox, and choose **Edit Watermarks** from the pop-up menu (as shown here). *Note:* I'm covering watermarking here in the Export chapter, because you can add your watermark when you're exporting your images as JPEGs, TIFFs, etc., but you can also add these watermarks when you print an image (in the Print module), or put it in a web gallery (in the Web module).

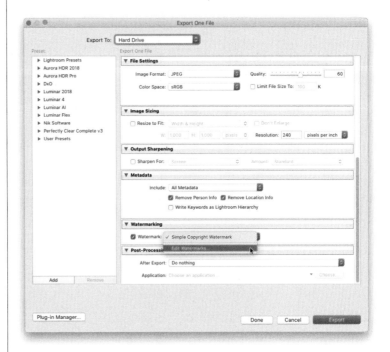

Step Two:

This brings up the **Watermark Editor** (seen here), and this is where you either (a) create a simple text watermark, or (b) import a graphic to use as your watermark (maybe your studio's logo, or some custom watermark layout you've created in Photoshop). You choose either Text or Graphic up in the top-right corner (shown circled here in red). By default, it displays the name from your user profile on your computer, so that's why it shows my copyright down in the text field at the bottom of the dialog. The text is also positioned right up against the bottom and left borders of your image, but luckily you can have it offset from the corners (I'll show you how in Step Four). We'll start by customizing our text.

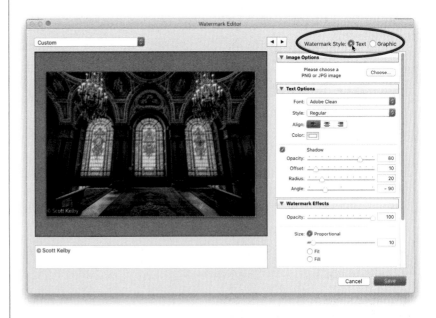

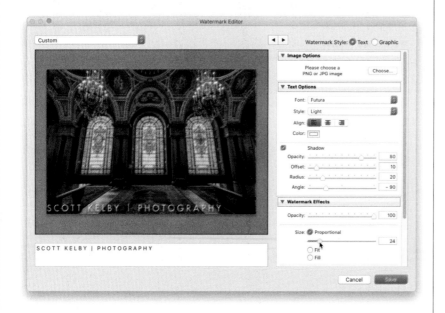

Step Three:
Type in the name of your studio in the text field at the bottom left, then choose your font in the **Text Options section** on the right side of the dialog. In this case, I chose Futura Light. (By the way, the little line that separates SCOTT KELBY from PHOTOGRAPHY is called a "pipe," and you create one by pressing Shift-Backslash.) Also, to put some space between the letters, I pressed the Spacebar after each one. You also can choose the text alignment (left justified, centered, or right justified) here, and you can click on the Color swatch to choose a font color. To change the size of your type, scroll down to the **Watermark Effects section**, where you'll find a Size slider (as seen here) and radio buttons to Fit your watermark to the full width of your image, or Fill it at full size. You can also move your cursor over the type on the image preview and corner handles appear—click-and-drag outward to scale the text up, and inward to shrink it down.

Step Four:
At the bottom of the section, you'll see an Anchor grid for positioning your watermark. To move it to the bottom-right corner, click the bottom-right anchor point (as seen here). To move it to the center of your image, click the center anchor point, and so on. To the right of that are two Rotate buttons if you want to switch to a vertical watermark. Also, back in Step Two, I mentioned there's a way to put some space (a margin) between your text and the edge of your image—just drag the Horizontal and Vertical Inset sliders (right above the Anchor grid). When you move them, little positioning guides will appear in the preview window, so you can easily see where your text will be positioned. Lastly, the Opacity slider at the top of the section controls how see-through your watermark will be. Also, my text looked kinda big so I used the Size slider to go from 24 down to 18.

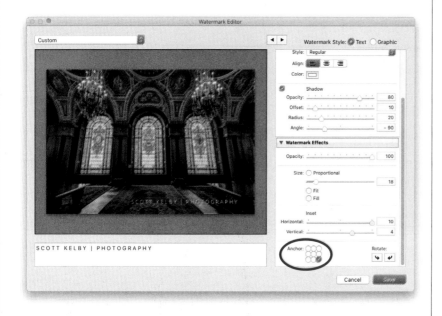

Step Five:

By default, the Watermark Editor adds a drop shadow behind your text to help it stand out. You can turn it on/off using the checkbox to the left of Shadow in the **Text Options section** or you can tweak it using the Shadow sliders. The Opacity slider controls how dark the shadow will be. The Offset controls how far from the text your shadow will appear (the farther you drag it to the right, the higher your text appears from the background). Radius is Adobe's secret code name for softness, so the higher you set the Radius slider, the softer your shadow. The Angle slider is for choosing where the shadow appears, so the default setting of –90 puts the shadow down and to the right. A setting of 145 puts it up and to the left, and so on. Just drag it, and you'll instantly see how it affects the position of your shadow. The best way to see if the shadow looks good with your text is to simply toggle the Shadow checkbox on/off a few times.

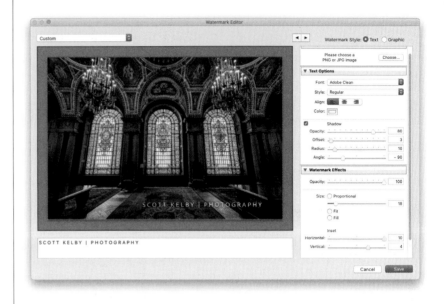

Step Six:

Now let's look at adding a graphic of your logo as your watermark (rather than just text). Scroll back up to the Image Options section up top, and click the **Choose button** to the right of Please Choose a PNG or JPEG Image (those are the only two file formats its supports). Find your logo, then click Choose, and your graphic appears (unfortunately, the white background behind the logo is visible, but we'll deal with that in the next step). It pretty much uses the same controls as when using text—go to the Watermark Effects section and drag the Opacity slider to the left to make your graphic see-through (as seen here), and then use the Size slider to change the size of your logo. The Inset sliders let you move your logo away from the edges, and like with a text logo, the Anchor grid lets you position the graphic in different locations on your image. The Text Options and Shadow controls are grayed out, since you're working with a graphic.

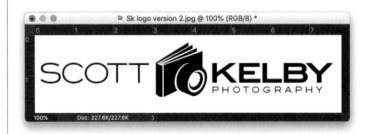

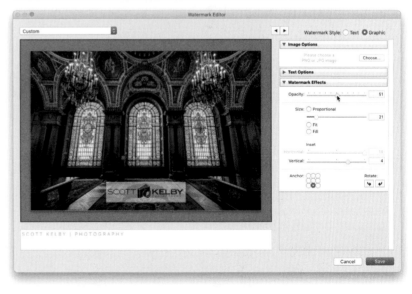

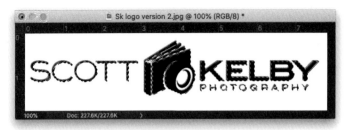

In Photoshop, get the Magic Wand tool and click it once on the white background to select it. Go under the Select menu and choose Similar, so you don't miss any white areas inside the letters or graphics

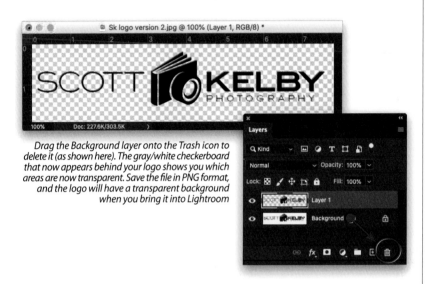

Drag the Background layer onto the Trash icon to delete it (as shown here). The gray/white checkerboard that now appears behind your logo shows you which areas are now transparent. Save the file in PNG format, and the logo will have a transparent background when you bring it into Lightroom

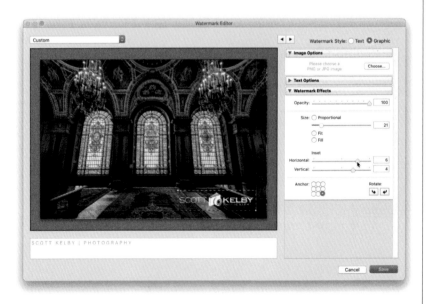

Step Seven:

To make that white background behind your logo transparent (so you only see the logo, and not the white box), open your logo in Photoshop and do three things: (1) Get your logo up on its own separate layer. You do that by clicking Photoshop's Magic Wand tool (press **Shift-W** until you have it) anywhere on the white background. Then, go under the Select menu and choose **Similar** to select every bit of white in your logo. Now, press **Command-Shift-I (PC: Ctrl-Shift-I)** to Inverse that selection, so now, instead of having the white background selected, the logo is selected (as seen here, at the top). Press **Command-J (PC: Ctrl-J)** to put your logo up onto its own layer with a transparent background. Next, (2) delete the Background layer by dragging it onto the Trash icon at the bottom of the Layers panel (as shown here). At this point, your logo will appear in black. But, if you want it to be white, press the letter **D**, then **X** to set your Foreground color to white, and then press **Option-Shift-Delete (PC: Alt-Shift-Backspace)** to fill your logo with white. Lastly, (3) choose Save As from the File menu, then choose **PNG** from the Format pop-up menu, and click Save. This file format keeps your background transparent when you bring your logo into Lightroom (if you save your logo as a JPEG, you'll still see the white background).

Step Eight:

In the Watermark Editor, click the Choose button again, and select your new PNG logo file. It now appears over your image without the solid white background (as seen here). You can now resize, reposition, change the opacity, and so on in the Watermark Effects section. Let's save it as a preset (so you can use it again, and also apply it from the Print and Web modules) by clicking the Save button in the bottom right or choosing **Save Current Settings as New Preset** from the pop-up menu in the top left. Your watermark is now always just one click away.

Emailing Photos from Lightroom

If you want to email someone a photo, you don't have to go through the whole export process. Believe it or not, you can email an image directly from Lightroom (well, you can start the process here in Lightroom. At some point, it hands it off to your email program. But, it feels like it's all in Lightroom, so that's all that counts, right? Right? Hello? Anybody out there with me? Anybody? ;-).

Step One:
In Grid view, Command-click (PC: Ctrl-click) on the images you want to email. Now, go under the File menu and choose **Email Photos** (as shown here).

Step Two:
This brings up Lightroom's **email dialog**, and it chooses your default email application to send this email from. If you want, you can choose a different email application from the From pop-up menu to the right of the Subject field. Now, enter the same standard info you would for any regular email: the email address of the person you're sending these images to, and enter something in the subject line. At the bottom of the dialog, in the Attached Files section, you'll see the thumbnails of the images you just selected. Okay, so what happens if it can't find your email app, or your app isn't listed in the From pop-up menu? Then, from that same From menu, choose **Go to Email Account Manager**. In that dialog, click the Add button (in the bottom left) and when the New Account dialog appears, choose your email provider from the Service Provider pop-up menu (you'll see Gmail, Yahoo! Mail, and even AOL Mail). If yours isn't listed there, then choose Other, and you'll have to add the server settings yourself. Name your account, click OK, and then add your email address, user name, and password in the Credential Settings section (it will verify that it's correct), click Done, and your email server will be added to your From pop-up menu. Hopefully, you won't have to go through all that, though.

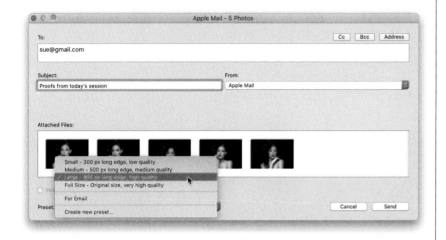

Step Three:

To choose the physical size of the images you're emailing, use one of the four built-in size presets from the **Preset pop-up menu** in the bottom-left corner of the dialog (as shown here). When you look at the preset sizes, you can see this was created a long, long time ago, because their Large setting is just 800-pixels wide (remember when that actually was large? I think the Spin Doctors were a top band then). Anyway, you can add your own Export presets to this menu, so you can pick your own preferred size and quality, and best of all, you create this preset in Lightroom's regular Export dialog. To create a size/quality preset, choose **Create New Preset** from the bottom of the Preset pop-up menu and it brings up the standard Export dialog to enter your specs (be sure to choose Email from the Export To pop-up menu up top). Click the Add button at the bottom-left corner of the dialog, then click Done, and now that preset will appear in your Preset pop-up menu when you choose Email Photos again, from the File menu.

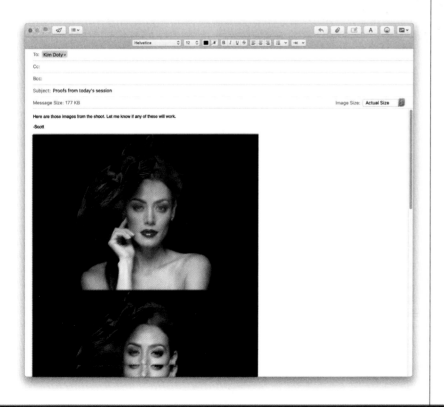

Step Four:

When you click the Send button in the email window, it launches your selected email program (as seen here), automatically fills in all the info you entered in the Lightroom email dialog (email address and subject line), and it attaches your images. Type in your email message (if you want to), hit the Send button, and off it goes.

Exporting Your Original RAW Photo

So far, everything we've done in this chapter is based on us tweaking our photo in Lightroom and then exporting it as a JPEG, TIFF, etc. But, what if you want to export the original RAW photo? Here's how it's done, and you'll have the option to include the keywords and metadata you added in Lightroom—or not.

Step One:

First, click on the RAW photo you want to export, then press **Command-Shift-E (PC: Ctrl-Shift-E)** to bring up the Export dialog (shown here). From the Export To pop-up menu up top, choose **Hard Drive**, then in the Export Location section, choose where you want this original RAW file saved to (I chose my desktop). In the File Settings section, from the Image Format pop-up menu, choose **Original** (shown circled here in red).

SUPER IMPORTANT: When you export an original RAW photo, any changes you applied to it in Lightroom (including keywords, metadata, and even edits you made in the Develop module) are saved to a separate file called an **XMP sidecar file**. That's because you can't embed metadata directly into the RAW file itself, so you need to treat the RAW file and its XMP sidecar file as a team.

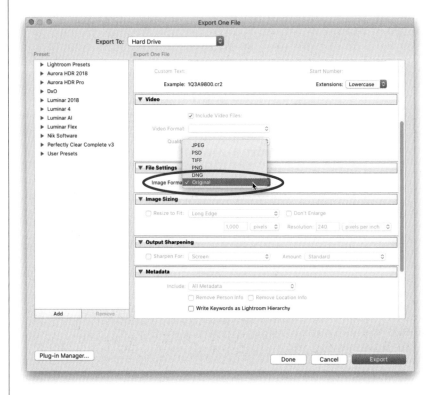

Step Two:

Now click Export, and since there's no processing to be done, in just a few seconds your file appears on your desktop (or wherever you chose to save it)—you'll see your file and its XMP sidecar (with the same exact name, but .xmp as its file extension) in a folder (as seen here, on my desktop).

Here's how the image looks in Lightroom with all your edits and cropping, etc.

If you don't include the XMP sidecar file along with the original RAW file, here's how that same original RAW file will look to your client. It ignores all the edits you made in Lightroom without that XMP sidecar file, so if you want it to have your edits, send both files—the RAW original and XMP file

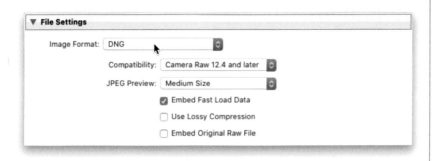

Step Three:

If you need to send this RAW file to a client or co-worker, and you want it to look exactly as it did when you last saw it in Lightroom, make sure you include both the original RAW file and the XMP sidecar file. As long as these two files stay together, when they open the RAW image in a program that supports XMP sidecar files (like Lightroom, or Photoshop, or Adobe Bridge to name a few), they'll see your RAW image with the changes you made to it in Lightroom, as seen here at top. The bottom image shown here is what they'll see in Photoshop's Camera Raw when you don't include the XMP file—it's the untouched original file with none of the changes you made in Lightroom. Of course, if you decide you don't want the file to include your edits, just don't include the XMP file with it.

TIP: If You Don't Want to Send Two Files

One way around this "two file tango" is to export your RAW file in Adobe's own RAW format called "DNG." When you save a RAW file as a DNG, it stores your Lightroom changes, and any other metadata you added in Lightroom, right within the DNG file itself (something you can't do with a regular RAW file). So, then you'd only have to send this one single file to your client, and your edits would be intact when they open it. To save an image as a DNG, in the Export dialog, choose **DNG** from the Image Format pop-up menu (as shown here. See page 11 for more on DNGs).

Drag & Drop to Export Your Images Using Publish Services

There's a feature called "Publish Services" that lets you make a button that will save images to your hard drive by simply dragging-and-dropping them onto that button. The original idea behind this feature was to let you upload directly to sites like Facebook or Flickr, keep track of your images, and let you swap out or delete them there, all from within Lightroom. Unfortunately, that relied on third parties keeping their Publish Services plug-ins up to date and many (like Facebook) have discontinued doing so. So, while it was a great idea at first (and a few sites still update their plug-ins), it has slowly died on the vine, and now we mostly just use it for saving images to our hard drives.

Step One:

The Publish Services panel is in the Library module, at the bottom of the left side panels. By default, it has two services you can set up: (1) save (publish) images to your hard drive, and (2) upload (publish) images to Adobe Stock (if you're an Adobe Stock photos contributor). We're just going to configure the Hard Drive publish service here, but what's nice about this is, not only does it make the process "drag-and-drop" easy, if you want to update the images you save (publish), you can re-edit them, crop them, etc., and quickly update those saved images with your new edits (it creates a new folder for saved image for you automatically). To start the process, click on **Set Up** to the right of Hard Drive.

Step Two:

This brings up the **Lightroom Publishing Manager**, which looks very much like the Export dialog, with two small exceptions: (1) at the top, there's a naming field for your Publish Service, and (2) at the bottom, there's no Post-Processing section (what happens after you save the file). But, once your file is saved, that's pretty much the end of it. We'll configure this so it saves any files we drag onto this publish service as high-resolution JPEGs with sharpening for print applied, and it saves them to your hard drive (so think of this as a drag-and-drop shortcut for making JPEGs, rather than having to use the Export dialog). Give this publish service a name (I named mine "For Instagram"), then fill out the rest just like you would when exporting a JPEG that you'd wind up uploading to Instagram (see page 298 for more on exporting).

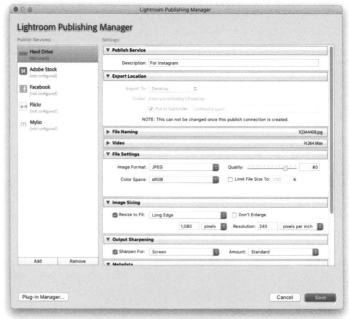

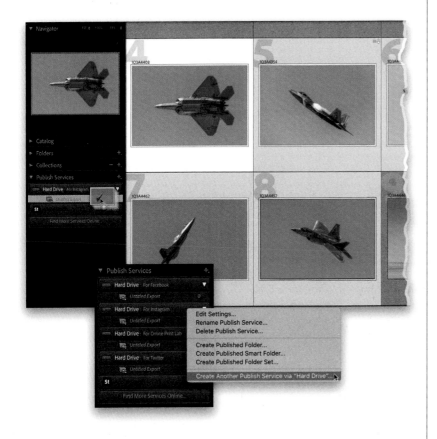

Step Three:

When you click Save, it replaces the words "Set Up" with whatever you named your publish service (in this case, it now it reads "Hard Drive: For Instagram"). To save images to your hard drive with your favorite Instagram image settings, simply drag-and-drop them onto that Publish Services button you created (as shown here, where I'm dragging a stack of selected images). Once you've dragged them there, they are "waiting" in an area called "New Photos to Publish," so they haven't actually been exported yet. To see the images "in waiting," click on that export's button and it shows them. If everything looks good, click the Publish button in the top-right corner to export (publish) them. By the way, you can add more of these Hard Drive publish services by Right-clicking on a Hard Drive button and choosing **Create Another Publish Service via "Hard Drive."** That way, you can have some that export your images with the sizing and specs for Twitter, or Facebook, or for printing to an online photo lab, etc. (as seen here in the inset).

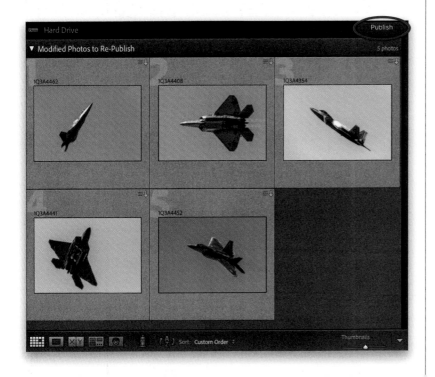

Step Four

Perhaps the best feature of Publish Services is that is once you've exported (published) images, Lightroom is still keeping track of them, so you can easily update any of them and re-export (republish) them. For example, if you go back into Lightroom, find and update any or all of those photos (like I did here, converting these to black and white), you can go back to Publish Services, click on that export's button (which shows you the images you previously published), and you'll see it now says "**Modified Photos to Re-Publish.**" Click the Publish button again and it re-exports those images you edited with their new changes. By the way, if you want to change the settings of a Publish Service you created, just Right-click on it and choose **Edit Settings**.

LR WITH PHOTOSHOP
when and how to use Photoshop with Lightroom

You are going to find this hard to believe, but there are things that Lightroom can't do. I know, this freaked me out too, but it's true. There will be times when you'll have to leave the safe, warm bosom of Lightroom and head to the bleak, dystopian, postapocalyptic world of Photoshop. This act of leaving Lightroom and jumping over to Photoshop to do some additional editing is called "Clevening" (though, in the hit movie about this process, starring Chris Pratt and Letitia Wright, it was actually referred to as "The Clevening"). If you search on Google, you'd find that the official dictionary definition of Clevening is "one who cleaves in Lightroom," or cultivates and encourages other "cleavers." Now, this next part really caught me by surprise, because while researching this topic, at the bottom of the definition page, was a cross-reference to a television show from a few years back that was actually written and produced by Adobe themselves. It was about a wholesome Midwest family—a dad, mom, their precocious young boy, and his dim-witted older brother. It chronicled their daily lives, and how they would often take an image from Lightroom over to Photoshop, make a few edits there, and then take the edited image back to Lightroom. You can still find a few of these episodes posted on YouTube. Do a search for "Leave it to Cleaver" (it starred Paul Rudd as "Eddie Has Fill," and Angela Bassett as "Cloney," the nosy neighbor). There was this one episode where the Cleaver and Cloney get into a fight with a maid, and there was this conveyor belt that wouldn't stop, and well…it's just a hoot. Anyway, what's most important to remember at this point is that this is a chapter opener, so there's no guarantee that any of this is legit or real or even spelled correctly.

Choosing How Your Files Are Sent to Photoshop

When you take a photo from Lightroom over to Photoshop for editing, you get to choose the type of file it sends over there (the file format, color space, all that stuff). It already has a set of defaults in place, which work fine if you don't want to mess with them, but if you want to tweak the kind of file you send over (I sure do), here's how to do it:

Step One:

Press **Command-, (comma; PC: Ctrl-,)** to bring up Lightroom's preferences, and click on the **External Editing tab** up top (seen here). If you have Photoshop on your computer, it assumes you want to use it for editing photos that leave Lightroom (alternately, if you have Photoshop Elements, it chooses that instead). If there's another program or plug-in you'd also like the option to use, you can choose that below in the Additional External Editor section. So, for files going over to Photoshop, you choose the file format you want to use from the **File Format pop-up menu** (shown outlined here in red). By default, it sends the file over in TIFF format, but I change mine to **PSD** (Photoshop's native file format) because the file sizes are smaller than TIFFs, but don't lose any quality.

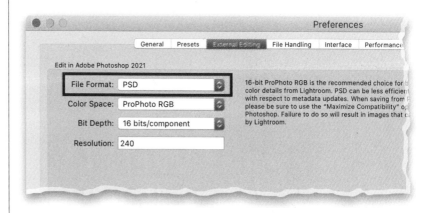

Step Two:

You can choose your **Color Space** from the next pop-up menu down. Adobe recommends **ProPhoto RGB**, which is Lightroom's native color space. The only thing is, if you're going with this, you should change Photoshop's color space to ProPhoto RGB, as well. You don't want your colors to look one way when you view images in Lightroom and another in Photoshop. You want your colors to be consistent.

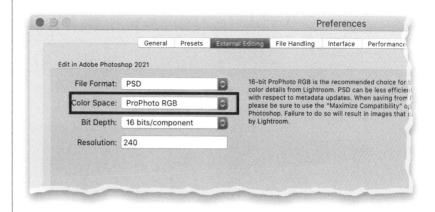

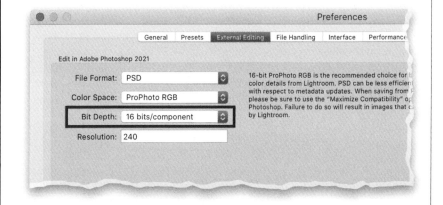

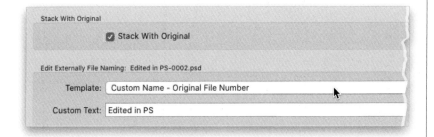

Step Three:
Adobe also recommends a 16-bit depth for the best results. But, if you shoot in JPEG, your image is already 8-bit and you can't just add bits in after the fact, so this only applies to folks shooting in RAW. While, technically, 16-bit offers an advantage, especially if you wind up having to tweak your image a lot in Photoshop, there's more data, so it's more forgiving. The downsides of 16-bit are your file sizes are much larger, so Photoshop goes a bit slower, and some features simply aren't available in 16-bit mode. So, which do I use? I mostly send my images over in 8-bit (so none of Photoshop features will be grayed out and unavailable). As for the Resolution field—don't mess with it. Leave it as is.

Step Four:
At the bottom of the dialog is a **Stack With Original checkbox**, which stacks the edited copy of your image on top of your original (as long as you have Collapse All Stacks turned on. See page 56 for more on stacking. But, the good news is, even if you don't have this turned on, it doesn't hurt anything, but I turn it on). Lastly, you can choose the name applied to photos sent over to Photoshop. What I do is have it add "Edited in PS," along with the original file number. You can do that by choosing **Custom Name – Original File Number** from the Template pop-up menu, and then in the field that appears below, type in "Edited in PS" (or whatever you want). It shows you a preview of how your naming will look right above the pop-up menu. Okay, those are your options, but remember, if you just go with the defaults, you'll still be fine. This is just if you can't help but mess with stuff (like me).

How to Jump Over to Photoshop, Do Your Stuff, and Jump Back

Lightroom is awesome for so many essential editing tasks, but it doesn't do the incredible, awesome, mind-numbing magic that Photoshop can do. Luckily, these two applications were designed to work together from the start. So, there will be times when you might need to jump over to Photoshop to do some quick "Photoshop magic," and then jump right back to Lightroom to finish off the image.

Step One:

To take the image you're working on in Lightroom over to Photoshop, go under the Photo menu, under Edit In, and choose **Edit in Adobe Photoshop** (as shown here), or just press **Command-E (PC: Ctrl-E)**. We're taking this image over to Photoshop because it has a boring, empty sky, and Photoshop has a built-in Sky Replacement feature (and it's pretty awesome—and powered by the same AI technology that sent Terminators from the future back to earth to kill John Conner. Just so you know).

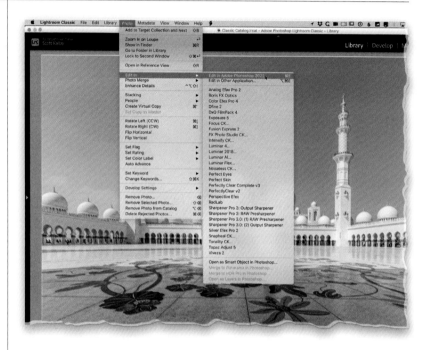

Step Two:

If you took the photo in RAW format on your camera, a copy of your image just appears over in Photoshop. No dialogs. It doesn't ask any questions, it just opens it. However, if you shot in JPEG or TIFF mode, the dialog you see here appears asking: (1) If the copy of your image it's sending over to Photoshop should have any edits you already made in Lightroom applied to it. This is the one I *always* choose (it's the top one for a reason). (2) If it should send the copy over without anything you did to it in Lightroom. I've never chosen this option, even once. (3) If it should send the original. Now, if Edit Original sounds terrifying, that's because it is. You're not safe working on the original. If you mess up, it's forever. I don't ever choose this, with the exception of one very particular situation, which I cover on page 330. But, 99% of the time, Edit Original is a scary, frightening, horrifying choice, so just don't.

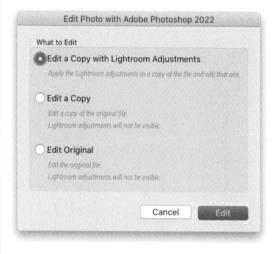

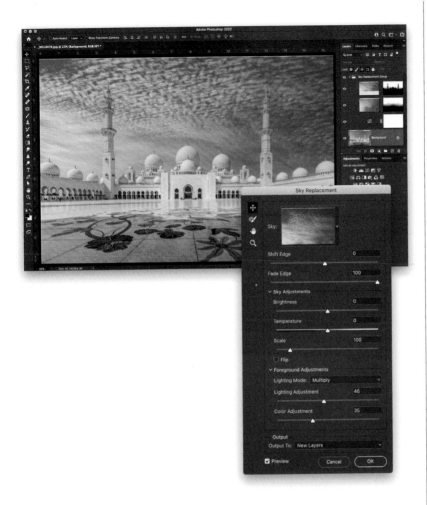

Step Three:

Here's the copy of the image opened in Photoshop. Go under the Edit menu up top and choose **Sky Replacement**. When the dialog appears (shown here in the inset), pick which sky you want by clicking on the Sky thumbnail, and from the pop-up menu, choosing one of the sample clouds that come with Photoshop. That's it—you click on a sky and it does the rest. It does a pretty brilliant job (even adding a color tint over part of your original image to help it blend color-wise with the new sky). You can reposition the sky by clicking right on it within your image and dragging it (and there are sliders here for tweaking everything from the softness of the edge where the clouds meet your image, to the brightness and white balance of the sky). When you find one that looks good, just click OK at the bottom of the dialog, and you're done. This is the kind of Photoshop stuff we're talking about that Lightroom just can't do. This is just one simple, quick thing, but it gives you an idea of why people use the phrase "Photoshop magic."

Step Four:

One more thing: while you can play around with those built-in skies, you can (and should) upload your own skies, so people don't recognize (and call out) the fact that you used a Photoshop default sky in your photo. When you're done tweaking your sky or doing any other edits in Photoshop, all you have to do to get your image back to Lightroom is: (1) Save your file **(Command-S [PC: Ctrl-S])**. And, (2) close the window. When you go back to Lightroom, your new Photoshop-edited image will appear right next to your untouched original image (as seen here). That's all there is to it. Save and close, and it goes back to Lightroom. It's a very smooth, easy, simple workflow.

Adding Photoshop Automation to Your Lightroom Workflow

If there's a "finishing move" you like to do in Photoshop (after you're done tweaking the image in Lightroom), you can add some automation to the process, so once your photos are exported, Photoshop launches, applies your move, and then resaves the file. It's based on you creating an action in Photoshop (an action is a recording of something you've done in Photoshop, and once you've recorded it, Photoshop can repeat that process as many times as you'd like, really, really, fast). Here's how to create an action, and then hook that directly into Lightroom:

Step One:
We start this process in Photoshop, so go ahead and press **Command-E (PC: Ctrl-E)** to open an image in Photoshop (don't forget, you can follow along with the same photo I'm using here, taken in Chicago, by downloading it from the webpage I gave you back on page xv). What we're going to do here is create a Photoshop action that adds a nice, simple matte border around the image, then a simple black frame around the outside, and then puts your nameplate under the image (it looks better than it sounds). Once we create this action, you'll be able to add this same frame with a matte around any image automatically when you export your final image as a JPEG (or TIFF or whatever) from Lightroom. The whole process is automated once your image leaves Lightroom.

Step Two:
To create an action, go under the Window menu and choose Actions to make the Actions panel visible. Click on the **Create New Action icon** at the bottom of the panel (it looks just like the Create a New Layer icon in the Layers panel and is circled here), which brings up the New Action dialog (shown here). Go ahead and give your action a name (I named mine "Add Frame") and click the **Record button** (notice the button doesn't say OK or Save, it says Record, because it's now recording your steps).

Step Three:

We're going to need to get this photo off the Background layer and put it on its own separate layer. To do that, press **Command-A (PC: Ctrl-A)** to put a selection around the entire image, then press **Command-Shift-J (PC: Ctrl-Shift-J)** to "cut" the image off the Background layer and put it on its own layer (as seen in the Layers panel here—you can see the image is now on Layer 1 and the Background layer is empty).

Step Four:

Now we're going to add some white space around the image by going under the Image menu and choosing **Canvas Size** (or you can use the shortcut **Command-Option-C [PC: Ctrl-Alt-C]**). When the Canvas Size dialog appears, at the bottom, choose **White** from the Canvas Extension Color pop-up menu, then turn on the Relative checkbox in the middle (that lets us specify how much space we want to add, without having to do any math, by adding it to the current dimensions). For the Width, add 4 inches, and for the Height, add 6 inches, so we'll add more space below the image than on the sides. Click OK to add this space. Now press **V** to switch to the Move tool, and click-and-drag your image up a bit on the canvas (press-and-hold the Shift key to keep it centered), so it's about an inch or so higher than center (as shown here). That leaves us room to add our nameplate in just a minute.

Step Five:

We need to get the selection back around our image, so go to the Layers panel, press-and-hold the Command (PC: Ctrl) key, and click directly on the layer thumbnail for Layer 1 (the Chicago skyscraper image, in this case), which puts a selection around the image. You're going to make that selection around 1/2" larger all the way around your image (this is what we're going to use to create our matte), so go under the Select menu and choose **Transform Selection** to switch your selection into a transformation border. Now, click-and-drag the center handles on each side out about 1/2" from the image (as shown here). It should be about equal distance on all sides (you could technically measure out the sides by making the Rulers visible by pressing **Command-R [PC: Ctrl-R]**, but I honestly just "eye" it). When it looks like what you see here, press **Return (PC: Enter)** to lock in the selection's resizing.

Step Six:

We're going to fill this selected area with white, but we need this matte to appear below our image (not covering it), so click on the **Create a New Layer icon** at the bottom of the Layers panel (it's the second icon from the right). When this new blank layer appears in the Layers panel, click-and-drag it below your skyscraper image layer. Your selection will still be in place, so press **D**, then **X**, to set your Foreground color to white, then press **Option-Delete (PC: Alt-Backspace)** to fill your matte selection with white. Deselect by pressing **Command-D (PC: Ctrl-D)**. To create the matte effect, at the bottom of the Layers panel, click on the Add a Layer Style (*fx*) icon, and choose **Inner Glow** to bring up the Inner Glow options in the Layer Style dialog (seen here). Set your Blend Mode to **Normal**, your Opacity to 35%, and then click on the color swatch and choose black as your glow color. Next, set your Size to 20 pixels, click OK, and it adds a thin shadow inside your white box, which looks like a cut matte.

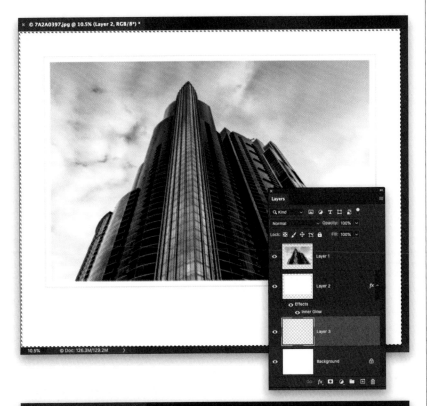

Step Seven:

Now that our matte is done, we're going to add a thin, black frame border around the outside of the image area. In the Layers panel, click on the Background layer and press Command-A (PC: Ctrl-A) to put a selection around the entire Background layer (as seen here). We'll need to add another blank layer, so click on the **Create a New Layer icon** at the bottom of the Layers panel to add this new layer directly above the Background layer (as seen here in the Layers panel).

Step Eight:

To add a stroke around the outside of the image, go under the Edit menu and choose **Stroke** to bring up the Stroke dialog (seen here). We want the stroke to appear inside that selected area, so choose Inside for Location, enter 125px for the Width (it's a high-res image, so it won't be nearly as thick as it sounds), then make sure your Color is set to black, and click OK, and it adds a thin black frame to the outside of your image (as seen here). Press Command-D (PC: Ctrl-D) to Deselect.

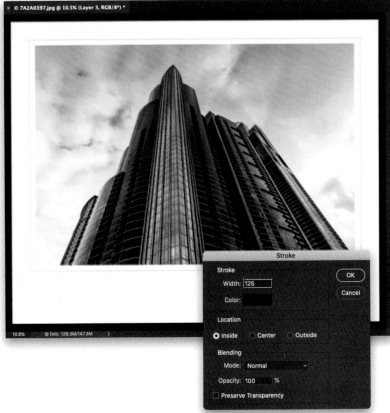

Step Nine:

Now let's add that nameplate below our image. Get the **Horizontal Type tool (T)**, click below your image, and type in your name or the name of your studio. In our example here, I typed in my name, and then I added a "pipe" (a vertical separator line) by pressing **Shift-Backslash**, then "Photography." I typed this nameplate in all caps using the font Gil Sans Light at 24 points. To add space between the letters, first highlight them to select them, then press-and-hold the Option (PC: Alt) key and press the Right Arrow key on your keyboard a few times (you'd press the Left Arrow key to tighten the space). It still needs to be centered, and we could lower the opacity a bit, so it's gray instead of black and doesn't compete with the image, but that's what Step 10 is for.

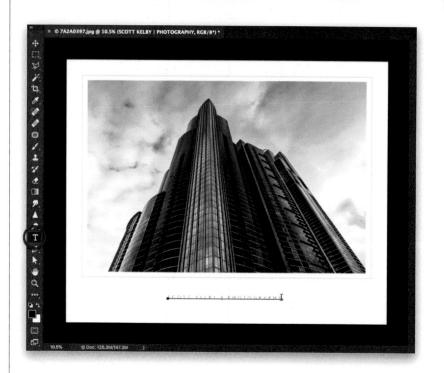

Step 10:

To center your text under the image, first click on the **Move tool** in the Toolbar, then in the Layers panel, Command-click (PC: Ctrl-click) on the Background layer, so both the text layer and Background layer are selected. Now, go up to the Options Bar and click the **Align Horizontal Centers button** (as shown circled here in red). Then, if you'd like, click on the Type layer in the Layers panel, and in the top-right corner of the panel, lower the Opacity of this layer to 50%, which gives it a gray color, rather than black, and helps it to recede (I didn't end up doing that here, but it's up to you). Now, let's save and close the file by pressing **Command-S (PC: Ctrl-S)**, and then **Command-W (PC: Ctrl-W)**.

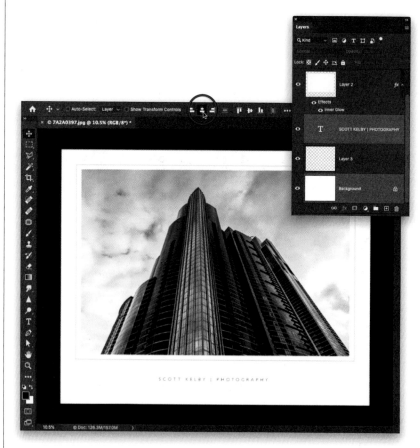

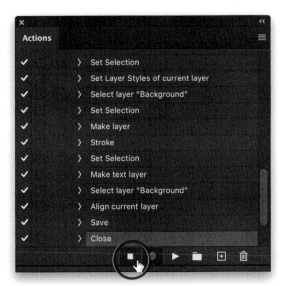

Step 11:

You may have forgotten by now, but we've been recording this process the whole time (remember that action we created a while back? Well, it has been recording our steps all along). So, go back to the Actions panel and click on the **Stop icon** at the bottom of the panel (as shown here). What you've recorded is an action that will apply the effect, then save the file, and then close that file. Now, I generally like to test my action at this point to make sure I recorded it correctly, so head back to Lightroom, click on a different photo, press Command-E (PC: Ctrl-E) to bring that photo over to Photoshop, then in the Actions panel, click on the Add Frame action and click the Play icon at the bottom of the panel. It should apply the effect very, very quickly, then it will save and close the document and send it back to Lightroom. If it looks good, we can move on to the final step.

Step 12:

We're now going to turn that action into what's called a "droplet," and we can use this droplet inside of Lightroom. When you drop an image onto a droplet, it automatically launches Photoshop, opens that photo, and runs the action you turned into a droplet (in our case, it would automatically run the frame action). Then it saves and closes the photo automatically, because you recorded those two steps as part of the action. Pretty sweet. So, to make a droplet, go under Photoshop's File menu, under Automate, and choose **Create Droplet** (as shown here).

Step 13:

This brings up the Create Droplet dialog (shown here). At the top left of the dialog, click the Choose button, choose your desktop as the destination for saving your droplet, and then name your droplet "Add Frame." Now, in the Play section of this dialog, make sure to choose **Add Frame** (that's what we named our action earlier) from the Action pop-up menu (as seen here). That's it—you can ignore the rest of the dialog, and just click OK in the top-right corner. If you look on your computer's desktop, you'll see an icon that is a large arrow, and the arrow is aiming at the name of the droplet (as seen here at the bottom).

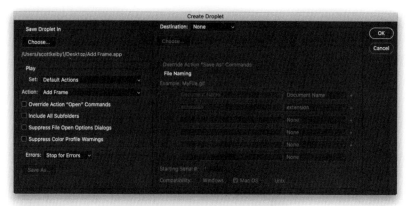

Step 14:

Now that we've built our Add Frame droplet in Photoshop, we're going to add that droplet to our Lightroom workflow using a feature called **Export Actions**, which are things that happen after you export an image. To become an Export Action, you have to place this droplet in the folder where Lightroom stores its Export Actions. Luckily, Lightroom can bring this folder right to you. Go back to Lightroom, and under the File menu, choose **Export**. When the Export dialog appears, go down to the Post-Processing section, and from the After Export pop-up menu, choose **Go to Export Actions Folder Now** (as shown here). This brings up the folder on your computer where Lightroom stores Export Actions (shown at the top). All you have to do is drag that droplet you saved earlier on your desktop into this folder, and then simply close the folder—it's now an Export Action in Lightroom.

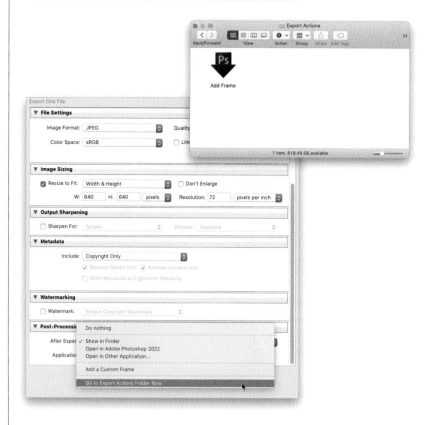

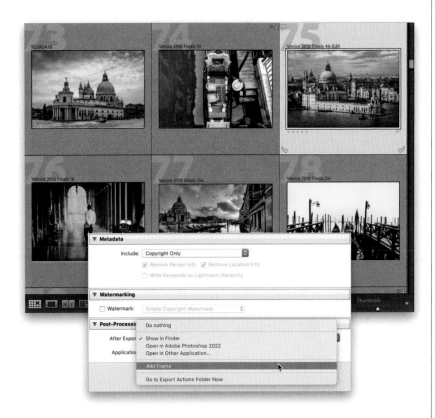

Step 15:
Okay, let's put it to work: In Lightroom's Grid view, select the photo (or photos) you want to have that effect applied to, then press **Command-Shift-E (PC: Ctrl-Shift-E)** to bring back the Export dialog. In the Preset section on the left, click on the right-facing triangle to the left of User Presets, and then click on the Save JPEG to Hard Drive preset we created in Chapter 10 (if you didn't create that one, go ahead and do it now). In the Export Location section, click on the Choose button and select the destination folder for your saved JPEG(s) (if you want to change it). Then, in the File Naming section, you can give your photo(s) a new name (if you'd like). Now, in the Post-Processing section at the bottom, from the After Export pop-up menu, you'll see **Add Frame** (your droplet) has been added as a choice, so choose it (as shown here).

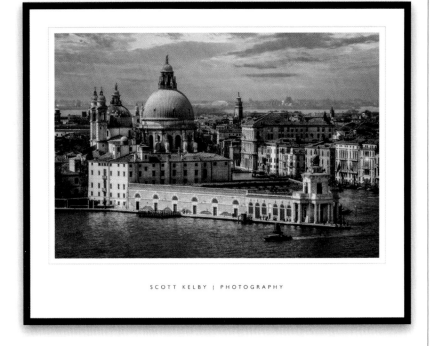

Step 16:
When you click Export, your photo(s) will be saved as a JPEG, then Photoshop will automatically launch, open your photo(s), apply your Add Frame action, then save and close the photo(s). Pretty slick stuff! Here's that image we just selected in Lightroom after having Photoshop run the Add Frame action when we exported it. I love it when a plan comes together.

Keeping Your Photoshop Layers Intact in Lightroom

If you take an image over to Photoshop, and you add a bunch of layers, and then you just "save and close," like I've been saying, what happens to those layers? They actually stay intact, even though, in Lightroom, you only see the thumbnail image like any other photo (as if you had flattened the image). The trick is how to reopen the layered image in Photoshop and still have the layers intact.

Step One:

Lightroom doesn't have a Layers feature (that's a Photoshop thing), so if you take an image over to Photoshop, and add a bunch of layers, and then bring that file back to Lightroom (by hitting Save and closing the file), you won't see those layers in Lightroom. However, those layers are actually still there, fully intact behind the scenes. But, if you take that layered file back over to Photoshop, like we usually do, the file actually will be "flattened" and all the layers will be gone. So, how do you get them back? It's easier than you'd think (but you click a button that I would only click in this one particular instance).

Step Two:

Okay, let's go through the steps really quickly: Start in Lightroom by taking this photo of the Eye Filmmuseum in Amsterdam, over to Photoshop, so we can use it as part of a calendar project (they make nice gifts). In Lightroom, press **Command-E (PC: Ctrl-E)** and open a copy of it in Photoshop, since that's where we're going to add our text and our calendar dates (by the way, you can find free, downloadable text calendars like this on the web). Add a logo, some header text, contact info, and whatever else you want until our multi-layer project is done (as seen here).

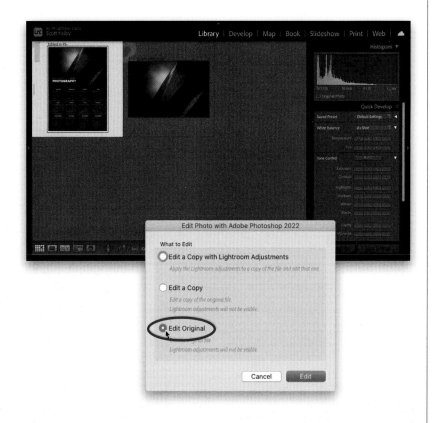

Step Three:
Here's the image back in Lightroom after saving and closing the file. It looks like it always does, and there's nothing to indicate that the file has layers—it looks like a regular thumbnail, like always. No special icon or badge, either. If you decide you want to go back to Photoshop and edit that file by pressing Command-E (PC: Ctrl-E), you'll get the standard the Edit Photo with Adobe Photoshop dialog, but because we want our layers back when we get to Photoshop, in just this one particular instance, for this sole reason and only this reason, we choose **Edit Original** (as shown here). The "original" in this case, is already a copy (it made this copy when we took it to Photoshop the first time), so your original RAW image of the Eye Filmmuseum is still protected.

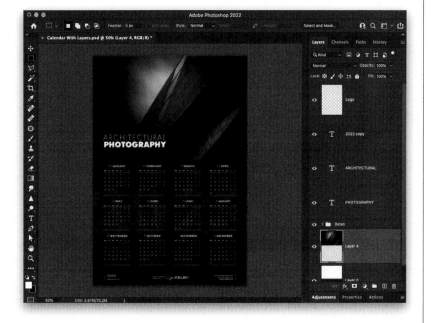

Step Four:
When you click the Edit button (with Edit Original selected), it reopens the file with all the layers you previously created still intact (as seen here).

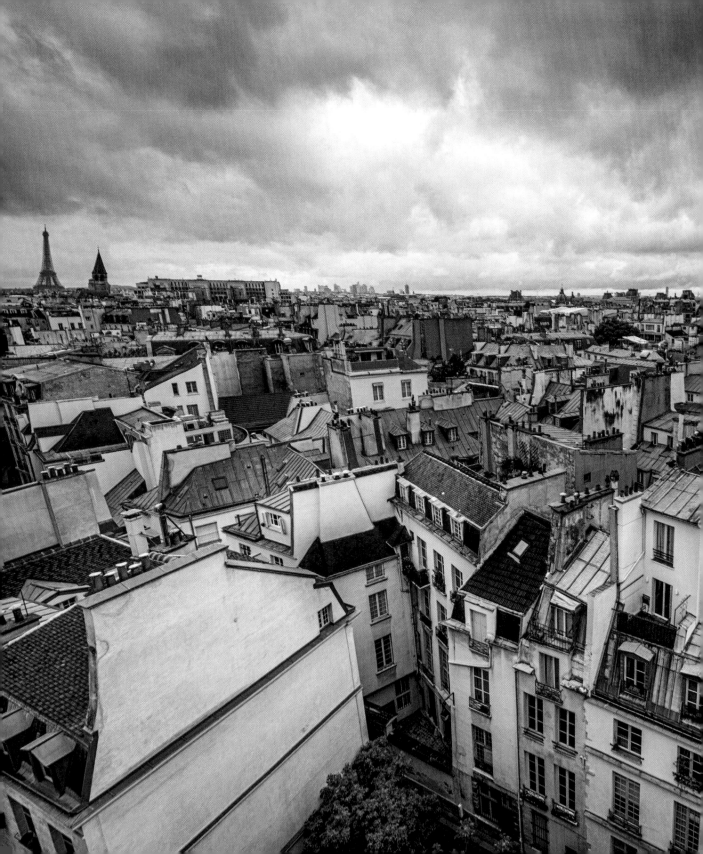

CHAPTER 12

PHOTO BOOKS
creating your own coffee table book

One thing I think every photographer dreams of is having their own coffee table book. An entire hardcover book with beautiful layouts and spreads of their photography—one that's available for sale online, where friends and family could pick up a copy for themselves. But, this isn't some pipe dream or fantasy, you could have every bit of this tonight, and do it all right within Lightroom (of course, if it's already night where you are as you read this, you might not be able to get it all set up and online for sale tonight. Well, if it's early in the evening, say like seven or eight o'clock at night, then definitely, but if it's much later than that, you're probably going to be a little tired, and you might want to catch some Netflix before you sack out. So, I would save this for tomorrow. But then, certainly then, you could gather your images, lay out your book, upload it for printing, and put it up for sale on Blurb's online photo bookstore.

Of course, if you have to work tomorrow, or you're in school, or you work in a school, then you'll probably have to wait until you get home from work, and then maybe after dinner. Now, this is where this whole process gets tricky. You don't want to build your photo book on a full stomach, right after dinner, because you'll be kind of full and sloggy, but then if you wait too late, you'll be tired and run up against your Netflix time. So then you wind up putting it off until the next day, and it never really gets done. That's bad, because there's a good chance your photo book would have won an Iris Award—presented in the US and New Zealand—and that would have put in motion a chain of events that would change you, and your photography, forever, and you'd spend your spare time autographing books and making appearances around the world. Sure, that sounds amazing, but ya know, the new season of *Ozark* just kicked off, so…).

Before You Make Your First Book

Here are a couple of quick preference settings you'll want to tweak before you actually build your first book. These are one-time "set-it-and-forget-it" types of things, but they will make your book-building process even easier, so they're worth doing up front.

Step One:

When you jump over to the Book module (up in the taskbar, or just press **Command-Option-4 [PC: Ctrl-Alt-4])**, a Book menu appears up top, and if you go under that menu, at the bottom of it, you'll find **Book Preferences**. Go ahead and choose that before we get rollin' here. Okay, let's start at the top: Just like in the Print, Slideshow, or Web modules, in the Book module, you get to choose whether the default setting for your frames is Zoom to Fill or Zoom to Fit (I leave it set at Zoom to Fill, simply because it usually looks better, but you can choose whichever you like best).

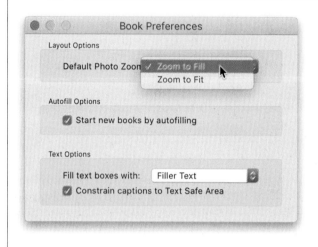

Step Two:

You have the option of having Lightroom automatically fill all the pages of your book with the photos you've chosen (as seen circled here), so you don't have to drag-and-drop them into the book one by one. Of course, you can rearrange the pages or swap out photos after the fact, but it's a great starting place to have a book all laid out for you. At the bottom of the dialog, there's a preference to help you visually see where you can add text. Some of the layouts have areas where you can put text, and it's easy to see in the thumbnail, but once you apply it to your actual page, unless there's some text already in place (filler text), then you wouldn't know there was a text box there at all. So, choosing **Filler Text** (as seen here) acts as a reminder (it doesn't actually print that filler text, so you don't have to worry about it showing up in your final book).

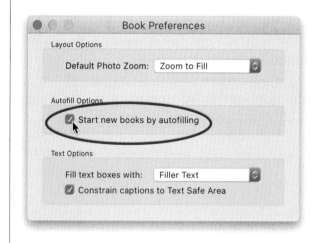

That's right—once you create your book, you'll have the option to let other people buy it, and it's as easy as one click to make it happen.

Making the Print Version of Your Book Available for Sale

Step One:

When your book is done, if you want to get it printed, you can do this right from within Lightroom itself. You click the Send to Blurb button (more on this later), which compiles your book and sends it online to Blurb.com—the hugely popular publishing and marketing firm for creatives (like us). One of the coolest things about Blurb is, when you upload your book to them, you don't have to buy a copy. Instead, you can make your printed photo book for sale in their massive online bookstore (you can also make an eBook version for sale there, too). Just click the **Set Up to Sell** button (as shown here) to get started. *Note:* You'll only see this button in Blurb once you've uploaded your book.

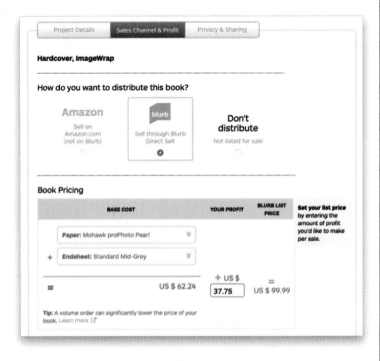

Step Two:

When you choose to Set Up to Sell, in the Project Details tab, it asks you for some info about your book (like a description of it, who the author is, stuff like you might expect). When you're done, click on the all-important Sales Channel & Profit tab up top. There, you can choose to distribute your photo book on Blurb or over on Amazon, instead (it's one or the other—you can't do both). From there, in the Book Pricing section, you can chose your paper, and most importantly, how much profit you want to make from the sale of each copy, and then it does the math. So why am I telling you all of this up front? I hope it inspires you to get started on your book today. Because there's money to be made from your photography.

Here Are the Types of Books You Can Make in Lightroom

One of the first things you're going to have to decide before you build your book is what kind of book you are going to build. There are four different main styles, and I'm going to briefly describe each of them here to help you make the right choice for you.

Photo Book:

This is probably the most popular choice—the coffee-table-style photo book, which is perfect for telling photo stories (like the story of your vacation), or putting your portfolio in print, or for a personal photo project. You can choose a hard cover or a soft cover, and if you choose hard cover and want the legit coffee table book look, one of the options is to add a glossy dust jacket that goes over your book (like you'd see at your local bookstore). They look really nice (especially when you choose a large-sized book, like the 13x11" or the 12x12"). Interestingly, they still print the cover image on the regular hard cover, under the dust jacket. You can also upgrade the paper for a high-end look.

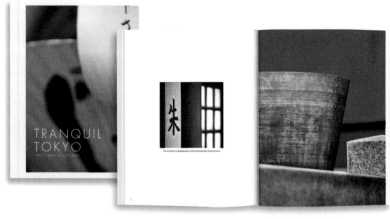

Trade Book:

This is the cheapest book option, and it's made for photographers who want to sell small-sized books to the mass market. So, keeping the cost low per book is your main concern with this choice. The paper quality is much lower, and thus the print quality overall is much lower, so you'd choose this when the photo quality isn't your biggest concern (you'd choose a photo book instead, if it was). To keep the cost down even further, you can print the book in all black and white (there's a black-and-white paper choice). Also, the default size is a 5x8" book (5 inches wide is fairly small), and the largest option is just 8x10", but again, cost is the main concern, here.

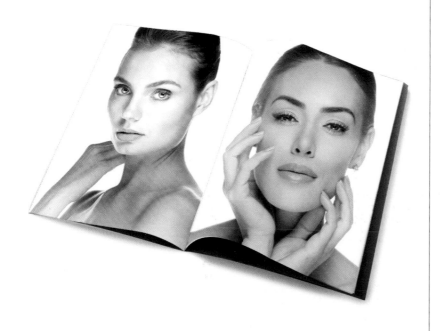

Magazine:

This one is just what it sounds like—it's designed to look like a magazine with taller pages and a high-gloss finish. This might be really nice if you're sending some of your work to a potential client and you want to have a modern, high-end feel without doing something more traditional, like a photo book. It only comes in soft cover (makes sense; it's a magazine), there's only one choice for paper on the inside (Magazine Paper; hey, that's what they call it), and there's only one size (standard 8.5x11", which they call "Magazine Size," but the rest of the country calls "letter size").

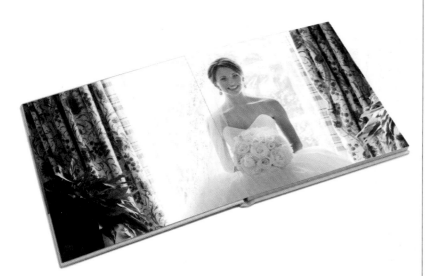

Layflat Book:

This is the most expensive option (but they come standard with a dust cover), with ultra-thick paper (they actually glue the pages together, back to back, with a thin insert in between them, so they're really thick and glorious). They also feature a special book binding that allows the pages to sit perfectly flat when the book is open. This looks particularly awesome for two-page spreads, as you'll barely notice the seam in between the pages. These are especially popular with wedding photographers because clients these days are pretty much expecting a lay flat book. Choosing the Layflat option is a little bit hidden, though. First, you'd choose Photo Book from the Book pop-up menu, and then from bottom of the Paper Type pop-up menu, you'd choose Standard Layflat. Just a heads up: when I said these lay flat books were "the most expensive option," I wasn't kidding. They are between 35% and 40% more per book. This is a cost you'll pass on to the client for a wedding, but I'm just letting you know up front in case you're the client.

Making Your First Book in Just 10 Minutes

This is kind of my quick start guide on how to build a photo book from scratch. It'll take you more time to pick which photos you think you might want in the book than it will to actually make the book (10 minutes, tops). The rest of the chapter will dig into individual topics, like adding captions, creating custom layouts, etc., but for now, let's just build a book the fast and easy way. When you see how quick (and fun) this is, you'll be making books from here on out.

Step One:

The first step is simple: make a new collection with the finished photos you think you might want to put in your book. It's okay if there are photos in it that don't wind up in the book, and they don't have to be in any order at this point, but you need to start somewhere, right? So, I always start by creating a collection of final edited images (here, I created a "Paris For Book" collection inside my Travel collection set). Now, click on Book in the taskbar to switch to the **Book module** (as shown here) .

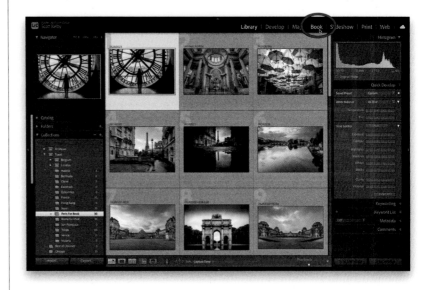

Step Two:

When you switch to the Book module it does an auto layout, placing all the photos in your collection onto the book pages for you, which is a huge time-saver. It places your photos in the same order they appear in your collection, but you can change what appears on each page very easily (as you'll see shortly). The default auto layout puts one photo on the right page and leaves the left blank (it's not awesome-looking), but if you want one photo on each page, then go to the right side panels, scroll down to the Auto Layout panel, click the Clear Layout button, and then choose one of the built-in presets from the Preset pop-up menu. Here, I chose a custom preset I created with more of a fine art layout (see page 352 for more on this). Click the Auto Layout button, and it will automatically fill both pages now with the layout you chose (as seen here). One more thing: since you won't be using the left side panels for a while, close them by pressing **F7** and it'll make your book layout area much larger (as seen here).

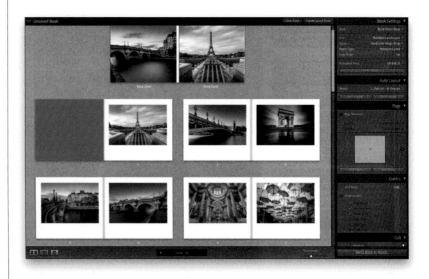

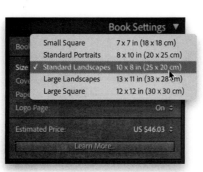

Step Three:
Before we get too far into this, you'll need to choose what style of book you want (Photo Book, Trade Book, Magazine, or Layflat), so choose that from the **Book Settings panel** at the top of the right side panels (in this case, I chose Blurb Photo Book, as shown here, on the left). Next, choose the size you want from the Size pop-up menu (as shown here, on the right). You can change the book size later, but it kind of messes up your layouts a bit, so you're better off picking and sticking with a size up front. Most of the books I build are 10x8" standard landscapes. They cost less and research shows people prefer viewing printed books at smaller, easier-to-hold sizes, like 10x8", even though as photographers, we would love to do those large 13x11" or 12x12" coffee-table-sized books. But either way, the size choice is completely yours.

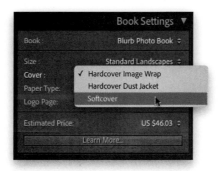

Step Four:
Next, choose the **Cover** style you want for your book. The majority of books I print are soft cover (as seen here). They use "perfect binding," which gives it a nice professional look, and these soft cover books look surprisingly nice overall, (plus they're the least expensive). If you choose Hardcover Image Wrap, of course, it's a hard cover and your image wraps around the front and back (though you have a lot of control over what goes on the front, spine, and back). If you want a real "coffee table book" look, then go with the Hardcover Dust Jacket, which still gives you the hardcover image wrap, but adds a glossy, detachable cover that wraps around the book with flaps that tuck inside the front and back cover. It gives your book a higher-end look like you'd see in coffee table photography books at your local bookstore. I have to say, it really does add that high-end feel to your book, but of course, it adds to the cost.

Step Five:

Lastly (in this panel anyway), choose your **Paper Type**. Blurb's Standard paper is okay—not great, but still pretty decent. However, if you upgrade to their Premium Lustre (it costs about 20% more, but it's totally worth it), you'll definitely see a difference in quality, and these days, for most of the books I print, I use Premium Lustre. If you want a legit coffee table book-style quality, go with their ProLine Pearl Photo. It is just beautiful (but again, much more expensive. It's around 33% more expensive than Premium Lustre and nearly 60% more expensive than the Standard paper). There's also a logo page option in this panel that we'll talk about later in this chapter (on page 364), so we'll skip over that for now (especially since you can deal with that anytime in the process).

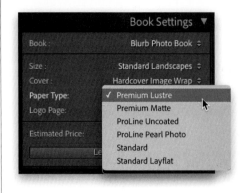

Step Six:

Near the bottom of the Book Settings panel it gives you an estimated price for your book. This price updates as you make various changes to paper quality, size, and cover, so you can try out different combinations and get an instant estimate right there in panel to have an idea of what the price will be before you start creating your book (the book we're creating here is 30 pages, plus cover and a blank page in the back, and it's right around $30. I even upgraded the paper to Premium Lustre. Not too bad!). By the way, if you click the **Learn More button**, it takes you to Blurb's website where you can learn more about the different cover options and get more in-depth descriptions on their paper. If you really want to know more about the paper, you can order a paper Swatch Kit from Blurb, with actual samples, by going to blurb.com/swatch-kit (it currently costs $7.95 as I write this book, but that price, and even the link I just gave, are subject to change at any time, so…there's that).

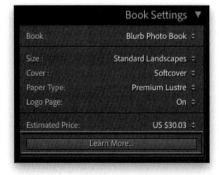

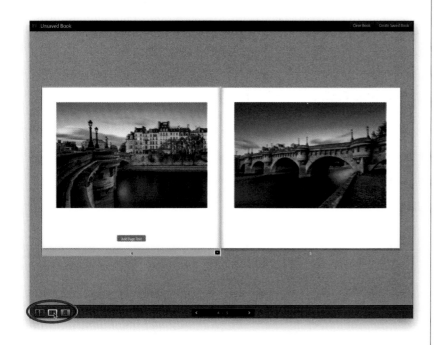

Step Seven:

One more semi-boring thing before we get to the fun stuff, and that is learning how to choose different working views while you're putting your book together. To see small thumbnails of your pages (kind of an overall grid view of your book, like we've seen so far), press **Command-E [PC: Ctrl-E]**. If you want to focus in on just a two-page spread (like you see here), with a nice large preview, press **Command-R (PC: Ctrl-R)**. Lastly, you can work on a single page by itself by pressing **Command-T (PC: Ctrl-T)**, but you'll probably only use this single-page, super-close-up view if you're writing or editing text. Also, you don't have to just use the keyboard short-cuts to get these views—there are three little buttons (shown circled here in red) just below the bottom left of the Preview area that you can click on to toggle through these different page views.

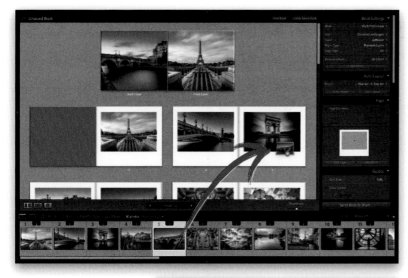

Step Eight:

Okay, now comes the fun part: custom-izing your book. What we're going to do first is put our photos in the order we want them, and the good news is: it's all drag-and-drop. Simply click on a photo down in the Filmstrip and drag-and-drop it directly onto the page where you want it to appear in your book (as shown here), and it replaces the photo that was on that page. That tiny thumbnail of your image appears at your cursor once you start dragging. You can see the "after" spread (after I put the two bridge images in the same spread) below. By the way, the number in the black bar that appears above each thumbnail in the Filmstrip lets you know how many times that image appears in your book. Basically, if you see the number 2 or 3 (or higher), it's alerting you that you have some duplicates of that same photo someplace in the book.

Step Nine:

You're not just limited to dragging-and-dropping from the Filmstrip. You can drag any photo in a layout, drop it on another photo, and they swap places (here, I'm dragging-and-dropping an image from one page to another).

TIP: Removing a Photo

To remove a photo from a page, click on it and hit the **Delete (PC: Backspace) key**. It doesn't delete it from your collection, so you'll still see it down in your Filmstrip and you can drop it onto another page or just ignore it.

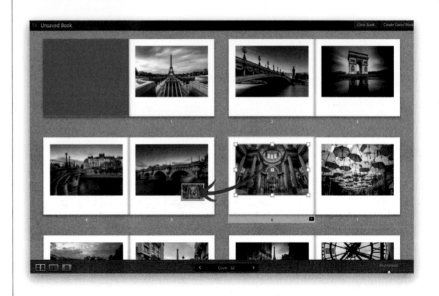

Step 10:

While we're having this "drag-and-drop fest," let's look at how you can also drag-and-drop individual pages (maybe you want to move a page from one spread to another spread), or you can even move entire spreads as one to reorder your pages. To move two pages (like we're doing here), click on the left page, then Shift-click on the right page, and both will highlight in yellow (as seen here). Now, click anywhere along that bottom yellow bar, and drag that spread wherever you'd like it in your layout. Take a look at the spread selected here. I want to drag it so those two pages are right after that black-and-white arch image in the center. When I start dragging the spread, a thin yellow bar appears between those two spreads letting me know "I'm good to put it here". Just release your mouse button and your pages appear to the right of where the yellow line is. To move a single page, just click on that one page, and then click-and-drag it from the yellow bar, as well. When you drag to a spread, it will separate and you can then drop the page you're moving right in and the original page moves over by one page. This will make a lot more sense once you try it yourself.

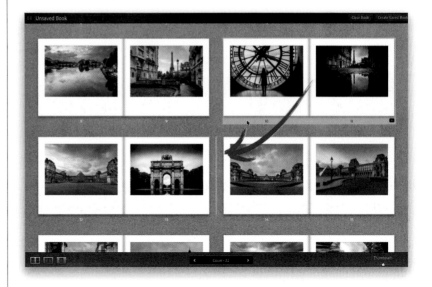

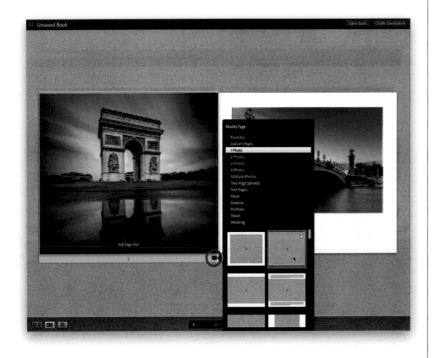

Step 11:

So far, each page in our book has one photo with a fine-art-style layout, but there are tons of built-in page templates you can choose from for each page. There are single photo layouts, two photos per page, three or four photos per page, and multi-photo layouts. There are two-page spread layouts, layouts just for text, there are just so many templates to choose from. To change to a different page layout, click on a page to select it (that yellow border appears letting you know it's selected), then click on the little arrow button (circled here in red) in the bottom right and a pop-up menu appears. From the top, choose how many photos you want on the page, and a scrolling list of layouts appears below. Here, I clicked on **1 Photo**, and then in the list of layout thumbnails, I clicked on a template that fills the page with the image (as seen here). That's all there is to it. If you see a layout that looks good to you, click on it. If you see a layout you really like, click on the little circle in the top-right of the thumbnail to add it to your Favorites (at the top of the pop-up menu).

Step 12:

Now let's choose a page template that has more than one photo. Here, I clicked on the right page in the spread to select it, and then clicked on the little arrow button to bring up the template pop-up menu (it actually pops up to the right of the page, but I moved it out of the way here, so you could see the right page). When you click on a multi-image template (here, I clicked on **4 Photos**), it doesn't just pop four photos on it. There's only the one photo on the page, so when you choose to make it a four-photo page, you'll only see that one small photo there. To get the other three photos on the page, just drag-and-drop them from the Filmstrip or from other pages. Lightroom can actually show you gray boxes for where the other photos are supposed to go: in the Guides panel, turn on the **Show Guides checkbox**, then turn on **Photo Cells**.

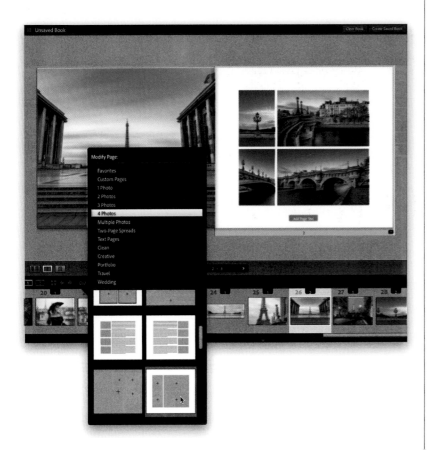

Step 13:

One of my favorite layouts is a two-page spread, and I include a decent amount of these in every book I make for two reasons: (1) they have a big impact, stretching across two pages, and (2) it seems like almost any photo looks great as a two-page spread. When you choose one (here, I clicked on Two-Page Spreads in the template pop-up menu, and then chose the full edge-to-edge template), it puts one photo across two pages. When you choose one photo to stretch across two pages, the photo on the second page doesn't just disappear—a new page is created for it. But, notice how it's cutting off part of the bridge at the top of the frame, here? Luckily, you can reposition the image within the photo cell by clicking-and-dragging left/right or up/down (here, I dragged it straight down to reveal more of the sky). Also, when you click on an image, a Zoom slider appears above it (as seen here, at the bottom), so you can zoom in/out (if you zoom in too tight, you may not have enough resolution to print the image, but if that happens, you'll see a warning appear in the upper-right corner of the page).

Step 14:

There are a number of options for adding text to your photo book—anything from captions under or over your photo to full paragraphs on the page. Templates that have a stack of lines beside, under, or above a gray box have both a photo cell (the gray box) and a cell just for text. Here, on the right page, I chose a template with a tall photo on the left and a tall, thin cell for text on the right. To add your text, just click inside that text cell and start typing (or you can copy-and-paste text from a text editor). You can also add a caption over your image (as seen on the full page image on the left page). Just click where it says **"Add Photo Text"** right at the bottom to type in a caption over your photo. Once you enter your text, you can pick the font, size, leading, and so on over in the Type panel (seen above in the inset).

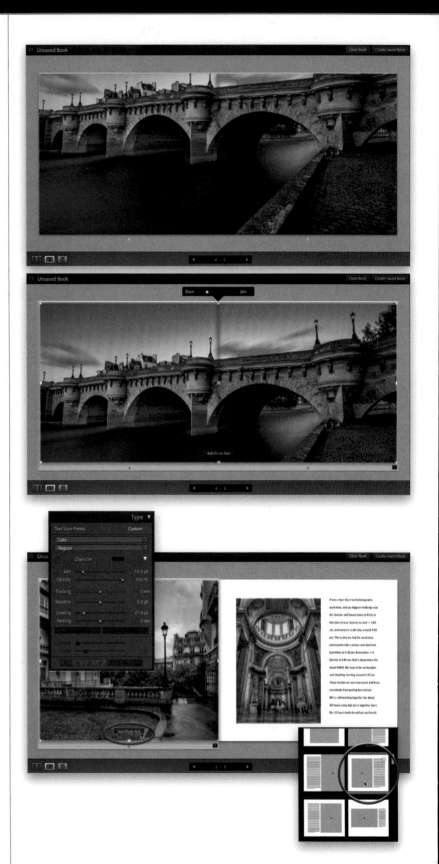

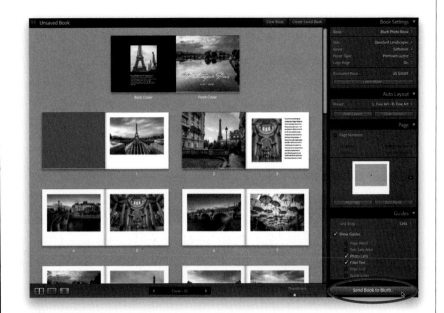

Step 15:

Once you have your page layouts in place, your front and back covers designed (see page 365), and the pages in the order you want them (and you've checked any text for typos—there's nothing more embarrassing than receiving your printed book and finding a horrendous typo. I know a guy this happened to and he was crushed. Okay, it was me. I was crushed. Learn from my mistake. See what I did there?). Anyway, once everything looks good to you, click the **Send Book to Blurb button** (shown circled here in red) at the bottom of the right side panels. You don't have to worry about resolution issues (outside of what I mentioned in Step 13), or color space issues, or any of that stuff—Lightroom takes care of all of that, packs it up, and gets ready to upload the whole thing to Blurb (well, after the next step).

Step 16:

When you click that Send Book to Blurb button, it brings up the **Purchase Book dialog** you see here. Near the top, it shows the specs of your book (including style, paper, number of pages, and price). Below that are fields for the book's title, subtitle, and author. If you don't already have a Blurb account, you'll be asked to create one (they need to know where to ship the book, your payment info, etc.), so you'll do that next, and once you're finished, Lightroom compiles everything, uploads it (it doesn't take as long as you'd think), and then in a few days, your book arrives, followed by a reasonable amount of oohing and aahing. That's the process—it's surprisingly straightforward. If you want to dig further into some of the details, well…that's what the rest of this chapter is all about.

Working with Photo Cells

The Book module was originally designed with a "photo cell," and you repositioned an image using Padding sliders (which are essentially margin sliders for each photo). Today, we mostly just click on a photo box, grab the resizing handles (which didn't exist until fairly recently), and resize, and we move the photo by dragging a center point. That all being said, you'll still be working with these photo cells during this process, so here are four quick things you'll probably find helpful to know:

Your Photos Go into Those Gray Boxes:

When you see a page with a gray box(es), that's a photo cell and it's where you drag-and-drop your image. On the left page here, there's just one big photo cell (so one photo goes in there), and on the right page, we have three cells, so we can go down to the Filmstrip and drag-and-drop three photos onto that page. By the way, once you've dragged a photo into a cell, you can swap it out with any of the other photos in other cells by simply dragging-and-dropping them, and they'll swap places.

Adding Space around Your Photo:

There are **Padding sliders** that let you resize your photo proportionally inside the photo cell—they're over in the Cell panel in the right side panels. There are four sliders, and they are linked together by default, so if you drag one slider, it drags them all the same amount (as shown here, in the inset). To unlink them, turn off the Link All box and now you can move each side, the top, or the bottom individually. In older versions of Lightroom, this was the only way to resize or reshape a photo cell on a page, but now you can just click on a photo, then click on a corner or side point, and resize or reshape it by just dragging.

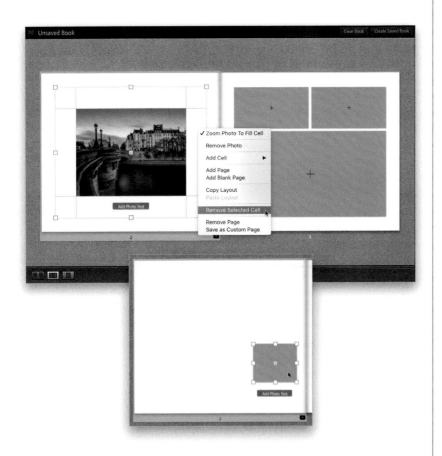

How to Delete or Add a Photo Cell:

Right-click on the cell you want to delete and from the pop-up menu that appears, choose **Remove Selected Cell**. To add a photo cell to a page, Right-click anywhere on the page and from the pop-up menu, under Add Cell, choose **Photo** and a gray box with those resizing points appears on the page ready for you to reposition (just click-and-drag the center point), resize (again, click-and-drag one of the side or corner points), or drag-and-drop a photo right onto it. In the inset here, I deleted the large cell from the left page, then did that Add Cell/Photo thing, and it created that new, small, gray photo cell ready for us to work on.

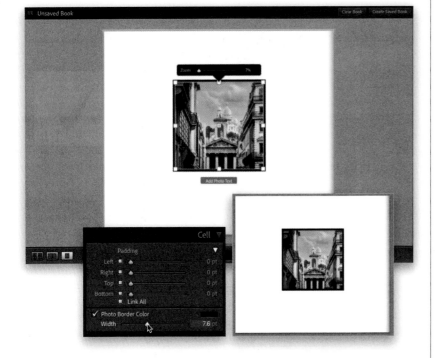

Adding a Border around Your Photo:

To add a border, go to the bottom of the Cell panel and turn on the **Photo Border Color checkbox** (I don't know why it says "Color"—it should just be "Photo Border"). Anyway, you can change the border color by clicking on the black color swatch to the far right, and you can control its thickness by dragging the Width slider (as shown here, where I added a reasonably thick border). It's a little weird to see when you're first adding this border because the yellow resizing box and points still appear onscreen, but once you click off of the image, the yellow border goes away and it'll look like what you see in the inset here, at the bottom right.

Four Things to Know About Layout Templates

There are a few things about making books in Lightroom that aren't really obvious, so I thought I'd put them all together here, so you don't have to go digging for them. It's all easy stuff, but since Adobe likes to sneak some features in "under the radar," or give them names that only mechanical design engineers could figure out, I thought this might keep you from reaching for a pistol. Ya know, metaphorically speaking. ;-)

#1: The Advantage of Match Long Edges

If you create an Auto Layout preset (see page 352) and choose Zoom Photos to Fit (rather than Zoom Photos to Fill, where the image zooms to fill the cell), there's a chance you'll have pages that look way out of balance, like the one shown here on the left—the tall photo looks much larger than the wide photo. You can have Lightroom automatically balance the two, so their longest edges are the same size. That way, while one will be taller and one wider, their relative size will look the same, creating a much more pleasing balance (as seen here on the right, where the tall image is as tall as the wide image is wide). You do this in the Auto Layout Preset Editor, where when you choose Zoom Photos to Fit, you'll also want to turn on the **Match Long Edges checkbox** (again, see page 352 for more on this).

With Match Long Edges off, the tall photo looks larger and out of balance

With Match Long Edges on, the long edges are the same size, creating a better balance

#2: Saving Your Favorite Layouts

If you see a layout template you like in the Modify Page pop-up menu and will want to use it again (without having to remember where to find it), you can save it to your **Favorites** (shown here in the red rectangle), so you can get to it quickly. To mark a layout as a favorite, just hover your cursor over its thumbnail, then click on the little circle in the top right (as shown circled here ; it looks like a Quick Collection marker). That's it—you'll now find that template in your Favorites. To remove any template from your Favorites, go to the Favorites and click on the gray circle to turn it off.

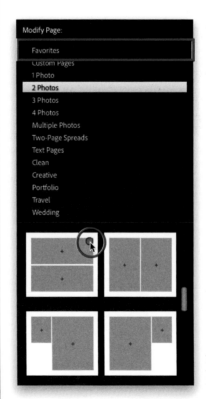

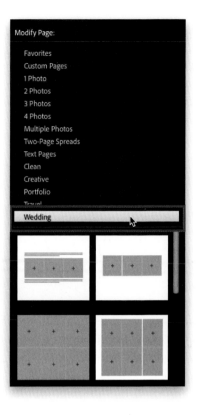

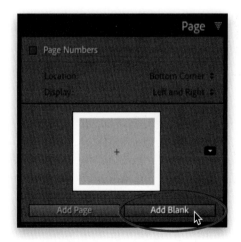

#3: Those Wedding, Travel, and Portfolio Presets Aren't More Templates

I super-wish they were, but unfortunately, Adobe just picked existing layout templates it thought would go well for weddings and grouped them under the "Wedding" heading. Same with Travel, Portfolio, and the others, so they're not additional templates, they're just existing ones that have been curated into convenient groups. I wish I had better news on this one.

#4: There Is No "Blank Page" Layout Template (Plus, How to Add More Pages)

It's true—there's not a template that just has nothing (well, technically the text templates only have filler text or nothing if you didn't choose that as an option in the preferences, like we did back at the beginning of this chapter). Actually, there is an **Add Blank page button** (shown circled here in red), but it's over at the bottom of the Page panel. One really important thing to note, though, is that this doesn't make your current page blank. This adds a page to your book (and you get charged by the page), so keep that in mind. If you want to take an existing page and have it appear blank, I would just choose a 1 Photo layout in the Modify Page pop-up menu, then Right-click on the photo cell and choose **Remove Selected Cell** from that pop-up menu. Now, there's nothing on that page. Also, you'll notice to the left of the Add Blank button is an Add Page button. Each time you click this one, it adds another page to your book. What's the difference between these two buttons? Add Page adds a page with a photo cell ready for dragging-and-dropping photos into; Add Blank does not.

Making Your Own Custom Layouts

As far as book page designs go, we have those predesigned templates that come with Lightroom, and we can mark the ones we use the most as favorites (so we can get to them quickly without digging through tons of thumbnails). But, beyond that, we can also create our own custom layouts—pages with our own specs—and have them easily available, in their own separate menu, when we want 'em.

Step One:
To create your own custom page layout, go to a page and click on an image, or the gray photo cell where an image is supposed to go (here, I'm using the same fine art layout I used earlier in the chapter; see page 352 for how to create it), and you'll notice that little control points appear all the way around the image (as seen circled here).

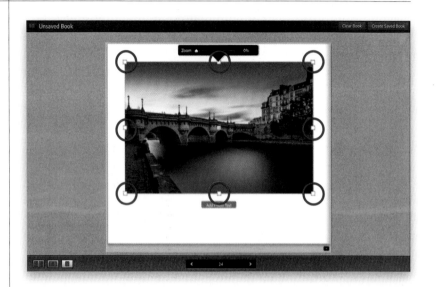

Step Two:
You can click-and-drag any of those control points, in any direction, to make the photo cell any size and shape you want (well, any square or rectangular shape anyway). Here, I simply clicked-and-dragged the bottom center point straight upward to create kind of a panoramic layout, so any photo I drop into this layout will look like a pano, but that's just one idea. To move your image around the page, just click directly on the yellow square in the center (you can see it up in Step One) and drag it where you want it. You can make wide, edge-to-edge photo cells, tall cells, whatever, and you can add multiple cells to create multi-photo layouts (as you'll see in the next step).

Step Three:

To add more photos to your page, just Right-click anywhere on it and from the pop-up menu that appears, under Add Cell, choose **Photo** (as shown here, at the bottom left), and an empty gray photo cell appears on the page (you have to drag-and-drop a photo into it to see an image in this new cell). If you want to add a text cell, instead of choosing Photo, choose **Photo Description** (we'll look at adding text a little later in this chapter). Once your photo cell appears, click-and-drag the control points to get it to the size and shape you want. One thing that helps you get your cells lined up with each other is to turn on the Grid Snap option, so as you drag those control points, it snaps to an invisible grid. It makes aligning cells so much easier. You can turn this on at the top right of the Guides panel (as shown here, at the bottom right). It's off by default, so click on that pop-up menu, and choose **Grid**. Now, when you drag those control points, you'll feel it snap to the grid.

Step Four:

When you've got a page looking the way you want it, Right-click anywhere on it, and from the pop-up menu that appears, choose **Save as Custom Page** (as shown here). Now, your new page layout will appear under Custom Pages in the Modify Page pop-up menu, so you can apply this template to any page, any time (you can see its thumbnail circled here). Each time you create a new custom page, it will be added to this menu for you.

Using Auto Layout to Automate Your Layout Process

In our first project (on page 338), when we switched to the Book module, Lightroom took the images in our collection and arranged them on pages for us. That feature is called "Auto Layout," but the default layouts are pretty simplistic—one photo, edge-to-edge, on every page or right-hand page. Snooze. That's what you'd expect to get doing a photo book at Walgreens. Luckily, we can create and save our own auto layouts, using the layouts and spreads we want, which makes a much more interesting-looking book, and after we get this set up, it's still just one click away.

Step One:

Here's what we're going to do: we're going to pick one template for all our left pages, a different one for all our right pages, and then save this as our own custom Auto Layout preset, so we can make a better-looking book from the start with just one click. Let's go ahead and start from scratch with an empty book, so go to the Auto Layout panel (up near the top of the right side panels) and click the **Clear Layout button** (as shown here, at the top) to erase whatever layout was already there. Then, from the Preset pop-up menu, choose **Edit Auto Layout Preset** (as shown here, at the bottom).

Step Two:

When you choose that, the Auto Layout Preset Editor appears (seen here). It's split into two parts: the Left Pages and the Right Pages. On the left side, the pop-up menu is set to Same as Right Side or Blank (depending on which preset was originally chosen in the Preset pop-up menu), so whatever you choose for your right side pages (on the right side of the dialog), the same will happen for the left side pages, or they will just be blank. Instead, choose **Fixed Layout** from that pop-up menu. That way, we can choose what appears on our left and right pages separately.

Note: You can see the 1 Photo template selected here that I used for both the left and right pages to create my custom fine art layout preset that I used in the previous projects.

Step Three:

Let's set up a preset to make the left page photo square and the right page photo full page. Here's what you do: In the Left Pages section, after choosing Fixed Layout, make sure **1 Photo** is selected in the pop-up menu below that. Now, scroll down to the square image page layout and click on it, then leave the right side at Fixed Layout, with one full-page photo chosen from the 1 Photo thumbnails (as shown here).

Set to Fit

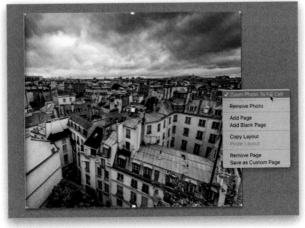

Set to Fill

Step Four:

There's another option you need to know about with these custom layouts: you get to choose how your image appears, once you click-and-drag it into place, using the **Zoom Photos To pop-up menus** below the layout thumbnails. If you choose Fit (as I did in Step Three), it scales your image down to fit inside the photo cell (as seen here at the top, where there's a white gap above and below the photo when I was expecting it to fill the page, since I chose a full-page cell template). To have it fully fill the cell, you need to choose Fill (like you see here, at the bottom). Luckily, you can always change this after the fact, on a per-page basis, by Right-clicking on a photo and choosing **Zoom Photo To Fill Cell** from the pop-up menu to turn it on or off (as shown here, at the bottom). But, when creating auto layouts, I always choose Fill from the Zoom Photo To pop-up menus, so that my images always fill the cells in the custom layouts I create.

Step Five:

Now, let's choose some different templates for our Auto Layout preset. For the left page, from the second pop-up menu, choose **2 Photos**, then scroll down and click on the two horizontal images layout (as seen here). Make sure to choose **Fill** from the Zoom Photos To pop-up menu. Over on the right page, we'll still use a 1 Photo layout, but this time, we're going to choose one that has a white margin area around the photo. Again, set the Zoom Photos To pop-up menu to Fill. There are some other options here, as well: For example, if you know you're going to want to add some text to your pages, turn on the **Add Photo Text checkbox**, and your pages will be ready for you to add text by just clicking in a text field. Of course, you could just choose a layout template that has a text area already built-in, but this is at least another option if you want to use a layout that doesn't already have text.

Step Six:

Okay, let's save this layout by choosing **Save Current Settings as New Preset** from the Preset pop-up menu up top (as shown here). This will bring up the New Preset naming dialog (seen below). It helps to name presets with a descriptive name, calling out what you chose on the left page and the right page (as seen in Lightroom's default presets). Lastly, click the Create button, then Done, and you've made you're first Auto Layout preset. Now, let's go try it out!

TIP: Hide Info Overlay

By default, info about your book appears in the top left of the Preview area (size, page count, and price). If you'd rather not see this information (it's pretty distracting), then just go under the View menu and choose **Show Info Overlay** (or press the **I key**) to turn it off.

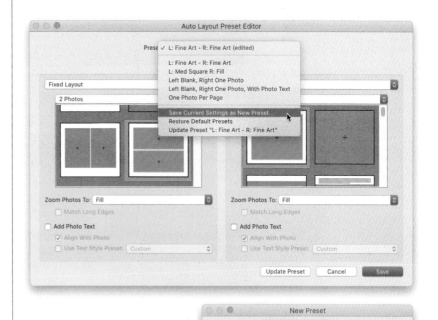

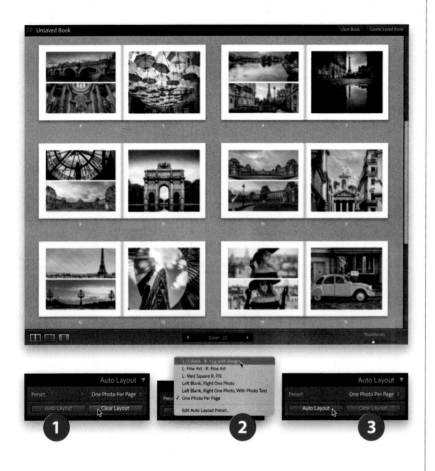

Step Seven:

Go back to the Auto Layout panel, click the **Clear Layout button** (as shown below in #1), and then from the Preset pop-up menu, choose the preset you just created with the two horizontal images on the left page, and one image on the right page with white margins (as shown below in #2). Now, click the **Auto Layout button** (as shown below in #3) and it fills those blank pages with all the images in your collection, using the preset you created (as seen here). Of course, this is just your starting place—you can edit any individual page you'd like by clicking on it, then clicking the small arrow button in the bottom-right corner and choosing a different layout. *Note:* Have you noticed that it takes your first photo and makes it the front cover, but then it also puts that same image on the first page? I don't get it, and there's not much you can do about it, except replace the first page (or cover) with a different photo, which is what I do. But, it still kinda frosts my Wheaties that we have to do that.

Step Eight:

Okay, ready to take it up a notch? Check this out: you don't have to just use the page templates Lightroom gives you because you can create Auto Layout presets using custom pages you've designed! When you're making your preset, choose **Custom Pages** from the second pop-up menu (under Fixed Layout), and you'll see thumbnails for all the custom pages you've created, and you can choose any one you'd like. Here, for the left pages, I chose that custom page with four images we created a few pages back, and then a custom page with a small, square photo for the right pages. Now, you can save these two custom pages as your own Auto Layout preset by choosing Save Current Settings as New Preset from the Preset pop-up menu up top. I think this is when these Auto Layout presets really get fun!

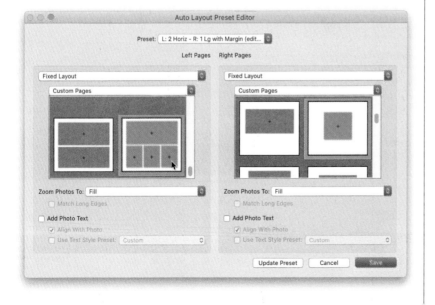

Adding Text and Captions to Your Photo Book

If you've been using Lightroom for a while, you know the text capabilities have been really limited. But, when it came to books, Adobe added their full-featured type engine right into the Book module, so you have a surprising amount of control over how your type looks and where you can put it. Now, if we can only get them to put a copy of the Book module's type feature over into the Slideshow and Print modules (don't get me started).

Step One:

There are two ways to add text to your photo book: (1) Choose a page layout that has a text area already in place, so all you have to do is click in the text box and start typing. Or, (2) you can add a text caption below your photo by clicking on the photo and you'll see an **Add Photo Text button** appear below the photo (as seen here. Even though the button is way down on the page, when you click on it, your text doesn't appear down there—it appears right beneath your photo, like a traditional caption, as seen in Step Two below). So, for now, go ahead and click that button.

Step Two:

To change the font, size, style (here, I chose italic), font color, and so on, highlight your text, then go to the Type panel in the right side panels. There are also alignment options there (left, centered, right, and justified. We'll look at the Type panel again in a bit). There's also a **Text panel** (right above the Type panel) with some caption options, including having your caption appear right over the photo itself, below it (the default), or above it. Also, Lightroom doesn't refer to this text as a "caption." It calls it "Photo Text." The Offset slider in the Text panel controls how close the caption (errr, Photo Text) is to your photo (though you can just click-and-drag the text box to move it up/down). *Note:* If you choose to add a caption to a full-page photo layout, the only option you'll have for placement is Over, since there's no white space above or below the photo to fit a caption.

Step Three:

If you want to tell a longer story than would fit comfortably in a caption, click down near the bottom of the page and the **Add Page Text button** appears (as seen here). Now, you can type longer blocks of text, or just copy-and-paste into it like I did below in Step Four. Again, you can format the text in the Type panel, and in the Text panel, you can place your paragraph of text at the bottom or the top of the page. Use the Offset slider to move the block of text up or down the page (drag it back and forth a couple of times to see what it does). But, again, you can just click on the text to select its text box, then manually click-and-drag it up or down the page, so I'm not sure how much you'll even go to the Text panel when it comes to page text.

Step Four:

By default, your text is aligned with the left side of your photo, but again, if you go to the bottom of the **Type panel**, you'll see alignment buttons—you can choose Align Left (as seen here), Align Center, or Align Right (the fourth choice is Justification, which only comes into play if you're using columns of text). *Note:* If your Type panel doesn't look like this one (you see a lot fewer sliders), then you just need to click on the little white left-facing triangle to the far right of the word "Character" and this expands the panel down to show more options.

Step Five:

What if you've created some text and then decide you don't want it after all? How do you "turn off" a caption or page text? It's not real obvious, but you'd go to the Text panel and turn off the caption by turning off the **Photo Text checkbox** (shown circled here in red), which would hide the line of text you see here over the image. If you have a paragraph of text on the page, you'd turn that off by turning off the **Page Text checkbox**. You can also turn them both back on here, as well.

Step Six:

Here's one of those kinda hidden things: By default, your text fields appear as "custom text," meaning you're going to type something in yourself, but there are automated ways to add text to your image. If you look in the far right of your text box, you'll see a tiny, down-facing arrow (if you don't see it, increase the font size). Click on it and a pop-up menu of text content choices appears (as shown here). For example, if you choose Exposure, instead of text you've typed, it would display the shutter speed and f-stop you used to take the photo. Okay, I have no idea why you'd want this in your photo book, but hey, ya never know, right? There are other just as puzzling choices in this menu, but if you choose Edit at the bottom, it brings up the **Text Template Editor** (seen here, which works the same as the Filename Template Editor we looked at back on page 88) where you can create extreme text strings to auto-populate your text fields. If you do this, though, just know you're a nerd. I'm sorry to be the one to tell you.

Step Seven:

If you wind up adding a lot of text to a page, you can divide it into multiple columns (up to three) using the **Columns slider** near the bottom of the Type panel. The Gutter slider right below it controls the amount of space between your columns—drag it to the right to increase the amount of space between them (which I did here because they were a little too close together). I will say this: the Columns feature is a little finicky, and you might find it grayed out most of the time. But, one sure way to get columns is to Right-click on the page, and in the pop-up menu, under Add Cell, choose **Photo Description**, which creates a text box that you can click-and-drag anywhere and resize as you'd like. Type (or copy-and-paste) your text into that cell, and then you'll see that the Columns slider is available. Also, once you have your columns, you can change the spacing by clicking-and-dragging the side control points.

Step Eight:

Let's stay in the Type panel to learn this last text option: right at the top of the panel is a very handy feature—**Text Style presets**, which are already set up using popular fonts and styles. So, if you're working on a wedding photo book and choose Title – Wedding from the pop-up menu, you'll get a font style that's appropriate (as seen here). A nice time-saver. While we're talking presets, if at any time you format your text (choose a font, font style, leading, etc.) and you like how it looks, you can save the settings as a preset by choosing **Save Current Settings as New Preset** from the pop-up menu. That way, the next time you want a similar look for your text, you don't have to start from scratch. Here, I also went to the Text panel and clicked on the Over button, so my line of text would go over the photo, rather than under it.

Adding and Customizing Page Numbers

Another nice Book module feature in Lightroom is automatic page numbering. You have the ability to control the position, the formatting (font, size, etc.), and even which page the numbering starts on (along with hiding the page numbers on blank pages if you want).

Step One:
To turn on page numbering, go to the Page panel and turn on the **Page Numbers checkbox** (shown circled here in red). By default, it places page numbers in the bottom-left corner of left pages and the bottom-right of right pages (as seen here).

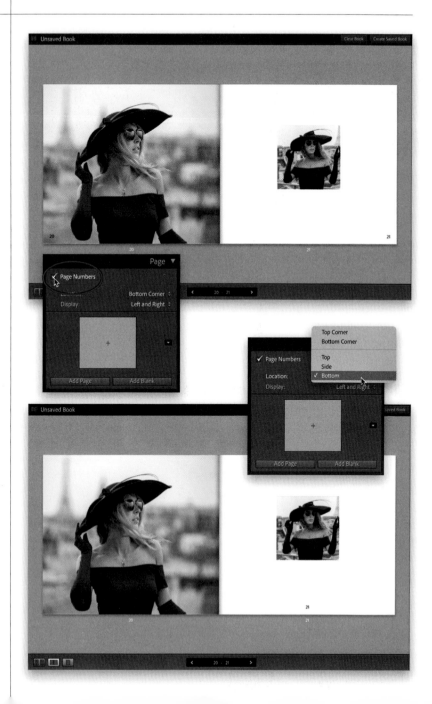

Step Two:
You can choose where you'd like your page numbers to appear using the **Location pop-up menu**. The Top and Bottom options center the page number at the top or bottom of the page (respectively; as shown here, where I moved them to the bottom center). Choosing Side places the page number at the outside center of the page. If you look at this spread here, you're already seeing one issue you might run into: there is a page number at the bottom center of that left page, but it's black type over her black dress, so the number is lost.

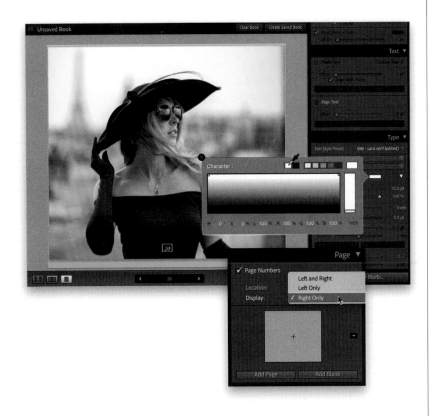

Step Three:

To get around that black type on a black background, you can simply highlight the page number and change the type color to white (as seen here, where I went to the Type panel and clicked on the black color swatch, which brings up the **Character color picker**. Just click the eyedropper on the white color swatch and it's fixed). While you've got your type highlighted you can also change the font, style, size, etc., in the Type panel. I changed the font to Minion Pro and set the Style to Italic (I didn't change the size, but it's nice to know I could have). Another way to deal with this is to have page numbers appear on only one side of each spread (like I chose here in the Page panel, from the **Display pop-up menu**—now my page numbers will only appear on the right pages). This is particularly handy if you have a full-page image on one side (let's say on the left pages), and a smaller image (with white space around the photo) on the other side. By choosing Right Only, the page numbers would only appear on right pages, and would no longer appear over your full-page images on the left pages.

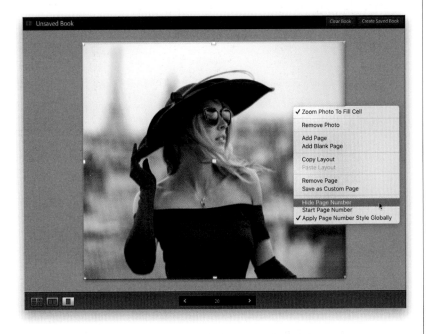

Step Four:

Besides just customizing their look, you can also choose which page the numbering starts on. For example, if the first page of your photo book is blank (so the images or opening story start on a right page), you can have that right page become page 1 by Right-clicking directly on the page number itself on the right page and from the pop-up menu that appears, choosing **Start Page Number**. Lastly, if you have a blank page(s) in your book, and you don't want it to have a printed page number, just Right-click on the number on the blank page, and choose **Hide Page Number** (as shown here).

Customizing Your Backgrounds

By default, all your book pages have white backgrounds, but it doesn't have to be that way. Here are four different ways to colorize or customize your page backgrounds:

Step One:

If you want to change the background color of a page, click on it, then go to the Background panel and turn on the **Background Color checkbox**. Choose a new background color by clicking on the color swatch to bring up the **Background Color picker** (seen here). Click on any of the preset color swatches at the top, or choose any shade from the gradient bar below (here, I clicked on the black swatch to make my background color solid black). To access all colors (not just white, black, and shades of gray), click-and-drag the little black horizontal bar on the far right of the big gradient straight upward to start revealing the color hues.

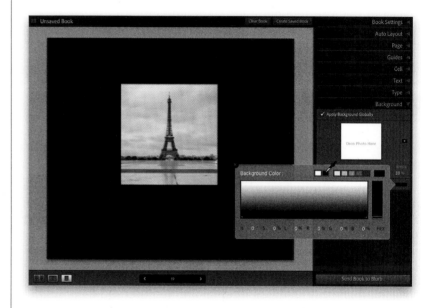

Step Two:

Besides just a solid color for your background, you can also choose from a collection of built-in background graphics, including one for travel with things like maps and page borders, and one for weddings with elegant little page ornaments. To get to these, turn on the **Graphic checkbox**, then to the right of the square background graphic well in the center of the panel, click the little black button to bring up the **Add Background Graphic pop-up menu**, with a thumbnail list of built-in backgrounds (as seen here). Just click on a category at the top, then scroll down to the graphic you want to use, click on it, and it appears behind your photo (as seen here). You can control how light/dark the graphic is using the Opacity slider and change its color by clicking on the color swatch (more on this in the next step).

Step Three:

If you want a pattern, rather than a graphic, you can add vertical lines, and better yet, you can choose their color. First, go to the Travel category and choose the lines background from the pop-up menu. Set its Opacity (lightness or darkness), then click on the color swatch to the right of the Graphic checkbox to bring up the **Graphic color picker** (seen here) and choose any color you'd like for your line pattern (I chose a yellow color here, and lowered the Opacity to 62% to make it fade into the background a bit more).

Step Four:

There is one more Background panel option, but before we get to that, look up at the top of the Background panel and you'll find the **Apply Background Globally checkbox**. Turning this on will repeat your current background throughout the entire book (if that's what you want), and it saves you the time of adding the background manually to every single page (I usually leave this off, so I can customize my page backgrounds individually). Okay, now on to the last option: using a photo as a background (very popular in wedding albums). In the Filmstrip, find the photo you want to use as a background, drag-and-drop it onto the square background graphic well in the center of the Background panel (as shown here), and that photo becomes your page background. I usually like this background photo to be very light behind my main photo (so it doesn't compete with it), so I lower the Opacity quite a bit—usually to between 10% and 20%. By the way, to remove your background image altogether, Right-click on the background graphic well and choose **Remove Photo**.

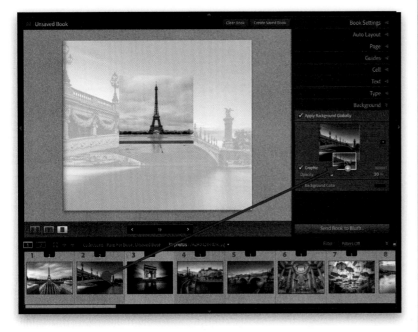

Upgrade to Premium Lustre Paper without Any Out-of-Pocket Costs

Okay, here's a great way for you to upgrade to that Premium Lustre paper I was talking about at the beginning of this chapter, but without coming up with any out-of-pocket extra cash (it costs about 20% more). Once I share this, you'll wonder why everybody wouldn't do this.

Step One:

Scroll all the way down to the last page in your book (as seen here). The gray page on the right is the inside back cover of the book, which is blank. The left page is just a blank page that ends every photo book and there is no way to add an image or text to this page. However, there is something you can add that is even better. In the Book Settings panel, there's a **Logo Page pop-up menu**, and if you let Blurb put their logo on this last page of your book—very tiny, at the bottom of the page, in a light gray with a single line of text below it, which reads "Designed Using Adobe Photoshop Lightroom"—they give you 20% off the cost of your entire book. That's about enough to upgrade to the better Premium Lustre paper without any out-of-pocket cost. First, take a look at the book price now without the logo—$35.44.

Step Two:

Now, choose **On**, from the Logo Page pop-up menu (as seen here), and look at the price drop! It's only $29.19 now. Wow!!! Come on, how worth it is that?! And, by the way, all you're adding is a light gray blurb logo (it doesn't even say Blurb.com—it's just "Blurb"), and the line of type below is in 6-point-type size, so only a pre-teen could even read something that small. Might even take a toddler. I've never had a client, or anyone for that matter, even take notice of the logo because when they get to the last page and there's not a photo on it, they close the book. Anyway, I take advantage of this every time I print a book to get a deal on the printing. Awwww, yeah!

If you want to create your cover text here in Lightroom's Book module, you're in luck, because it's more powerful and flexible than you might think. You can create multiple lines on the cover, different text blocks with different typefaces, and you can even add text to the spine for hardcover wrap layouts.

Designing Your Book Cover

Step One:
Click on the Front Cover page to make it active, and then click the small, black, down-facing arrow button in the bottom-right corner to bring up the **Modify Cover pop-up menu**. For soft cover photo books, I like the template you see selected here, with a full-page image on the front cover (you can add a title and author info right over the image—there's already a text box waiting for you), and then on the back cover, there's a square photo cell. In the template, there's also a text box right below the back cover photo.

Step Two:
If you decide to go with the **Hardcover Dust Jacket**, then there is a different set of cover templates to choose from in the Modify Cover pop-up menu, because with a dust jacket, you can add photos and text to the two flaps that tuck in the front and back covers to hold the dust jacket in place. You see that tall white area to the right of the front cover? That's one of the flaps, where you can add a photo and text box directly below it. Traditionally, you'd either see a short bio from the author there, or a brief description of the book, or even quotes from people about the book. On the front cover flap, the text usually goes below the photo; on the back cover flap, the text goes above it.

Step Three:

We'll continue on with a soft cover photo book from here. The cover's background color (that you can see behind the photo on the back cover) is white by default, so if you want to give the background a color, it helps if you choose one from your cover photo. So, first, make sure you have the image you want for your front cover. Then, go to the Background panel where you'll steal a color right from your photo to use as your background color, so you'll know the color will work with your image. First, turn on the **Background Color checkbox**, then click on the color swatch, and when the color picker appears, click-and-hold anywhere inside the color gradient (keep holding), and then move the eyedropper right out of the color picker and onto your image. Whatever color that eyedropper hovers over is shown as your background color. Keep moving around, trying different areas of your cover photo until you find one you like (here, I sampled a reddish gray color from the top step of the stairs), then click the X in the top-left corner of the color picker to close it.

Step Four:

Next, let's add our headline (title) text. There's already a text box in place for this template (to make it visible, just move your cursor over the front cover and you'll see it), so click inside it and start typing your headline text. To format this text, highlight it, and then go to the **Type panel**. Here, I chose the Trajan Pro 3 font, increased the point Size quite a bit (it is the title of the book), aligned it in the center, and then I clicked on the black color swatch, and in the color picker that appeared, I clicked on a white color swatch to make the text white. This template's text box is at the bottom of the cover, but I moved it up higher by clicking on the text box's center control point and dragging straight upward to position it closer to the top of the cover (as shown here).

Step Five:

To add a subhead beneath your title, click on the cover image, then click on the **Add Photo Text button** that appears and another text box will appear where you can type your subhead. Format the subhead to match the title (but with a smaller font size, of course), then do the same thing we did to get the title up higher on the cover—click on the center control point and drag straight upward, stopping just below the headline (as shown here).

TIP: Adding Type to the Spine

If you're using a dust jacket, you have the option of adding a row of type vertically to the spine. Just move your cursor over the spine (that space between the front and back covers) and a vertical text box will appear. Click inside it, and then type your text sideways down the spine. You can edit the font, color, position, etc., just like you would any other text box.

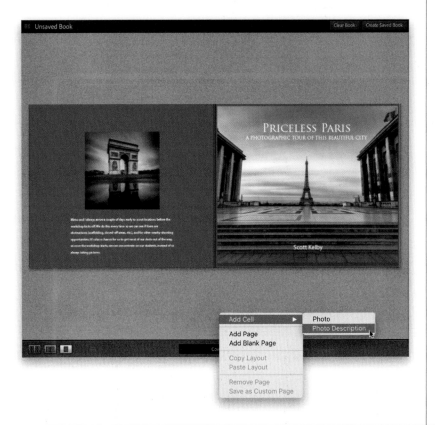

Step Six:

If you want to add a third text box (perhaps for the photographer's name), just Right-click directly on your image and under Add Cell, choose **Photo Description** (as shown here), and a large text box will appear where you can type in the photographer's name. Click on the center control point to position it near the bottom of the front cover (as seen here). The back cover is even easier as there's already a text box waiting there for you, as well (you'll see it when you move your cursor over the back cover). Just click in it and start typing, then highlight all of your text and format it (font, size, color, etc.) over in the Type panel. Okay, your cover's ready to roll!

Guides Can Make Your Layout Life Easier

There are all sorts of guides you can lean on while building your book pages that will help with everything from aligning photo cells and text cells, to making sure you don't get into trouble when you go to print.

Page Guides:

Lightroom has six different types of non-printing guides (they only show onscreen, not in our printed books) in the **Guides panel**. There are four basic types of guides: (1) Page Bleed, grays out the small area on the very outside edges of your page, which will be cropped off if you choose to have a photo fill the page. It only crops off around 1/8", so you won't even notice it. (2) Text Safe Area shows the area where you can add text without it getting lost in the gutter between spreads or being too close to the outside edges of the page. (3) Photo Cells fills your cell with solid gray, so you know it's a photo cell. If you turn it off, you won't see the photo cell unless you know where to click, so this is a good one to leave on all the time. (4) Filler Text puts dummy text in place in a text cell, so you can easily see where you can add type to the page.

Grids and Lines:

The last two guides (which I didn't have turned on yet in Step One) are for helping you line up photo cells and text boxes. Page Grid will give you a light blue grid over your page (it doesn't print—it's just a visual aid) and by aligning things to the grid, you know they're lined up (so you're not just "eyeing" it). Here, I dragged the text box up, so the top of it touched the top of the nearest grid line. Then, I did the same thing with the photo cell, so I know they're perfectly lined up. Guide Lines gives you thin, black horizontal and vertical lines that extend from the edges of your cell across the page. Again, they're there to help you align your photo cells and text boxes.

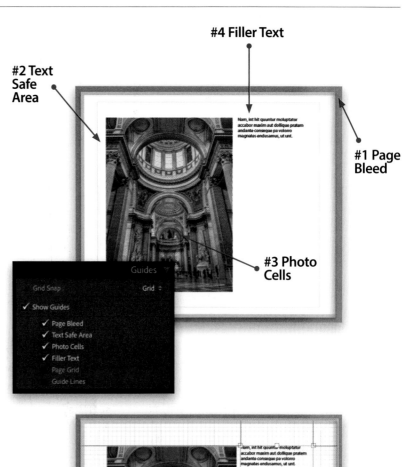

#4 Filler Text

#2 Text Safe Area

#1 Page Bleed

#3 Photo Cells

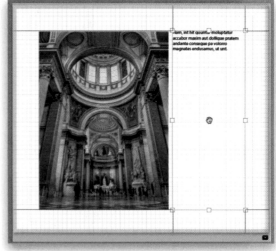

There are all sorts of reasons why it might be helpful to have a PDF of your book. One might be to send it as a proof (I always send wedding clients a PDF of the book first, so they can let me know of any changes). You might also want to just provide it to your clients as a digital add-on they can share via email. But, a big reason is you want to send the book to another source for printing instead of Lightroom's built-in printing partner Blurb.com.

Making a PDF (and the Option to Print Your Photo Book Somewhere Else)

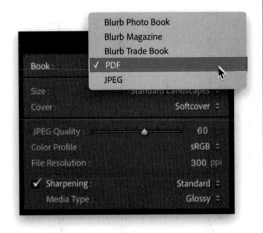

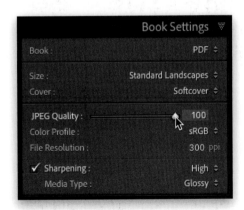

Step One:
To create a PDF of your entire photo book, go to the Book Settings panel (at the top of the right side panels), and from the Book pop-up menu, choose **PDF** (as shown here). If you are thinking of sending this to an outside photo lab for printing, first contact the photo lab and make sure they accept PDFs from Lightroom (they might not, so it's worth checking). Also, ask them which color space they prefer you save the file in (that's in the next step). By the way, if you choose JPEG from this menu, it creates an individual JPEG image of each book page.

Step Two:
When you choose PDF, the bottom half of the Book Settings panel changes to a PDF options section. The first slider determines the quality of the JPEG images. If you're going to be emailing this or making it available for download, you'll want to keep the file size fairly small, so you might go with 80 for your quality (the photos will still look great). If you're going to print it, and you don't mind waiting a few minutes when you upload it to your photo lab for printing, heck go with 100 (as shown here). As for Color Profile, many of the big photo labs today recommend using sRGB as your color space, but again, ask the lab before you make this choice. You can leave the File Resolution at its current setting (probably 300 ppi, by default). Set your desired amount of Sharpening and the type of paper you'll be printing on (I use High sharpening and choose Glossy for printing on standard or a premium luster paper). That's it.

PRINTING
unlocking the power of the print

I'm somewhat of a printing evangelist. I have prints all over my home and office and I'm always preaching to everyone the importance of making prints. I always say that when you make a print, that's the moment your image is actually born. That's when it comes alive because it has been trapped behind a sheet of glass (either on your phone, tablet, or computer). But, when you print it, that's when it becomes real. When you hold that print, there's a feeling and a connection you have with that image that you can't get any other way. That is the power of the print. Now, I'm going to let you know about something, and this is something I've shared in my live seminars, and that is besides being real, there's another benefit to the print, and that is the magic of "scale." People mostly see our images on their phones or if we're lucky, someone sees our images on a larger screen, like a computer screen, but even on

that, your image will only appear so big. But, with a print, you can make your image huge, and (here's the secret) images that look kind of "meh" at a small size can look really fantastic at huge sizes in print. You can see this phenomenon in person the next time you're in a hotel lobby. Stop and take a look at the huge images you'll see on the walls. Ignore the framing and matting and just look at an image itself and you'll be like, "Um, that's just a peach with a house key on top," but at that huge size, somehow it looks like… art. Now, here's another secret I've learned: your image has to look at least as good as a peach with a house key on top because while scale seems to help most images, even "meh" images, it doesn't help bad images—it just makes them bigger. If you do make a big print and it doesn't look all that great, the only solution is to (wait for it, wait for it…) add a second house key.

Printing Individual Photos

If you like everything else in Lightroom, it's the Print module where you'll fall deeply in love. It's really brilliantly designed (I've never worked with any program that had a better, easier, and more functional printing feature than this). The built-in templates make the printing process not only easy, but also fun (plus, they make a great starting point for customizing and saving your own templates).

Step One:

In the task bar along the top, click on Print, then click the **Page Setup button** at the bottom left (seen circled here in red), and choose your paper size now (so you won't have to resize your layout once it's all in place). Next, go to the Template Browser (in the left side panels) and click on the **Fine Art Mat template** (as seen here) to bring up the template you see here, displaying the first photo in your current collection (unless you have a photo selected—then it shows that one). A few lines of info appear over the top-left corner of your photo. It doesn't actually print on the photo itself, but if you find it as distracting and useless as I do, you can turn this off by pressing the letter **I**, or going under the View menu and choosing **Show Info Overlay**.

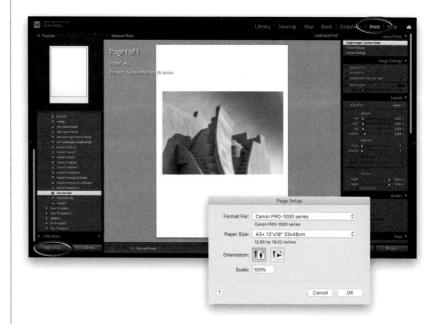

Step Two:

There are three layout styles (in the Layout Style panel at the top right), and this one is called **Single Image/Contact Sheet**. This works by putting each photo in a cell you can resize. To see this photo's cell, go to the Guides panel and turn on the **Show Guides checkbox**. Now you can see the page margins (in light gray), and your image cell (outlined in black, as seen here). If you want to print more than one photo using this same layout, select as many photos as you want to print down in the Filmstrip and it adds as many pages as you need to print them all (here, you see just one image, but if you look down in the toolbar, you can see that this is print 1 of 19 images set to print).

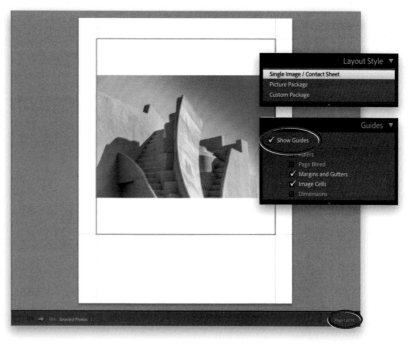

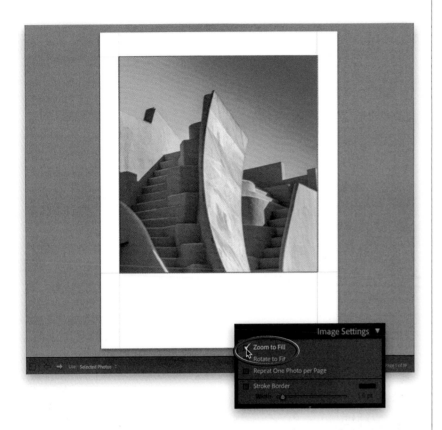

Step Three:

If you look back at the layout in Step Two, did you notice that the image fit the cell side-to-side, but there was a gap on the top and bottom? That's because, by default, it tries to fit your image in that cell so the entire image is visible. If you want to fill the cell with your photo, go to the Image Settings panel and turn on the **Zoom to Fill checkbox** (as shown here), and now your image fills it up (as seen here). Now, of course, this crops the image a bit, too (well, at least with this layout it did). This Zoom to Fill feature was designed to help you make contact sheets, but as we go through this chapter, I bet you'll totally start to love this little checkbox because with it you can create some really slick layouts—ones your clients will love. So, even though it does crop the photo a bit, don't dismiss this puppy yet—it's going to get really useful very soon.

Step Four:

Now, let's work on the whole cell concept, because if you "get" this, the rest is easy. First, because your image is inside a cell and you have the Zoom to Fill checkbox turned on, if you change the size of your cell, the size of your photo doesn't change. So, if you make the cell smaller, it crops off part of your image, which is really handy when you're making layouts. To see what I mean, go to the Layout panel, and at the bottom of the panel are the Cell Size sliders. Drag the **Height slider** to the left (down to 5.46 in), and look at how it starts to shrink the entire image size down, until it reaches its original unzoomed width, then the top and bottom of the cell move inward without changing the width any further. By the way, the image you see here is a small section of the world's largest sundial at the Jantar Mantar astronomical observatory, in Rajasthan, India. It was built in the early 1700s, but its architecture looks so modern. I super-dig it. Okay, back to printing.

Step Five:

Now drag the Height slider back to where it was before, and then drag the **Width slider** to the left to shrink just the width. This particular photo is wide (in landscape orientation), so dragging the Width slider to a lower number, like we are here, shrinks just the sides of the cell inward (this will all make sense in a minute). See how the left and right sides of your cell have moved in, creating the tall, thin cell you see here? This tall, thin layout is actually kind of cool on some level (well, it's one you don't see every day, right?).

TIP: Print Module Shortcut

When you want to jump over to the Print module, you can use the same keyboard shortcut you do in almost any program that lets you print: it's the standard old **Command-P (PC: Ctrl-P)**.

Step Six:

One of my favorite things about using these cell layouts is that you can reposition your image inside the cell. Just move your cursor over the cell, and it turns into the **Hand tool**. Now, just click-and-drag the image inside the cell to the position you want it. In this case, I just slid the photo over to the left until the stairs on the right were visible inside the tall cell.

TIP: Rotating Images

If you have a tall photo in a wide cell (or on a wide page), you can make your photo fill as much of that page as possible by going to the Image Settings panel, and turning on the **Rotate to Fit checkbox**.

Step Seven:

At the bottom of the Cell Size section is the **Keep Square checkbox**. Go ahead and turn this checkbox on, which sets your Height and Width to the exact same size, and now they move together as one unit (since it's perfectly square). Let's try a different way of resizing the cell: click-and-drag the cell borders themselves, right on the layout in the Preview area. You see those vertical and horizontal lines extending across and up/down the page, showing the boundaries of your cell? You can click-and-drag directly on them, so go ahead and give it a try. Here, I'm clicking on the top horizontal guide (shown circled here in red), and dragging outward to enlarge my square cell (and the photo inside it). So, by now you've probably realized that the cell is like a window into your photo.

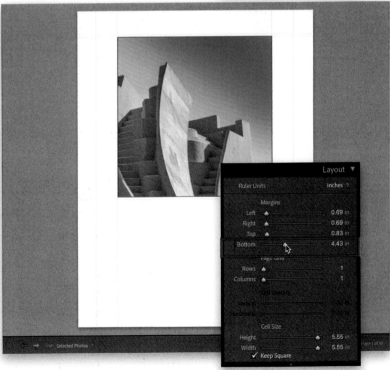

Step Eight:

Interestingly enough (or confusingly enough—your choice) the **Margins sliders** in the Layout panel still play a role in your layout, but they don't change the page margins (those are set in the Page Setup [PC: Print Setup] dialog). This is kind of a second set of margins that just surround your image. So, if you wanted your entire image higher on the page, you could drag the Bottom slider to the right (leaving a larger margin below your image, as shown here), which moves your square cell and image up the page (just like dragging the Top slider would add space above your photo, moving it down farther on the page). Same thing with the Left and Right sliders—if you wanted your image offset to one side or the other, you'd drag one of those two sliders. *Note:* The cell doesn't resize while it's moving unless you drag a slider so far it has no choice to proportionally shrink your cell. For example, if you keep dragging the Bottom slider to the right, at some point, the image won't fit, so it starts shrinking the cell so that it will.

Creating Multi-Photo Contact Sheets

The reason you jumped through all those hoops just to print one photo was because the whole Single Image/Contact Sheet was really designed for you to have quick access to multi-photo layouts and contact sheets, which is where this all gets really fun. We're picking up here, with another set of photos, to show you how easy it is to create really interesting multi-photo layouts that clients just love!

Step One:

Start by clicking on any of the multi-photo templates that come with Lightroom (if you hover your cursor over any of the templates in the Template Browser, a preview of the layout will appear in the Preview panel at the top of the left side panels). For example, click on the **2x2 Cells template**, and it puts your selected photos in two columns and two rows (as shown here). I turned off the guides we used in the previous section, so you can see a cleaner view of the layout here, which honestly looks kind of "meh," but we'll fix that in the next step. By the way, you can toggle on/off the guides by pressing **Command-Shift-G (PC: Ctrl-Shift-G)**.

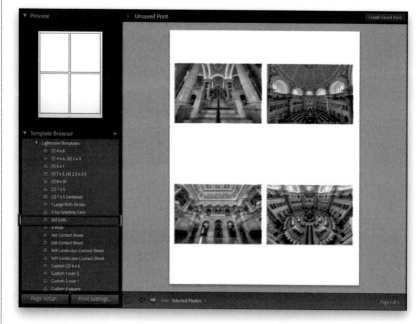

Step Two:

These multi-photo templates seem to look best with the **Zoom to Fill checkbox** (in the Image Settings panel at the top of the right panels) turned on (as shown here). I think it's a much better look as far as the layout goes, but of course, turning this feature on takes your wide images and crops them into tall cells (as seen here), so you have to decide if you're okay with that. If you're not, I have a solution on the next page. One more thing: don't forget, you can reposition the images inside their cells by clicking-and-dragging them.

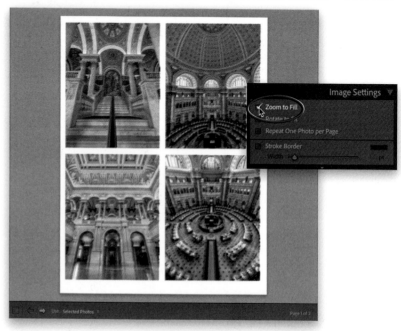

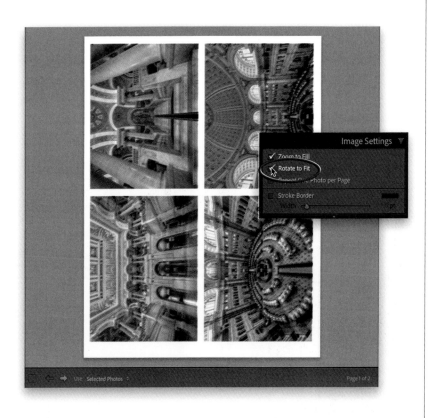

Step Three:

If you want to use a 2x2 layout like this, but you don't want your wide images to be cropped into a tall cell, you can turn on the **Rotate to Fit checkbox** (as shown here), which is also in the Image Settings panel, right below Zoom to Fill. Turning this on rotates the wide photos so they best fill the tall cells (as seen here, where the wide photos are now turned sideways to fit in the cells as large as possible). When you turn on Rotate to Fit, it applies that to all your pages, so if you have other wide photos on other pages, it will rotate them, as well. One more thing about this particular 2x2 template: when you rotate to fit these wide images, you're still not seeing the full width of the photo—they are still cropped in a bit on the sides. To get them to their full width, go to the Layout panel and drag the Cell Size Width slider to the left, to shrink the image inside the cell until it fully fits. I tried it, and I can tell ya, it looks fairly awful, but they do fit. If an ugly layout is your goal, that should do the trick.

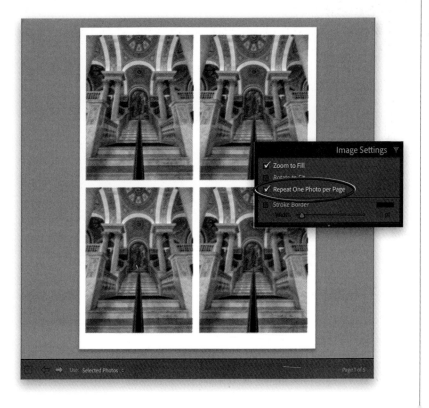

Step Four:

Here's an interesting option: If you want to repeat the same photo, at the same exact size, multiple times on the same page, then you can go to the Image Settings panel and turn on the **Repeat One Photo per Page checkbox**, as shown here. If you want to print the same photo multiple times on the same page, but you want them to be different sizes (like one 5x7" and four wallet-size photos), then turn to page 390 for details on how to set that up.

Step Five:

If you click on a different multi-photo layout, like the **4x5 Contact Sheet** (as shown here), your photos instantly adjust to the new layout. One nice feature of this template is that the names of your images appear directly below each image. If you want to turn this feature off, go to the Page panel and, near the bottom of the panel, turn off the **Photo Info checkbox**. By the way, when you have this checkbox turned on, you can choose other text to appear under your images from the pop-up menu to the right of the words Photo Info. Here, I turned on the Zoom to Fill checkbox, but of course, that's totally optional—if you don't want your images cropped, then you should leave Zoom to Fill turned off.

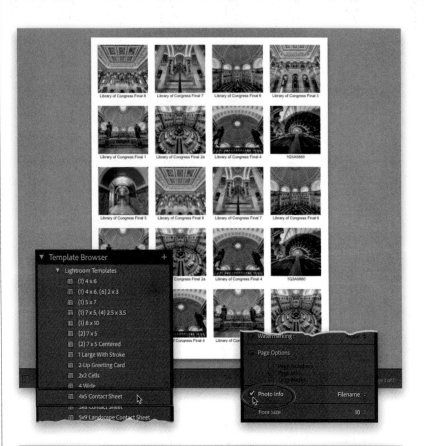

Step Six:

So far, we've been using Lightroom's built-in templates, but half the fun of this process is building your own, and it's surprisingly easy, as long as you don't mind having all your cells being the same exact size, which is the limitation of using the Single Image/ Contact Sheet type of layout. You can't have one photo that's square, and two that are rectangular. They're either all square or all rectangular, but don't worry, we'll tackle how to create multiple photos at any size you want a little later. For now, we'll use this contact sheet power to create some cool layouts. Start by selecting some photos (eight or nine should be fine), then click on the **Maximize Size template** (as shown here; it's a decent starting place for building your own templates). Since we're going to be adding photos, I turned off the Rotate to Fit checkbox (it's on by default in this template) in the Image Settings panel.

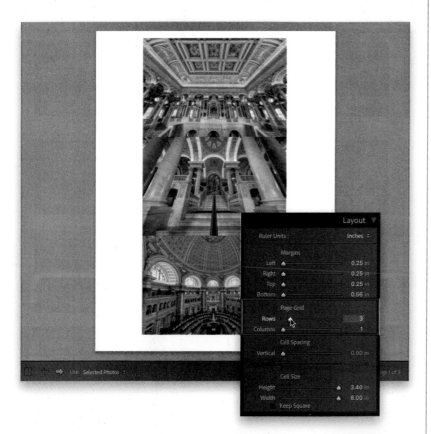

Step Seven:

You create custom multi-photo layouts in the Layout panel. There's a Page Grid section, which is where you pick how many rows and columns you want in your layout, so start by dragging the **Rows slider** over to 3, while leaving the Columns set at 1, so you get three photos each in their own row (like you see here). You'll notice that the three photos are stacked one on top of another with no space between them. *(Note: I still have the guides turned off here. If you want to see black guide lines around the cells, so you can see where the cell borders are, go to the Guides panel and turn on the Show Guides checkbox, and then make sure the Image Cells checkbox is also turned on.)*

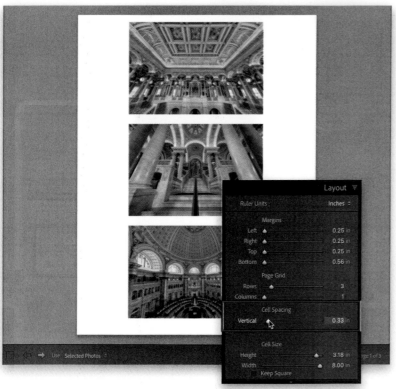

Step Eight:

To create some space between your photos, go to the aptly named Cell Spacing section and click-and-drag the **Vertical slider** to the right (as shown here, where I dragged it over to 0.33 in to put a little more space between the photos). Ahhhh, that looks better. Now let's take things up a notch.

Step Nine:

Now go back to the Page Grid section and increase the **Columns slider** to 3, so you have this layout of three columns wide by three rows deep. Of course, since the default setting is to not have any space between photos, the columns of photos don't have any space between them horizontally (yet).

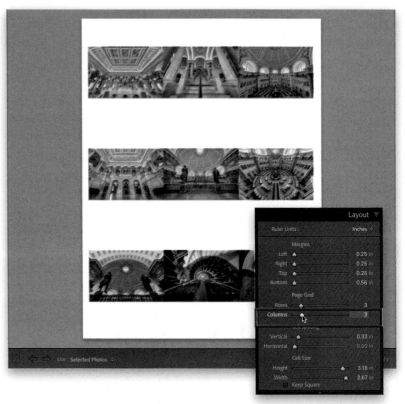

Step 10:

You add space between the photos in columns by going to the Cell Spacing section, and clicking-and-dragging the **Horizontal slider** to the right (as shown here, where I dragged it to 0.27 in). Now that you've got space between your columns, take a look at the page margins. There's lots of space at the top and bottom, and just a little bit of space on the sides of the page. One reason this page looks pretty lame is that you're seeing wide photos in tall cells. In the inset below left, I turned on the guides so you can see the cells and how the wide photos are centered in those tall cells.

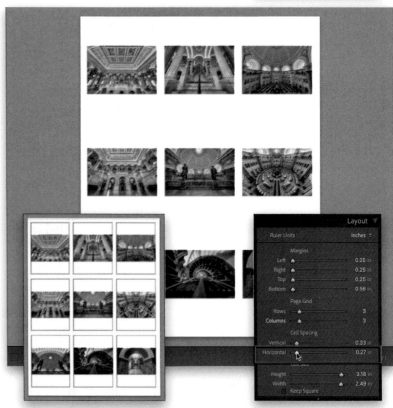

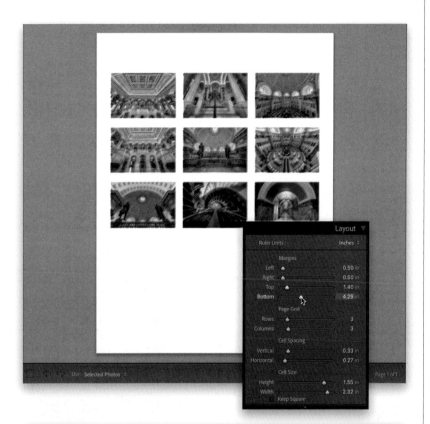

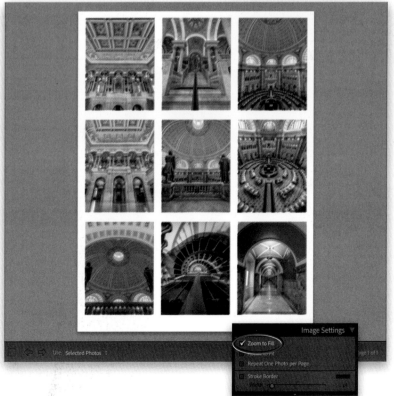

Step 11:

To get rid of all that extra space, you can use the **Margins sliders**. To add more space at the bottom of the page, drag the Bottom slider way over to the right (here, I dragged it to 4.29 in). Notice how it moved the bottom three cells up (leaving lots of white space at the bottom) and compressed the space between the other rows? Now add more white space above your cells by dragging the Top slider to the right (here, I went to 1.40 in). Then, you could add some space on both sides of the page by dragging the Left and Right sliders to the right (or you can do what I did here, which was click directly on the numbers to the right of the sliders and type 0.50 in for both, and then hit the Return [PC: Enter] key to lock in these new side margins). Doing all that gives you the layout you see here, which is pretty decent looking, and the bonus is your images maintain a wider aspect ratio. However, for me, this would be "Plan B."

Step 12:

Let's look at what my "Plan A" would be: Undo all that stuff we just did with the Margins sliders (press **Command-Z [PC: Ctrl-Z]** until you're back to what our layout looked like in Step 10), then go back up to the Image Settings panel and turn on the **Zoom to Fill check-box** to fill the cells with the images (as seen here).

Step 13:

Let's wrap this section up with a few examples of cool layouts you can create using these Contact Sheet style layouts (this one is based on a borderless 8.5x11" page size, which you can choose by clicking the Page Setup button at the bottom of the left-side panels). Start by turning on the Zoom to Fill checkbox in the Image Settings panel. Then, go to the Layout panel, under Page Grid, and change the number of Rows to 1 and the number of Columns to 3. Drag the Left, Right, and Top Margins sliders to around 0.75 in, and the Bottom Margins slider to around 2.75 (to leave lots of room for your Identity Plate text, as seen here). Jump down to Cell Spacing and set Horizontal to 0.14. Under Cell Size, for the Height, drag it to around 7.50 in, and set the Width at only around 2.24 in, which gives you very tall, narrow cells (as shown here). Now, select three photos and turn on the Identity Plate feature (in the Page panel), make it larger, and click-and-drag it so it's centered below your images, giving you the look you see here. *Note:* If you like this layout, you can save it as a custom template (see page 397).

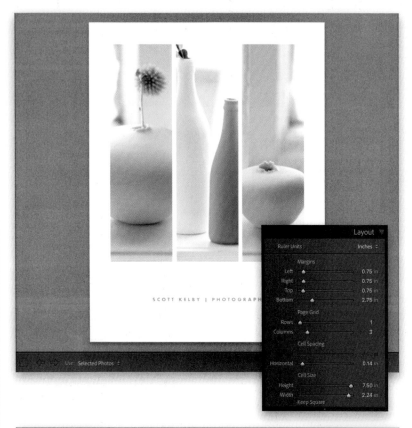

Step 14:

Here's another layout with that same fine art feel that has four square images and room for your Identity Plate below them (this one is borderless 13x18"). Start by selecting four photos, then go to the Image Settings panel and turn on the Zoom to Fill checkbox. In the Layout panel, set your Rows to 2 and Columns to 2, set your Left and Right Margins to 2.00 in, set the Top to 2.75 in, and then set the Bottom to 7.25 in. Now, set the space between your cells to 0.40 in using the Vertical and Horizontal Cell Spacing sliders to give you the layout you see here. Turn on your Identity Plate (in the Page panel) to add your text or graphic logo (this is a combination of text and my signature in very light gray behind it, created in Photoshop and saved as a PNG file).

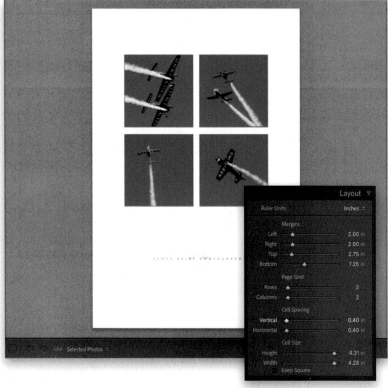

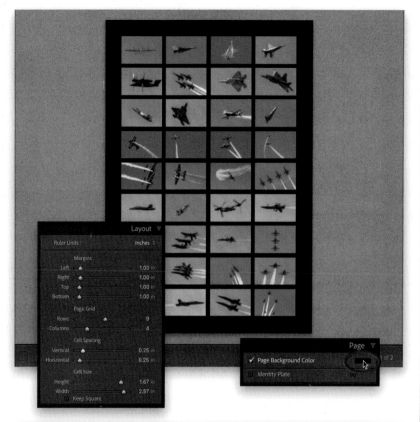

Step 15:

How about a 13x19" poster, on black, with 36 wide images? Easy. Start by creating a collection made up of only wide images. Then, go to the Image Settings panel and turn on the Zoom to Fill checkbox. Go to the Layout panel and set a 1.00 in margin all the way around the page, using the Margins sliders. Now, set your Page Grid to 9 rows and 4 columns, and set your Horizontal and Vertical Cell Spacing to 0.25 in. Lastly, in the Page panel, turn on the Page Background Color checkbox, then click on the color swatch to the right of it (shown circled here, bottom right) and choose black for your background color. If you see a white border around the outside edge of your poster, click on the Page Setup button and under Paper Size, choose A3+ 13"x19" Borderless, and now you can print that solid black background all the way to the edge of the page.

Step 16:

Okay, this one's kinda cool—one photo split into five separate thin vertical cells (this one is an 8.5x11"). Here's how it's done: Start by clicking the Page Setup button, and set your page to be Landscape orientation (wide). Then, Right-click on a photo in the Filmstrip and choose **Create Virtual Copy**. You need to do this three more times, so you have a total of five photos, but they're all the same photo. Now, in the Image Settings panel, turn on Zoom to Fill, then in the Layout panel, set your Margins to 0.50 in all the way around the page. For your Page Grid, choose 1 Rows and 5 Columns. Add a little Horizontal Cell Spacing—around 0.25 in. Then, drag the Cell Size Height slider to around 7.50 in and the Width to around 1.80 in. Select all five photos in the Filmstrip, and then starting with the far-right cell, drag the image inside that cell to where you're seeing its right edge. Then go to the fourth cell and drag it a little to the left, so it picks up visually where the fifth one left off, and so on for the rest until they appear to be one single image (like you see here).

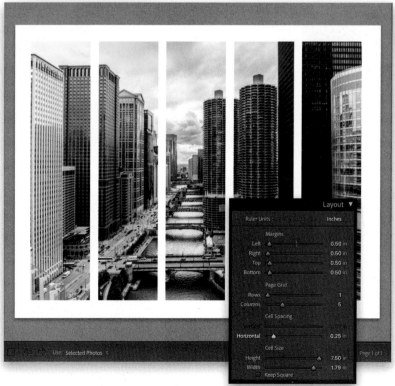

Creating Custom Layouts Any Way You Want Them

If you want to break away from the uniform cell layouts of the Single Image/Contact Sheet we've been using, you can easily create your own custom layouts with multiple photos in any size, shape, and position using a Layout Style called "Custom Package." Not only can you put images anywhere you want, but there's something else you can only do here, which is to have multiple images overlap one another.

Step One:

Start in the Layout Style panel by clicking on **Custom Package** (as seen in the inset on the right). We want to start with an empty page, so if you see any cells already on the page, go to the Cells panel and click the **Clear Layout button** (shown circled down in Step Two). There are two ways to get photos onto your page: The first is to go down to the Filmstrip and simply drag-and-drop images right onto your page (as shown here). The image appears inside its own fully resizable cell, so you can click-and-drag one of the corner handles to resize the image (this image came in at a pretty small size, so I scaled it up to the size you see here). It will resize proportionally at the photo's aspect ratio, but if you want to make it thinner or wider, go to the bottom of the Cells panel and turn off the **Lock to Photo Aspect Ratio checkbox**.

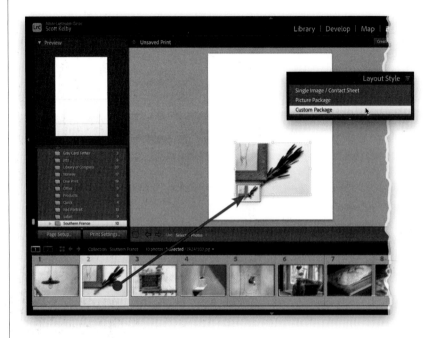

Step Two:

Go ahead and hit the Clear Layout button, so you can try the second way to get your images into your layout, which is to create the cells first, arrange them where you want, then drag-and-drop your images into those cells. You do this by going to the Cells panel, and in the **Add to Package section**, just click on the size you want. For example, if you wanted to add a 3x7" cell, you'd just click on the 3x7 button (as shown here) and it creates an empty cell that size on the page (in this case, up in the left corner). Now you can click inside that cell, drag it anywhere you'd like, and then drag-and-drop a photo into it from the Filmstrip. Easy peasy.

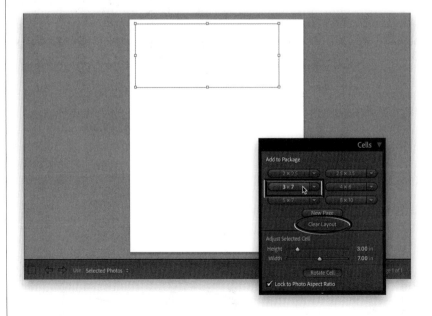

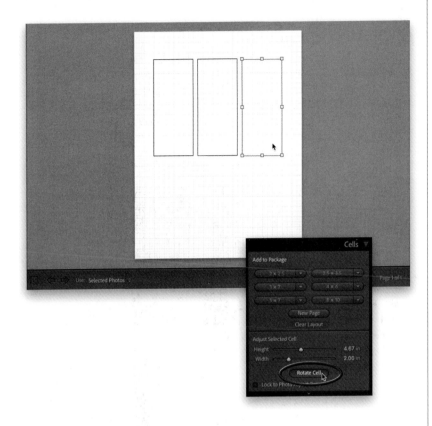

Step Three:

Let's create a layout using these cell buttons, so hit the Clear Layout button to start from scratch. First, turn off the Lock to Photo Aspect Ratio checkbox or when we drop a photo into a cell, it will expand to fit the photo. Then, click the **3x7 button** to add a long, thin cell to your layout. Now click the **Rotate Cell button** to flip it, making it a tall, thin cell instead. This cell is pretty large, but you can resize it by grabbing any of the corner handles and dragging inward or you could use the Adjust Selected Cell sliders—shrink your Height to 4.67 in and Width to 2.00 in. Now, we need two more cells just like this one, so press-and-hold the **Option (PC: Alt) key**, then click anywhere inside the cell and drag to the right, and as you do, it makes a copy. Do this once more, so you have three of the same-sized cells and arrange them side by side (as shown here). As you drag a cell, you'll feel it snap to an invisible alignment grid that's there to help you line things up. If you don't feel the snap or see the grid (I turned it on here), go to the Rulers, Grid & Guides panel, turn on the checkboxes for **Show Guides** and **Page Grid**, and make sure **Grid** is selected from the Grid Snap pop-up menu.

Step Four:

Next, let's add a larger photo to the bottom of our layout. Click the **4x6 button** and it adds a larger cell to the layout. Drag this cell below the three tall cells, and you'll see that it's not quite as wide as them. So, click on the right side handle and drag it over until it matches the width (as shown here).

Step Five:

Now you're ready to start dragging-and-dropping photos into your layout. If you drag one that doesn't look good in your layout, just drag another one right over it. You can reposition your photo inside a smaller cell by pressing-and-holding the **Command (PC: Ctrl) key** and your cursor will change into a grabber hand. You can then just click directly on the image and drag it left/right (or up/down) inside the cell until just the part you want is showing. (*Note:* I turned off the Show Guides checkbox here, so you can get a cleaner look at the layout.) Once again, don't forget to save any of these that you like as a custom template (see page 397 for more).

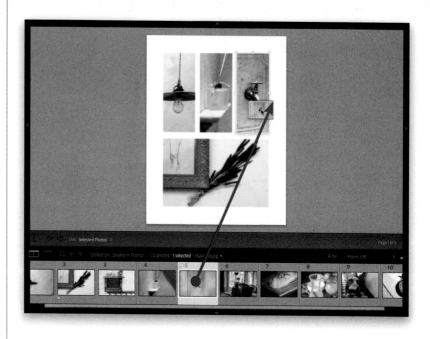

Step Six:

Another advantage of these custom layouts is that you can stack images so they overlap. Let's start from scratch again, but first click the Page Setup button (at the bottom left), and turn your page orientation to Landscape. Now, go back to the Cells panel, click the Clear Layout button, then click the 8x10 button and then scale it down a little and position it so it takes up most of the page. Next, click the 2x2.5 button three times and position them so they overlap the main photo (as seen here), and then drag-and-drop photos on each cell. You can move the photos in front or behind each other by Right-clicking on a photo and from the pop-up menu, choosing to send the photo backward/forward one level or all the way to the bottom/top of the stack. To add a white photo border around your images (like I did here), in the Image Settings panel, turn on the **Photo Border checkbox** (turn on the guides to see this better, if you turned them off).

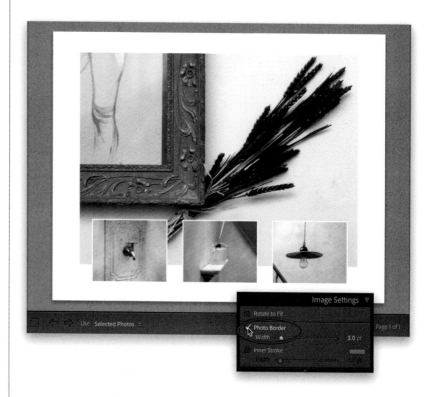

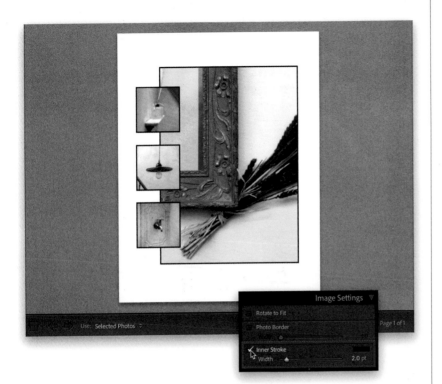

Step Seven:

Want a different look really quickly? Try switching your page orientation back to Portrait (tall) to see how that looks. It doesn't auto-adjust to fix your new tall layout, so you'll have to drag the cells around to make the layout fit this tall format, but it only takes a few seconds to get them into place. When you get it looking like you see here, go back to the Image Settings panel, turn off the Photo Border checkbox, and then turn on the **Inner Stroke checkbox**, which adds a black stroke around all your images (as seen here). If, for any reason, the stroke isn't black, click on the color swatch to the right and choose black as your stroke color. Lastly, drag the Width slider to around 2.0 pt.

Step Eight:

Here's an alternate look to the page you just created, and it only took about 60 seconds to get from the layout in Step Seven to what you see here. I just changed the **Inner Stroke** to white, and I dragged all of the small images over to the right, so they appear over the main image (instead of peeking in from the side). I also dragged out the sides, top, and bottom of the main image to make it fill the page better. (Note: If you saved this layout as a custom template, you can update it with the changes you made to it by Right-clicking on it in the Template Browser and choosing **Update with Current Settings**. Again, see page 397 for more on saving custom layouts.)

Adding Text to Your Print Layouts

If you want to add custom text to your print layouts (like your name or the name of your company), it's pretty simple. You can even have Lightroom automatically pull info that's already embedded in your photo (by your camera), and have it appear on the print. Here's what you can add, and how you can add it:

Step One:

To add text to your layout (I'm using the Fine Art template here), go to the Page panel and turn on the **Identity Plate checkbox**. Now, just below that, you'll see a preview of your text. Click-and-hold on the little arrow in the bottom right, and from the pop-up menu, choose **Edit** (as shown here, at the top right). This brings up the **Identity Plate Editor**, where you can add your text (if you didn't already do this back in Chapter 4) or change it by highlighting it and choosing your font (I chose Gill Sans Light here). Don't worry about the size right now—there's a better way to do this. Click OK and your text appears centered on your page, and you can then click on it and drag it where you want it (here, I dragged it down beneath the photo). To resize it, click on a corner handle and drag, or use the Scale slider in the Page panel. To make it gray, drag the Opacity slider to the left.

Step Two:

Sadly, there aren't many formatting options, or even a way to add a second line, like you see here. Wait? If there's no way, how did I get it there? Using a cool trick: Format the text the way you want it in a text editing app (I used TextEdit on my Mac, where I centered the text, varied the sizes [the second line is smaller], and added a lot of space between the letters). Then, just select it and copy-and-paste it into the Identity Plate Editor, and it keeps all the formatting, tracking, and font info. I can't believe it actually works, but it does (as seen here. I used the Lato font).

Step Three:
Besides adding text using the Identity Plate, Lightroom can also pull text from your photo's metadata (things like exposure settings, camera make and model, filename, or caption info you added in the Library module's Metadata panel; see page 101). In the Page panel, turn on the **Photo Info checkbox** and then choose the type of info you want displayed at the bottom of your photo cell from the pop-up menu on the right. I chose **Equipment** here, and now that info is automatically displayed directly under my image (as seen here). You can also choose Custom Text to type in whatever text you'd like, or choose Edit to use Lightroom's Text Template Editor if you need to do something more complex (like including multiple types of metadata and other info). While you can't change the font for this Photo Info text, you can change its size from the Font Size pop-up menu right below its checkbox. Now, I can't imagine why anyone would want that type of information printed beneath a photo. But you know, and I know, there's somebody out there right now reading this and thinking, "All right! Now I can put the EXIF camera data right on the print!" The world needs these people.

Step Four:
If you're printing pages for a photo book, you can have Lightroom automatically number those pages. In the Page panel, turn on the **Page Options checkbox**, then turn on the checkbox for Page Numbers. Lastly, if you're doing a series of test prints, you can have your print settings (including your level of sharpening, your color management profile, and your selected printer) appear near the bottom of the print (as seen here) by turning on the Page Info checkbox.

Printing Multiple Photos on One Page

You saw earlier in this chapter how to print the same photo, at the same exact size, multiple times on the same page. But what if you want to print the same photo at different sizes (like a 5x7" and four wallet sizes)? That's when you want the Picture Package Layout Style.

Step One:

Start by clicking on the photo you want to have appear multiple times, in multiple sizes, on the same page. Go to the Template Browser in the left side panels and click on the built-in template named **(1) 4x6, (6) 2x3**, which gives you the layout you see here. If you look over in the Layout Style panel at the top of the right side panels, you'll see that the selected style is **Picture Package** (as seen here). *Note:* Here, I turned off the guides and grid so it's easier to see the layout, but you can turn them on by pressing **Command-Shift-G (PC: Ctrl-Shift-G)**.

Step Two:

By default, this template puts a white border around each photo. If you don't want the white border, go to the Image Settings panel and turn off the **Photo Border checkbox** (as seen here), and now the images will be snug up against each other.

Step Three:

Another option it has on by default is that it puts a black stroke around each image (yup, it's got a white border *and* a black border). To remove this stroke, turn off the **Inner Stroke checkbox** (as shown here, bottom left). If you still see lines that separate the images, that's probably because you have the guides turned on. One thing you might want to consider to make things easier when you go to cut these out (especially the wallet size) is to turn on some very thin guidelines that print right on the page to let you know where to do your cutting (as seen here). You can get these by turning on the **Cut Guides checkbox** at the bottom of the Page panel. You can also choose the style, from lines or crop marks (as shown here). By the way, if you like this layout, as always, don't forget to save it as your own custom template (by clicking on the + [plus sign] button on the right side of the Template Browser header).

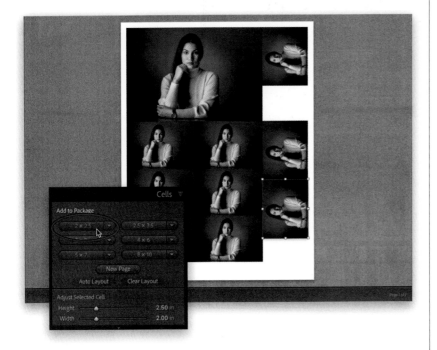

Step Four:

If you want to maximize your paper usage by adding more photos to this same page, it's easy. Go to the Cells panel and you'll see a number of pill-shaped buttons marked with different sizes. Just click on any one of those to add a photo that size to your layout. Of course, you're not going to fit an 8x10" or a 5x7" on this page, but some more 2.25" wallet-sized photos would fit. Just click on the **2x2.5 button** three times to add three more wallet-sized images (if you click a fourth time, it adds it on a new blank page, so three extras is the max on this page). To delete a photo, just click on it, then press the **Delete (PC: Backspace) key** on your keyboard.

Step Five:

If you want to create your own custom Picture Package layout from scratch, go to the Cells panels and click on the **Clear Layout button** (as shown here), which removes all the cells, so you can start from scratch.

Step Six:

Now you can go to the Cells panel and start clicking on **Add to Package buttons** for various photo sizes, and it will place them on the page as you click each one. What's nice is it will do the math for you and rotate the photos if necessary, so you can fit as many as possible on the page (which is pretty cool when you think about it, but with all the stuff going on in the world today, I wouldn't waste a bunch of time thinking about it—it's your call). Here, I clicked the 5x7 and 4x6 buttons, and then I added two 2x2.5 wallet sizes and you can see how it rotated those wallet sizes so they'd fit on the page.

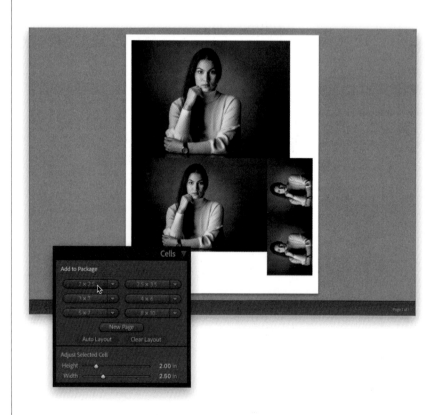

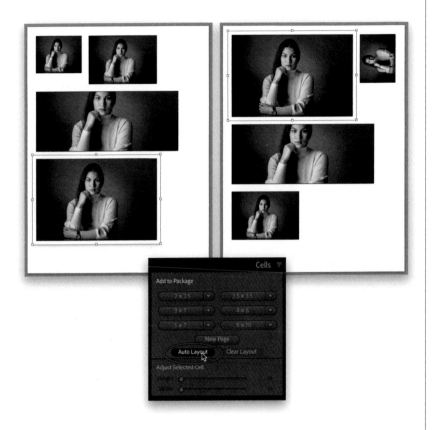

Step Seven:

Let's click on the Clear Layout button again, so we can start over and try a pretty handy feature. Now, once you've hit the Add to Package buttons to add a few photos (as seen here on the left, where I added a 2x2.5, 2.5x3.5, 3x7, and 4x6), you might not end up with the optimum layout to add more photos, but you can fix that by clicking the **Auto Layout button** in the Cells panel. Doing that rearranges the photos to give you room to add more photos (as seen here on the right, where the images have been rearranged and I now have room to add one or two more). That's pretty slick.

TIP: Dragging-and-Copying

If you want to duplicate a cell, just press-and-hold the **Option (PC: Alt) key**, click-and-drag yourself a copy, and position it anywhere you'd like. If one of your photos overlaps another photo, you'll get a little warning icon up in the top-right corner of your page.

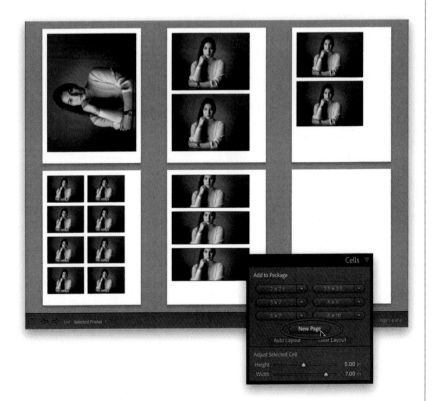

Step Eight:

If you add so many cells that they can't fit on one page, Lightroom automatically adds new pages to accommodate your extra cells. For example, start by adding an 8x10, then add a 5x7 (which can't fit on the same letter-sized page), and it automatically creates a new page for you with the 5x7. Now add another 5x7 (so you have two-up), then two 4x6s (which won't fit on the same page), and it will add yet another page. Add a bunch of wallet-sized photos and so on, and it adds additional pages. Pretty smart, eh? Also, if you decide you want to add another blank page yourself (this lets you drag an image from one page and drop it on this empty page anywhere you want it), just click on the **New Page button** (as shown here).

Step Nine:

If you want to delete a page, just hover your cursor over it and a little X appears in the top-left corner (as seen here, on the third page). Click on that X and the page is deleted (I already deleted the last three pages I created in the last step, here).

TIP: Zooming In on One Page

Once you have multiple pages like this, if you want to work on just one of them, you can zoom right in on the page by clicking on it, and then clicking on **Zoom Page** on the right side of the Preview panel header (at the top of the left side panels).

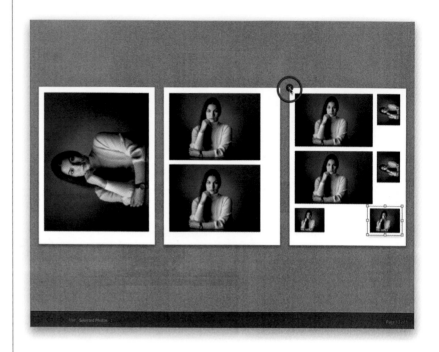

Step 10:

You can also manually adjust the size of each cell (which is a handy way to crop your photos on the fly, if you have Zoom to Fill turned on). For example, go ahead and delete the bottom 5x7 image on the second page. Now, click on the top image (to bring up the adjustment handles around the cell), then click-and-drag the bottom handle upward to make the cell thinner (as shown here). You can get the same effect by clicking-and-dragging the **Adjust Selected Cell sliders**, at the bottom of the Cells panel (there are sliders for both Height and Width), and you can also press-and-hold the Command (PC: Ctrl) key and click-and-drag on the photo to move it within the cell.

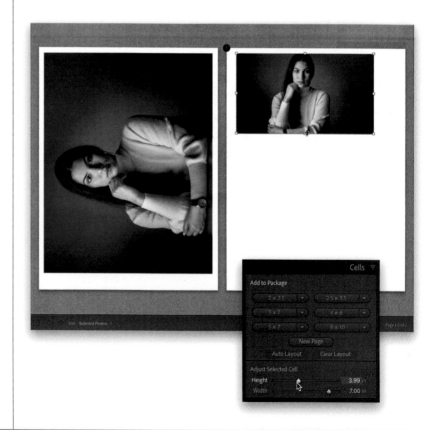

Once you've gone through the trouble of creating a cool print layout, with the photos right where you want them on the page, you don't want to lose all that when you change collections, right? Right! Luckily, you can create a saved print, which keeps everything intact—from page size, to the exact layout, to which photos in your collection wound up on the page (and which ones didn't) and in which order. Here's how ya do it:

Having Lightroom Remember Your Printing Layouts

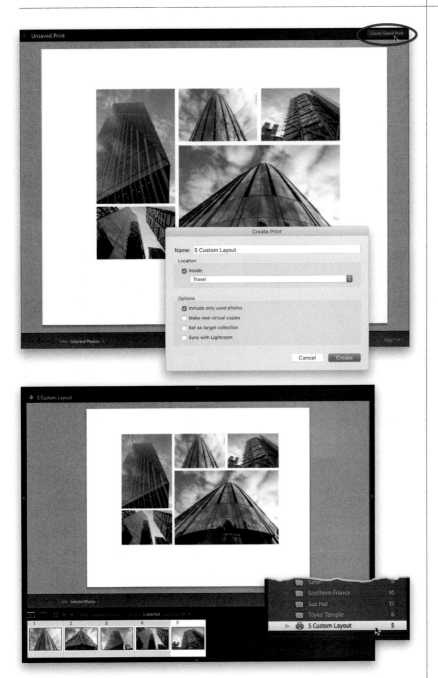

Step One:
Once you make a print, and you're happy with the final layout (and all your output settings and such, which we'll get into in a bit), click on the **Create Saved Print button** (shown circled here) that appears above the top-right corner of the center Preview area. This brings up the **Create Print dialog** (shown here), where you'll save a print collection. The key thing here, though, is to make sure the Include Only Used Photos checkbox is turned on. That way, when you save this new print collection, only the photos that are actually in this print are saved in it. Also, in the dialog, you'll have the option of including this new print collection inside an existing collection—just turn on the Inside checkbox and then choose the collection or collection set you want it to appear within.

Step Two:
Now click the Create button, and a new print collection is added to the Collections panel (you'll know at a glance that it's a print collection because it will have a printer icon right before the collection's name). That's it! When you click on that print collection and select all the photos in it, you'll see the layout, just the way you designed it, with the images already in order ready to go, including all your output settings (like which printer you printed to, your sharpening and resolution settings—the works!), even if it's a year from now. *Note:* If all your images don't appear in the layout, just go to the Filmstrip and select them all—now they'll appear in your layout.

How to Set Up Borderless (Edge-to-Edge) Printing

This is one of those questions I get asked a lot, and it's probably because, by default, you can't print an image, or a background color, all the way to the edge of a page (edge to edge, known as borderless printing). Luckily for us, it's an easy fix.

Step One:

There might already be a borderless page preset available to you, so let's start there. Click the Page Setup button at the bottom of the left side panels to bring up the **Page (PC: Print) Setup dialog** (seen here), and under Paper Size, choose the size you want to print on (for example, A3+ is a super-popular size for photo-quality printers). Over in your choice's submenu, you may see there's already a borderless preset you can choose (so here, the borderless size is the same 13x19", but the margins are all set to zero, rather than the defaults of 0.25 of a inch). Most of the paper sizes that offer a submenu of choices offer a borderless page preset.

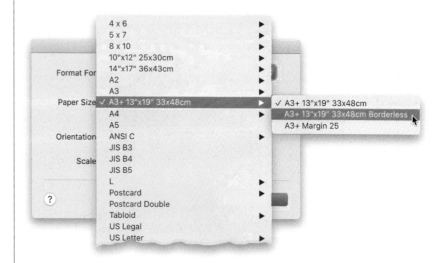

Step Two:

If you can't find a borderless preset, from the Page Size pop-up menu, choose **Manage Custom Sizes**, which brings up the dialog you see here. (*Note:* On a PC, click on Properties and then just turn on the Borderless Printing checkbox.) At the top, enter the Paper Size dimensions you want, and then in the Left, Top, Right, and Bottom margin fields, enter 0 in to set the borders to zero, and you're ready for borderless printing. If you want to save this as a preset, this is mighty weird, but you kinda have to work in reverse. First, click the + (plus sign) button at the bottom of the sizes column on the left and it enters totally different size and margin settings in all the fields (weird). So, re-enter your desired Paper Size and zero margins. Then, double-click on the preset you created and give it a name. Completely backward, but at least it works.

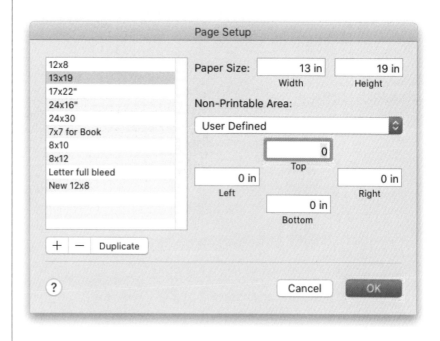

If you've come up with a layout you really like and want to be able to apply it at any time with just one click, you need to save it as a template. But beyond just saving your layout, print templates have extra power, because they can remember everything from your paper size to your printer name, color management settings, the kind of sharpening you want applied—the whole nine yards!

Saving Your Custom Layouts as Templates

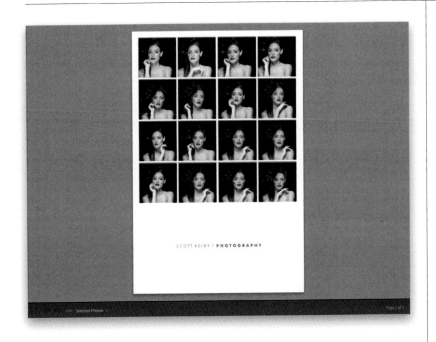

Step One:

Go ahead and set up a page with a layout you like, so you can save it as a print template. The page layout here is based on a 13x19" page (you choose your page size by clicking the Page Setup button at the bottom of the left side panels). The layout uses a Page Grid of 4 Rows and 4 Columns. The cell sizes are square (around 3" each), and the page has a 1/2" margin on the left, right, and top, with around a 6.50" margin at the bottom. I turned on the Stroke Border checkbox and changed the color to light gray, and turned on my Identity Plate. Also, make sure the Zoom to Fill checkbox (in the Image Settings panel) is turned on.

Step Two:

Once it's set up the way you like it, go to the Template Browser and click the plus sign (+) button on the right side of the header to bring up the **New Template dialog** (shown here at the bottom). By default, it saves templates you create in a folder called User Templates, but you can create your own folder and name it whatever you'd like (and you can create as many of these template folders as you want. For example, you could have one folder for letter-sized prints, one for 13x19" prints, and so on). To create a new template folder, choose **New Folder** from the Folder pop-up menu (as shown here), create your new folder, then give your template a name, click Create, and your new template will appear in this new folder in the Template Browser panel.

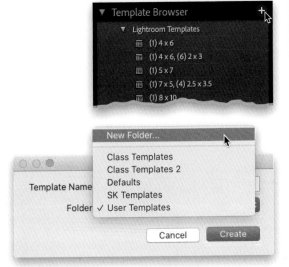

The Final Print & Color Management Settings

Once you've got your page set up with the printing layout you want, you just need to make a few choices in the Print Job panel, so your photos look their best when printed. Here are which buttons to click, when, and why:

Step One:

Get your page layout looking the way you want. In the capture shown here, I clicked on Page Setup at the bottom of the left side panels, chose a 17x22" page size, set it to a wide (landscape) orientation, and then I went to the Template Browser and clicked on the **Maximize Size template**. Lastly, I set my Left, Right, Top, and Bottom Margins sliders all to 0.50 in. Once that's done, it's time to choose our printing options in the Print Job panel, at the bottom of the right side panels.

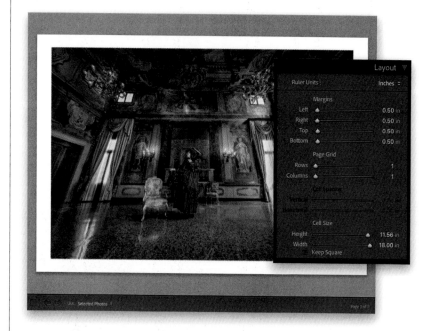

Step Two:

You have the choice of sending your image to your printer, or just creating a high-resolution JPEG file of your photo layout (that way, you could send this finished page to a photo lab for printing, or email it to a client as a high-res proof, or use the layout on a website, or…whatever). You choose whether it's going to output the image to a printer or save it as a JPEG from the **Print To pop-up menu**, at the top right of the Print Job panel (as shown here). If you want to choose the Print to JPEG File route, go to the next tutorial in this chapter for details on how to use the JPEG settings and export the file.

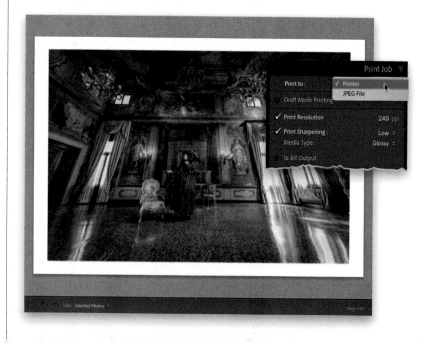

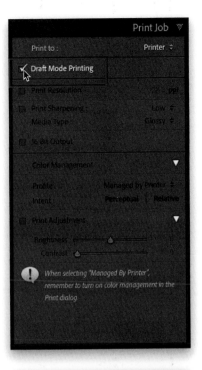

Step Three:

Since we've already started at the top, we'll just kind of work our way down. The next setting in the panel is a checkbox for **Draft Mode Printing**, and when you turn this on, you're swapping quality for speed. That's because rather than rendering the full-resolution image, it just prints the low-res JPEG preview image that's embedded in the file, so the print comes out of your printer faster than a greased pig. It works beautifully—the small images look crisp and clear. However, I would only recommend using this if you're printing multi-photo contact sheets. Notice, though, that when you turn Draft Mode Printing on, all the other options are grayed out. So, for contact sheets, turn it on. Otherwise, leave this off.

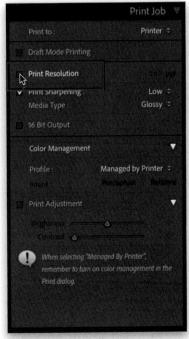

Step Four:

Make sure the Draft Mode Printing checkbox is turned off, and now it's time to choose the resolution of your image. For me, this is really simple—I go with Adobe's own recommendation and turn the **Print Resolution checkbox** *off* (as shown here) and let Lightroom do the math for me behind the scenes, so essentially I'm using the image's native resolution. (*Note:* You'll still see 240 ppi grayed-out in the resolution field to the right when you turn this off.) If you search this topic online, you'll find a bunch of outdated posts with people arguing back and forth about which setting is right, and they range from recommending 180 ppi to 720 ppi (literally). I've realized over the years that if there's one thing no two photographers on earth can agree upon, it's the proper amount of printing resolution. So, I'm going with what Adobe recommends, because I've had great success with that (leaving the Print Resolution checkbox turned off) for many years now, printing everything from huge prints on metal, to fine art papers, canvas, matte papers, lusters, glossy paper—you name it—without a single resolution issue.

Step Five:

Next is **Print Sharpening**. When you tell Lightroom which type of paper you're printing on and which level of sharpening you'd like, it looks at those, along with the resolution you're printing at, and it applies the right amount of sharpening to give you the best results on that paper media at that resolution (sweet!). So, start by turning on the Print Sharpening checkbox (I always turn this on for every print, and every JPEG file I save), then choose either Glossy or Matte from the Media Type pop-up menu (based on whichever one you're printing to). Now choose the amount of sharpening you want from the Print Sharpening pop-up menu (I generally use High for everything these days. The Low setting seems so subtle that I can't tell it did any sharpening at all, and Medium seems kind of "meh" to me. But, after you do a test, if you think High is too high, then Medium is your next stop). That's all there is to it—Lightroom does all the math for you.

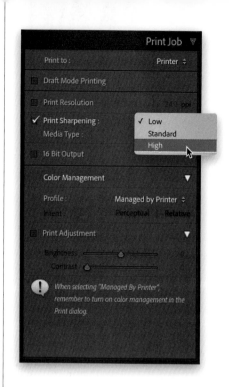

Step Six:

The next checkbox down reveals another feature: **16 Bit Output**, which theoretically, gives you an expanded dynamic range on printers that support 16-bit printing. However, as it always is when it comes to printing, there is considerable debate over whether turning this 16 Bit Output checkbox on actually makes a visual difference in your prints—some folks claim you cannot see any difference with the naked eye whatsoever, and others argue it makes a difference. The important thing is: people are arguing about stuff online, and that's what keeps the Illuminati running the show (and it's why we can't have nice things). So, what do I do in regards to the 16 Bit Output? I leave it turned on. It might help, and "it couldn't hurt." (Plus, it gives me something to argue about online.)

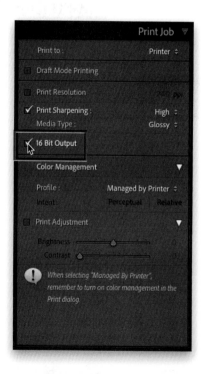

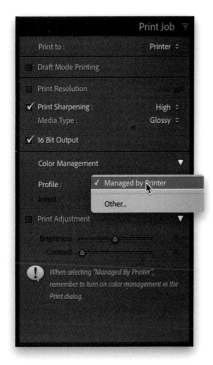

Step Seven:

Now it's time to set the **Color Management options**, so what you see onscreen and what comes out of the printer both match. (By the way, if you have any hope of this happening, you've first got to use a hardware monitor calibrator to calibrate your monitor. Without a calibrated monitor, all bets are off. More on this in a bit.) There are only two things you have to set here: (1) you have to choose your printer profile, and (2) you have to choose your rendering intent. For Profile, the default setting is Managed by Printer (as shown here), which means your printer is going to color manage your print job for you. This choice used to be out of the question, but today's printers have come so far that you'll actually now get decent results leaving it set to Managed by Printer (but if you want "better than decent," read on).

Step Eight:

You'll get better-looking prints by assigning a custom printer/paper profile. To get these, go to the website of the company that manufactures the paper you're going to be printing on and download their free ICC color profiles for your printer. So, if you're printing to a Canon imagePROGRAF PRO-1000, and you want to use Hahnemühle Photo Rag® Ultra Smooth paper, you'd go to Hahnemühle's website, click on ICC Profiles, then click on Download Center. From the pop-up menus, choose your printer make and model, then the type of paper you want to print on, and it displays a list of free paper profiles (as seen here), and there's the Photo Rag® Ultra Smooth profile. Click on it to download it. Now, on a Mac, the unzipped profile file should be placed in your Library/ColorSync/Profiles folder. To get to that folder (it's hidden), press-and-hold the Option key, then go under the Go menu, and choose **Library**. There, you'll find the ColorSync folder, and within that, you'll find the Profiles folder. Just drag-and-drop it in there. In Windows, just Right-click on the unzipped file and choose **Install Profile**.

Step Nine:

Once your color profile is installed, click-and-hold on the Profile pop-up menu (right where it says Managed by Printer), and choose **Other**. This brings up the **Choose Profiles dialog** (shown here) listing all the color profiles installed on your computer. Scroll through the list and find the paper profiles for your printer, then find the profile(s) for the paper(s) you normally print on (in my case, I'm looking for that Hahnemühle Photo Rag® Ultra Smooth paper for the Canon imagePROGRAF PRO-1000), and then turn on the checkbox beside that paper (as seen here). Once you've found your profile(s), click OK to add it to your pop-up menu.

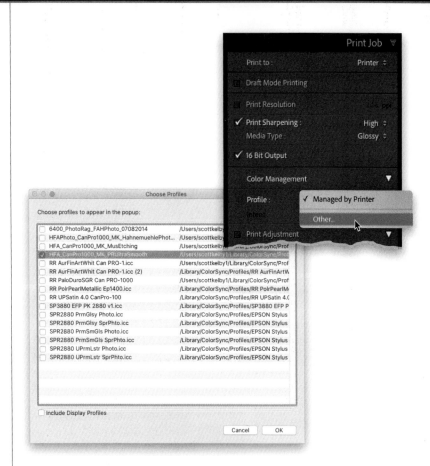

Step 10:

Return to that **Profile pop-up menu** in the Print Job panel, and you'll see the color profile for your printer is now available as one of the choices in this menu (as seen here). Choose your color profile from this pop-up menu, if it's not already chosen. In my case, I would choose the Hahnemühle paper profile for my Canon PRO-1000 printer, but in the pop-up menu seen here, they use the cryptic code-name "HFA_CanPro1000_MK_PRUltraSmooth." (They do that to throw off the North Koreans.) Okay, now you've set up Lightroom so it knows exactly how to handle the color for your particular printer, using this particular brand and style of paper. This step is really key to getting the quality prints we're looking for.

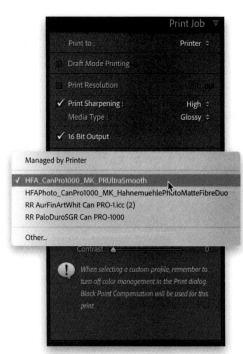

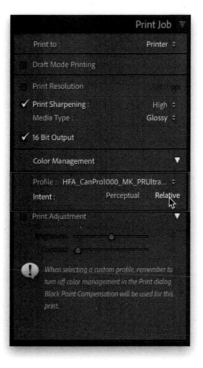

Step 11:

Next to **Intent**, you have two choices: (a) Perceptual, or (b) Relative. I feel that Relative will get you better results most of the time, so that's my default choice when printing. It keeps more of the original color, so it's a more accurate interpretation of the tones in the photo. Of course (and I'm cringing just writing this phrase that I hate so much), "it just depends on the photo." In certain cases, Perceptual may look better, but it can shift the color so much (to get all your colors into the color gamut of your printer) that it usually doesn't look as good, and it's not necessarily accurate to what you see tonally onscreen (as you can see, I'm not a Perceptual fan). So, which one is right for you? The best way to really find out is to do a few test prints. Try one print with Perceptual and the same image with Relative—when the prints come out, you'll know right away which one looks best to you (but know that this is somewhat image dependant). But for me, as I said, my default choice is always Relative. We'll cover the last option, Print Adjustment, after you make your first print.

Step 12:

Now it's time to click the **Printer button** (not the Print button) at the bottom of the right side panels. This will bring up the **Print dialog** (shown here. If you're using a Mac, and you see a small dialog with just two pop-up menus, rather than the larger one you see here, click the Show Details button to expand the dialog to its full size, more like the one shown here). On a Windows PC, when the Print dialog appears, click the Properties button and when its dialog appears, click on Photo Printing in the Commonly Used Settings section at the top of the Quick Setup tab.

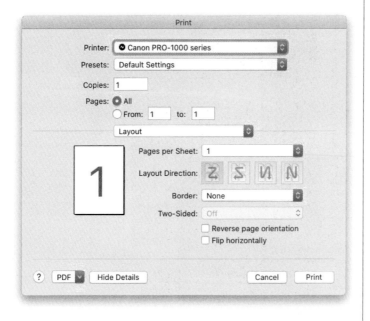

Step 13:

Click-and-hold on the Print dialog's main section pop-up menu, and choose **Color Matching** (as shown here). By the way, the part of this dialog that controls printer color management, and your pop-up menu choices, may be different depending on your printer, so if it doesn't look exactly like this, don't freak out. On a Windows PC, when you click on the Properties button, and then Photo Printing (like you did in the previous step), you'll see the **Color Intensity Manual Adjustment checkbox**. Turn this on and it will bring up the Manual Color Adjustment dialog. We'll pick up on what to do next in the next step, but at least now you're in the right place.

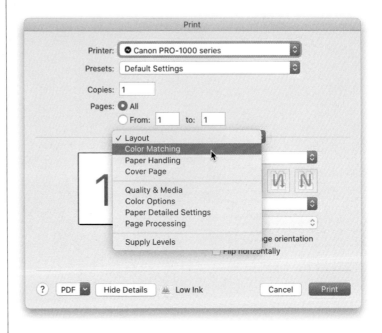

Step 14:

On a Mac, when the Color Matching options appear, you'll see your printer's color management may be turned off and grayed out (as seen here. If it is, ColorSync should be selected rather than Canon Color Matching) since you're having Lightroom manage your color. You don't want the printer also trying to manage your color, because when the two color management systems both start trying to manage it, nobody wins. So, if you're on a Mac, and if it's not already set to **ColorSync**, be sure to switch it. On a Windows PC (this may be slightly different, depending on your brand of printer), you should already be in the Manual Color Adjustment dialog. Click on the Matching tab up top, then click **None** under Color Correction (that way, only Lightroom is managing the color; not both the printer and Lightroom), and click OK.

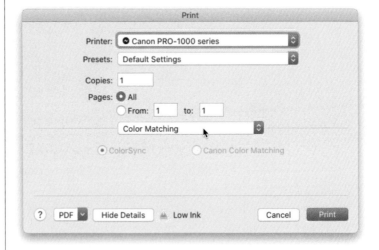

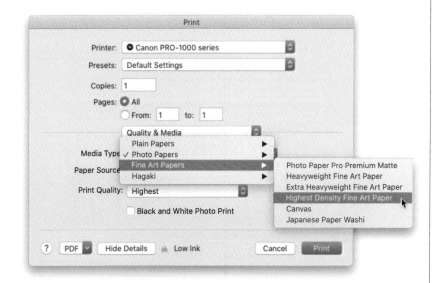

Step 15:

Now, choose **Quality & Media** from the pop-up menu (on a Windows PC, these paper choices are at the bottom of the Quick Setup tab in the Properties panel, so when you closed the Manual Color Adjustment dialog, you should be back in the right place already.) For Media Type, choose the type of paper you'll be printing to from the pop-up menu (as seen here, where I chose Highest Density Fine Art Paper). In that same Quality & Media section, select Highest from the Print Quality pop-up menu. Again, this is for printing to a Canon printer. If you don't have a Canon printer, choose the one that most closely matches the paper you are printing to. On a Windows PC, for Print Quality, choose High from the pop-up menu. Now, click Print on a Mac. On a PC, click OK twice to close the dialogs, then click the Print button at the bottom of the right side panels.

Step 16:

Now, sit back and watch your glorious print(s) roll gently out of your printer. So far, so good. But there's a little bit more to go.

Step 17:

Once your print comes out of the printer, now it's time to take a really good look at it to see if what we're holding in our hands actually matches what we saw onscreen. If you use a hardware-based monitor calibrator, and you followed all the instructions up to this point on downloading printer profiles and all that stuff, the color of your image should be pretty spot on. If your color is way off, my first guess would be you didn't use a hardware-based calibrator (the X-Rite i1Display Studio and the Datacolor SpyderX Pro are both popular) and using one is seriously a no-brainer. You put it on your monitor, launch the software, choose "easy-you-do-it-all-automatically-for-me" mode (not it's actual name), and in about four minutes your monitor is calibrated. This is such a critical step in getting your color right that without hardware calibration of some sort, you really have little hope of the colors on your monitor and your print actually matching.

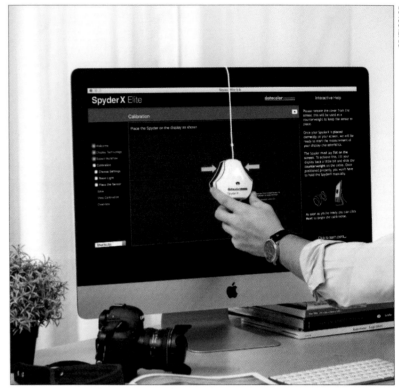

©DATACOLOR

Step 18:

If you've used a hardware calibrator, and followed the instructions in this section of the book, your color should be pretty much spot on, but there's another printing problem you're likely to run up against. Your color probably matches pretty darn well, but my guess is that the print you're holding in your hand right now is quite a bit darker than what you see on your screen. That's mostly because, up to this point, you've been seeing your image on a very bright, backlit monitor, but now your image isn't backlit—it's flat on a printed page (imagine how a backlit sign looks when you turn off the back lighting. Well, that's what you're holding). Luckily, Adobe addressed this problem with the **Print Adjustment option** at the bottom of the Print Job panel (seen here).

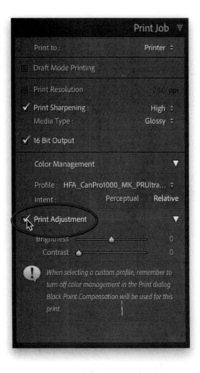

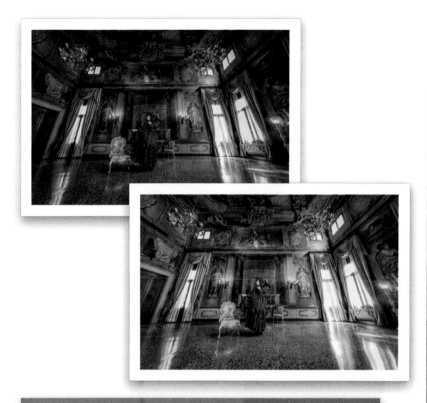

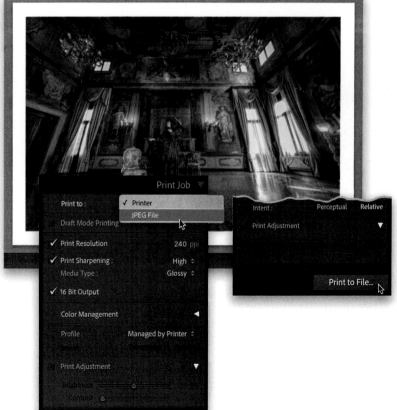

Step 19:
The thing that's so awesome about Print Adjustment is that it doesn't mess with the brightness or contrast of your actual image—your image doesn't change at all, just the print. It literally only affects the brightness of the print, while leaving the image at the same brightness as you had it onscreen. That is incredibly helpful. So, how do you know how much to increase the brightness of the print so it matches your screen? You do a test print. In fact, you kind of have to do a test print, since the changes you make with the Brightness and Contrast sliders aren't seen onscreen (they're only applied as the image is printed). Your test prints don't have to be output on big, expensive, 16x20" sheets of paper—they can be small 4x6" prints.

Step 20:
This whole matching the brightness thing is so important that I think we should go ahead and set up a test print together, so we can know, with just one test print, exactly how much of a brightness print adjustment we need to add. Here's how we do it: The first step is to make sure you don't have any print adjustment added to your photo (if you do, drag the Brightness slider back to zero or just turn off the Print Adjustment checkbox). Next, go to the Print Job panel, and up at the top where it says "Print to:" choose **JPEG File** (as shown here on the left). When you do this, the button at the bottom right of the right side panels, which normally says "Printer," changes to **Print to File** (as seen here on the right). Click that button and when the Save File dialog appears, name this file "Original," since it's the unadjusted original image.

Step 21:

Now, turn the **Print Adjustment check-box** back on (if you turned it off in the previous step), and then drag the **Brightness slider** to +10 (as shown here). You're now going to save this file (click the Print to File button again) and name it "Brightness +10." By the way, the Print Adjustment feature also has a Contrast slider if you're noticing a loss of contrast between what you're seeing onscreen and on the print. I haven't had this issue myself, but if you do experience it, you can set up a Contrast test sheet, like we're doing here for brightness, but do it separately. Now, let's do it again, but this time, boost the Print Adjustment Brightness amount to +15, and then save this file, naming it "Brightness +15." Do this one more time, setting the Brightness to +20. You'll wind up with four files: Original.jpg, Brightness +10.jpg, Brightness +15.jpg, and Brightness +20.jpg.

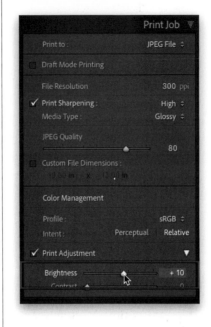

Step 22:

You're now going to re-import those four images back into Lightroom, so press **Command-Shift-I (PC: Ctrl-Shift-I)** to bring up the Import window. Go to the location where you saved those four test images, and then import them by clicking the **Import button** (as shown here)

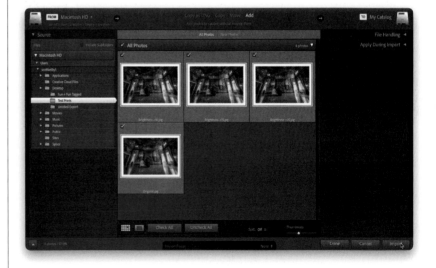

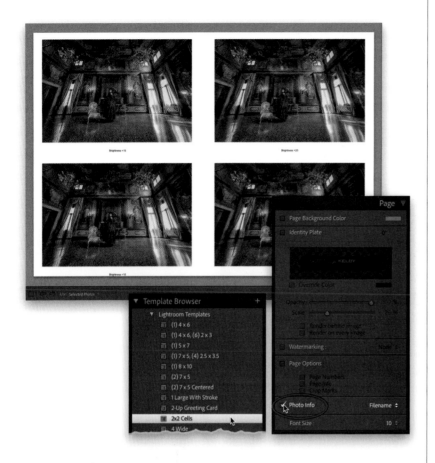

Step 23:

Okay, now that your test images are imported, press **Command-P (PC: Ctrl-P)** to jump back over to the Print module. To compare the test prints, we're going to use one of Lightroom's built-in templates. So, first, select all four images down in the Filmstrip (Command-click [PC: Ctrl-click] on them), then go to the Template Browser in the left side panels and click on the **2x2 Cells template** (as shown here, bottom left), and all four images appear on the page. But, to know which one is which, we need to see their filenames. So, go to the Page panel (in the right side panels), and turn on the **Photo Info checkbox** (as seen here, bottom right), and make sure **Filename** is selected to the right of it. You'll now see the test prints' filenames on the page (the text is pretty small, but you can make it bigger using the Font Size pop-up menu right below Photo Info. I usually make mine 14 point because I'm 112 years old, but it's a spry 112). However, the filenames for the bottom two images are really close to the edge here. Easy fix.

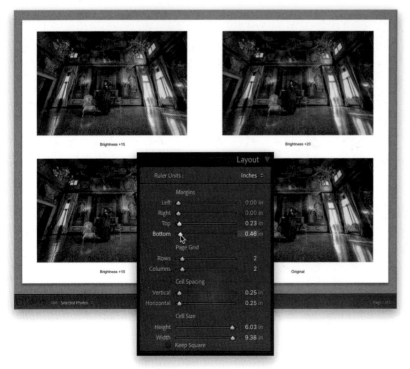

Step 24:

To get those filenames up off the bottom edge of the page, go to the Layout panel and drag the **Bottom Margins slider** to the right to shift the images up higher on the page. I also dragged the Top Margins slider a little to the left just so the page looked more balanced. Not necessary, but hey, why not, eh? So, here you can see the results of moving the images up the page, and increasing the Font Size to 14 points. Your test sheet is all set up now. If you're making prints on your own printer, just go ahead and print it, then hold the print up next to your monitor and determine which of these test prints most closely matches your monitor's brightness, and now you know. If you send your images to a photo lab for printing, hit Print to File to save this test print as a JPEG, and then upload that to your lab and have them make a test print for you. That's it—now you know.

Saving Your Layout as a JPEG (for Photo Lab Printing)

You can save any of these print layouts as JPEG files, so you can send them to a photo lab, or have someone else output your files, or email them to your client, or one of the dozen different things you want JPEGs of your layouts for. Here's how it's done:

Step One:

Once your layout is all set, go to the Print Job panel (at the bottom of the right side panels), and from the Print To pop-up menu (at the top right of the panel), choose **JPEG File** (as shown here).

Step Two:

When you choose to print to a JPEG, a new set of features appears. First, ignore the Draft Mode Printing checkbox (it's just for when you're printing contact sheets with lots of small thumbnails). For File Resolution, the default is 300 ppi, and I don't ever change it, but if for some reason you want to change it, click directly on "300" to highlight the field, and then you can type in a new resolution. When we're printing, we choose the size of our print in the Page Setup (PC: Print Setup) dialog, but if you want to change the size of your print, turn on the **Custom File Dimensions checkbox**, then click directly on the numbers beneath it, and it highlights the fields so you can type in new dimensions. I would only do this if I were shrinking the size of my print, not to increase its size, as you'll see a visible loss of quality (see page 412 for how to increase the size of your image without losing quality).

Step Three:

Next, is the **Print Sharpening pop-up menu**. There's more about this on page 400, but in short, you choose which type of paper you'll be printing on (Matte or Glossy), and which level of sharpening you'd like applied (Low, Standard, or High). Lightroom looks at your choices and comes up with the optimum amount and type of sharpening to match your choices (I apply print sharpening to every photo I print or save as a JPEG). If you don't want this output sharpening, just turn off the Print Sharpening check-box. Next, is **JPEG Quality**. Unless file size is a big concern, there's not much reason to not use a quality of 100. If file size is a concern, try 80 as good balance between quality and compression of the file size.

Step Four:

Lastly, you set your **Color Management Profile** (many of the major photo labs prefer sRGB as your profile, but your best bet is to contact the lab and ask them what they prefer). If you want to use a custom color profile (some labs have their own custom color profiles), go back to the last project for info on how to install them. You can also find info there on which rendering Intent to use. Also, if you want to include a print adjustment (making the print brighter to offset the difference in brightness between your bright backlit monitor and the non-backlit print), you can find that back on page 408 in Step 21. Now, just click the Print to File button at the bottom of the right side panels to save a JPEG file of your print layout.

Increasing the Size of Your Image (without Losing Quality)

Making an image smaller in size has never really been a problem—it tosses away any extra pixels it doesn't need, and your image still looks great. However, if you needed to make your image larger in size, it can't create pixels that aren't there, so there has always been a loss of quality when you upsize an image a lot. Well, thanks to some of that amazing AI, machine-learning stuff of Adobe's, you can use the Super Resolution feature to double the physical size of your image and it still looks great. Best of all, Lightroom does all the work for you.

Step One:

This technique works best with RAW photos because while you can also use it on JPEG and TIFF images, the higher quality the original image is, the better the results will be. Here, I'm using it on a JPEG image. To double the physical size of the image, either go under the Photo menu up top and choose **Enhance**, or just Right-click anywhere on the image and choose it from the pop-up menu (as shown here).

Step Two:

This brings up the Enhance Preview dialog (seen here). First, make sure the **Super Resolution checkbox** on the right is turned on, and then take a look at the preview on the left. It gives a zoomed-in-tight preview of your image at a 200% (double the size) view. If you really want to see the effects of the crazy AI machine-learning stuff, click-and-hold on that preview to see a before view of what your image would've looked like at 200% size without using this AI wizardry (you will be amazed!). It also tells you, near the bottom right, how many seconds it estimates it will take to work its magic. Now click the Enhance button and let it "do its thing."

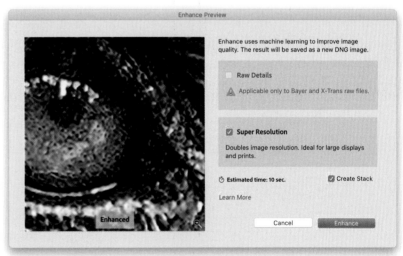

Step Three:

When it's complete, you'll see a new file next to your original (well, it'll be stacked with your original if you left the Create Stack checkbox turned on in the Enhance Preview dialog). You'll know which image is which because the super-resolution upscaled image will have the word **"Enhanced"** added to the end of its name (as seen circled here in red).

Step Four:

That's all there is to it. Like I said, Lightroom does all the work for you. Here's a side-by-side before/after with the original image on the left viewed at 100%, and the image on the right viewed at 200% size, and not only does the enhanced image on the right look as good, it might even look better because of the sharpening it adds during the AI upsizing process. So, when you're ready to make a large print, make sure you use this feature to double the size of your image.

GOING MOBILE
using Lightroom on your phone or tablet

Okay, imagine that you're on vacation, lugging around your camera gear, and you want to be able to see, edit, and share your images while you're still on your trip, but you don't want to lug around a laptop, too. Now imagine that you can do all of this right on your phone or tablet, with the same editing power, the same sliders, the same tools, and the same flexibility you'd have if you were working on your computer. How cool would that be? Imagine being somewhere, like Paris, and you get this killer shot from the backstreets of Montmartre. You stop at a charming outdoor cafe, but you don't want to wait until you get back to your hotel and offload the images from your memory card onto your computer to see it. No, you want to see it, edit it, and even share it, right now. This is all so doable with Lightroom mobile, and after you edit the image, you could share it with your waiter, who you can tell loves it because he says, "Cette photo ressemble à une poubelle. Ce mec n'a pas de talent. Il devrait vendre son appareil photo." Now, I don't speak French, but I can look at those words and probably figure out what he's saying—something like, "This photo resembles a pure miracle. This guy has incredible talent. I would love for him to take a photo of my son." So, you know you hit one out of the park, and you decide to share this photo on the French version of Instagram, where it's a big hit, garnering praise like, "Cette photo donne envie de vomir. C'est la pire chose que j'ai vue toute la journée," which I have to imagine means, "I envy this guy's photo. He should be shooting for an important journal," and this all happened using a simple mobile app. Incredible time we live in, folks. As they say in France, "Je suis un très mauvais photographe!" (Which probably means, "I am a marvelous photographer!")

Setting Up Lightroom on Your Mobile Device

Getting this up and running is actually really easy, and after the initial setup, you're good to go. There are three ways to get images into Lightroom mobile: (1) you can sync collections from Lightroom Classic on your computer; (2) you can import photos already on your mobile device (like from your camera roll); or, (3) you can use Lightroom's built-in camera to take photos, which of course, go straight into Lightroom mobile.

Step One:

We'll start in regular ol' Lightroom Classic on your computer. At the far right of the taskbar at the top of the window, you'll see a cloud icon. Click on that icon and the Cloud Storage pop-up menu appears, where you'll click the **Start Syncing button** (as shown here). It will prompt you to enter your Adobe ID and password, so have those handy. Okay, that's all we have to do in Classic for now. Simple enough. By the way, later, if you want to see the status of the images you're syncing, go back to the Cloud Storage pop-up menu, and under **Local Activity**, you'll see how many photos are left to sync (as seen here, at the bottom, where there are 10 photos still syncing). When they're done, you'll see a green checkmark followed by "Synced."

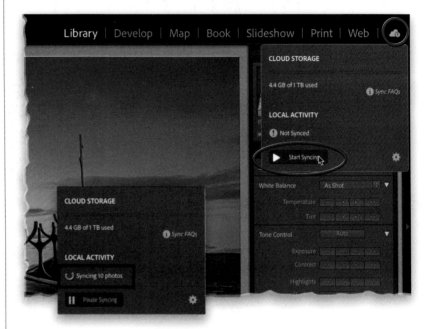

Step Two:

If you have an iPhone, go to Apple's App Store, or if you have an Android device, go to the Google Play app, and download the free Lightroom app. Once you download it, launch the app, and then tap the **Continue with Adobe button** and sign in with your Adobe ID and password (signing in like this is how it knows Lightroom Classic on your computer and Lightroom on your mobile device are linked to each other). Once you log in, at this point, you won't see any photos in Lightroom mobile because you haven't chosen any collections from Lightroom Classic to sync over to your mobile device yet (that's next). For now, let's just get the app and log in, so it's up and running.

Getting images from Lightroom Classic over to Lightroom mobile is super easy: You simply tell Lightroom Classic which collections you want to have on your mobile device and it does the rest. However, note that I said "collections"—it will not sync folders. So, if you don't have any collections created yet, go to the Folders panel, Right-click on the folder you want to make a collection from, and from the pop-up menu that appears, choose Create Collection. Okay, you're ready to mobilize (see what I did there?).

How to Get Images from Lightroom Classic onto Your Phone

Step One:

Once you turn syncing on in Lightroom Classic on your computer, you'll see a little checkbox appear to the left of each collection's name (as seen here, circled in red). That's the checkbox you'll turn on to sync that collection over to Lightroom mobile. So, just click on that tiny check-box, and a little **sync icon** will appear (its icon kinda looks like a sideways "Z." You can see a few of them here beside the collections I chose to sync to mobile). That's the whole process—turn on the checkbox beside any collection you want over on mobile, and that's it. Couldn't be easier. *Note:* Again, Lightroom mobile only works with collections, so if you've only been working with folders, follow the instructions up in the introduction above.

Step Two:

Now, head over to the Lightroom app on your mobile device (it'll sync to all your devices, so if you have, say an iPhone and an iPad, it automatically syncs to both), and you'll see that the collection you chose to sync now appears under **Albums** in Library view (as seen here). If you don't see it, tap on the **Library icon** (it looks like a little stack of books and is circled here at the top left). That's really all there is to it. If you decide you don't want a particular collection synced to Light-room mobile any longer, just go back to Lightroom Classic and click on the sync icon to the left of your collection's name to turn it off, and it no longer syncs. *Note:* Collections are called "Albums" in Light-room mobile, so from here on out, that's what we're callin' 'em, too—albums.

Four Quick Things You'll Want to Know Next

These are some of those interface things that people get stuck on, and then they get frustrated, and then they email me, or call me on my cell really late at night, and ask me this stuff, and all I can do is reply, "Who is this, and how did you get this number?" So, to avoid those uncomfortable situations, here are four things you'll probably want to know now to save yourself from pulling out your hair (or reaching for your cell phone) later.

#1: Show or Hide the Filmstrip

If you're on an iPad or an Android tablet, there is a Filmstrip you can bring up along the bottom of your screen in the Lightroom app that is similar to the one in Lightroom Classic (it's not available in the phone version of the app, because it would be so tiny only ants would be able to use it). To make the Filmstrip visible, once you're in Edit mode, tap on the little icon that looks like a rectangle with little baby rectangles below it (seen circled here, in the bottom right) and it appears. To hide the Filmstrip, tap that same icon.

#2: Get a Full-Screen Preview

This one throws a lot of people because it's not really obvious and it's kind of different from what we're used to doing in Classic. You have a bunch of thumbnails in the Library, and to see one larger, you'd tap on it, but it doesn't just make it larger, it takes you into Edit mode. So, while the image is bigger, it's not really as big as you'd probably like it to be. To get it into full-screen mode (where it's just your photo and no interface stuff or icons), you'd tap it a second time and it hides the interface, making your image full screen, and you can then swipe to see more images. To return to Edit mode, just tap on the image once. Now, if you've got a wide image and you're holding your device tall, tapping once might not make the image larger—it'll just hide the interface. To see your wide image as large as possible, you'll need to turn your phone sideways.

#3: Getting Back to the "Home" Screen

In Lightroom Classic, pressing the G key gets you back to Grid view in the Library module, which is kind of your "home" starting place. Library view is your "home" in Lightroom mobile, but of course, there's no keyboard shortcut to get back there. Instead, you'd tap on the left-facing arrow up in the top-left corner of the screen (it's kind of like the back button in your web browser and is circled here on the left) until you either (a) see the word "Library" up there (as seen on the right), or until you see the Library icon (it looks like a little stack of books). That lets you know you're "home" and back to the screen where you organize your images.

#4: Some of the Same Stuff Has Different Names

Lightroom Classic came first, and then many years later, Adobe added Lightroom mobile, and they changed some of the names of things in the mobile version to help people who were new to the platform better understand what they did. Two of them I totally agree with; the other two, I...I still don't get why they changed the names of those because they seem nerdier and less helpful to new users. But, as they say, "It is what it is." Here are the four main differences: Like I've mentioned, in mobile, collections are called "albums" (like a photo album. Makes sense). And, instead of collection sets, you put multiple "albums" in a "folder." That makes sense, too. The other two, well...in mobile, they call the Lens Corrections panel the "Optics" panel. Oy. And, the Transform panel is called the "Geometry" panel. Well, you know another thing they say: "If you want to make something more fun and less intimidating, bring math into it" (wink). But, that's what they're called, and now ya know. Having two programs designed to work together, but having certain parts—that do the exact same thing—have different names is really a lot of fun (read as: not).

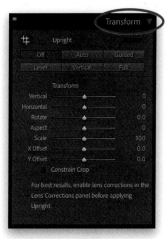

Lightroom Classic

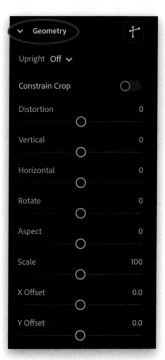

Lightroom mobile

Organizing Your Images in Mobile

Here's how to get around Library view in Lightroom mobile, where it offers the standard Grid view, and a nice variation of it that I wish Adobe would add to Lightroom Classic. Remember, this is the same stuff you're used to doing in Classic, with a slightly different interface, and that whole "they call collections 'albums' and collection sets 'folders'" thing, but outside of that, you're just learning how to do the same things here in mobile that we do in Classic's Library module.

Seeing Your Albums:

When you launch Lightroom mobile on your device, you'll be in Library view. In this view, small thumbnails for all your collections (again, they're called "albums" here) appear in a tall vertical column. If you don't see that vertical column, tap on Library (or its icon; it looks like a little stack of books) in the top-left corner of the screen. To see the images inside any album (collection), just tap on an album thumbnail and it shows you the images in the standard Grid view (as seen here, where I tapped on the Anna Yellow album).

TIP: Automatically Add Photos

You can automatically add photos you take with your phone's or tablet's camera to a particular album by tapping on the three dots to the right of an album's name, and then tapping the toggle switch for **Auto Add from Camera Roll**.

Resizing Thumbnails and Closing the Left Side Panels:

To close the left side panels (if you're holding your device sideways), so you can just focus on your thumbnails, tap on the Library icon in the top left, which gives you the view you see here. To change the size of the thumbnails, pinch out/in to zoom in/out. I will tell you that this "pinch-to-zoom to resize thumbnails" is a bit finicky, so you might have to try it a couple of times before they actually change size. If that seems too hit or miss, try tapping on the three dots in the top right of the screen, then tapping on **View Options**, and from the bottom of that pop-up menu, you can choose small, normal, or large thumbnails.

Separating By Date or Time:

There are actually two different Grid views on mobile: a standard flat view (seen in the previous image), and a segmented view (seen here), which separates your photos by date or time. To enter segmented view, tap on the three dots in the top right, and then in the pop-up menu, tap **Segmentation**. You can then set it to segment your photos by year, month (as shown here), day, or the hour the images were taken to give you the date-based layout you see here (tap the three dots again to hide the menu). To return to the flat view, go back to the Segmentation pop-up menu, and tap on None.

Creating Folders:

Lightroom mobile can't sync collection sets from Lightroom Classic, but you can create a collection set from scratch on mobile and add albums to it (but, again, on mobile, they're called "folders," instead of collection sets, but they do the same thing as they do in Classic). To create a folder, in Library view, tap on the + (plus sign) icon (seen circled here in red) on the right side of the Albums panel's header. When the Create New pop-up menu appears, tap on **Folder**. This brings up the Create Folder dialog, where you can name your new folder (collection set). Name it (I named mine "Portraits"), tap OK, and you will then see this new folder appear at the top of the Albums panel.

Adding Albums to a Folder:

Okay, so now you have an empty folder. How do you get albums inside that folder? Find the album you want to move inside that new Portraits folder (or whatever you named yours) and tap on the three dots to the right of the album's name. In the pop-up menu that appears, tap **Move To** to bring up the **Destination screen** (seen in the inset here). Tap on the Portraits folder, and it takes you to another screen (in case there were other folders inside that main Portraits folder). Once you get to that second screen, tap on Move, in the top right (it's grayed out until you get to that second screen). So, what if you have a collection set in Lightroom Classic that you want in Lightroom mobile? It's just one extra step: Go to your collection set in Classic and sync each of the collections inside it over to mobile. Then, in mobile, create a new folder with the same name as your collection set. Now you can move those synced collections (well…albums) into that new folder. It does take an extra step, but it does work.

Adding Photos to an Album:

If you want to add photos to an album, with the album open, tap on the **Add Photos icon**, on the left side of blue pill-shaped button (seen circled here), in the bottom right of the screen. If, instead, you want to take a photo with your device's camera and have it go straight into this album, tap on the little camera icon on the right side. Anyway, from the pop-up menu that appears, choose where the photos are coming from that you want to add to this album: from All Photos (all the photos you've synced), from your device's Camera Roll, or from a cloud storage service like iCloud or Google Photos (From Files). Tap on one of those options (I chose From All Photos here), then from the resulting screen with the blue bar across the top, tap on the photos that you want to add to this album (as seen here, in the inset), and then tap the blue **Add button** in the bottom right. That's it!

Showing Info Overlays:

There's a bunch of information you can have displayed over your thumbnails: just tap with two fingers on the screen and each time you tap, it will cycle through various info you can display. For example, by default, you see a small badge with the file type (RAW, JPEG, etc.) in the top right of the thumbnail. Tap with two fingers, and it will display any flags or star ratings you assigned to the photos in this album. Two-finger tap again, and it displays the capture date and time, pixel dimensions, and filename of each image. Two-finger tap again, and it displays the f-stop, ISO, and shutter speed for each image (as seen here). Two-finger tap again, and it shows any "likes" or comments for these images (more on this part later), and another two-finger tap hides the data and just shows you the thumbnails again (that's the view I stick with—I just want photos, not a bunch of data clutter, but hey, that's just me).

Deleting/Copying/Moving an Image:

Just a few more organizational things before we wrap this part up: If you want to delete an image, do a "long-press" (tap-and-*hold* on the image) to select it, which opens the screen seen here, with the blue bar across the top. To delete the image, tap **Remove** (the trash can) at the bottom of the screen. To delete other images, just tap on them to select them (you don't have to long-press once you're in this screen with the blue bar), then tap Remove. When you're done deleting images, tap Done in the top right. This is also the same screen you'll use if you want to copy an image (or images) from one album to another. You'd tap on the image to select it, then tap on **Add To** to leave it here in the open album and place a copy in a different album (or albums). If you tap on **Move To** instead, it moves the selected image(s) out of this album and into the album(s) you choose.

How to Reorder Your Thumbnails

In Lightroom Classic, once our images are in a collection, putting the thumbnails in the exact order we want them is a simple drag-and-drop. It's drag-and-drop in Lightroom mobile, too, but getting to the screen where you can actually do this takes a bit of digging. Not sure why they made this so hard to find, but on some level, I'm glad they did because if they made it easy to find (or if it just worked as simply as Classic's does), then this page would be blank, so…there's that.

Step One:

First, it's helpful to know that if you move your thumbnails around in a collection in Lightroom Classic, they move to the same order in your album in Lightroom mobile (they're synced together after all). If they're not in the same order, tap the three dots in the top right of the album screen, and in the pop-up menu that appears, tap **Sort By**, and then tap **Custom**. That should do the trick. Changing your thumbnail order here in mobile is a bit more involved. It starts the same— tap the three dots in the top-right corner, tap Sort By, and then tap Custom—but then you have to tap **Edit** to the right of Custom to bring up the Reorder Photos screen (seen in Step Two).

Step Two:

Once you're in the **Reorder Photos screen** (seen here), to change the order of a thumbnail image, long-press (press-and-hold) on that image until a smaller, mini-thumbnail appears floating above your selected thumbnail. Okay, you're now ready to drag-and-drop this mini-thumbnail to a new location (as shown here, where I dragged the mini-thumbnail from the third image in the third row up to the second spot in the top row). A blue vertical line will appear, showing you where that thumbnail is going to land when you lift your finger. That's the process: tap-and-hold until the mini-thumbnail appears, then drag it where you want it, and lift your finger. When you're done reordering, tap Done in the top-right corner.

Part of the fun in all of this is trying and creating new ideas and being able to experiment, without risking damage to your image. To that end, there are a surprising number of ways to undo whatever it is you're doing to your image in Lightroom mobile. Here's a quick look at your options when things start to not go your way editing-wise:

How to Undo a Little or a Lot

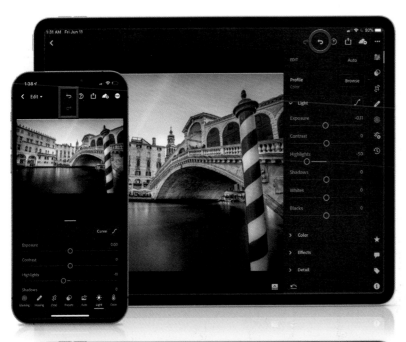

Simple Undos:
If you want to undo the last thing you just did to your image, tap the **Undo icon** (the left-facing curved arrow, seen circled here in red) near the top right of the screen. To redo that step you just undid, tap the Redo icon (the right-facing curved arrow). On a phone, there aren't two arrows side by side like there are on a tablet, but if you tap-and-hold on the Undo icon, the Redo icon will pop down below it (as seen here, in the inset). Easy enough.

Picking How Much to Undo:
But, what if you reach a point where you're like, "Okay, I need to start over from scratch"? In that case, head to the bottom of the right side panels (on a tablet or a phone, when you're holding it wide) where you'll see the **Reset icon** (the downward-facing curved arrow with a line beneath it; seen circled here). On a phone, if you're holding it tall, swipe left to the very end of the edit icons at the bottom of the screen to find it (it's also circled here, in the inset). When you tap on that Reset icon, the **Reset pop-up menu** appears (seen here), where you can choose how much you want to reset. Tap Adjustments for just the adjustments you've made in Lightroom; tap All to revert to the original image; tap To Import to undo what you did here in mobile, but not the stuff you did to the image in Lightroom Classic on your computer; and tap To Open to reset your image to when you last opened it. That's a lot of options when it comes to undo, right?

Adding Pick Flags and Ratings to Photos

Adding Pick flags and star ratings is definitely more fun here in Lightroom mobile than it is in Lightroom Classic. Plus, it's nice to just sit back after a shoot, get comfy on the couch, pour yourself a nice pinot grigio (er, I mean Propel Fitness Water, ummm…yeah, that's what I meant), and just swipe through your images, tagging your favorites as you go.

Step One:
You add Pick flags and star ratings in the **Rate & Review panel**. To get there, you start by tapping once on a photo to enter Loupe view (seen here), then:

iPad/Android Tablet: Tap the **star icon** (circled here in red) near the bottom right of the screen.

iPhone/Android Phone: Tap the Panels pop-up menu in the top left (to the right of the back arrow icon), and then tap on **Rate & Review** (seen here, on the phone).

Step Two:
This closes the right side panels and now your image fills the screen. If you tap that star icon again, it reveals a row of stars and flags at the bottom of the screen that you can tap to add a star rating or Pick or Reject flag, but there's actually a faster, more fun way: it's called "**speed rating**." To give an image a star rating, just swipe up/down on the *left* side of the screen and a dark gray overlay will appear in the center of the screen (as seen here), where you can choose which star rating you'd like to apply. Just stop on the star you want. To flag an image as a Pick, just swipe up/down on the *right* side of the screen and an overlay appears in the center, where you can choose which flag (Pick, Unflagged, or Reject) you want (as seen here, in the inset). Now, just swipe to bring up the next image to rate or flag. It's a really quick way to cull through a shoot.

Step Three:
Once you're finished making your ratings and flags, to see just your Picks (or just your star-rated images), tap the back arrow icon (in the top left) to return to Library view, and then tap the **Filter icon** (the little funnel) in the top right (shown circled here) to bring up the **Filter By pop-up menu**. You'll see the three flags, and to their right, the number of images you've flagged. Tap on the Pick flag (the first one—its icon has a checkmark on it), and now it only displays the images you marked as Picks (as seen here). To see only your un-flagged shots, or only your rejected ones, tap those flags. Just above the flags are the star ratings—just tap on the star rating for the images you want to see (hopefully, you're tapping the fifth star because there are so many awesome shots with that rating). Tap anywhere outside the pop-up menu to close it, and then tap the little "X" near the top right of the screen, to turn the filters off to see all your images in that album again.

Step Four:
When you have the filter on, so you're seeing only your Picks or 5-star images, you can put those images into their own separate album. Here's how: Long-press (tap-and-hold) on an image until you see a blue bar across the top of the screen, then tap on the other images you flagged (rated) to select them (you don't have to long-press again, just tap). Once they're all selected, tap Add To at the bottom of the screen, which brings up the Destination screen (seen here) with all of your albums. But, we want a new album for our picks, so tap the + (plus sign) icon in the right side of the Albums panel's header, and then in the Create New pop-up menu, tap **Album**. Name your new album (I named mine "Chicago Picks"), tap OK, and then tap Add in the top right to copy your Picks into this new album. Now, close the filter screen, tap the Library icon in the top left, and it returns you to Albums view, where you'll see your new album.

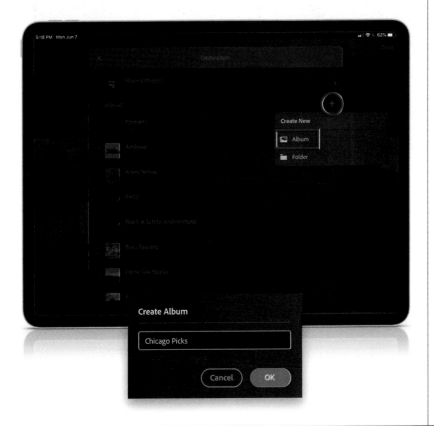

Editing Your Images in Mobile

Good news: you already know this stuff—it's the same sliders that do the same things, using the same math. The interface is slightly different, but if you turn your screen sideways, it looks much more like Lightroom Classic—with your panels and sliders on the right side—than if you use it tall (where, on a phone, it's a more mobile-like interface, with the sliders along the bottom). But, either way, you're already most of the way there, bunky.

Tablet: Edit Mode (Develop Module)

Tap on an image and you immediately enter Edit mode (seen here), with the familiar right side panels. They're actually very close to the same panels that are in Classic, but as you can see here, they've changed the names of a few of them to more closely describe what the sliders in each panel do. So, all the same stuff is here, it's just that some of their names have changed (for example, the Lens Corrections panel is called the "Optics" panel here, in mobile, and the Transform panel is called the "Geometry" panel). They also moved some of the sliders into different panels. It's just enough change to make you a little bit grumpy, but not a full, "Get off of my lawn!" level of grumpy, but still, ya know, grumpy. By the way, whether you're holding the tablet tall or wide, the panels are still on the right side, but you can tap-and-drag your image in the Preview area to reposition it for a better view.

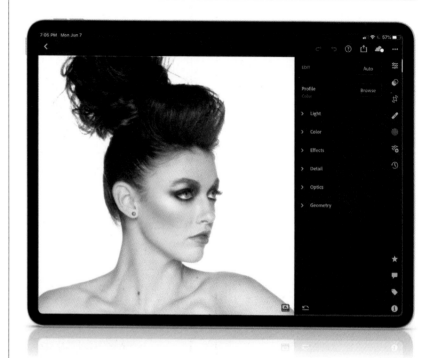

Phone: Edit Mode (Develop Module)

Tap on a photo to enter Edit mode, and if you're holding your phone vertically, a row of edit icons appears across the bottom of the screen. Tap one and its panel pops up from the bottom (as seen here, on the left). If this seems really different and "un-Lightroom-like," I totally agree. Luckily, if you turn your phone sideways, the icons move to the right side, and now when you tap on them, the panels pop out from the right, so it looks and feels more like Lightroom Classic, and the image size is much larger, as well (as seen here, on the right).

RAW and Creative Profiles:

On a tablet, you'll see the word "Profile" near the top left of the Edit panel (I'm going to switch to a different image here for this). Just tap on the Browse button to its right, and the **Profiles Browser** appears (seen here). The RAW Profiles are up top, and the Creative Profiles are below. On a phone, Profiles is the fourth icon from the right down in the edit icons (or the fourth icon from the bottom, if you're holding the phone wide). At the top of the browser, tap on the name of the Profile set (like Adobe Raw), and a pop-up menu appears, where you can choose other sets of Creative Profiles. When you choose a Creative Profile, an Amount slider appears at the bottom center of the screen (as seen on the phone down below), which you can drag for a more, or less, intense effect. The thumbnails give you a preview of your image with each profile applied, but there is no live preview, so you'll need to tap on a profile to see it applied to your image in the Preview area. If you don't like its look, either tap on a different profile, or tap the Undo icon (the left-facing curved arrow) at the top right of the screen.

Applying These Profiles:

Once you're done picking your RAW or Creative Profile (here, I chose a Creative Profile from the Artistic set—notice the Amount slider at the bottom of the phone's screen), on a tablet, just tap the **back arrow icon** (seen circled here), at the top left of the Profile Browser, to apply the profile and close the browser. On a phone, it's a little different: tap the **gray checkmark** (seen circled here, on the phone) in the bottom-right corner to apply your profile and return to Edit mode. Lastly, tap the "X," in the top-right (or bottom-left) corner of the browser at any time to close it without applying a profile.

Exposure and Curves:

Adobe rearranged the sliders in each panel, so they make more sense together. For example, tap on the **Light panel** (on a phone, its icon looks like the sun), and it brings up the sliders that control exposure (the Exposure, Contrast, Highlights, Shadows, Whites, and Blacks sliders). You can just tap-and-drag these sliders like always. At the top right of the Light panel is the **Curve icon** (circled here) and tapping that brings up the curve right over your image as an overlay (as seen here), which is pretty clever (I would love to see this as an option in Classic). To add a point to the curve, just tap once along the diagonal line, and then drag up to brighten, or down to darken, the tones in that area. To remove a point from the curve, double-tap on it. There's a thin grid behind the curve, but it's kind of hard to see over the solid white background in the image we have here. When the curve is active onscreen and you tap on the image, the panels tuck away, so it's just you and your curve (as seen here, on the phone). When you're done with the curve, on a phone, tap on the image, and then tap the Done button. On a tablet, just tap on the downward-facing arrow in the left side of the Light panel's header.

Clipping Warning:

If you want to see if your highlights are blowing out, you can get an onscreen warning, while adjusting the Exposure, Shadows, Highlights, Whites, and Blacks sliders. Just press two fingers anywhere on the slider you're adjusting, and as you drag (you can still drag the slider with two fingers, no problem), the image will turn black and only display any areas that are clipping the highlights. Here, the white background is totally clipping (that's okay though—it's supposed to be solid white), but that red on her face is letting you know that her skin is clipping, but just in the red channel. If it clips in other channels, you'll see them in their colors (blue, green, yellow), and if you see solid white, that's clipping in all three channels (yikes!)

Auto Tone:

On a tablet, the **Auto tone button** is really obvious (as seen here, where it's right at the top of the Edit panel). However, once I applied an Auto correction to this image (you can see what it looks like on the phone here), I couldn't hit the Undo icon fast enough because this is supposed to be a bright, high-key, beauty-style image, and the Auto tone correction made it way too dark (so that's why you see the "Undo Auto Settings" message on the screen here). On a phone, the Auto icon is the fifth icon down (or the fifth icon from the left, depending on which way you're holding your phone, tall or wide; its icon looks like a photo with magic little sparkles in the top-right corner) in the edit icons. Just one tap on Auto and either your image looks good, or you'll tap the Undo icon, like I did.

White Balance:

To change your white balance, tap on the **Color panel** (its icon looks like a thermometer on a phone) and the Temp, Tint, Vibrance, and Saturation sliders appear. At the top of this panel is a pop-up menu of White Balance presets (it's a longer list if you shot in RAW; quite short if you shot in JPEG). The **White Balance Selector tool** that you know and love (see page 136) is also here (its the eyedropper icon to the right of the WB pop-up menu)—tap on it and it brings up a loupe that you can drag over your image (as shown here, where I've made a pretty poor white balance choice). The preview is live, so as you move the loupe over your image, you'll see how it affects the color as you drag-and-release. When you find an area where the white balance looks good, tap the checkmark on the loupe and it returns to base. To cancel the white balance adjustment, just tap the eyedropper icon again.

Converting to Black and White:

While we're still in the Color panel, you'll see that there's a **B&W button** here to convert your image to black and white, but I avoid this button because it creates a very flat black-and-white. Instead, I use the B&W profiles in the Profile Browser (seen back on page 429) because there are lots of B&W options to choose from for a much better conversion (I chose the B&W 09 Creative Profile here). Also, at the bottom of the Color panel (at the top on a phone) is the **Color Mix button**, which brings up the HSL sliders, along with the Targeted Adjustment Tool. It works the same way here in mobile that it does in Classic: tap on the TAT to activate it, then tap-and-drag up/down over the area of color in your image you want to adjust. Below Color Mix is the **Color Grading button**, and it works the same as it does in Classic, as well. But, what's nice is as soon as you start tapping-and-dragging on a color wheel, the panel disappears and the color wheel overlays right on your image.

Apply Effects and Sharpening:

I'm going to tap that B&W button to return the image to color here. It's interesting to note that, even if you applied a B&W Creative Profile, you can still tap the B&W button to return the image to color (it works just like the Undo icon does after applying a B&W Creative Profile). Next, let's head to the **Effects panel** (on a phone, its icon is a square with a circle cut out in the center), which has the Texture, Clarity, Dehaze, and Vignette sliders, along with Grain (film grain noise), and again, they all work the same way here that they do in Lightroom Classic. Below the Effects panel is the **Detail panel** (on a phone, its icon is a white triangle), and you'll find the same Sharpening and Noise Reduction sliders here that, again, work the same way and do the same things that they do in Classic. Nothing much else to see here, folks. Let's move along.

Applying Presets:

Presets are here too, and tapping the Presets icon (the two overlapping circles seen circled here) brings up the **Presets Browser** with thumbnails of how a preset would look if you chose it. They work just like they do in Classic—simply tap a preset and if it looks good to you, tap the Done button (on a phone, tap the checkmark icon). In Lightroom mobile, there are three types of presets at the top of the Presets Browser (seen here, in the inset): (1) Recommended presets are AI suggestions for what might look good for your selected image. (2) Premium presets were created by pro photographers who Adobe hired to create them for you (well, for people who subscribe to Creative Cloud, like you). And, (3) Yours are the presets that come with Lightroom, along with any that you've created, which appear under User Presets. Of course, like in Classic, once you apply a preset, you can still make adjustments with the sliders (Exposure, Contrast, etc.). Here, I applied the **Flat & Green preset**, found under Yours, within the Creative set, which isn't exactly awesome, but some of the others were so subtle that I just went with this one, despite the fact that it's a tad not awesome.

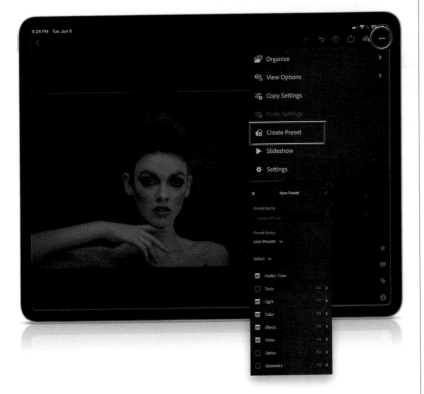

Saving Presets:

Now, you'd think that to save a preset you'd use the Presets panel, right? Nope. Too obvious. Instead, you tap on the three dots (seen circled here) up in the top-right corner of the screen, and from the pop-up menu that appears, tap on **Create Preset**, and the **New Preset window** appears. At the top, name your preset, and if you want to create a new group within your User Presets, tap on User Presets, and then tap on Create New Preset Group. Below that, you choose which edits you do, or don't, want included in your new preset (if you tap on the right-facing arrow to the right of any one of those adjustments, you'll see checkboxes for the individual settings).

Lens Corrections:

If you have an image with lens problems (like this one here does), you can apply a lens correction profile by tapping on the **Optics panel** (on a phone, it's the lens icon, seen circled here in the middle), and then turning on **Enable Lens Corrections** (also seen here, in the middle). It will choose a built-in lens profile for your particular make and model of lens (if one is available, of course). If it doesn't find one (as seen here, where it didn't fix the problem), well…you're out of luck because it doesn't have the pop-up menus and options to tell it which lens brand you used or which lens profile to choose here, like in Classic. It either finds one or it doesn't, in which case, you'll have to go to the **Geometry panel** (seen here, at the bottom; its icon on a phone is the grid right below the lens icon) and use something like **Guided Edit**, which it does have and which does work the same way as it does in Classic. But, of course, you'll use your fingers to tap-and-drag out the guides, instead of a mouse (or trackpad or pen).

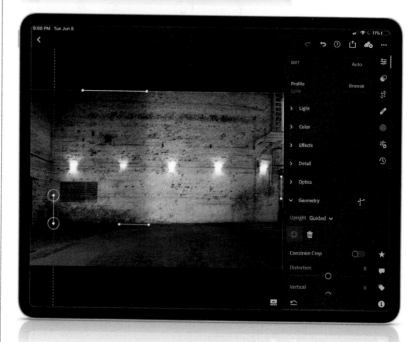

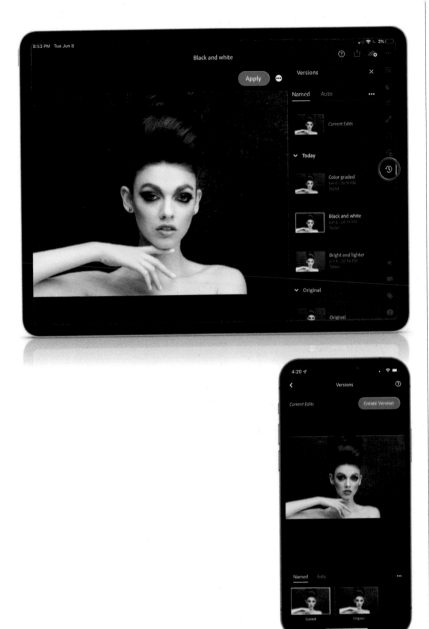

Using Versions:

The **Versions panel** is kind of similar to Lightroom Classic's Snapshots panel (see page 262 for more on snapshots), and in the toolbar on the right, its icon looks like a stop watch (it's circled here). Just as a refresher: If you get to a point where you like what you see onscreen, but want to keep experimenting, you can "freeze" that moment in time as a version (snapshot) of your photo. You can then continue editing and experimenting, knowing that you can use this feature to easily get back to a version of your image when you liked how it looked. So, to save any edits you've made as a version, tap the Versions icon, then tap the **Create Version button** (it'll appear at the top of the Preview area, as seen in the phone below). To switch to a saved version, just tap on its thumbnail in the Versions panel, and then tap the **Apply button** (seen here at the top).

Masking in Mobile

All the same masking miracles you can perform in Lightroom Classic (see Chapter 7), you can perform in Lightroom mobile—it's just learning where the features are located and how to use them in this smaller interface. But, I have to hand it to Adobe, because they came up with some very clever ways to pull this off. So much so that you'll probably enjoy masking on a mobile device more than you do on a desktop. It brings a much more organic feeling to the masking experience, and I bet you'll find it a lot more fun, too.

Creating Masks:

(1) The **Masking icon** (the circle with the white dotted lines around it) is in the edit icons at the bottom of the screen (on a phone, if you're holding it tall), or is in the toolbox on the right (if you're holding your phone or tablet wide). When you tap that icon, (2) a blue circle with a + (plus sign) appears, floating near the bottom right of the screen (as seen here on the right). That's the **Create New Mask icon**, and when you tap it, a pop-up menu appears, similar to the one in Classic, with the different tools you can use to mask your image. Just tap on a tool, like Select Subject, and it selects your subject (and you'll see the masked area appear in a red-tinted overlay like usual).

Editing Your Masked Area:

Once your mask is in place, to make an adjustment, instead of a long scrolling panel of sliders, like we have in Classic, here in mobile, those sliders are divided among five icons along the bottom (if you're holding your phone tall), or along the right side of the screen (as seen here, where the phone is wide). These are the same sliders as the ones in Classic; they're just grouped under different panels to make it easier to work with them on a mobile device. For example, to get to the Exposure, Contrast, Highlights, Shadows, Whites, and Blacks sliders, tap on **Light** (the sun icon) and those sliders pop out (seen here). To get to the Temp and Tint sliders, tap on Color (the thermometer). For Texture, Clarity, and Dehaze, tap on Effects (the square with the circle in it). To close any of these panels, tap its icon again.

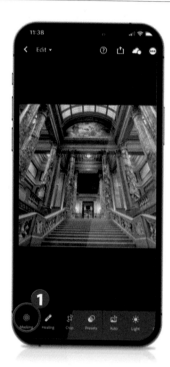
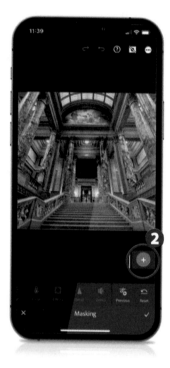
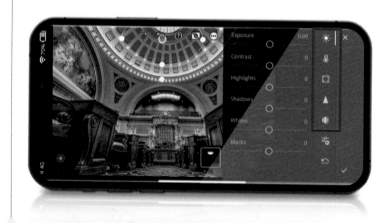

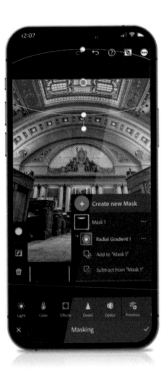

Getting to the Larger Masks Panel

Here on mobile, the **Masks panel**, by default, is collapsed into a thin, floating bar at the lower right of the screen, so you only see tiny thumbnails (not each mask's name). If you want to see the full panel (like the one in Classic), along with each mask's name, you can slide this mini-panel out (like a drawer) by tapping-and-swiping left directly on the thin, vertical white line on the bottom left of it (seen circled here, on the left). To hide the panel altogether, you can swipe that thin, vertical white line to the right until it disappears, leaving only the white line still visible.

Using the Linear and Radial Gradients:

They work the same here, but you use your finger instead of a mouse. You tap-and-drag the **Linear Gradient** up/down or from the sides, and you pinch outward to make a **Radial Gradient** (as seen above). So, you just tap-and-drag out the tool (or paint with it), and then you tap on the adjustment you want to make.

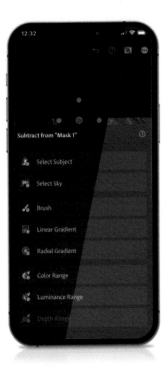

Adding and Subtracting from Your Mask:

Once you have a mask in place, you can add and subtract from it, like always, but you access these choices either by tapping on the tiny **+/– (plus and minus signs) icon** at the bottom of the Masks panel (seen circled here, on the left), or you can tap on any of the tiny mask thumbnails and a pop-up menu appears, where you can choose to add or subtract. Tap on either Add or Subtract to bring up the pop-up menu (seen here, on the right) with the Subtract from "Mask 1" or Add to "Mask 1" tools you can choose from, just like in Classic. Once that menu appears, if you change your mind, just tap once in the empty area above it and it goes away.

Using the Brush Tool:

This is probably the most fun because you get to paint with your finger (like you're doing a finger painting). When you choose the **Brush tool** and begin painting, an Options Bar appears on the left (seen circled here). Tap the second icon down to get the Erase brush to erase areas from your mask; tap the third icon down (with the number in it) to change the brush Size (a vertical slider appears for you to choose a new size). The next icon down is the Feather amount, and the icon below that is the Flow amount. Just tap-and-drag up/down on either of those icons to change their amounts.

Using the Range Mask Tools:

These are cleverly done here in mobile. First, tap the Create New Mask icon, and then tap **Color Range**. A large ring appears onscreen that you'll tap-and-drag the center of over the color you want to mask (as I did here, on the left; the center ring indicates which color you are masking). Once the area is selected, increase the Refine slider to include more colors as it masks, or decrease it to have it use fewer (as seen here). When the mask looks good, tap the Apply button to start adjusting those masked areas. **Luminance Range** works similarly, with a ring you tap-and-drag over bright or dark areas you want it to mask (like I did here, on the right with the shadow areas). Refine the mask using the sliders above the ramp, and control the falloff using the white tabs on either side of the white rectangle on the ramp. Also, for both range masks, you can change to manual mode and bypass the ring method by tapping the dotted square icon to the right of Mode.

Inverting Masks:

If you have a mask in place—say Select Subject, but you want the background masked, not the subject—you can invert the mask by tapping the **Invert icon** (the square with a circle inside) in the Options Bar on the left, and it inverts your mask.

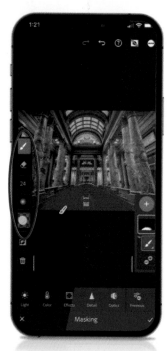

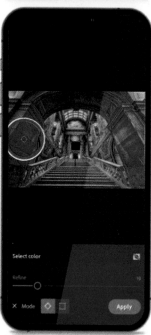

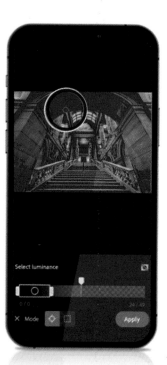

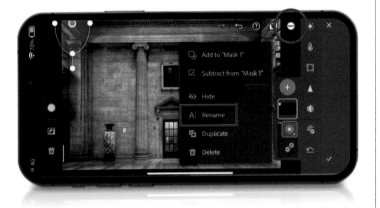

Renaming Your Masks and Working with Overlays:

You can rename a mask by tapping-and-holding on a thumbnail in the Masks panel, and then tapping **Rename** in the pop-up menu. To see the names of your masks, again, tap-and-drag out the side of the Masks panel, so it's full size (see page 437). There are also a bunch of overlay options you can access by tapping the three dots in the white circle (circled here) up at the top, and a **Mask Overlay pop-up menu** will appear, where you can change the color of your tinted overlay, turn overlays on/off, and so on.

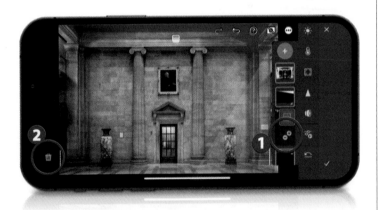

Deleting Masks:

At the bottom of the Options Bar on the left side of the screen is a **trash can icon**. To delete a mask, (1) tap on the mask in the Masks panel on the right, then (2) tap the trash can icon on the left.

How to Undo and What to Do When You're Done:

If you decide, at some point, you want to undo the masking you've done thus far, tap on the Reset icon (the downward-facing arrow with a line below it) at the bottom of the toolbox (or at the end of the edit icons), and it brings up the **Reset pop-up menu** you see here, and the very top choice is to reset Masking. Tap that, and now you're starting from scratch with your masking, but you're still in Masking mode. If, instead, you want to cancel any masking you've done and leave Masking mode, then tap the "X" at the top right (if you're holding your phone wide) or at the bottom left (if you're holding it tall). If you want to keep your masking edits in place and move on to other edits, tap the check-mark at the bottom right to apply those masking edits and leave Mask mode.

Cropping & Rotating

If there's one thing that really translated well in Lightroom mobile, it's cropping and I gotta tell you, I might like it better here, than in Lightroom Classic. It really feels quick and intuitive, and you can pretty much do all of the same cropping stuff you can do on your computer, but somehow, it just seems smoother and easier here.

Step One:

If you need to crop your image, just tap on the **Crop icon** in the toolbox on the right (or in the edit icons at the bottom, on a phone), It puts a cropping border around your entire image (as seen here), and the Crop & Rotate panel pops out (on a phone, a row of option icons appears along the bottom, or along the side, depending on if you have your phone tall or wide). Here, you'll find all the different cropping options you're used to seeing in Lightroom Classic.

TIP: Flipping the Crop to Tall

By default, a crop is applied wide (landscape), but if you want to flip it to tall (portrait), but with the same aspect ratio, tap the icon right below Aspect, at the top of the panel (on a phone, this icon is up in the top-left corner), and it flips to a tall crop.

Step Two:

To apply any of the preset cropping ratios (1x1, 4x3, 16x9, and so on), just tap on the **Aspect pop-up menu** (or the icon with the stacked rectangles, on a phone), then tap on any preset and your image is cropped to that ratio. Here, I tapped on **16x9** and the cropping border updated to the new ratio. The areas that will be cropped away are still visible, but they're shown in dark gray (you can see here a horizontal strip would be cropped off along the top and bottom if I were to go with this cropping ratio). Now that you've applied a crop, you can reposition your image within that cropping border by just tapping-and-dragging the image right where you want it.

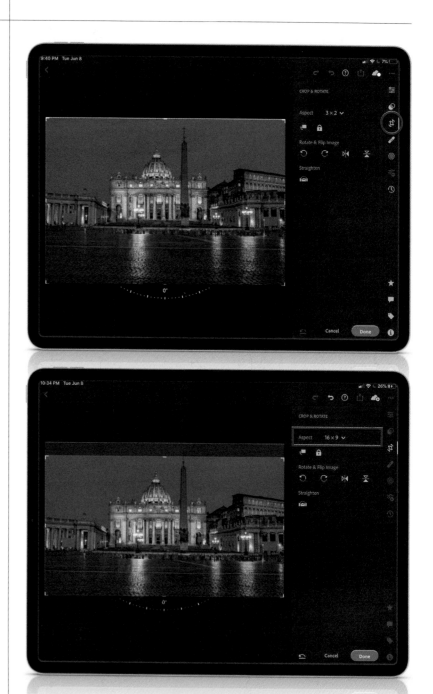

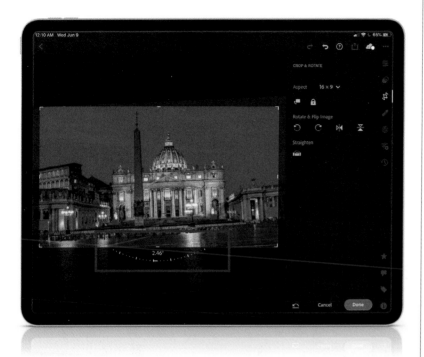

Step Three:
You'll see a **half-circle** sticking out from the bottom of the rotation thingy (technical name). To rotate your image, just tap-and-drag left/right on that half-circle, and it rotates your image (so you're rotating the image, not the border), and it shows you the percentage of rotation at the bottom of the circle. If you need to straighten your image, the Straighten tool is here in this panel, as well—just tap-and-drag it out over something that's supposed to be straight. When you're done with cropping or straightening, tap the Done button (the checkmark, on a phone).

TIP: Changing the Crop Overlay
When you choose the Crop tool, you can have it temporarily display a Rule of Thirds overlay grid by just two-finger tapping within the cropping border.

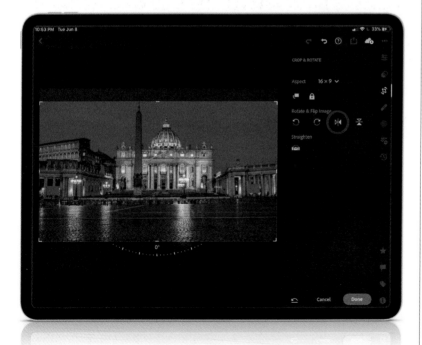

Step Four:
Besides the cropping ratio presets, there's the familiar Lock icon in this panel for locking or unlocking your aspect ratio for a freeform crop. In the **Rotate & Flip Image section**, if you tap the icon with the two arrows facing each other (seen circled here), it flips your image horizontally (if I did that here though, in an image that has text like this one does on the front of the building, it wouldn't work all that well, but since this is written in Latin, only a small percentage of people would even realize that. That's a joke by the way, in case you're playing along at home). Anyway, tapping the icon to the right, with the two vertical triangles, will flip your image upside down.

TIP: Resetting the Crop
To return to the original uncropped image, just tap the **Cancel button** in the bottom-right corner (on a phone, tap the "X," in the top-right corner).

Sharing Your Lightroom Albums Online

If you want to share images in a particular collection that you've synced (maybe with a client, or family, friends, stalkers, etc.), it's super-easy because those images are available on a private website made just for you, and hosted by Adobe (as part of your subscription). You can use this for client proofing or for sharing images online with just a click. This is called "Lightroom Web," and it's really well-designed and full of really handy features.

Step One:

What's nice about this is your client (or friends, family, etc.) doesn't have to have Lightroom—all they need is a regular old web browser to see the collections you choose to share. To see the collections you've synced online, Right-click on one in the Collections panel in Classic, and from the pop-up menu that appears, under Lightroom Links, choose **View on Web** (as shown here). Another way to see them is to just go to lightroom.adobe .com from your web browser, where it'll ask for your username and password, and then you're "in." Either way will get you to the page hosting your synced collections. Reminder: This page is private, so only you can see these collections here, unless you choose to share them. That's why you have to log in to get to this page.

Step Two:

When the page loads in your browser, you'll be looking at a web version of your Library view, with the synced albums (collections) in the left side panels, and when you click on one (like I did here), your image thumbnails will show up on the right, just like in Lightroom mobile. So, what's the advantage of having them here? Sharing! It makes sharing your Lightroom albums really easy. For example, let's say you shot a high school football game, and you wanted to share the images with the other players' parents. You could share just that collection by emailing or texting the parents, or you could share it publicly by posting the link on Facebook or Twitter.

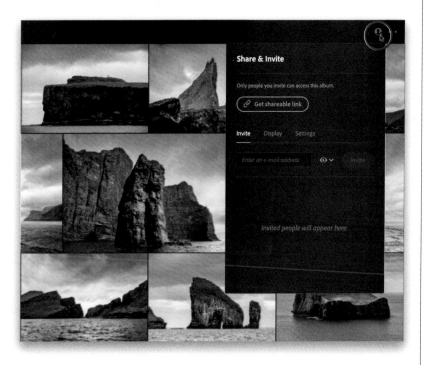

Step Three:
Now, to share an album, click on it, and then click the **Share & Invite icon** (shown circled here; its icon looks like a person with a + [plus sign] in the bottom-right corner) in the top-right corner of the webpage. This brings up the Share & Invite window (seen here), where you can invite people via email to view this album. We'll talk about sharing a link in a few moments—for now, we're sticking with just people we invite.

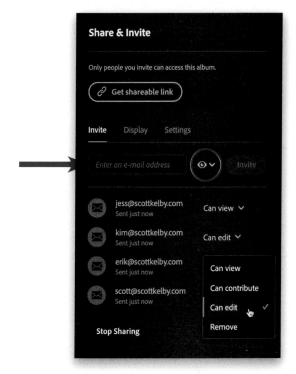

Step Four:
To invite someone to view this album, just type their email address in the email field (to invite multiple people, put a comma between each email address). The **eye icon** to the right of the email field (seen circled here) is a pop-up menu, which lets you assign access privileges to the people you are inviting. For example, if you choose Can View, it means the people you are inviting can only see the images—they can't edit them or add their photos to this album. If you want them to be able to edit the images (maybe you're sharing this album with other photographers in your photo group), then you'd choose Can Edit from that pop-up menu. If you're okay with them uploading their images to your album, then choose Can Contribute (perfect for family reunions, or weddings, or sporting events, etc.). You can also give individuals you've already invited more, or less, access using the pop-up menus to the right of their email addresses (as shown here, where I gave Erik the ability to edit images in this album). You can also cut people off from seeing this album altogether by choosing Remove from that pop-up menu.

Step Five:

Not only do you have control over who sees, edits, or contributes their images to the album, but you can choose how much image info they see (including GPS info), whether they can add comments or add likes to an image, or if you want them to be able to download JPEGs of the images (though, as noted right there within the window itself, if you give someone editing privileges, they'll be able to do all this stuff, even if you turned off any, or all, of these options for the album. Good to know). You choose these options by clicking on the **Settings tab** (shown circled here in red). And, at the bottom of this tab is the all-important Stop Sharing button, in case you decide you want this album to be private once again.

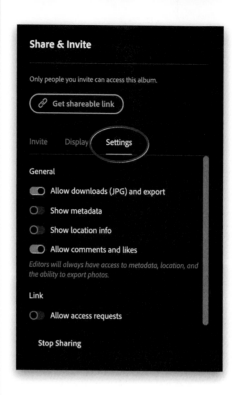

Step Six:

So far, all our sharing has been a private, "view by email invite only" kind of affair, but if you'd like to share a link to this page (maybe you just want to text it to somebody), click the **Get Sharable Link button** near the top of the window (seen in the previous step), and it displays the direct web address to that album online (click the clipboard icon to the right of it to copy that address into memory). But, at this point, it's still private—only someone you send that link to can see that album. So, what if want to share that link with everybody (maybe by posting it on Facebook, or Twitter, or TikTok, etc.)? In that case, right above the web address field, you'll see a **Link Access pop-up menu**. Choose Anyone Can View (as shown here), and now anyone with that link (not just folks you invited) can see this album online. To the right of the web address are three icons: The first one is for embedding the code for this album, so you could embed it on a blog, for example. The others are direct links for sharing your album to Facebook or Twitter.

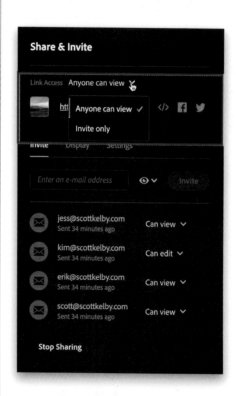

Step Seven:

Now, when someone clicks the link you sent them, they'll see what you see here. They can click on any image to see it larger, and then they can scroll through the images by clicking the left and right arrows that appear at the bottom right of the page (you can see them in the next step). They can also see a full-screen slide show by clicking the Play icon (circled here) in the top-right corner, and a set of slide show controls will appear at the bottom of the page.

Step Eight:

When viewing an individual image, they'll see two icons on the right side of page. If they click the round **Info icon** (the "i"), they can see any image metadata or GPS info you've allowed to be seen. If they click the **Activity icon** (the comment bubble), they will be able to leave comments, but it will tell them that they'll need to sign in to their Adobe account first. Adobe accounts are free, so they could just sign up for one, but what I've done for my clients is to create a generic account (like proofing@KelbyStudios.com), with a simple password (like "client"). That way, they can start liking and commenting without any hassle. Now, once they're logged in, if they see an image they like, they can click the **heart icon** (at the bottom left of the page), or if they want to leave a comment, they can click either Activity icon (there are two on the page). Clicking the Activity icon now brings up the comment field (seen here, at the bottom right), and not only will their comments appear on this page, but you'll see a small yellow badge on the collection's thumbnail back in Lightroom Classic, letting you know someone commented on a photo in that collection. To see the comments in Classic, go to the **Comments panel** (seen here), in the bottom of the Library module's right side panels. You can even respond to them right there in the panel.

Sharing a Live Shoot as It's Happening

I think this is one of the coolest features of Lightroom mobile, and it really impresses clients because the technology here is pretty slick. We're going to set things up so that, during a live shoot, you can hand your client a tablet (or give them a web address, if you don't have a tablet), and not only will they see the images coming in live as you shoot, they can make their own Picks, comments, and even share the link with coworkers or friends, so they can be part of the shoot, and the approval process, too, all live as it happens! This is really that next-level stuff (but it's so easy to do)!

Step One:

We'll start by shooting tethered into Lightroom Classic (see page 18 for more on how to do this). Here's a behind-the-scenes shot from a fashion shoot at the Rialto Theater in Tampa, Florida, where as I shoot the images, they come right into Lightroom Classic on my laptop. Having the client standing beside me as I shoot, looking over my shoulder and evaluating images on my laptop as they come in, is fairly stressful to say the least. I'd prefer the client take a comfortable seat, and I hand them my iPad (or Android tablet), where they can follow along during the shoot. That way, they'll only see the shots I think look good, and not those where the subject's eyes are closed, or the flash didn't fire, or my timing was off. They only see the good ones, and they can mark their favorites and leave me comments, which I can see in Classic, all without them ever leaving their seat (or breathing down my neck). Ahhhh, that's better.

Step Two:

Create a new collection, and when the **Create Collection dialog** appears, give it a name, and then turn on the Set as Target Collection checkbox (very important). Also, turn on the Sync with Lightroom checkbox (also very important). Setting this collection as a target does this: any time I see a photo during the live shoot that I want my client to see on the iPad they're holding, I press the **B key** on my keyboard and it adds that photo to that collection (my target collection), so my client will see just those shots on the iPad.

Step Three:

Now that the tethering is up and running, and the target collection is set up to sync, I launch Lightroom mobile on my iPad (or tablet). I tap on my newly synced album, then tap on the Star icon to enter **Rate & Review mode** (see page 426), and then I hand the iPad to the client or art director (or friend, assistant, guest, etc.) on the set, where they're positioned well behind where I'm shooting from, and we're ready to start shooting. When I see a shot I like that I want the client to see, I simply reach over to my laptop and tap the B key. That image now goes to the target collection on my laptop, which is synced to the same album on the iPad my client is holding, and right there in Lightroom mobile, they see the shot. Here, I left the first two images in this album as an example of shots I generally wouldn't want the client to see—white balance gray card shots, or lighting test shots, stuff like that.

Step Four:

Your client (friend, family member, etc.) can tap on any shot to make it larger (as seen here), and I tell them if they like a shot, to tap the Pick flag at the bottom of the screen to let me know. Now, if you don't have a tablet, you can share the shoot as a collection online, using Lightroom Web (see page 442), and just text them the album's web address. It will work pretty much the same way, but they'll see the images on their phone's web browser, rather than on an iPad (tablet). One difference on their phone is that they will use the heart icon to mark their favorites, instead of a Pick flag. They can also leave comments, if they have (or you give them) an Adobe user ID and password (I mentioned this on page 445). The cool thing about doing it this way is that they can now share that web address with other people (maybe folks back in their office or friends), so they can watch the shoot live, too, right from their web browser no matter where in the world they are. How cool is that?!

Finding Photos in Mobile Is Like Magic

Lightroom uses some pretty incredible AI technology called "Adobe Sensei," which has created a magical unicorn-type of search feature that lets you search by simply describing what you're looking for—like "cars," or "guitars," or "photos with the color blue," or "Nikon Z7," or "ISO 1,600," and so on. While it's not 100% (no AI tech is), it's surprisingly good and getting better all the time—until it gets to the point where it enslaves us to evil robots, and we all wind up in factories building more evil robots. It's inevitable. But, until then, at least we have a really good image search.

Step One:

In Lightroom mobile's Library view, first tap on All Photos, so it searches your entire library of photos (otherwise, it'll only search the current album you're in). Now, tap on the magnifying glass icon (circled here. It's normally up in the top-right corner, but once you tap on it, it jumps down to the Search field) to bring up the Sensei-powered **Search field**. Type in a description of what you're looking for, then tap the Search button, and it will use its lethal AI autonomous killer death robots to visually search for images that contain that subject, or object, or color, with no prior keywording necessary.

Step Two:

I typed "food" in the Search field, tapped the Search button, and instantly, it displayed just the images that matched my query (as seen here, where it brought up images with food in them, even if food wasn't the subject of the image. It even found a wrapped fortune cookie, which is ironic because the fortune itself read, "One day, a photo of this will show up in a Lightroom search"). It did mistake an art brush holder for food, so that was in the results as well, but outside of that one miss, all the rest were images of food. You can see your search term (or terms, since you can enter multiple words, like "food + red") below the Search field, and if you want to cancel the search, or remove a search term, just tap the little "X" to the right of a word (seen here to the right of the word "food").

Step Three:

Here, I searched for "red" to get images that have a lot of the color red. By default, images appear sorted by relevancy, but you have a couple other options. Tap the three dots in the top-right corner of the screen, and in the pop-up menu that appears, tap on Sort by Relevancy to bring up the **Sort By pop-up menu** (seen here) with the other sort options. If you choose to sort by Capture Date, it puts your most-recent images at the top. To reverse the order (and see the oldest shots first), after you tap Capture Date, tap the down-facing arrow to its right. It's the same with Modified Date, which displays images from the most-recently edited ones to the longest amount of time since you edited them. Reverse the order here the same way: tap on Modified Date, and then tap the arrow to its right.

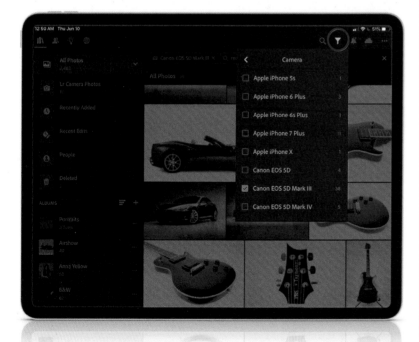

Step Four:

To narrow down these search results even further, tap the Filter icon (it looks like a funnel) in the top right of the screen. In the **Filter By pop-up menu** that appears, you can choose to filter down the results by star rating, Pick Flag, Type (RAW, Panorama, etc.), Camera make and model (as seen here), tagged people, GPS location, by keywords you added manually, or by Edited versus Non Edited images (whew!). Just tap on one of those and another pop-up menu appears showing you how many images there are for those options. Just tap on the one you want to see those images.

Using Lightroom's Built-In Camera

I mentioned at the beginning of this chapter that Lightroom mobile has a pretty killer built-in camera feature, and once you start using it, you won't be able to go back to the regular camera app that comes with your phone. Here's how to unlock all those features that take it over the top:

Getting to the Camera:

If you're in Library view, or if you're in an album, you'll see a blue pill-shaped button in the bottom-right corner of the screen. Tap the **camera icon** (shown circled here in red) on the right side of that button to bring up Lightroom mobile's camera. If you tap on this camera icon when you're in an album, the images you shoot with this camera will appear in that album. Otherwise, they will appear in All Photos at the top of Library view.

TIP: Saving RAW Photos to Your Camera Roll

RAW photos taken with Lightroom's camera go into Lightroom mobile, not into your phone's Camera Roll (or Gallery). To save a RAW image to your Camera Roll, tap the image, then tap the Share icon up top. In the pop-up menu that appears, tap on **Export to Camera Roll**. Easy as that.

Switching to Pro Mode:

When the camera appears, it's in Automatic mode, by default, which works like your phone's camera app (boooo!)—it makes all the exposure decisions for you; you just point and shoot (snore). However, if you want full control over the white balance, ISO, shutter speed, and aperture, individually, like you would on a DSLR or mirrorless camera, tap on Auto and a pop-up menu will appear (seen here) with different choices, including High Dynamic Range (more on this in a moment). For now, just tap **Professional**. Now, if you tap on ISO, shutter speed, etc., a slider appears where you can dial in the exact settings you want.

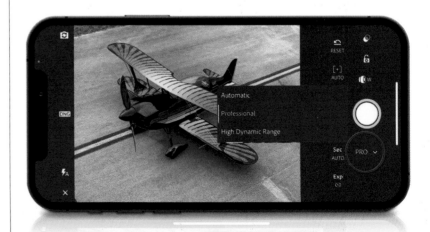

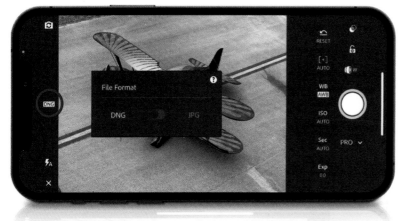

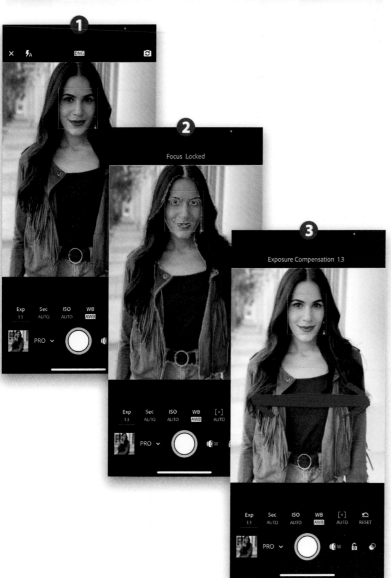

Shooting in RAW:

When you switch to Pro mode, all of the Pro adjustment icons will now appear (as seen here, to the left of the shutter button). Tap on any one of them and, again, a slider will appear (or icons, if you tap WB). Also, by default, your camera will be shooting in Adobe's RAW DNG format, but if your phone's tight on free space, just tap on DNG (seen circled here) on the left side (or top) of the screen and the **File Format options** will appear (seen here). Just tap on the button to toggle over to shoot in JPG, and instead of seeing "DNG," you'll see "JPG," letting you know you're shooting in JPG mode now.

Focusing and Changing Brightness:

When it comes to focusing, Lightroom's camera does a pretty decent job of determining what it is you want to focus on, all on its own. But, if you want to manually focus, then it works pretty much like your phone's built-in camera: (1) Tap on what you want in-focus, and a focus square appears. That's what it's currently focused on. (2) If you want to lock your focus on a particular area (so you can recompose without losing focus), then tap-and-hold for a moment, and you'll see "Focus Locked" appear at the top of the screen (as seen here), and a neon-green outline around what your focus is locked on (also seen here). If you tap the Manual Focus icon (the brackets with the plus sign in the center, to the right of WB), a slider appears that lets you control how much of that area is in focus (you'll see the differences in neon green as you drag). To unlock the focus, just double-tap inside the focus square. (3) To change the brightness of the image you're about to take (its version of Exposure Compensation), tap to set your focus, then drag your finger on the screen to the left to darken the exposure, or to the right to brighten it (as seen here, on the right). It's quick and easy, and it shows you up top (in stops) how much Exposure Compensation has been applied.

Live Presets and Clipping Warnings:

You already know, of course, that you can apply presets to any photo you take in Lightroom (Classic or mobile; see pages 216 or 433 for more on presets), but here in Lightroom's camera, there are presets you can apply before you actually take the photo, so you can see the effect applied before you even press the shutter button. Adobe calls these "shoot through presets" and you get to them by tapping on the **Presets icon** (it looks like two overlapping circles, and is circled here on the left), and a row of live preset thumbnails appears below the image area (as seen here). Just tap on one to apply it before you shoot. I chose the Flat B&W preset here. (*Note:* These are non-destructive looks, so if after you take the shot you change your mind, you can reset the image to its normal look.) Besides these presets, if you tap on the three dots at the top right of the image area, a row of additional options appears. Tapping the **Highlight Clipping icon** (the triangle circled here, on the right) turns on/off this warning. When it's on, clipped highlight areas appear with a moving zebra pattern over them, as seen here (on the right), where the pavement behind the subject is clipping from the direct sun.

Adding a Rule of Thirds Grid:

If you want a rule of thirds grid onscreen, as you compose and shoot (like the iPhone's camera app has, for example), tap on the **Grid & Level icon** (circled here) to bring up its options, and then tap the **Thirds icon** (the third icon from the left) to bring up the rule of thirds grid. The Level icon (on the far right), is a level that actually works really well. It gives you a horizontal line across your image, and if your image isn't straight, it'll be a broken line in three pieces. When your image is perfectly straight, it's a solid line, and check this out: when it's perfectly straight, it "buzzes" your phone (called "haptic feedback"), so you know it's straight without even having to look at the screen.

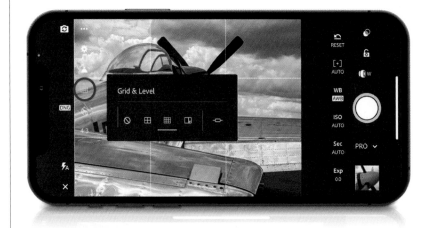

Self-Timer, Image Ratios, and Preferences:

Also in that row of options, on the side (top, if you're holding your phone tall) of the image area, is the Self-Timer icon (the stopwatch), which lets you choose between 2, 5, and 10 seconds before it takes the shot. At the bottom (beginning) of the row, you'll see the numbers "4:3." That's the default aspect ratio (the ratio of the width to the height) for most camera phones. If you tap 4:3, you can choose other ratios in the **Aspect Ratio screen**, including 1:1 (new photos would all be perfectly square), or 16:9 (the ratio of HDTV), or 3:2 (which is a ratio more like a DSLR or mirrorless camera, so it's a little thinner—notice the image here doesn't extend as far to the edge). The Settings (gear) icon has some of Lightroom's camera preferences, like whether to embed GPS location data into your shots, or to automatically set your screen to maximum brightness when using Lightroom's camera. To the left of (above) that row of options is a lightning bolt icon, which as I'm sure you know, turns on/off the flash (phone photography tip: leave it off. Always. It's awful).

Taking Selfies:

To take a selfie, tap the camera icon with the curved arrows (circled here) in the top-left (or top-right) corner. That switches you to the **Front Camera**, so you can take your selfie (from L to R here: my buddy Robby, who took the shot; my buddy Mimo beside him; yours truly; and my buddy "Magic" Juan on the far right. None of that has anything to do with Lightroom, but I wanted to give my buddies a shout out. Okay, more camera stuff to go).

Shooting in HDR Mode:

This is one of my favorite features because when you shoot in HDR mode (which we would do to capture a wider range of tones than a single shot can capture), it uses the same HDR technology as what's in Lightroom Classic. You press the shutter button once, but behind the scenes, it actually takes three images (a normal image, one that's two stops darker, and one two stops lighter), and combines them into a single HDR image. By the way, if you want to shoot HDR, but also want to have Lightroom keep the original "un-HDRed" image, tap on that Settings (gear) icon we looked at earlier, and then tap the toggle switch for Save Unprocessed Original. Take, for example, these two images I took inside a restaurant: In Pro mode (at the top), the detail in the textured/glazed glass is gone, and the highlights are blown out so much that you can't even make out anything outside the windows. When I shoot the same scene in **HDR mode** (tap on PRO, and then tap on High Dynamic Range), look at the difference (seen here, at the bottom). You can see the outside patio, and the texture/glaze in the glass. It captured a much wider range of tones by combining multiple exposures into one image for me.

Burst Mode:

If you want to take a series of photos (like you would with your mirrorless or DSLR camera), just press-and-hold the **Volume Up button** on your phone, and it takes a rapid-fire series of shots. Now, as of the writing of this book, there are a couple of extra camera features that Adobe calls "Technology Previews," so while they're not fully completed features, you can try them out now (of course, by the time you read this, they may be fully baked, in which case, you can ignore the first part of what you're about to read next. But, seeing as these have been stuck in this "preview" state since back in 2018, they may not come out of that preview state at all. Who knows).

Long Exposures:

One of these preview features is Long Exposure, and to start using it today, go to Library view, and tap the Settings (gear) icon in the top right. At the bottom of the Settings menu, tap Technology Previews, then turn on **Long Exposure**, and it's added to the same pop-up menu where PRO and HDR live (next to the shutter button). To create a long exposure, choose it from that menu, then tap the Sec (shutter speed) icon to bring up a slider, where you choose how long you want your exposure to be (up to 5 seconds). It'll show you at the side (top) of the screen exactly how long you set it for (as seen circled here). Now, when you tap the shutter button (and hold your camera very, very still), it takes the long exposure for you.

Depth Map:

This last one, another current technology preview, creates a depth map (we looked at this on page 209). If you have a phone that can create one, like an iPhone, turn on **Depth Map Capture** in the Settings menu (like you just did with Long Exposure). Choose it from the shooting menu (as seen here), take your shot, and it does its thing behind the scenes. You're going to use that embedded depth map as a mask to adjust different parts of the image. (1) Tap on the photo you just took to enter Edit mode, then tap on the Masking icon in the row of edit icons, and then tap the blue **Create New Mask icon**. (2) In the pop-up menu, tap on **Depth Range**, which you can use to affect just certain parts of your photo. (3) To determine which parts, either move the ring that appears onscreen over the area you want to mask (here, I moved it to the background behind the tiny plant); tap on the square icon to the right of Mode, and tap-and-drag out a selection over the part of the image you want to mask; or use the Select Depth sliders. Once your mask is in place, tap Apply and then use the editing tools to adjust only that area in the red-tinted mask.

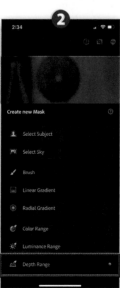
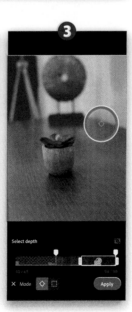

Index

S

ON1 NoNoise AI
The Ultimate Lightroom Plugin for Superior Noise Reduction

LEARN MORE at WWW.ON1.COM

AI-Based Noise Reduction
Produces amazing results by leveraging machine learning to build an AI network to remove luminance and color noise while maintaining the details like no other application.

Super-Fast Live Preview of the Adjustments
View the results instantly versus others apps taking forever to view results. Fewer controls make it easy to adjust results without sacrificing image sharpness to reduce noise.

Combine and Mask
Easily combine multiple renditions of a photo or even multiple photos as layers. This allows you to keep the noise where you want it in your photo and remove it elsewhere.

Before

After

DOWNLOAD SERGE RAMELLI'S LIGHTROOM PRESETS FOR—FREE!

Take Your Images to the Next Level— With Easy Post Processing

At KelbyOne our goal is to provide you with the knowledge and tools to create the type of images you've always dreamed of. This is why we like to occasionally provide free presets, brushes, eBooks and more. Transform your photos in Lightroom with 70 powerful presets created by travel and landscape photographer Serge Ramelli. Serge has provided everything—from B&W to Pastels and Warm Skies to Gloomy Nights— to easily boost your images from good to amazing.

visit kel.by/lspresets to redeem.